THE AMERICAN ART BOOK

Phaidon Press Limited
Regent's Wharf
All Saints Street
London N1 9PA

©1999 Phaidon Press Limited

ISBN 0 7148 3845 4

A CIP catalogue record for
this book is available from
the British Library.

Library of Congress Cataloging
in Publication Data available.

Printed in Hong Kong

Note

The art contained in this book
is the art of the United States
of America. Most of the artists
included in THE AMERICAN ART
BOOK were either born in or
immigrated to America at an
early age. We have also
included some artists who
established a career elsewhere
before moving to America
and others who have made
extended visits to the United
States. Such artists were only
considered eligible if their
stay, whether temporary or
permanent, had an important
influence on them, resulting in
works that have entered the
nation's artistic consciousness.

abbreviations:
c=circa
b=born d=died
h=height w=width l=length
diam=diameter

The publishers have made every
effort to include dimensions
wherever possible. As some
installations consist of multiple
pieces and cover entire rooms
or outdoor spaces, the correct
measurements have been
impossible to acquire and
are therefore omitted.
In the case of photographs, as
prints and negatives vary in
size, dimensions have been
omitted.

THE AMERICAN ART BOOK is a vibrant guide to the most influential and best-loved American artists from colonial times to the present. Covering three centuries, the art ranges from Puritan portraits to the luminous paintings of the Hudson River School and the American Impressionists, to the videos and neon and digital works of today's most intriguing conceptual artists. THE AMERICAN ART BOOK presents 500 artists in an A to Z format that departs from the usual emphasis on genres and time periods: Grandma Moses sits next to Robert Motherwell, and Winslow Homer faces Jenny Holzer, encouraging readers to contemplate the connections between art, American history, and popular culture. Each artist is represented by a full-page color plate of a significant work, accompanied by an informative and engaging text that places the artist in the context of contemporary movements and preceding traditions. The book includes an easy-to-use glossary of terms and artistic movements, and a directory of museums and public collections across the United States and abroad with important holdings in American art, making it a valuable reference work as well as a stimulating way to approach this multifaceted subject.

Φ

Abbott Berenice

The Night View

The lights of Manhattan sparkle with a cheerful clarity in this homage to the skyscraper spirit of the early twentieth century, taken paradoxically in the midst of the Great Depression. By choosing to photograph the buildings at night from a perch on an even taller skyscraper, Abbott makes the city seem virtually abstract. Yet by using a camera that produces a large negative, she renders its every detail with great exactitude. Her inspiration for photographing what she called "Changing New York" — a project that consumed ten years of her life — was the example of Eugene Atget, a photographer of Paris whose work Abbott had saved from extinction during the 1920s, when she was an expatriate living in Paris and working first as an assistant to Man Ray and then as a commercial portrait photographer. In the 1950s Abbott switched gears once again, taking scientific photographs that illustrated basic principles of physics, such as wave interference and the effects of gravity.

☞ Bourke-White, Lozowick, Shaw, Storrs

4

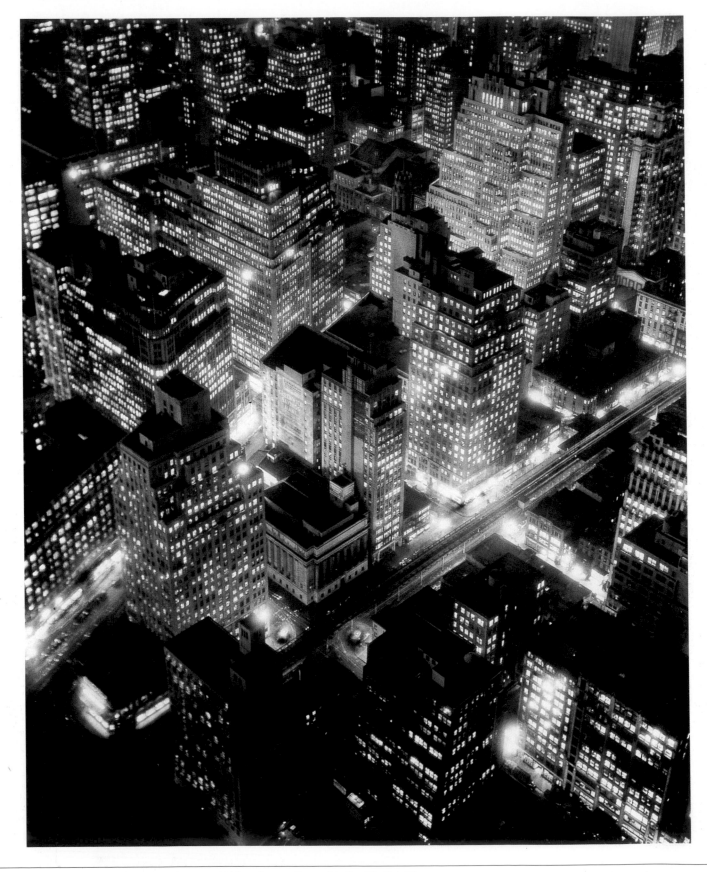

Berenice Abbott. b Springfield, OH, 1898. **d** Monson, ME, 1991. **The Night View.** c1936. Gelatin silver print. Museum of the City of New York, NY.

Acconci Vito

Adaptable Wall Bra

A giant brassiere, made of stiff steel mesh and thick white plaster, is suspended from the gallery walls and ceiling by steel cables. Inside the bra's "cups" are lights and stereo speakers, playing soft radio music. The effect is at once comical, ominous, and strangely comforting; the space inside the bra is, improbably, almost womblike. Acconci was originally a poet and became famous in the 1960s and early 1970s for

his Conceptual performances, which explored the limits of the artist's body as well as of societal acceptance. Acconci's most notorious "action" (*Seedbed*, 1972) involved masturbating under a wooden platform, fantasizing aloud about the viewers walking above. In 1974, Acconci removed himself from his art, turning to installations that demanded viewers' participation and challenged the educational and

commercial function of museums and galleries. Landmarks of the 1970s, Acconci's artworks reference the burgeoning sciences of sociology and psychology, as well as the aggressively intellectual punk and New Wave music of the time.

☛ **Bourgeois, Burden, Oldenburg, Wesselman**

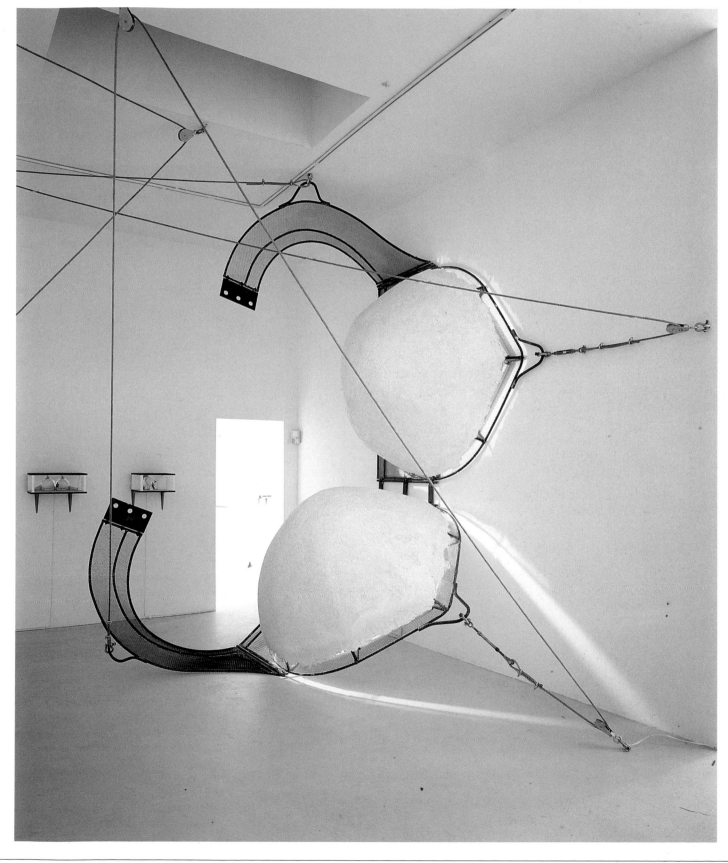

5

Vito Acconci. b New York, NY, 1940. **Adaptable Wall Bra.** 1990. Rebar, plaster, canvas, steel cable, audio and lights. Each cup: **h**8 x **w**8 x **d**3 ft. **h**2.43 x **w**2.43 x **d** .91 m. Barbara Gladstone Gallery, New York, NY.

Adams Ansel

Moon and Mount McKinley, Denali National Park

The natural landscape has seldom been recorded with such splendid majesty as in this photograph of the tallest mountain in the United States. A flat, horizontal foreground merges into striated foothills that in turn reach toward the regal mountaintop piercing the sky. Adams's mastery of the black-and-white process is such that the mountain and its surrounding foothills overwhelm the imagination.

For the most part Adams is known as the photographic bard of Yosemite Valley, but after World War II he embarked on a project to photograph in all of the country's national parks, capturing breathtaking vistas as well as more intimate details of nature. A member of Group f.64 that formed in California in 1932 around Edward Weston, Adams adhered to the notion that the sharper the picture,

the better. In addition to his photographs, Adams gained fame for his ardent environmentalism, mostly on behalf of the Sierra Club, and for long advocating the recognition of photography as an art.

☛ Dove, T. Hill, Kent, C. M. Russell, Watkins, Weston

6

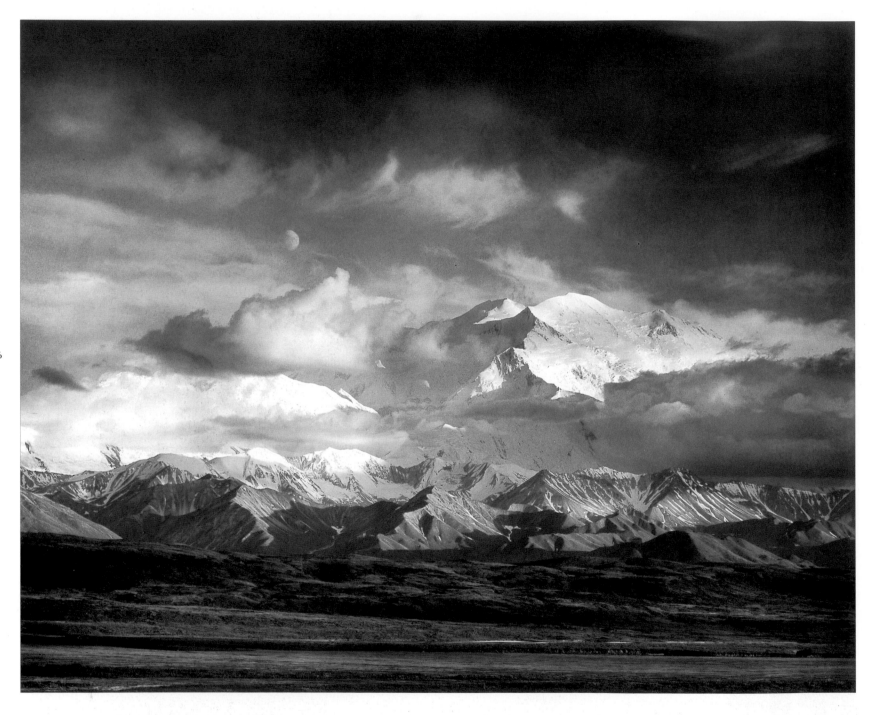

Adams Robert　　　　Colorado Springs, CO

The architecture of this suburban house is unremarkable except that the parallel alignment of two windows allows for a view through the front window to the back. Light also passes directly from back to front, creating a bright rectangle where the silhouette of a woman lends a degree of poignancy to what otherwise could seem a sterile image. Adams took the picture at the beginning of his career and included it in his book *The New West: Landscapes Along the Colorado Front Range. The New West* and a subsequent book, *Denver,* were Adams's attempt to document the changing face of the West using a style characterized by restraint and subtlety that came to be known as New Topography. Of all contemporary landscape photographers, Adams is most capable of conveying a love for the natural world and its endurance in the face of man's deprecations.

☛ Baltz, Christenberry, Graham, Strand, Traylor

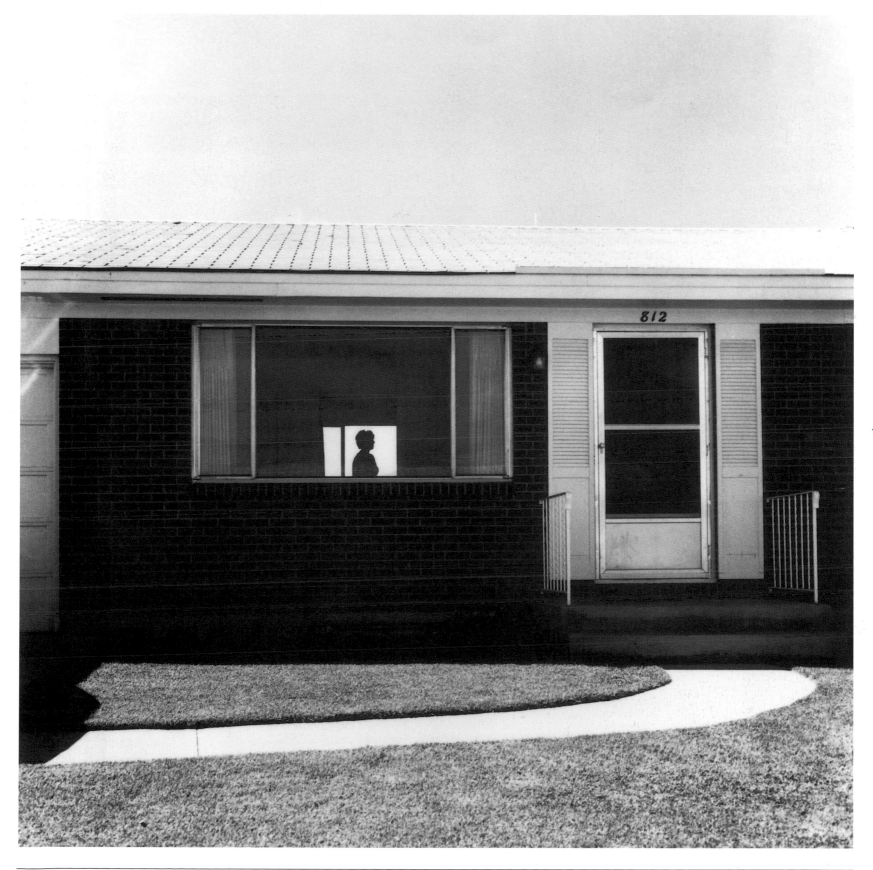

Robert Adams. b Orange, NJ, 1937. **Colorado Springs, CO.** 1968. Gelatin silver print. Fraenkel Gallery, San Francisco, CA.

Albright Ivan Le Lorraine Poor Room

The ransacked interior and the disembodied hand resting on the sill have macabre overtones — with money and valuables strewn about, it seems as if there has been a break-in and possibly a murder. Around the window, grotto-like encrustations add to the memorial quality. The painting's lengthy subtitle, *There is No Time, No End, No Today, No Yesterday, No Tomorrow, Only the Forever, and*

Forever and Forever Without End (The Window), suggests an existential limbo, described in suffocating detail. Albright was so well known for his fascination with decadence that he was commissioned to portray Dorian Gray for the 1945 film *The Picture of Dorian Gray,* starring Hurd Hatfield. In his own view, however, his paintings were loving tributes to his subjects, no matter how grotesque. Entirely

unresponsive to the major trends in contemporary art, Albright revised his canvases continually, reinforcing their impression of time's ravages by allowing them to evolve in real time.

☛ Cornell, Jess, Samaras, Tanning

8

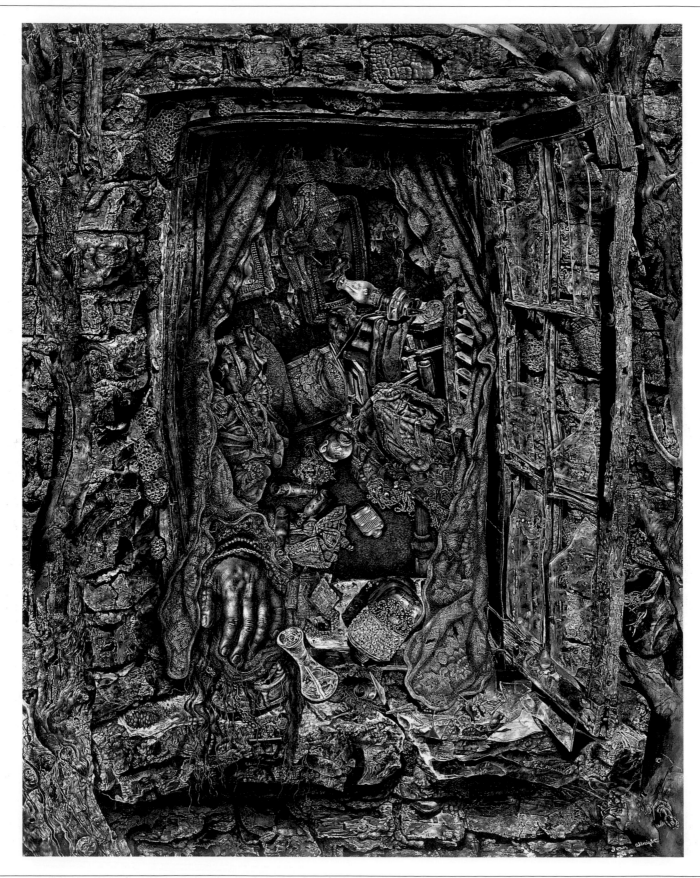

Ivan Le Lorraine Albright. **b** Chicago, IL, 1897. **d** Woodstock, VT, 1983. **Poor Room.** 1942–43, 1948–55, 1957–63. Oil on canvas. **h**48 x **w**37 in. **h**121.9 x **w**94 cm. The Art Institute of Chicago, IL.

Alexander John White

Portrait of Mrs. John White Alexander

Strong light plays across the face of a beautiful woman who sits on a balustrade overlooking a loosely painted landscape consisting of foliage and sky. The artificial illumination, her romantic costume, and landscape elements that register more as a stage set than as nature emphasize the theatricality of the scene. These elements also add meaning to this portrait of the artist's wife, Elizabeth, by underscoring her talents as a costume and stage designer. The sweeping, sinuous lines that enclose broad areas of muted, rich color manifest Alexander's alignment with Symbolist ideas he absorbed in Paris from 1890 to 1901. From his associations with such writers and artists as Stéphane Mallarmé, Octave Mirabeau, and James McNeill Whistler, Alexander developed a style based on the emotive potential of line. A prominent figure in the American arts after the turn of the century, Alexander was also a noted muralist and served as president of the National Academy of Design.

☛ Hathaway, Glackens, Sully, W. Williams

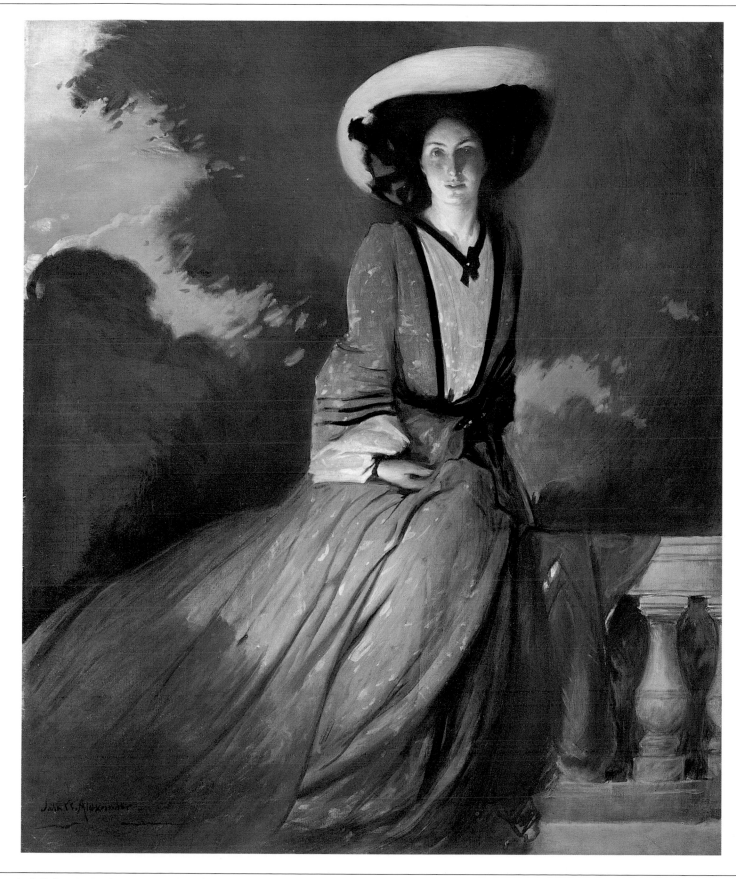

John White Alexander. b Allegheny, PA, 1856. **d** New York, NY, 1915. **Portrait of Mrs. John White Alexander.** 1902. Oil on canvas. **h**62¼ x **w**52⅛ in. **h**158.2 x **w**132.4 cm. Los Angeles County Museum of Art, CA.

Allston Washington

Moonlit Landscape

Moonlight floods a placid landscape, endowing this scene with a sense of mystery in accord with Allston's reputation as the foremost representative of the Romantic tradition in early nineteenth-century American art. Although no specific narrative is evident, this painting is generally believed to signal Allston's recognition of a transitional point he had reached in his career.

The bridge spanning the water may symbolize his recent Atlantic crossing, and the light streaming through the center of the composition is often interpreted as the hope he held for his future. The first work he executed in the United States after living six years in Europe, this painting marks Allston's resumption of landscape subjects. It bears the fruits of his admiration for the great Baroque landscapist Claude Lorrain and the luminous works of his English contemporary J. M. W. Turner.

☞ A. Adams, Blakelock, Gottlieb, Mark, Ryder

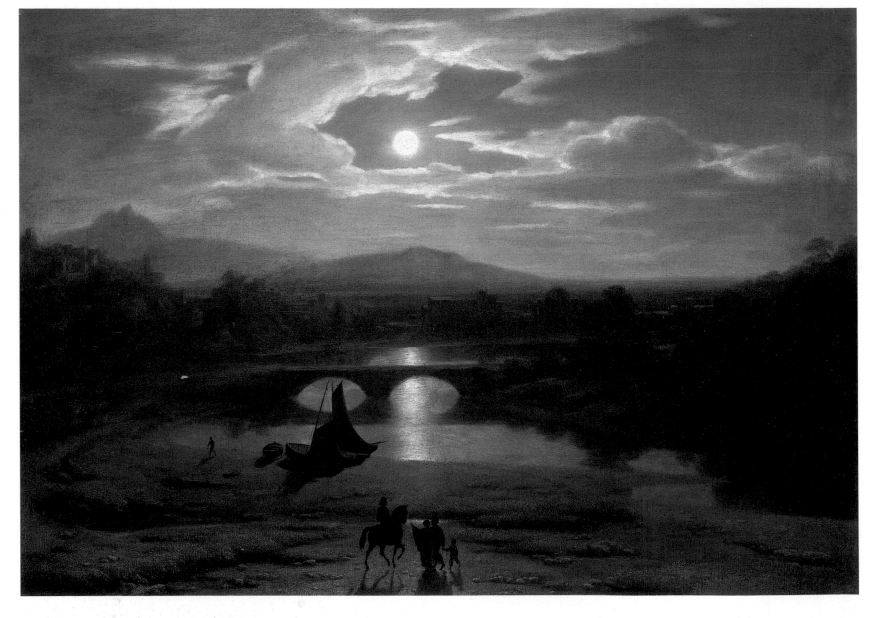

10

Washington Allston. b Charleston, SC, 1779. d Cambridgeport, MA, 1843. **Moonlit Landscape.** 1819. Oil on canvas. **h**24 x **w**35 in. **h**61 x **w**89 cm. Museum of Fine Arts, Boston, MA.

Andre Carl

Equivalent I

Sand-lime bricks are arranged on the gallery floor in a precise configuration of three units by twenty units, as if left by a particularly fastidious construction crew. *Equivalent I* is one part of a series of four similar sculptures, each consisting of 120 bricks arranged in rectangles of varying sizes. Andre is a paragon of Minimalism, the movement that sought to reduce art to its most basic elements.

Andre has described the idea behind his art as "form = structure = place," an ethos similar to that of Earth artist Robert Smithson. In other artworks, Andre has used huge blocks of orange Styrofoam, steel and copper plates, wood, and plastic, evoking industrial sites and decaying urban outskirts. Before his "Equivalents," Andre made conventional sculpture in the style of Constantin Brancusi. His radical

decision to make art flat on the floor came in 1965, while he was canoeing on the mirror-smooth waters of a New Hampshire lake.

☛ Crawford, Judd, Lewitt, Penn

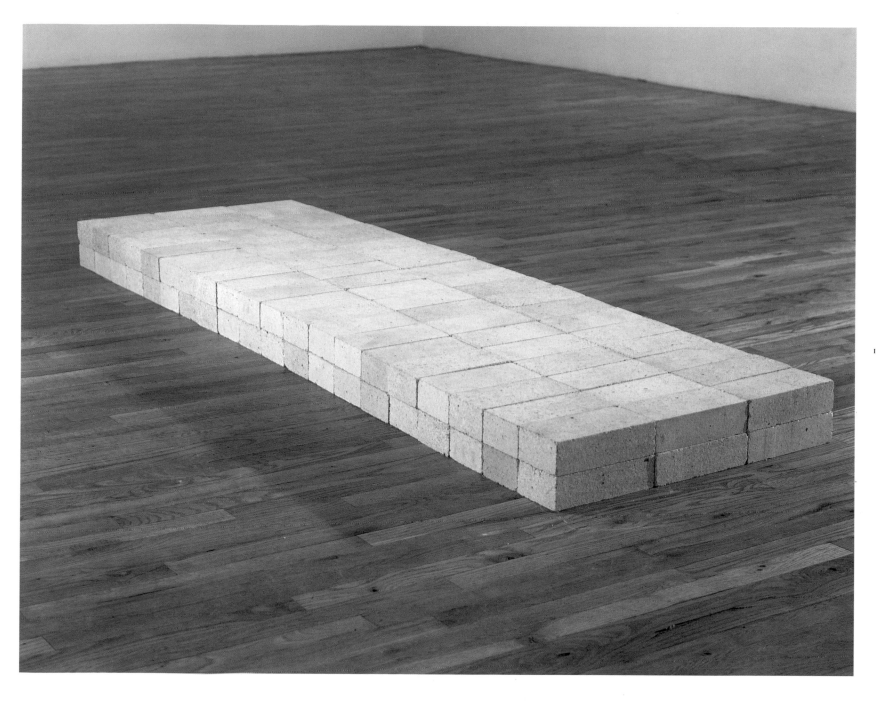

II

Carl Andre. b Quincy, MA, 1935. **Equivalent I.** 1966 (destroyed), 1969 (remade). Sand-lime brick/firebrick, 120-unit rectangle. Overall dimensions: **h**2½ x **w**27 x **d**90 in. **h**6.4 x **w**68.6 x **d**228.7 cm. Kunstmuseum, Basel, Switzerland.

Anshutz Thomas

The Ironworkers' Noontime

Under the shadow of the huge ironworks where they labor, exhausted men rest briefly, preparing to return to the heat of the furnaces. Soaked with sweat, they remove their clothes, stretch their weary, pale limbs, and douse themselves with water in an effort to reclaim the energies lost in the grueling toil of the day. While Anshutz's painting seems to exalt the nation's increasing industrial power, it also focuses on the numbing effects of factory work. The duality is underscored by the foremost figure, who may at first seem to be flexing his muscles in a show of strength, but on second look is massaging a painful arm. Anshutz was one of the first American painters to focus on realistic depictions of American life rather than on allegorical scenes or European-derived themes. Trained by Thomas Eakins, he applied the Realist theories of his teacher to create in this unusual work a rare glimpse of social and anatomical truth that conflicted with the genteel aesthetics that prevailed in the arts at the time.

☞ Davies, Eakins, Hine, Nahl, Neagle, J. A. Weir

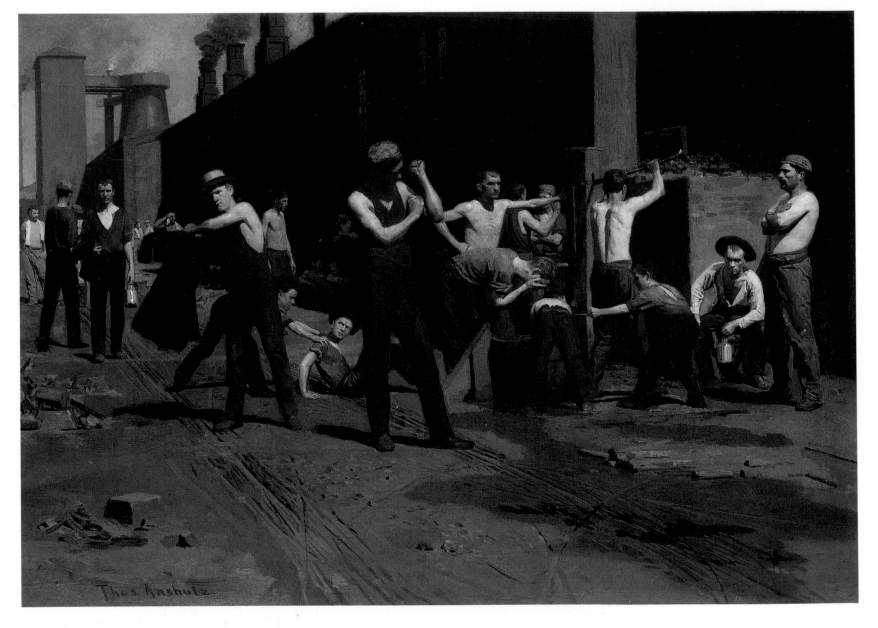

12

Thomas Pollock Anshutz. b Newport, KY, 1851. **d** Washington, PA, 1912. **The Ironworkers' Noontime.** 1880. Oil on canvas. **h**17 x **w**23⅞ in. **h**43.2 x **w**60.6 cm. Fine Arts Museums of San Francisco, CA.

Aragón Jose Rafael

El Alma de la Virgen (Virgin with Dove)

The Virgin Mary is seen here in a quiet moment of spiritual reverie, surrounded by her traditional symbols: halo, dove, and lily. These elements are reduced to simple geometric forms — the halo a series of single brushstrokes, the lily a three-pronged suggestion of a flower on a stalk, and the dove a triangular shape evoking the Holy Spirit. This work is a *retablo*, a devotional painting of pigment on wood found in church interiors and above private altars. Artists such as Aragon who were active in Spanish colonial New Mexico in the early nineteenth century were influenced by traditional Catholic religious imagery from Mexico and Spain. Their work, however, is distinguished by bolder lines, inventive color combinations, and figures depicted in a more abstract style. Aragon established his reputation through commissions for several monumental altar screens for parish churches in the Santa Cruz Valley. As he became increasingly successful he traveled extensively throughout this area, although he also maintained a studio with several assistants.

☛ Beaux, Hirshfield, Kuhn, Ramirez

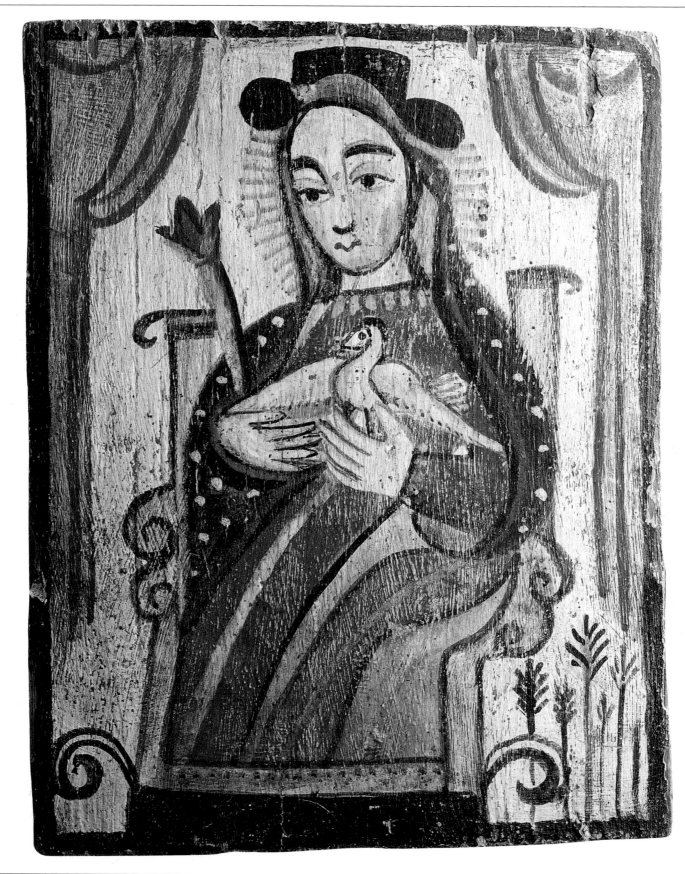

13

Jose Rafael Aragón. **b** (city unknown), NM, c1795. **d** (city unknown), NM, 1862. **El Alma de la Virgen (Virgin with Dove)**. c1840–60. Tempera and gesso on wood. **h**11⅜ x **w**8½ in. **h**29 x **w**21.7 cm. Museum of International Folk Art, Santa Fe, NM.

Arbus Diane

Teenage Couple on Hudson Street, N. Y. C.

As awkward as children dressed in their parents' clothing, these teenagers seem determined to project into the world their own sense of adulthood. Yet their illusion is undermined by the photographer's scrutiny, which has fixed them, immobile and vulnerable, like butterfly specimens. By pointing the camera down toward the sidewalk, Arbus has foreshortened the couple and made their heads appear too large for their bodies. Arbus is best-known for taking pictures of circus freaks and other people with unusual, obvious traits, but in all her photographs there is a sense of the thin line between the familiar and the strange. While she took many of her pictures on assignment for magazines, she also exhibited them in museums and galleries, most importantly in a 1967 exhibition called *The New Documents* at The Museum of Modern Art in New York. In 1972, following her death, a retrospective exhibition of her work opened at The Museum of Modern Art and attracted more than 250,000 viewers.

☛ **Bishop, Disfarmer, Levitt, Winogrand**

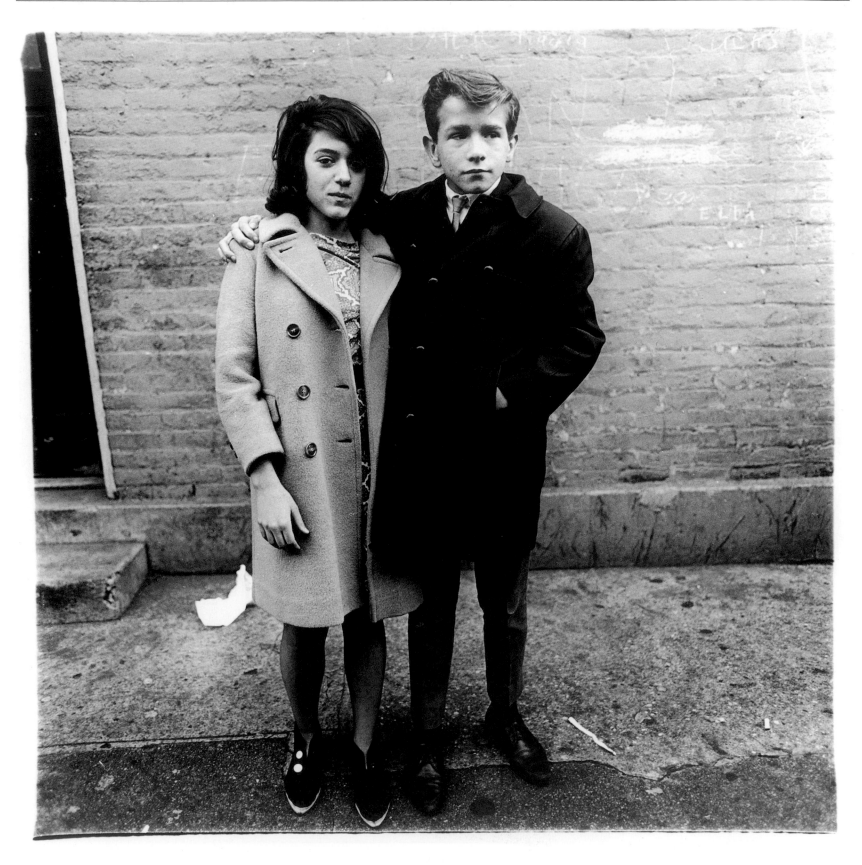

Diane Nemerov Arbus. b New York, NY, 1923. **d** New York, NY, 1971. **Teenage Couple on Hudson Street, N. Y. C.** 1963. Gelatin silver print. Robert Miller Gallery, New York, NY.

Arneson Robert

Self-portrait of the Artist Losing His Marbles

A ceramic bust of Arneson, glazed in metallic blue and silver, is split down the middle; spilling out of the crack is a trail of glass marbles encased in clear epoxy. This is the first of Arneson's self-portraits, a form for which he would later become famous. The sculpture was originally intended to express a standard likeness, but when the clay cracked in the kiln, Arneson took advantage of the accident by adding marbles and a punning title. Arneson was a pioneer of "Funk Art," a jovial and ironic West Coast reaction to the seriousness of New York-based Abstract Expressionism and Pop. His portraits in clay turned more somber and political in 1981, however, after San Francisco refused to display his controversial bust of the city's assassinated mayor. His later works have referenced nuclear power and warfare, race relations, and the artist's own battle with cancer.

☛ Coburn, McIntire, Nixon, Hiram Powers

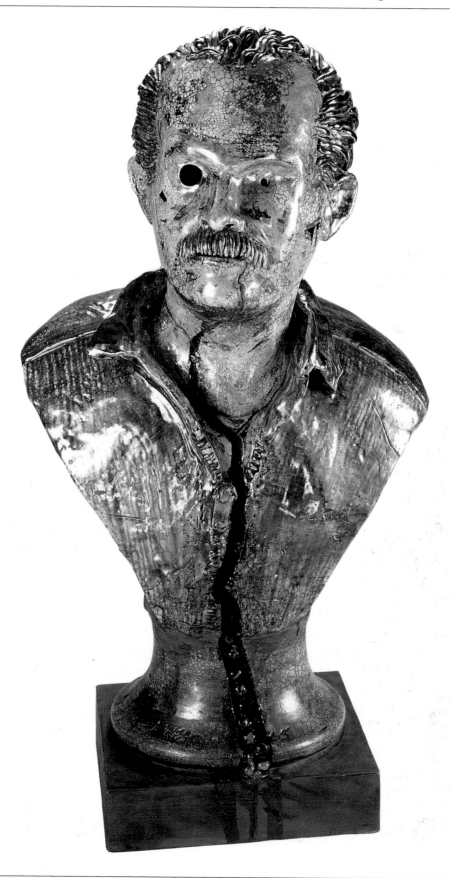

Robert Arneson. b Benicia, CA, 1930. **d** Benicia, CA, 1992. **Self-portrait of the Artist Losing His Marbles.** 1965. Earthenware, lustre glaze. **h**31 x **w**17½ x **d**9½ in. **h**78.8 x **w**44.5 x **d**24.1 cm. American Craft Museum, New York, NY.

Artschwager Richard

Table with Pink Tablecloth

Three colors of Formica create a waist-high table: pink for the table-cloth, white for the table legs, and black for the empty space below. Artschwager calls *Table* a "painting pushed to three dimensions." Essentially, it is a two-dimensional representation that unfolds, like illustrations in a child's pop-up book. Artschwager describes the conceptual goal of his art as "thought experiencing itself." His sculptures

and paintings wend a path through Minimalism, Conceptualism, and Pop Art, thwarting convention at every turn. Unlike Pop, Artschwager's approximations of furniture do not take excessive liberties with their source material, in this case, a table. Unlike Minimalism, they do not transform them into pure abstraction. Artschwager's use of industrial construction materials like Formica and Celotex (a fibrous painting

support) is rooted in his previous career as a designer and builder of furniture. These materials also serve to distance his artworks from art-historical landmarks of preciousness and privilege.

☞ Bartlett, Halley, Judd, Oldenburg

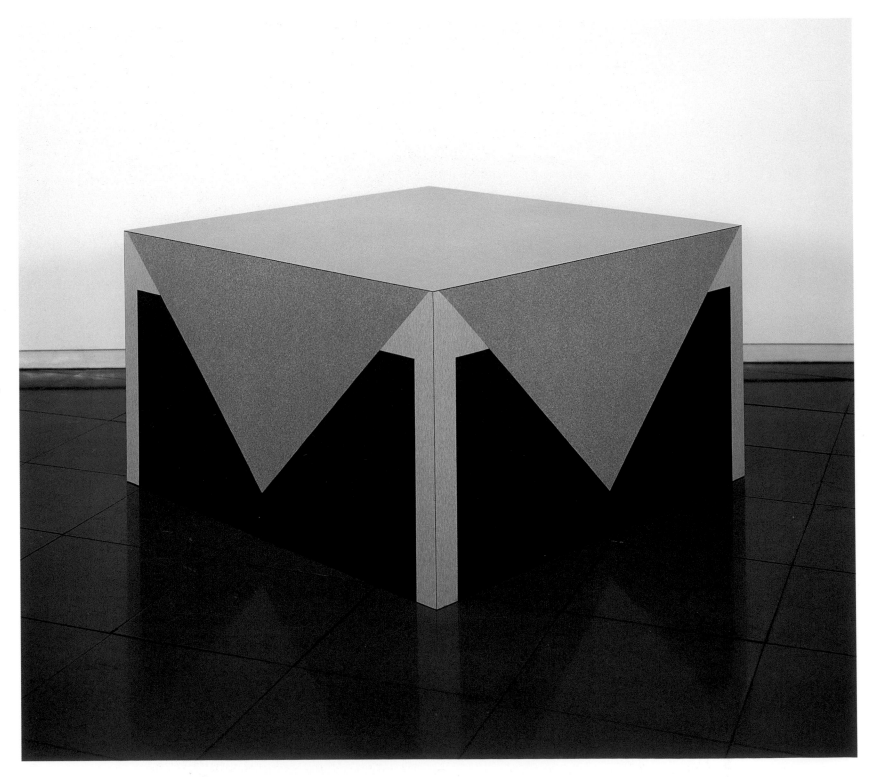

Richard Artschwager. b Washington, D.C., 1923. **Table with Pink Tablecloth.** 1964. Formica/wood. **h**25½ x **w**44 x **d**44 in. **h**64.8 x **w**111.8 x **d**111.8 cm. Mary Boone Gallery, New York, NY.

Audubon John

Great Blue Heron

The magnificent Great Blue Heron fills the composition, its long neck forming a characteristic sweeping downward curve as the bird surveys the water for fish. This large watercolor is one of more than four hundred that appeared in engraved form in Audubon's portfolio, *Birds of America*. The portfolio, issued over a ten-year period, presented Audubon's painstaking record of all known species of birds inhabiting North America. Unlike many previous scientific catalogs, Audubon's watercolors and prints depicted the birds in their natural settings and incorporated an aesthetic sensitivity that elevated them to works of art. Audubon was raised in France, where he reportedly studied briefly with the Neo-Classical painter Jacques-Louis David before emigrating to America in 1803. The clean lines and disciplined, elegant composition of his paintings reflect David's influence, but the passion for ornithological studies that Audubon had held since childhood proves the source for these remarkable documents.

☛ Bates, Bellamy, Catesby, Heade, Pope

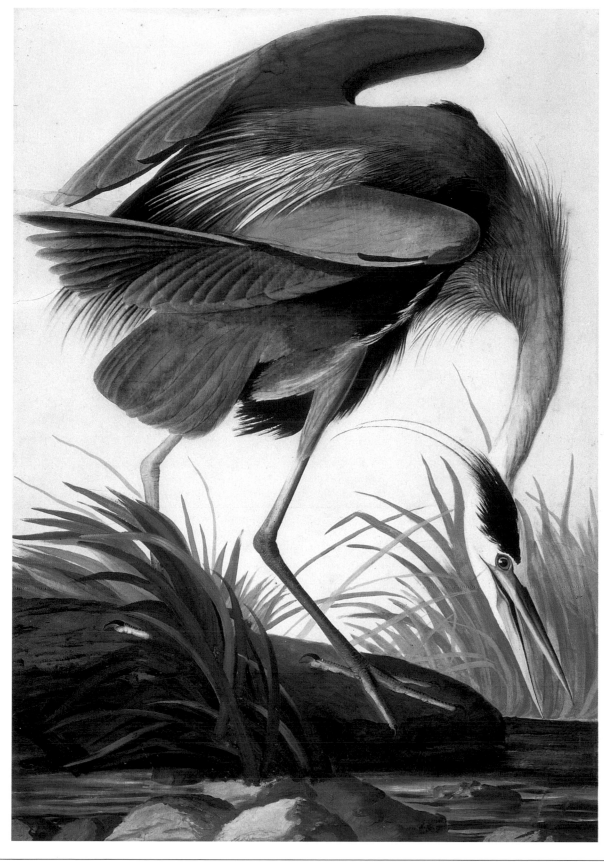

John James Audubon. b Les Cayes (now Cayes), Haiti, 1785. **d** New York, NY, 1851. **Great Blue Heron.** 1821, 1834. Watercolor and oil. **h**36 x **w**25⅜ in. **h**91.5 x **w**64.5 cm. The New-York Historical Society, New York, NY.

Avedon Richard

Bill Curry, drifter, Interstate 40, Yuko, Oklahoma, June 16, 1980

The confident but wary appraisal in the eyes of this man, hardened by the elements and by time spent on the road, suggests that he has become accustomed to dealing with unfamiliar, potentially dangerous circumstances. Avedon is one of the world's most renowned portrait photographers, and since the late 1950s he has also focused on black-and-white reportage. In photographing Bill

Curry, Avedon has isolated him from his surroundings by using a white studio backdrop that creates the same penetrating focus that Avedon captures in his portraits of cultural figures, politicians, and other notables. Curry is one of a number of drifters, prison inmates, cowboys, coal miners, and people of other occupations whose portraits Avedon published in his 1985 book *In the American West*.

Although the book may have presented a gritty view of the West, its subjects are photographed with the same uncompromising technical facility and psychological insight that Avedon has brought to his projects throughout his fifty-year career.

☞ **Clark, Disfarmer, Gardener, Kane**

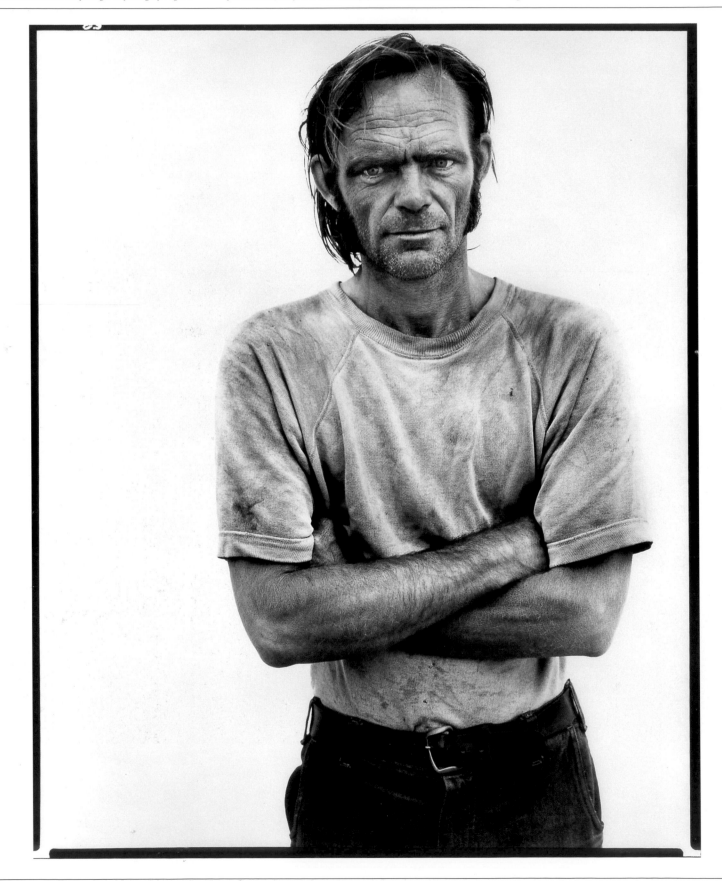

Richard Avedon. b New York, NY, 1923. **Bill Curry, drifter, Interstate 40, Yuko, Oklahoma, June 16, 1980.** Gelatin silver print. Richard Avedon Studio, New York, NY.

Avery Milton

Surf Fisherman

A morning fishing scene is dissolved into a series of muted colored and textured shapes set against horizontal bands of color. There is no question what these elements represent: scavenging gulls, the morning's catch laid out on the sand, and the fisherman himself. The man's fishing tackle is not shown, yet his posture and position of his hands clearly convey that he is reeling in a fish. In this characteristic canvas, Avery has eliminated all nonessential details and concentrated on evoking mood through color. Working outside the artistic mainstream, he developed an approach to figural abstraction akin to Arthur Dove's "extraction" of nature motifs. Avery progressively simplified his compositions as he clarified and refined his approach. He eventually arrived at his primary strategy — the juxtaposition of a few flattened shapes and simplified textures in shallow space. His poetic use of color and his understated, accomplished style were admired by many of his fellow painters, including Mark Rothko and Adolph Gottlieb.

☛ **Baziotes, Mount, Rothko, Thompson**

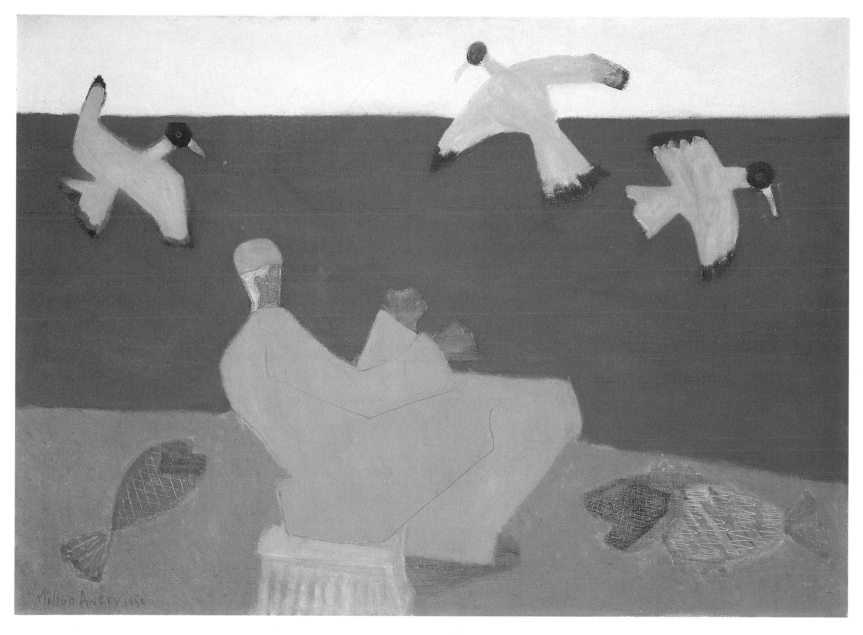

Milton Avery. b Altmar, NY, 1893. **d** New York, NY, 1964. **Surf Fisherman.** 1950. Oil on canvas. **h**30 x **w**42 in. **h**76.2 x **w**106.7 cm. Smith College Museum of Art, Northampton, MA.

Bailey William

Manhattan Still Life

A serene tableau of bowls, pitchers, and cups emerges dramatically from a dark background, appearing at turns realistic and almost abstract. Bailey has said his goal is to make modern art that is true to lived experience; by strict definition, this is a contradictory plan. Bailey's carefully modeled still lifes and female nudes maintain complex relationships to the tenets of Abstraction and Minimalism.

Bailey studied at Yale University with the German expatriate Josef Albers, the dean of American Abstract painting; his juxtaposition of subtle colors, as in the blue and green stripes on the crockery in this painting, reveals Albers's influence. But the dramatic chiaroscuro of the objects emerging from blackness is a homage to Bailey's other influences, classical Italian painters such as Titian and Caravaggio.

Bailey names his paintings after the palettes they reflect. In this case, the dour greenish gray of the background evokes the concrete corridors of New York City on a rainy day.

☞ Francis, Groover, Hunt, Penn

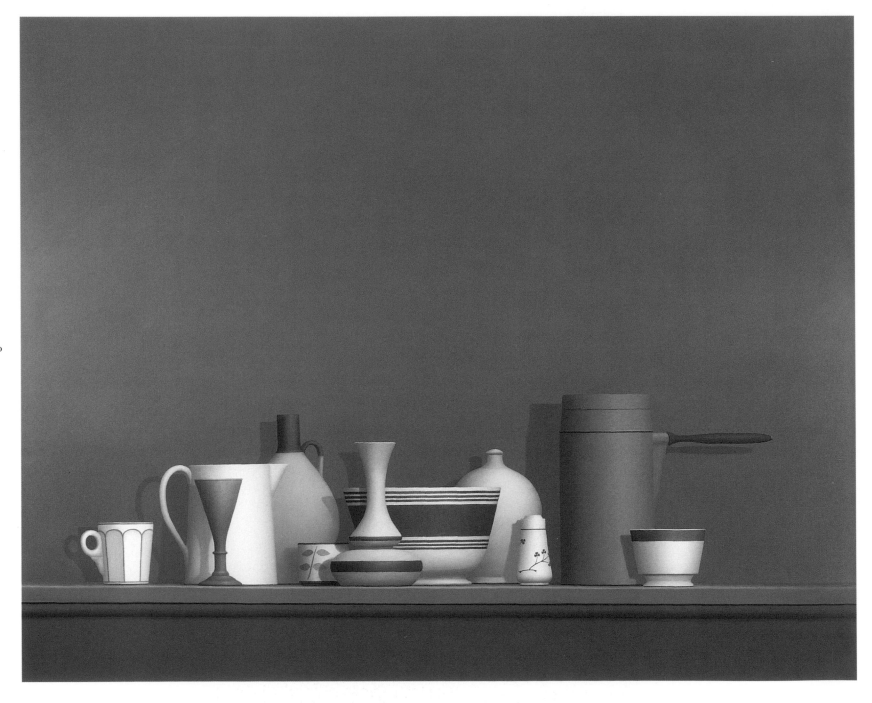

20

William Bailey. b Council Bluffs, IA, 1930. **Manhattan Still Life.** 1980. Oil on canvas. **h**40 x **w**50 in. **h**101.6 x **w**127 cm. Barbara Mathes Gallery, New York, NY.

Baldessari John

Two Stories

Three columns of photographs tell three different kinds of stories. On the left is a history of Jesus, made up of movie stills and found photographs, and on the right is a series of images whose only commonality is that each contains yellow grass. In between is a woman and an accordion, with a different key painted in each otherwise identical frame. As in the music of John Cage, Baldessari's

Conceptual collages thwart standard ways of reading while encouraging alternative avenues of thought: In *Two Stories*, for example, the strongest story may be the "filler" in the middle, where the colored accordion keys change with regularity. Unlike other artists who became famous in the 1980s for their work with media imagery (such as Cindy Sherman and Richard Prince), Baldessari is not interested

in the particular history of his sources. In fact, his signature colored dots cover up these landmarks of personality, nudging our attention to the interesting corners.

☞ Rauschenberg, Shaw, Warhol, Wojnarowicz

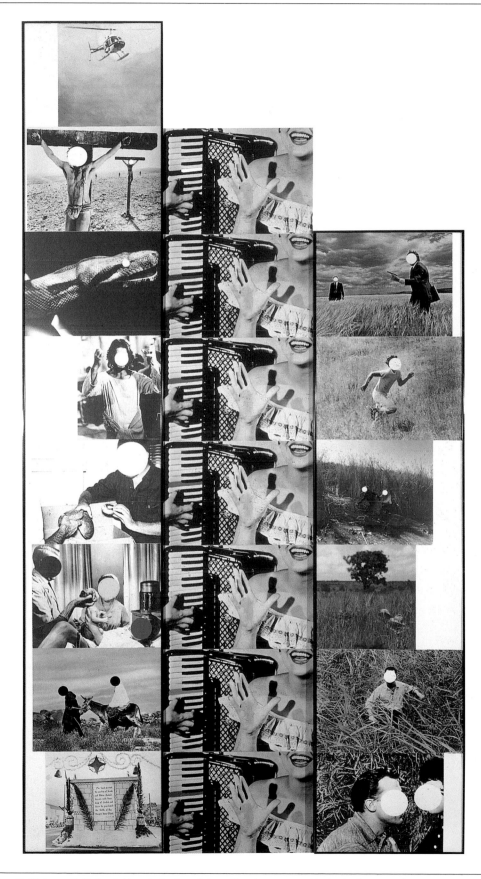

21

John Baldessari. b National City, CA, 1931. **Two Stories.** 1987. Oil tint, acrylic, black-and-white and color photos. **h**96 x **w**50⅞ in. **h**244 x **w**129 cm. Sonnabend Gallery, New York, NY.

Ball Thomas

The Emancipation Group

As he holds a parchment representing the Emancipation Proclamation, Abraham Lincoln solemnly gestures for a man, newly freed from slavery, to rise. Ball's image of Lincoln as the liberator of the nation's slaves was extremely popular in the decades after the Civil War, especially in the north, where life-size bronze versions were installed in Washington and Boston. Ball's early job as an errand boy at a

Boston museum probably sparked his interest in the arts. He began as a painter, but, lacking formal training, suddenly shifted to sculpting in the early 1850s. Ball sailed for Europe in 1854 and settled in Italy, where he became friends with the noted sculptor Hiram Powers. Ball eventually received a number of important commissions for public monuments commemorating national heroes, and he is best known

for these and for his 1853 bronze statuette of the Massachusetts orator Daniel Webster — one of the first American sculptures to be mass-produced in editions for the domestic market.

☞ Peto, Rogers, Spencer, Walker

22

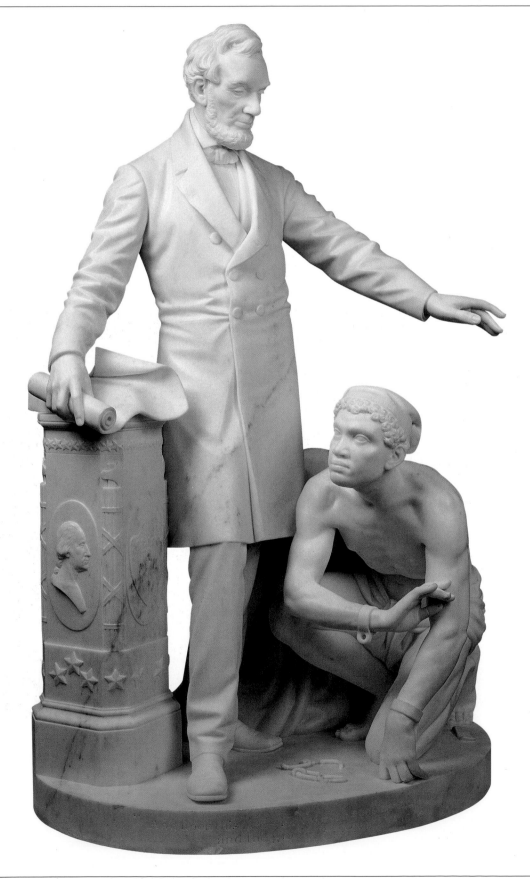

Thomas Ball. b Charlestown, MA, 1819. d Montclair, NJ, 1911. **The Emancipation Group.** 1872. White marble. **h**44 in. **h**111.8 cm. Private collection.

Baltz Lewis

Southwest Wall, Vollrath, 2424 McGraw, Irvine

The dark, nearly featureless facade of this building seems an unlikely subject for artistic attention, but it is precisely its lack of distinctive qualities that makes it fascinating. Unlike most architecture, its simple boxy form provides little hint of its function. Only the title gives us a clue that the building is part of a large industrial complex erected in Southern California in the late 1960s. The structure also resembles Minimalist sculpture, such as a cube fashioned by Donald Judd. In framing the scene so that most of the building's context is hidden, Baltz shows an appreciation for its abstract form. He was part of an influential photography movement in the 1970s called New Topography. Much as mapmakers chart territory, this group focused with a purposefully dispassionate, unsentimental eye on the landscape as altered by humans. In his subsequent photographs, Baltz has sought to analyze the ways in which the built environment influences human behavior.

☞ Flavin, Halley, Marden, N. Spencer

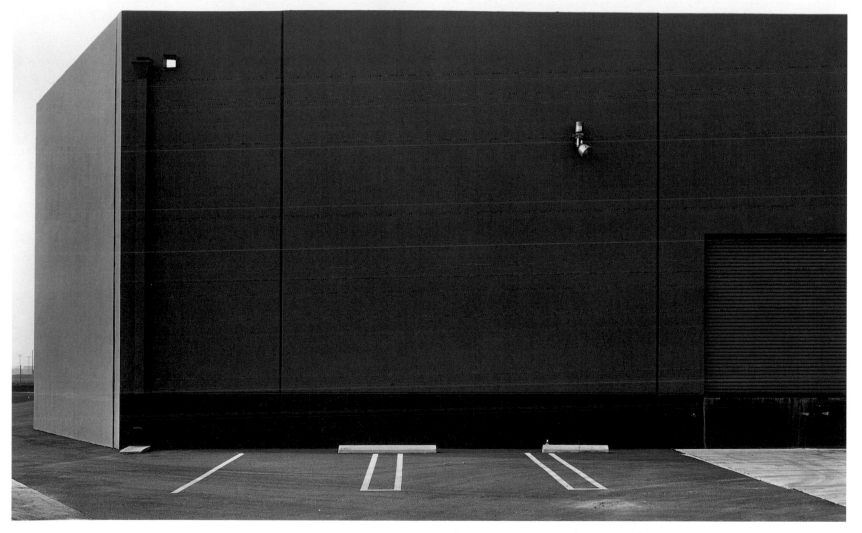

Lewis Baltz. b Newport Beach, CA, 1945. **Southwest Wall, Vollrath, 2424 McGraw, Irvine.** Gelatin silver print. Collection of the artist.

Bard James

Glen Cove

Flags flying proudly and smoke puffing modestly, a crisp white paddle steamer plies the waters of New York's Hudson River, carving a wake in the blue water just as clouds animate the late afternoon sky above. The ship's flag obscures the national one, but the painting unquestionably celebrates American prosperity as well as local enterprise. Over a long career that began in collaboration with his twin brother, John, James Bard was said to have painted over three thousand ships and "made drawings of almost every steamer that was built at or owned around the port of New York." Collecting measurements in shipyards, often while his subjects were under construction, he prepared and annotated meticulously detailed pencil drawings that were transferred to watercolor or oil. Bard painted the *Glen Cove* the year after she was commissioned, presumably for the ship's builder, Thomas Collyer, whose name is inscribed on the painting opposite the painter's signature and address.

☞ **Colman, Persac, Rush, Tirrell**

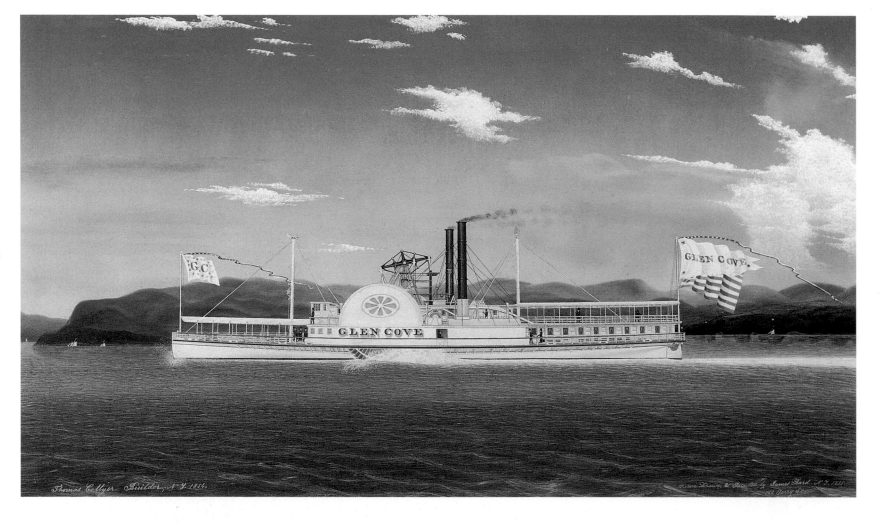

James Bard. b New York, NY, 1815. **d** White Plains, NY, 1897. *Glen Cove.* 1855. Oil on canvas. **h**30 x **w**52½ in. **h**76.2 x **w**133.4 cm. Private collection.

Barnard George

Burning Mills, Oswego, NY, July 5, 1853

The blazing skies and billowing smoke tell the story even now: On the night of July 5, 1853, the New York village of Oswego was nearly destroyed when the town mills burned to the ground. A relatively new breed of businessman in the town, a Daguerreotypist, roused himself and took this exquisite picture of the blaze despite using quite primitive and bulky equipment. As a result, George

Barnard can lay claim to having taken the first news photograph made in the United States. His enterprise surely paid off, for he later sold copies of this and other fire pictures, as well as "views of the ruins as they now appear," to the townsfolk. Barnard would get another opportunity to photograph ruins during the Civil War when, as a military photographer, he documented General Sherman's

legendary and pyrotechnic "March to the Sea" in 1864. He was also employed for a time by Mathew Brady, the great entrepreneur of Civil War photography.

☞ Deas, Misrach, Tirrell, Westermann, Whistler

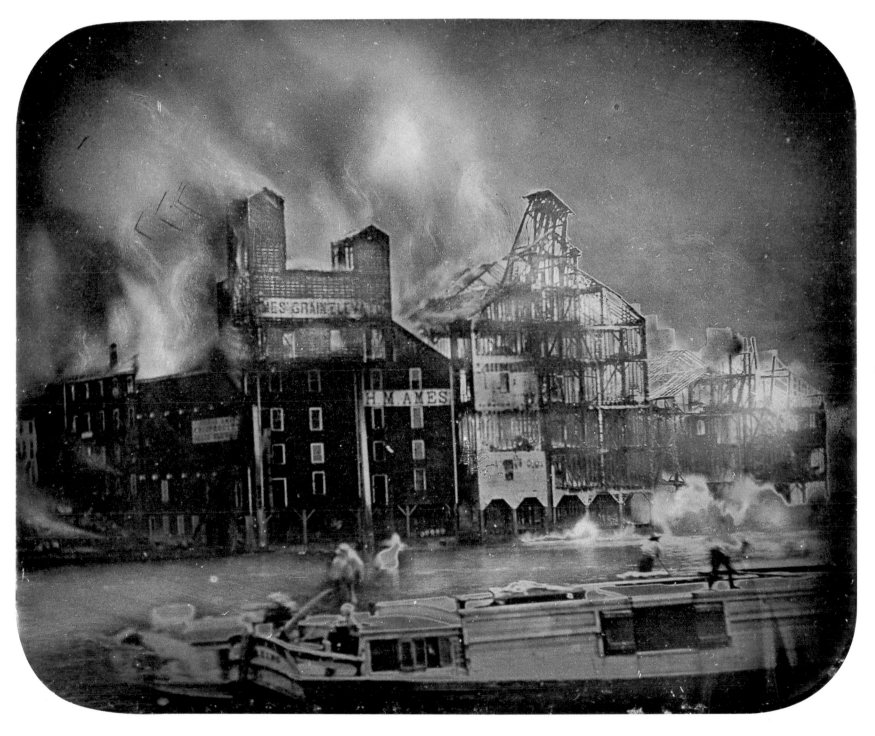

George Barnard. b New York, NY, 1819. d New York, NY, 1902. **Burning Mills, Oswego, NY, July 5, 1853.** One-sixth plate Daguerreotype. George Eastman House, Rochester, NY.

Barney Matthew

CR I: Goodyear Chorus

Who is this enchanting woman walking gracefully toward us, dressed in a layered Art Deco hoop skirt, alabaster hands grasping the taut lines of two miniature Goodyear blimps? And what is the blue football field where she and her Busby Berkeleyesque chorus stand, with goalposts rising like odd companions to the hovering blimps? This glamorous blonde is the character Goodyear, star of *Cremaster 1*,

the first of Barney's five-part video epic begun in the mid-1990s and scheduled for completion in 2000. In the "Cremaster" cycle (the cremaster muscle controls the ascent and descent of the testicles) biology, art, mythology, and Barney's singular aesthetic vocabulary — drawn from athletics, popular culture, and an interest in sculpture and narrative — merge in a complex set of references. *Cremaster 1*,

described by Barney at its premiere in 1995 as a "biological farce," presents the initial stages of a form coming to terms with, and resisting, processes of differentiation.

☛ Davies, G. Hill, W. Kuhn, Mayer

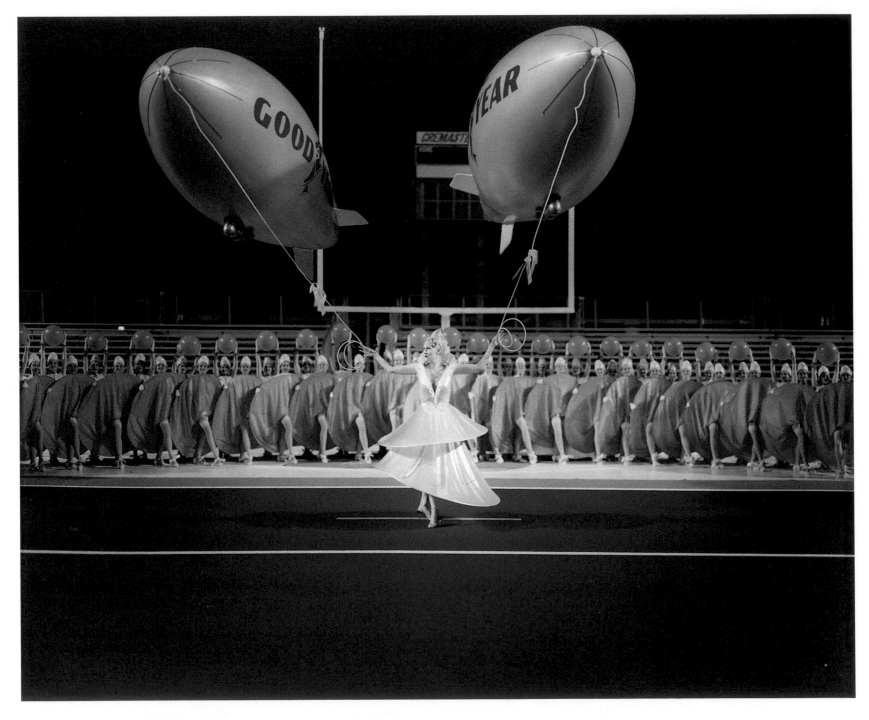

Matthew Barney. b San Francisco, 1967. **CR I: Goodyear Chorus.** 1995. C-print in self-lubricating plastic frame. **h**43¾ x **w**53¾ in. **h**111.2 x **w**136.6 cm. Barbara Gladstone Gallery, New York, NY.

Barney Tina

Sarah, Mike, and Michael

This photograph places as much emphasis on the furniture and furnishings as it does on the people who inhabit the space. The nearly empty built-in hutch and pristine wallpaper tell us that the house is perhaps a summer rental, while the model ship being assembled on the dining table suggests an attempt to entertain the children while parents relax elsewhere. In the original, large-scale (4 x 5 ft) print of this color photograph, this unremarkable family moment takes on a monumental importance. Barney prefers to let the narratives of her pictures remain ambiguous. She overwhelms the viewer with descriptive detail but provides little in the way of resolution. She even refuses to address whether the picture is candid or posed. At least Barney's milieu is consistent: she photographs her family, her friends, and herself in luxurious surroundings in New York City or — in the case of this picture — at summer homes on the New England shore.

☞ Field, Peck, F. Porter, J. S. Sargent

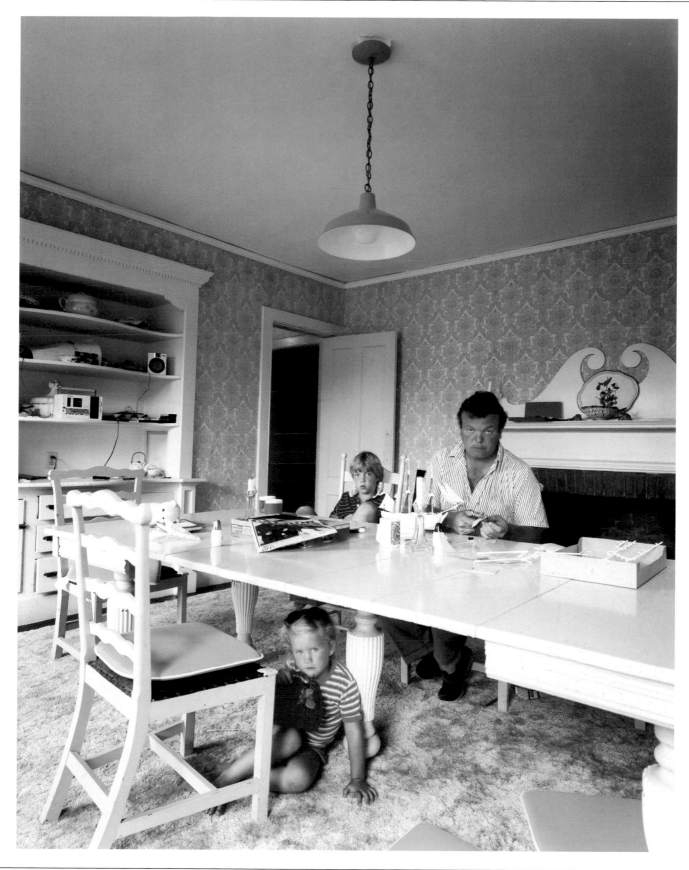

Tina Barney. b New York, NY, 1945. **Sarah, Mike, and Michael.** 1985. Chromogenic color print. Janet Borden, Inc., New York, NY.

Bartlett Jennifer

27 Howard Street; Day and Night

Two houselike forms and the sky above them are rendered in an astounding array of marks: multicolored cross-hatching, gestural dots, and stippled specks. Made from enamel baked onto a screenprinted grid of ninety-six steel plates, *27 Howard Street* is typical of Bartlett's fluid combination of Conceptualism, Abstraction, and Realism. Bartlett is a virtuosic renderer of nature's hues and seasonal light,

yet makes her art according to self-imposed regimens and formulas for the combination of color and line. Her most famous series, "In the Garden," is an ongoing chronicle of drawings, prints, and paintings based on a single view of the garden of a patron's house in Italy. The tension between order and abandon in Bartlett's art makes it popular among the many corporations who commission her to create murals

for their lobbies. It also allies her with such Pop abstractionists as Jasper Johns and Conceptualists as Vito Acconci.

☛ Artschwager, Christenberry, Lee, Lewitt

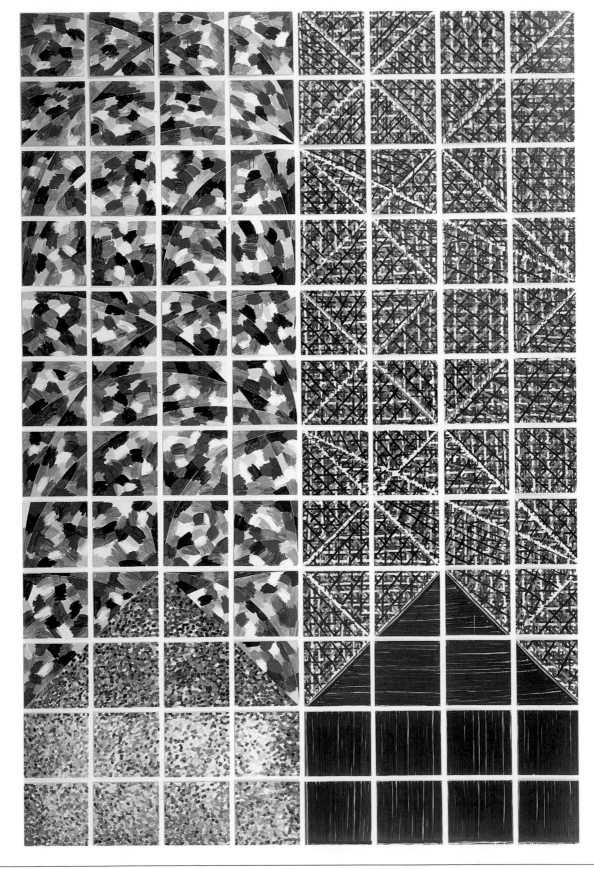

28

Jennifer Bartlett. b Long Beach, CA, 1941. **27 Howard Street; Day and Night.** 1977–78. Enamel paint, silkscreen grid and baked enamel on steel plates, in 96 parts. **h**155 x **w**103 in. **h**394 x **w**262 cm. Collection of the artist.

Bartram William

Savannah Pink or Sabatia & Imperial Moth

A moth aims toward blooms of a ripening flower known as a pink. The adult flower leans away to display its petals, pistil, and stamen, and a nascent bud and spent petals complete the summary of the pink's flowering cycle. With artful clarity, Bartram's image supports the revolutionary taxonomy of Carl Linnaeus, the Swedish naturalist who based his classification of plants on their reproductive systems. Bartram was raised by a botanist father, who began sending his son's illustrations to British naturalists in 1754. Father and son traveled to Florida in 1765 to observe and collect wildlife, and William Bartram returned to that territory in 1773. For four years he studied plants, animals, and Indians from the Atlantic coast to the Mississippi River. His influential, illustrated account of this expedition was published in 1791. After 1777, Bartram ceased traveling but continued to write, draw, and publish while caring for the botanical gardens his father had established in 1730.

☞ **Audubon, Baziotes, Blume, Catesby, O'Keeffe**

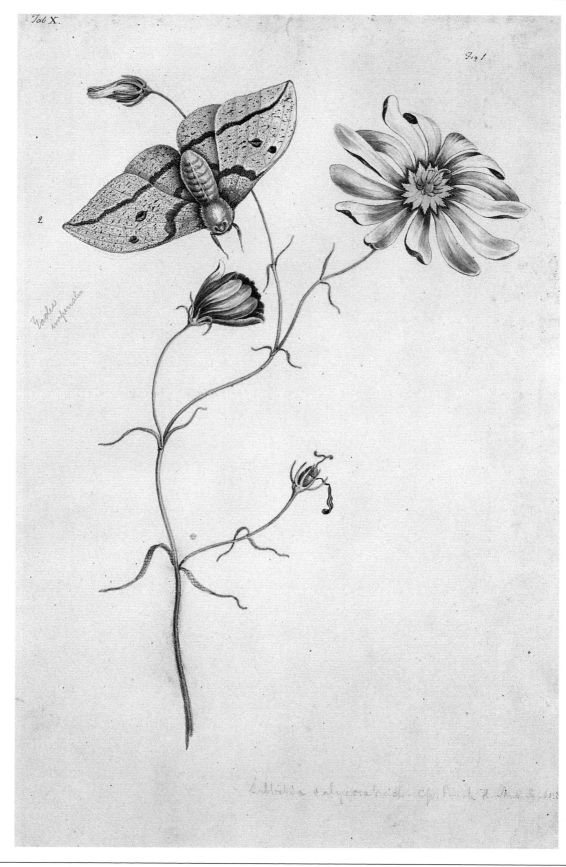

William Bartram. b Kingessing, PA, 1739. **d** Kingessing, PA, 1823. **Savannah Pink or Sabatia & Imperial Moth.** Pen and ink with watercolor on paper. **h**15 x **w**9⅝ in. **h**38 x **w**24.3 cm. Drawing 11 (Ewan 38) from Bartram, *Botanical and Zoological Drawings* (London, 1756–88). The Natural History Museum, London, United Kingdom.

Basquiat Jean-Michel

Untitled "Skull"

At once cartoonish and clinical, this cross-section of a human head is rendered as a pastiche of slashes and stitch marks that seem to literally patch the skull together. Surrounding the head is a glowing blue reminiscent of electronic medical imagery, and scrawled lettering suggests a cryptic message. Basquiat was a creature of the 1980s art world who was both an artistic prodigy and a media celebrity, much like his mentor, Andy Warhol. Basquiat's deceptively simple paintings use images and words appropriated from European languages and African cave painting, hobo signs and graffiti tags, as well as the racially polarized legacies of American popular culture. Like other 1980s Neo-Expressionists, Basquiat looked toward art-historical sources for inspiration, from Outsider Art to the early figurative works of Jackson Pollock. As his fame grew, Basquiat obscured his Brooklyn roots with lore about his Haitian heritage, as well as with rampant drug use — a habit that eventually took his life.

☞ De Kooning, Haring, Maurer, Mapplethorpe, Twombly

30

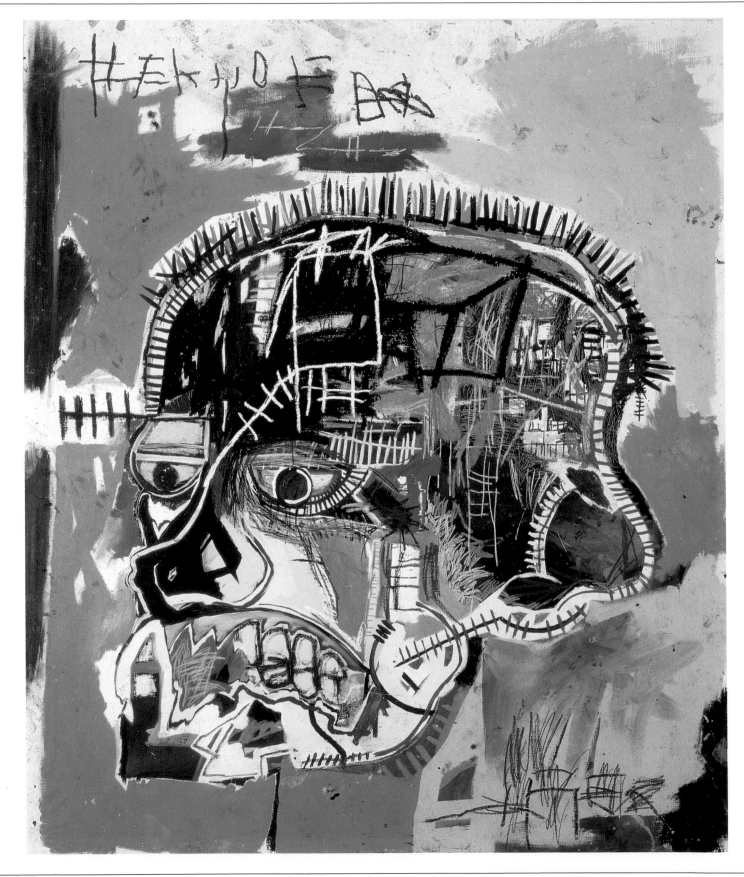

Jean-Michel Basquiat. **b** Brooklyn, NY, 1960. **d** New York, NY, 1988. **Untitled "Skull."** 1981. Acrylic and mixed media on canvas. **h**81½ x **w**69¼ in. **h**207.1 x **w**176 cm. The Eli Broad Family Foundation, Santa Monica, CA.

Bates David

Anhinga

A large aquatic bird holds a small fish in its mouth, triumphantly displaying its prize. In the background, a remarkable natural world of lily pads, tall trees, and mountains unfolds before an apocalyptic sunset painted in riotous shades of red and blue. Bates pictures the inhabitants of his hometown of Dallas, Texas, as well as the teeming natural life in the swamps of neighboring Arkansas and Louisiana. Cowboys, snake handlers, and other colorful characters populate his paintings, along with a menagerie of local fauna. Bates's work shares an affinity with some American folk art, especially contemporary examples from the Southern regions that Bates depicts. Bates's paintings became popular in the mid-1980s, when Neo-Expressionism was at its height. His muscular, enigmatic paintings recall one famous German Expressionist in particular: Max Beckmann.

☞ Audubon, Heade, Mark, Stella

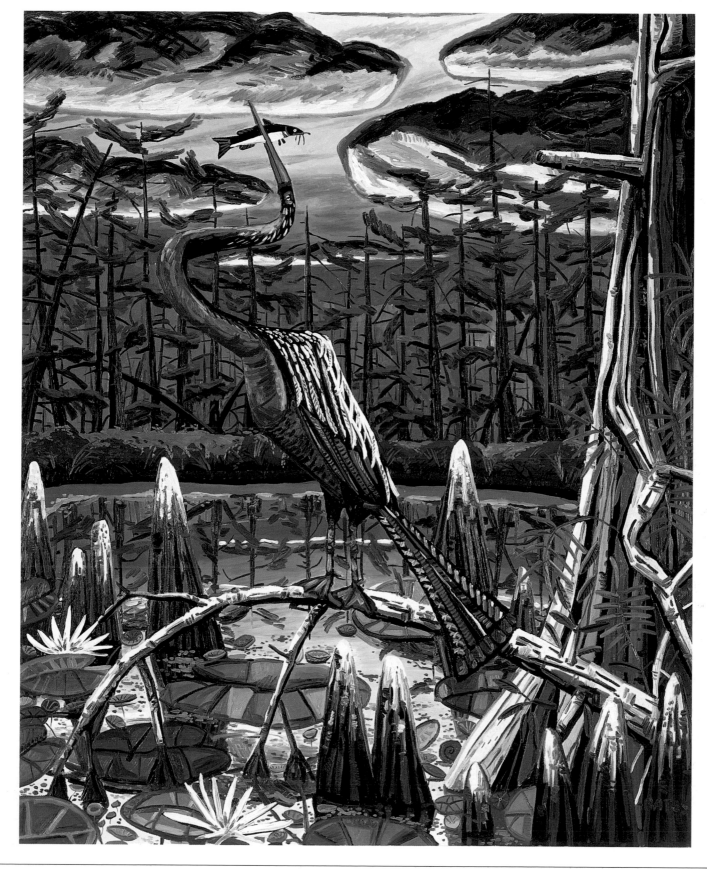

David Bates. b Dallas, TX, 1952. **Anhinga.** 1987. Oil on canvas. **h**96 x **w**78 in. **h**244 x **w**198 cm. Gerald Peters Gallery and John Berggruen Gallery, Dallas, TX.

Baziotes William Dusk

Floating in a shadowy limbo, hieratic forms suggest simplified organisms in suspended animation. The somber colors shimmer with veiled undertones, an effect that often took the artist weeks or months to achieve. Echoes of Baziotes's early interest in Surrealism remain evident, although by the 1950s he had eliminated specific references to the fantastic creatures and mythological content that

had originally preoccupied him. Like his friends Arshile Gorky, Mark Rothko, and Theodoros Stamos, he created nature-based abstractions using automatic gestures to conjure mutant shapes inhabiting imaginary realms. Joan Miró in particular provided him with a precedent for a personal abstract style at once spontaneous and refined. In 1959, Baziotes explained his approach in the

vanguard artists' magazine *It Is:* "It is the mysterious that I love in painting. It is the stillness and the silence. I want my pictures to take effect very slowly, to obsess and to haunt."

☛ **Calder, De Maria, Dove, Rothko**

32

William Baziotes. b Pittsburgh, PA, 1912. **d** New York, NY, 1963. **Dusk.** 1958. Oil on canvas. **h**60⅜ x **w**48¼ in. **h**153.3 x **w**122.5 cm. Solomon R. Guggenheim Museum, New York, NY.

Bearden Romare

Sunday Morning Breakfast

Scraps of colored and painted paper are collaged with cut-out photographs to create a breakfast scene combining African and rural Southern imagery. Bearden borrowed the composition of this work from a painting with the same title by folk artist Horace Pippin. The tribal mask and the potbellied stove express Bearden's identification with both the urban African-American culture of New York City and

his rural North Carolina roots. He explored this dual cultural heritage in Cubist-inspired collages that also incorporate areas of watercolor, oil paint, and drawing. Bearden studied at the Art Students League in New York with George Grosz, who introduced him to art with social and political content. A friendship with painter Stuart Davis helped him find pictorial equivalents for the jazz rhythms they both loved.

It was not until the 1960s, however, that Bearden began using photomontage and collage as his primary media and established himself as one of the most important African-American artists to emerge after World War II.

☞ Berman, Hayden, Jones, Saar, Wolcott

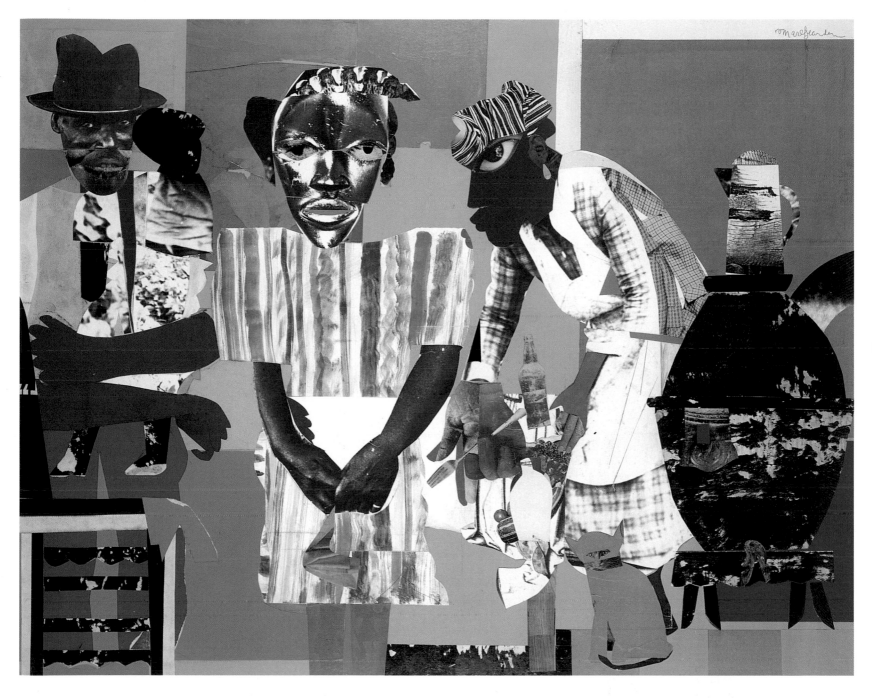

33

Romare Bearden. b Charlotte, NC, 1914. **d** New York, NY, 1988. **Sunday Morning Breakfast.** 1967. Collage on masonite. **h**44 x **w**56 in. **h**111.8 x **w**142.3 cm. Michael Rosenfeld Gallery, New York, NY.

Beardsley Limner The Little Boy in a Windsor Chair

Dreamy, bored, perhaps just tired of sitting, a young boy props an arm on his chair and rests his head. The Windsor chair has been painted with a disregard for conventional perspective; its legs and seat tilt, one armrest drops low and the other stretches, as if the chair has absorbed the child's squirming energy. With clumsily effective draftsmanship, the artist captures the natural appeal of the young sitter and gives the portrait an awkward charm. The Beardsley Limner remains unidentified, although nearly twenty works can be attributed to him, including the ambitious portraits of Mr. and Mrs. Hezekiah Beardsley that lend him their name. Although it is safe to say that he had no formal training, he worked in the same region of western New England as Ralph Earl, and his portraits betray the unmistakable influence of that more experienced painter's style and compositions.

☞ Benson, Chandler, Hopkins, Johnson

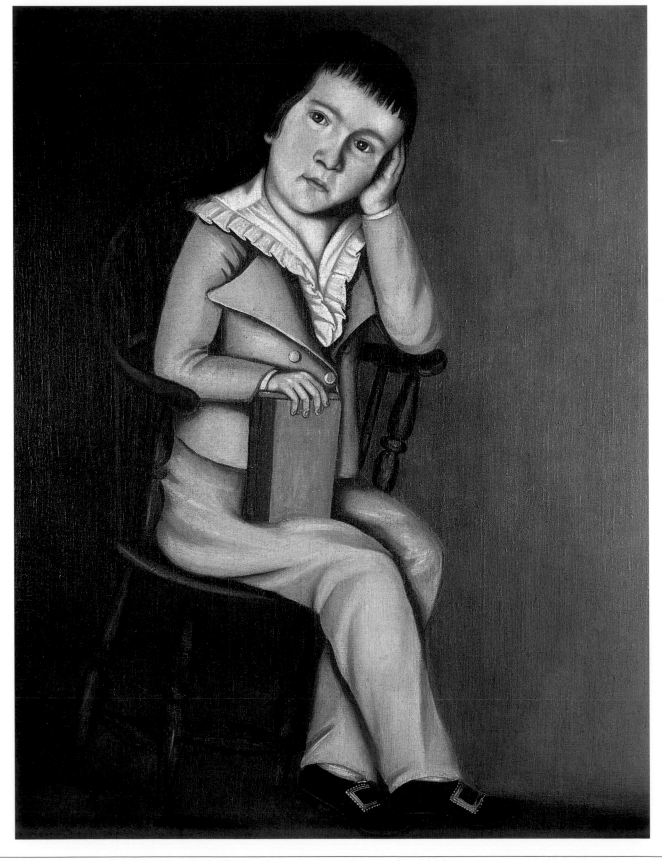

34

The Beardsley Limner. Active New England and NY, c1785–1800. **Little Boy in a Windsor Chair.** Early nineteenth century. Oil on canvas. **h**32 x **w**25 in. **h**81.3 x **w**63.5 cm. The Montclair Art Museum, Montclair, NJ.

Beaux Cecilia

Man with the Cat; Portrait of Henry Sturgis Drinker

A marvelous balance of tension and relaxation exists in this fluidly brushed portrait of Beaux's brother-in-law, Henry Sturgis Drinker. Drinker leans into the curve of the chair and crosses his long legs to accommodate the sleepy cat lounging in his lap. The suggestion of nonchalance this introduces to the painting is contradicted by the mannered position of his splayed fingers and the strict frontality of his head. The exquisite modeling of that head, constructed of a skillful working of lights and darks, confirms Beaux's high rank among the practitioners of the international style of portraiture practiced around the turn of the century. Like John Singer Sargent and William Merritt Chase, Beaux also synthesized the effects of European training, her admiration for the art of Diego Velázquez, and her knowledge of French Impressionism to create an identifiable style within the broader mode of society portraiture.

☛ Aragon, Earl, Neel, J. S. Sargent, Southworth & Hawes

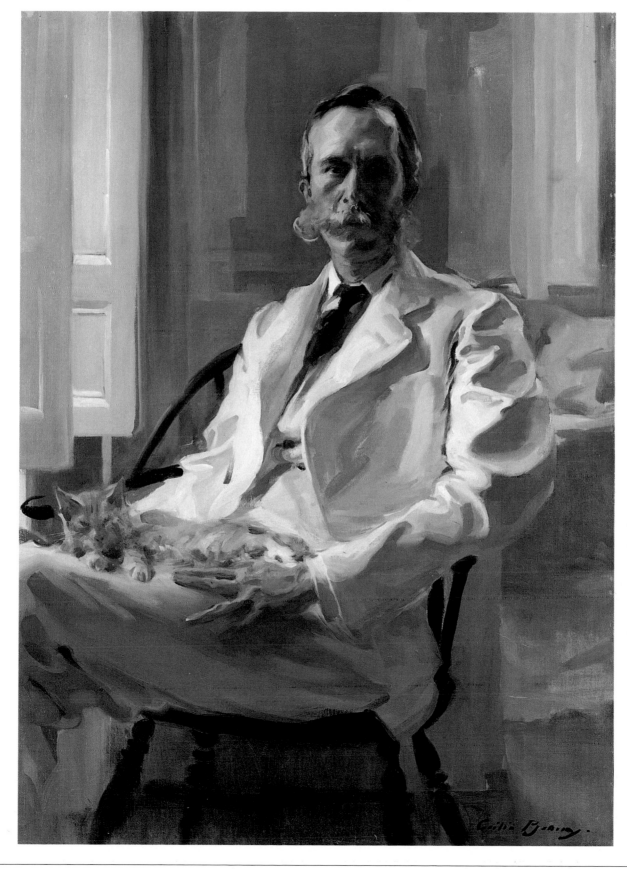

35

Cecilia Beaux. b Philadelphia, PA, 1855. d New York, NY, 1942. **Man with the Cat; Portrait of Henry Sturgis Drinker.** 1898. Oil on canvas. h48 x w34⅝ in. h122 x w88 cm. National Museum of American Art, Washington, D.C.

Bellamy John

Carved American Eagle

This proudly patriotic carving unites two potent American symbols: the eagle and the flag. The eagle's impressive wingspan, sharp beak, and massive talons are manifestations of its strength. The bird's graceful curves blend seamlessly with the folds of the flags below to create a harmonious overall effect. Carver John Bellamy specialized in eagles, supplying the US Navy with ship figureheads as well as

relief works such as this one intended to decorate interior spaces. Bellamy also fulfilled commissions for commercial vessels, government offices, and lodge halls. His unique carving style was influential and spawned many imitations. Hallmarks of his work include the sharp curve of this eagle's beak as well as the solid line beneath its eye. His skill as a carver is evident here in both the rendering of the

drapery and in the subtle suggestion of depth through the slight overhang of the eagle's wings.

☞ Audubon, Robb, Rush, Schimmel, Tanning

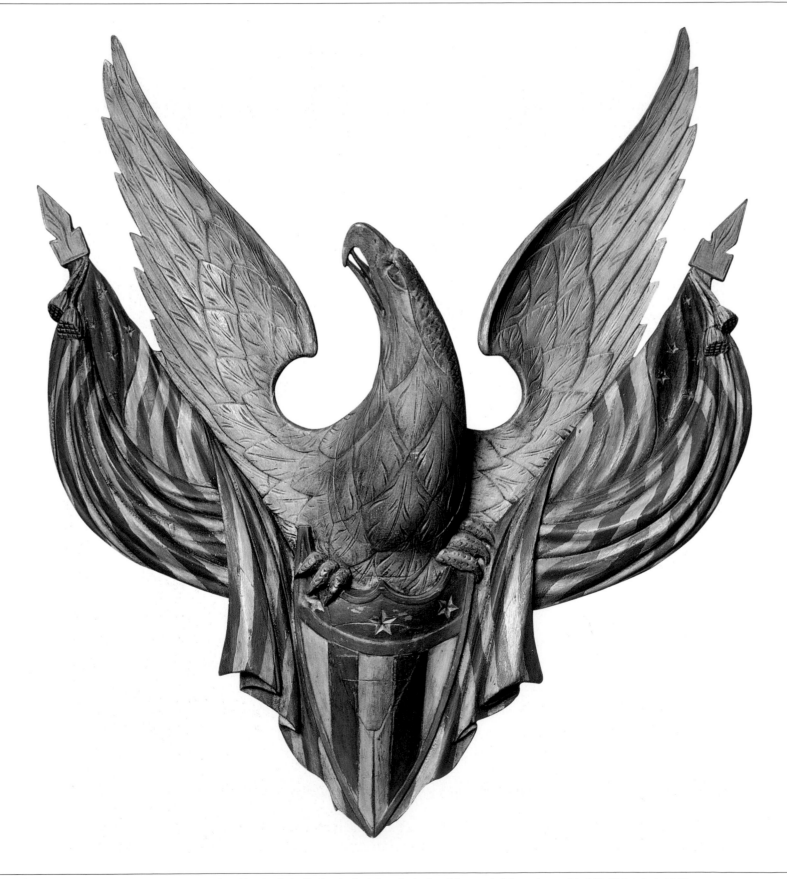

John Haley Bellamy. b Kittery Point, ME, 1836. **d** Portsmouth, NH, 1914. **Carved American Eagle.** 1880. Carved and polychromed painted wood. **h**30 x **w**25 in. **h**76.24 x **w**63.54 cm. John F. Rinaldi, Kennebunkport, ME.

Bellocq E. J.

Storyville Portrait

Voluptuousness may be in the eye of the beholder, but the direct gaze, tilted head, and formal pose of this well-endowed, partly clad woman make her a beauty for all time. Certainly men in New Orleans – including this photographer – made her an object of desire, for she worked as a prostitute in a brothel in the city's red-light district known as Storyville. The brothel's rooms, by the look of this one,

exhibited a spare approximation of domestic normalcy. The unknown woman's portrait is one of nearly a hundred surviving portraits made by Bellocq, an obscure but apparently possessed professional photographer at the turn of the twentieth century who is thought to have been a dwarf, a hunchback, or both. In the 1960s Lee Friedlander, a photographer from New York, bought a cache

of Bellocq's dusty and abused glass-plate negatives and printed them, bringing this mysterious work into the limelight. The 1978 film *Pretty Baby*, directed by Louis Malle, is a fictionalized account of Bellocq's career.

☞ French, Hansen, Hirshfield, Kasebier

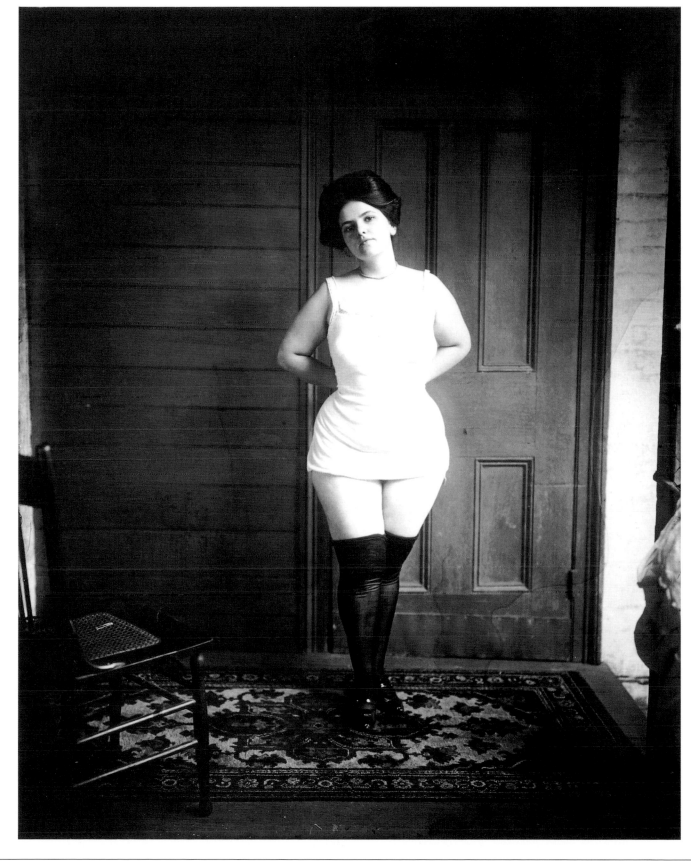

E. J. (Ernest James) Bellocq. b New Orleans, LA, 1873. d New Orleans, LA, 1949. **Storyville Portrait.** c1912. Gold-toned, printing-out paper. Fraenkel Gallery, San Francisco, CA.

Bellows George Stag at Sharkey's

Two boxers strain to maintain balance, their misshapen bodies torqued under the pressure of powerful blows. Their muscles are rendered in aggressive, multicolored brushstrokes, and light bounces off their gleaming flesh while all else remains in shadow, abstracted. Even the referee appears flattened, depicted with less dimension than the dynamic pugilists. Organized boxing was outlawed in New York City from 1900 to 1911, but private "athletic clubs" — such as ex-prize fighter Tom Sharkey's saloon — allowed "members" to pay a price for an evening of bloody fisticuffs. Bellows lived across the street from Sharkey's and used the club as a site to explore his teacher Robert Henri's mandate to paint the life of urban New York. Bellows studied under Henri at the New York School of Art, where many of the Realist painters known as The Eight got their start. He painted other notable boxing scenes and views of the city, but *Stag at Sharkey's* has become one of the iconic images of the energetic independent movement.

👈 **duBois, Glackens, Luks, Sloan**

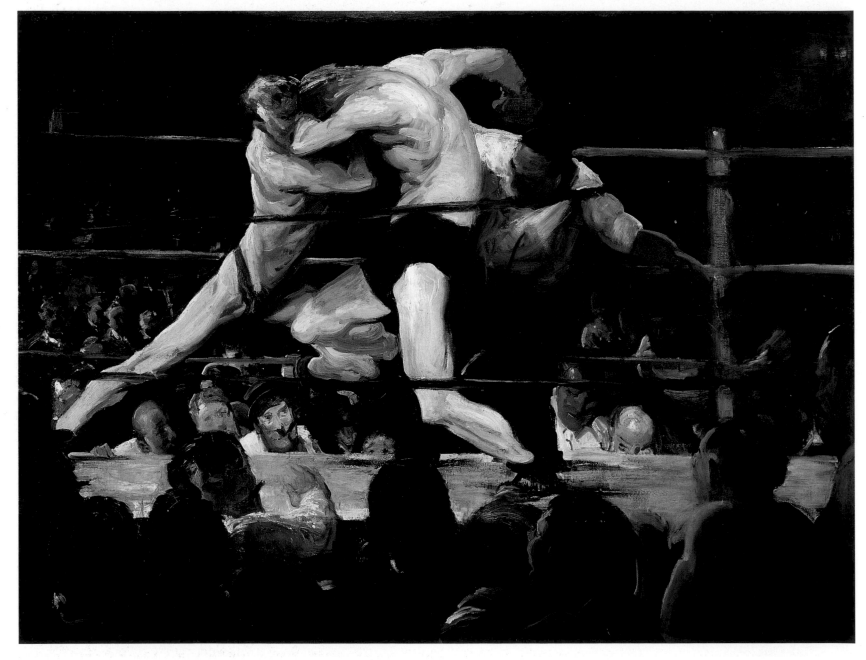

George Wesley Bellows. b Columbus, OH, 1882. **d** New York, NY, 1925. **Stag at Sharkey's.** 1909. Oil on canvas. **h**36¼ x **w**48¼ in. **h**92 x **w**122.6 cm. The Cleveland Museum of Art, Cleveland, OH.

Benson Frank Weston

Red and Gold

A beautiful model carefully angles the fan she holds to shield her eyes from the direct and reflected sunlight that plays across her face in a complex orchestration. The irregular patterns of light and shade echo Benson's generally decorative approach and subtly reveal a formalist attitude confirmed by the painting's title. Benson was closely associated with Impressionism, especially because of his many light-saturated canvases of women and children painted in the outdoors. In this interior scene, however, a different facet of his style emerges: the dry, scumbled paint surface assumes a tapestry-like appearance that accentuates abstraction. While the subject of a solitary woman in an interior was a hallmark of the Boston Impressionist school (in which Benson was a leading figure), the unusual directness of her gaze acknowledges the act of posing and thereby asserts the modern idea of artistic process. Although it is essentially conservative, this tendency may indicate Benson's response to the Modernist aesthetics that had begun to take hold in America by this time.

☛ Dewing, Hathaway, Kasebier, Reid

Frank Weston Benson. b Salem, MA, 1862. **d** Salem, MA, 1951. **Red and Gold.** 1915. Oil on canvas. **h**31 x **w**39 in. **h**78.8 x **w**99.1 cm. The Butler Institute of American Art, Youngstown, OH.

Benton Thomas Hart

Cradling Wheat

A swirl of undulating rhythms and swollen bundles of golden wheat unifies this study of threshers harvesting by hand. Ignoring the crop failures endemic to the Dust Bowl era, as well as the mechanization of modern agriculture, Benton has painted a land of abundant bounty reliant on manual labor — an allegory of the pioneer spirit. Although he became famous for his Americana subject matter, Benton was an abstract painter before World War I and understood Modernist principles of formal analysis. After several years teaching at the Art Students League (where his most celebrated student was Jackson Pollock), Benton's combative personality led him to reject the New York art establishment and return to his native Missouri, where he painted murals for the state capitol and the Harry S. Truman Library.

A vociferous champion of Regionalism, he nevertheless instilled in his students a respect for the Old Masters and a conviction that art should be socially relevant.

☞ Curry, Gwathmey, Hogue, E. Johnson

40

Thomas Hart Benton. b Neosho, MO, 1889. **d** Kansas City, MO, 1975. **Cradling Wheat.** 1938. Tempera and oil on board. **h**31 x **w**38 in. **h**78.7 x **w**96.5 cm. The Saint Louis Art Museum (Modern Art), St. Louis, MO.

Berman Wallace

Papa's Got a Brand New Bag

In the upper right corner a hand holds a transistor radio covered with a picture of James Brown, who sang the Grammy-winning song that lends its title to the collage. Activist Malcolm X appears as a glyph between repeated photos of boxer Muhammad Ali, who had recently converted to Islam. The metaphorical "new bag" may well be the changing social and political climate of the mid-1960s, when

Malcolm X and Lee Harvey Oswald competed for media attention with pop music stars. Like Robert Rauschenberg, Berman looked to radio, television, newspapers, and magazines for the raw material of his collages. Early in his career he made assemblages that combined visual imagery and text, including Hebrew and Latin inscriptions. In 1964, he began using mechanical duplication technology. The data

Berman presents in his work tend to require translation, although here he implies that print and broadcast sources effectively digest and revise information before it ever reaches us.

☞ Hansen, Indiana, Jess, Saar

41

Wallace Berman. b New York, NY, 1926. **d** Topanga, CA, 1976. **Papa's Got a Brand New Bag.** 1964. Mixed media collage. **h**43 x **w**30¾ in. **h**109.2 x **w**78.1 cm. Nicole Klagsbrun Gallery, New York, NY.

Bess Forrest

Untitled (No. 13)

These mysterious hieroglyphics resemble a code from an ancient world. Painted in a simple, direct fashion, this composition invites and defies interpretation. Bess himself did assign meanings to certain markings; in this work, the white slashes signify the passing of time. Bess was a commercial fisherman on the Texas Gulf Coast, where he lived in virtual isolation, pursuing his interest in Jungian psychology and documenting his visions of archetypal symbols through small abstract paintings. His efforts to faithfully transcribe these apparitions account for his unadorned painting style and his handmade frames of weathered wood. Despite his self-imposed solitude, Bess found an appreciative audience in New York's avant-garde, including a twenty-five-year correspondence with the eminent art historian Meyer Schapiro. Schapiro responded to "the air of secret insight" in Bess's paintings, a quality they manifest still.

☞ Hartley, Ryman, Twombly, Winters

Forrest Clemenger Bess. b Bay City, TX, 1911. **d** Bay City, TX, 1977. **Untitled (No. 13).** 1950. Oil on linen. **h**6 x **w**10 in. **h**15.2 x **w**25.4 cm. Hirschl & Adler Modern Gallery, New York, NY.

Biederman Charles

Work #4, Paris

Shadows cast by blue, yellow, and black rectangular relief elements introduce diagonals into an otherwise strictly linear composition. After meeting Piet Mondrian in Paris, where this piece was executed, Biederman embarked on an intensive study of his work, applying many of his two dimensional strategies to multilevel surfaces. Biederman's earlier paintings and reliefs included biomorphic and mechanistic forms that reflect a kinship with Alexander Calder, Joan Miró, and Fernand Léger. These artists were among the Abstractionists he met in Europe in 1937 and 1938, although he was also involved with the New York vanguard of the period. He did not join the American Abstract Artists group, but he did exhibit with several of its members. Some of his reliefs incorporate interior lighting to articulate form and color, and he was perhaps the first artist to use fluorescent light. An important theorist as well as a pioneering geometric abstractionist, Biederman expressed his philosophy in his book, *Art as the Evolution of Visual Knowledge*, published in 1948.

☞ Diller, Flavin, Halley, Stella

Charles Karel Joseph Biederman. b Cleveland, OH, 1906. **Work #4, Paris.** 1937. Wood and lacquer relief. **h**35⅞ x **w**31⅝ in. **h**91.2 x **w**80.4 cm. Collection J. Donald Nichols.

Bierstadt Albert

Sunrise, Yosemite Valley

The grandeur of the towering peaks of the Yosemite Valley in California is dramatized by the splendorous light that transforms the scene into a transcendent vision. Morning light floods the valley, moving westward to illuminate the dark foreground framing the scene. This progression of light is a metaphor for divine approval of westward expansion across the New World. Bierstadt devoted much of his career to creating images such as this — often on a much larger scale. These Romantic affirmations of the American policy of Manifest Destiny registered strongly with Eastern and European audiences and brought the painter extraordinary fame. Raised in humble circumstances in New Bedford, Massachusetts, Bierstadt began his career working for a framemaker. After study in Dusseldorf and a period of travel in Europe from 1853 to 1857, he returned to the United States. As a member of the Lander Expedition to the West, Bierstadt discovered in the seemingly infinite American landscape a subject that appealed to a nation concerned with expansion.

☛ Heizer, Hill, Jewett, Moran, Watkins

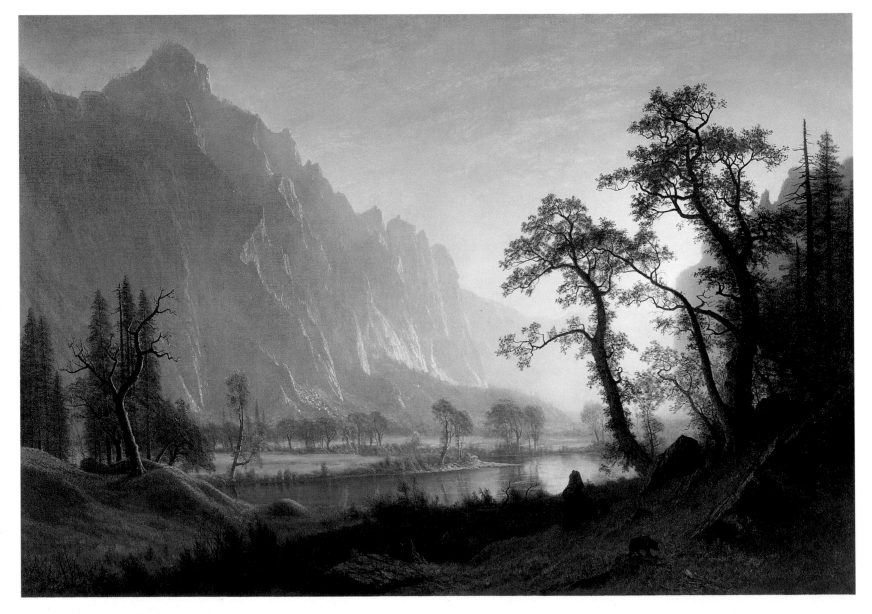

Albert Bierstadt. b Solingen, Prussia, 1830. d New York, NY, 1902. **Sunrise, Yosemite Valley.** c1870. Oil on canvas. h36½ x w52⅜ in. h92.8 x w133.1 cm. Amon Carter Museum, Fort Worth, TX.

Bingham George Caleb

Raftsmen Playing Cards

Early morning light gently illuminates a group of men playing cards on a raft that plies the Missouri River. The tranquil scene is deceptive. The raft is being carefully guided between the dangers of a sandbar (faintly visible on the left) and a snag that surfaces on the right. The stable geometries of this pyramidal composition underscore the subdued mood. The redundant remains of a fire in the foreground and the man on the left who seems to fight sleep suggest that the game lasted through the night. Now only two players are left in the contest. Bingham returned to Missouri, where he was raised, after establishing himself as a portraitist in the East, and concentrated on subjects of daily frontier life. While they pictured men living in harmony with nature, these works also supported the idea of westward expansion for economic gain by portraying the rugged men who transported raw materials from the wilderness toward urban Eastern markets.

☛ Durrie, Greenwood, Mount, Woodville

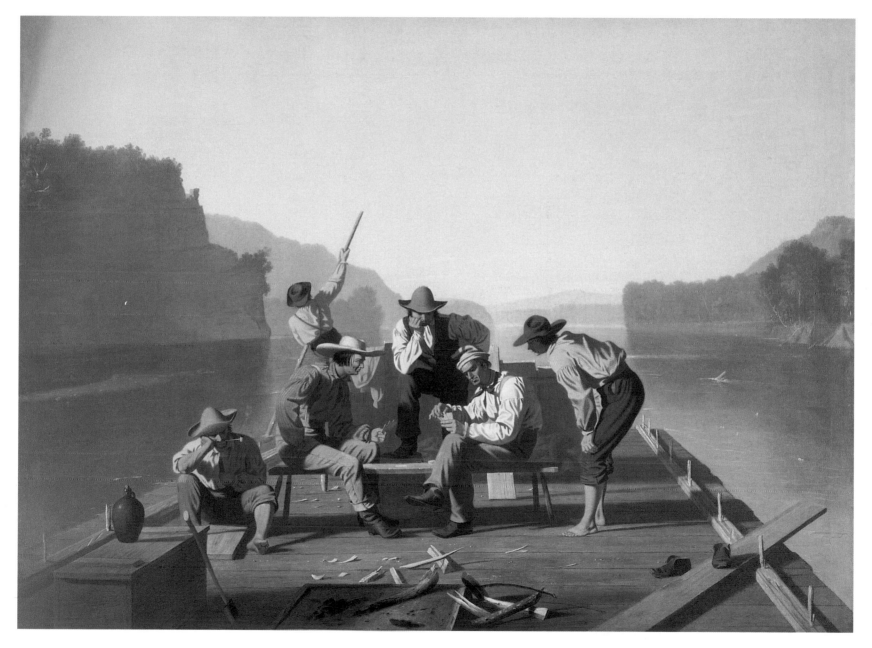

George Caleb Bingham. b near Charlottesville, VA, 1811. d Kansas City, MO, 1879. **Raftsmen Playing Cards**. 1847. Oil on canvas. h28¹/₆ x w38¹/₆ in. h71.3 x w96.7 cm. The Saint Louis Art Museum (Modern Art), St. Louis, MO.

Birch Thomas

The United States and the Macedonian

Two sailing vessels duel "to the death," isolated against the vast backdrop of a sky where clouds and the smoke of battle blend. With the Stars and Stripes flying and its sails full, the American frigate the *United States* is propelled sideward by the force of its cannon fire. Meanwhile, the ruined hulk of the *Macedonian* stands lifeless, its crew already taking to the lifeboats on the left.

The drama of this naval engagement of the War of 1812 is heightened by the moment depicted: it is the *coup de grace* dealt by the American ship against its British rival. At the age of fifteen Birch arrived in Philadelphia with his artist father, William. The son was the first American painter to specialize in marine subjects, a direction that was fortuitous in that the taste for such subject

matter increased with the outbreak of the 1812 war with Britain, which was fought largely at sea.

☛ **Blunt, Bradford, Lane, Salmon**

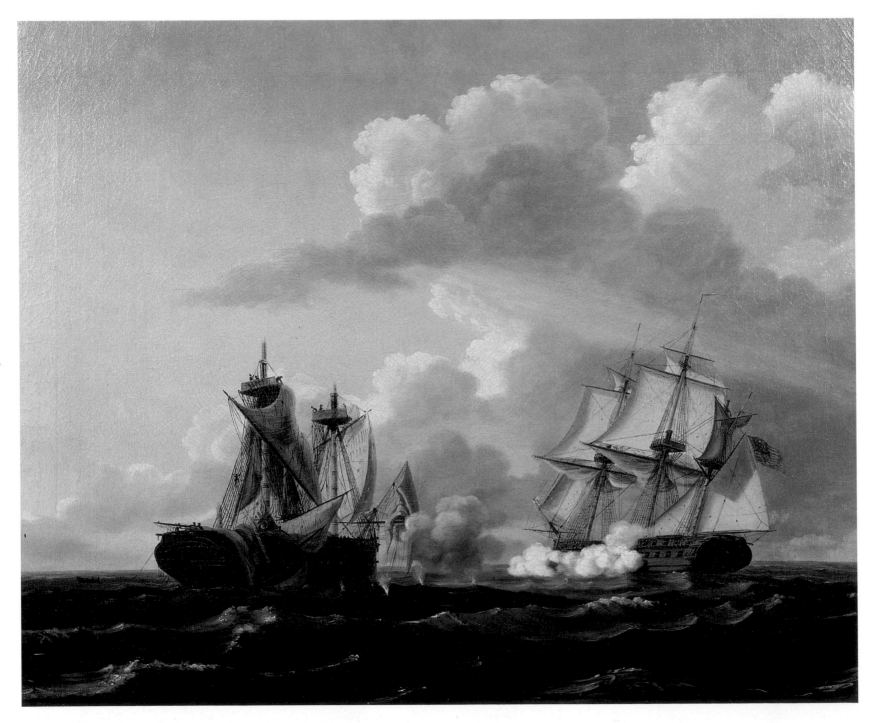

Thomas Birch. b (city unknown), United Kingdom, 1779. **d** Philadelphia, PA, 1851. **The United States and the Macedonian.** 1812. Oil on canvas. **h**29 x **w**34¹/2 in. **h**73.7 x **w**87.7 cm. The Historical Society of Pennsylvania, Philadelphia, PA.

Bischoff Elmer

Two Figures at the Seashore

Anonymous bathers inhabit a generalized landscape, with all elements of the painting unified by energetic brushwork. Strong but diffused light, filtered by the moisture-laden atmosphere of the Northern California coast, accents the bodies and glistens on the water, yet all areas of the painted surface are treated with equal emphasis. Even the figure facing the viewer is robbed of individuality by the heavy shadow that cloaks its identity. Adapting the style of Abstract Expressionism, his early artistic direction, Bischoff moved toward representational imagery in the early 1950s. "The thing was playing itself dry," he said of Abstract Expressionism. "I can only compare it to the end of a love affair." With Richard Diebenkorn and David Park, he became a leader of the Bay Area group that established figure-based gestural painting as a regional phenomenon. Some twenty years later, believing that "figurative painting was getting to be too much of a one-way street," Bischoff returned to abstraction.

Avery, Fischl, Marsh, Park

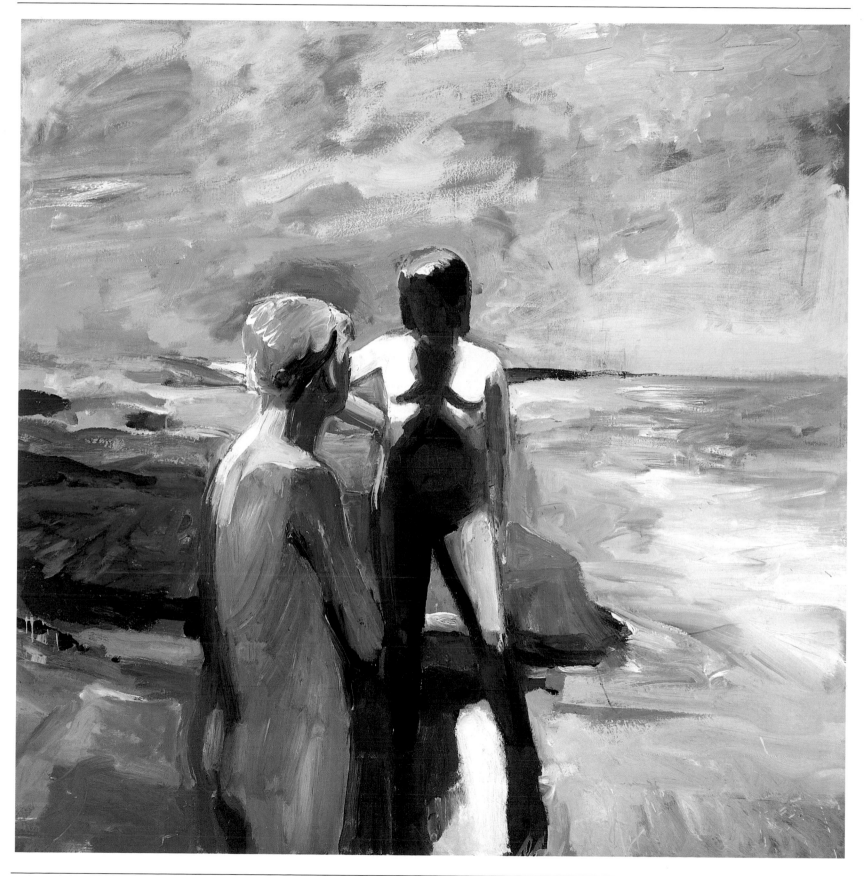

Elmer Nelson Bischoff. b Berkeley, CA, 1916. d Berkeley, CA, 1991. **Two Figures at the Seashore.** 1957. Oil on canvas. h56⅞ x w56⅞ in. h144.5 x w144.5 cm. Orange County Museum of Art, Newport Beach, CA.

Bishop Isabel

On the Street (Fourteenth Street)

Two fashionably dressed women stroll toward the viewer arm in arm. Unlike the men who stand behind them in dark anonymous groups, these women are depicted in detail with clean airy lines, down to their solid legs and sensible shoes. Two companions lost in thought, they accompany one another through the gritty streets of 1930s America. Raised in Cincinnati and Detroit, Bishop moved to New York City in 1918 to study illustration, eventually studying under Kenneth Hayes Miller at the Art Student's League. A major figure of Depression-era Social Realism, she distinguished herself from her male colleagues Reginald Marsh and Yasuo Kuniyoshi by her refined portrayal of the inner life and mood of the modern office women who worked in New York's Union Square, near Bishop's studio.

She is widely regarded as one of the pioneers of feminist art although, as she put it late in life, "I didn't want to be a woman artist. I just wanted to be an artist."

☞ Hahn, Luks, Winogrand, Wong

48

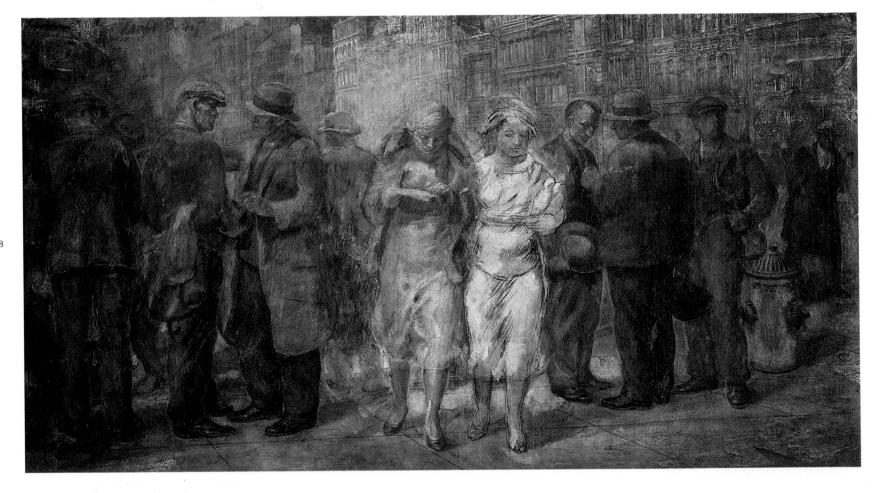

Isabel Bishop. b Cincinnati, OH, 1902. **d** Riverdale, NY, 1988. **On the Street (Fourteenth Street).** 1932. Oil on canvas. **h**14¹/₂ x **w**26 in. **h**36.9 x **w**66.1 cm. Private collection.

Blakelock Ralph

The Poetry of Moonlight

Lacy contours of foliage form decorative patterns silhouetted against a silvery moonlit sky. The striking contrasts of light and dark in this nocturnal landscape are typical of Blakelock's mature style, and perhaps give material evidence of the radical mood swings that plagued him throughout his life. The son of a doctor, Blakelock dropped out of school, resolving to become an artist. Although he was virtually self-taught, his paintings were soon included in the prestigious National Academy of Design exhibitions. A two-year sojourn in the West around 1870 provided him with the subject matter he preferred: moody landscapes, often populated by isolated figures of Native Americans. Back in New York by 1871, Blakelock was tormented by lack of recognition and the financial burdens of a large family. In 1891 he suffered the first of many mental breakdowns which, after 1899, kept him institutionalized for most of his remaining years. Blakelock's art continued to draw appreciative audiences, even though personal tragedy prevented him from fully enjoying the attention.

Allston, Caponigro, Irwin, Mark

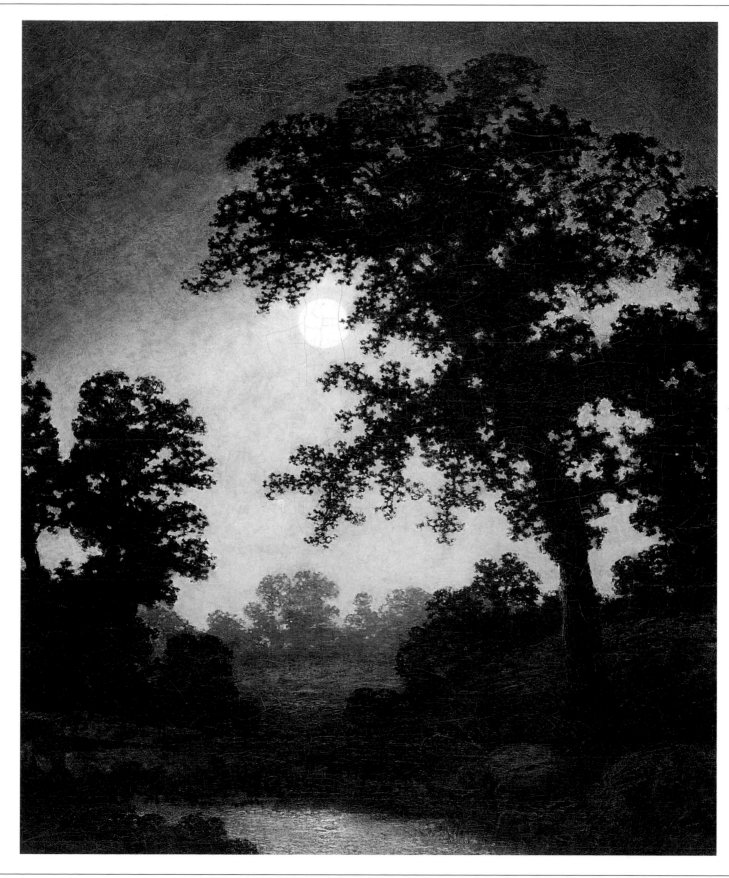

Ralph Blakelock. b New York, NY, 1845. **d** Elizabethtown, NY, 1919. **The Poetry of Moonlight.** c1880–90. Oil on canvas. **h**30 x **w**25¼ in. **h**76.2 x **w**64.2 cm. Heckscher Museum, Huntington, NY.

Blume Peter

Flower and Torso

With its angular shoulders and slim, boyish hips, this torso could be male if it were not for its pendulous breasts adorned with lush blossoms. Although the woman's arm curves as if to cradle the flowers, these seem instead to emanate from her body. It is possible that this is a symbolic portrait of Georgia O'Keeffe, whose lean, voluptuous body and tapering hands were famously photographed by Alfred Stieglitz. Not only was O'Keeffe known for her sensuous closeup paintings of flowers, but she and Stieglitz summered at Lake George, New York, in surroundings much like the landscape behind the anonymous torso. Blume's work is always symbolic and often elaborately detailed. An admirer of the Renaissance masters and a believer in the social responsibility of the artist, he is best known for complex allegories with surreal overtones. Working outside the mainstream of both representational and abstract painting, Blume upholds an academic tradition adapted to express modern themes.

☛ Cunningham, O'Keeffe, Pearlstein, K. Smith

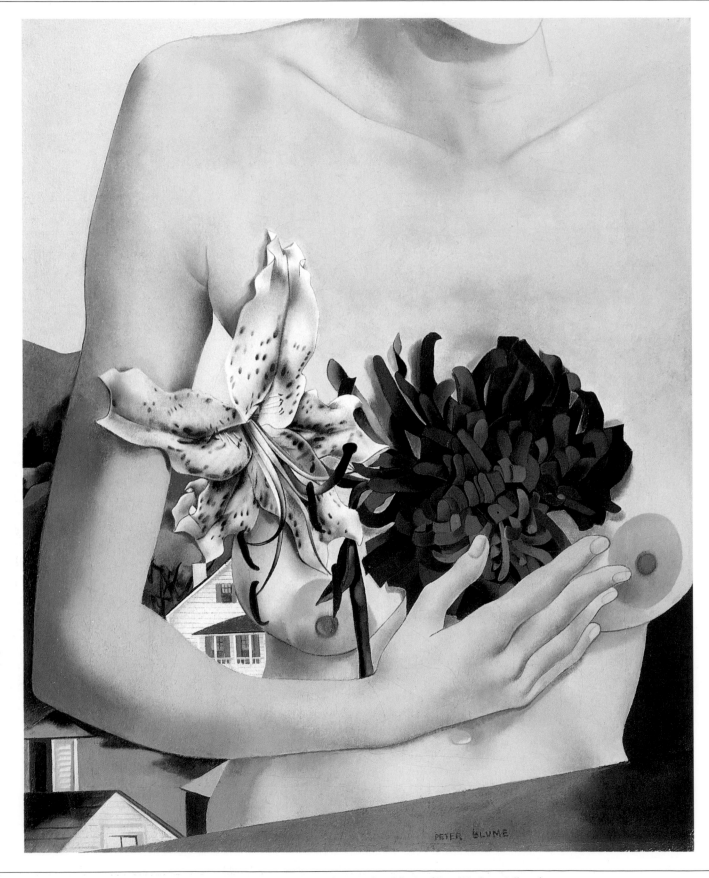

Peter Blume. b Smorgon, Russia, 1906. **d** Sherman, CT, 1992. **Flower and Torso.** 1927. Oil on canvas. **h**20¼ x **w**16⅜ in. **h**51.5 x **w**41.6 cm. Collection of Mr. and Mrs. Barney A. Ebsworth.

Blunt John

Boston Harbor

Two men stand at the edge of the ice, surveying the stillness of the usually bustling Boston Harbor. That they were forced to walk a considerable distance over the ice to inspect the ships is indicated by their snowshoes, which are at odds with their business attire. These small details insert a thin but relevant narrative focus on the commercial hardships imposed by the ice, which prevents the normally efficient transfer of goods between the ships and the docks. Blunt's attention to atmospheric effects, the intricate riggings silhouetted against the lowering sky, and the jagged contour of the ice also reveals his interest in creating an aesthetically satisfying work. Born into a family of seafarers, Blunt painted a number of marine subjects reflecting this heritage. Though apparently untrained, he set up a studio in Boston in 1831. He left a small body of work that indicates the promise of talents that went unfulfilled.

☛ Bradford, Colman, Lane, Salmon

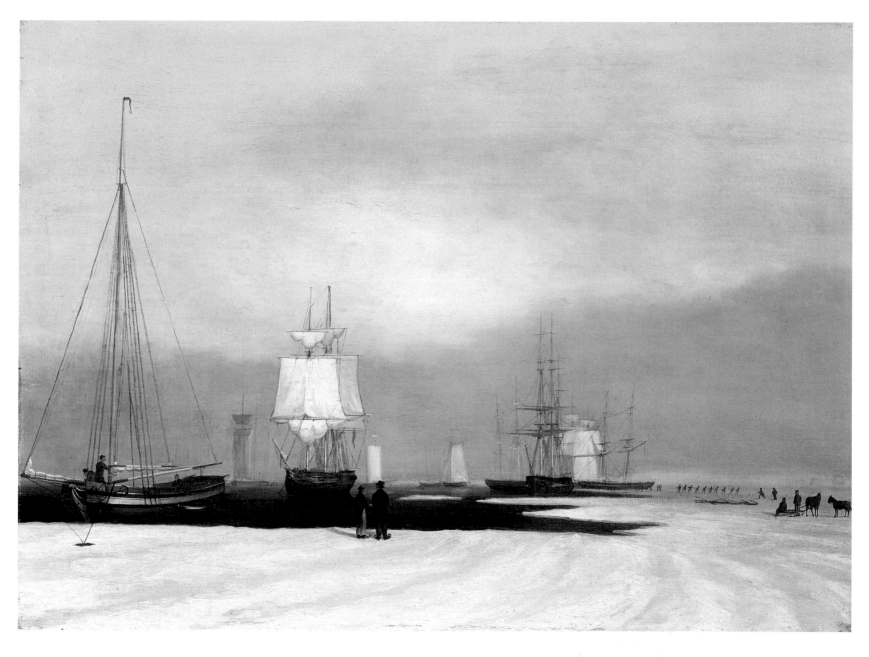

John Samuel Blunt. b Portsmouth, NH, 1798. **d** At sea (traveling from Boston to New Orleans), 1835. **Boston Harbor.** 1835. Oil on panel. **h**20½ x **w**28 in. **h**52.1 x **w**71.1 cm. Museum of Fine Arts, Boston, MA.

Blythe David Gilmour

Street Urchins

Eight scruffy, pasty-faced boys crowd around another, who leans forward to set the fuse of a toy cannon with the tip of his burning cigar. Their squat bodies, dirty, ragged clothes, bare feet, and grim expressions mark them as vivid caricatures of the hordes of indigent children who roamed the streets of American cities during the mid-nineteenth century. Indeed, Blythe's emphasis on these cigar-smoking boys is often read as a reference to the soot-blackened skies of Pittsburgh, where he had lived intermittently since he was sixteen. Although he spent much of his life as an itinerant portraitist, the self-taught Blythe also created a significant number of genre paintings that reflected his cynical view of American society. In the tradition of the English painters William Hogarth and George Cruikshank, whom he admired, Blythe concentrated on disenfranchised social classes to satirize the vast inequalities in urban living brought on by industrial expansion.

☛ Durand, Duveneck, Henri, Mann

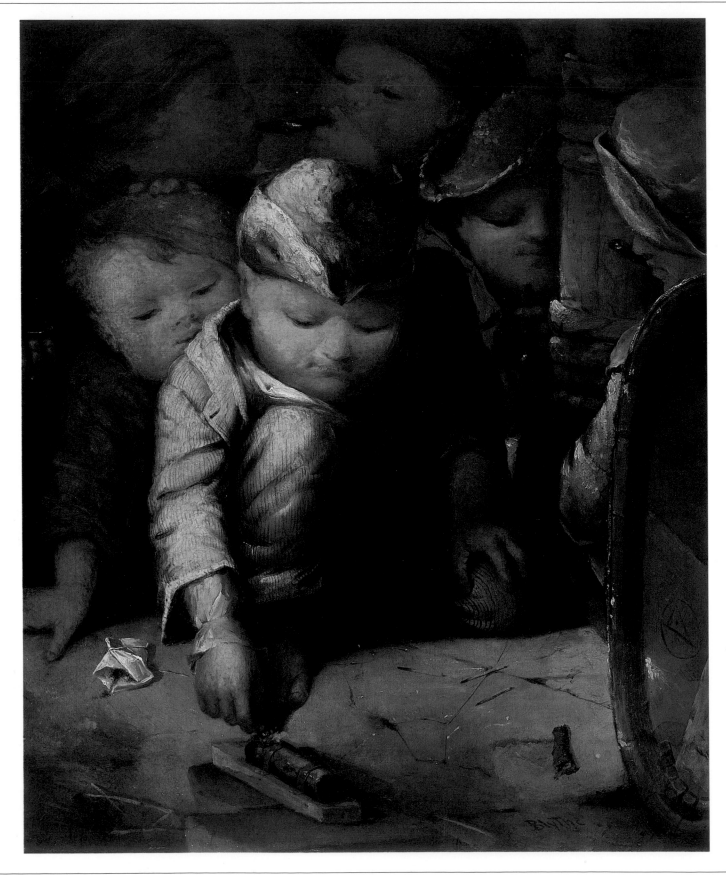

52

David Gilmour Blythe. b East Liverpool, OH, 1815. d Pittsburgh, PA, 1865. Street Urchins. c1856–58. Oil on canvas. h26¾ x w22 in. h68 x w55.9 cm. The Butler Institute of American Art, Youngstown, OH.

Bolotowsky Ilya Emerald Rectangle

The large gray curved element at the composition's center marks this as a transitional work for Bolotowsky, who was moving away from the use of tilted planes and eccentric shapes, toward a strict formalism based on right angles and derived from Constructivist principles. He began painting as a figurative artist, but in 1933, after seeing work by Piet Mondrian and Joan Miró in New York galleries, he turned to non-objectivity and created sophisticated compositions combining geometric and biomorphic elements. During the 1930s he was employed by the federal government's work-relief programs, where he was among the elite group of abstract muralists whose wall paintings adorned a municipal radio station, a housing project, and the 1939 World's Fair in New York. A founding member of the American Abstract Artists group, Bolotowsky was dedicated to "art that searches for new ways to achieve harmony and equilibrium," and continued to follow that direction single-mindedly for the rest of his life, regardless of prevailing art-world trends.

☛ Biederman, Diller, Kelley, Kelly

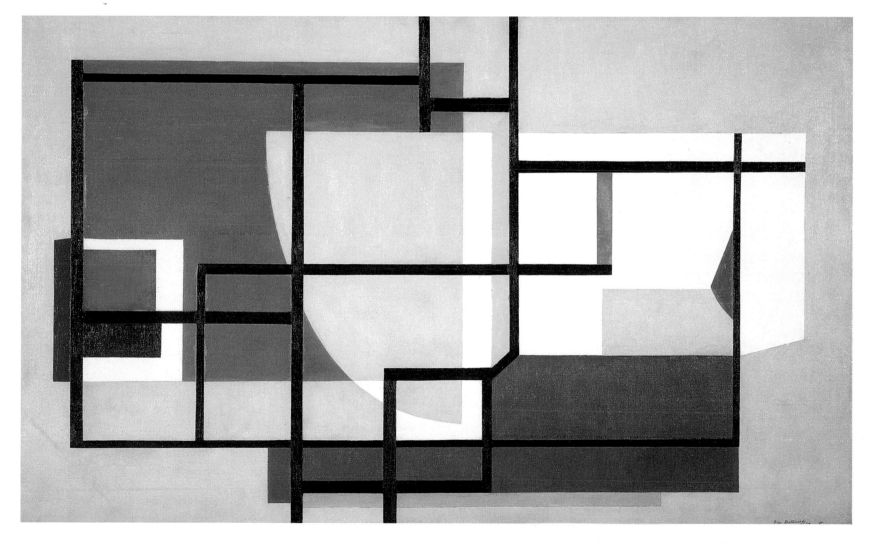

53

Ilya Bolotowsky. b Petrograd (now St. Petersburg), Russia, 1907. **d** New York, NY, 1981. **Emerald Rectangle.** 1946. Oil on canvas. **h**22 x **w**36 in. **h**55.9 x **w**91.5 cm. Collection J. Donald Nichols.

Borofsky Jonathan

Walking Man

A 56-foot-high male figure, made of hand-shaped fiberglass over steel, strides across a park in Munich, Germany. This commissioned sculpture represents a new addition to Borofsky's growing stable of stock characters, which includes running, hammering, flying, fighting, briefcase-toting, and perforated "molecule" men. Borofsky is a Conceptual artist whose eclectic drawings, sculptures, and sound-and-light installations are all politically oriented yet deeply personal. He has declared that his "thought process is an object" and has made detailed drawings of his dreams, numbering his works sequentially to focus his mind. Borofsky's monumental sculptures are often mechanized, and embody his own fears and anxieties. His running men of the 1980s suggested a fearful humanity looking back over its shoulder at the superpowers' Cold War machine, but his *Walking Man* may invoke a more optimistic figure for the post-Cold War era.

☛ Lachaise, Nadelman, Oldenburg, Shapiro

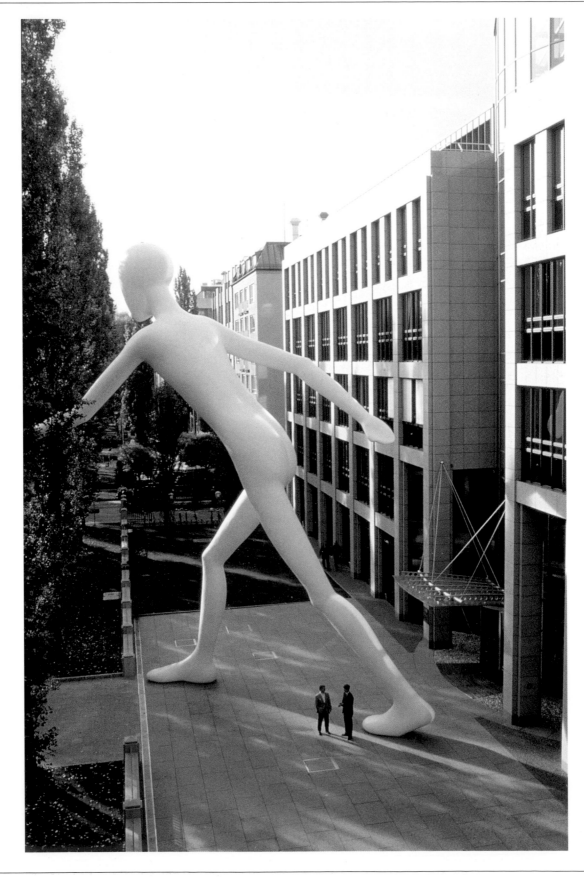

Jonathan Borofsky. b Boston, MA, 1942. **Walking Man.** 1994–95. Fiberglass hand shaped over steel. **h**56 ft. x **w**57 ft 6 in. x **d**19 ft 8 in. **h**17.1 x **w**17.5 x **d**6 m. Paula Cooper Gallery, New York, NY.

54

Bourgeois Louise

Untitled

A tangle of mattress springs is covered in sheer nylon fabric, eerily taking the form of a human torso. At once deeply disturbing and classically elegant, this work embodies the two poles of Bourgeois's art. Bourgeois calls the driving force behind her art "toi et moi" (you and me), the give-and-take interaction between two individuals. This has taken the form of sculptures that are at once male and female, old and young, confined and liberated — as in the anatomic protrusions yet overall feminine roundness of Untitled. Born and educated in France, Bourgeois moved to New York City in 1938, but her sculpture and drawings went generally unnoticed in the United States until the late 1970s, when the feminist art movement allied her work to that of such sculptors as Eva Hesse and Lee Bontecou.

Never beholden to any one style or school, Bourgeois's art is rooted in memories of her French childhood, as well as in her idiosyncratic philosophies about sex and interpersonal interaction.

☛ Blume, Kane, Puryear, K. Smith, Witkin

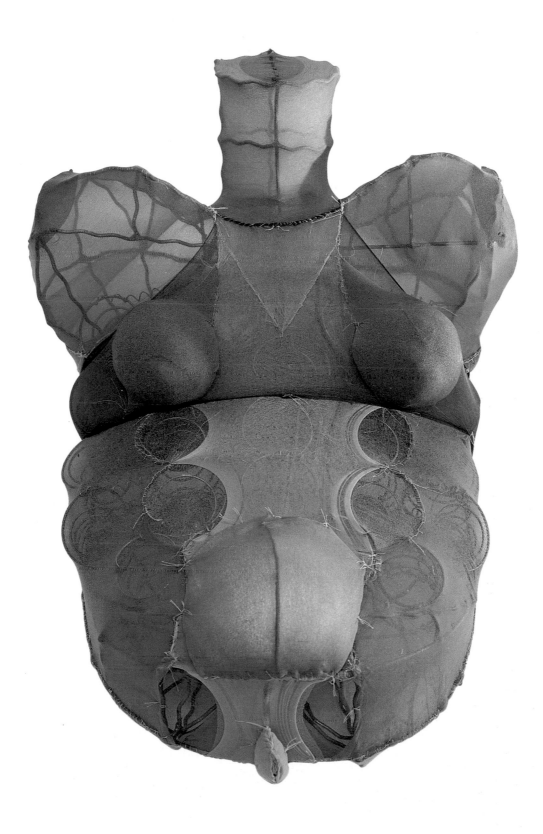

55

Louise Bourgeois. b Paris, France, 1911. Untitled. 1998. Fabric and metal. h10 x w25½ x d18 in. h25.4 x w64.8 x d45.7 cm. Cheim & Read, New York, NY.

Bourke-White Margaret

Chrysler Building

As if scanning Manhattan for prey, a precariously balanced stainless-steel gargoyle glints in the sunlight from a corner near the top of the Chrysler Building. A stunning monument to modernity, the 1,000-foot-high skyscraper was the tallest building in the world when Margaret Bourke-White photographed it for *Fortune* magazine in 1931. Industrial splendor was Bourke-White's forte in the early 1930s:

She traveled to Russia to photograph steel plants for *Fortune* and to Idaho to photograph the Fort Peck dam for the first issue of *Life* magazine. Her repertory expanded during the Depression, when she photographed victims of the Dust Bowl. During World War II, she was one of a handful of female combat photographers and was present at the liberation of Nazi concentration camps. A *Life* staff photographer

for most of her career, Bourke-White for a time kept an office in the Chrysler Building and was herself photographed leaning out of the hatch visible near the top of this steel ornament.

☞ Abbott, Bellamy, Roszak, Storrs

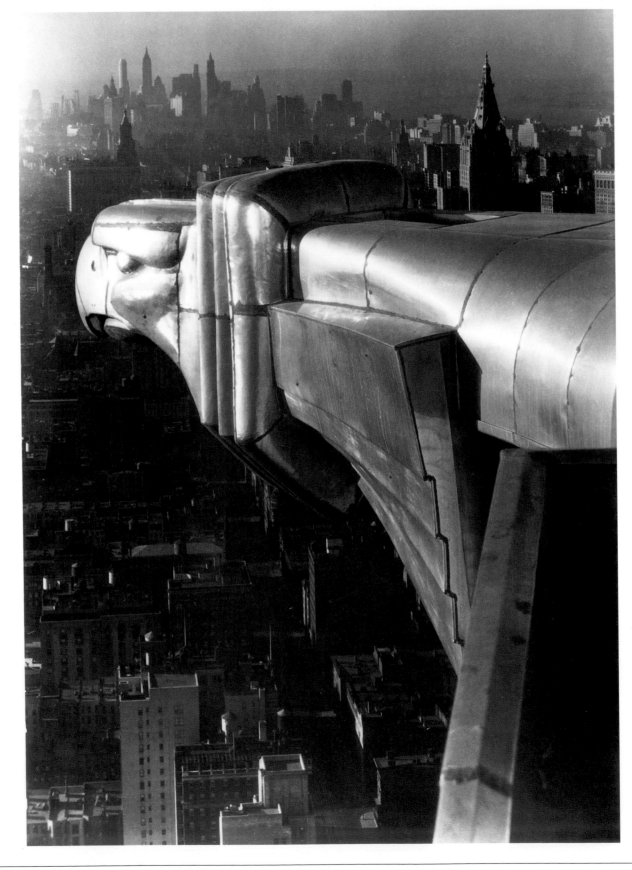

Margaret Bourke-White. b New York, NY, 1904. **d** Stamford, CT, 1971. **Chrysler Building.** 1931. Gelatin silver print. George Eastman House, Rochester, NY.

Bradford William

The Ice Dwellers Watching the Invaders

The dazzling brilliance of a sunset spills across the icy arctic wilderness. A ship, her sails at half-mast, lies quietly in the waters, an anomalous presence in the otherwise quiet territory of the polar bears and seals whose curiosity it draws. This type of eerie, exotic vision of the northern regions of Newfoundland around Labrador brought fame to Bradford, who had begun his career in Massachusetts as a painter of ship portraits. His formal training came from the Dutch-born marine painter Albert Van Beest, with whom he collaborated occasionally. The writings of the American arctic explorer Elisha Kent Kane prompted Bradford's travels to Labrador and Greenland throughout the 1860s. The sketches and photographs Bradford made on those trips were later elaborated into impressive oils, which, like those of his contemporaries Thomas Church and Albert Bierstadt, amazed viewers with their grandiose, operatic depictions of far-off lands.

☞ Blunt, Kent, Lane, Misrach

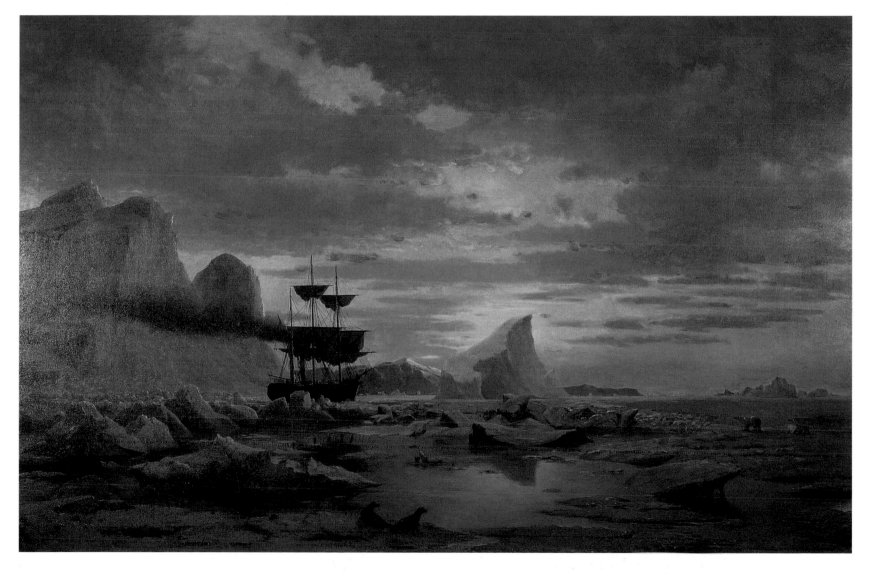

William Bradford. **b** Fairhaven, MA, 1823. **d** New Bedford, MA, 1892. **The Ice Dwellers Watching the Invaders.** c1870. Oil on canvas. **h**36 x **w**53 in. **h**91.5 x **w**134.7 cm. New Bedford Whaling Museum, New Bedford, MA.

Brady Mathew

Lt. Gen Ulysses S. Grant

General Ulysses S. Grant, Lincoln's last and best choice to command the Union forces in the Civil War, knits his brow and stares past the camera as he poses at his Virginia headquarters for a photograph. Grant's pose is reminiscent of Brady's renowned studio portraits of illustrious dignitaries. Here, a tree fills in for the iron posing stand, and the folds of the campaign tent replace the studio's velvet drapery. Brady put his money and reputation on the line to create a visual record of the Civil War, but he hired experienced operators to do most of the dirty work in the field. He displayed his images of the war's protagonists and its grisly carnage in his New York City and Washington, D.C., studios, and popular newspapers and magazines of the day reproduced them as engravings. After the war Brady fell into financial ruin and eventually lost possession of the glass-plate negatives he treasured. Brady was not entirely the combat photographer he claimed to be, but he made history as the sponsor of America's first important documentary project.

☛ Ball, Jarvis, Payne, C. W. Peale

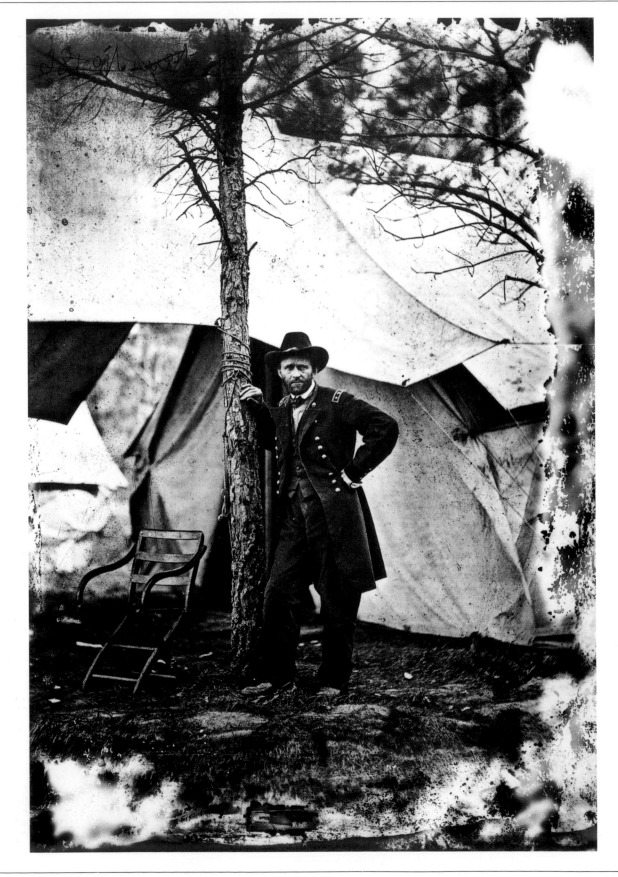

58

Mathew B. Brady. b near Lake George, NY, 1823. d New York, NY, 1896. Lt. Gen Ulysses S. Grant. 1864. Albumen print. National Archives & Records Administration, College Park, MD.

Brewster John

James Prince and Son William Henry

A solemn boy stands holding a sealed letter and his father pauses from writing a letter in this portrait centered around learning and communication. James Prince wears a genial expression that denotes satisfaction in his circumstances and pride in his youngest son. Prince was an influential citizen of Newburyport, Massachusetts, whose well-appointed home became Brewster's own for several weeks while the artist completed portraits of the family. Brewster was born a deaf-mute but supported himself through painting. He studied with the self-taught portraitist Joseph Steward at a time when Ralph Earl was painting in nearby Hartford, Connecticut. Earl's influence is especially apparent in this double portrait, with its relaxed formality and emphasis on the material details of the sitter's livelihood. Using portraits like this one as references, Brewster advertised his ability to paint a "striking likeness" at a "reasonable" price. He also used family connections to find patrons in Connecticut, Massachusetts, and Maine.

☞ Chandler, de Forest Brush, Field, Tanner

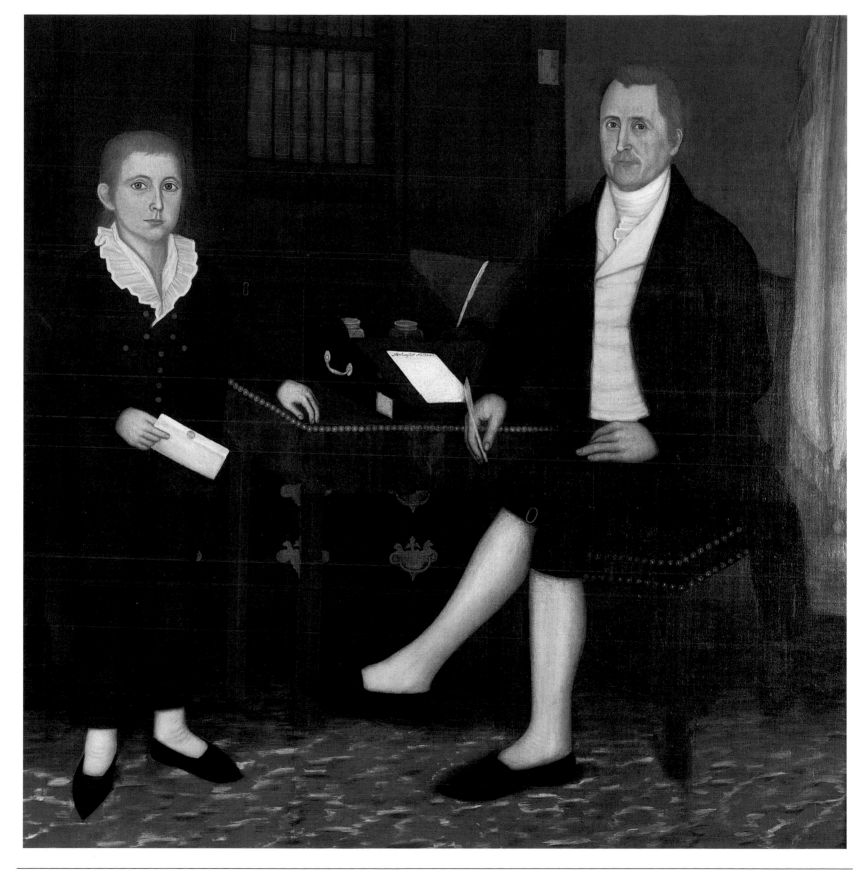

John Brewster, Jr. b Hampton, CT, 1766. **d** Buxton, ME, 1854. **James Prince and Son William Henry.** 1801. Oil on canvas. **h**60⅜ x **w**60½ in. Cushing House Museum, Newburyport, MA

Bricher Alfred T. Time and Tide

Late afternoon sunlight creates shimmering reflections on the water-soaked sandy beach as it rakes across the tips of the headlands. A distant rain shower, turned to silvery sheets by the light, signals the advent of the more severe weather promised by the gathering clouds. Bricher's exhibition of this work at the National Academy of Design in New York in 1874 emphatically announced a new direction in his art, away from mountainous landscapes in the Hudson River School manner and toward these luminous, large seascapes. The linking of "time" and "tide" in the painting's title probably registered strongly with the nineteenth-century audience, for it was a pairing made familiar through a number of literary sources, including Charles Dickens's serialized novel *Martin Chuzzlewit* ("Time and tide will wait for no man . . ."). From the mid-1870s onward, Bricher specialized in marine subjects in which the actions of man were minimized in deference to the inexorable power of nature.

☛ Church, Kensett, Smithson, Vedder

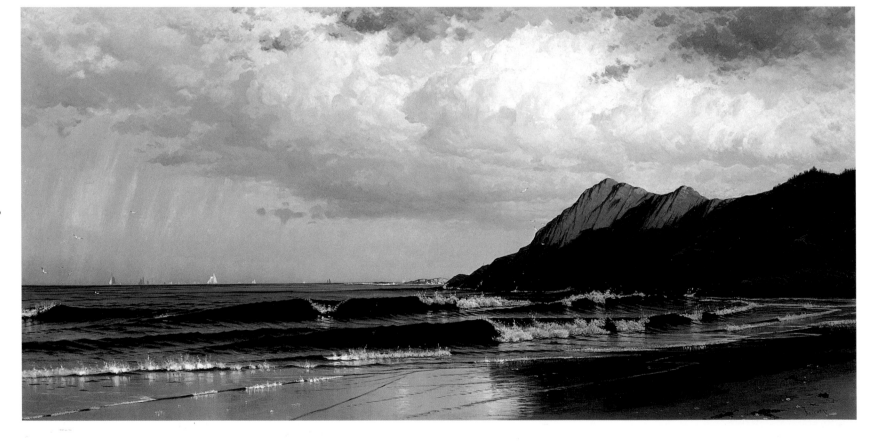

60

Alfred Thompson Bricher. b Portsmouth, NH, 1837. **d** New Dorp, NY, 1908. **Time and Tide.** c1873. Oil on canvas. **h**20¼ x **w**50 in. **h**51.5 x **w**127.1 cm. Dallas Museum of Art, Dallas, TX.

Brook Alexander

Georgia Jungle

This uncompromising study of a devastated landscape and its impoverished inhabitants takes a hard look at the blighted life of rural African-Americans during the Great Depression. Not a trace of greenery enlivens the spent earth, rendered as a field of straggling branches and barbed wire. The shrunken contour of a muddy pond further suggests depletion. Brook neither applied a veneer of picturesqueness nor imposed an overtly Social Realist message on this work, painted when the artist was dividing his time between New York and Savannah, Georgia. Instead, he let the environment speak for itself, using an overcast sky to emphasize the gloomy mood. One of the most celebrated and respected figurative painters to emerge after World War I, Brook was an early member of the Woodstock art colony in upstate New York. He was also assistant director of the Whitney Studio Club, where he did much to further the cause of modern American art in the 1920s.

☞ Curry, Gropper, Gwathmey, Hogue

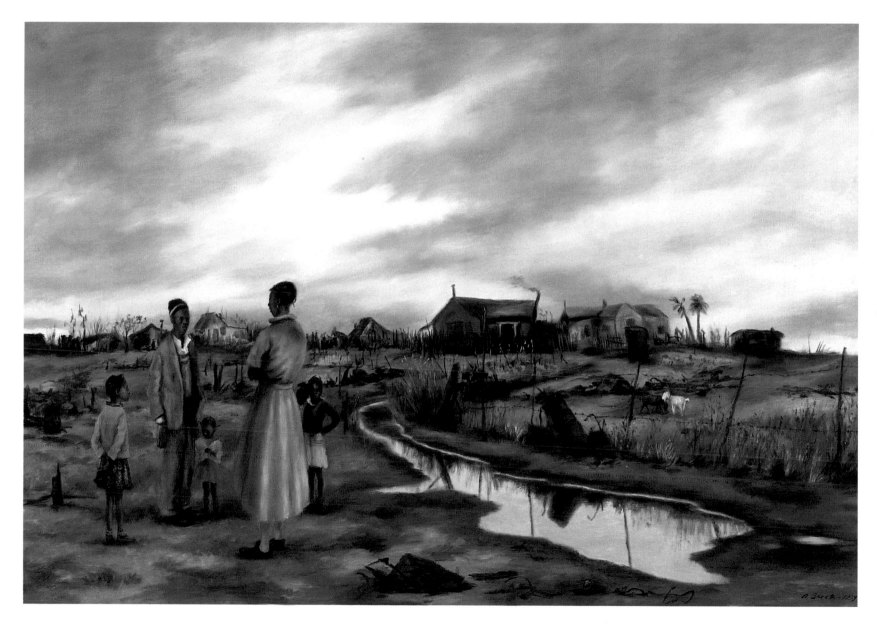

61

Alexander Brook. b Brooklyn, NY, 1898. d Sag Harbor, NY, 1980. Georgia Jungle. 1939. Oil on canvas. h35 x w50 in. h88.9 x w127 cm. Carnegie Museum of Art, Pittsburgh, PA.

Brooks James

Imagined Flight (detail of Flight)

In this section of Brooks's 2,800-square-foot mural, people from an early civilization huddle around a fire and imagine flight as spiritual transcendence, symbolized by a ritual bird-mask behind them. Also represented is the mythic quest of the winged Daedalus and his son Icarus, whose curled body falls to Earth. Circling the rotunda of the Marine Air Terminal at New York's LaGuardia Airport, this mural is the largest work of public art created under the WPA Federal Art Project. It traces the development of flight from Leonardo da Vinci's designs, to the Wright brothers' airplane, to intercontinental air transport service. Brooks, who later became an important Abstract Expressionist, was inspired by such diverse sources as Giotto's frescos and Picasso's *Guernica*. Rather than relating anecdotal incidents in aviation history, he opted for the more generalized theme of "historical attitudes toward flying." His aim, he wrote, was "to identify the spectator with the broad scope of man's yearning for flight and its final realization."

☞ French, Palmer, Shahn, Tanning

62

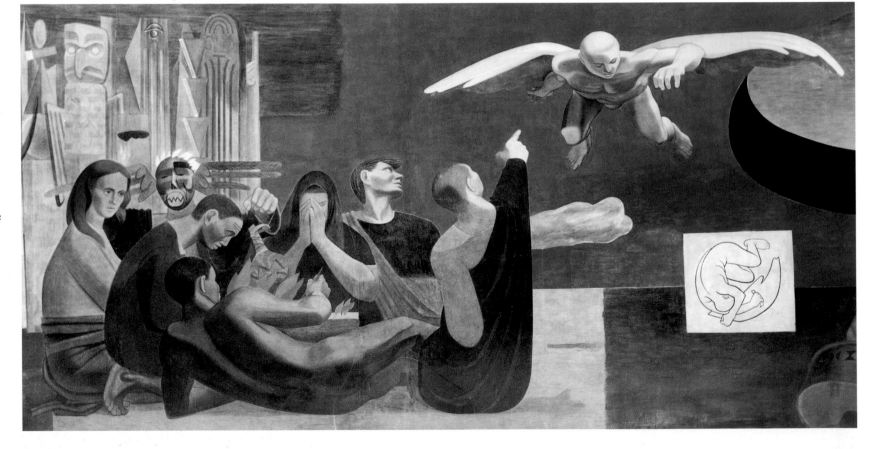

James Brooks. b St. Louis, MO, 1906. **d** Long Island, NY, 1992. **Imagined Flight (detail of Flight).** 1942. Tempera on linen with chalk and glue. **h**12 x **w**237 ft. **h**3.7 x **w**72.3 m. As installed at the Marine Air Terminal, LaGuardia Airport, New York, NY.

Bruce Patrick Henry

Peinture/Nature Morte

Bruce's still-life objects, which look like fragments of wooden trim cut on a jig saw, are reduced to a collection of planes, curves, and angles. Their bold, flat colors and lack of shading recall Matisse's cutouts, and indeed Bruce attended Matisse's class in Paris, where he spent most of his career. After studying at the New York School of Art, Bruce moved to France in 1903 and, as a regular visitor to Gertrude Stein's salon, traveled in the forefront of the expatriate vanguard. Bruce's early work was influenced strongly by Paul Cézanne's analysis of form and by Robert Delaunay's color theories, but after 1920 his style clarified and he developed the geometric formalism for which he is best known. Few of his mature paintings survive, however. Personal misfortunes led Bruce to abandon art in 1933, when he destroyed most of his work. Three years later, depressed and frustrated, he returned to the United States and took his own life.

☞ Cady, Carles, Francis, Hartley, Man Ray, Roesen

63

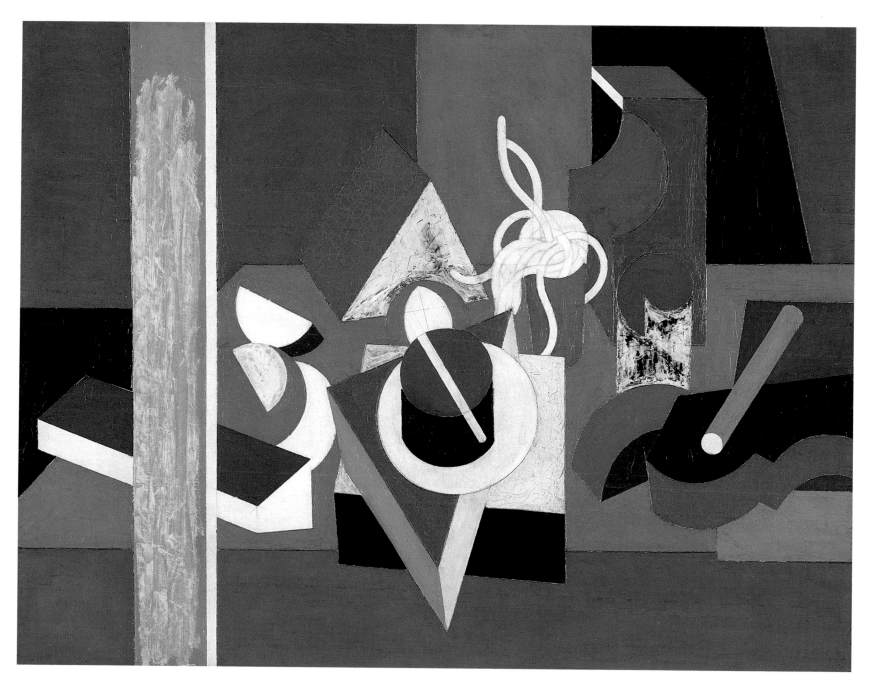

Patrick Henry Bruce. b Long Island, VA, 1881. **d** New York, NY, 1936. **Peinture/Nature Morte.** c1920–21. Oil on canvas. **h**35 x **w**46 in. **h**91.5 x **w**117 cm. The Museum of Fine Arts, Houston, TX.

Bundy Horace

Vermont Lawyer

From the exceptional detail in this painting, it seems that Bundy was directed or inspired to represent every aspect of his sitter's professional world in this portrait, possibly of Leonard Sargeant of Manchester. He painted the lawyer's head from both side and front, and provided a view of the top surface of the writing table as well as the titles on the bookshelf above it. As a final touch, he included the column and drapery typical of aristocratic state portraiture. Bundy trained as a decorative coach painter, but made his earliest portraits near Boston, where he must have seen paintings on canvas. After 1842, when he converted to the millennial Advent faith, Bundy worked as an itinerant preacher, yet his travels provided opportunities to paint in several New England towns. Bundy created larger portraits than this example, but his portrayal of a Vermont lawyer remains unique for the intensity of its execution, so proudly embodied in the sitter's upright posture and clear, piercing eyes.

☛ Chandler, Field, Maentel, Southworth & Hawes

64

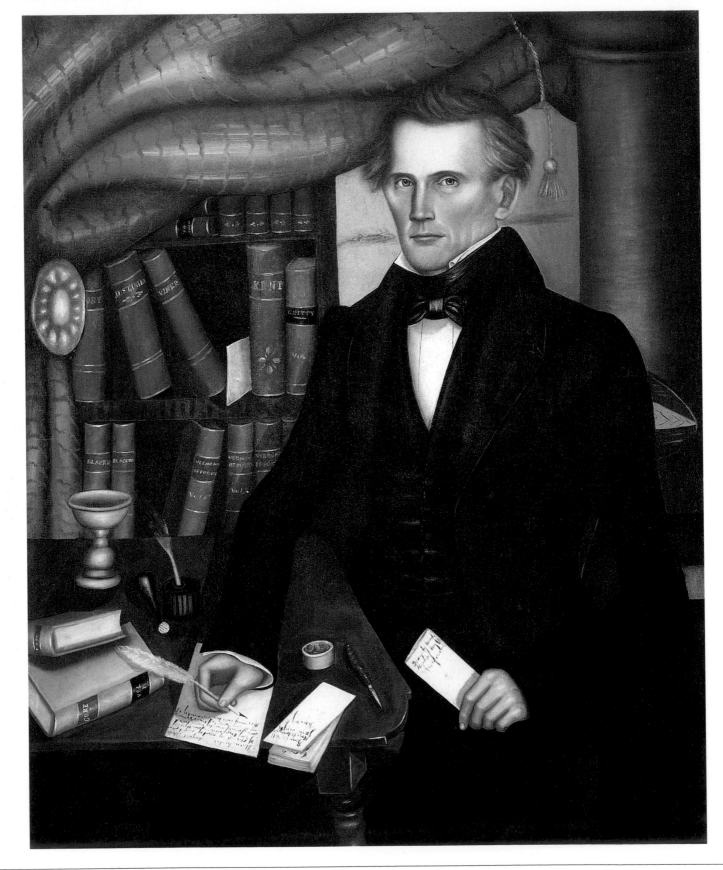

Horace Bundy. b Hardwich, VT, 1814. **d** Concord, NH, 1883. **Vermont Lawyer.** 1841. Oil on canvas. **h**44 x **w**35½ in. **h**111.8 x **w**90.3 cm. National Gallery of Art, Washington, D.C.

Burchfield Charles

Sun, Moon, Star

The title's "star" is found in the sign hanging over the unpaved street of this small Midwestern town. The crescent "moon" illuminates the tranquil scene. The "sun" is the name of the town's newspaper emblazoned on a prominent building that also bears in its pediment the year of the artist's birth. Best known for his expressionistic watercolors of eccentric buildings and fantastic foliage, Burchfield alternated between abstracted interpretations of nature and more literal representations of cityscapes, industrial structures, and rural scenes. Although often grouped with the Regionalists, he rejected the label, insisting that his art was a response to elemental forces. *Sun, Moon, Star* was begun during Burchfield's first extended period of full-time painting. Like many of his pieces, it was revised years later, after he had moved from his native Ohio to a suburb of Buffalo, New York.

☛ Cottingham, Feininger, Hahn, Steinberg, Wong

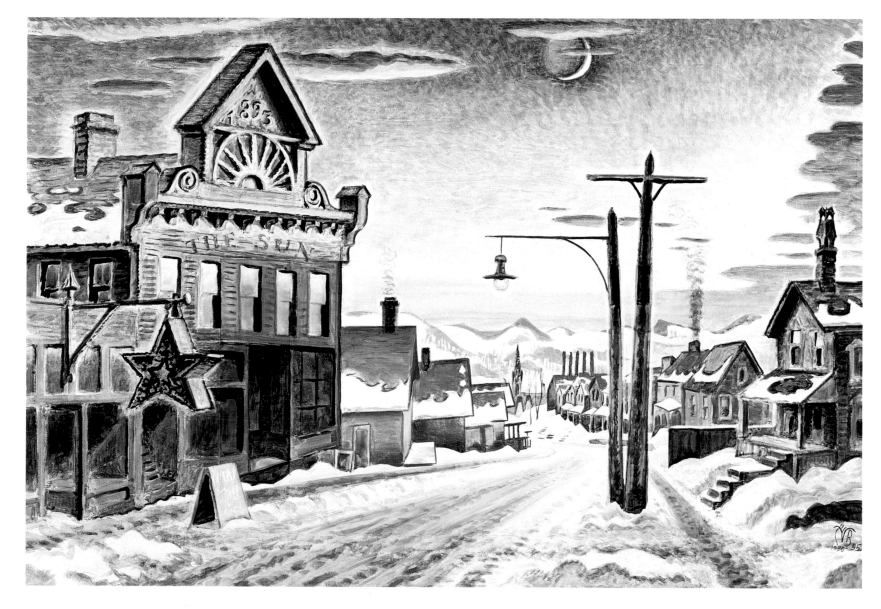

Charles Burchfield. b Ashtabula Harbor, OH, 1893. **d** Gardenville, NY, 1967. **Sun, Moon, Star.** 1920–55. Watercolor on wove paper. **h**37¹/2 x **w**54¹/2 in. **h**95.3 x **w**138.5 cm. Syracuse University Art Collection, Syracuse, NY.

Burden Chris

The Big Wheel

A six-thousand-pound cast-iron wheel is held in place by thick wooden timbers and abutted to the back tire of a motorcycle. When the piece is exhibited, the motorcycle is run at full power and then moved away. The iron flywheel continues to spin at 200 r.p.m. for over two hours. *The Big Wheel* embodies several hallmarks of Burden's art: impotence (in this case, the sculpture is literally "spinning its

wheels"), violence, and the intensity of immediate experience. Burden became notorious in Los Angeles during the early 1970s for solo performances in which he burned, impaled, shot, and (almost) drowned himself. Distinct from 1960s Happenings, Burden's self-destructive acts were carefully planned, and "relics" from them sold in galleries. The nonetheless unpredictable outcomes of these

Conceptual performances implicated viewers, calling bystanders' inactivity into question. In the 1980s, Burden gave up performance to make mechanical sculptures that embody the same themes.

☛ DiSuvero, Outerbridge, Ray, Rush

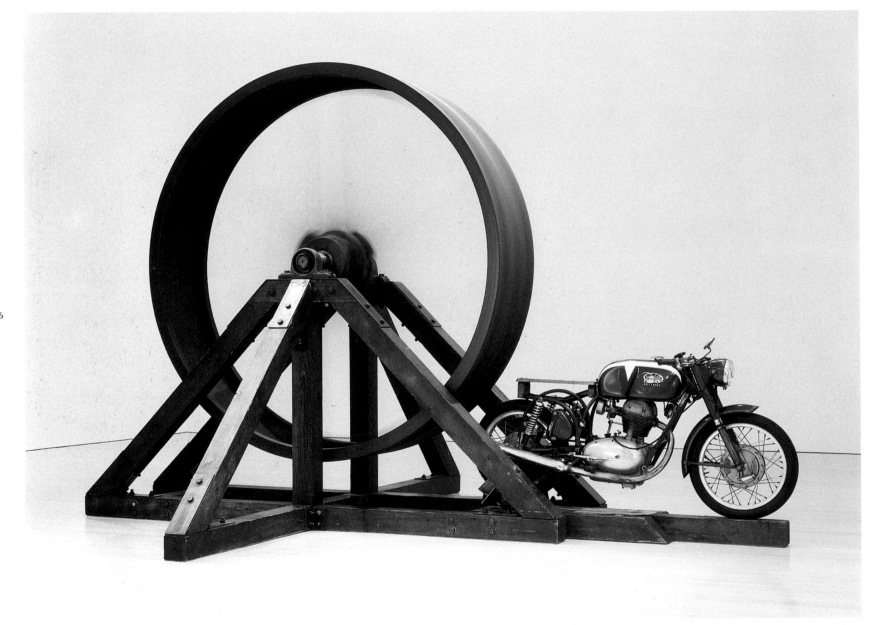

Chris Burden. b Boston, MA, 1946. **The Big Wheel.** 1979. 3-ton, 8-foot diameter cast-iron flywheel, powered by a motorcycle. **h**9 ft. 4 in. x **l**14 ft. 7 in. x **w**11 ft. 11 in. **h**2.8 x **l**4.4 x **w**3.6 m. Museum of Contemporary Art, Los Angeles, CA.

Burdett Edward

Daniel the Fourth of London

This meticulous rendering of the whaling ship *Daniel IV* was made on the unlikely medium of the tooth of a sperm whale, a technique called scrimshaw. The crew of the British vessel, with its dramatically etched rigging, is depicted "cutting in the whale," the process in which sheets of blubber from the captured whale are hauled aboard. Burdett, the carver of this scene, was a frequent member of such whaling expeditions. He sailed on his maiden voyage at the age of seventeen and continued whaling for the next eleven years until he died prematurely, drowning at sea. Like many of his colleagues, Burdett passed the many long, dull hours at sea by carving whaling scenes and other subjects into the teeth and jawbones of his quarry, the sperm whale. Burdett is noteworthy not only for the quality of his work, but also for being America's first documented scrimshander, or scrimshaw artist. A subsequent owner of this tooth has converted it into a snuff box, adding a silver lid and spoon.

☞ **Blunt, Bradford, Lane, Salmon**

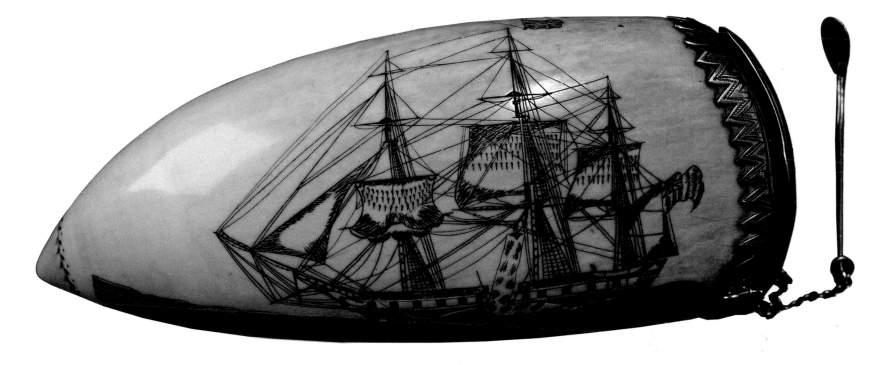

Edward Burdett. b Nantucket, MA, 1805. **d** Nantucket, MA 1833. **Daniel the Fourth of London.** c1822–33 (silver mounting added 1916). Scrimshaw whale tooth. l 7 in. l 17.8cm. John F. Rinaldi, Kennebunkport, ME.

Butterfield Deborah Ikezuki

An uncannily lifelike horse is constructed from pieces of found metal that have been hammered, pierced, and patinated to a uniform rusty brown. From its cocked ears made from twisted bits of steel to the sweep of its metal-pipe mane, the essence of the horse is communicated with exceptional economy. Horses are the sole subject of Butterfield's art; in the past, she has sculpted them from mud,

welded metal, bronze, tree roots, and steel. Though Butterfield's horses are not Photorealistic, they capture the distinctive posture and underlying musculature that immediately let us know which type of animal they represent. In this respect, Butterfield's work is different from that of other artists, such as the painter Susan Rothenberg, who use horses as a springboard to evoke human emotions or memories.

Butterfield's horses are more traditional in their insistence on evoking the animal's spirit only by revealing its architecture.

☞ Chamberlain, Curtis, Rothenberg, Troye, Voulkos

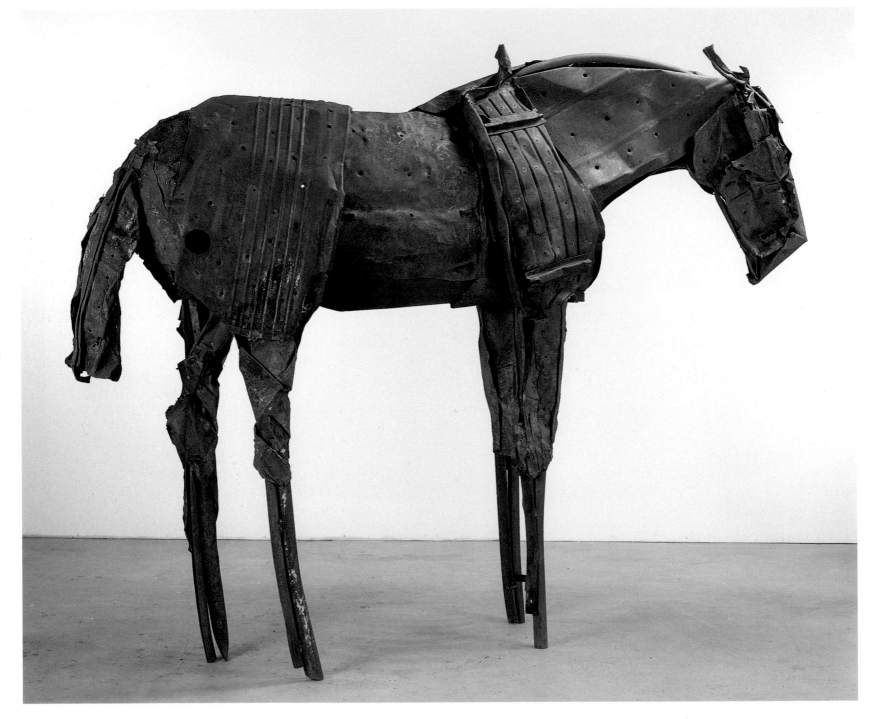

Deborah Butterfield. b San Diego, CA, 1949. **Ikezuki.** 1994. Found and pierced metal. **h**84 x **w**103 x **d**36 in. **h**213.5 x **w**262 x **d**91.5 cm. Greg Kucera Gallery, Seattle, WA.

Cadmus Paul

The Fleet's In!

In a merciless caricature of carousing sailors on shore leave, both male and female admirers in tight clothing flirt with the men as a scandalized spinster glares in disapproval. Painting with garish colors and overblown forms, Cadmus updates the tradition of the British social satirist William Hogarth, although Cadmus's precise technique owes more to Renaissance models. Painted for the federal government's Public Works of Art Project, the canvas was denounced by Navy top brass and removed from a national exhibition of project art at Washington's Corcoran Gallery. Ironically, however, it hung for years over the fireplace in a private club for naval officers, where the seamen's antics amused their superiors. Like his contemporaries George Tooker and Jared French, Cadmus uses stylized naturalism to create complex allegories of modern life, often rendered in the demanding egg tempera medium.

☞ Bishop, Greenwood, Marsh, Motley

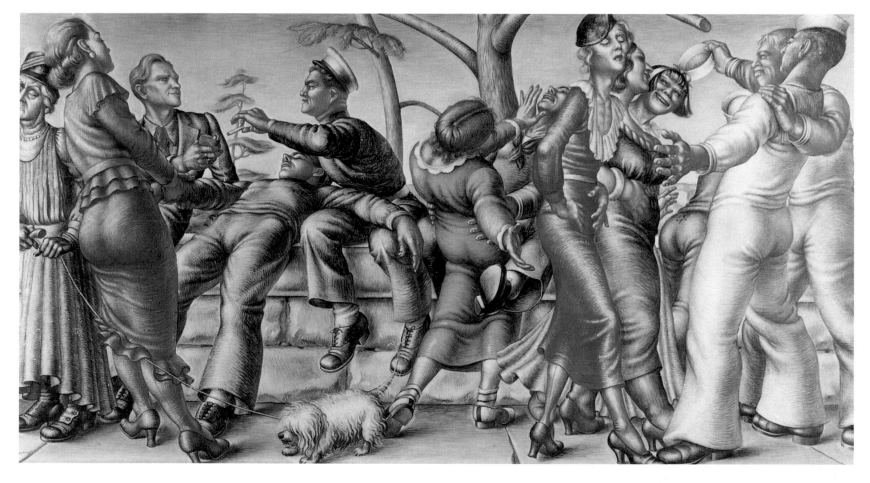

Paul Cadmus. b New York, NY, 1904. **The Fleet's In!** 1934. Oil on canvas. **h**30 x **w**60 in. **h**76.2 x **w**152.5 cm. US Navy Art Collection, Washington, D.C.

Cady Emma Jane

Fruit in a Glass Compote

A cold beauty emerges from this still life, with rich colors juxtaposed against whites and grays. Scattered mica flakes pasted within the outlines of the compote distinguish its surface from that of the marble around it. Created with the use of theorems, or stencils, the work transcends the inherent flatness of its method through Cady's careful modeling and arranging of forms. Theorem painting was a

popular occupation for women in the early nineteenth century, an accomplishment, like needlework, that provided both a creative outlet and an ornament for the home. The method was becoming outdated by the time Cady practiced it and seems to have played only a small role in her activities, which revolved around farmwork, family, and rural community life. For nearly fifty years this

watercolor was Cady's only known work, but now with the attribution to her of three additional theorem paintings and one still life in oil, Cady's exceptional talents can be better understood.

☞ Bailey, Francis, Reed, Roesen

70

Emma Jane Cady. b East Chatham, NY, 1854. **d** Grass Lake, MI, 1933. **Fruit in a Glass Compote.** 1898. Mica flakes, watercolor on wove paper. **h**15⅞ x **w**19¾ in. **h**40.4 x **w**50 cm. Abby Aldrich Rockefeller Folk Art Center, Williamsburg, VA.

Calder Alexander

Red Petals

Rising from a static base that tapers to a supporting arc, Calder's painted metal and wire construction culminates in a graceful cascade of stylized petals that swing into motion when animated by air currents. The artist described this series of so-called Totems as "pyramidal shapes with mobile festoons on their heads." The son and grandson of distinguished academic sculptors, Calder was an engineer before studying art and did not make his first sculpture until 1925, when he was twenty-seven. Moving to Paris the following year, he began working abstractly in wire, wood, and sheet metal, and his first exhibition of *mobiles* (a term coined for his work by Marcel Duchamp) was held there in 1932. Dividing his time between America and Europe, Calder became world-renowned for his enchanting biomorphic mobiles and stabiles, many commissioned for public sites. More than any other modern abstract artist, Picasso included, Calder achieved popular acclaim as well as the art world's respect.

☛ Baziotes, Cohoon, O'Keeffe, Shapiro

Alexander Calder. b Lawnton, PA, 1898. **d** New York, NY, 1976. **Red Petals.** 1942. Plate steel, steel wire, sheet aluminum, soft-iron bolts, and aluminum paint. **h**102 in. **h**259.1 cm. The Arts Club of Chicago, Chicago, IL.

Callahan Harry

Chicago

Perhaps stark to some eyes, the bare branches of these trees in winter suggested to Harry Callahan a lacelike visual rhythm that is both graphically simple and complex in its particulars. Callahan, whose interest in making an art of photography was first sparked by Ansel Adams, focused his career on experimenting with the effects of light and shadow, often exaggerating their contrast at the expense of a full range of tones. When he took this picture he was teaching in Chicago at the Institute of Design, a school founded by Bauhaus veteran László Moholy-Nagy. Inspired by Moholy-Nagy's legacy, Callahan developed the urge to investigate the core principles of the medium, but he added his own brand of American pragmatism to Moholy-Nagy's formalist idealism.

The result is a body of work that is deceptively simple, sometimes abstract, and full of feeling.

☛ Calder, Caponigro, Hammons, Porter, Welliver

72

Harry M. Callahan. b Detroit, MI, 1912. **Chicago.** 1950. Gelatin silver print. PaceWildensteinMacGill, New York, NY.

Caponigro Paul

Kentucky Trees

Looking like penumbral tufts of cotton balanced on the ends of thin poles, the leaves in this horizonless view of a Kentucky hillside emerge slowly from the depths of the darker ground. They seem to be spun from a magical, silvery substance, and it is difficult to tell if the season is spring or fall. While the dramatic landscape of the American West has fascinated photographers and their audiences for more than one hundred years, this picture reminds us that the East's subtle landscape should not be ignored. For Caponigro, who has photographed nature's subtleties in England, Ireland, and Japan, as well as across the United States, the aim of photographs like this is to suggest a spiritual world that transcends the merely picturesque. A student of Minor White in the 1950s, Caponigro shared White's interests in meditation and Eastern religions. His pictures consequently are often close to being abstract, and they reward close inspection. Like Ansel Adams, whose work also was an important formative influence, Caponigro originally intended to be a concert pianist.

☞ Callahan, Celmins, Metcalf, Porter, Taafe

73

Paul Caponigro. b Boston, MA, 1932. **Kentucky Trees.** 1965. Gelatin silver print. Collection of the artist.

Carles Arthur B. Still Life with Silver Lustre Vase

Cubist faceting and bold Fauvist color transform a floral still life into a richly colored prism, with a gray vase calmly centering the composition. Carles applied the Modernist principles he had learned in Paris from 1907 to 1910 to a classic formal arrangement, yet the result is an intuitive response to his subject. "I do not know when I begin to paint what will appear on the finished canvas," he said in

1924, prefiguring Abstract Expressionism's spontaneity by more than two decades. An intense, charismatic figure, Carles was associated with Gertrude and Leo Stein's vanguard circle in Paris and exhibited at Stieglitz's "291" gallery in New York. Possessed of a mercurial temperament, Carles nonetheless enjoyed professional honors and personal popularity as a teacher and cultural activist. A friendship

with Hans Hofmann revitalized his art in the 1930s, reinforcing his convictions that expressive color is the bedrock of painting, and "the subject of all works of art is the artist."

☛ Bruce, Krasner, MacDonald-Wright, Weber

74

Arthur Beecher Carles, Jr. **b** Philadelphia, PA, 1882. **d** Philadelphia, PA, 1952. **Still Life with Silver Lustre Vase.** c1928. Oil on canvas. **h**35¾ x **w**31½ in. **h**91 x **w**80 cm. Private collection.

Casilear John

Lake George

Deep in the Adirondack Mountains of upstate New York the shadowed forest gives way to a broad view of the still, silvery surface of Lake George. On the boulder at the lower right, a man takes advantage of the quiet summer day and surveys the natural beauty that unfolds before him. Casilear doubtless identified with the process of quiet contemplation of the American scenery that he portrayed here, for he was among the artists of the Hudson River School, who traveled to this region in the warmer months to make sketches in preparation for work in their New York studios over the winter. Like his friends Asher B. Durand and John F. Kensett, Casilear started as an engraver, which partly accounts for his careful attention to detail in his oils. Although he started painting when he was twenty, it was not until 1854, when he was forty-three, that his engraving business yielded the financial security that permitted him to pursue seriously a career as a painter.

☞ Cole, Duncanson, Gifford, Stoddard

75

John William Casilear. b New York, NY, 1811. **d** Saratoga, NY, 1893. **Lake George.** 1860. Oil on canvas. **h**26¹/₄ x **w**42¹/₄ in. **h**66.7 x **w**107.4 cm. Wadsworth Atheneum, Hartford, CT.

Cassatt Mary

The Child's Bath

A young woman tenderly supports a little girl in her lap as she bathes the child's feet. The physical intimacy of this quiet scene is enhanced by the shared concentration of the two performing this simple nursery routine. The angle from which they are viewed emphasizes the two-dimensional quality of the image, which is reduced to a densely patterned surface relieved by the light-colored but strong vertical mass of the child's body. This radical compositional device is indicative of Cassatt's place in the avant-garde of her time. Like many of her contemporaries on the eve of Modernism, she was influenced by an awareness of Japanese art and photographic cropping techniques. A close associate of Edgar Degas, Cassatt was the only American to exhibit with the French Impressionists. Despite her expatriate life in France, Cassatt's art was frequently seen in American exhibitions, and she was a leader in promoting the taste for contemporary French art among American collectors.

☛ **Brewster, Couse, de Forest Brush, Tanner**

76

Mary Stevenson Cassatt. b Pittsburgh, PA, 1844. **d** Mesnil-Beaufresne, France, 1926. **The Child's Bath.** 1893. Oil on canvas. **h**39½ x **w**26 in. **h**100.4 x **w**66.1 cm. The Art Institute of Chicago, Chicago, IL.

Catesby Mark

Largest White Billed Woodpecker (Picus Maximus Rostro Albo) with Willow Oak

A black and white bird with glossy feathers and a jaunty red crest perches on a tree as if pausing between pecks at its bark. The bird's talons rest insecurely, however, and the sprig of acorned leaves branches off at an unusually artful angle. Catesby often joined flora and fauna when depicting specimens of natural history, suggesting a world of interrelated organisms that contrasts dramatically with contemporary images of single plants or animals isolated on the page. Catesby's passion to study "the Animal and Vegetable Productions in their Native Countries, which were strangers to England" led him to Virginia in 1712 and later to South Carolina, the West Indies, and the Bahamas. These expeditions resulted in the first fully illustrated survey of North American wildlife. Catesby "was not bred a Painter," but his images "done in a Flat, tho' exact manner" proved remarkably influential to later naturalist-illustrators such as John James Audubon.

☛ **Audubon, Bartram, Bates, Le Moyne**

Mark Catesby. b England, c1679. **d** London, United Kingdom, 1749. **Largest White Billed Woodpecker.** Hand-colored engraving. **h**14 1/8 x **w**10 3/8 in. **h**36 x **w**26.5 cm. From Catesby, *The Natural History of Carolina, Florida, and the Bahama Islands.* Vol. 1 (London, 1731–43). William L. Clements Library, The University of Michigan, Ann Arbor, MI.

Catlin George

Buffalo Chase on the Upper Missouri

An Indian hunter pulls back his bow, ready to let loose an arrow into a buffalo who has stampeded blindly into the horse of a fellow hunter. Nearby, his horse struggles to regain its footing, crushed by the impact of an already defeated, and bloody, buffalo. Working in the 1830s, Catlin was one of the first white observers to record such scenes of a Plains Indian buffalo hunt. A self-taught painter, Catlin gave up a burgeoning legal career and an established portrait painting business in Philadelphia to travel west. "By aid of [his] brush and pen," Catlin vowed "to rescue from oblivion" a Native American way of life threatened with annihilation by white Western expansion and disease. His desire to chronicle everyday Native American life was so strong that in his own day he was regarded as an ethnographic recorder more than an artist. Today, he is viewed as the forerunner of such painters of nineteenth-century Native American life as Charles Wimar, John Mix Stanley, and Alfred Jacob Miller.

☛ Couse, Deas, Russell, Wimar

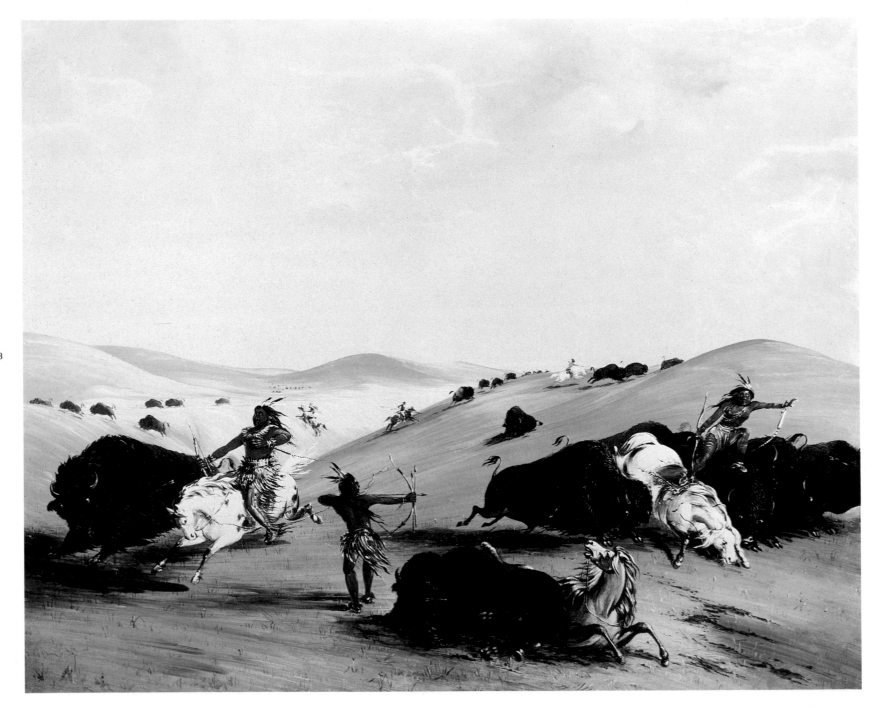

78

George Catlin. b Wilkes-Barre, PA, 1794. **d** Wilkes-Barre, PA, 1872. **Buffalo Chase on the Upper Missouri.** n.d. Oil on canvas. **h**25¾ x **w**32 in. **h**65.4 x **w**81.3 cm. Gerald Peters Gallery, Santa Fe, NM.

Celmins Vija

Untitled

Ocean waves are rendered in gray paint, the unfamiliar color and the compressed space of the picture-plane transforming a familiar image into an abstract object of fascination. Though she began as a Pop-Realist painter of banal objects like heaters and pencils, since the late 1960s Celmins has been capturing waves, stars, and deserts in heavily worked graphite drawings and prints, all inspired by the landscape surrounding her Venice, California, studio. In the late 1980s, Celmins returned to painting, with small works in oils of natural phenomena that have an aura of devotion and meditation, a result of their active yet smooth surfaces and Celmins's dedication to "a single image without having something in the middle." Celmins works from photographs, subtly changing aspects of focus and density to solidify the space and focus viewers' attention. Similar abstracting strategies appear in the paintings of Jasper Johns and Chuck Close.

☛ Gowin, Ryman, Tack, Weston

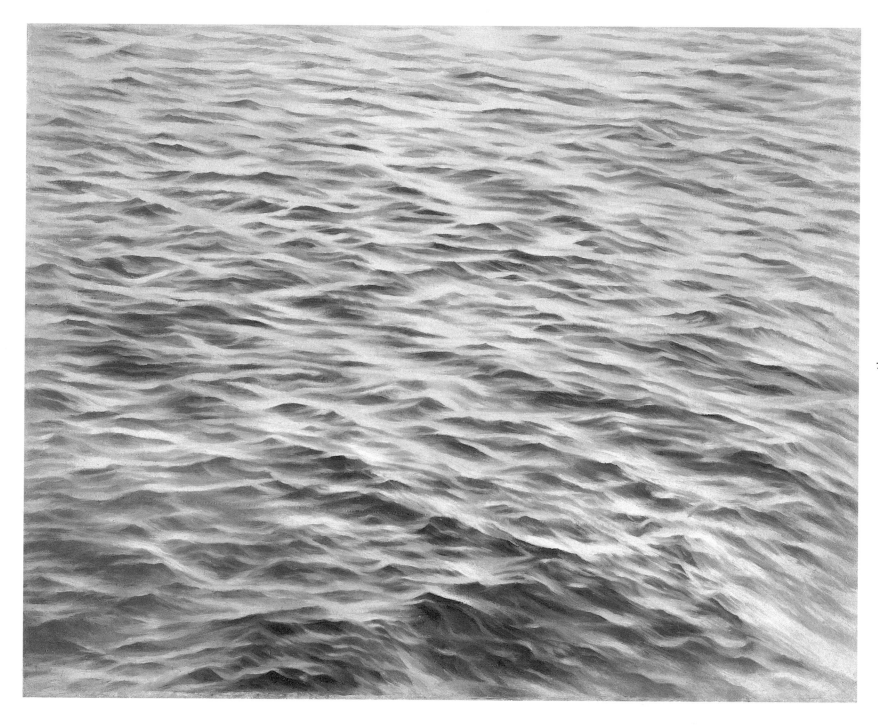

79

Vija Celmins. b Riga, Latvia, 1938. **Untitled.** 1990. Oil on linen. **h**15¼ x **w**18¾ in. **h**38.8 x **w**47.7 cm. McKee Gallery, New York, NY.

Chamberlain John Nanoweap

Crushed and dented chromium-plated steel from wrecked automobile bodies is molded into twisting cavities and faceted surfaces that recall a Cubist painting or sinuous, melting plastic. Despite the violence inherent in the sculpture's material, Chamberlain has used this work to explore the steel's formal qualities — such as its texture, color, and malleability — rather than any symbolic or social meaning.

Nanoweap defies analysis. Like the work of Minimalist artists such as Donald Judd, its outward form and appearance are pure justification for its presence. Influenced by sculptor David Smith, Chamberlain began fashioning abstract pieces made from auto bodies and scrap metal in the late 1950s. His work is situated within the context of "junk art" of the 1960s, in which artists used discarded and found materials in an attempt to eliminate evidence of craftsmanship and the artist's own signature. In later years, he has worked with materials including Fiberglass, plastic, galvanized steel, and aluminum.

☞ Covert, Kline, Murray, Ray, Voulkos

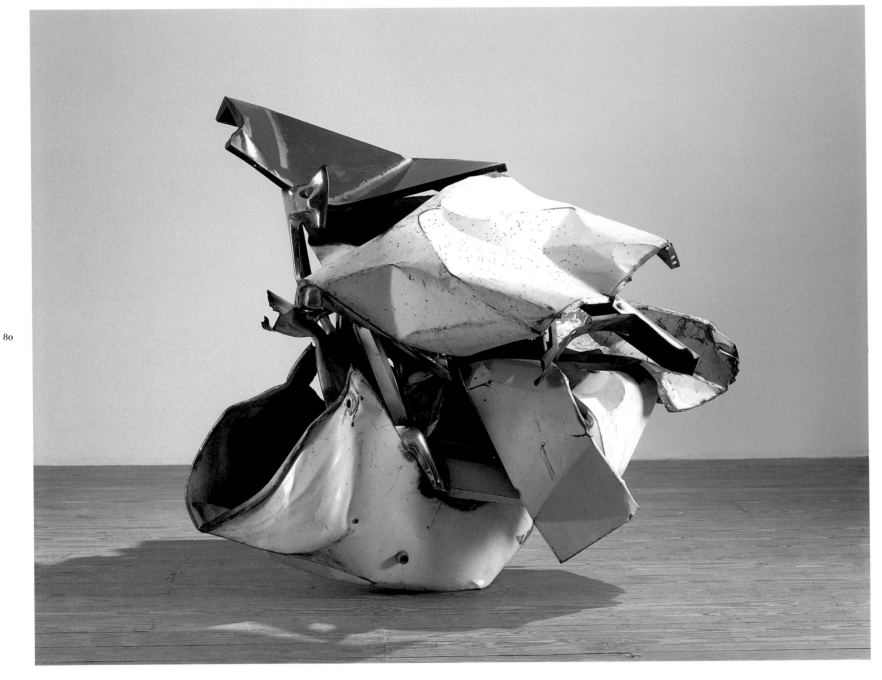

John Chamberlain. b Rochester, IN, 1927. **Nanoweap.** 1969. Painted and chromium-plated steel. **h**54 x **w**63 in. **h**137.1 x **w**160 cm. The Menil Collection, Houston, TX.

Chambers Thomas

View of Cold Spring and Mount Taurus, about 1850

Dramatic contrasts and vivid colors animate this river landscape, where blasted trees, scenic ruins, imposing peaks, and a distant view all vie for attention. In the foreground, a hiker stops beside a genteel couple reposing on a ledge. Their ostensible view is the West Point Foundry at Cold Spring below Mount Taurus in New York; their location is the ruins of Fort Putnam on the west side of the Hudson

River, a picturesque site favored by nineteenth-century tourists and painters alike. Chambers rearranged elements of this landscape, however, and exaggerated features and colors to heighten its already considerable impact. Chambers often derived his landscape and marine subjects from contemporary engravings of naval battles and American scenery, and used his bold manner to create scenes both

familiar and fantastic. Little is known of his background or training, although his painting style has led some to speculate that he was a china or theater set painter in England before coming to America in 1832.

☞ **Cole, Colman, Duncanson, Tiffany**

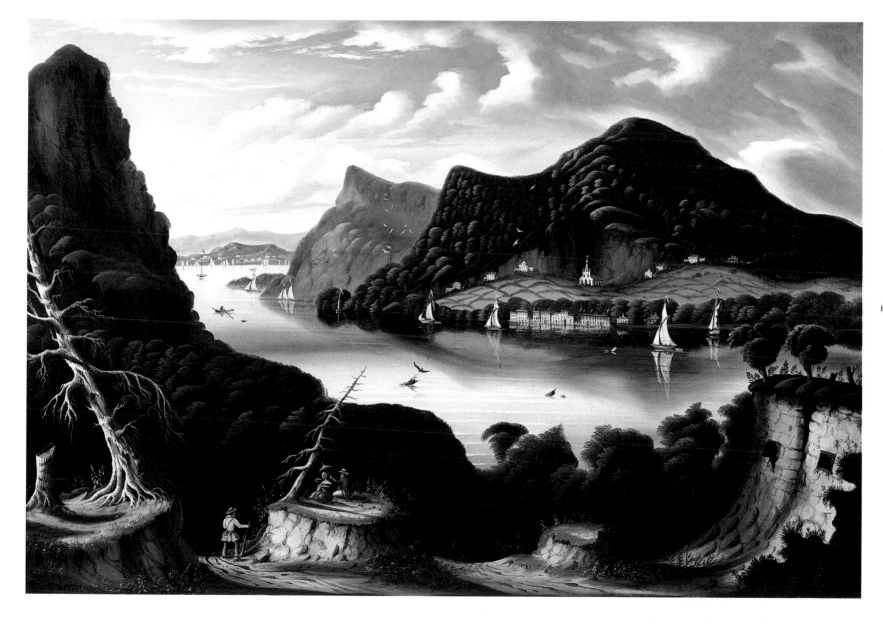

Thomas Chambers. b England, c1808. d place unknown, c1866. **View of Cold Spring and Mount Taurus, about 1850.** Oil on canvas. h35 x w50⅛ in. h88.9 x w127.4 cm. Hirschl & Adler Galleries, New York, NY.

Chandler Winthrop

Captain Samuel Chandler

Stern of visage but proudly relaxed in bearing, Samuel Chandler sits poised between parlor and battle, his tricorn hat beside him, his silver-hilt sword at hand. The scene behind him may not depict a particular engagement, but it must refer to Chandler's service as a militia captain in the Revolutionary War. Particular details, from a burning house to a dog licking blood off a corpse, seem to indicate a personal experience that the sitter communicated to the artist, who was his brother. Winthrop Chandler was born on his family's farm. He was self-taught, or perhaps trained as a house-painter; an 1862 local history indicates that he studied painting in Boston. Chandler paid close attention to detail as well as to character in his portraits, employing dramatic color and strongly decorative linear patterns. His patrons were also rural folk, often family members or neighbors, whom Chandler depicted with hard realism and sober monumentality.

☞ Beaux, Brewster, Bundy, Smith

82

Winthrop Chandler. b Woodstock, CT, 1747. **d** Woodstock, CT, 1790. **Captain Samuel Chandler.** c1780. Oil on canvas. **h**54¾ x **w**47⅞ in. **h**139 x **w**121.7 cm. National Gallery of Art, Washington, D.C.

Chase William Merritt

The Bayberry Bush

The sparkling white dresses and brightly colored sashes and ribbons of three little girls — the artist's daughters — lend vital compositional accents to this idyllic sunlit scene. Standing sentinel-like on the horizon is the massive house that, for many years, accommodated the artist's large family and private studio during their summers at Shinnecock, Long Island. Chase took obvious delight in portraying his children as they explored the fields around their home, yet the painting may also be interpreted as a subtle form of self-promotion. By the time this work was painted, Chase was already enjoying a strong public profile as a leading American Impressionist. He gained further celebrity through teaching at his nearby Shinnecock Summer School of Art for Men and Women, where painting in the out-of-doors was central to the curriculum. With its beautiful light and landscape, Long Island at this time was beginning to attract a number of artists, among them Childe Hassam and Thomas Moran.

☞ Homer, Johnson, J. Thompson, Vonnoh, Wendel

83

William Merritt Chase. b Williamsburg (now Ninevah), IN, 1849. **d** New York, NY, 1916. **The Bayberry Bush.** c1895. Oil on canvas. **h**25¹/₂ x **w**33¹/₈ in. **h**64.8 x **w**84.2 cm. The Parrish Art Museum, Southampton, NY.

Chicago Judy

Rainbow Shabbat

A Jewish Shabbat (Sabbath) table is set for the traditional Friday evening ceremony and meal. At one end of the table, a man raises the traditional cup of wine, while at the other, a woman lights the candles. Seated around the table is a multi-ethnic, multicultural series of guests — including a cat. Chicago states that this work is "an image of international sharing across race, gender, class, and species." The stained-glass triptych is the final image in "The Holocaust Project," a multimedia series Chicago undertook to represent the horrors of the German extermination of Jews and others during World War II. Rainbow Shabbat embodies all the concerns of Chicago's art, which seeks to unite feminism with Chicago's own utopian ideals for a more harmonious society.

Chicago's most famous installation is *The Dinner Party* (1979), a landmark of feminist art that metaphorically presents a world history of famous women.

☛ Evergood, H. Sargent, Shahn, Tiffany

84

Judy Chicago (Judy Cohen). b Chicago, IL, 1939. **Rainbow Shabbat.** 1992. Center panel from the *Holocaust Project.* Stained glass. Hand-painted by Dorothy Maddy from cartoon by Judy Chicago; fabricated by Bob Gomez. **h**54 x **w**16 in. **h**137.2 x **w**40.7 cm. Collection of the artist and Through the Flower, Belen, NM.

Christenberry William Store, Greensboro, Alabama, 1967

An unprepossessing shack that once served as a store sits vacant and crumbling in the flat soil of Alabama cotton country. Except for the ad hoc addition of a bare branch, which seems bent by the task of propping up the overhanging roof, the shack is perfectly bilaterally symmetrical, even down to the soda signs on the facade. The photograph is as plain and straightforward as any of Walker Evans's well-known pictures of the South taken thirty years earlier, except that it is in color. The soft focus of this print lends this subject a dreamy, nostalgic sensibility. It was made with a primitive Kodak Brownie camera and is among Christenberry's first photographs. Christenberry is a native of Hale County, Alabama, who started his art career as a painter. Today he uses a sophisticated view camera to make photographs of the buildings in his home county, some of which he transforms into sculptural wooden models.

☛ Brook, Evans, Lee, Traylor

William Christenberry. b Tuscaloosa, AL, 1936. **Store, Greensboro, Alabama, 1967.** Ektacolor print. Collection of the artist.

Church Frederic E. Niagara

The uncontrollable rush of the waters of Niagara River pulls the viewer to the brink of the Horseshoe Falls, the curved shape of which forces our eye along the diagonal edge of the chasm to the flat horizon. Unlike his predecessors, Church adopted a disorienting, close-up view that offered a frisson of danger because it denied the comfort of a secure vantage point. The compositional drama matches the might of the Falls, which by the early nineteenth century was already an icon in the compendium of the New World's natural wonders. *Niagara* drew rave reviews when it debuted on its own at a New York commercial gallery. Shortly afterward it toured Britain, where critics interpreted the natural power of the Falls as a metaphor for America's maturing cultural strength. Church, initially a student of the Hudson River School painter Thomas Cole, went on to create a series of monumental canvases that focused on the sublime spectacle of nature.

☛ Bricher, Heizer, P. Kane, Kensett

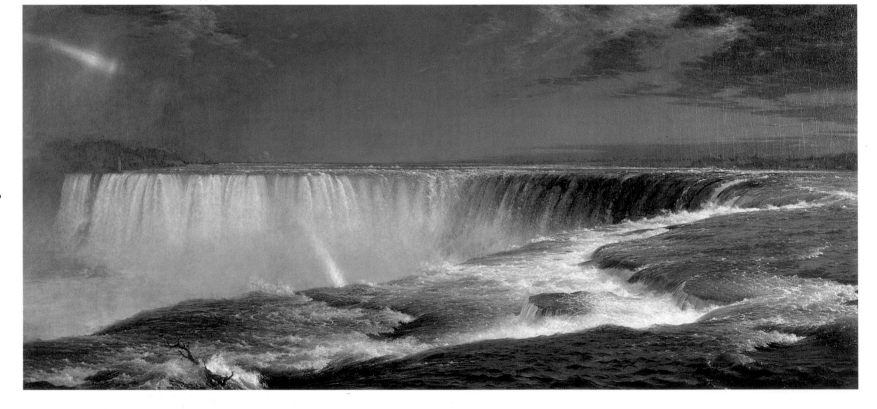

86

Frederic Edwin Church. b Hartford, CT, 1826. **d** New York, NY, 1900. **Niagara.** 1857. Oil on canvas. **h**42¼ x **w**90½ in. **h**107.3 x **w**229.9 cm. The Corcoran Gallery of Art, Washington, D.C.

Church Henry

The Monkey Picture

Two monkeys are making a mess of this Victorian dining room. The policeman about to charge in will certainly have his hands full — even the tiger rug has come alive to join the pandemonium. Henry Church was an iconoclast in rural Chagrin Falls, Ohio. He was trained by his father as a blacksmith, but could also claim skills as a self-taught painter, sculptor, woodsman, and musician. After making several traditional still lifes, Church created this work, a gleeful satire on the rigid conventions of academic painting. *The Monkey Picture* was painted at the turn of the nineteenth century, and the painting's central theme of upheaval parallels the many social changes taking place at the dawn of the modern era. An original to the end, Church recorded his own voice saying "goodbye at present" to be played on a gramophone at his funeral.

☛ **Francis, Koons, Roesen, H. Sargent**

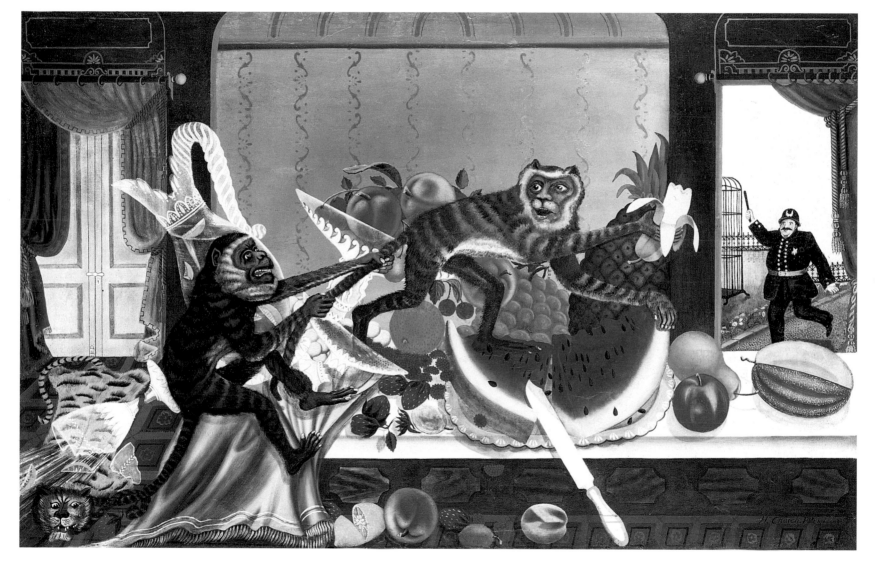

Henry Church. b Chagrin Falls, OH, 1836. **d** Chagrin Falls, OH, 1908. **The Monkey Picture.** c1895–1900. Oil on canvas. **h**28 x **w**44 in. **h**71.2 x **w**111.8 cm. Abby Aldrich Rockefeller Folk Art Center, Williamsburg, VA.

Clark Larry

Untitled

The knitted brow and averted face of the man holding this wide-eyed child suggest that this is not a typical proud-parent picture. Taken from an overhead angle, the photograph seems to treat the two figures as equals, and as strangers to each other. In fact, the man is an intensely troubled high school dropout engaged in a world of petty criminality, intravenous drugs, and casual sex — a disorderly, destructive life of which the child is both a product and a victim. The Oklahoma teenager is a central character in Clark's classic 1971 book *Tulsa,* which features vivid, intimate scenes of the photographer's friends and acquaintances shooting up amphetamines, playing with guns, and lounging about in drug-induced stupors. Clark's insider point of view distinguished his work from most photojournalism of the time and gave it an unmatched immediacy, though critics called it disturbing. His more recent work, less autobiographical but still focused on teenage boys, includes the 1995 film *Kids.*

☛ **Avedon, Cassatt, Gardener, Tanner**

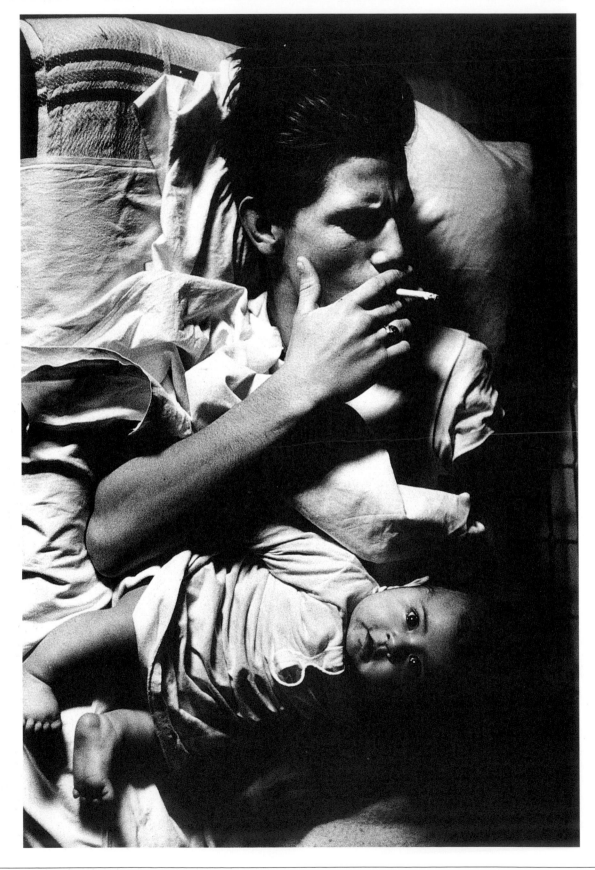

Larry Clark. b Tulsa, OK, 1943. **Untitled.** 1963. Gelatin silver print. Luhring Augustine, New York, NY.

Close Chuck

Robert

The artist Robert Rauschenberg is pictured in full and disorienting close-up, his face constructed from hundreds of gridded diamond-shapes filled with abstract whorls of paint. Since the 1960s, Close has painted stunning self-portraits and pictures of friends and fellow artists, using photographs as models and various types of grids for accuracy. Though Close was long considered a Photorealist painter, his use of grids and his toying with expectations of photographic focus has allied his work with that of Conceptual art contemporaries such as Sol Lewitt, as well as minimalist-influenced Pop painters like Alex Katz. Though equally massive in scale, recent works such as this one are a departure from Close's earlier, hyper-real renderings. Here, the image loses focus at close range, dissolving into a mosaic of miniature abstract compositions.

Arneson, Coburn, Nutt, Schnabel

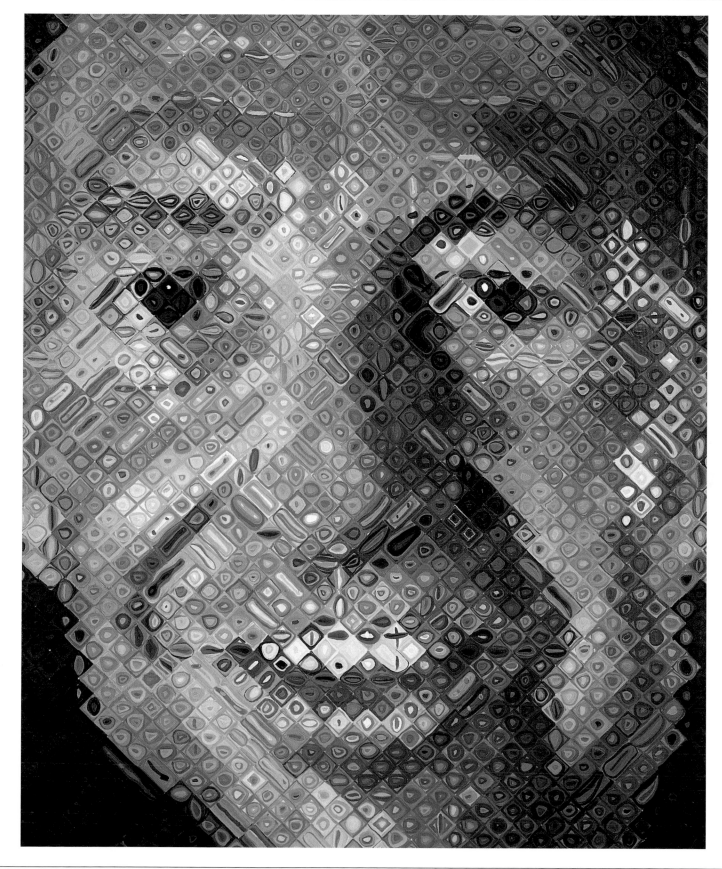

Chuck Close. b Monroe, WA, 1940. **Robert.** 1997. Oil on canvas. **h**102 x **w**84 in. **h**259.2 x **w**213.5 cm. Private collection.

Coburn Alvin Langdon

Ezra Pound

The great modern poet Ezra Pound never looked exactly like this, of course, unless you happened to see him through an arrangement of three shaving mirrors, which are what Coburn used to create this fractured picture on a single negative. An American photographer who lived in London after 1904, and whose first mentor was his cousin, the Pictorialist F. Holland Day, Coburn called the result of his peculiar, kaleidoscopic technique a vortograph in homage to vorticism, a short-lived literary movement started by Pound and Wyndham Lewis. Like the Futurists in Italy, Coburn sought to convey a sense of modern life as dynamic and flickering, as in the frames of a film. In other cases, he was known to kick his tripod during the exposure to create a sensation of blur. His other vortographs are pure abstractions. As with the later work of Man Ray, László Moholy-Nagy, and Christian Schad, such abstract images were new territory for the medium of photography.

☛ Covert, Currier, Maurer, Michals

90

Alvin Langdon Coburn. b Boston, MA, 1882. **d** Colwyn Bay, North Wales, 1966. **Ezra Pound.** 1916. Gelatin silver print. George Eastman House, Rochester, NY.

Cohoon Hannah

Tree of Life

Aglow from a mysterious, otherworldly source of light, this decidedly unnatural tree catches the eye with an uniquely vibrant system of geometric forms. Painted in the nearly abstract style associated with the Hancock, Massachusetts, branch of the Shaker religious community, this "Tree of Life" — the quintessential Shaker icon — contrasts sharply with the more intricate and complex style pioneered by members of the same faith living in other communities. Such intimate "inspirationals," testaments to divine visions, were typically created by women, and this one is rare for its prominent signature. In the text that accompanies her painting, the artist has recounted her spiritual vision: "I saw it plainly; it looked very singular and curious to me . . . the spirit shew'd me plainly the branches, leaves and fruit. . . The leaves were check'd and cross'd and the same colors you see here. . . Seen and painted by Hannah Cohoon."

☛ Callahan, Reed, S. F. W. Williams, Winters

91

Hannah Cohoon. b Williamstown, MA, 1788. **d** Hancock, MA, 1864. **Tree of Life.** 1854. Ink and watercolor on paper. **h**18⅛ x **w**23⁵/₂₆ in. **h**46.1 x **w**58.9 cm. Hancock Shaker Village, Pittsfield, MA.

Cole Thomas

View from Mount Holyoke, Northampton, MA, after a Thunderstorm — The Oxbow

The Oxbow, a distinctive serpentine curve in the Connecticut River, dominates a panoramic view seen from the elevated vantage point of a heavily wooded ridge. Nestled among the bushes in the center foreground is an artist who looks toward the viewer, as if to invite attention to his own activity in the outdoors. Cole, who arrived in the United States from England at eighteen, devoted himself to landscape subjects beginning in 1825 and soon became the central figure of the Hudson River School. He was well versed in contemporary European landscape theory and set out to apply those accepted principles to the invention of a wholly American landscape art. In *The Oxbow* he incorporated the British ideas of the Sublime (symbolized by the rugged forest and the powerful thunderstorm) and the Beautiful (symbolized by the placid sunlit vista) to make a pointed statement about the rapid domestication of American land.

☛ **Church, Cropsey, Metcalf, Moses**

92

Thomas Cole. b Bolton-le-Moor, United Kingdom, 1801. **d** Catskill, NY, 1848. **View from Mount Holyoke, Northampton, MA . . . The Oxbow.** 1836. Oil on canvas. **h**51½ x **w**76 in. **h**130.8 x **w**193 cm. The Metropolitan Museum of Art, New York, NY.

Colman Samuel

Storm King on the Hudson

Fishermen pull in their nets while tugs, steam-powered side-wheelers, and barges dominate the waters on the left. This scene presents commerce on New York's Hudson River in microcosm, contrasting the fishermen's modest labor with grander economic purposes represented by the large boats. In the background is Storm King Mountain, swathed in clouds whose forms mix with the billowing smoke from the side wheeler stacks as if to provide a metaphor for the harmony of man's work within the increasingly domesticated wilderness. *Storm King on the Hudson* displays the painter's desire to capture transitory atmospheric effects, perhaps in emulation of J. M. W. Turner, whose work he probably saw in England in 1861. Colman explored similar effects of changing light in his watercolors. He co-founded and was the first president of the American Society of Painters in Water-Colours the same year he completed this painting.

Bard, Lane, Stoddard, Tirrell

Samuel Colman. b Portland, ME, 1832. d Newport, RI, 1920. **Storm King on the Hudson**. 1866. Oil on canvas. h32⅛ x w59⅞ in. h81.6 x w152.2 cm. National Museum of American Art, Washington, D.C.

Conner Bruce

Shoes

Parodying the bronzed baby shoes of childhood displayed on suburban end tables, Conner lovingly presents his own battered shoes as a relic of a time when his deep anxiety over the escalation of nuclear weapons testing and the Cuban missile crisis caused him to flee the country. The eccentric, levitating souvenirs are connected to Earth only by the most tenuous and ornamental attachment, anticipating the advent of hippie "love beads" and symbolizing the artist's estrangement from the mainstream. Bridging the gap between the 1950s Beat Generation and the counterculture of the following decade, Conner dissected the American Dream's social, political, and sexual contradictions in assemblages and underground films. Together with Edward and Nancy Kienholz, H. C. Westermann, Claes Oldenburg, and other artists working in a pop-culture idiom, Conner used three-dimensional objects to signify modern reality while critiquing its values and verities. *Shoes* expresses Conner's outsider sensibility: His feet are definitely not firmly on the ground.

☞ **Cornell, Durham, Kienholz, Samaras**

Bruce Conner. **b** McPherson, KN, 1933. **Shoes**, worn by Bruce Conner. 1960–64. Mixed media. Size 10½ D. Curt Marcus Gallery, New York, NY.

94

Copley John Singleton

Paul Revere

Pausing to ponder before he takes up engraving tools, the silversmith holds a teapot in one hand, his chin in the other. His craft and mind are linked. The forthright yet intimate presentation of character typifies Copley's best American work, as does the startling illusion of material reality, achieved with hard lines and meticulous brushstrokes. Although this portrait predates Revere's famous ride to forewarn American troops of the British army's advance, the silversmith was already known as a patriot by the time Copley painted him as a fellow artist. Copley received training from his stepfather, a mezzotint engraver, and studied paintings by local artists, whose talents he quickly surpassed. Despite his lucrative status as Boston's premier portraitist, Copley left America in 1774 intending to avoid political tensions and advance his career. Settling in London, he adjusted his hard-edged colonial style to prevailing English standards, and began a second career painting dramatic, even sensational, subjects from modern history.

☛ J. Kane, C. W. Peale, Neagle, T. Smith

John Singleton Copley. b Boston, MA, 1738. **d** London, United Kingdom, 1815. **Paul Revere.** c1768–70. Oil on canvas. **h**35 x **w**28½ in. **h**88.9 x **w**72.3 cm. Museum of Fine Arts, Boston, MA.

Cornell Joseph

Object, 1941

This assemblage of found objects, dominated by several varieties of parrots and parakeets perched under a clock, seems the antithesis of a garden paradise. The box confines the birds to a claustrophobic space, and the clock is a reminder of the limits of time. Cornell's tableaux, however, have the power to transcend literal interpretation. Birds are a recurring theme in his work and could well serve as emblems of the artist and his circumstances. He chose to stay within the limits of his circumscribed world in Queens, New York, yet he remained spiritually free to soar on imagination's wings. Cornell never traveled far from his small home on Utopia Parkway, but his dreams and fantasies took him to far-off realms. His boxed constructions are souvenirs of those journeys, which were enriched by a wide acquaintance with poetry, music, dance, and literature, as well as contemporary art. His kinship with the Surrealists is widely acknowledged, yet their ironic nihilism is absent from his work, which is instead infused with nostalgic reverie.

☛ Conner, Jess, Pollock, Samaras

Joseph Cornell. **b** Nyack, NY, 1903. **d** New York, NY, 1972. **Object, 1941.** 1941. Box construction. **h**14¹/₂ x **w**10 x **d**3¹/₂ in. **h**36.9 x **w**26.4 x **d**8.9 cm. Collection of Marguerite and Robert Hoffman.

Cottingham Robert Roxy

The neon-encrusted marquee of an arcade is seen in stunningly sharp relief, as if on the clearest fall day. Cottingham's Photorealist paintings of the 1970s depict commercial signs and city street corners, almost abstract in their sinuous lines and bright planes of color. Like numerous artists of his generation, Cottingham worked in advertising before becoming a painter and printmaker. His sign-paintings, like the photographs of Walker Evans, mark the passing of an era, as many of the dilapidated buildings he captured have long since been torn down. His work also has an affinity with Pop Art, especially the word-paintings of Edward Ruscha, in which letters take on personalities all their own. In the 1980s, Cottingham turned his attention to railroads. The faded insignias of railroad lines painted on boxcars recall the artist's previous preoccupation with lettering, though they signal a shift in his interest to more painterly terrains of color and texture.

☞ Estes, Goings, Indiana, Ruscha

Robert Cottingham. b Brooklyn, NY, 1935. **Roxy.** 1972. Oil on canvas. **h**78 x **w**78 in. **h**198.2 x **w**198.2 cm. Private collection.

Couse E. Irving

Hunting for Deer

Crouched gracefully inside a wooded clearing, two striking figures assess the movement of their prey in the sunlight before them. Painted nineteen years after the final battle of the Indian Wars of the nineteenth century — the Battle of Wounded Knee of 1890 — *Hunting for Deer* alludes to alert Indian hunters unscathed by this bloody history. This is an image of Native Americans existing outside of

history, bound to nature. This image represents nineteenth-century myth rather than twentieth-century culture. Couse was raised in Michigan and trained in the Classical technique of the French Academy in Paris. He was a leading figure of the Santa Fe artists colony active at the beginning of the century. Although idealized, Couse's paintings grew from a genuine desire to, as he put it,

"remove the contempt in which the Indian had been held, and to show that they are human beings worthy of consideration and a place in the sun."

☞ Ranney, Sharp, Tanner, Whittredge

Eanger Irving Couse. b Saginaw, MI, 1866. **d** Albuquerque, NM, 1936. **Hunting for Deer.** 1909. Oil on canvas. **h**24 x **w**29 in. **h**61 x **w**73.7 cm. Gerald Peters Gallery, Santa Fe, NM.

Couturier Henri

Governor Peter Stuyvesant

Gleaming armor and a ceremonial sash honor his military rank, but the simple broad collar and a tight skullcap over straggly hair indicate the sterner tastes of Peter Stuyvesant, the colonial governor of New Netherland, in the present-day areas of New York and New Jersey. Painted in a competent Dutch style marked by solid form and effective treatment of light and shade, the portrait conveys the firm resolve and rough strength for which the director-general was known. It may be the work of Couturier, a member of the Leyden Guild of Painters who emigrated to the colonies around 1660 and secured burgher, or merchant's rights, in New Amsterdam by painting the governor's likeness. The oval format of this portrait suggests that the artist anticipated its being engraved for wider distribution.

Soon after it was created, however, Stuyvesant was forced to surrender his colony to the English, effectively extinguishing the market for his image, as well as the promise of a fully realized Dutch style taking root in America.

☞ Feke, Johnston, Rivers, T. Smith, P. Vanderlyn

Attributed to **Henri Couturier.** Active probably Leyden, mid-17th century. **Governor Peter Stuyvesant.** c1660–63. Oil on wood panel. **h**21¹/₂ x **w**17¹/₂ in. **h**54.6 x **w**44.5 cm. The New-York Historical Society, New York, NY.

Covert John R.

Brass Band

With strips of string for texture, Covert's sensuously modeled relief painting, which suggests an organic machine, marks the high point of his brief tenure at the forefront of American Modernism. Although he studied in Munich and Paris during the heyday of Cubism and other advanced trends, Covert was a traditional painter until after his return to the United States in 1915. At the New York salon of his cousin, the art collector Walter Arensberg, he met Marcel Duchamp and Francis Picabia, with whom he founded the Society of Independent Artists. His style then changed radically and he began making abstract reliefs using string, upholstery tacks, and found objects. "How can I explain it?" he later mused. "It was play. It was work. It was happiness." In 1923, however, Covert became disillusioned with art. He destroyed many pieces, gave some away, and went to work for a steel company.

☞ Bartlett, Mangold, Ryman, Schamberg

John R. Covert. b Pittsburgh, PA, 1882. **d** New York, NY, 1960. **Brass Band.** 1919. Oil and string on composition board. **h**26 x **w**24 in. **h**66.1 x **w**61 cm. Yale University Art Gallery, New Haven, CT.

Crawford Ralston

Overseas Highway

The precise, pointed geometric forms of a highway railing, boardwalk, and building race toward — or away from — the sky with the force of an accelerated film. This painting documents not place so much as the sharp lines of perspective converging at the point where the man-made environment pierces clouds and sky. Crawford grew up in Buffalo, New York, among the grain elevators and shipyards of the industrial Northeast. He was trained as a painter at the Pennsylvania Academy, where he was introduced to the work of the Precisionist artist Charles Sheeler. Crawford took up photography in the late 1930s, and his several photographs of grain elevators in Buffalo exhibit the geometric abstraction then associated with American Modernist painting. In turn, his paintings were heavily influenced by the bold graphic simplifications of photography, as was the case with many of the Precisionists with whom Crawford was associated.

☛ Andre, Frank, Ramirez, Steinberg

Ralston Crawford. b St. Catherines, Ontario, Canada, 1906. **d** Houston, TX, 1978. **Overseas Highway.** 1939. Oil on canvas. **h**28 x **w**45 in. **h**71.2 x **w**114.4 cm. Curtis Galleries, Minneapolis, MN.

Cropsey Jasper Francis

Autumn — On the Hudson River

Golden sunlight streams across the Hudson River, suffusing the autumnal landscape with a gentle haze that suggests the waning year. This painting, with its meticulously detailed leaves and branches and attention to the quality of light, established Cropsey as America's leading painter of fall scenery. Although trained as an architect, Cropsey dedicated himself to landscape painting by 1845, fashioning his art after the Hudson River School manner of Thomas Cole and Asher B. Durand. From 1856 to 1863 he lived in London, where he determined to dazzle the English audience with paintings featuring the brilliantly colored fall foliage unique to North America. The English critics' response to this painting (shown first to the public in his studio and then in a Pall Mall gallery) brought Cropsey great acclaim, which led to his presentation to Queen Victoria and the painting's inclusion in the 1862 London International Exhibition.

☛ Chambers, Cole, Gifford, Parrish

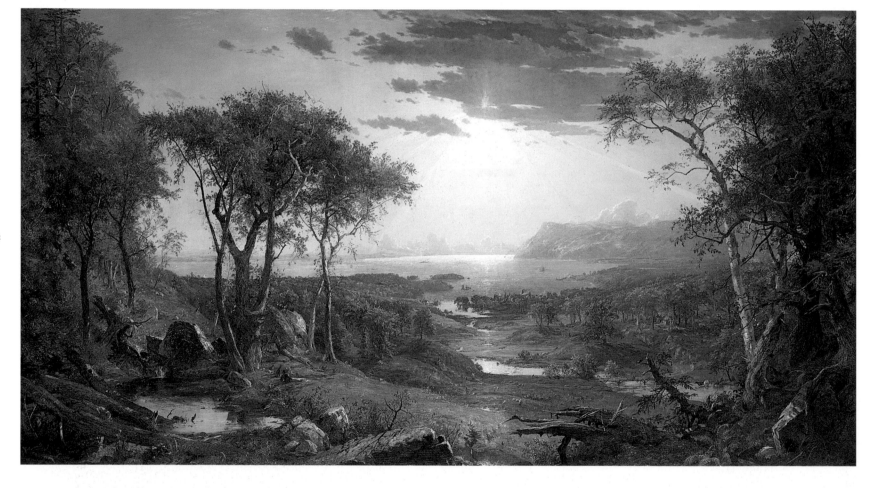

102

Jasper Francis Cropsey. b Staten Island, NY, 1823. **d** Hastings-on-Hudson, NY, 1900. **Autumn — On the Hudson River**. 1860. Oil on canvas. **h**60 x **w**108 in. **h**152.5 x **w**274.3 cm. National Gallery of Art, Washington, D.C.

Cunningham Imogen

Magnolia Blossom

Seen in extreme close-up from an apparent perch at the edge of one of its petals, this magnolia blossom takes on the appearance of a dreamscape rather than a botanical specimen. The intimacy of the image emphasizes the sensuality of natural form that the photographer also would reveal in her now-famous images of female nudes. One of a number of Northern California photographers who pioneered a new style of photography in the late 1920s and early 1930s, Cunningham was a friend and colleague of Edward Weston and Ansel Adams. Together with several others, they exhibited their work as Group f.64, a name chosen to indicate their preference for small lens apertures. Like Weston and Adams, she adhered to the idea that photographs should be sharp, pure, and pristine, and that form was the essential characteristic of photography as an art. Coincidentally, her pictures of flowers look like black-and-white versions of paintings by Georgia O'Keeffe at roughly the same time — although Cunningham did not see O'Keeffe's flower paintings until 1934.

☛ Heade, Irwin, O'Keeffe, Taaffe

103

Imogen Cunningham. b Portland, OR, 1882. d San Francisco, CA, 1976. **Magnolia Blossom.** 1925. Silver gelatin print. The Imogen Cunningham Trust, Berkeley, CA.

Currier Charles H.

The Bicycle Messengers Seated

These uniformed gents, pausing for a snack before proceeding on their delivery rounds, are a far cry from today's more urban but less urbane bicycle messengers. Their trusty high-wheeler mounts are historical relics as well. At the time this photograph was taken the popularity of the bicycle was rivaled only by the popularity of photography, and many a middle-class amateur eagerly tried to master the techniques of both. However, Currier was a professional photographer. He abandoned his Boston jewelry business in 1889 to open a photography studio specializing in pictures of buildings, bridges, and railroads. He retired in 1909 and subsequently destroyed many of his glass-plate negatives; those that survive were given to the Library of Congress after his death. Little else is known about him, except that his only son, Harold, was killed when he was thrown from a high-wheeler bicycle in 1900.

☛ Mapplethorpe, Warhol, Witkin

Charles H. Currier. b Boston, MA, 1851. d Boston, MA, 1938. **The Bicycle Messengers Seated.** c1900. Gelatin silver print from glass-plate negative. The Library of Congress, Washington, D.C.

Curry John Steuart

Tornado Over Kansas

Frozen in attitudes that heighten the drama of their race against time, Curry's figures are unified by repeated rhythms and gestures, all directed toward the safety of the storm cellar. Under an ominous gray sky the mother protects her infant and the father urges on his frightened daughter, while one son cradles a litter of puppies and his brother fights to control the cat in his arms. Curry once wrote that the struggle of humankind with nature "has been a determining factor in my art expression. It is my tradition and the tradition of the great majority of Kansas people." Curry's work is deeply rooted in personal experience, and he devoted much of his brief career to scenes of midwestern life. Together with Thomas Hart Benton and Grant Wood, he was a leader of the Regionalist movement that gained prominence in the 1930s and sought to represent true American scenes and values, often by depicting rural and midwestern themes.

☛ Deas, Gropper, Hogue, Rimmer

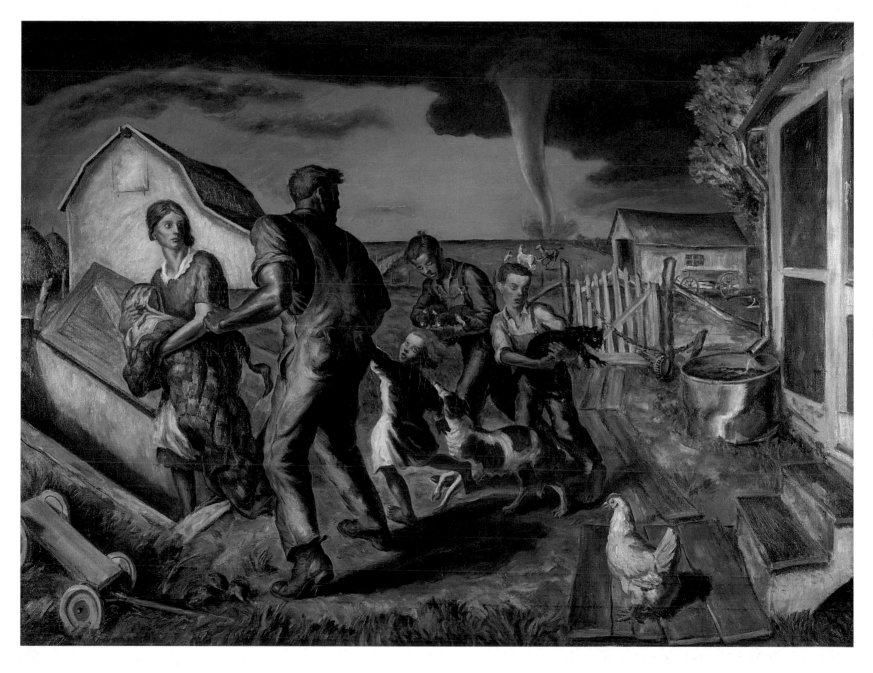

John Steuart Curry. b Dunavant, KN, 1897. d Madison, WI, 1946. **Tornado Over Kansas.** 1929. Oil on canvas. h50½ x w64¾ in. h128.3 x w164.6 cm. Muskegon Museum of Art, Muskegon, MI.

Curtis Edward S. An Oasis in the Badlands

The blurred, barren horizon in the distance here seems an appropriate omen of the future for this Native American, whose proud bearing, traditional headdress, and command of his horse disguise the fact that he has been confined to a reservation. Photographed as one example of what the photographer referred to as the "vanishing race," such tribal leaders once freely roamed the Badlands area of South Dakota.

In all, Curtis photographed eighty Native American tribes between 1895 and 1930, producing some 40,000 glass-plate negatives. His pictures were reproduced starting in 1907 in a lavish, twenty-volume publishing venture called *The North American Indian*, which featured a foreword by one of the photographer's biggest fans, President Theodore Roosevelt. Unfortunately, the production was perhaps too lavish, for it drove Curtis into bankruptcy at the beginning of the Depression. Today Curtis is remembered for both his industry and his subjectivity. He often dressed his subjects in costumes they no longer wore and posed them in activities no longer a part of their daily life.

☛ Butterfield, Remington, C. M. Russell, Stanley

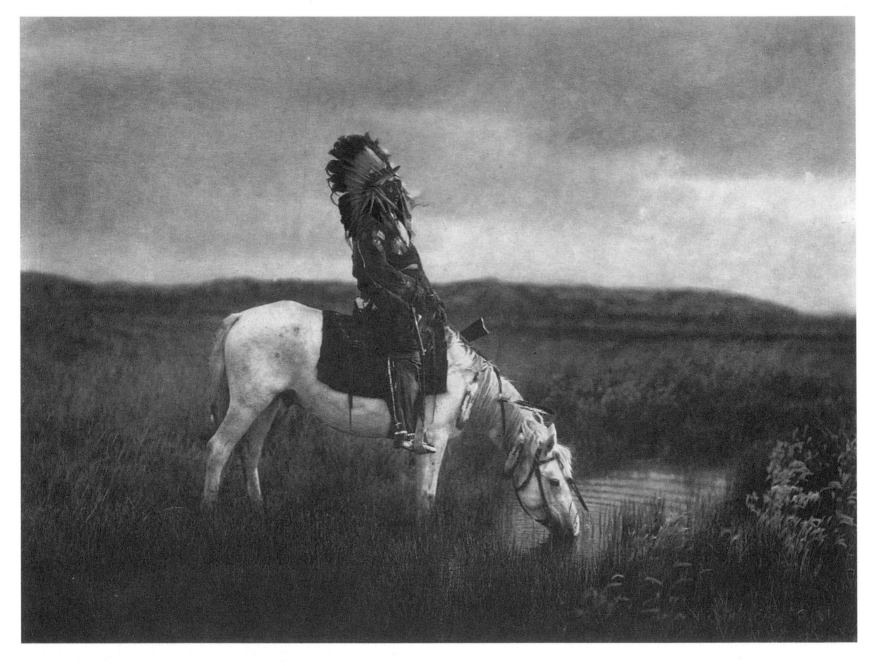

106

Edward Sherrif Curtis. b White Water, WI, 1869. d Los Angeles, CA, 1952. An Oasis in the Badlands. 1905. Photogravure. Andrew Smith Gallery, Santa Fe, NM.

Dasburg Andrew

Pueblo Village

The red earth and clay building blocks of a traditional adobe settlement of the Southwest are rendered as a clean geometric composition, with even the wooden fence at bottom right and the ladders at top tilting at complementary angles. Taking advantage of the naturally cubic structure of traditional adobe buildings, Dasburg applied imported Cubist principles to indigenous American subject matter.

Like other early Modernists, including Marsden Hartley, Stuart Davis, and Georgia O'Keeffe, he found in the New Mexican landscape an ideal source of raw material for investigation. Born in Paris, Dasburg trained at the Art Students League in New York City, then returned to Paris to study the work of Henri Matisse and Paul Cézanne, among other European artists. He exhibited in the 1913

Armory Show and eventually settled in Taos, New Mexico, in the late 1920s, establishing himself as one of the most esteemed and Modernists working in the Southwest.

O'Sullivan, Penn, Marin, Nevelson

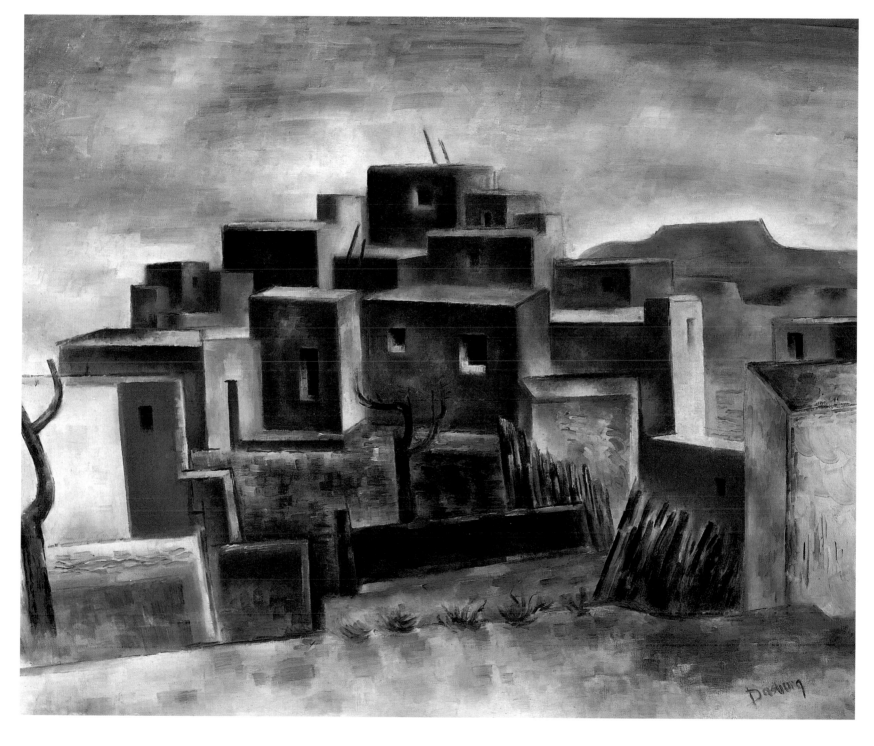

Andrew Michael Dasburg. b Paris, France, 1887. **d** Taos, NM, 1979. **Pueblo Village.** n.d. Oil on canvas. **h**20 x **w**24¹/₄ in. **h**50.8 x **w**61.6 cm. Gerald Peters Gallery, Santa Fe, NM.

Davies Arthur Bowen

Line of Mountains

Two lines of nude figures emerge from each side of this composition, heading toward each other in a manner that suggests an ensuing confrontation. The friezelike arrangement of the men is echoed in the horizontal bands of landscape and sky, thus establishing a formal connection between man and nature. The alternative title of this painting, *Moral Law*, sheds light on Davies's meaning. Just as the

dawn light appears above the mountain ridge to soften the bleak landscape, this encounter suggests the awakening of humankind's sense of moral values that will lift the species from a savage state. A man of eclectic, sophisticated taste, Davies did not limit himself to one style, and his later art reveals his assimilation of European Modernism. He was especially attracted to this movement during

his involvement in organizing the 1913 Armory Show, a groundbreaking international exhibition of contemporary art that introduced Modernist aesthetics to the American public.

☛ M. Barney, Fisher, Hunt, Kent

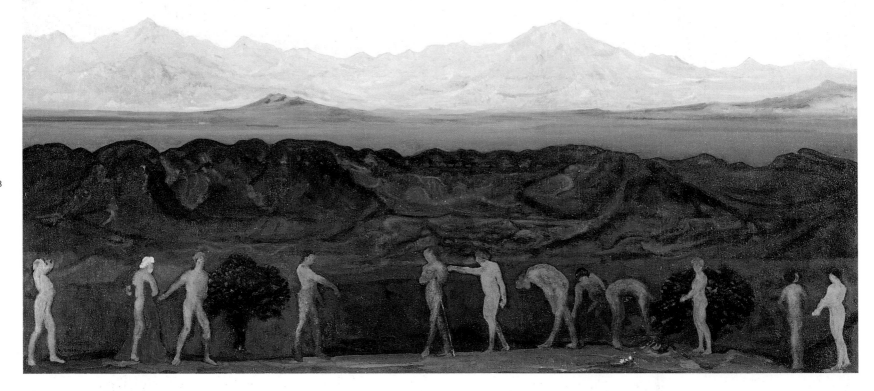

Arthur Bowen Davies. b Utica, NY, 1862. **d** Northern Italy, 1928. **Line of Mountains.** c1913. Oil on canvas. **h**18 x **w**40⅛ in. **h**45.7 x **w**101.9 cm. Virginia Museum of Fine Arts, Richmond, VA.

Davis Stuart

The Mellow Pad

Combining motifs from numerous sources, including his own previous work, Davis generated syncopated visual rhythms that pay homage to the jazz music he loved. The "pad," hipster slang for living quarters, is "mellow" because the artist has unified its individual dissonances into a harmonious composition. The overall structure and several other details come from Davis's 1931 painting, *House and Street*, which itself was derived from an earlier sketch of lower Manhattan. This framework is overlaid with a mosaic of graphic elements that include the painting's title and the artist's signature. Adapting the flattened space and abstracted shapes of Synthetic Cubism to American subject matter, Davis combined analysis and intuition to create "physical equilibrium in tension." To him, art's formal qualities were paramount, outweighing any consideration of subject matter. As he wrote in his sketchbook: "The artist has no concern as to what the picture means. His attitude is Absolute Objectivity."

☛ Bolotowsky, Delaney, Hartley, Man Ray

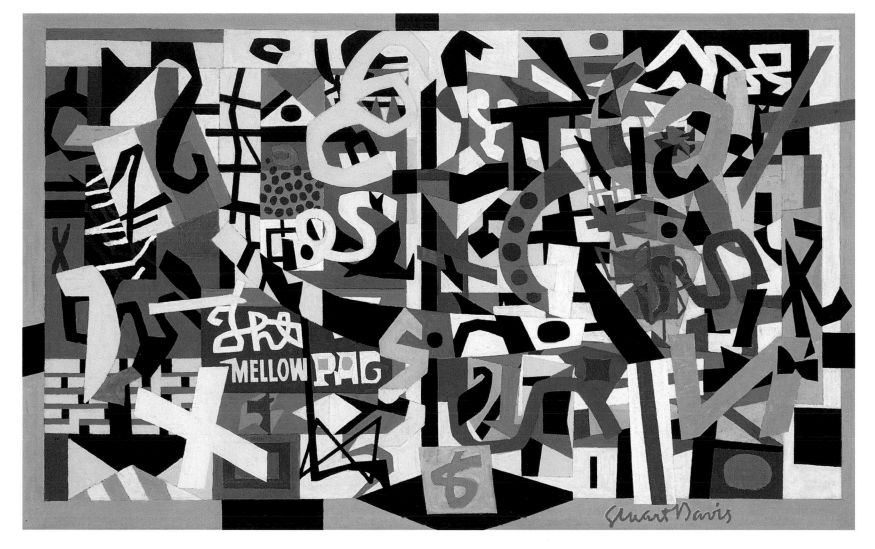

Edmund Stuart Davis. b Philadelphia. PA, 1894. **d** New York, NY, 1964. **The Mellow Pad.** 1945–51. Oil on canvas. **h**26 x **w**42 in. **h**66 x **w**106.7 cm. The Brooklyn Museum of Art, Brooklyn, NY.

Deas Charles

Prairie Fire

A young frontiersman clutches the body of an unconscious woman as he urges his frightened horse onward and checks the progress of the flames that rip across the prairie toward them. An older man riding beside them points the way to safety, but it is not clear that they will successfully outrun the conflagration. This horrific depiction of attempted escape from a common natural disaster corresponds with the drama that Deas invested in most of his Western subjects. A strong narrative element had prevailed in Deas's genre paintings from the beginning, as witnessed by his early canvases inspired by literary sources, such as Washington Irving's *The Devil and Tom Walker*. However, after spending approximately seven years on the frontier, basing himself in St. Louis, Missouri, Deas became known for his vibrant genre paintings of Western life. In 1847 Deas relocated to New York City, and the following year he was reported hospitalized, suffering from the "derangement" from which he never recovered.

☛ Butterfield, Hunt, Misrach, Remington

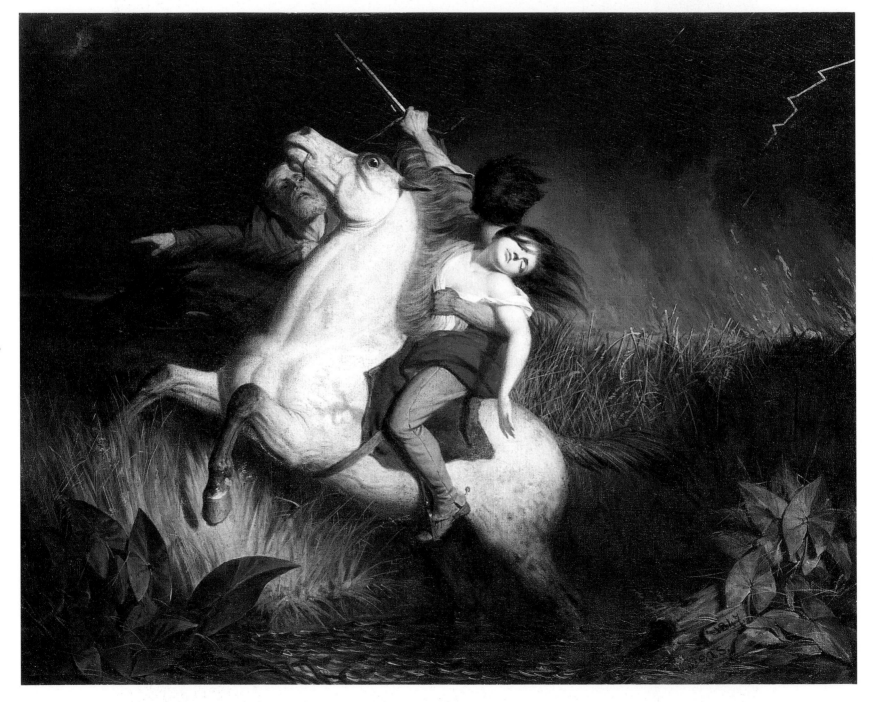

Charles Deas. b Philadelphia, PA, 1818. **d** New York, NY, 1867. **Prairie Fire.** 1847. Oil on canvas. **h**28⅞ x **w**36¹/₁₆ in. **h**73.4 x **w**91.6 cm. The Brooklyn Museum of Art, Brooklyn, NY.

de Forest Brush George Mother and Child

A small boy straddles his mother's lap as they inspect the open book propped on the arm of their chair. The tranquil landscape they occupy supports Brush's romantic portrayal of motherhood, linking the grander scheme of nature to the intimate world of maternal nurturing and instruction. After having concentrated on Native American subjects for a number of years with great success, Brush shifted to mother-and-child imagery — possibly because of his own growing family. Here, Brush featured his wife, Mittie, their son, Gerome, and daughter Nancy. The maternal theme was popular during the late nineteenth century, partly because it reinforced idealized notions of womanhood at a time of social flux and the beginnings of the women's rights movement. Brush drew especially upon Italian Renaissance iconography. His many portraits of his wife and children may be read as secularized versions of the Virgin and Child motif that was meant to inspire viewers with thoughts of a higher natural and divine authority.

☛ Brewster, Cassatt, Peck, Tanner

George de Forest Brush. b Shelbyville, TN, 1855. d Hanover, NH, 1941. **Mother and Child.** 1892. Oil on canvas. h45¼ x w35⅜ in. h115 x w89.8 cm. Addison Museum of American Art, Andover, MA.

De Kooning Willem Woman I

Is this a misogynistic attack or a celebration of formidable female power? The figure's inherent ambiguities and contradictions — terrifying and laughable, sexy and repulsive, monumentally massive and fragmented in a welter of energetic strokes and spatters — have been hotly debated since the painting was first exhibited in March 1953 and may never be resolved. Notwithstanding its title, this was

by no means the first of De Kooning's generic "Women," a theme he had been exploring since the early 1940s. By this time, however, he had also produced biomorphic abstractions and a series of all-over canvases inspired by the congested urban milieu. Highly respected by his New York School colleagues, De Kooning was perhaps the only painter of his generation to succeed in developing abstract and

figurative work simultaneously. Academic training in his native Holland developed his natural talent, which flourished in the dynamic, iconoclastic atmosphere of New York in the 1940s that gave rise to Abstract Expressionism.

☛ Basquiat, J. McCarthy, Mitchell, Nutt

112

Willem de Kooning. b Rotterdam, the Netherlands, 1904. **d** The Springs, Long Island, NY, 1997. **Woman I.** 1950–52. Oil on canvas. **h**75⅞ x **w**58 in. **h**192.7 x **w**147.3 cm. The Museum of Modern Art, New York, NY.

Delaney Beauford

Marian Anderson

Schematically rendered in thick impasto, Delaney's cityscape features a billboard portrait of the celebrated contralto, whose name is encrypted in the zigzag decoration on the opposite wall. Stars festooning the pavement and a simplified musical staff descending like steps from her image indicate her status in the music world. Delaney — like Anderson, an African-American artist — was known for his abstracted Harlem and Greenwich Village street scenes. After studying art in Boston, he moved in 1929 to New York City, where he developed an expressionistic style of urban landscape and figure painting. In the early 1950s, he adopted a Cubist approach, simplifying and flattening his subjects while retaining the richly textured surfaces of his earlier work. Delaney moved to Paris in 1953, after which his work became nonrepresentational. His last years were marred by physical and mental illness, but by then he was celebrated as the foremost African-American painter living in Europe.

☞ Davis, W. Johnson, Man Ray, Morgan

Beauford Delaney. b Knoxville, TN, 1901. **d** Paris, France, 1979. **Marian Anderson.** 1951. Oil on board. **h**45 x **w**34¹/2 in. **h**114.4 x **w**87.7 cm. Private collection.

De Maria Walter

The Lightning Field

A loud crack can almost be heard as a vein of lightning is photographed at the moment of contact with the ground. This photograph documents one of the most sensational pieces of Land Art produced in the 1970s: Four hundred pointed stainless steel rods pierce the ground in sixteen rows of twenty-five, 220 feet apart, in the shape of a rectangle. When lightning is not crackling along the landscape, the rods are invisible, seen only in the oblique light of dusk or dawn. The atmospheric conditions or cycles from day into night transform the base metal into a sublime work of art; thus few people actually ever see *The Lightning Field* except in this photograph. For practitioners of Land Art, such as Walter De Maria, Robert Smithson, or James Turrell, the journey to such a remote location as this flat mountain-rimmed area, two hundred miles southwest of Albuquerque, New Mexico, is an integral component of the viewer's aesthetic experience.

☞ Curry, Heizer, Judd, Misrach

114

Walter De Maria. b Albany, CA, 1935. **The Lightning Field.** 1977. 400 custom-made stainless steel poles with solid pointed tips. **dims** 1 x ⅝ mi. **dims** 1.6 x 1 km. Quemado, NM.

Demuth Charles

Buildings Abstraction, Lancaster

A silo shaded with bold geometric shadows stands against an exterior cut with shafts of light, as if seen through a prism or as a film montage flattened onto the canvas. Demuth painted his fine-lined, kaleidoscopic poem of industrial America the year the French Modernist painter Fernand Léger said of the country, "Mechanical life here is at its apogee." Demuth, a brilliant watercolorist early in his career, became a central figure of Precisionism in the 1920s and 1930s. A writer for the avant-garde magazine *Broom* wrote about this movement in 1922: "Our epoch demands a proud and simple art," one inspired by "great industry, great finance, great administration," and in the "spirit of love of precision, objectivity, and calculation." Demuth's restrained, prismatic, technically virtuostic portrayals of water towers, grain elevators, and factories in his hometown of Lancaster, Pennsylvania, celebrate just such a vision of industrial America.

☛ Baltz, Crawford, Feininger, N. Spencer

Charles Henry Demuth. b Lancaster, PA, 1883. d Lancaster, PA, 1935. **Buildings Abstraction, Lancaster**. 1931. Oil on board. h27⅞ x w23⅝ in. h70.8 x w60 cm. The Detroit Institute of Arts, Detroit, MI

Dewing Thomas Wilmer

The Spinet

Golden light falls on the exquisitely rendered contours of a woman's shoulders to form the focal point of this decorative orchestration of rusted browns, muted greens, and yellows. The bowl of artfully arranged flowers on the piano suggests that her overall beauty matches their delicate charm, yet an aura of mystery persists because the woman's averted face will forever be unknown to the viewer. Dewing returned to the United States after academic training in Paris and built his reputation as a painter of rarefied female beauty in an era when figure subjects had surpassed landscape as the dominant imagery in art. For Dewing's audience, his lithe, elegant, isolated female figures were equated with the idea of aesthetic perfection. Ironically, much of his patronage came from titans of American industry, some of whom looked to this type of imagery as a means to renovate their own public personae; as collectors of beautiful paintings, they would be seen as genteel, cultivated members of society.

☞ Benson, Kasebier, Reid, Sully

116

Thomas Wilmer Dewing. b Boston, MA, 1851. d New York, NY, 1938. The Spinet. 1902. Oil on wood. h15¹/₂ x w20 in. h39.5 x w50 cm. National Museum of American Art, Washington, D.C.

Diebenkorn Richard Ocean Park No. 54

A classic grid enlivened by vigorous brushwork and diagonal accents provides a framework for Diebenkorn's homage to the coastal landscape visible from the window of his Southern California studio. Earlier in his career, as a member of a Bay Area group of figurative painters who gained prominence in the 1950s, Diebenkorn was recognized for his ability to adapt principles of gestural abstraction to representational subject matter. After seeing Matisse's 1914 painting, *Porte-fenêtre à Collioure*, a starkly simplified view through an open window, Diebenkorn used its essentials — which one critic described as "allusions to reality [mingled] with the sparest quasi-geometrical drawing" — as the basis for his long series of Ocean Park compositions. Like the Abstract Expressionists, with whom he shared an interest in nature's fundamental qualities, Diebenkorn allowed the canvas to chronicle its own development by leaving the evidence of changes clearly visible in the finished work.

☛ **Bolotowsky, Mangold, Marden**

Richard Diebenkorn. b Portland, OR, 1922. **d** Berkeley, CA, 1993. **Ocean Park No. 54.** 1970. Oil on canvas. **h**93 x **w**81 in. **h**236 x **w**206 cm. C&M Arts, New York, NY.

Diller Burgoyne

First Theme

Independent rectangular forms lie in balanced opposition on a flat plane, a compositional theme that Diller called "free elements." This was the first of three themes the artist developed simultaneously throughout his career. Diller was one of the first American painters to adopt the principles of pure geometric abstraction based on Constructivism, the movement founded in Russia in 1913 in which

forms often derived from the precision of mechanical processes. In Diller's second theme, rectangles were created by intersecting lines, while the third theme produced jazzy mosaics of primary colors, black and white, similar to Piet Mondrian's late compositions. As a supervisor on the Works Progress Administration's (WPA's) Federal Art Project in New York City during the 1930s, Diller oversaw the cre-

ation of several important abstract murals for public sites, including the 1939 New York World's Fair. He was among the founding members of the American Abstract Artists, formed in 1936 to "foster public appreciation of this direction in painting and sculpture."

☞ Halley, Martin, Newman, Rembrandt Peale

118

Burgoyne Diller. b New York, NY, 1906. d New York, NY, 1965. **First Theme.** 1962. Oil on canvas. **h**72 x **w**72 in. **h**106.7 x **w**106.7 cm. The Art Institute of Chicago, Chicago, IL.

Dine Jim

Two Blackish Robes

Two bathrobes stand side by side, painted in tones of deep red and black. They evoke crushed velvet and seem to glow from within, like embers. The garments are animated but not filled by a human body. Bathrobes are part of a personal iconography Dine recycles throughout his art, stand-ins for the artist's self-portrait. Dine was, along with Allan Kaprow, a founder of Happenings, the improvisational 1960s performances that contributed to the beginnings of Pop Art. Later in his career, Dine turned away from Pop, which he considered a youthful experiment. Since the 1970s, Dine's paintings, prints, and drawings have been more concerned with painterly effects than with sensationalism, inspired by historical European artists like Balthus and contemporaries like Francis Bacon. However, the eclectic, often autobiographical subjects of Dine's art — from fans and screwdrivers to fairy-tale animals — still retain Pop's notion that all of culture, high and low, is ripe subject matter for art.

☛ Ives, W. Kuhn, Wesselman, Witkin

Jim Dine. b Cincinnati, OH, 1935. **Two Blackish Robes.** 1976. Oil on panel. Two panels, each: **h**80 x **w**36 in. **h**203.2 x **w**91.4 cm. PaceWildenstein, New York, NY.

Disfarmer Mike

Homer Eakers, Loy Neighbors and Julius Eakers, brothers-in-law

The rakishly held cigarettes and comfortable slouches of these young men suggest the familiarity of family members and old friends (and a hint of prior libation as well). They are gathered in the small studio of a small-town photographer in Heber Springs, Arkansas, during World War II, and the middle figure, Loy Neighbors, has recently returned from Germany, where he was a prisoner of war.

By photographing the people of a single place during a singular time in American history, the photographer, born Mike Meyer, made a unique and vivid record that rises to the level of art. (Disfarmer adopted the name he used professionally because he believed he was a changeling, and thus was not really from a farming family.) His work was made for purely commercial purposes and went

unrecognized until some twenty years after his death, when his glass-plate negatives were rescued from a Heber Springs carport and captured the attention of a New York magazine editor, Julia Scully.

☛ Avedon, Hawthorne, W. Kuhn, F. Porter

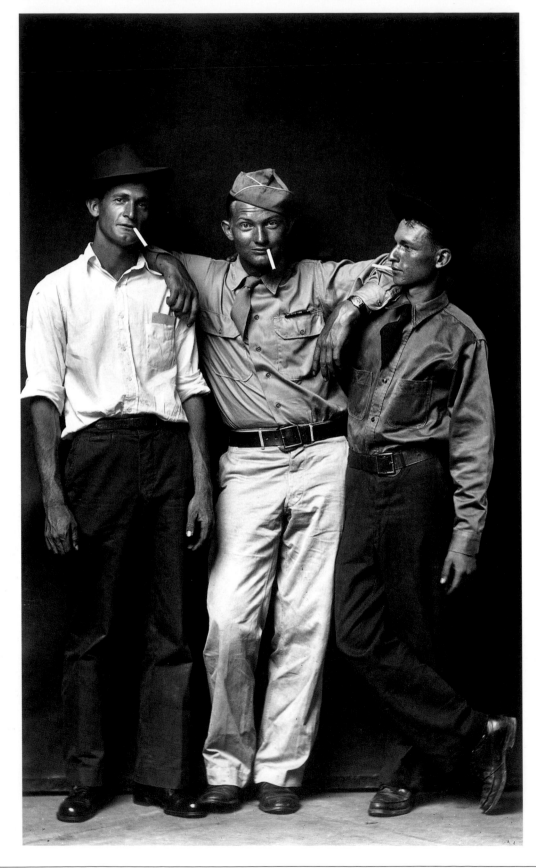

120

Mike Disfarmer (Mike Meyer). b Heber Springs, AR, 1884. d Heber Springs, AR, 1959. Homer Eakers, Loy Neighbors and Julius Eakers, brothers-in-law. 1945. Gelatin silver print. Staley-Wise Gallery, New York, NY.

DiSuvero Mark

Pyramidian

A towering pyramid of steel beams supports itself like a surveyor's tripod or seaman's sextant. A pendulum made from another girder and chains hangs below, swaying in the mountain breeze. Installed in the bucolic setting of an outdoor sculpture park in New York's Hudson River Valley, *Pyramidian* demonstrates an American industrial sensibility through its material and construction. DiSuvero's soaring sculptures are Abstract Expressionist in outlook, their energetic lines recalling the slashing paintings of Franz Kline. Although DiSuvero's works use the same industrial materials favored by Minimalist sculptors such as Donald Judd, they diverge from this style in that they are full of off-kilter angles and are unrefined. As imposing as DiSuvero's sculptures are, they practically invite viewers to climb on them. DiSuvero's life has been as turbulent as some of his sculptures are serene: His childhood was spent in China during the period of Japanese invasion; and, as a young artist in New York City in the early 1960s, an elevator accident left him wheelchair-bound for two years.

☛ **Crawford, Durham, Kline, D. Smith**

Mark DiSuvero. b Shanghai, China, 1933. **Pyramidian.** 1987–98. Steel. **h**60 x **w**60 ft. **h**18.3 x **w**18.3 m. Permanent installation, Storm King Art Center, Mountainville, NY.

Doughty Thomas

In Nature's Wonderland

A solitary man rests his rifle at his side as he pauses to gaze across the still surface of a lake toward a light-filled range of mountains in the distance. Enclosed in the quiet embrace of nature, the figure is simultaneously a part of the wilderness spectacle he beholds yet remains separate from it. In this relatively early landscape painting, his role is that of a spectator transfixed by the natural beauty spread before him; man is not depicted here as an agent of change in nature. The self-taught Doughty abandoned his trade as a leather merchant in 1820 and devoted his artistic career to landscapes of this type. Although in his own time he was ultimately criticized for the formulaic compositions he depended on, he retains a place in history as America's first landscape specialist. Careful examination of his work often provides insight into the subtleties of early nineteenth-century Americans' attitudes toward their shifting relationship with nature as the land was settled.

☛ Cole, Duncanson, Durand, Stoddard

Thomas Doughty. b Philadelphia, PA, 1793. d New York, NY, 1856. In Nature's Wonderland. 1835. Oil on canvas. h24½ x w30 in. h62.2 x w76.2 cm. The Detroit Institute of Arts, Detroit, MI

Douglas Aaron

Building More Stately Mansions

Inspired by the monuments of past civilizations, with an Egyptian sphinx and pyramid looming overhead and providing dominant African prototypes, modern African-Americans plan and build their own future. Muted tones, flattened space, and abstract structure reinforce the symbolic nature of Douglas's allegorical program. By the mid-1920s, his inventive adaptation of African design elements to the formal devices of Cubism established him as the foremost painter of the Harlem Renaissance, and he illustrated many of the movement's publications. Douglas's distinctive style was readily adaptable to mural painting. One of his earliest mural commissions, in 1930, was *The Negro Through the Ages*, for the library at Fisk University, an African-American school in Nashville, Tennessee, where seven years later he founded the art department. Among his best-known murals is *Aspects of Negro Life* (painted in 1933–34 for the federal government's Public Works of Art Project), at the Schomburg Center in New York City.

☞ **Anschutz, Feininger, Fuller, Lozowick**

Aaron Douglas. b Topeka, KS, 1899. **d** Nashville, TN, 1979. **Building More Stately Mansions.** 1944. Oil on canvas. **h**58 x **w**42 in. **h**147.4 x **w**106.7 cm. Fisk University Art Galleries, Nashville, TN.

Dove Arthur G.

Sunrise I

The sun's glow, tempered by mist, radiates with phantasms, possibly engendered by the artist's prolonged scrutiny of the sunrise. With Prussian blue, rose madder, and Indian yellow as his dominant pigments, Dove responded to the experience of dawn rather than to its appearance. Dove's quest to express nature from the inside out was fueled by intense curiosity about such phenomena. "You get to the point," he once wrote, "where you can feel a certain sensation of light." Perhaps as early as 1910, paralleling the work of Wassily Kandinsky and František Kupka in Europe, he began to develop nature-based abstractions, which he called "extractions." Championed by photographer Alfred Stieglitz throughout his career, Dove steadfastly pursued his visionary style in spite of chronic financial problems. For several years he lived and painted on a boat on Long Island Sound, and in 1938 moved to a shorefront cottage, where his surroundings supplied him with "form motives" for his increasingly essentialized compositions.

☛ **Bierstadt, Gottlieb, Noland, Puryear**

Arthur Garfield Dove. b Canandiagua, NY, 1880. **d** Huntington, NY, 1946. **Sunrise I.** 1937. Tempera on canvas. **h**25 x **w**35 in. **h**63.5 x **w**88.9 cm. Museum of Fine Arts, Boston, MA.

124

Doyle Sam

Dr. Crow

The legendary Southern "root doctor" Dr. Crow brandishes a rattlesnake like a talisman in this lively portrait. He straddles a bubbling cauldron as he adds the snake's blood to his "rattle soup." Folk artist Sam Doyle was raised in the Gullah culture of South Carolina's Sea Islands, an isolated rural area where African-Americans have retained significant elements from their African heritage. The term Gullah possibly derives from "Angola," and refers specifically to the culture endemic to this region. Upon his retirement, Doyle began documenting Island life in bold, colorful paintings that were displayed in his outdoor art gallery. According to Gullah lore, a root doctor is a kind of medicine man able to administer potent hexes. Doyle shows Dr. Crow's left hand upraised, in the act of casting such a spell. The doctor's aggressive stride and serpentine cloak lend dramatic force to this otherwise quiet gesture.

 Basquiat, Haring, J. McCarthy, Park

Sam Doyle. b Saint Helene Island, SC, 1906. **d** Saint Helene Island, SC, 1985. **Dr. Crow.** c1980. House paint and conch shell on tin siding. **h**41 x **w**25 in. **h**104.2 x **w**63.5 cm. Private collection.

duBois Guy Pène

Trapeze Performers

Seen from an aerial vantage point, three enigmatic trapeze artists gesture to one another like posed, expressionless muses. Reduced to essential, doll-like templates, their arms create a rhythm of lines that connect them body to body, mirroring the curve of their trapeze ropes. This work is less a document of an actual scene than a stylized composition of expressionistic geometry and perspective.

Pène duBois painted *Trapeze Performers* at the outset of the Depression, a year after he was forced to return to New York after living contentedly in France. Born in Brooklyn, Pène duBois studied as a teenager at the Art Students League in New York City with William Merritt Chase, Robert Henri, and Kenneth Hayes Miller. Although known today primarily as a painter, he worked as a

reporter and critic for various New York papers, eventually serving as editor of *Arts and Decoration* magazine. In 1913 he was among the young American Realists and moderns to exhibit at the legendary Armory Show in New York City.

☛ Hirshfield, Kuhn, Nadelman, Shinn

126

Guy Pène duBois. **b** New York, NY, 1884. **d** Boston, MA, 1958. **Trapeze Performers.** 1931. Oil on canvas. **h**25 x **w**20 in. **h**63.5 x **w**50.8 cm. The Butler Institute of American Art, Youngstown, OH.

Duncanson Robert

The Land of the Lotus Eaters

Wending their way to the water's edge in the midst of a tropical, Edenic land is a group of brown-skinned people. Several others have preceded them, swimming across the placid river to welcome some Europeans with garlands of soporific lotus leaves. Although this work may be Duncanson's response to the enormously popular paintings by Thomas Church of Latin-American landscapes, it is also based on Alfred Lord Tennyson's 1833 poem "The Lotos-Eaters" [*sic*], which decried the Victorian work ethic founded on material gain. Duncanson's decision to explore this theme of cultural contrasts (which he enlarged by inserting racial references) may have originated out of his own feelings against rigid systems of social and economic power. His parentage (an African-American mother and a Scot father) automatically placed him at the margins of society, as did his career as an artist. Despite these particular challenges, Duncanson enjoyed considerable success both at home and abroad.

☞ Chambers, Cole, Doughty, Fisher, Hill, P. Kane

Robert S. Duncanson. **b** (city unknown) NY, c1817–1822. **d** Detroit, MI, 1872. **The Land of the Lotus Eaters.** 1861. Oil on canvas. **h**52¾ x **w**88½ in. **h**134 cm x **w**225 cm. The Royal Collections, Stockholm, Sweden.

Durand Asher Brown

Kindred Spirits

Isolated on a rocky outcropping in a northern American forest, two men survey the mountainous wilderness before them. With its setting in New York's Catskill Mountains and its faithful, detailed rendering of nature, the painting bears the hallmarks of the Hudson River School. It also pays homage to the memory of the school's acknowledged founder, Thomas Cole (portrayed on the right), who had died in 1848. Cole is shown here with his friend, the nature poet and newspaper editor William Cullen Bryant. Durand, whose own specialty as a landscapist originated in his friendship with Cole, complied with his patron Jonathan Sturges's suggestion to show his friends as "kindred spirits" linked by their love of nature and their belief in its power to enhance humankind's spiritual existence. Durand began his career as an engraver and helped found the National Academy of Design in New York in 1826.

☛ Cole, D. Johnson, Watkins, Whittredge

128

Asher Brown Durand. b Jefferson Village (now Maplewood), NJ, 1796. **d** Jefferson Village, NJ, 1886. **Kindred Spirits.** 1849. Oil on canvas. **h**44 x **w**36 in. **h**111.8 x **w**91.4 cm. The New York Public Library, New York, NY.

Durand John

The Rapalje Children

With freshly scrubbed faces and Sunday best clothes, the children of Garret and Helena Rapalje practice adult manners and deportment. Subtly ranked by age and gender, the eldest boys stand forward in casual, open postures. Their sister stands still, holding an ornamental flower. The hard linearity of Durand's style gives the figures a pattern-book clarity, but the children are arranged on the canvas with surprising naturalness to give them a charming appeal. Little is known of the artist, who painted portraits in New York, Virginia, and Connecticut; his ancestry may have been French. His use of dark contours and flat modeling implies the absence of formal training and his palette is effectively original. Like many artists in eighteenth-century America, Durand hoped to expand beyond portraiture. He advertised his talents for drawing instruction and history painting, but found little support for these ambitions, surviving instead on portrait commissions and decorative coach painting.

Field, The Freake-Gibbs Painter, F. Porter, Sargent

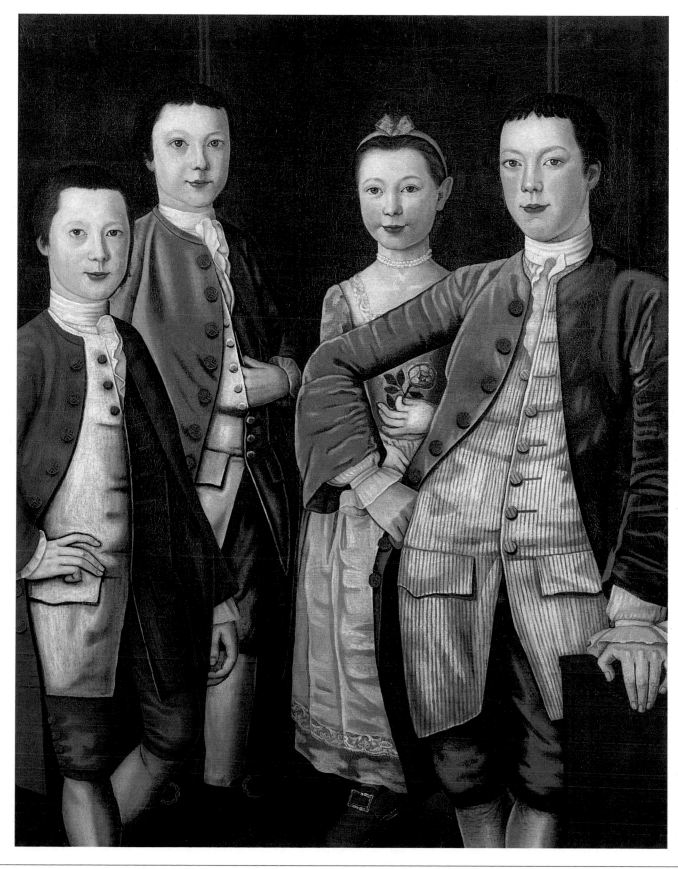

John Durand. Active 1766–1782, New York, NY; New Haven, CT; Virginia. **The Rapalje Children.** c1768. Oil on canvas. h50¾ x w40 in. h129 x w101.7 cm. The New-York Historical Society, New York, NY.

Durham Jimmie

Tlunh Datsi

The skull of a fierce desert animal bristles with metallic paint and a headdress of steel saw blades. Draped in fur and feathers, it perches on part of a New York City police barrier painted with prairie flowers. In this piece, the disconsonant combination of the natural and the manmade, of clichéd Native American and urban elements, forces the viewer to reconsider and question stereotypes of Native culture as well as the exclusionary strategies of modern art. A Native American of Cherokee descent, Durham sees no distinction between his political work for Indian causes and his artwork; both allow him to subvert European-inspired myths about Native culture. Durham calls *Tlunh Datsi* and similar works "new folk art," his sardonic reaction to the faux-naif pastiche of Postmodernism. While Durham's sculptures, drawings, and paintings appear to fall into the category of 1980s bricolage, their open-ended meanings and lyrical, sometimes mischievous texts have roots in more political early twentieth-century movements such as Dada and Surrealism.

☞ **Conner, Cornell, DiSuvero, Schimmel**

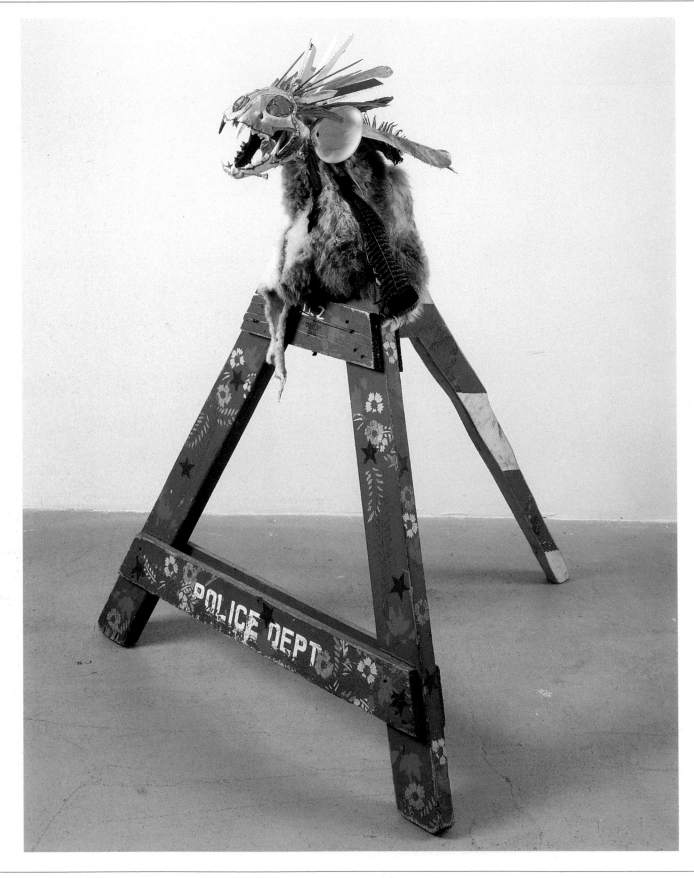

Jimmie Durham. b Washington, AR, 1940. **Tlunh Datsi.** 1985. Skull, feathers, fur, turquoise, acrylic paint, shells, wood. **h**43 x **w**38 x **d**34 in. **h**103.2 x **w**91.2 x **d**81.6 cm. Collection of Mimi Dusselier

Durrie George Henry

Settling the Bill

An old man casts an eagle eye on the arithmetic being scrawled on the barn door as he awaits the reckoning of his bill for the corn heaped in the sleigh on the right. A younger man (perhaps his son, judging from their similar profiles) prepares to pay, smoothing the wrinkles from crumpled bills by stretching them across his knee. The crushed condition of the bills implies that they are hard-won savings eked from an agrarian existence. Yet whatever their financial difficulties, the men remain privileged compared to the African-American boy who gazes at the money spread before him. The rustic simplicity of this farmyard transaction is unintentionally reinforced by Durrie's unpolished artistic skills. His numerous picturesque scenes of rural America in winter, particularly his depictions of his native New England, gained popularity when they were converted to the print medium and widely distributed by Currier & Ives.

☛ Bingham, Rogers, J. Thompson, Woodville

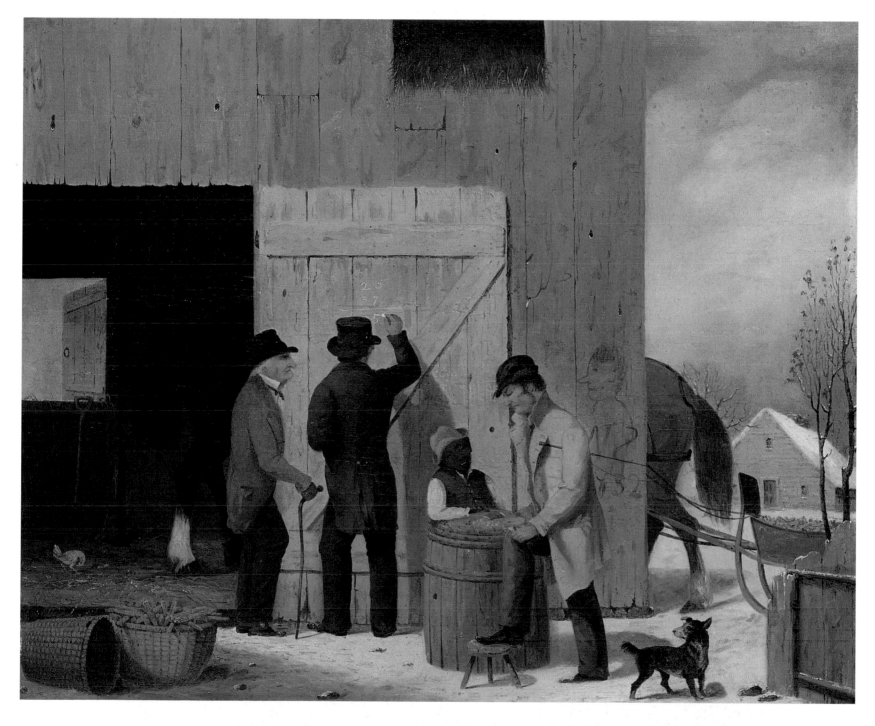

131

George Henry Durrie. b Hartford, CT, 1820. **d** New Haven, CT, 1863. **Settling the Bill.** 1852. Oil on wood. **h**19½ x **w**24 in. **h**50 x **w**61 cm. Shelburne Museum, Shelburne, VT.

Duveneck Frank

The Whistling Boy

A tough young apprentice stares warily at the viewer, his lips pursed as if whistling. Originally, however, it was clear that he was exhaling smoke, the wisps of which are no longer visible due to the effects of time on the paint surface. Duveneck's realist, non-narrative approach to a common social type was a hallmark of the style he mastered while studying at the Royal Academy in Munich. The rich *alla prima* technique, in which paint is brushed directly on the canvas without a preliminary drawing, and the dark Old Master palette displayed here are also characteristic of this painterly style popular among the followers of the German painter Wilhelm Leibl. Like other Munich-trained American artists of his generation (among them William Merritt Chase, John Twachtman, and John White Alexander), Duveneck subsequently modified his style, lightening his palette and expanding his subject matter. Duveneck lived mainly in Europe, but exhibited frequently in the United States. In 1889 he moved to Cincinnati, where he became an influential teacher.

☛ Blythe, Henri, Savage, Wright

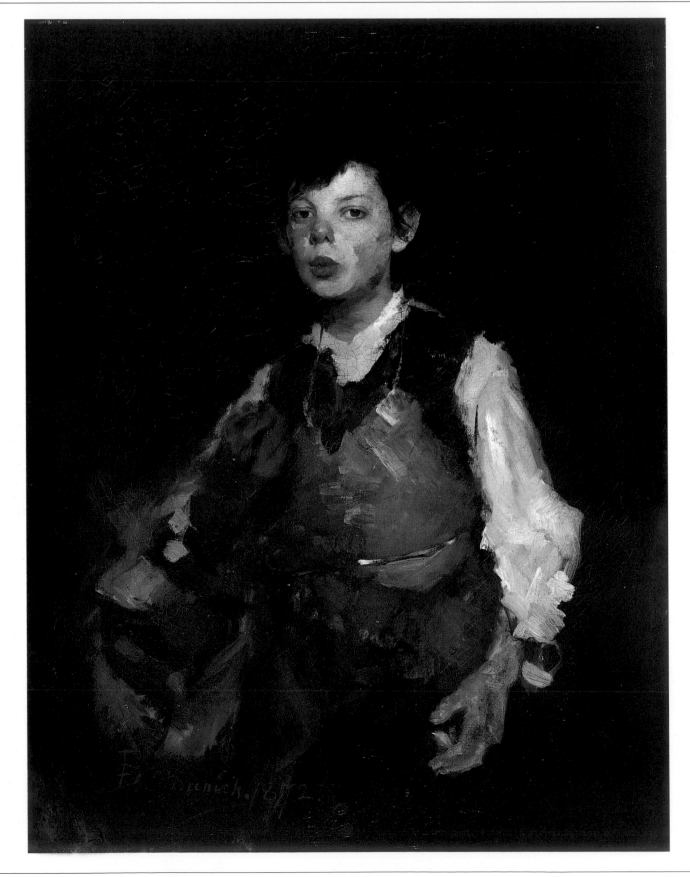

132

Frank Duveneck. b Covington, KY, 1848. **d** Cincinnati, OH, 1919. **The Whistling Boy.** 1872. Oil on canvas. **h**27⅞ x **w**21⅛ in. **h**71 x **w**57 cm. Cincinnati Art Museum, Cincinnati, OH.

Eakins Thomas

The Gross Clinic

In an amphitheater filled with students, a surgeon turns from his patient to make a critical point about the procedure he demonstrates. To the left, a woman recoils, shielding her eyes, possibly from the operation, but more likely from the doctor's bloodied hand that holds the scalpel. Contemporary audiences recoiled from the painting as well, even though it was a portrait of the respected Philadelphia physician Samuel Gross. Eakins had intended this monumental work to launch his career to a higher level, and he submitted it to the art jury for the Philadelphia Centennial Exposition. Rejected because of its brutal realism, the portrait was finally displayed in the Exposition's medical section. Eakins's passion for anatomical study and uncompromising realism foreshadowed his later teaching methods. His practice of allowing female students to draw from the live nude model broke with convention and led to his dismissal from the Pennsylvania Academy of the Fine Arts.

☞ Leutze, Pratt, Smibert, Trumbull

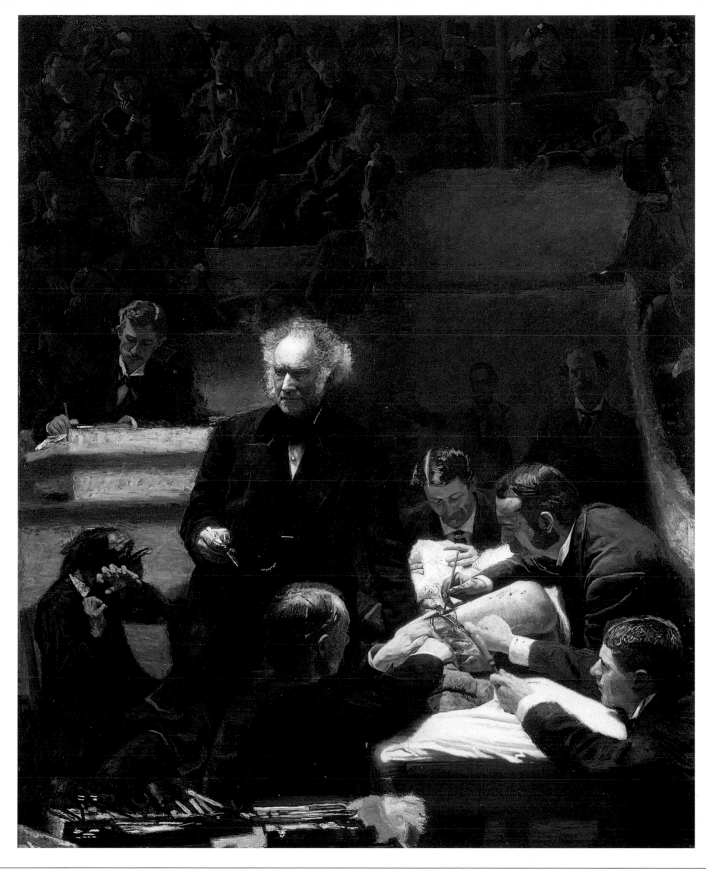

Thomas Cowperthwaite Eakins. b Philadelphia, PA, 1844. **d** Philadelphia, PA, 1916. **The Gross Clinic.** 1875. Oil on canvas. **h**96 x **w**78 in. **h**243.8 x **w**198.1 cm. Thomas Jefferson University Art Museum, Philadelphia, PA.

Earl Ralph

Roger Sherman

No trace of fashion or flair colors this portrait of Roger Sherman, the Connecticut cobbler turned lawyer and patriot. Dressed in a plain, well-worn suit, his hair unadorned by a wig, Sherman sits awkwardly on a Philadelphia-type Windsor chair that alludes to his recent service in the First Continental Congress. Earl's early style, self-taught and based on direct observation rather than European prototype, complements the sitter so well that this portrait has become the archetypal image of the frugal, forthright, self-determined Yankee. Earl maintained Loyalist sympathies, however, and left the colonies soon after war broke out. In London, he learned to paint with the softer contours, lighter palette, and more expansive backgrounds of the English manner, but he reclaimed many aspects of his plainer colonial style upon returning to Connecticut in 1785. His example was enormously influential on scores of country artists who responded to the tempered sophistication of his art.

☛ Beaux, Chandler, Feke, Neel

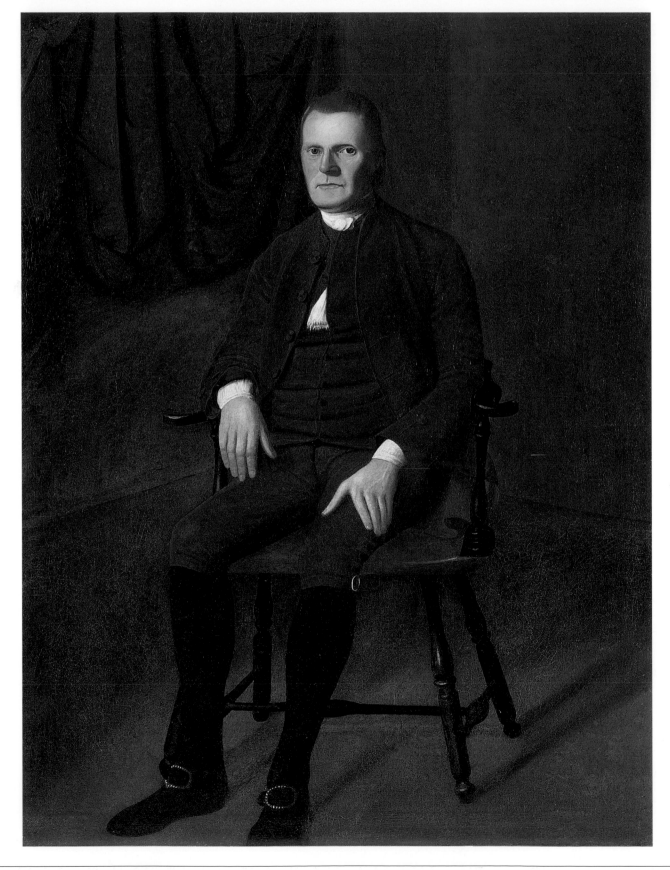

Ralph Earl. b Worcester County, MA, 1751. d Bolton, CT, 1801. **Roger Sherman.** c1775–76. Oil on canvas. h64⅝ x w49⅞ in. h164.1 x w126 cm. Yale University Art Gallery, New Haven, CT.

Edmondson William J. Preacher

With his right hand raising the Bible high into the air and his left hand clasping the lapel of his elegant jacket, this preacher is the embodiment of authority. William Edmondson began creating his remarkable limestone sculptures after experiencing a vision in which, he said, God instructed him to carve. His first works were tombstones fabricated for members of his church congregation, but he went on to create figurative works such as this one. Edmondson was profoundly religious and often depicted Biblical subjects, including Adam and Eve, angels, and the Crucifixion. Here, he has powerfully rendered a preacher, the moral and political keystone of many African-American communities of the South. Though he was entirely self-taught, Edmondson's minimal aesthetic appealed to the fine art community of the 1930s. In 1937, he became the first African-American sculptor to receive a one-person show at New York's Museum of Modern Art.

☞ Greenough, Moulthrop, Nadelman, Robb, Zorach

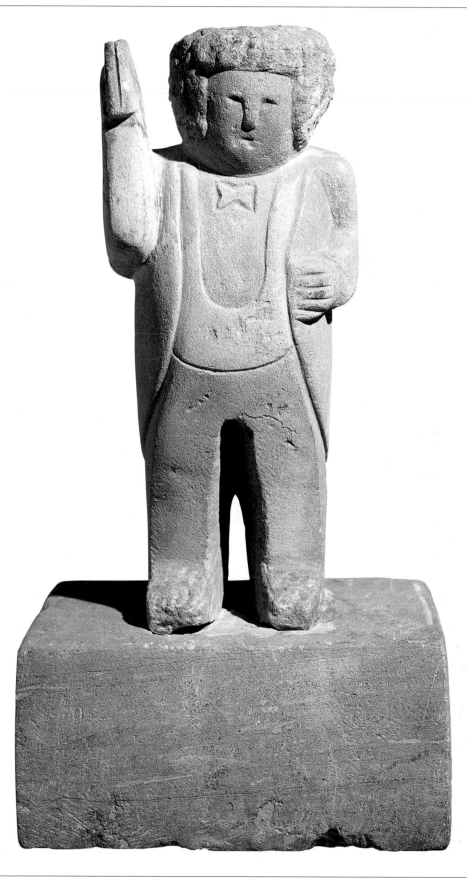

William J. Edmondson. b Nashville, TN, 1870. **d** Nashville, TN, 1951. **Preacher.** Carved limestone. **h**26½ in. **h**67.3 cm. Private collection.

Eggleston William

Jackson, Mississippi

A sagging divan, a thin woman with a thin cigarette, a garden trellis — these obvious details of Eggleston's picture are less interesting than its color and its apparent casualness. What the photographer really seems to be photographing is the near contiguity of the woman's flowered dress and the divan's print cover, a juxtaposition that is all the more striking because only we, the viewer and the photographer, are aware of it. But Eggleston does not laugh at his subjects: He photographs family and friends and familiar surroundings in his native Mississippi and nearby Memphis, Tennessee. Thrust into the limelight in 1976 by John Szarkowski, then the director of photography at The Museum of Modern Art, Eggleston's work was hailed as the coming of age of color photography. Since then, he has continued to work on projects that allow him to respond intuitively to his visual experience, including a series of pictures of Elvis Presley's home, Graceland.

☛ Hathaway, Hawthorne, Reid, Wood

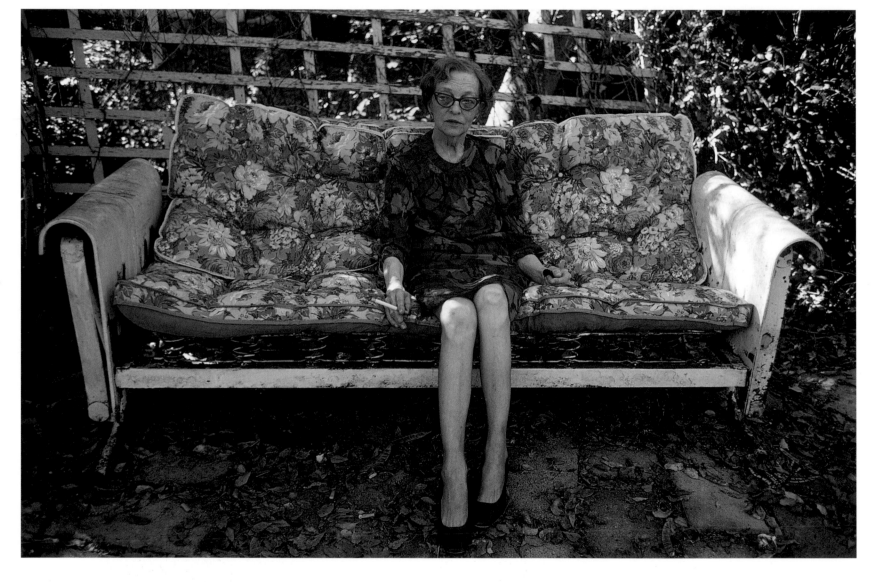

136

Elliott Charles Loring

Portrait of Mrs. Thomas Goulding

The dainty ruffled bonnet that frames the stern face of Mrs. Thomas Goulding does little to relieve the severity of her expression. She sits erect, her matronly bulk encased in costly but conservative clothing. Her penetrating gaze is likely intensified by the fact that she does not wear the eyeglasses that might have softened her expression. Elliott's career in portraiture thrived after the death of Henry Inman in 1846, which left Elliott the painter of choice within a strong market driven by the demands of New York's upper-middle classes. Having trained as an architect, he abandoned that profession early on in favor of becoming a painter, a goal he pursued mainly through studying the work of established artists. While his unidealized portrayals of his sitters have been linked with the sharp qualities of Daguerreotypes, it is just as likely that his unsentimental approach suited the apparently pragmatic Mrs. Goulding's world view

☞ Hawthorne, Page, Peck, Southworth & Hawes

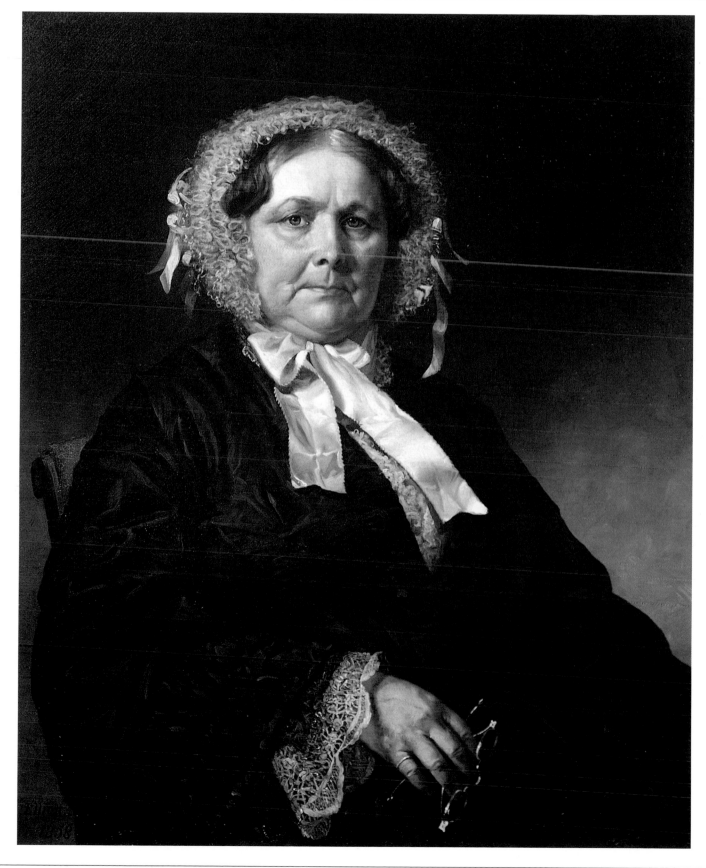

Charles Loring Elliott. **b** Scipio, NY, 1812. **d** Albany, NY, 1868. **Portrait of Mrs. Thomas Goulding.** 1858. Oil on canvas. **h**34 1/2 x **w**27 in. **h**87.7 x **w**68.6 cm. National Academy Museum, New York, NY.

Elmer Edwin Romanzo

Mourning Picture

A mournful child is visibly separated from her parents and dwarfed by a looming house in this painting, which resembles a glimpse into a disturbing dream more than it does a conventional family portrait. The artist and his wife appear dressed in funereal black with their daughter, her pet lamb, her cat, and her favorite doll, in front of the house he built for his family. This painting belongs to the folk tradition of the "mourning picture," a genre developed for the express purpose of commemorating the beloved deceased. Elmer made a living executing such paintings in his signature style of "magical realism," in which the odd, rather sharp light and shadows and deliberately placed objects lend the work a chilling, Victorian-gothic feel. Yet this work is especially poignant, as it depicts his own daughter Effie, who died tragically at the age of eight. Elmer abandoned the house soon after the death of his child.

☞ J. E. Kühn, Persac, Prior, F. Porter

138

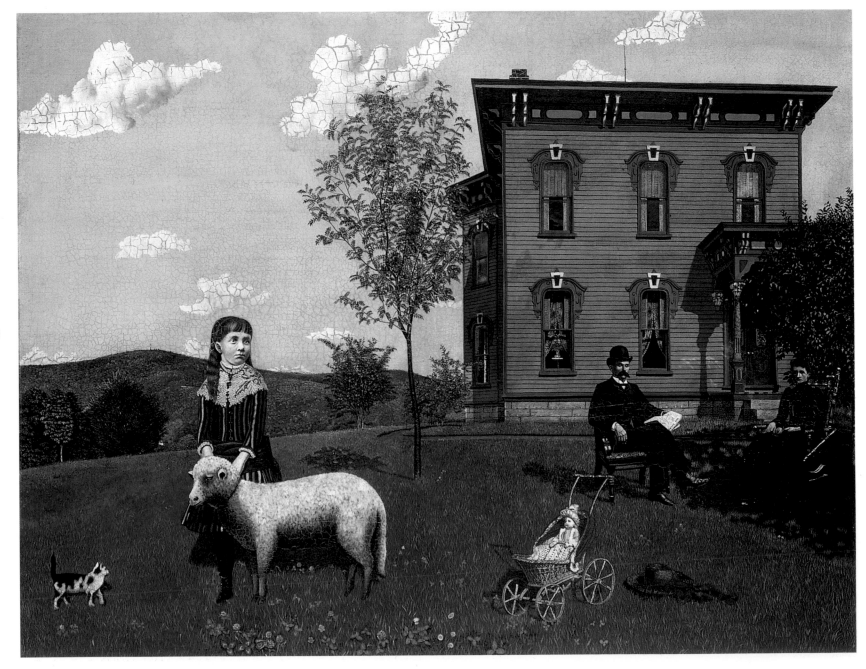

Edwin Romanzo Elmer. b Ashfield, MA, 1850. d Ashfield, MA, 1923. **Mourning Picture.** 1890. Oil on canvas. h28 x w36 in. h71.1 x w91.5 cm. Smith College Museum of Art, Northampton, MA.

Estes Richard

Central Savings

What at first appears to be a high-contrast color photograph of a busy streetscape reflected in the window of an empty diner is in reality an oil painting. Although Estes is technically a Photorealist painter, his interest in complex reflections and his complete exclusion of human subjects (after 1970) lend his art an affinity with both Conceptualism and Abstraction. Estes's paintings participate in a lengthy history of New York street scenes, but they are uniquely cold, timeless, and clean — characteristics that distinguish them from the gritty photography of Edward Weston and the emotion-filled paintings of Edward Hopper. The more one looks at Estes's paintings, the more disorienting their apparently truthful recording of life becomes: their raking light and razor-sharp shadows, for example, are more characteristic of arid Los Angeles than humid New York.

☞ Cottingham, Goings, Goodes, Graham

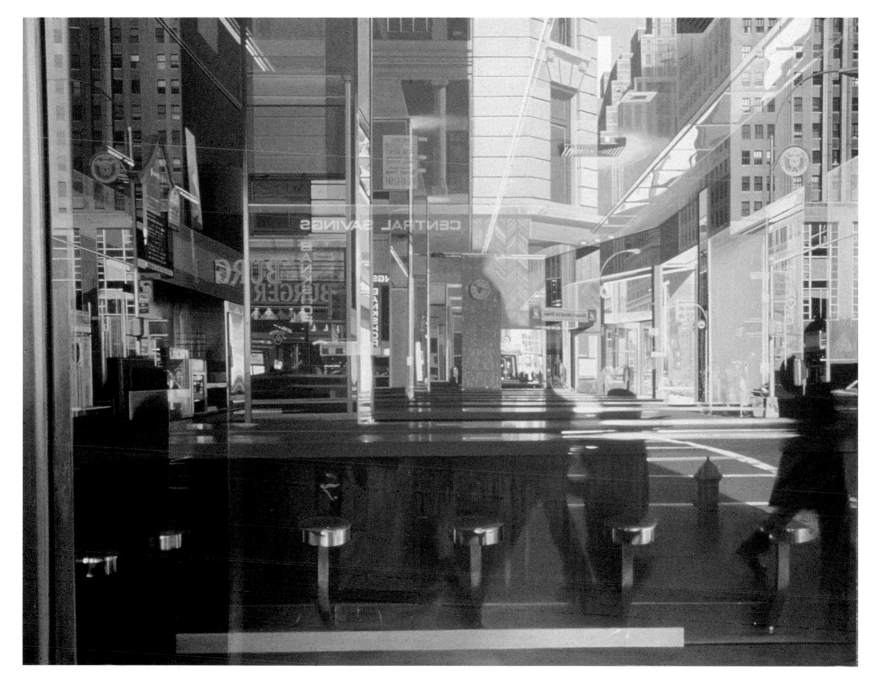

Richard Estes. b Kewanee, IL, 1932. **Central Savings.** 1975. Oil on canvas. **h**36 x **w**48 in. **h**91.4 x **w**121.9 cm. Marlborough Gallery, New York, NY.

Evans Walker

The Cotton Room at Frank Tengle's Farm, Hale County, Alabama

A straw hat hangs above the fireplace like an object of art, and above it a sign simultaneously cautions and welcomes visitors. These gestures were made by this room's inhabitants, a family of Alabama sharecroppers during the Depression. Evans's straightforward depiction of this ramshackle interior respects their intentions. The exact function of this "cotton room" is not clear from the picture,

nor did the photographer explain it. What is clear is that the chimney has been breached so that inside and outside merge. Frank Tengle was a cotton farmer and one of the subjects of Walker Evans's most recognized and enduring project, *Let Us Now Praise Famous Men*, a book that combines Evans's pictures with text by James Agee. The photographer and writer journeyed to the South on behalf of

Fortune magazine, which had commissioned an article on tenant farmers. What resulted was not an article but a classic work of words and pictures, independent yet complementary, that included some of Evans's best portraits, interiors, and landscapes.

☛ **Christenberry, Lee, M. White, Wolcott**

140

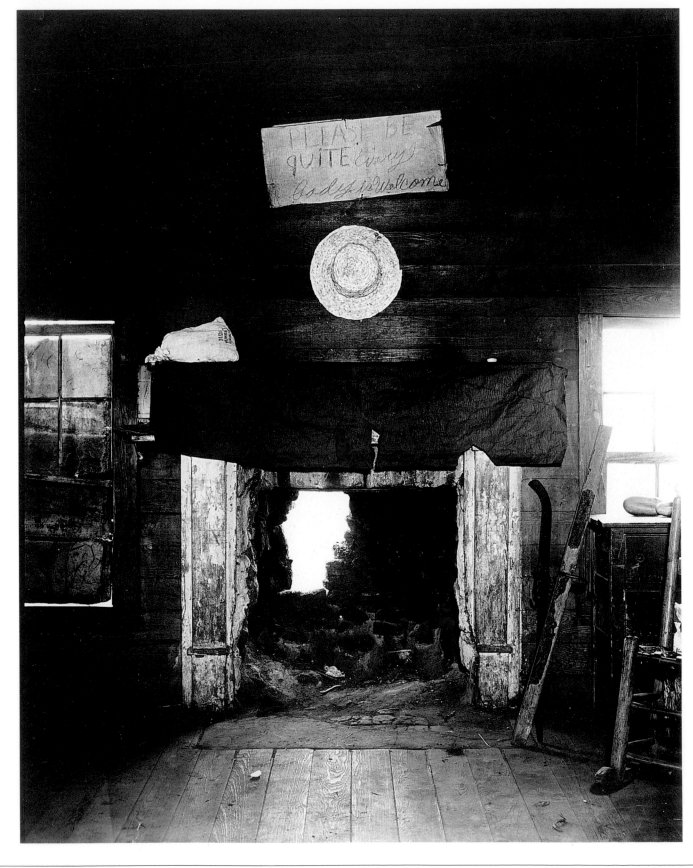

Walker Evans. b St. Louis, MO, 1903. **d** New Haven, CT, 1975. **The Cotton Room at Frank Tengle's Farm, Hale County, Alabama.** 1936. Gelatin silver print. The J. Paul Getty Museum, Los Angeles, CA.

Evergood Philip

The Future Belongs to Them

In an idealistic allegory of racial integration, black and white infants embrace with the support of their encouraging families. The figures' upturned faces and raised arms project a spirit of optimism, while in the background, a bridge symbolically links the two groups. Evergood studied art in London, Paris, and New York, developing an expressionist style of muscular figuration bordering on the gro-

tesque. His distortions may be amusing or bitingly satiric, although many of his later figure studies are poignant examinations of individual character and spirit. Deeply committed to social themes, although far from a straightforward Social Realist, he was active in the Artists Union and other politically oriented groups during the 1930s and became known as a leading proponent of humanistic painting. "I was

born with a heart," he wrote, "and, thank God, a good sense of humor as well."

☛ Chicago, Marsh, Shahn, Tanning

Philip Evergood (Howard Francis Blashki). b New York, NY, 1901. **d** Bridgewater, CT, 1973. **The Future Belongs to Them.** 1938–53. Oil on canvas. **h**60 x **w**40 in. **h**152.5 x **w**101.7 cm. Private collection.

Feininger Lyonel

Gables I, Luneburg

Quaint historic buildings in a provincial German city near Hamburg appear as an amalgam of abstract architectural elements. Feininger has exploited the inherent geometry of doors, shutters, stairs, and gabled roofs. He applied Cubist faceting to the space around them, organizing solids and voids into a harmonious abstract arrangement. Although American by birth, Feininger spent most of his career in

Germany, his family's ancestral home. After working as a cartoonist for Berlin periodicals and the *Chicago Tribune* (for which he drew the famous comic strip "Katzenjammer Kids"), he developed a prismatic painting style and became a leading member of the pre–World War I German avant-garde. In 1919, he joined the faculty of the new Bauhaus, where he remained until the school was closed by the Nazis in 1933.

Labelled a "degenerate" artist by the Germans, he returned to the United States in 1936 and executed two major mural commissions for the 1939 World's Fair in New York.

☛ **Dasburg, Demuth, Morgan, Spencer**

Lyonel Feininger. **b** New York, NY, 1871. **d** New York, NY, 1956. **Gables I, Luneburg.** 1925. Oil on canvas. **h**37¾ x **w**28½ in. **h**95.9 x **w**72.4 cm. Smith College Museum of Art, Northampton, MA.

Feke Robert

The Reverend Thomas Hiscox

A jutting chin and firmly set mouth underscore the vitality and resolve of this fifty-nine-year-old Baptist minister, who served as church pastor and town treasurer in Westerly, Rhode Island. The portrait suggests a man without pretense or affectation, an effect achieved through the stern simplicity of the artist's style (here shown at its most severe and least aristocratic) as well as the sitter's

forthright gaze and lack of periwig. Feke, himself the son of a Baptist minister, made his artistic debut in Boston in 1741 with a portrait that demonstrated both individual talent and the artist's knowledge of John Smibert's work. Essentially self-taught, Feke developed a style marked by simplified shapes, strong contours, and elegant surfaces; the portraits he painted in Newport, Boston, and Philadelphia set a

new standard of sophistication in the colonies. With his hard-edged but stylish manner, the native-born Feke is widely considered to have produced the first discernably American style.

☞ **Couturier, Eliot, T. Smith, Stuart**

Robert Feke. b probably Oyster Bay, NY, c1705–10. **d** probably Bermuda or Barbados, after 1750. **The Reverend Thomas Hiscox.** 1745. Oil on canvas. **h**30 x **w**25 in. **h**76.2 x **w**63.5 cm. Redwood Library and Athenaeum, Newport, RI.

Field Erastus Salisbury Joseph Moore and His Family

Dressed uniformly in black and white, the family of dentist and hatmaker Joseph Moore stares with calm intensity out of this life-sized portrait, painted in the year the Daguerreotype camera was introduced to America. The adults, each grouped with two children, sit on either side of a central mirror and table, their heads aligned with opposite window frames. The splendid rhythm of figures and furnishings, fixed horizontally by the sitters' gazes, keeps intact a composition that might otherwise slide off the canvas with the colorful, nearly vertical, floor patterns. Field never learned to render correct perspective or anatomy. His pictorial solutions depended on an innate sensitivity to character, color, and decorative pattern, never more masterfully employed than in this example. After 1841, Field gave up his itinerant practice. He increasingly based his portraits on photographs while devoting his creative intelligence to religious and historical themes.

☛ Brewster, J. Durand, Peck, Smibert

144

Erastus Salisbury Field. b Leverett, MA, 1805. **d** Sunderland, MA, 1900. **Joseph Moore and His Family.** c1839. Oil on canvas. **h**82¾ x **w**93¼ in. **h**209.2 x **w**237.2 cm. Museum of Fine Arts, Boston, MA.

Finster Howard

The Angel Turns the Storm

With a wave of the hand, an angel averts ominous gray storm clouds from the bucolic valley below. There, a verdant garden flourishes in the presence of Christ himself, whose teachings are spelled out on his robes. This religious scene is infused with patriotism in the guise of Thomas Jefferson, who appears at the bottom, below Christ, while the artist himself appears in the lower left corner as a smiling young man. "Paint sacred art" was the divine dictum issued to Howard Finster in 1976, who at that time had already begun his outdoors sculptural environment, Paradise Garden. Finster had been a Baptist preacher since his teenage years, and his painting became an extension of his ministry. Beside his self-portrait, he has inscribed this painting with "414" — the number of paintings he had completed at the time. Since then, Finster has created well over 40,000 artworks, each one individually numbered.

☞ Aragón, Fisher, Reed, Yoakum

Howard Finster. b Valley Head, AL, 1916. **The Angel Turns the Storm.** 1977. Tractor enamel on board. **h**19½ x **w**26½ in. **h**49.5 x **w**67.3 cm. Private collection.

Fischl Eric

Far Rockaway

A naked man, perhaps on his way from a late-night swim, confronts a woman attired in fancy evening dress. A striped chaise is the lone witness to their incongruous encounter. Fischl gained fame in the 1980s for his unflinching yet enigmatic depictions of suburban angst, set amid such mundane locales as the beach and backyard barbecue. (The Far Rockaway of this painting's title is a far-flung suburb of New York City.) Fischl has called suburbia an "American tragedy," lamenting its soullessness and corruption of the American Dream. His large, colorful, sometimes awkward paintings of suburbia's affluent denizens in extreme emotional situations, as well as his frequent use of photographs in lieu of live painting models, ally Fischl with his Neo-Expressionist contemporaries like David Salle. However, Fischl's singular fascination with the silent desperation of the suburban lifestyle links his paintings to those of his mid-century predecessor, Edward Hopper.

☞ **Bischoff, Park, F. Porter, Wesselman**

Eric Fischl. b New York, NY, 1948. **Far Rockaway.** 1986. Oil on canvas. **h**110 x **w**135½ in. **h**279.6 x **w**344.4 cm. Mary Boone Gallery, New York, NY.

Fisher Jonathan

A Morning View of Blue Hill Village

Beyond a pastured hill marked by a running fence and the stumps of trees, a young New England village is revealed in morning light. Ships are being built near the harbor at left, woods are giving way to fields, and the village road leads to a steepled church. While two sunbonneted women admire this bucolic vista, to the right, a man strikes at a snake, driving evil from this cultivated Eden. Fisher was the pastor of Blue Hill Congregational Church and his landscape is a painted sermon, bridging earlier topographic views and later, more Romantic work by the Hudson River School artists. Fisher's broad-ranging intellect embraced poetry, languages, and natural history as well as painting, engraving, and publishing. He attended Harvard College, but as an artist he was self-taught. The innocent practicality of his ambitions is evident in a diary entry of July 1793: "Worked on the farm; engraved on boxwood, began a small printing press."

☛ Finster, Hofmann, Moses, Seifert

A morning View of Blue hill
Village Sept. 1824
Jno Fisher pinx

Jonathan Fisher. b New Braintree, MA, 1768. d Blue Hill, ME, 1847. A Morning View of Blue Hill Village. 1824. Oil on canvas. h24⅝ x w52¼ in. h62.6 x w132.8 cm. Farnsworth Library and Art Museum, Rockland, ME.

Flavin Dan

Untitled (for A.C.)

An extraordinary effect is produced by everyday fluorescent light fixtures. Two 8-ft pink tubes frame the top and bottom, while green and blue tubes facing the walls illuminate the corner with a mesmerizing glow. A "latch" made of four short yellow tubes indicates where the flat picture plane would be if this were an ordinary two-dimensional artwork. As a young artist in the early 1960s, Flavin introduced his groundbreaking materials, unbeholden to any particular style or movement. Flavin's first works were "icons," fluorescent lights and wooden boxes that hung on the wall. Later, he used only the lights themselves, in white and other commercially available colors, to simultaneously describe, expand, and dissolve the space of his art. Flavin's art combines the stripped-down color and forms of Minimalism with the elegiac aspirations of Abstract Expressionism. It also presages Conceptualism's elimination of the art object itself.

☞ Biederman, Diller, Halley, Turrell

Dan Flavin. b New York, NY, 1933. **d** Riverhead, NY, 1996. **Untitled (for A.C.).** 1992. Pink, blue, green and yellow fluorescent light. Cast 1 of 3. **h**96 x **w**96 x **d**9 in. **h**244 x **w**244 x **d**22.9 cm. PaceWildenstein, New York, NY.

Francis John F.

Strawberries, Cream, and Sugar

A bowl of luscious strawberries is the centerpiece to this austere but nonetheless elegant still life. The plain white tablecloth contrasts with the shadowed ground and lends a theatricality to the objects, which, although few in number and simple in form, are artfully arranged. This painting exhibits the special charm of Francis's art: the particular attention he paid to reflected light bouncing off the smooth surfaces of the china, the silver, and the glass containing the cream. These elaborate chiaroscuro effects and the manipulation of the subtle tones of creams and whites suggest the self-taught artist's desire to prove his talents as an accomplished painter. After starting out as an itinerant portrait painter, Francis set up a studio in Philadelphia in 1845 and began to specialize in still life subjects, perhaps in response to the attention the genre had received from the Peale family of artists. This spare arrangement is representative of Francis's early forays into still life, which in later decades took on greater complexity and exuberance.

☛ H. Church, Groover, Oldenburg, Roesen

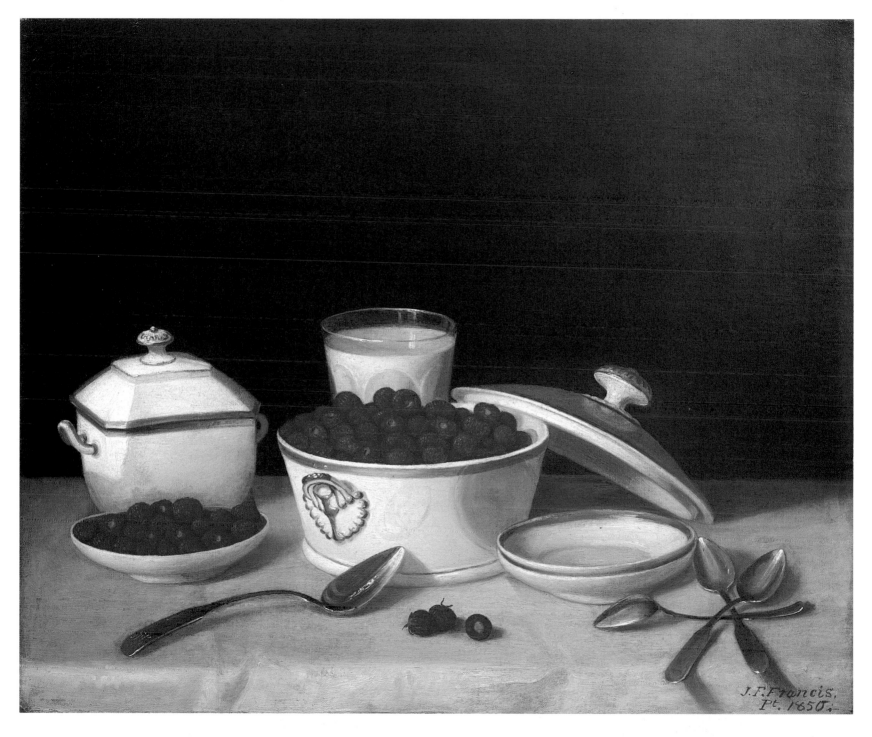

John F. Francis. b Philadelphia, PA, 1808. d Jefferson, PA, 1886. **Strawberries, Cream, and Sugar.** 1850. Oil on canvas. h20 x w24 in. h50.8 x w61 cm. Private collection.

Francis Sam

Shining Back

Clumps of luminous color floating like islands in a milky sea are characteristic of Francis's lyrical approach to gestural abstraction. His canvases seem suffused with light and his spontaneous, free-form imagery pulses with vibrant organic energy. Francis began painting while recovering from injuries sustained in a plane crash during World War II. He studied art in California and in Paris, where he joined a group of young American abstractionists, including Joan Mitchell, Norman Bluhm, and the Canadian Jean-Paul Riopelle. Following his first trip to Asia in 1957, Francis incorporated references to Oriental calligraphy in his paintings, watercolors, and prints, although his forms never took on specific symbolic meanings. With studios in Europe, Japan, and the United States, Francis was a true internationalist who raided the lexicons of Eastern and Western art to create a distinctively subjective visual language.

☞ Frankenthaler, Gorky, Mitchell, Pollock

Sam Francis. b San Mateo, CA, 1923. d Santa Monica, CA, 1994. **Shining Back.** 1958. Oil on canvas. **h**79¹/₂ x **w**53 in. **h**202 x **w**134.6 cm. Solomon R. Guggenheim Museum, New York, NY.

Frank Robert

U.S. 285, New Mexico

A potential symbol of freedom, endless promise, and possibility, the American highway stretching endlessly into the distance here seems to speak to something else. It suggests the alienating effects of a vast, unbroken emptiness, the anxiety of the traveler with too far to go and too little gas, and the danger that one might drive off the edge of the known world. Frank, a Swiss émigré who traveled and photographed throughout the United States in the mid-1950s on a Guggenheim fellowship, was probably not thinking about the romance of the open road when he made this picture, but about how far he was from the culture of his birth. When Frank's photographs were published in 1958, in a book titled *The Americans*, he was accused of being too cynical and critical, and of sloppy craftsmanship. Today, his book is recognized as a complex and dark masterpiece about the quality of American life, and Frank as one of the most important photographers of the century. After *The Americans* he went on to make films, returning to still photography only in the 1970s.

☞ Crawford, Friedlander, Kelley, Kensett

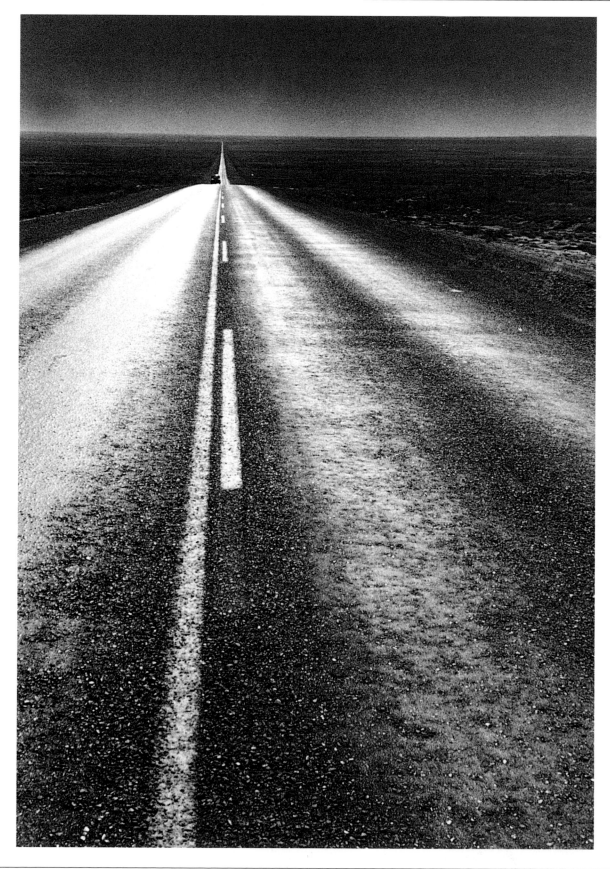

151

Frankenthaler Helen Mother Goose Melody

Three enigmatic brown figures on the left appear to soak and blend into the canvas, and energetic splashes of blue and black paint lead the eye around the composition. In light of its title, this painting could suggest a connection with children's nursery rhymes. Indeed, the gooselike shape outlined in red invites us to imagine the pictured space as a child's fantasy environment. Frankenthaler stresses the subjective, intuitive response to physical or emotional stimuli. Her stain paintings of the 1950s, inspired by De Kooning's arabesque forms and Pollock's use of liquid paint on unprimed canvas, won her acclaim as a second-generation Abstract Expressionist, but her approach has always been rooted in Cubist structure. The spontaneity of her drawing-with-color technique is tempered by contemplation and deliberation, a balance of freedom and restraint. "Consciously and unconsciously," she explains, "the artist allows what must happen to happen."

☞ S. Francis, Gorky, Louis, Man Ray

152

Helen Frankenthaler. b New York, NY, 1928. **Mother Goose Melody.** 1959. Oil on canvas. **h**82 x **w**104 in. **h**208.2 x **w**264.1 cm. Virginia Museum of Fine Arts, Richmond, VA.

Freake-Gibbs Painter The

The Mason Children: David, Joanna, and Abigail

Facing his sisters in an authoritative stance, eight-year-old David Mason displays a gentleman's gloves and cane while the girls hold feminine accessories in their hands. Six-year-old Joanna at center, however, looks out at the viewer and tugs gently at her dress, suggesting a vital human reaction amid the stiff restrictions of this pre-Enlightenment world. The children's fine laces, linens, and accessories indicate their parents' wealth and a pride in appearance that stretches the boundaries of Puritan modesty and strict sumptuary laws. These children are the largest group painted in Boston before John Smibert's arrival in 1729; theirs is one of about twenty-five demonstrably American portraits that survive from seventeenth-century New England. The artist's name remains unknown, but he is probably the same one who painted members of Boston's Freake and Gibbs families. Trained in England, he was proficient in the flattened, decorative style of Elizabethan-Jacobean portraiture that was out of fashion in London but still current in provincial centers even by 1670.

☞ J. Durand, J. Johnson, J. E. Kuhn, T. Smith

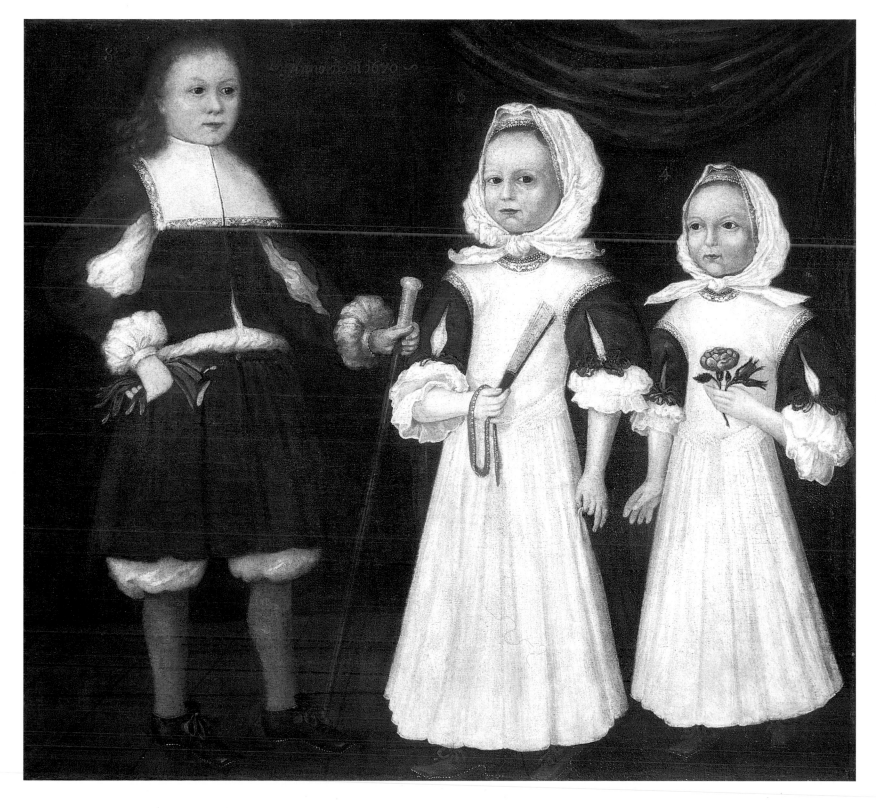

153

Attributed to **The Freake-Gibbs Painter.** Active Boston, MA, 1670–74. **The Mason Children: David, Joanna, and Abigail.** 1670. Oil on canvas. **h**39 x **w**42½ in. **h**99.1 x **w**106.8 cm. Fine Arts Museums of San Francisco, CA.

Freilicher Jane

Still Life with Calendulas

A stark white wall and bare wood floor in an East Village cold-water flat provide the backdrop for an arresting floral motif. Lush floral drapery surrounds living flowers in a ceramic pitcher, itself decorated with a floral design. Freilicher updates the still-life tradition by blending acute observation with Modernist compositional devices adapted from the work of Henri Matisse and Pierre Bonnard, especially the compression of elements against the picture plane. As a student of Hans Hofmann, she learned principles of formal analysis that could be applied to abstract and representational art alike. With other members of the New York School of figurative painters — including Larry Rivers and Fairfield Porter — she challenged the domination of Abstract Expressionism in the 1950s. Her friendship with some of the era's leading poets, especially Frank O'Hara, John Ashbery, and Kenneth Koch, contributes to her deft balancing of the prosaic and the poetic.

☛ Carles, O'Keeffe, Stella, Taaffe

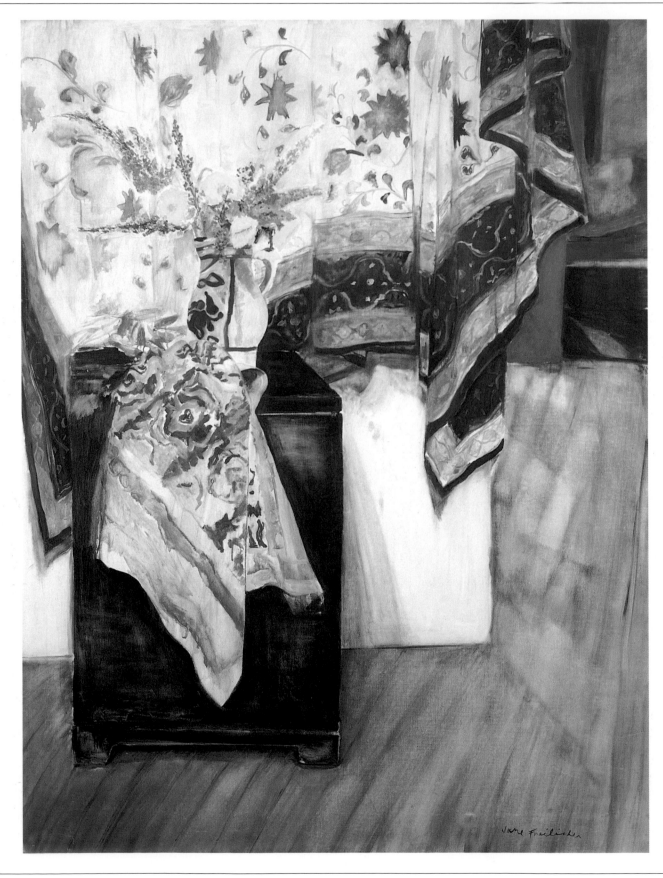

Jane Freilicher. b Brooklyn, NY, 1924. **Still Life with Calendulas.** 1955. Oil on canvas. **h**65½ x **w**49½ in. **h**166.5 x **w**125.8 cm. Tibor de Nagy Gallery, New York, NY.

154

French Jared

Woman and Boys

Like characters in an ancient Greek drama, French's figures seem to be acting out an elaborate but obscure ritual charged with sexual ambiguity. The artist has placed a statuesque woman front and center, but the crouching young man who gazes wistfully at her is the one on the pedestal, while his two companions engage in a *pas de deux* of attraction and capture. French's use of archaic stylization reflects a strong interest in the archetypes of Jungian psychology, although many of his compositions are based on photographs of actual scenes he and his friends staged on the beach at Fire Island, New York. The photographs, collectively titled "PAJAMA," were a collaborative project among PAul Cadmus, JAred French, and his wife, MAry. Although French is often grouped with the Magic Realists, his work is more psychologically probing, aiming to plumb the depths of the collective unconscious.

☛ Bischoff, Blume, Fischl, W. Kuhn

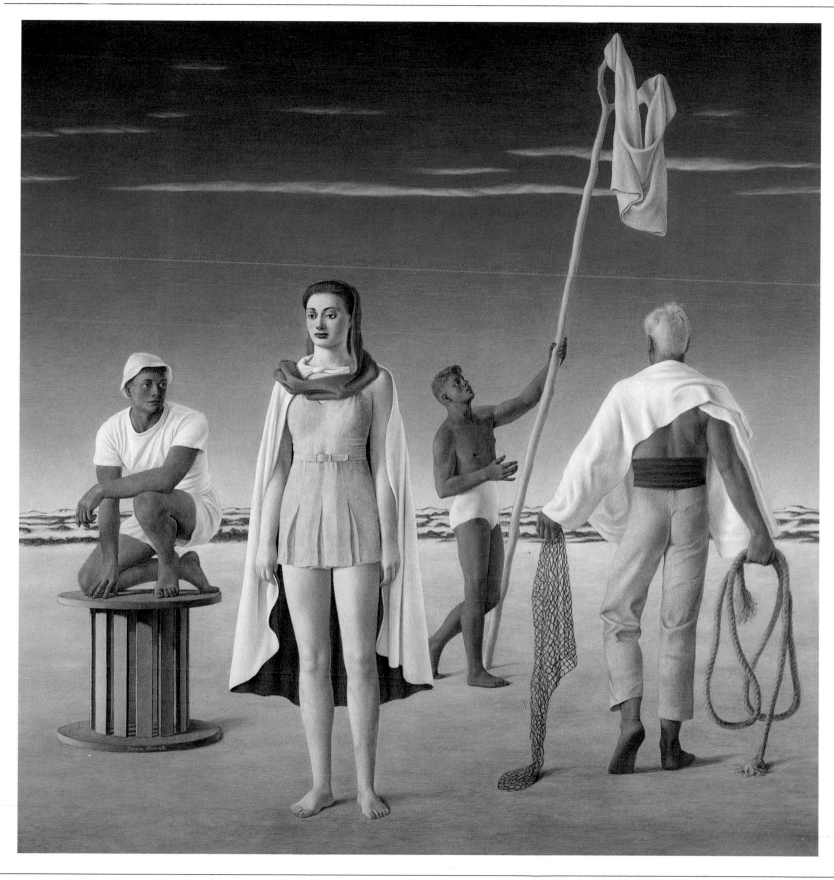

Jared French. b Ossining, NY, 1905. d Rome, Italy, 1988. **Woman and Boys.** 1944. Egg tempera on gesso on linen. **h**32¹/₂ x **w**31⁵/₈ in. **h**82.6 x **w**80.4 cm. Private collection.

Friedlander Lee Galax, Virginia

The distorted face of a baby stares from a television set in a rural Virginia motel room, resembling an Orwellian vision of Big Brother or the somewhat angry "inner child" of the room's occupants. The odd infantilism of the televised talking head reinforces the blankness of the room and supplies much of the illumination for the photograph. The foreground bed, given the bars at its foot, functions both as a safe haven for the viewer and as a metaphorical prison. Friedlander, a photographer who takes many of his pictures while traveling, knows well the alienating effects of such places and, with his customary casual grace, has made a scene that reflects this feeling. Friedlander first came into the public eye with Diane Arbus and Garry Winogrand in the 1967 exhibition *New Documents* at The Museum of Modern Art in New York. His reliance on complex but seemingly unpremeditated compositions and his love for vernacular American subjects can be seen in his books *The American Monument, Factory Valleys* and *American Musicians*.

☞ R. Adams, Berman, Gober, Nauman

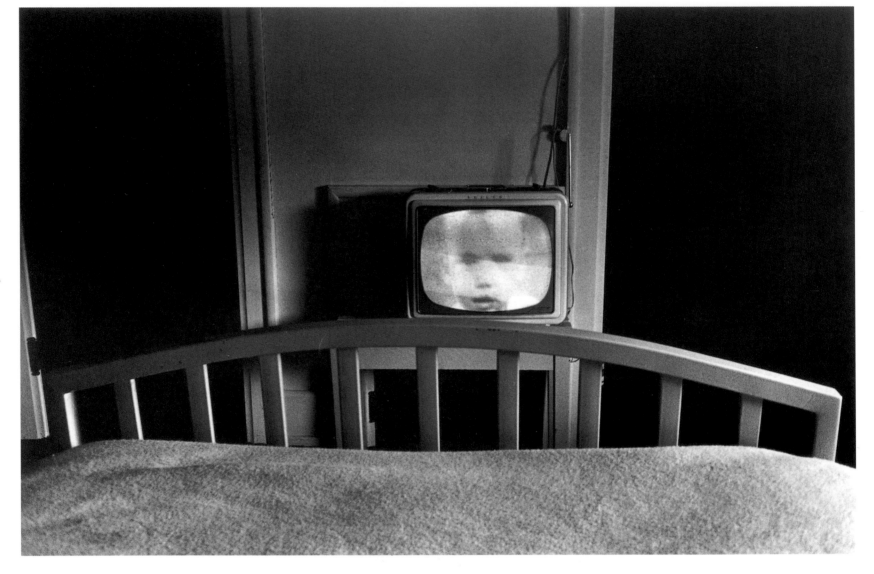

Lee Friedlander. b Aberdeen, WA, 1934. **Galax, Virginia.** 1962. Gelatin silver print. Fraenkel Gallery, San Francisco, CA.

Fuller Meta Warrick

The Awakening of Ethiopia

Bound from the waist down in a tight formal garment that suggests Egyptian burial wrappings, a female figure symbolizing Africa seems to emerge from a long sleep. Her right hand touches her chest, as if to confirm a heartbeat and register the shallow breath she draws through parted lips. Fuller's allegory of awakening black consciousness anticipated a major theme of the Harlem Renaissance. Trained in Philadelphia and Paris, where her work was praised by Auguste Rodin, she developed a naturalistic style based on his example. Her subject matter, however, tended to be somber, even morbid, and her work was often criticized as macabre. After returning to the United States in 1907, Fuller struggled against racial prejudice to gain her rightful professional recognition. She lived and worked near Boston, away from Harlem's creative ferment, but she continued to treat many of the subjects that preoccupied African-American artists in the 1920s and 1930s.

☞ Douglas, Ives, Jones, Savage

Meta Vaux Warrick Fuller. b Philadelphia, PA, 1877. d Framingham, MA, 1968. The Awakening of Ethiopia. n.d. Plaster. h67 x w16 x d20 in. h170.3 x w40.7 x d50.8 cm. Schomburg Center for Research in Black Culture, New York, NY.

Gardner Alexander Lewis Paine

Lewis Paine, a co-conspirator in the assassination of President Abraham Lincoln, seems to show little remorse in this portrait from late April 1865. Perhaps it was because his criminality was not in dispute: while his partner John Wilkes Boothe was at Ford's Theatre, Paine was attempting to murder Secretary of War Edwin Stanton. Here, in a precursor to the police mugshot, Paine appears in shackles aboard the USS *Saugus*, where he and several others were held while awaiting trial. Alexander Gardner recorded every aspect of Lincoln's assassination that he could, including the mass hanging of the conspirators. At the beginning of the Civil War he worked for Mathew Brady, then he launched his own rival business. As a battlefield photographer Gardner was responsible for many of the gut-wrenching Civil War views for which Brady is often credited. But it was Gardner's *Photographic Sketch Book of the Civil War* (1865) that became the first — and for many years the only — published collection of Civil War photographs.

☞ Avedon, Brady, Riis, Southworth & Hawes, Weegee

158

Alexander Gardner. b Paisley, Scotland, 1821. **d** Washington, D.C., 1882. **Lewis Paine.** 1865. Wet-plate negative. Library of Congress, Washington, D.C.

Gifford Sanford R.

Lake Scene

Within this tranquil rural scene a man and a woman labor on the upkeep of a stone wall that, along with the tree stumps in the foreground, implies their ownership of the land. The relationship between humans and nature was an important theme in nineteenth-century American landscape painting and, like Thomas Cole, whose work he admired, Gifford sometimes incorporated into his compositions subtle marks of humankind's transformation of the pristine North American wilderness. Although this iconography was relatively old-fashioned by 1866, Gifford may have adjusted it to more topical concerns, namely the need to heal the social and political wounds of the Civil War by emphasizing the common experience of the country's pioneering settlers and the harmony symbolized in humankind's rapport with nature. A second-generation Hudson River School artist, Gifford's style is particularly defined by his warm palette and his attention to atmospheric light.

☞ Caponigro, Cropsey, Parrish, Stoddard

Sanford Robinson Gifford. b Greenfield, NY, 1823. **d** New York, NY, 1880. **Lake Scene.** 1866. Oil on canvas. **h**18 x **w**32⅛ in. **h**45.7 x **w**81.6 cm. Brigham Young University Museum of Art, Provo, UT.

Glackens William At Mouquin's

Two sophisticated, turn-of-the-century patrons sit entranced, their gazes directed at the cafe entertainment before them. The woman's enormous black hat frames her delicate expression, and her flushed mustached escort is caught mid-sip in this unguarded moment. Reflections of their fellow *bon vivants* populate the mirror overhead. The subjects' attire, their posture, and the painting's Impressionist style evoke the world of Parisian nightlife as painted by the French Impressionists. Yet the nightspot pictured here is New York City's Mouquin Restaurant at Sixth Avenue and Twenty-eighth Street, a favorite nightspot of the group of realist painters known as The Eight. Glackens trained as a newspaper artist-reporter, covering such events as the Spanish-American War in Cuba in 1898. After turning to painting, his interest in charming, commonplace New York scenes allied him with the Ash Can School and fellow artists such as George Luks and John Sloan.

☛ Benson, W. Johnson, Reid, Shinn

William James Glackens. b Philadelphia, PA, 1870. **d** New York, NY, 1938. **At Mouquin's.** 1905. Oil on canvas. **h**48 x **w**39 in. **h**121.9 x **w**99.1 cm. The Art Institute of Chicago, Chicago, IL.

Gober Robert

Untitled

An urban sewer grate, re-created in hand-hammered bronze, is inserted in the gallery floor. Inside the brick-lined shaft is the torso of a man, a metal sink drain placed squarely in the middle of his disturbingly lifelike chest. Like much of Gober's work, this disorienting and deeply macabre tableau is part of an all-encompassing environment that transports the viewer, at least metaphorically, inside the artist's head.

Gober's lifelike wax-and-hair limbs, faux-Arcadian environments, and carefully handmade approximations of utilitarian objects — from bathroom sinks to copies of the *New York Times* — evoke a world that is at once mournful and revolutionary. Gober's art is based in his youthful experiences as the child of religious parents, and his life as a gay man in a frequently puritanical, intolerant

America. His work encompasses both Minimalism and Conceptualism but infuses these styles with a quiet persuasiveness and emotion that transcend the usual kinds of personal politics expressed in art of the late 1980s and 1990s.

☛ Blume, Bourgeois, Serrano, K. Smith

Robert Gober. b Wallingford, CT, 1954. **Untitled.** 1993–94. Bronze, wood, brick, aluminum, beeswax, human hair, chrome-plated bronze, recycling pump and water, plywood, brick facing, plaster and latex paint. **h**56 x **w**37½ x **d**34 in. **h**142.3 x **w**95.3 x **d**86.4 cm. Private collection.

Goings Ralph

Unadilla Diner

A roadside diner and its patrons are seemingly frozen in time, sunlight spilling in the windows and across the reflective surfaces of Formica and chrome. Along with fellow Photorealist painters like Richard Estes and Robert Cottingham, Goings captured the texture of Modernism in the 1970s. Unlike them, however, Goings ventured beyond the city, to the American suburbs and heartland. While the diner's shiny surfaces and circular cake containers recall the Pop paintings of Andy Warhol and Wayne Thiebaud, Goings's tabletop tableaux of ketchup bottles and napkin dispensers hark back to the classic European tradition of still life, in which utilitarian objects and food were depicted mainly because they were so familiar and so readily at hand. Other influences include the serene, beautifully lit figure studies of seventeenth-century painter Jan Vermeer. The Dutch Masters cigar box below the diner's counter may be a sly reference to Goings's painterly predecessor.

☞ Cottingham, Graham, Hopper, Segal

162

Ralph Goings. b Corning, CA, 1928. **Unadilla Diner.** 1977. Oil on canvas. **h**68 x **w**48 in. **h**173 x **w**122 cm. State Russian Museum, St. Petersburg.

Goldin Nan

Cookie at Tin Pan Alley, NYC

It is that time of night when the fun has faded — or never materialized — and one is left with liquor and cigarettes and the consolation of a close friend. The two glasses on the table suggest that the tired and seemingly troubled woman here, Cookie Mueller, a young writer and scene-maker, is sharing a table with her friend, the photographer Nan Goldin. The photograph is part of Goldin's visual diary of her life in the 1980s, when making the scene entailed indulging in sex, drugs, and rock and roll. The diary originated as a slide show accompanied by rock music that Goldin created as a form of performance art and titled *The Ballad of Sexual Dependency*. Later published as a book, *Ballad* explores the complexities of women's sexuality and the rituals of growing from adolescence into adulthood.

Admired for the urgency and authenticity of her style, Goldin went on to chronicle Mueller's marriage and her subsequent death from AIDS.

☛ Glackens, Hopper, Kuniyoshi, Pippin, Sherman

163

Nan Goldin. b Washington, D.C., 1953. **Cookie at Tin Pan Alley, NYC.** 1983. Cibachrome print. Matthew Marks Gallery, New York, NY.

Golub Leon

Viet Nam II

On the left of the huge, unstretched canvas, soldiers in American uniforms fire at Vietnamese civilians on the right. In the center of the picture is a blank expanse, along with pieces cut from the canvas's lower edge. These voids represent the real world, including our own thoughts, intruding upon the scene. Golub creates his paintings by collaging different characters from newspaper and magazine photographs, and by violently scraping and rubbing paint onto the canvas. In the mid-1960s, his art changed from macabre Abstract Expressionist-inspired paintings that resembled primitive sculpture to activist works that described specific injustices and acts of human cruelty. Golub's paintings in protest of the Vietnam War and his later series depicting mercenaries and government police in Central America and South Africa, did not gain notice until the late 1970s, when figurative painting again became popular — and when public awareness of human rights began to increase.

☞ Leutze, Saint-Gaudens, Shahn, Spero

Leon Golub. b Chicago, IL 1922. **Viet Nam II.** 1973. Acrylic on linen. **h**9.8 x **w**39 ft. **h**3 x **w**11.9 m. Rhona Hoffman Gallery, Chicago, IL.

Gonzalez-Torres Felix Untitled (Lovers — Paris)

A continuous string of lightbulbs in ceramic sockets lies tangled on the floor, their haphazard arrangement surprising when seen in staid museum surroundings. This is among a series of artworks Gonzalez-Torres created to be displayed in any way owners or curators wish. Similar acts of generosity, combined with a sly undermining of art-world norms, abound in the art of Gonzalez-Torres, who died of AIDS in 1996. In other works, he left piles of candy and printed posters for gallery goers to take. His pieces incorporate the political activism and store-bought aesthetics that characterize much American art of the late 1980s and early 1990s with a desire to create art objects that resonate emotionally with viewers. Evoking feelings of memory and loss, while indicting America's penchant for violence and intolerance, Gonzalez-Torres's work is an elegant attempt to meld politics and art into one discipline.

Flavin, Holzer, Irwin, Turrell

Felix Gonzalez-Torres. b Guáimaro, Cuba, 1957. d Miami, FL, 1996. **Untitled (Lovers—Paris)**. 1993. 84 fifteen-watt lightbulbs, extension cord, porcelain light sockets. Overall dimensions vary. As installed at Andrea Rosen Gallery, New York, NY.

Goodes Edward

Fishbowl Fantasy

Intense color permeates the profusion of objects in this bizarre tabletop still life. The articles, all apparently belonging to a woman, include a fancy hat, gloves, a gold cross, correspondence, and writing necessities. The composition is dominated by a large, flower-laden bowl containing three oversized goldfish. The bowl reflects two fashionably dressed women strolling down what appears to be the main street of a small American town. Although the specific content of this curious work is not known, a thematic unity emerges to suggest that Goodes intended this to be a wry comment on the strictures of etiquette. The painting seems to express that American codes of appropriate social behavior, especially for women, were so closely observed that a female's existence was like "living in a fishbowl." *Fishbowl Fantasy* is atypical within Goodes's oeuvre, which consists mainly of marine subjects and landscapes.

👉 **H. Church, Estes, Michals, Roesen**

Edward Ashton Goodes. **b** Wilmington, DE, 1832. **d** Philadelphia, PA, 1910. **Fishbowl Fantasy.** 1867. Oil on canvas. **h**30 x **w**25¹⁄8 in. **h**76.2 x **w**63.9 cm. Private collection.

Gorky Arshile

The Liver is the Cock's Comb

Gorky's visceral garden is a collection of ambiguities. Lush, velvety shapes sporting teeth and claws seem at once enticing and menacing, with blatantly erotic overtones. As the painting's title suggests, a form may be either an internal organ or a flower. Having worked his way painstakingly through a series of influences, from Ingres to Cézanne and Picasso, Gorky embraced Surrealism's reliance on imagery arising in dreams and the unconscious mind. With a charismatic personality and intense analytical skills, he was an influential figure in the New York avant-garde during the 1930s. In the early 1940s he began to spend long periods in the country, making studies from nature and arriving at a mature style that prefigured Abstract Expressionism. His breakthrough enabled him to combine deep-seated memory and direct experience to create transcendent, evocative compositions, but illness and personal tragedy overwhelmed him. Gorky committed suicide in 1948.

☞ Frankenthaler, Hartigan, Winters, Yoakum

Arshile Gorky (Vosdanik Adoian). b Khorkom Vari, Armenia, 1904. **d** Sherman, CT, 1948. **The Liver is the Cock's Comb.** 1944. Oil on canvas. **h**93½ x **w**155 in. **h**237.6 x **w**393.9 cm. Albright-Knox Art Gallery, Buffalo, NY.

Gottlieb Adolph

Rolling

Like polar opposites, a pair of floating discs — one a warm red, one a cool blue — might represent the sun and moon serenely presiding over a chaotic Earth. Celestial calm contrasts with terrestrial turmoil in Gottlieb's canvas, one of his "burst" series begun in the late 1950s. A leading member of the Abstract Expressionist vanguard, Gottlieb had earlier experimented with pictographic symbolism based on Native American and mythological precedents in an effort to harness the collective unconscious. Reflecting the anxiety of the nuclear age, his subsequent series of so-called imaginary landscapes pictured a fragmented environment symbolic of the modern world. With the "bursts," Gottlieb reaffirmed his conviction that abstract painting, far from being divorced from reality, is an imaginative but universally valid response to contemporary experience. "To my mind," he wrote, "certain so-called abstraction is not abstraction at all. On the contrary, it is the realism of our time."

☞ Allston, Dove, Irwin, Kline

168

Adolph Gottlieb. b New York, NY, 1903. d Brooklyn, NY, 1974. Rolling. 1961. Oil on canvas. h72 x w90 in. h183 x w228.6 cm. Virginia Museum of Fine Arts, Richmond, VA.

Gowin Emmet

Aeration Pond, Toxic Water Treatment Facility, Pine Bluff, Arkansas, 1989

An array of caustic-looking blots exudes a sense of disquietude appropriate to its identity: toxic water. The photographer's use of a chemical toning agent to color the black and white print enhances the almost palpable feeling of toxicity. This technique gives the water in the pond a feeling of dimensionality, as if its flat surface were in fact gathered into small hills. Gowin photographed the landscape from a perch in a small airplane, a method he first used in 1980 when he photographed the havoc wreaked by the eruption of Mount St. Helens in Washington. Before turning to aerial environmental landscapes Gowin was best known for portraits of his wife, Edith, and their children in and around his family home in Danville, Virginia. Like his mentor, Harry Callahan, with whom he studied at the Rhode Island School of Design, Gowin blends formal experimentation and emotional sensitivity in his carefully crafted pictures.

☞ **Smithson, Weston, Winters**

Emmet Gowin. b Danville, VA, 1941. **Aeration Pond. Toxic Water Treatment Facility, Pine Bluff, Arkansas, 1989.** Toned gelatin silver print. Collection of the artist.

Graham Dan

Opening of New Highway Restaurant; Back Yards, Tract Houses

Two color photographs are juxtaposed: At top is a family dressed in their Sunday best, sitting in a roadside restaurant; at bottom is a row of tract houses, inexpensive single-family dwellings built for the masses in the United States after World War II. Graham's Conceptual art is concerned with notions of public and private, and of seeing and being seen. It is also political: In these images,

Graham comments on the modern commingling of public and personal space by comparing the family's bleak highway vista with the virtually nonexistent views available from the crowded houses' meager backyards. In addition to photography, Graham's work has taken the form of advertisements inserted into consumer magazines, written essays, films, and elaborate structures of semitransparent

glass that both alter and reveal the usual ways in which viewers watch films — and each other.

☞ R. Adams, Baltz, Estes, Goings

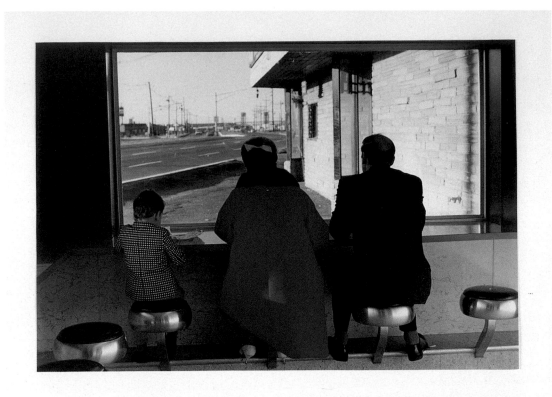

Dan Graham. b Urbana, IL, 1942. **Opening of New Highway Restaurant.** 1967. **Back Yards, Tract Houses.** 1966–67. Color prints. Each: **h**35¼ x **w**25¾ in. **h**89.6 x **w**65.4 cm. Marian Goodman Gallery, New York, NY.

Graves Morris

Nested Bird

In this ambiguous image, the nest appears to be less a shelter than a snare, trapping the bird in a jagged embrace. The creature's dark, sightless eye, constricted wing, and clenched talons suggest that it has already lost the struggle to free itself. Graves painted this image just after he returned from several years in England, and with it he created an apt metaphor of the agony into which Europe would soon be plunged. His art is infused with mystical symbolism, with the bird as a recurring motif. At an early age he was attracted to Eastern religion and philosophy, an interest reinforced by travel to Asia between 1928 and 1930. Soon after meeting Mark Tobey, Graves began to experiment with a calligraphic style derived from Tobey's "white writing," although he was equally indebted to Japanese and Chinese precedents. Graves and Tobey were grouped with the Abstract Expressionists in a 1949 New York exhibition, but Graves never abandoned his visionary, representational content.

Gottlieb, Pollock, Tanning, Tobey

171

Morris Cole Graves. b Fox Valley, OR, 1910. **Nested Bird.** 1938. Gouache and watercolor on paper. **h**25.5 x **w**28 in. **h**64.8 x **w**71.2 cm. Private collection.

Greenough Horatio

George Washington

George Washington sits enthroned like an Olympian god, his right hand held high in a powerful gesture of authority, his left hand holding the sheathed sword of state. Commissioned by the federal government for installation in the Capitol Rotunda in 1841, this massive Neo-Classical sculpture was the most important work of Greenough's career to that point. In it he attempted to endow the nation's great hero with the majesty of the ages and, drawing on the common association of Athenian democracy with that of the United States, based his work on the legendary colossal statue of Zeus by the Classical Greek sculptor Pheidias. Following its placement at the Capitol, it met with ridicule from the general public and was moved elsewhere. Despite the artist's disappointment, Greenough's career flourished and he was a leading figure among American expatriates in Italy, where he lived from 1824 to 1851.

☞ Edmondson, C. Peale, Powers, Stuart

172

Horatio Greenough. b Boston, MA, 1805. d Somerville, MA, 1852. George Washington. 1840. Marble. h136 x w102 ft x d82½ in. h41.48 x w31.1 m x d209.7 cm. Smithsonian Institution, Washington, D.C.

Greenwood John

Sea Captains Carousing in Surinam

Bewigged gentlemen, traditionally identified as sea captains from Newport, Rhode Island, smoke, converse, dance, and play cards in a South American tavern. Native punch dispensed in enormous white bowls conspires with brews in black flagons or tall glasses to make some men merry, others sly, sleepy, or miserable. One sorry fellow at center vomits into a colleague's jacket, unaware that his own

coattails are going up in flames. Such humor, as well as genre painting in general, was exceptionally rare in colonial America. Greenwood surely witnessed similar carousings during his five years in the Dutch colony of Surinam, but he was also inspired by William Hogarth's ribald and moralizing genre prints. Apprenticed to a Boston engraver, Greenwood began painting portraits around 1747

and for a brief time was the city's leading artist. In 1752, however, he sailed to Surinam and later on to Amsterdam, where he revived his interest in printmaking. Eventually he settled in London and became a successful auctioneer and art dealer.

☛ Cadmus, Disfarmer, Krimmel, Motley

John Greenwood. b Boston, MA, 1727. **d** Margate, United Kingdom, 1792. **Sea Captains Carousing in Surinam.** 1758. Oil on bed ticking. **h**37¾ x **w**75¼ in. **h**95.9 x **w**191.1 cm. The Saint Louis Art Museum (Modern Art), St. Louis, MO.

Grooms Red

Ruckus Manhattan

The twin towers of New York City's World Trade Center, one made of wood and the other of painted vinyl, soar thirty feet above the floor of Grand Central Terminal, where they were temporarily installed as part of *Ruckus Manhattan*, a sprawling, thirteen-month-long project. The West Side Highway lurches around these Manhattan icons, teeming with an unlikely traffic jam of cartoonish cars, trucks, and a horse-drawn carriage. Grooms intended to represent the entire island of Manhattan — including its subways — with his large-scale, often life-sized plastic figures and mixed-media environments, but the project was only partially completed. Grooms began his career in New York, as a performer of Happenings along with Jim Dine and Claes Oldenburg; later, he turned to his raucously comic drawing and sculpture, which has become as popular outside the world of art as within. Grooms refers to his art's jaunty angles and frenzied construction as a "chicken-coop creakiness."

Abbott, Bourke-White, Storrs, Wong

Red Grooms. b Nashville, TN, 1937. **Ruckus Manhattan.** 1976—77. Mixed media construction. World Trade Center pieces, each: **h**27 x **w**25 x **d**25 ft. **h**8.23 x **w**7.62 x **d**7.62 cm. As installed at Grand Central Terminal, New York, NY.

Groover Jan

Untitled

As if tossed into the kitchen sink and viewed through a magnifying glass, the tableware and utensils here seem spatially adrift. Yet they have been artfully arranged, together with some off-camera plants, to create a still-life image that is a meditation on the formal qualities of color photography. The shiny spatula and tableware capture colors and highlights that seem to come from nowhere, although they allude to materials outside the picture frame. Groover studied painting before taking up the camera, and she is interested more in exploiting photography's abstract potential than in depicting and commenting on the world itself. Her ability to make a photograph independent of its putative subject matter aligns her with such early experimental Modernists as Alexander Rodchenko and László Moholy-Nagy. Recently she has employed traditional, nineteenth-century photographic printing techniques to convey her avant-garde sensibility.

☛ Carles, J. Francis, Goodes, Weber

Jan Groover. b Plainfield, NJ, 1943. Untitled. 1979. Chromogenic color print. Janet Borden Inc., New York, NY.

Gropper William

Migration

Driven off their land by drought and falling crop prices, a downcast family prepares to abandon their failing farm. Painted at the onset of the four-year ordeal known as the Dust Bowl, Gropper's iconic image of agricultural ruin was reprised in 1936 by Arthur Rothstein's famous photograph of a farmer and his sons fleeing an Oklahoma dust storm. Gropper, a product of New York City's Lower East Side, studied with Robert Henri and George Bellows at the anarchist Ferrer School. Known as America's Daumier, Gropper was a keen observer of current events. His trenchant political cartoons often appeared in left-wing publications, but he also worked for *Vanity Fair* and the *New Yorker* and painted murals for federal buildings. Gropper focused on social commentary in paintings and drawings alike. "I'm from the old school, defending the underdog," he once said. "I feel for the people."

☛ Brook, Curry, Gwathmey, Hogue

William Gropper. b New York, NY, 1897. **d** Manhasset, NY, 1977. **Migration.** c1932. **h**23¾ x **w**35¾ in. **h**60.3 x **w**91 cm. Oil on canvas. Arizona State University Museum of Art, Tucson, AZ.

Guston Philip

Downtown

In this cartoonlike view of what might be a hideout, Guston depicts a pair of Ku Klux Klan members, one of whom points a finger at an unseen target, presumably a victim. Guston had first painted Klansmen as embodiments of evil in the early 1930s. Now, having evolved through allegorical figure painting and a shimmering gestural period that has been called "abstract impressionism," Guston returned to social critique, this time overlaid with satire and subjective reappraisal. At the height of the Vietnam War, he internalized the military and civil conflict and personified it in the guise of racist violence, dooming himself to echo it in the mirror image on his easel. Guston's later figurative work often features disembodied limbs, jumbles of furniture, and still-life objects strewn about in seemingly random but highly calculated juxtaposition. His change of direction was greeted with astonishment and even hostility by the art world, but his work of the 1970s inspired a new generation of figurative painters.

☞ Basquiat, Bates, Murray, Walker

Philip Guston (Goldstein). b Montreal, Canada, 1913. **d** Woodstock, NY, 1980. **Downtown.** 1969. Oil on canvas. **h**48 x **w**42 in. **h**121.9 x **w**106.7 cm. The John McEnroe Gallery, New York, NY.

Guy Francis

Winter Scene in Brooklyn

From his chimney perch atop the yellow clapboard house and store on the right, chimney sweep Samuel Foster surveys a busy street in downtown Brooklyn. This unusual urban landscape is remarkable not only for its size and its attention to atmospheric detail, but also for its truthful rendering of the streets of Brooklyn and its populace as witnessed by Guy from the second floor of his house overlooking Front Street. According to the 1869 *History of Brooklyn*, which identifies the people and buildings in the painting, Guy "would sometimes call out of the window to his subjects as he caught sight of them on their customary ground, to stand still, while he put in the characteristic strokes." Guy, who was originally a tailor and dyer in his native England, arrived in the United States in 1795.

His topographically accurate records of urban architecture and activity are not only important historic documents but also fine artistic achievements that joined landscape and genre imagery.

☞ Burchfield, Fisher, Hofmann, Moses

Francis Guy. b Lorton or Burton-on-Kendall, England, c1760. **d** Brooklyn, NY, 1820. **Winter Scene in Brooklyn.** c1817–20. Oil on canvas. **h**58¾ x **w**75 in. **h**149.2 x **w**190. 5 cm. The Brooklyn Museum of Art, Brooklyn, NY.

Gwathmey Robert

Hoeing

In this abstracted landscape of the rural South, people, animals, even the landscape itself, seem gaunt and worn out by time and toil. Although based on drawings from life, Gwathmey's subjects' faces are obscured, and his figures are more symbolic than literal, illustrating the harsh living conditions of Southern sharecroppers, black and white alike. Gwathmey's primary subject matter was life in the rural

South, which he painted in a Cubist-influenced style that became more schematic as his career progressed. Even his individual figure studies depict character types rather than specific personalities. Returning from study in Europe just as the Great Depression hit, Gwathmey used his art to express sympathy for victims of economic hardship, racial segregation, and political repression. Because of

his preoccupation with such themes, he is usually grouped with the Social Realists, but his approach is distinctively Modernist in its formal simplification and abstract design structure.

☛ Anschutz, Benton, Brook, Gropper

Robert Gwathmey. b Richmond, VA, 1903. **d** Southampton, NY, 1988. **Hoeing.** 1943. Oil on canvas. **h**40 x **w**60¼ in. **h**101.6 x **w**153 cm. The Carnegie Museum of Art, Pittsburgh, PA.

Haberle John

A Bachelor's Drawer

The booklet *How to Name Baby* at the upper right may provide the key to the content of this profusion of illusionistically rendered printed matter that includes money, newspaper clippings, photographs, theater ticket stubs, playing cards, and pictures of women. According to the painting's title, this miscellany represents a bachelor's memorabilia, souvenirs of the high life enjoyed presumably by the artist himself, since it is his own photograph that overlaps the prudently covered, but nonetheless racy nude. Haberle, a trompe l'oeil specialist, often created work relying on low humor. Here, for instance, his inclusion of varieties of money ("real," Confederate, and counterfeit) prompts consideration of the types of women displayed nearby, as if to suggest the artist's difficulty in distinguishing between genuine and counterfeit female companions. Whatever the nature of his romantic encounters, the outcome appears to be the baby-naming quandary.

☛ Harnett, Jess, Peto, Pope

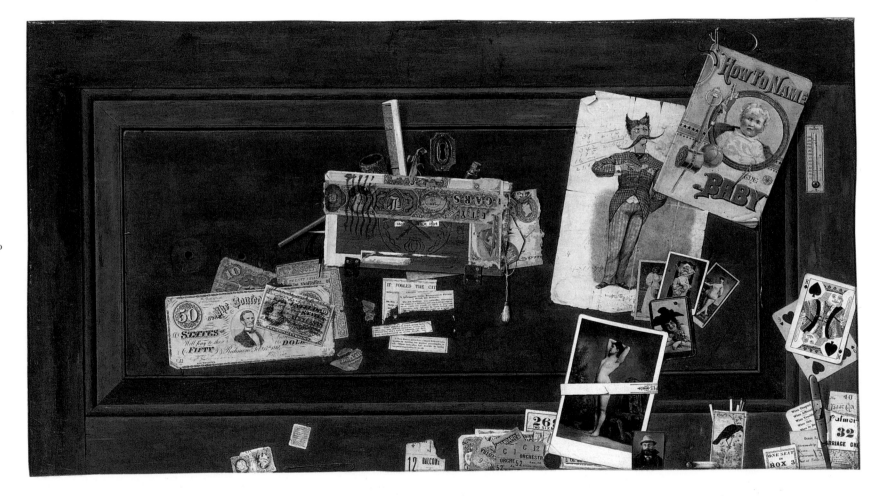

180

John Haberle. b New Haven, CT, 1856. **d** New Haven, CT, 1933. **A Bachelor's Drawer.** c1890–94. Oil on canvas. **h**20 x **w**36 in. **h**50.8 x **w**91.4 cm. The Metropolitan Museum of Art, New York, NY.

Hahn William

Market Scene, Sansome Street, San Francisco

A finely dressed woman and her two children stand on the edge of the commotion precipitated by the arrival of wagon loads of produce at the street market on San Francisco's Sansome Street. As they survey the profusion of vegetables, the young matron and her children create a quiet island of serenity in the clamorous scene. The variety and abundance of the market goods are a metaphor for the energy of San Francisco life. In choosing such a subject, Hahn took advantage of the opportunity to provide an informal catalog of the racial and social types contributing to the city's rapid growth and cultural transition. Although Hahn was active in the United States for only fourteen years, he painted works that confirm his fascination with American life, often elevating ostensibly genre subjects such as this market to the level of history painting. Shortly after emigrating in 1870 he opened a studio in Boston. By 1872 he was in San Francisco, where, except for a year in New York, he resided for the remainder of his stay in the United States.

☛ Krimmel, Luks, Winogrand, Wong

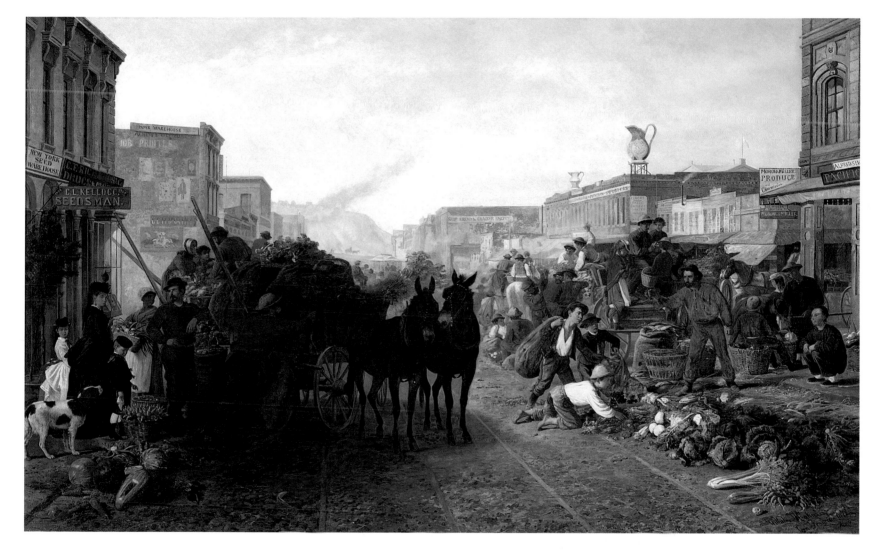

William (Karl Wilhelm) Hahn. b Ebersbach, Germany, 1829. **d** Dresden, Germany, 1887. **Market Scene, Sansome Street, San Francisco.** 1872. Oil on canvas. **h**60 x **w**96 in. **h**152.5 x **w**244 cm. Crocker Art Museum, Sacramento, CA.

Halley Peter

Figuration

A series of rectangles and lines are painted in aggressively bright designer colors, like metallic gold and Day-Glo pink. The only surface texture appears in precisely rolled rectangles of Roll-a-Tex, a kind of industrial stucco. Since the early 1980s, Halley has been both a student and a writer of texts defining Postmodernism, and yet for all their theoretical basis, his paintings are remarkably simple. Halley refers to his geometric forms as "cells" and "conduits," metaphors for the way information, and modern humanity in general, are shuttled from place to place via predetermined pathways. He sees the Modernist art that his paintings purposely resemble — the ideal geometries of Minimalists like Donald Judd and Constructivists like Alexander Rodchenko — as enforcers of straitjacketed society.

By revealing Modernism's code, Halley hopes to subvert it, but in the 1990s, his rigidly consistent paintings have taken on a new meaning. Like the logo-suffused society that surrounds them, they are now an instantly recognizable brand.

☞ Biederman, Diller, Flavin, Reinhardt

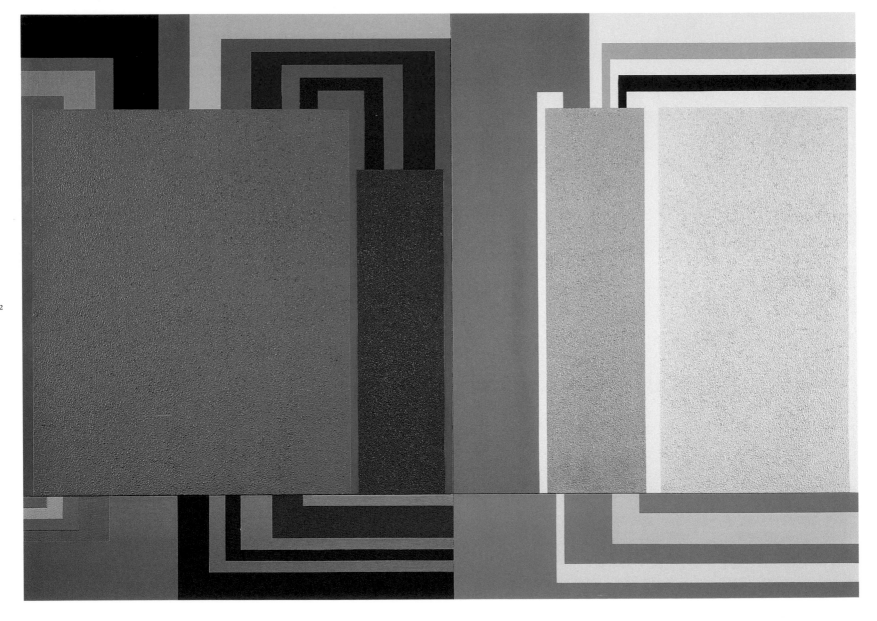

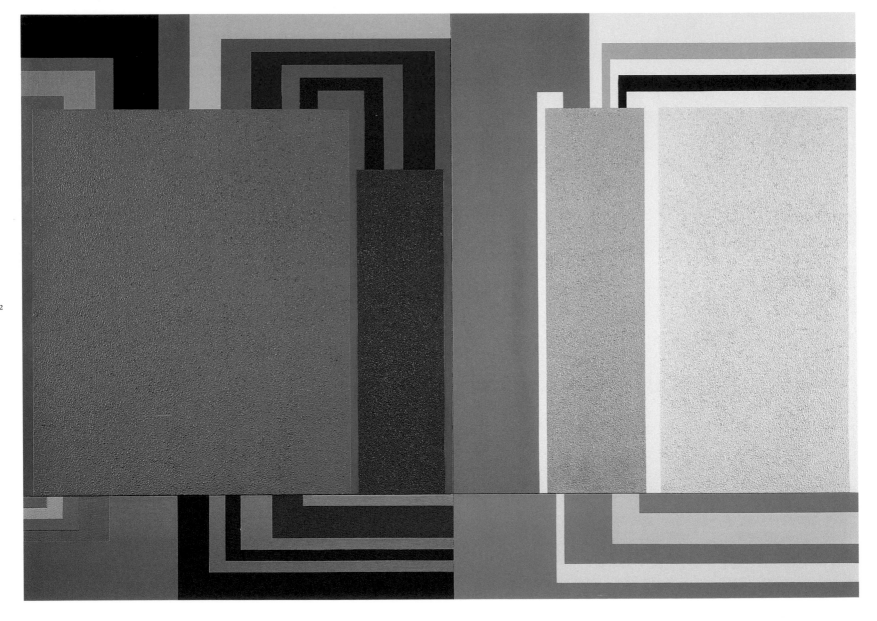

182

Peter Halley. b New York, NY, 1953. **Figuration.** 1998. Acrylic, Day-Glo, and metallic acrylic and Roll-a-Tex on canvas. **h**92 x **w**132¹/₂ in. **h**233.7 x **w**336.7 cm. Collection of the artist.

Hamilton Ann mantle

The artist sits in a chair, stitching one of thirty-three woolen coats. Behind her, eight steel tables are heaped with over 60,000 fresh-cut flowers. Such site-specific installations by Hamilton have been called "visual poems." After visiting a site and researching its history, she creates a metaphor about the city or building in which her artwork is to be located. These modest ideas nevertheless require astounding amounts of energy, time, and raw materials: past works have used ten tons of metal type, 750,000 honey-coated pennies, or 16,000 teeth. All of Hamilton's projects involve repetitive, meditative activity, usually performed by the legions of volunteers who fabricate and attend her artworks. This allies Hamilton with the artist Christo, who also uses local labor to realize his edifice-wrapping art. But Hamilton's works are different in that the accumulated labor becomes an integral part of the artwork — essentially, its soul.

☛ Eggleston, Lawrence, Reid, Vonnoh

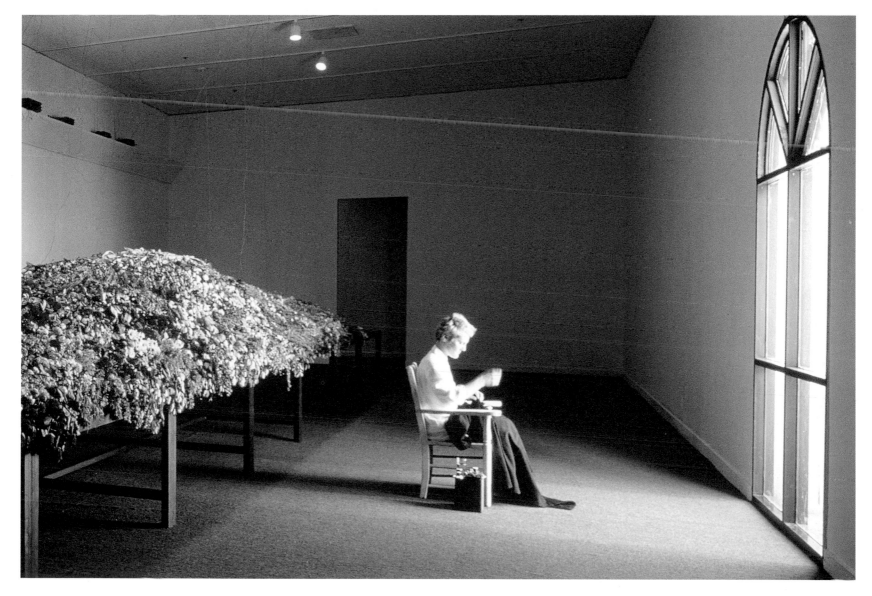

Ann Hamilton. b Lima, OH, 1956. **mantle.** 1996. Short-wave radio with voices in various languages, table mounded with 60,000 cut flowers, seated figure stitching up the seams of coats. As installed at the Miami Art Museum, Miami, FL, April 2–June 7, 1988.

Hammons David

Toiletries

These trees in a Belgian forest are hung, improbably, with porcelain urinals. The work's title is a pun ("toiletries" = "toilet-trees"), as is the installation itself — since trees are already a common place for males to relieve themselves, plumbing or no. The urinals are a tribute to Marcel Duchamp, the Dada artist, and a particular reference to Duchamp's famous *Fountain* of 1917. They also make a political statement, introducing the "dirty" world of cities and institutional bathrooms to the "clean" world of nature. Hammons's art is a kind of urban Dada. The artist aims to communicate the African-American experience to art viewers and to involve street-level audiences in the world of art. Hammons's works since the early 1970s include sculpture made with chicken bones, hair, grease, dirt, and cheap-wine bottles, all of them melding gritty urban materials with the rarefied strategies of Conceptual and Installation Art.

☞ Callahan, Conner, Durham, Welliver

David Hammons. **b** Springfield, IL, 1943. **Toiletries.** 1990. Installation in Temse, Belgium.

Hansen Al

Calliope Venus

A buxom female form is constructed from Hershey's chocolate-bar wrappers — red sections delineating her body, brown her thigh-high stockings, along with word games resulting from Hansen's cutting and pasting of the wrappers' text. This humorous collage, reminiscent of Dada with its harmless exaggeration of stereotypically sexy terms, is typical of Fluxus, a loosely organized art movement whose genesis coincided with the Happenings of the early 1960s. While Happenings evolved into the more famous and critically oriented Pop Art, Fluxus survived throughout the 1970s and into the 1980s in the pranksterish ephemera — postcards, manifestoes, and street and musical performances — of a revolving cadre of international artists, including Nam June Paik, Joseph Beuys, John Cage, and Yoko Ono.

Hansen was an original Fluxus artist and later an expatriate to Germany; he is also grandfather of the rock musician, Beck Hansen.

☞ Berman, Bourgeois, Lachaise, Jess

Al Hansen. b Queens, NY, 1927. **d** Cologne, Germany, 1995. **Calliope Venus.** 1986. Hershey bar wrappers, silver paint on board. **h**24¹/₂ x **w**27 in. **h**62.3 x **w**68.6 cm. Collection of Bibbe Hansen.

Hanson Duane

Museum Guard

A museum guard with a dour expression stands at his post amid contemporary art, his gnarled hands clasped. The guard is one of Hanson's uncannily lifelike sculptures, made from a shell of polyvinyl acetate cast from a real person. (When *Museum Guard* is shown, viewers often ask the sculpture where to find itself.) Inspired by Pop artists like George Segal, Hanson set out in the 1960s to make sculptures that reflected the strife of the times; his early career was marked by disturbing and highly controversial works depicting war, abortion, and political protest. Later, Hanson set out to reflect the "quiet desperation" of middle-class life. His unflinching sculptures of vacant-eyed shoppers, elderly people, joggers, and janitors have since taken on a warmer, even heroic tone. Hanson's "universal types" are utterly different from statues in a wax museum, which try to capture perfect images of celebrities — who are sometimes not very lifelike at all.

☛ Goings, Haberle, R. Peale, Peto

Duane Hanson. b Alexandria, MN, 1925. **Museum Guard.** 1975. Polyester, Fiberglass, oil and vinyl. **h**69 x **w**21 x **d**13 in. **h**175.4 x **w**53.4 x **d**33 cm. The Nelson-Atkins Museum of Art, Kansas City, MO.

Haring Keith

Untitled

An alarmed stick figure, reminiscent of those found on street-crossing signs and bathroom doors, serves as a hoop for a pack of spotted dogs. Painted in an engagingly cartoonish style with bright, wet-look paint on a vinyl tarpaulin, this early work of Haring's means nothing more than what it conveys: pure exuberance. Haring employed his crowd-pleasing style in the service of political causes and to support the fight against AIDS, the disease that eventually took his life. He was part of a Pop renaissance in the 1980s that included artists such as Kenny Scharf and Jean-Michel Basquiat, and which was allied with break dancing and hip-hop music. Haring began as a graffiti "tagger," drawing his trademark figures on empty advertising boards in the New York City subway. Haring wanted his art to be accessible to all· His Pop Shop in New York City still sells t-shirts, posters, and other affordable goods featuring his much-loved designs.

☞ Basquiat, Murray, Wesselman, Westermann

Keith Haring. b Kutztown, PA, 1958. **d** New York, NY, 1990. **Untitled.** 1982. Vinyl ink on vinyl tarpaulin. **h**144 x **w**144 in. **h**365.8 x **w**365.8 cm. Collection of Tony Shafrazi.

Harnett William Michael After the Hunt

Through the masterful orchestration of dead game and hunting equipment, Harnett created a monumental trompe l'oeil still life that evokes the idea of upper-class masculine leisure. Its content — a horseshoe, keys and a lock, weapons, and spoils of the hunt — symbolizes the unknown fortunes of life and the inevitability of death. Raised in Philadelphia, Harnett trained at the Pennsylvania Academy of the Fine Arts and later in New York at the National Academy of Design. By 1880, when he went to Europe for further study, Harnett had already developed a specialty in still life. The artist exhibited *After the Hunt* at the Paris Salon in 1885 and returned with it to the United States in 1886. It was soon purchased by a New York saloon proprietor who displayed it in his bar, where it gained great notoriety and exerted considerable influence on a generation of American trompe l'oeil painters.

☛ Haberle, Ranney, Peto, Pope

William Michael Harnett. b Clonakilty, Ireland, 1848. **d** New York, NY, 1892. **After the Hunt.** 1885. Oil on canvas. **h**71½ x **w**48½ in. **h**181.6 x **w**123.2 cm. Fine Arts Museums of San Francisco, CA.

Hartigan Grace

Billboard

Using bold motifs inspired by the signs and advertising graphics decorating the New York City streetscape, Hartigan constructed a densely packed mélange of shapes and colors. In making her art she searched for significant content, responding instinctively to the visual stimuli in her immediate surroundings. She was especially drawn to the urban dynamism of her Lower East Side neighborhood, a heterogeneous tableau of immigrants, ethnic food shops, pushcarts, and buzzing streetlife. After an early flirtation with Abstract Expressionism, Hartigan began studying the work of past masters, from Rubens to Matisse. In 1956 she wrote: "I have found my 'subject'; it concerns that which is vital and vulgar in American life, and the possibilities of its transcendence into the beautiful." By that time she was recognized as a leading member of a new generation of painters — including Larry Rivers, Bob Thompson, and Lester Johnson — who adapted Abstract Expressionist techniques to figurative themes.

☛ Frankenthaler, Gorky, Krasner, B. Thompson

Grace Hartigan. b Newark, NJ, 1922. **Billboard.** 1957. Oil on canvas. **h**78¹/₂ x **w**87 in. **h**199.4 x **w**231 cm. The Minneapolis Institute of Arts, Minneapolis, MN.

Hartley Marsden

The Iron Cross

Elements of military decorations, uniforms, and banners — including the black cross at top — are combined in a symbolic homage to the German army officer Karl von Freyburg, an early casualty of World War I, to whom Hartley had a deep romantic attachment. Hartley traveled to Europe in 1912 and quickly developed a distinctive style that synthesized aspects of Cubism and Wassily Kandinsky's Expressionism.

Although he spent time in Paris and Munich, it was Berlin's military pageantry and homosexual subculture that attracted Hartley, but the war forced him to return to the United States in 1916. A protégé of Alfred Stieglitz and one of America's foremost Modernists, Hartley suffered frequent bouts of depression and often despaired of finding a place in the art world in spite of Stieglitz's steadfast support. He

traveled widely throughout his career, and his later paintings — landscapes, still lifes, and idealized portraits — are alternately elegiac, somber, and mystical.

☞ Davis, Delaney, Hartigan, Weber

Edmund (Marsden) Hartley. b Lewiston, ME, 1877. d Ellsworth, ME, 1943. **The Iron Cross**. 1915. Oil on canvas. **h**47¼ x **w**47¼ in. **h**120.1 x **w**120.1 cm. Washington University Gallery of Art, St. Louis, MO.

Hassam Childe

Allies Day, May 1917

The red, white, and blue of the national flags of the United States, England, and France are the brightest color notes in this unusual bird's-eye view of New York's Fifth Avenue. *Allies Day, May 1917* is one of an important group of "Flag" paintings that records Hassam's response to the pictorial potential of the patriotic displays that lined the avenue in celebration of the recently formed alliance which occasioned the United States' entry into World War I. The stirring subject allowed for a decorative realism that particularly suited Hassam's Impressionist style and recalls the painter's earlier depictions of Paris on Bastille Day from the late 1880s. These, in turn, found precedent in Claude Monet's 1878 depictions of the flag-draped city for the national holiday. Hassam believed in the enduring artistic and national importance of his Flag series and exhibited the group (in whole and in part) several times.

☛ Metcalf, Tarbell, Twachtman, J. A. Weir

Frederick Childe Hassam. b Dorchester, MA, 1859. **d** East Hampton, Long Island, NY, 1935. **Allies Day, May 1917.** 1917. Oil on canvas. **h**36½ x **w**30¼ in. **h**92.7 x **w**76.8 cm. National Gallery of Art, Washington, D.C.

Hathaway Rufus

Lady with Her Pets (Molly Wales Fobes)

Among the most fantastic and appealing of all eighteenth-century portraits is this one, showing a woman surrounded by a curious menagerie of birds, butterflies, and a cat. Thought to be identified as eighteen-year-old Molly Fobes, a minister's daughter, the sitter is fashionably dressed in a gown and fichu, and wears her frizzed and powdered hair *à l'hérisson,* or "like a hedgehog." She also sports a

modish hat — but whether Miss Fobes splayed its black and white ostrich feathers for fashion's sake, or the artist did so for compositional effect, we cannot know. This strangely emblematic portrait is probably Hathaway's first; it is also his most distinctive. Nothing is known of Hathaway's training, but by 1790 he was painting portraits in southern Massachusetts. After five years of itinerancy

Hathaway married. Apparently at his father-in-law's suggestion, he took up the study of medicine and became a physician, painting only a few works after 1795.

Benson, J. Kühn, Wood, Williams

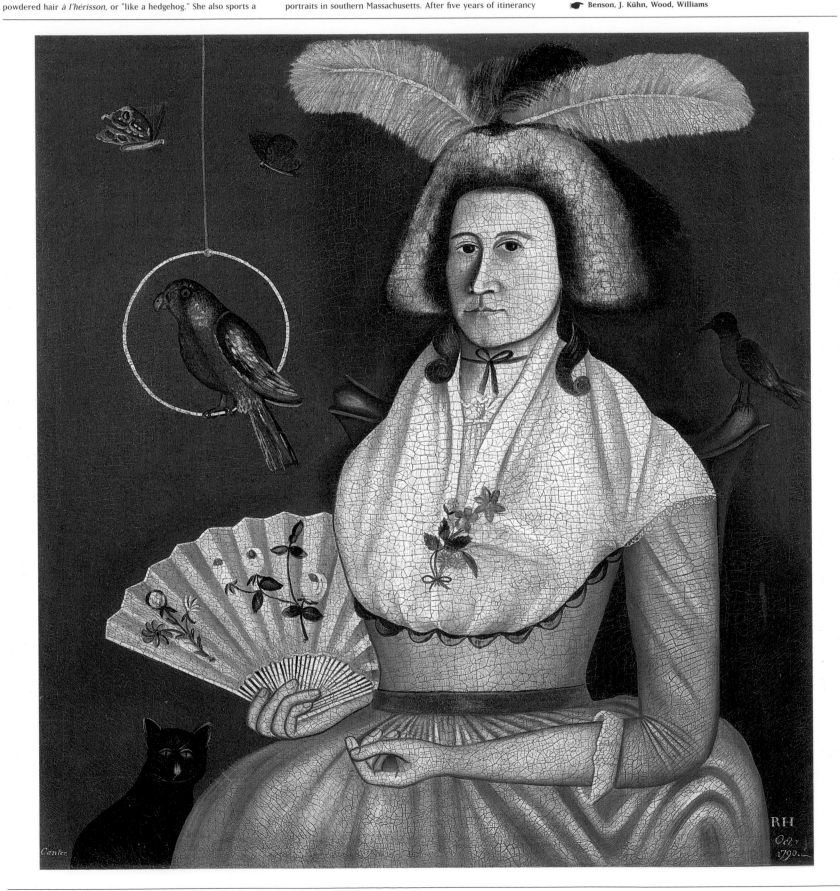

192

Rufus Hathaway. b Freetown, MA, 1770. d Duxbury, MA, 1822. **Lady with Her Pets (Molly Wales Fobes)**. 1790. Oil on canvas. **h**34¼ x **w**32 in. **h**87 x **w**81.3 cm. The Metropolitan Museum of Art, New York, NY.

Hawthorne Charles

Three Women of Provincetown

The alert but impassive expressions of three elderly women are magnetic in their psychological impact. Despite the absence of overt interaction between these women, their arms form a chain of subtle junctures of physical contact, thus insinuating an intimacy nurtured through decades of common experience. Hawthorne, who had conducted his Cape Cod School of Art in Provincetown,

Massachusetts, since 1899, surely knew his sitters as individuals. Yet his aims went beyond portraiture — he intended his picture to be emblematic of the stoic dignity that he associated with the small hard-working New England community as a whole. By the early 1920s, Hawthorne had mastered various styles ranging from a bright, plein-air approach to landscape to the dark, somber mode

established here. In all likelihood this work was inspired by the seventeenth-century masterpiece by Dutch/Flemish painter Frans Hals, *Lady Governors of the Old Men's Home of Haarlem*, which Hawthorne admired greatly.

☞ Disfarmer, Eggleston, W. Kuhn, Wood

Charles Webster Hawthorne. b Lodi, IL, 1872. **d** Baltimore, MD, 1930. **Three Women of Provincetown.** c1921. Oil on board. **h**40 x **w**60 in. **h**121.9 x **w**152.4 cm. Mead Art Museum, Amherst College, Amherst, MA.

Hayden Palmer

Christmas

Cradling his sleeping infant tenderly in his arms, a father reflects on the miracle of birth. The decorated tree and wrapped gifts tell us it is Christmas, while the religious significance of the holiday is more subtly suggested by the swaddled newborn child. Hayden is best known for his scenes of African-American life, and he spent his formative years in New York during the Harlem Renaissance. On his return from

Paris, where he studied and worked from 1927 until 1932, he moved from a Post-Impressionist style to one dominated by flat, posterlike forms. Inspired by folk art, Hayden believed his "consciously naïve" style was best suited to his genre subjects, but he was criticized by his fellow African-Americans for portraying stereotypes. By the late 1930s, after eight years on the Works Progress Administration

(WPA) Federal Art Project, he had returned to the more naturalistic approach he used in this canvas.

☛ Bearden, Cassatt, de Forest Brush, Tanner

194

Palmer Hayden (Peyton Cole Hedgeman). b Widewater, VA, 1890. **d** New York, NY, 1973. **Christmas.** 1939–40. Oil on canvas. **h**27 x **w**34¾ in. **h**68.6 x **w**88.3 cm. Private collection.

Heade Martin Johnson

The Hummingbirds and Two Varieties of Orchids

Seen against the foil of distant mountains and a lowering sky, this tropical microcosm takes on gigantic proportions that lend the painting a bizarre sensibility. The serpentine stems of these robust orchids seem almost capable of independent movement. On the left, two hummingbirds flutter amid trailing vines, the imagined palpitations of their wings adding a vibratory intensity to this scene. Heade's wanderlust took him far from his rural Pennsylvania roots. He visited Europe twice and South and Central America several times, and lived in numerous American cities. He finally settled in New York City, where he stayed from 1866 to 1881. After 1870, he concentrated on images of exotic flora and fauna, which, although they seem scientific in their approach, are really composite inventions. Heade's focus on the orchid was unique among his contemporaries, and it may be that the flower's association with erotic desire excluded it from the visual vocabulary of the time.

☛ Bates, Cunningham, O'Keeffe, J. Stella

195

Martin Johnson Heade. b Lumberville, PA, 1819. d St. Augustine, FL, 1904. **The Hummingbirds and Two Varieties of Orchids.** After 1870. Oil on canvas. h18 x w12 in. h45.7 x w30.5 cm. Private collection.

Healy George P. A. John Tyler

An elderly man of statesmanlike bearing stares absently, as if considering what he has just read in the crumpled newspaper he holds. The documents on the table beside him and the masthead of the paper help to identify the sitter, John Tyler, for they refer to his problematic term as tenth president of the United States. The newspaper, the *National Intelligencer*, consistently criticized Tyler because after being elected he broke with the political platform of his predecessor, Whig party member William Henry Harrison. Healy had attained international acclaim for his portraits of European royalty, officials, and high society, and he enjoyed the patronage of King Louis Philippe of France. Healy had painted Tyler once before. This time, however, his aim was not only to paint a likeness of Tyler in his retirement, but also to create a sympathetic image justifying Tyler's actions during his beleaguered presidency.

☞ Chandler, Hubard, Jarvis

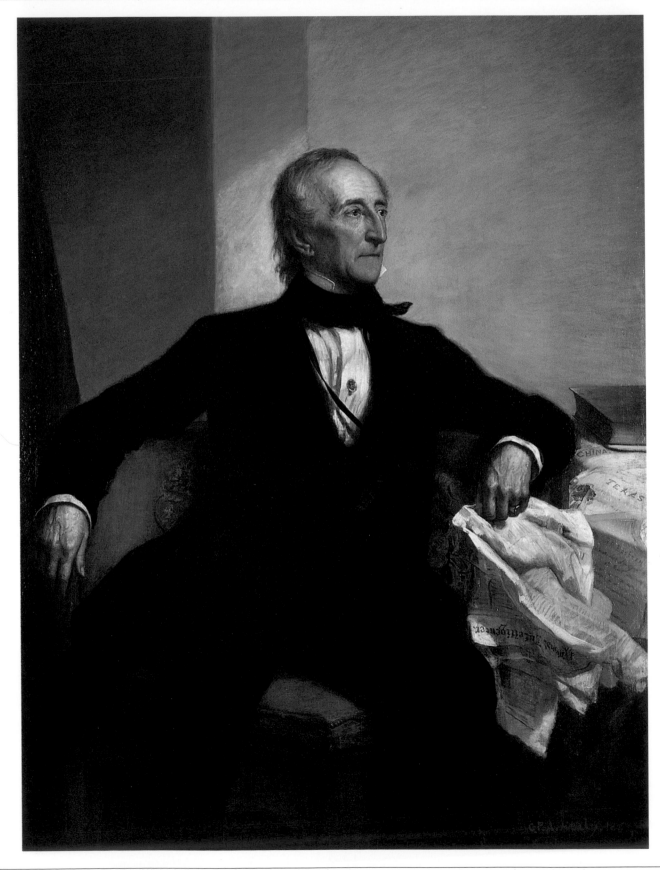

George Peter Alexander Healy. **b** Boston, MA, 1813. **d** Chicago, IL, 1894. **John Tyler.** 1859. Oil on canvas. **h**62 x **w**47¹/8 in. **h**157.6 x **w**119.8 cm. The White House, Washington, D.C.

Heizer Michael

Double Negative

A fifty-foot-deep, thirty-foot-wide cut — or better, "line" — in the sand runs one-third of a mile along the Mormon Mesa in Nevada, forming a pioneering piece of site-specific art. Heizer's medium was the very earth itself, and he created *Double Negative* by "carving" into the desert with bulldozers, removing one-quarter million tons of rhyolite and sandstone from the ground. A small canyon interrupts the cut, so two sections of the line face each other across a gap. In the mid-1960s Michael Heizer reinvigorated, if not revolutionized, the genre of nineteenth-century Western landscape. The artist grew up in a family of geologists and archeologists in Northern California and Nevada, deeply fascinated with the massive art projects of ancient cultures. *Double Negative* is a homage to such ritualistic art and marks a new genre — Land Art — that arose in the 1960s in response to the traditional gallery and museum system and involved artists altering the topography of a specific natural site.

☛ De Maria, Judd, A. J. Russell, Smithson

197

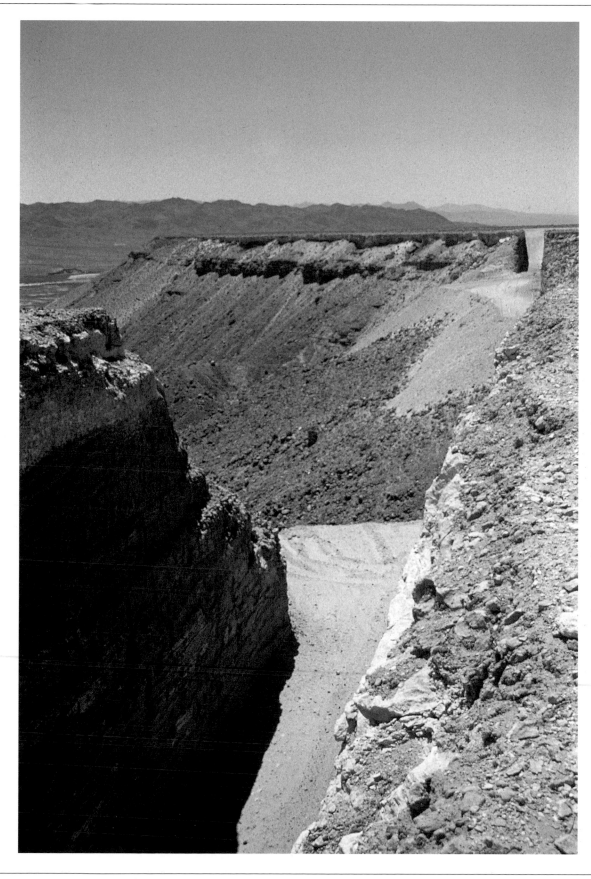

Michael Heizer. **b** Berkeley, CA, 1944. **Double Negative.** 1969. 240,000-ton displacement. l1,500 x w40 x d30 ft. l974.5 x w12.2 x d9.1 m. Mormon Mesa, Overton, NV.

Henderson Frank

Medicine Vision

A spiritual being astride a stunning blue horse radiates energy down to the figure at the bottom of the page. This ledger drawing depicts a Native American from the Arapaho nation receiving divine guidance, or medicine, through a dream. The artist has dramatically confined the colorful vision to the top half of the page, using the page's seam as a divider between sacred and secular worlds. The ledger drawing tradition among the Plains Indians began in the mid-nineteenth century, when military personnel, traders, and other Western explorers exposed Native American communities to paper via their inventory books. In these ledgers, Native Americans recorded special events, much in the way they had previously decorated the hides of shields and tipis. Frank Henderson, a young Arapaho, presented this ledger book of drawings to an elderly resident of the Pennsylvania town in which he was residing in 1882. The work of several artists appears in the ledger, and while this drawing is by the book's dominant hand, one can only assume it is Henderson's own.

☞ **Curtis, Reed, Traylor, Yoakum**

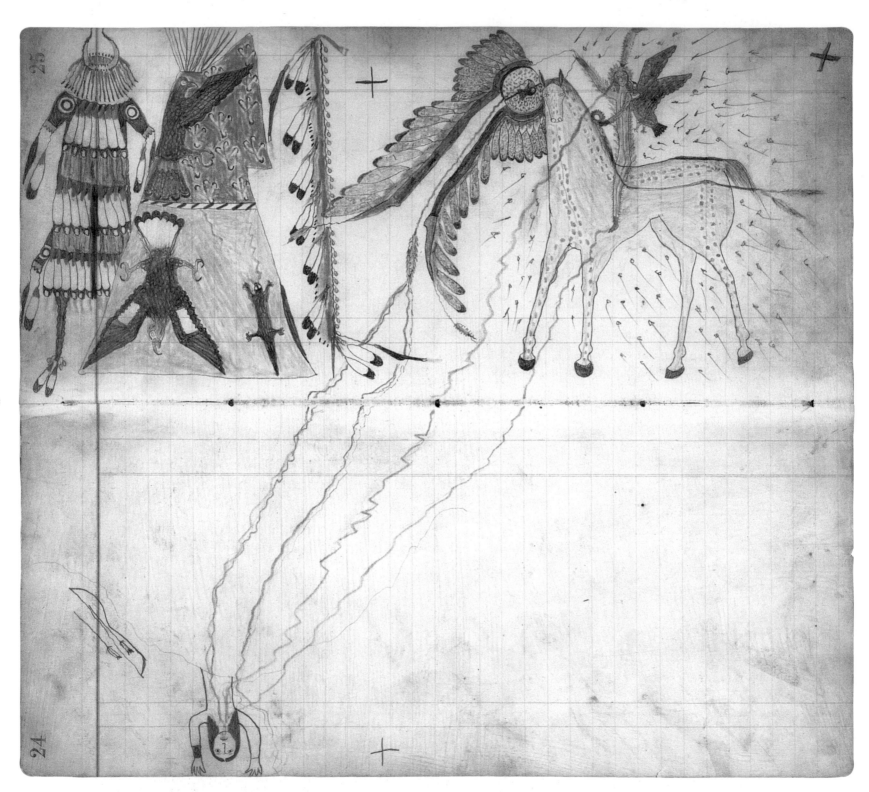

198

Frank Henderson. **b** (location unknown), 1862. **d** Carlisle, PA, 1885. **Medicine Vision.** 1882. Pencil, colored pencil, and ink on paper. **h**15¹/₂ x **w**24 in. **h**39.4 x **w**61 cm. Private collection.

Henri Robert

Eva Green

Thick, precise brushstrokes define a young girl's skin, molding her lips and cheeks and creating a rich surface texture. The skin as well as the enigmatic, knowing expression of this young African-American girl are precisely the focus of this portrait. Painting at a time when African-Americans were more likely to be represented by (and in) blackface, Henri challenged the artifice of stereotype with a realistic, dignified style that gave rise to the first radical American art movement of the twentieth century. The year after Henri painted this portrait of Eva Green, the group of artists later known as The Eight — most of whom had been Henri's students in Pennsylvania and New York — held a legendary and controversial exhibition at the Macbeth Galleries in New York City. Reacting to what they perceived as the stilted academic policies of the National Academy of Design, these artists presented realistic paintings of urban, working-class New York, initiating a movement that came to be known as the Ash Can School.

☛ Blythe, Duveneck, Hine, Savage

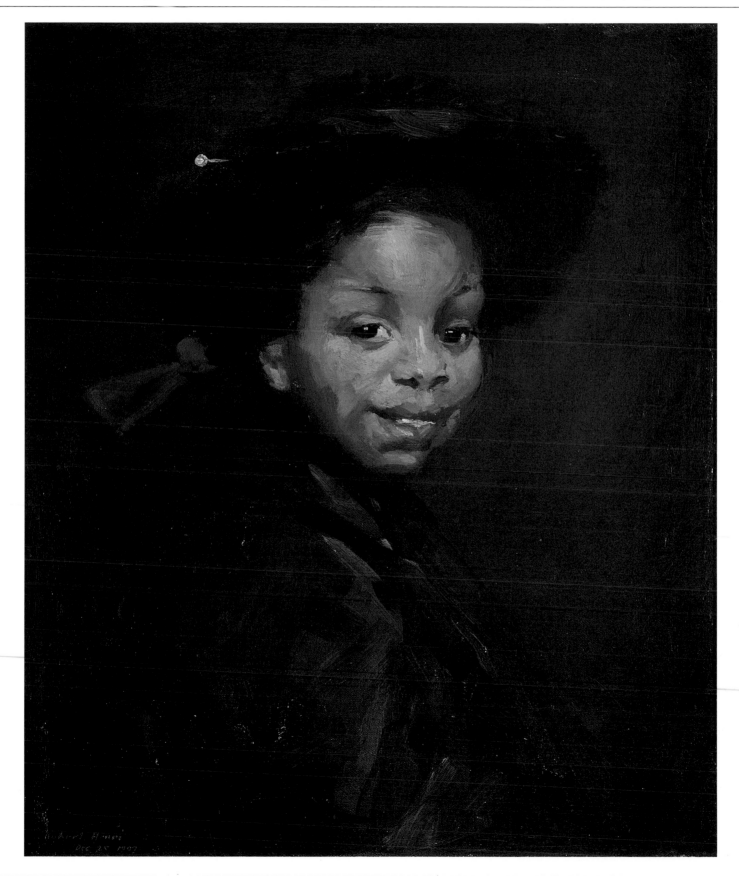

Robert Henri (Robert Henry Cozad). b Cincinnati, OH, 1865. **d** New York, NY, 1929. **Eva Green.** 1907. Oil on canvas. **h**24⅛ x **w**20¼ in. **h**61.3 x **w**51.5 cm. Wichita Art Museum, Wichita, KS.

Hesse Eva

Expanded Expansion

A series of rubberized cheesecloth (also known as latex) panels is suspended accordian-like between sixteen fiberglass poles. The work can be expanded to as long as thirty feet, or compressed to the width of one ten-foot-high panel, thus emphasizing flexibility and impermanent form over the mass and volume traditionally associated with monumental sculpture. A leading figure of Process Art, which focuses on the process of making art rather than on the finished form, Hesse emphasized the fragility of latex (which decomposes over time) in all of her work. Jasper Johns once said of Hesse's sensuous yet abstract sculptures: "Everything was for the process — a moment in time, not meant to last." Johns's statement is sadly applicable to Hesse's short career, which ended abruptly in 1970 when Hesse died of a brain tumor at the age of thirty-four. Her choice of themes and materials reflected concerns central to feminist art and aesthetics of the 1960s and 1970s, and her legacy was important to the Women's Movement of that time.

☞ Gonzalez-Torres, Lewitt, Morris, Strand

200

Eva Hesse. **b** Hamburg, Germany, 1936. **d** New York, NY, 1970. **Expanded Expansion.** 1969. Fiberglass and rubberized cheesecloth. 3-pole unit: **h**122 x **w**60 in. **h**310 x **w**152.4 cm. The Solomon R. Guggenheim Museum, New York, NY.

Hesselius Gustavus Lapowinsa

Dressed in a cloak and squirrel-skin pouch, his face and neck ornamented with black pigments, Lapowinsa bears an impenetrable expression that seems to mix weariness, sorrow, and concern. The aged man was the principal orator among the Delaware chiefs who negotiated the 1737 Walking Purchase Treaty with the proprietors of the Pennsylvania colony. Although the settlers cheated the Delaware, sending a runner to mark off a land parcel that the Indians expected a walker to define, proprietor John Penn evidently respected their chiefs enough to commission this portrait from Hesselius. Trained in Sweden, Hesselius painted religious and decorative scenes in the colonies, as well as candid portraits. He was said to do special justice to men and "their blemishes, which he never fails shewing in the fullest light." The objectivity with which he painted Lapowinsa, however, was unusually sensitive for its time, when Native Americans were generally portrayed as types or curiosities.

☛ Curtis, Durham, Inman, J. Kane

201

Gustavus Hesselius. b Falun, Sweden, 1682. **d** Philadelphia, PA, 1755. **Lapowinsa.** 1735. Oil on canvas. **h**33 x **w**25 in. **h**83.9 x **w**63.5 cm. The Historical Society of Pennsylvania, Philadelphia, PA.

Hicks Edward

Peaceable Kingdom

This remarkable menagerie illustrates the Biblical prophet Isaiah's vision of a harmonious world under the dominion of the Messiah. Hicks is faithful to the prophet's words, showing us "the calf and the young lion . . . together" as well as the "little child [who] shall lead them." Hicks has placed a secular scene in the distance: William Penn is depicted purchasing the land that will become Pennsylvania from the Lenape Indians. This juxtaposition suggests the New World is a terrestrial parallel, a kind of worldly "Peaceable Kingdom." Hicks began his career as a sign painter, and his style was never fully free from naïve traits, such as the lion's two-dimensional profile in this work. He was also a celebrated Quaker minister, and the proximity of ox and lion here may indicate his moral belief in the nature of human disposition. The lion stands for an untamed savage state, and the benign ox represents the gentle spirit attained by yielding to divine will. Hicks created over sixty Peaceable Kingdoms, each a different meditation on the same theme.

☞ **Chambers, Finster, Hofmann, Tolson**

Edward Hicks. b Bucks County, PA, 1780. **d** Langhorne, PA, 1849. **Peaceable Kingdom.** c1830–35. Oil on canvas. **h**30¹⁄8 x **w**34¹⁄2 in. **h**76.6 x **w**86.7 cm. New York State Historical Association, Cooperstown, NY.

202

Hill Gary

Viewer

In this arresting, life-sized video installation, seventeen men emerge from darkness, shifting on their feet and staring straight ahead. *Viewer* is really a collage of video images that are seamlessly combined into one enormous tableau projected onto a gallery wall. When displayed, this mute "audience" seems to stare straight back at gallery-goers, effectively turning the table on the way art objects are traditionally viewed. None of the men is Caucasian, and all of them are dressed in workingman's garb. *Viewer* is partly a comment on the stereotypical racial makeup of art audiences and on the societal privilege implied by the owning and beholding of art objects. Hill's installation is also a more general treatise on seeing and being seen. He is celebrated for his innovations in and technical mastery of the video medium, and since the early 1970s his art has referenced the writings of social and literary theorists.

 Friedlander, W. Kuhn, Nauman, Viola

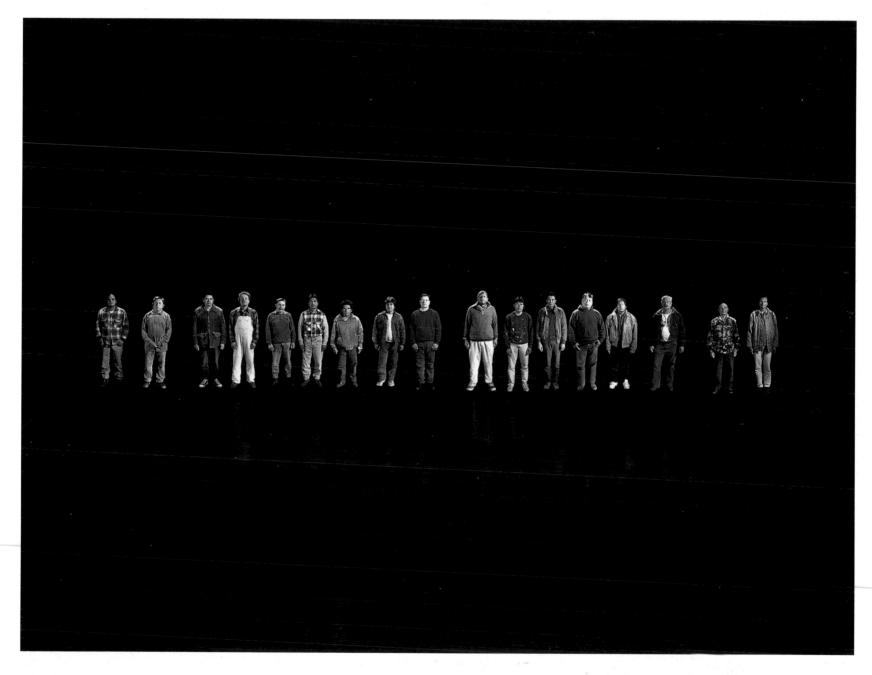

203

Gary Hill. b Santa Monica, CA, 1951. **Viewer.** 1996. Five-channel video installation. Five laserdisc players, five projectors, five-channel synchronizer. Donald Young Gallery, Chicago, IL.

Hill Thomas

Bridal Veil Falls, Yosemite

A Native American woman carrying her papoose stands alone on the flat stretch of land leading to the western entrance of California's famed Yosemite Valley. She is dwarfed by the sublime majesty of El Capitan, the peak that rises on the left, and by the landmark Bridal Veil (now Bridalveil) Falls on the right. The presence of the Native American encampment lends nostalgia to the scene, given that

Yosemite's original inhabitants, the Southern Sierra Miwok tribe, had been driven from this land years earlier. By the time Hill painted this monumental canvas, Yosemite had long been a tourist attraction. Hill's many paintings of this site held special appeal for wealthy Californians and foreign visitors who acquired them as extravagant souvenirs of their travels. Hill's reputation was virtually inseparable

from Yosemite, as was his livelihood, and in 1886 he established a permanent studio in nearby Wawona. Near the close of his career, he was characterized as the "most ardent devotee at the shrine of Yosemite and the most faithful priest of the valley."

☛ Bierstadt, Jewett, O'Sullivan, Watkins

204

Thomas Hill. b Birmingham, United Kingdom, 1829. **d** Raymond, CA, 1908. **Bridal Veil Falls, Yosemite.** c1870–84. Oil on canvas. **h**72 x **w**95 in. **h**183 x **w**241.4 cm. The Butler Institute of American Art, Youngstown, OH.

Hine Lewis

Breaker boys in coal chute, South Pittston, Pennsylvania, January, 1911

The dusty noses and mouths of these smudge-faced children, called "breaker boys," clearly suggest the hazards and misery of most child labor at the beginning of the century. Breaker boys separated freshly broken chunks of coal from unwanted pieces of slate — a job they performed twelve hours a day, six days a week, for a salary of 75 cents a day. Hine, a social reformer who worked for the National Child Labor Committee from 1911 to 1916, wanted Americans to witness this grueling hardship. Hine was trained as a sociologist and took up photography as an aid in documenting living and labor conditions in need of change. In the cause of child labor he was successful: His photographs were instrumental in persuading states to enforce often-overlooked laws restricting the use of children in the labor force.

Although he challenged the often-exploitative practices of the industrial era, Hine was not opposed to industrial progress. In the early 1930s he photographed the construction of the Empire State Building, making the workers appear as monumental as the structure itself.

☛ Anschutz, Blythe, Duveneck, Savage

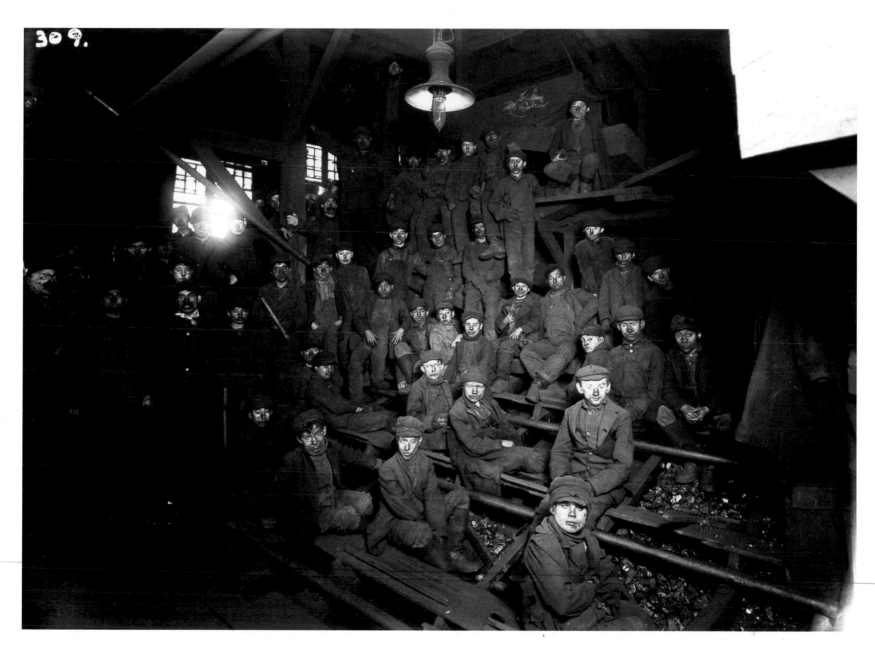

205

Lewis Wickes Hine. b Oshkosh, WI, 1874. d Hastings-on-the-Hudson, NY, 1940. **Breaker boys in coal chute, South Pittston, Pennsylvania, January, 1911.** Gelatin silver print. George Eastman House, Rochester, NY.

Hirshfield Morris

Nude with Cupids

This nude parts an elaborate curtain to reveal her idealized form. Her tranquil expression adds to her majesty as flowers bloom at her feet and cherubs flutter nearby. Hirshfield has created a memorable painting by juxtaposing his subject's stark silhouette against the drapery's intricate designs. Hirshfield emigrated from Eastern Europe at eighteen and began a long career as a tailor and manufacturer of women's slippers in New York City. On retiring, he began painting, often incorporating his affinity for fabrics and elaborate patterning in his art. Hirshfield was soon one of this century's most celebrated naïve painters. Here, his self-taught technique is evident in the way he depicts his subject's feet pointing to the left while her torso directly faces her admirers. While such details may deviate from reality, they are at home in this fanciful composition.

☛ Aragon, Bellocq, Hansen, Lachaise

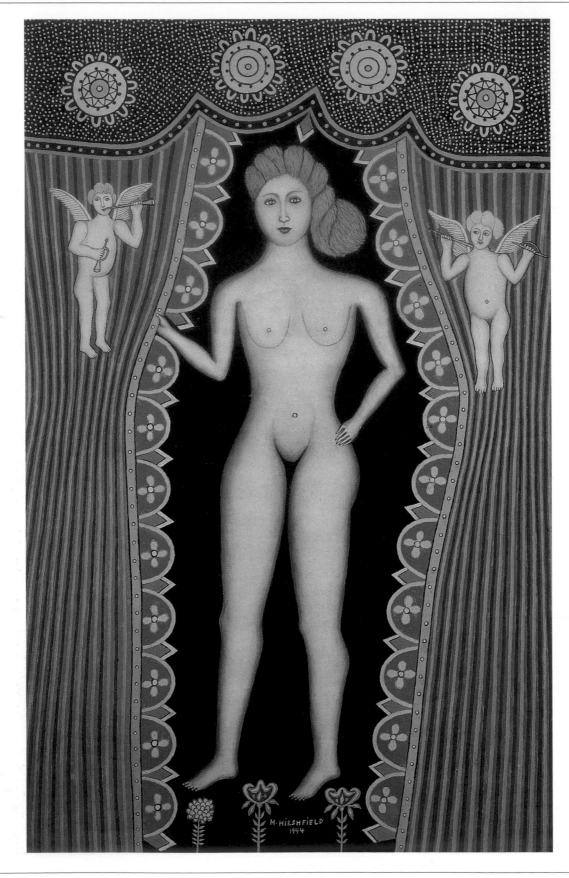

Morris Hirshfield. b Poland, 1872. d Brooklyn, NY, 1946. Nude with Cupids. 1944. Oil on canvas. h50 x w34½ in. h127.1 x w87.7 cm. Sidney Janis Gallery, New York, NY.

Hockney David

California Bank

An anonymous office building stands alone, disconnected from anything around it except a phalanx of thin, abstracted palm trees and three boulder-like hedges guarding the foreground. Hockney has rendered this quintessential Southern California scene at its most simple: A grid of blue and gray rectangles represents the glass-and-concrete bank building, while a neutral background extending to the

picture frame suggests endless space. Painted in 1964, this is the first of many portraits of California buildings that Hockney created. With their minimalist shapes and absence of detail, these paintings recall the sense of expansiveness and newness that captivated Hockney on his first visit to California in 1963. After settling in Los Angeles, he focused on depicting his adopted homeland, and in 1967 he painted a series of

swimming pool and lawn and sprinkler canvases that are among his greatest achievements. Photography has played an important role in his work, and he has based later paintings on large photographic studies and photocollages.

☛ Demuth, Morgan, Ruscha, N. Spencer, Steinberg

David Hockney. b Bradford, United Kingdom, 1937. **California Bank.** 1964. Acrylic on canvas. **h**30 x **w**25 in. **h**76.24 x **w**63.53 cm. Private collection.

Hofmann Charles C.

View of Henry Z. Van Reed's Farm, Papermill and Surroundings

Bright colors and crisp lines characterize this landscape, where the rewards of productive industry are implied by white houses, orderly fields, and clean roads. Smoke from the papermill blends into the hazy clouds above, suggesting a natural order even to the industrial site. Van Reed apparently paid Hofmann five dollars and a quart of whisky for this painting of his farm, then commissioned four

additional versions to be paid in the same currencies. Not surprisingly, the artist committed himself to the Berks County Almshouse for "intemperance" three weeks after this painting's date. Such poorhouses recurringly sheltered Hofmann throughout his career, and the artist is best known for his clear and vibrant depictions of these institutions. Little is known of the German-born Hofmann's

background, although his decorative inscriptions and bird's-eye compositions, as well as the word "lithograph" that follows his signature on an 1865 painting, suggest prior experience or sporadic employment in the graphic arts.

☞ Guy, Moses, Seifert, S.F.W. Williams

208

Charles C. Hofmann. b (city unknown), Germany, c1821. **d** Berks County, PA, 1882. **View of Henry Z. Van Reed's Farm, Papermill and Surroundings.** 1872. Oil on canvas. **h**39 x **w**54½ in. **h**99.1 x **w**138.4 cm. Abby Aldrich Rockefeller Folk Art Center, Williamsburg, VA.

Hogue Alexandre

Drouth Stricken Area

Under a cloudless sky that promises no rain, windswept sand literally engulfs a deserted homestead and its empty water tank. A patient vulture awaits the death of the last remaining cow. The effects of the prolonged drought that devastated Midwestern farmlands during the 1930s, including erosion that resulted in sculptural land formations, held a particular interest for Hogue. He was attracted to the formal properties of the blighted terrain, shown here in the shadowed dunes and the raked appearance of the sand. For him, drought was paradoxically "beautiful in its effects and terrifying in its results." Other Regionalist painters, among them John Steuart Curry, depicted the landscape ravaged by severe weather conditions, but Hogue made the Dust Bowl his special subject. Although essentially an apolitical artist, he implicitly criticized the farming practices that caused land depletion, describing his Dust Bowl series as "a scathing denunciation of man's persistent mistakes."

☛ Benton, Brook, Gropper, Gwathmey

209

Alexandre Hogue. b Memphis, MO, 1898. **d** Tulsa, OK, 1994. **Drouth Stricken Area.** 1934. Oil on canvas. **h**30 x **w**42¼ in. **h**76.2 x **w**107.4 cm. Dallas Museum of Art, Dallas, TX.

Holzer Jenny

Various texts

The distinctive spiral ramps of New York's Solomon R. Guggenheim Museum are covered with electronic LED signs, flashing statements such as "Men are not monogamous by nature" and "You are a victim of the rules you live by." These illuminated messages formed part of a retrospective exhibition of Holzer's work since 1979, a 105-minute program of almost three hundred excerpts from series including

"Truisms," "Inflammatory Essays," and "Laments." Holzer's short declarative sentences began as anonymous and enigmatic photocopied posters stapled to New York telephone poles. As the art world took notice in the 1980s, her increasingly more politicized work appeared on bronze memorial plaques, t-shirts, and subway message boards. Her works lie somewhere between street poetry and avant-garde

advertising. Not quite accusatory but chiding in a backhanded way, they reflect common wisdom back at us, sometimes revealing that it may not be so very wise at all.

☛ Horn, Kruger, Weiner, Wool

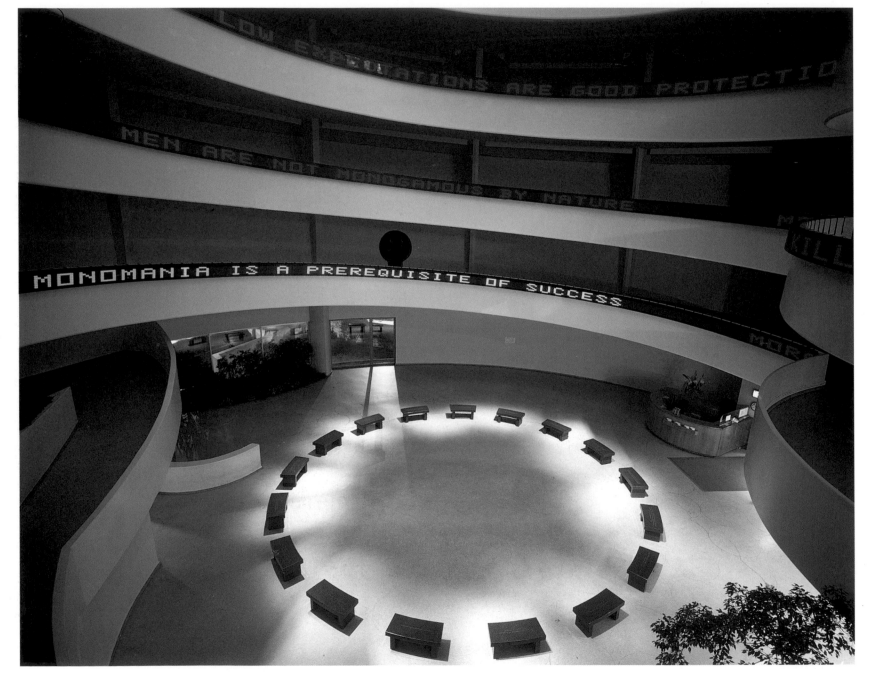

210

Jenny Holzer. b Gallipolis, OH, 1950. **Various texts.** Extended helical tricolor LED signboard; 17 Indian Red granite benches. Sign: **l**513 ft. **l**156.45 m; benches **l**42 x **w**18 x **h**17 in. **h**106.7 x **w**45.7 x **d**43.2 cm. As installed at the Solomon R. Guggenheim Museum, New York, NY, Dec. 12, 1989–Feb. 25, 1990.

Homer Winslow

Gloucester Farm

Bright sunlight brings a scowl to the face of the young woman who waits for the return of the cup from the farm worker who refreshes himself with the milk or water from her bucket. In contrast to the youth's relaxed attitude, she strains under the weight she holds and adopts an ungainly stance to counterbalance her load. This is one of a number of works depicting farm life that Homer painted during the 1870s. Although they are often viewed as forthright statements in praise of simple, national values, Homer's tendency to insert subtle tensions (as established here between the two figures) opens the way for more complex interpretations. One of America's greatest painters, Homer enjoyed a long career which may be traced from his beginnings as an illustrator to the final seascapes for which he is so well known, oils that capture the majesty of the Atlantic coast near his isolated Prout's Neck, Maine, studio.

☛ Fischl, E. Johnson, J. Thompson, Vonnoh

Winslow Homer. b Boston, MA, 1836. **d** Prout's Neck, ME, 1910. **Gloucester Farm.** 1874. Oil on canvas. **h**20¾ x **w**30⅛ in. **h**52.7 x **w**76.6 cm. Philadelphia Museum of Art, Philadelphia, PA.

Hopkins M. W.

Pierrepont Edward Lacey (1832–after 1860) and His Dog, Gun

A boy stands close to an enormous dog, Gun, who is portrayed almost as distinctly as his young master. Lacey's calm demeanor and relaxed grip on the dog's chain suggest trust in a well-trained animal. Gun was perhaps a favorite of the Lacey family, who raised mastiffs in a western New York town within Hopkins's painting circuit. Hopkins began painting portraits around 1830, having previously

worked as a farmer, glazer, chairmaker, sign painter, canal boat captain, and instructor in theorem painting. Without formal art training, he acquired the means to create credible likenesses and attractive designs on canvas. His talents appealed to rural patrons in New York and later Ohio, and drew at least one pupil, Noah North, to his studio. North and Hopkins painted in similar styles, and shared

politics, patron types, and working locales. Only recently have their oeuvres been distinguished; for many years this portrait was attributed to North.

☞ J. Johnson, J. Kühn, Lundeberg, Prior

Attributed to **Milton William Hopkins. b** Harwinton, CT, 1789. **d** Williamsburgh, OH, 1844. **Pierrepont Edward Lacey (1832–after 1860) and His Dog, Gun.** c1835–36. Oil on canvas. **h**42 x **w**30⅛ in. **h**106.7 x **w**76.6 cm. University of Rochester Memorial Art Gallery, Rochester, NY.

Hopper Edward

Automat

A bold rectangle of darkness dotted by two lines of reflected ceiling fixtures frames a lone woman as she sips her evening coffee in a deserted Automat, legs pressed demurely beneath the circular table. Stark and geometric, yet hauntingly real, the figure of the woman is utterly contained by the environment, a mere fixture in the space. This work can be understood best as a painting about urban isolation rather than about individual psychology. Hopper's style had little to do with either the Realist school in America at the beginning of the century or European Modernism. In 1927 he suggested that American art should remain independent of French influences, just as later he would remain distant from American Abstract Expressionism. It is precisely this stubborn reliance on an aesthetic of his own device that has made Hopper widely acknowledged as one of the most original American painters of the twentieth century.

☞ Goings, Goldin, Pippin, Segal

213

Edward Hopper. b Nyack, NY, 1882. **d** New York, NY, 1967. **Automat.** 1927. Oil on canvas. **h**28⅛ x **w**36 in. **h**71.5 x **w**91.5 cm. Des Moines Art Center, Des Moines, IA.

Horn Roni

Untitled (Gun)

Twenty-six stacked aluminum cubes enclose black-plastic letters, spelling out a line of poetry: "My life had stood / A loaded gun." Literally backed into a corner, the texts add physical impact to the enigmatic yet ominous-sounding couplet. Horn's art is characterized by a unifying sensibility rather than by a single medium: She has created installations quoting Emily Dickinson and William Blake,

using the same Minimalist letter-cubes; made freehand drawings of simple geometric forms; and published colorful photographic books about her travels to Iceland. Horn, who lives in New York City, sees Iceland as a country that embodies her view of Minimalism as a humanistic, even romantic way of making art — rather than a purely idealistic approach. In her writing, Horn calls Iceland "a landscape

of infinite depth and transparence," a place where nature and its simple forms are respectfully unmediated by the humans who live among them.

☛ Artschwager, Holzer, Judd, Wool

214

Roni Horn. b New York, NY, 1955. **Untitled (Gun).** 1994. Solid aluminum and plastic. 26 units, each: **h**5 x **w**5 in. **h**12.7 x **w**12.7 cm x variable length. Stacked: **h**128 in. **h**325.3 cm. Matthew Marks Gallery, New York, NY.

Hovenden Thomas

Breaking Home Ties

A mother bids her son farewell, as generations of the family mutely attend his departure in the living room of a humble, albeit genteel, home. Although essentially a genre painting, the work's large scale and clear-cut content bring this canvas into the category of history painting. This work depicts the realities of the economic depression of the 1890s, which spurred many young Americans to leave their families for employment in urban centers. Hovenden, whose training in France honed his skills as a figure painter, adapted popular French peasant subject matter to an American vernacular, overlaying it with his taste for sentimental narrative drawn from British art. When shown at the 1893 World's Columbian Exposition, this work won the hearts of viewers. Hovenden's popular treatments of the nobility of simple American life were matched in the circumstances of his death, when he died attempting to save a child from an oncoming train.

☛ Disfarmer, Homer, L. M. Spencer, J. Thompson

Thomas Hovenden. b Dunmanway, Ireland, 1840. **d** Plymouth Meeting, PA, 1895. **Breaking Home Ties.** 1890. Oil on canvas. **h**52⅛ x **w**72¼ in. **h**132.8 x **w**183.6 cm. Philadelphia Museum of Art, Philadelphia, PA.

Hubard William James Horatio Greenough, the American Sculptor, in His Studio in Florence

An alert greyhound rests at the feet of a man whose pose implies sophistication and self-confidence. The two are surrounded by famous Neo-Classical marble sculptures, which help to identify the sitter as the American expatriate sculptor Horatio Greenough. The presence of the dog may at first seem odd in such a portrait, but its inclusion not only reveals a sentimental aspect of Greenough's personality but also refers to his popular 1839 sculpture of his beloved dog, Arno, part of which is visible on the left. The painting is typical of Hubard's portrait style, which was generally restricted to small-scale works showing full-length figures deep within the pictorial space. Hubard managed in this instance to create an unusual and memorable document of Greenough in his studio in Florence, Italy, a popular stop on the itinerary of many American artists on the Grand Tour.

☞ Beaux, Earl, Greenough, Healy

216

William James Hubard. b Whitchurch, United Kingdom, 1807. **d** Richmond, VA, 1862. **Horatio Greenough . . . in His Studio in Florence.** Oil on canvas. c 1839. **h** 39 x **w** 29⅜ in. **h** 99.1 x **w** 74.7 cm. The Valentine Museum, Richmond, VA.

Hunt William Morris

Study for "The Flight of Night"

A partially draped woman sits regally within a crescent moon, the seat of a mystical chariot of clouds drawn across the sky by three magnificent horses. This work, based on a Persian poem about the pagan goddess Anahita, was the study presented to the commission committee for murals at the state capitol in Albany, New York. The pair of murals — *The Flight of Night* and *The Discoverer* — were executed but are now lost from view, obscured by a false ceiling and known to contemporary audiences only through poor photographs or the preparatory drawings and paintings made by the artist. Together, the murals contrasted key phases in civilization, with *The Flight of Night* representing the passing of ancient beliefs into the darkness of night and *The Discoverer* representing the dawning of the Enlightenment as a result of Columbus's discovery of the New World. Hunt established himself in Boston, where he became one of the most influential artist/teachers of his era.

☞ **Deas, Rush, Tack, Vedder**

William Morris Hunt. **b** Brattleboro, VT, 1824. **d** Isle of Shoals, NH, 1879. **Study for "The Flight of Night."** 1878. Oil and chalk on canvas. **h**62 x **w**99 in. **h**157.6 x **w**251.6 cm. The Pennsylvania Academy of the Fine Arts, Philadelphia, PA.

Huntington Daniel Mercy's Dream

A young woman gently swoons in response to the angelic vision hovering above her. The delicate gesture that brings her hand to her breast indicates her receptivity to the spiritual grace transmitted to her through a heavenly messenger. *Mercy's Dream* was one of Huntington's first great successes. Drawing his subject from the immensely popular book *Pilgrim's Progress* by the English puritan cleric John Bunyan, the artist portrayed an episode of the religious allegory in which the dreaming Mercy experiences divine revelation. Huntington was primarily a portraitist and produced more than one thousand portraits over the course of his career. After absorbing the lessons of Renaissance and Baroque art during his first trip to Europe from 1839 to 1841, he turned to historical and religious subjects as well. His long career, which included the presidency of the National Academy of Design (1863 to 1869; 1877 to 1890) reflects the major concerns in American art over a seventy-year period.

☛ **Palmer, Ryder, Tanning, J. Vanderlyn**

218

Daniel Huntington. b New York, NY, 1816. **d** New York, NY, 1906. **Mercy's Dream.** 1841. Oil on canvas. **h**84½ x **w**66½ in. **h**214.7 x **w**169 cm. Pennsylvania Academy of the Fine Arts, Philadelphia, PA.

Indiana Robert

Love

A simple, square composition of the word *love*, with the letter *o* jauntily tipped, is rendered in bright primary colors. Indiana's seemingly innocuous logo is perhaps the most recognized symbol of 1960s America, and the most beloved. Unlike Andy Warhol's equally colorful Pop portraits of soup cans, Indiana's *Love* was embraced almost immediately by the public — from hippies to suburbanites.

The image was reproduced as a US postage stamp with a circulation of 330 million, and it was printed on shag rugs, Christmas cards, and other consumer items. According to Indiana, the original design for *Love* came from the Christian Scientist motto "God is Love" and its colors from a gasoline pump owned by his father. A child of the Depression and a beneficiary of the GI Bill, Indiana has called

himself "a people's painter." His flat graphic technique was inspired by the minimalism of writer Gertrude Stein and painter Josef Albers. *Love* remains Indiana's best-known work.

☞ Holzer, Horn, Kruger, Wool

Robert Indiana. b New Castle, IN, 1928. **Love.** 1966. Oil on canvas. **h**71⅞ x **w**71⅞ in. **h**182.7 x **w**182.7 cm. Indianapolis Museum of Art, IN.

Inman Henry

Sequoyah (after a painting by Charles Bird King)

Seated at a table bearing only a quill pen in a jar of ink, a turbaned man points to characters inscribed on the writing surface he holds. The surrounding objects help to identify this man as the Cherokee tribesman Sequoyah. He earned the Cherokee nation's commendation (signified by the medal he wears) for his invention of the eighty-six-character Cherokee alphabet, which led to the first written form of language among the Native American tribes. The original portrait by Charles Bird King was painted in 1828, when Sequoyah visited Washington, D.C., as member of the Cherokee delegation to the US government, but its fate remains unknown. At that time, King was painting numerous portraits of Indian delegates, many of which were destined for the War Department Indian Gallery, which was destroyed by fire in 1865. Inman began copying King's paintings in 1832, when he became involved in preparing illustrations for the publishing project *The Indian Tribes of North America . . .*, a major study of Native American culture first published from 1836 to 1844.

☞ **Bundy, Hesselius, King, Rembrandt Peale**

220

Henry Inman. b Utica, NY, 1801. **d** New York, NY, 1846. **Sequoyah (after a painting by Charles Bird King).** c1830. Oil on canvas. **h**30⅛ x **w**25 in. **h**76.6 x **w**63.5 cm. National Portrait Gallery, Washington, D.C.

Inness George

Old Farm — Montclair

An almost magical stillness presides over this scene in which a woman stands amid grazing sheep near the outbuildings of a farm. The soft, feathery brushwork used consistently throughout the painting helps to define shapes yet also creates an overall texture suggesting that this small universe of farm life occupies a spiritual as well as a material plane. Seen as if through a gauze of memory, all things, whether animate or inanimate, seem linked. This late work by Inness is a tangible expression of his belief in Swedenborgianism, an inward religious philosophy based on correspondences between the material and spiritual worlds. Inness's early work engaged a Hudson River School style. Later, as he came under the influence of the Barbizon painters, he arrived at a poetic suggestiveness that transmitted the essence of his religious views by elevating even this mundane farm near his Montclair, New Jersey, studio to a transcendent experience.

☞ Metcalf, Rothko, Steichen, Ulmann

221

George Inness. b Newburgh, NY, 1825. **d** Bridge of Alan, Scotland, 1894. **Old Farm—Montclair.** 1893. Oil on canvas. **h**30 x **w**50 in. **h**76.2 x **w**127 cm. The Nelson-Atkins Museum of Art, Kansas City, MO.

Irwin Robert

Untitled

A glowing yellow orb threatens to float into the gallery, bowing out into the viewer's space. This is one of Irwin's "disc paintings," abstract paintings made from convex, vacuum-formed plastic sheets that are bolted so they extend from the wall, creating an aura of color around the periphery of the artwork. As Irwin described the effect: "The Mondrian was no longer on the wall — the viewer was 'in' the Mondrian." Irwin was one of the founders of the "Light and Space" movement, a California-based outgrowth of Minimalism and Conceptualism that emphasized the possibilities of using colored light instead of paint, which led to the eventual dissolving of the physical artwork altogether. Irwin began his career as an Abstract Expressionist painter in the 1950s, eventually shifting to visual environments based purely on manipulated light. His current work includes architectural environments, public commissions, and gardens.

☛ Dove, Flavin, Noland, Turrell

222

Robert Irwin. b Long Beach, CA 1928. **Untitled.** 1965–67. Acrylic automobile lacquers sprayed on prepared, shaped aluminum surface with metal tube, four 150-watt floodlights. **diam:** 60 in. 152.5 cm. Walker Art Center, Minneapolis, MN.

Ives Chauncey B.

Undine Receiving Her Soul

The water nymph, Undine, the subject of a romantic French tale written in 1811, is portrayed in idealized form at the moment she emerges from the sea and reaches heavenward for a soul, a gift she is entitled to through marriage to a mortal. The marvelously illusionistic fabric of her gown clings damply to her, revealing the full suppleness of her body without denying her virtuous character and spiritual yearning. Ives made numerous replicas of this and other idealizing subjects in the Rome studio that he established in 1844 and which became a popular stop for Americans making their European Grand Tour. Ives catered to that trade and was a prominent figure in the community of American expatriate artists. To ensure payment by his transient patrons, he would tag unclaimed commissions displayed in his studio with the names of errant commissioners and the amounts they owed.

☛ Bishop, Fuller, Palmer, Rush

223

Chauncey Bradley Ives. b Hamden, CT, 1810. d Rome, Italy, 1894. **Undine Receiving Her Soul.** c1855. White marble. h61 in. h155 cm. Yale University Art Gallery, New Haven, CT.

Jackson William Henry

Berthoud Pass Looking North, Colorado

Unlike many nineteenth-century photographs of the American West, which show a landscape as remote and forbidding to humans as the surface of the moon, this picture depicts a prototypical frontiersman in his element. The fact that he is alert and poised with his rifle ready suggests that these mountains were not entirely benign, although they have an undeniable scenic beauty. The frontiersman is also dwarfed by the rugged peaks, a symbolic indication that man had not yet conquered this part of the country. Jackson was one of the leading exploration photographers of his day, working for the Hayden survey of the Rocky Mountains as well as for the Union Pacific Railroad and other lines. The rifleman is Harry Yount, who became the first ranger of Yellowstone National Park. Jackson's photographs of Yellowstone's outstanding geological features, including the geyser Old Faithful and Mammoth Hot Springs, were instrumental in Congress's decision to create the park in 1872.

☛ Doughty, T. Hill, Jewett, A. J. Russell

224

William Henry Jackson. b Keesville, NY, 1843. **d** New York, NY, 1942. **Berthoud Pass Looking North, Colorado.** 1874. Albumen print. George Eastman House, Rochester, NY.

Jarvis John Wesley

Portrait of Captain Samuel C. Reid

A young man strikes a heroic pose, gripping his sword in his right hand to signal his readiness for conflict and grasping a speaking trumpet in his left to amplify the orders he will shout to the men in his command during the War of 1812. The prominent flag at the upper right coincidentally foreshadows the continuing relationship of artist and sitter, in that Jarvis produced the model for Reid's design for the standard version of the American flag, which was approved by Congress in 1818. This portrait of Samuel Chester Reid, in reality a privateersman hired by the US Navy, was commissioned a short time after his victorious return to New York. His privateer *General Armstrong* had engaged British ships in battle long enough to delay their arrival in New Orleans, thus aiding Andrew Jackson's successful defense of the Southern port during the War of 1812. Jarvis, who was the premier portraitist in New York at the time, was the likely choice for such a commission. He produced a number of vigorous images of the 1812 heroes for the New York City Hall.

☛ Chandler, Healy, Neagle, C. Peale

225

John Wesley Jarvis. b probably near Newcastle-on-Tyne, United Kingdom, 1780. **d** New York, NY, 1840. **Portrait of Captain Samuel C. Reid.** 1815. Oil on canvas. **h**50½ x **w**36⅜ in. **h**101.6 x **h**92.4 cm. Minneapolis Institute of Arts, Minneapolis, MN.

Jess

Arkadia's Last Resort; or, Féte Champètre up Mnemosyne Creek

As its title indicates, the scene is an outdoor festival celebrating the goddess of memory, Mnemosyne, whose sacred waters nourish a fantastic, Hieronymus Bosch-like environment. Punctuating the collage — with its seemingly random selection of motifs from high art, illustration, and advertising — are jigsaw patterns that symbolize the puzzle structure (and puzzling character) of Jess's Neo-Dada homage to American pop culture. As a scientist disillusioned by the advent of nuclear weapons, he turned to art in the early 1950s as "an antidote to the scientific method." Like the Beat poets with whom he associated in San Francisco, Jess disrupts stability, overthrows logic, and uses rambunctious disorder as an existential weapon in the battle against complacency. Anticipating Pop Art by nearly a decade, he based many of his early collages on comic strips, appropriating an accessible, lightweight vehicle to carry the heavy load of his subversive commentaries.

☛ Berman, Cornell, J. Stella, Wojnarowicz

Jess (Burgess Collins). b Long Beach, CA, 1923. **Arkadia's Last Resort; or, Féte Champètre up Mnemosyne Creek.** 1976. Magazine cutouts and puzzle pieces. **h**47 x **w**71 in. **h**119.4 x **w**180.4 cm. Dallas Museum of Art, Dallas, TX.

Jewett William Smith

The Promised Land — The Grayson Family

This family's relaxed demeanor and dress make them seem strangely out of place on this isolated summit overlooking California's vast Sacramento Valley. Andrew Jackson Grayson, the man pictured here, called on Jewett to paint a "memory" picture of the moment he and his family reached this summit in 1846 after making the difficult trek from Missouri to the "promised land" of California. Together, Jewett and Grayson devised imagery that not only recalled the past but also documented Grayson's successful status in the present — thus explaining the elegant clothing of Grayson's wife and child, and his own odd apparel (buckskins over a starched white shirt and black tie), along with the family's parlor-setting poses. Jewett had also succumbed to the lure of the West, leaving a moderately successful career in New York. Settling in San Francisco, he made his fortune painting pictures of Yosemite for the tourist trade and portraits for the newly rich businessmen of the city.

☞ Jackson, T. Hill, Moran, Stanley

William Smith Jewett. b South Dover, NY, 1812. d Springfield, MA, 1873. **The Promised Land — The Grayson Family.** 1850. Oil on canvas. h50¾ x w64 in. h129 x w162.6 cm. Terra Museum of American Art, Chicago, IL.

Job

Cigar Store Figure Female (African-American)

Carved in a robust fashion with minimal detail, this female cigar store figure is unlike any other from its time. Her simple attire and stylized facial features are unique among cigar store Indian sculpture, a folk tradition whose hallmarks are colorful dress and lifelike appearance. An African-American slave named Job is said to have made this work during the first half of the nineteenth century as a trade sign for the tobacconist of Freehold, New Jersey. Although no further details about the maker have survived, the fine joinery of this figure's many parts suggests that the artist may have been a cabinetmaker or carpenter. The figure's intense, mask-like expression exhibits an African influence, perhaps the result of cultural retention. Cigar store Indians were common throughout nineteenth century America and were typically fashioned in workshops that also made ship figureheads and other advertising figures such as baseball players and versions of St. Nicholas. The singular qualities of this example, however, are the result of a more individual and sensitive artistic effort.

☞ Edmondson, Lachaise, Pierce, Robb

Job. Active Freehold, NJ, early 19th century. **Cigar Store Figure Female (African-American).** c1850. Painted wood. **h**46 x **w**16½ in. **h**116.9 x **w**41.9 cm. New York State Historical Association, Cooperstown, NY.

Johns Jasper

Map

The rigid boundaries that distinguish individual states and the national borders between the United States, Canada, and Mexico are all but obliterated beneath a welter of unruly strokes. Using devices from Abstract Expressionism — all-over composition, energetic brushwork, and a raw, non-illusionistic finish — Johns draws a conceptual analogy between the map and the canvas as abstractions.

The map symbolizes a political concept of geography, while the painting represents the metaphysical reality of postwar America, in which regional distinctions are blurred by the homogenizing effects of interstate travel and nationwide television. Johns once said, "I am concerned with a thing's not being what it was, with its becoming something other than what it is," which is precisely what was

happening to the nation at the time. As an artist whose iconoclasm helped usher in the Pop era, Johns translated that flux into visual terms, using the map as a familiar benchmark against which to measure aesthetic as well as cultural change.

☞ Davis, Hartley, Murphy, Rauschenberg

229

Jasper Johns. b Allendale, SC, 1930. **Map.** 1961. Oil on canvas. **h**78 x **w**123⅛ in. **h**198.2 x **w**314.7 cm. The Museum of Modern Art, New York, NY.

Johnson David

Natural Bridge, Virginia

Virginia's famed rock formation, the Natural Bridge, appears in a panoramic format, enclosed within forested hills and from a distant vantage point that obscures its 200-ft height. Johnson depicted the tourist attraction — located in what is today Jefferson National Forest — in an atypical manner, foregoing the monumentalizing, vertical composition it traditionally inspired. Johnson, who was essentially self-taught, based his early style on the work of established Hudson River School artists and often depicted the same Catskill and White Mountain sites that regularly attracted his contemporaries. Unlike many of his colleagues whose work emphasized the grand, idealized aspects of nature, Johnson concentrated on portraying the quieter features of the American landscape on a small scale, an approach better suited to the Barbizon influence that informed his later work. His powers of observation and fine painterly skills gained him academician's rank in the National Academy of Design by 1861.

☛ Casilear, Cole, Cropsey, Gifford

230

David Johnson. b New York, NY, 1827. d Walden, NY, 1908. **Natural Bridge, Virginia.** 1860. Oil on canvas. h14¼ x w22¼ in. h35.9 x w56.2 cm. Reynolda House, Museum of American Art, Winston-Salem, NC.

Johnson Eastman

The Cranberry Harvest, Island of Nantucket

Brilliant sunlight sharpens the forms of the more than forty men, women, and children who harvest autumn cranberries on Nantucket Island, off Cape Cod, Massachusetts. Visible in the distance is the once great whaling port that had fueled the local economy until mid-century. By 1880, however, the fiscal health of the small island depended largely on tourism and on its relatively new focus on cranberries as a money crop. Johnson, one of the nation's foremost painters of American life, was captivated by the harvesters and executed many studies in preparation for this, his last great genre painting. Although they are often compared to romanticized images of French peasants, Johnson's workers are instead pragmatic emblems of change. The standing woman at the center turns her back on the whaling port and on the strategically placed top-hatted elderly man (symbols of the past) and looks across the cart laden with berries to the infant carried toward her (symbols of the community's hope for the future).

☛ Benton, Chase, Homer, Vonnoh

231

Eastman Johnson. **b** Lowell, ME, 1824. **d** New York, NY, 1906. **The Cranberry Harvest, Island of Nantucket.** 1880. Oil on canvas. **h**27³/₈ x **w**54¹/₂ in. **h**69.6 x **w**138.5 cm. Timken Museum of Art, San Diego, CA.

Johnson Joshua

Little Girl in Pink with Goblet Filled with Strawberries: A Portrait

Still wearing her teething rattle with a coral tip meant to ward off illness, a very young girl holds a strawberry while reaching for another from an enormous goblet of fruit. For many years critics considered this painting an anonymous "gem of the folk art style," but its attribution to Johnson now marks it as the product of America's first professionally active African-American artist. Fragmentary biographical records indicate that Johnson was a freeman and portraitist in Baltimore at least as early as 1796. He probably learned his trade by association with the family of Charles Willson Peale, to whom he was earlier indentured or enslaved, and he may have supplemented his portrait practice by decorating furniture. Johnson's 1798 claim to be "a self-taught genius," who "experienced many insuperable obstacles in the pursuit of his studies," may be read as testimony to his confidence and endurance in a society still contending with slavery and racial discrimination.

☛ Hopkins, J. E. Kühn, Prior, Wright

232

Joshua Johnson. **b** near Baltimore, MD, c1765. **d** Baltimore, MD, c1830. **Little Girl in Pink with Goblet Filled with Strawberries: A Portrait** (of Emma van Name) c1800–24. Oil on canvas. **h**29 x **w**23 in. **h**73.7 x **w**58.5 cm. Alexander Gallery, New York, NY.

Johnson William H. Cafe

An African-American couple relaxes in a Southern "juke joint," or rural tavern, where the woman's red-gloved hand on her lover's shoulder warns potential rivals to keep their distance. Although his cartoonlike style may appear unsophisticated, Johnson chose it deliberately as best-suited to the narrative potential of his subject matter, which included black cultural icons and scenes of everyday life. After studying at New York's National Academy of Design, Johnson went to Europe, where he was exposed to the abstracting devices of Cubism in Paris during the 1920s, and to North Africa, where he painted landscapes and portraits in an Expressionistic style. When he returned to the United States in 1938, however, he adopted a pseudonaïve approach and focused his attention on his African-American heritage. Johnson's career was cut tragically short by mental illness and, unable to paint, he spent the last two decades of his life in an institution.

☛ Arbus, Delaney, Glackens, Hopper

William H. Johnson. b Florence, SC, 1901. **d** New York, NY, 1970. **Cafe.** c1939–40. Oil on paperboard. **h**36½ x **w**28⅜ in. **h**92.7 x **w**72.2cm. National Museum of American Art, Washington, D.C.

Johnston Henrietta

Colonel Samuel Prioleau

Wearing a genial expression and a wig with softly cascading curls, the twenty-five-year-old Prioleau appears every bit the gentleman. The delicate lines and beautiful color of this pastel portrait reflect the attitudes of an affluent, almost courtly society developing in the South, in strong contrast to the more severe colonial portraits of New England Puritans. Behind Prioleau's worldly but modest demeanor is the silversmith, merchant, and planter who was one of Charleston's wealthiest men at the time of his death in 1752. The earliest recorded woman artist working in the colonies, Johnston apparently learned her trade in London and drew her first pastels in Dublin. The early works exhibit a confident strength that Johnston was hard-pressed to reproduce in America, where she saw little other art and was often deprived of basic materials. Johnston's social connections, along with her own Huguenot background, helped her find sitters for her pastel portraits, and at least forty often charming portraits survive to testify to Johnston's skill and perseverance.

☛ Feke, Malbone, Moulthrop, Phillips

234

Henrietta Deering Johnston. **b** possibly Ireland. **Active** Charleston, SC. **d** Charleston, SC, 1728/9. **Colonel Samuel Prioleau.** 1715. Pastel on paper. **h**12 x **w**9 in. **h**30.5 x **w**22.9 cm. Museum of Early Southern Decorative Arts, Winston Salem, NC.

Jones Lois Mailou

Les Fétiches

The subdued, earthy colors of five African masks contrast sharply with the vivid red of a carved effigy figure that seems to radiate a mysterious white aura. White is also used to highlight the masks' planes and contours, emphasizing the abstract qualities of tribal art that appealed so strongly to Modernist painters and sculptors. Jones, who studied art in her native Boston and taught for many years at Howard University in Washington, D.C., was one of the first African-American artists to focus on ancestral themes. She painted this work in Paris, where she attended the Académie Julian in 1937 and where she returned often after World War II. Jones continued to broaden her aesthetic vision through travel in France and Haiti, synthesizing aspects of those cultures' artistic traditions to express her strong identification with her African heritage.

☛ Bearden, Douglas, Fuller, Hartley

235

Lois Mailou Jones. b Boston, MA, 1905. **d** Washington, D.C., 1998. **Les Fétiches.** 1938. Oil on canvas. **h**25½ x **w**21¼ in. **h**64.8 x **w**54 cm. National Museum of American Art, Washington, D.C.

Judd Donald

Untitled Works in Mill Aluminum

One hundred heavy aluminum boxes, burnished to a gleaming shine, fill an artillery shed on an abandoned military site in southwest Texas. Constructed out of industrial mill aluminum and finished impeccably, these gorgeous yet uninterpretable boxes are arranged in clean parallel lines that echo the shed's Modernist architectural grid. Such pristine, abstract objects, devoid of decorative detail, epitomize Judd's work. He rejected the unrestrained emotion of Abstract Expressionism and abandoned painting altogether in 1961 to become one of the leading Minimalist sculptors of the 1960s. He was perhaps the most uncompromising practitioner of this style, insisting that his objects meant nothing beyond what they presented literally to the viewer. Judd acquired the thirty-two buildings on this site in Marfa, Texas, in the late 1970s, and he lived and worked there until the end of his life. The site is now owned by the Chinati Foundation and open to the public.

☞ De Maria, Flavin, Horn, Lewitt

236

Donald Judd. b Excelsior Springs, MO, 1928. **d** Excelsior Springs, MO, 1994. **Untitled Works in Mill Aluminum**. 1982–86. Permanent installation. The Chinati Foundation, Marfa, TX.

Kane John

Self-Portrait

This man's advanced age is apparent, yet so is his physical strength. In this remarkable self-portrait, folk artist John Kane honors his body and, in the process, the labor that shaped his brawny form. Kane presents himself as an archetypal laborer. His steady gaze suits his sturdy pose, and he is unafraid of unflattering details such as the lines below his eyes or the vein rising in his right arm. The white archway suggests a halo and elevates this picture beyond the specifics of Kane himself into a commemorative portrait of the American worker. Kane left Scotland at twenty and joined the ranks of immigrants helping to create a newly industrialized America. Throughout his life he professed an admiration for hard work, and he performed stints as a carpenter, miner, housepainter, and steelworker Kane frequently painted landscapes of his adopted hometown Pittsburgh, giving special attention to the very steel mills, railroads, and factories he had helped construct.

☛ Anschutz, Greenough, Hirshfield, Prior

237

John Kane. b West Calder, Scotland, 1860. **d** Pittsburgh, PA, 1934. **Self-Portrait.** 1929. Oil on canvas over composition board. **h**36¹/₈ x **w**27¹/₈ in. **h**91.8 x **w**68.9 cm. The Museum of Modern Art, New York, NY.

Kane Paul

Falls at Colville

Before a spectacle of craggy ledges, cascading waters, and billowing clouds, Chualpays Indians in various states of dress use spears, clubs, and basket traps to harvest salmon leaping upriver. Kane witnessed this annual hunt on the lower Columbia River, noting in his journals that only two months of fishing afforded the Indians "a sufficient supply to last them the whole year round." He also admired the site of the Chualpays' village near Fort Colville, overlooking the "exceedingly picturesque and grand" Kettle Falls. The first white artist to extensively document the native peoples west of the Great Lakes region, Kane used his field sketches to create one hundred paintings of the faces, customs, costumes, and landscapes he witnessed. Inspired by the example of George Catlin, whose Indian Gallery of paintings he saw in London in 1843, Kane made two western trips between 1845 and 1848, traveling overland from Toronto to the Pacific coast.

☞ Catlin, Sharp, Stanley, Wimar

Paul Kane. b Mallow, Ireland, 1810. d Toronto, Canada, 1871. **Falls at Colville.** 1848. Oil on canvas. **h**19 x **w**29 in. **h**48.3 x **w**73.7 cm. Royal Ontario Museum, Toronto, Canada.

Käsebier Gertrude

Portrait — Miss N. (Evelyn Nesbit)

The sleepy, slightly disheveled look of the mysterious Miss N. makes this picture stand out from the thousands of turn-of-the-century portraits in which the sitter and photographer collaborated to present a proper and polished appearance. The boudoir allure of the image was indeed something of a scandal, which befits its subject: a sixteen-year-old showgirl named Evelyn Nesbit, who had recently become the mistress of prominent New York architect Stanford White. The photographer, an influential member of the Pictorialist movement, scolded White for consorting with someone so young but took pains to emphasize her nascent beauty nonetheless. Nesbit would later marry Harry K. Thaw, an irrational, intensely jealous man who ended White's life and career with a single gunshot. Käsebier suffered no consequences on account of her picture, but her artistic reputation eventually was eclipsed by the rise of a harder-edged, more modern style of photography promoted by her erstwhile fellow Pictorialist, Alfred Stieglitz.

☞ Alexander, Benson, Reid, Sully

Gertrude Käsebier, b Des Moines, IA, 1852. **d** New York, NY, 1934. **Portrait — Miss N. (Evelyn Nesbit).** c1901–02. Platinum print on paper. National Gallery of Canada, Ottawa.

Katz Alex

Blue Umbrella #2

A woman in a patterned scarf looks over the viewer's shoulder, seemingly oblivious to the cartoonish raindrops that fall across the picture plane. The mood evoked by the huge painting is something between melancholy and ennui — emotions not usually associated with Pop Art. Katz's paintings of New York socialites, as well as of his family and friends, have been criticized as being aloof and icy.

Nevertheless, his attractive, larger-than-life subjects are far less iconic than most Pop subjects, such as Marilyn Monroe as painted by Andy Warhol. Katz describes his paintings as documents of Pop's influence on his surroundings, rather than as pure Pop paintings themselves. Like his portraits, Katz's landscapes of flowers and lakes approach abstraction in their vibrant colors and overly smooth

brushstrokes. Throughout all of Katz's work runs the same quality of stillness, a cool serenity that is both urban and modern.

☞ Kuniyoshi, Lichtenstein, Phillips, Wood

240

Alex Katz. b New York, NY, 1927. **Blue Umbrella** #2. 1972. Oil on canvas. **h**96 x **w**144 in. **h**243.8 x **w**365.8 cm. The Saatchi Gallery, London, United Kingdom.

Kelley Mike

Entryway (Genealogical Chart)

This type of roadside structure is unique to American small towns, a welcome sign that announces the volunteer and civic groups active in the area, from the Elks Club to the Lutheran Church. In this instance, Kelley has taken the form and altered it, painting out the name of the town and adding his own signs (including "The Anti-Christ Fan Club") to the usual mix. Since the late 1970s, Kelley's art has dealt with the unspoken undercurrents — sexual, metaphysical, and otherwise — of middle-class American society. Other colloquial forms he has made his own include stuffed animals, felt banners, and the photocopied signs on college bulletin boards. Kelley's art employs nostalgia and handicraft to reveal the dark psychologies and hidden morphologies embedded in overlooked examples of American visual culture. His humorous and disturbing reworking of this signpost is a prime example of his approach.

☛ Frank, Indiana, Kruger, Ray

241

Mike Kelley. b Detroit, MI, 1954. **Entryway (Genealogical Chart).** 1995. Acrylic on wood with steel frame. **h**101½ x **w**115 x **d**3 in. **h**258 x **w**292.3 x **d**7.6 cm. Private collection.

Kelly Ellsworth

Green Curve

A solid green arc is mounted on the bright white wall, like a section sliced from an oval. Kelly's colorful, hard-edged paintings and metal sculptures are touchstones of American abstraction, inspiring both simplicity-inclined Minimalists and sensation-seeking Op artists. Studies in Paris after World War II exposed Kelly to the work of European Abstractionists such as Jean Arp, as well as to Surrealism and Dada. Returning to the United States at the dawn of Abstract Expressionism, Kelly set out to make abstract paintings that did not rely on symbolism or illusionism, but rather on his own observation of the physical world. Kelly notes how certain forms and colors work in nature and then intuitively removes, distills, and rearranges them in his paintings. These observations can be seen in Kelly's eccentrically shaped canvases and vibrant colors as well as in his sketches of plants and photographs of urban shadows.

☞ Mangold, Marden, Martin, Reinhardt

Ellsworth Kelly. b Newburgh, NY, 1923. Green Curve. 1995. Oil on canvas. h119 x w64³/4 in. h302.3 x w164.5 cm. Anthony d'Offay Gallery, London, United Kingdom.

Kensett John F.

Eaton's Neck, Long Island

The spare, linear elegance and limited palette of this painting set it apart as one of the most admired canvases of Kensett's late years. With its simple composition, horizontal format, almost piercing light, and lack of narrative elements, the work stands as a primary example of the Luminist aesthetic, a modern term invented for the purpose of discussing nineteenth-century landscapes that share these formal features. Kensett took up painting in the 1830s and in 1840 went to Paris, where he lived for seven years, becoming an increasingly skilled painter. He began to work in the severe compositional style of this canvas in the last decade of his life, but it may reflect his early training in engraving, a technique rooted in drawing and emphasizing the linear qualities of form. Far removed from the overwrought Victorian aesthetic that dominated popular taste at the time of Kensett's death, *Eaton's Neck, Long Island* drew little attention until this century's general revival of interest in historic American art.

☛ Bricher, Marden, Smithson, Vedder

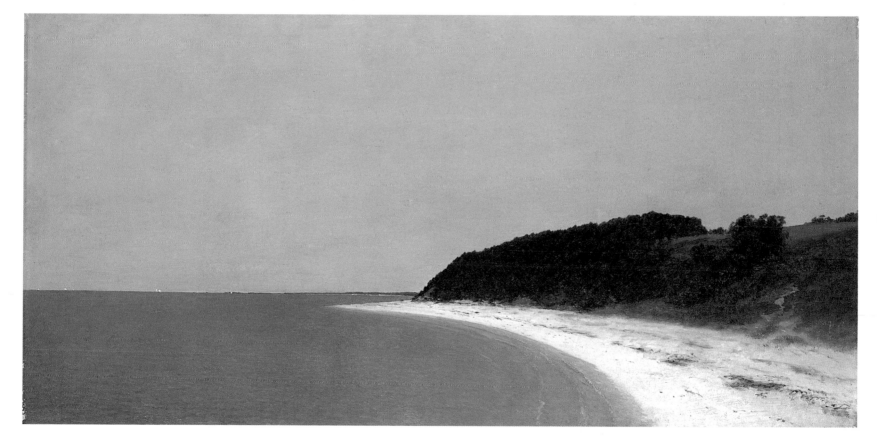

John Frederick Kensett. **b** Cheshire, CT, 1816. **d** New York, NY, 1872. **Eaton's Neck, Long Island.** 1872. Oil on canvas. **h**18 x **w**36 in. **h**45.7 x **w**91.5 cm. The Metropolitan Museum of Art, New York, NY.

Kent Rockwell

Resurrection Bay, Alaska (Blue and Gold)

A barren arctic landscape is dramatically infused with life by the use of purple and gold, contrasting complementary colors that create a luminous glow almost like stained glass. The awe-inspiring scene would have been observed firsthand by Kent, a world traveler who favored far-flung wilderness locales. But he was less interested in literally recording his observations or documenting natural phenomena than in expressing his mystical communion with the elements. "I cannot trust myself to paint what I see," he once wrote, "I paint only what I remember." Also a prolific writer and graphic artist, Kent is perhaps best known for his romantic, stylized illustrations of the works of Shakespeare, Chaucer, Melville, and Whitman. Politically left wing, he was active in the American Artists' Congress Against War and Fascism, which was centered in New York City in the 1930s and advocated social revolution. Such sentiments, however, are seldom reflected overtly in his art, which tends toward idealization and transcendence.

☛ A. Adams, Bierstadt, Davies, Ruscha

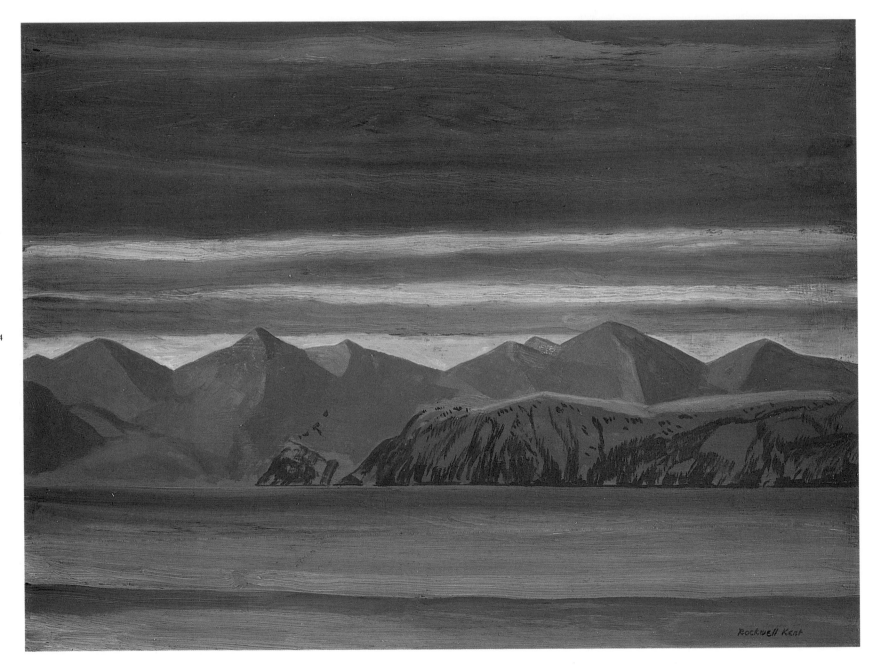

244

Rockwell Kent. b Tarrytown Heights, NY, 1882. **d** Au Sable Forks, NY, 1971. **Resurrection Bay, Alaska (Blue and Gold).** 1919. Oil on panel. **h**12 x **w**16 in. **h**30.5 x **w**40.6 cm. Bowdoin College Museum of Art, Brunswick, ME.

Kern Richard

Valley of Taos, Looking South, N.M., 1849

Hazy blue hills stretch beneath yellow sunlit mountains, as a lone abstracted figure framed by a simple beamed structure gazes out at the serene Valle de Taos below. Such a bucolic landscape belies the harsh conditions under which Kern documented the Southwest as part of a series of railroad survey teams funded by the US government. One year before he painted this scene, a survey expedition to which he belonged ended disastrously in Colorado, with ten men dead and rumors of cannibalism. Five years later, Kern died in an attack by Paiute Indians while working on yet another railroad survey. Nonetheless, his studies were published in *Reports of Explorations and Surveys to Ascertain the Most Practicable and Economic Route for a Railroad from the Mississippi River to the Pacific Ocean*, a twelve-volume, one-million-dollar opus of contemporary Western geography. *Valley of Taos* is therefore as much a record of mid-nineteenth-century Southwestern geography as it is an artist's rendering of a spectacular landscape.

☛ Dasburg, Marin, Miller, O'Sullivan

Richard Hovenden Kern. b Philadelphia, PA, 1821. **d** near Sevier Lake, UT, 1853. **Valley of Taos, Looking South, N.M., 1849.** 1849. Watercolor on paper. **h**3⅞ x **w**5¾ in. **h**9.8 x **w**14.6 cm. Amon Carter Museum, Fort Worth, TX.

Kienholz Edward, and Nancy Reddin Portrait of a Mother with Past Affixed Also

A mannequin of an elderly woman, her head represented by a photograph, stares at a photo of herself as a child whose three-dimensional doll arms reach out to her. This tableau is a shrine to Edward Kienholz's mother, the woman in the photographs, as well as a meditation on the passing of time. According to the artists, moments from the past, present, and future are depicted from left to right in this work. The past is commemorated in the exterior's black and white photograph of Kienholz's childhood home. The room itself is a recreation of the kitchen from that house. The central figure of Kienholz's mother represents the present, while photographs of his deceased father arranged inside signify a future in which husband and wife will be reunited. These walk-in collages made by Kienholz in collaboration with his wife might be called 'Social Surrealism.' They frequently draw inspiration from 1920s Dada and Surrealist art, but they are intended to comment on the travesties and absurdities of American life in the modern era.

☛ Lundeberg, Michals, Segal, Wesselman

Edward Kienholz. b Fairfield, WA, 1927. d Sandpoint, ID, 1994. Nancy Reddin Kienholz. b Los Angeles, CA, 1943. Portrait of a Mother with Past Affixed Also. 1980–81. Mixed media. Overall h99⅞ x w94⅝ x d81 in. h253.9 x w240.4 x d205.9 cm. Walker Art Center, Minneapolis, MN.

King Charles Bird

John Caldwell Calhoun

Although the stretcher of this straightforward portrait of John C. Calhoun (1782–1850) is inscribed with the date 1818, Calhoun's physical appearance and almost anxious expression suggest that this portrait was painted toward the end of the sitter's long political career. Calhoun held a variety of elected and appointed positions, including the vice presidency, which he resigned in 1832 to run for the Senate.

His association with King probably began around 1818, the date of another of the several portraits of Calhoun by the artist. The two doubtless became especially close after 1824, when Calhoun (then secretary of war) established the Bureau of Indian Affairs for which King subsequently painted a number of portraits of prominent Native Americans. King had no financial worries, having inherited a fortune

that allowed him to study in New York, and later in London, with Benjamin West. His artistic and philanthropic efforts were highly respected, yet his career never reached great heights.

☛ Earl, Inman, Hiram Powers, Stuart

247

Charles Bird King. b Newport, RI, 1785. **d** Washington, D.C., 1862. **John Caldwell Calhoun.** 1818. Oil on canvas. **h**36 x **w**27¹/₂ in. **h**91.4 x **w**69.8 cm. Redwood Library and Athenaeum, Newport, RI.

Klein William

4 Heads

The overcrowded condition of city life is one message of this claustrophobic scene, which is filled by four very different faces that seem about to collide. The sense of closeness is partly true: The people in the picture are part of a crowd gathered to watch a parade in New York City. Yet it is also an illusion fostered by the photographer, who chose a lens and a point of view that compress

the depth of the picture space into a nearly flat plane. In addition, Klein printed the picture in a way that adds to its posterlike effect. Known for his gritty style that captures the energy of the urban experience, Klein photographed in the United States at the same time as Robert Frank, and both artists deserve credit for revolutionizing the notion of documentary street photography. Klein's 1956 book

Life Is Good and Good for You in New York, Trance Witness Revels remains an unmatched testament to the vitality of the small hand camera as a gestural, subjective instrument of art.

☛ Arbus, Marsh, Weegee, Winogrand

William Klein. b New York, NY, 1928. **4 Heads.** 1955. Gelatin silver print. Collection of the artist.

Kline Franz

Lehigh

Boldly brushed black elements serve as interlocking supports, like the beams and girders of railroad bridges in Pennsylvania's Lehigh Valley, near Kline's boyhood home. Allusions to massive urban and industrial architecture are evident in many of Kline's stark gestural paintings, although he claimed he did not intend to depict such structures. In fact, his compositions are often based on small sketches of interiors, from which details were extracted and simplified. After years as a representational painter, Kline made a breakthrough to Abstract Expressionism in 1949, when he enlarged a tiny drawing of a rocking chair by means of an opaque projector. Thereafter his vision was radically altered, and he began working with housepainters' brushes and cans of enamel paint. Kline's sweeping strokes are often likened to Asian calligraphy, but in fact he gives equal emphasis to dark and light areas, dissolving the traditional figure-ground relationship into an overall interplay of forms.

☛ De Kooning, DiSuvero, Gottlieb, Mitchell

Franz Kline. b Wilkes-Barre, PA, 1910. **d** New York, NY, 1962. **Lehigh.** 1956. Oil on canvas. **h**81 1/8 x **w**113 1/2 in. **h**206.2 x **w**288.4 cm. Collection of Marguerite and Robert Hoffman.

Koons Jeff

Michael Jackson and Bubbles

A life-sized statue of the pop-music superstar and his pet chimp is rendered in creamy shades of white ceramic, lavishly decorated with gold paint. Like an ornately frosted wedding cake, Koons's sculpture is at once delicious looking and nauseatingly sweet. Then again, its exaggerated prettiness and discomfiting sensuality are not so different from the reality of the celebrity it depicts. With his carefully scripted public persona and hired-out artistic labor, Koons is to date the greatest pretender to Andy Warhol's throne. Koons's shiny, Minimalist re-presentations of banal consumer objects, from basketballs to vacuum cleaners, embody the acquisitive culture of 1980s America as keenly as Warhol's 1960s portraits of Marilyn Monroe marked its obsession with celebrity. By translating our media-influenced ache for happiness into fine art, Koons seeks to guarantee that his monuments to kitsch will be as accessible to future generations as Michelangelo's ubiquitously reproduced *David* is today.

☛ Hopkins, Manship, Rush, Warhol

Jeffrey Koons. b York, PA, 1955. **Michael Jackson and Bubbles.** 1988. Ceramic. **h**42 x **w**70¹/₂ x **d**32¹/₂ in. **h**106.7 x **w**179.2 x **d**82.6 cm. The Eli Broad Family Foundation, Santa Monica, CA.

Krasner Lee

Milkweed

Beneath stem- and leaf-shaped collage elements of cut canvas and torn black paper, the thinly brushed gray and yellow rectangular structure of Krasner's 1951 grid painting, *Number 12*, is clearly visible. Revising earlier canvases was a lifelong strategy of Krasner's, allowing her to move in new directions while maintaining continuity with the past. "If I'm going back on myself," she once said, "I'd like to think it's a form of growth." Indeed growth itself — in the form of organically evolving imagery and abstract evocations of natural phenomena — was a consistent theme in her work. The teachings of Hans Hofmann influenced Krasner's Cubist still lifes of the early 1940s, when she was among the vanguard of New York Abstractionists working on the WPA Federal Art Project. After meeting Jackson Pollock, whom she later married, Krasner began to develop a more intuitive and spontaneous approach that energized her subsequent nature-derived Abstract Expressionism.

☞ Motherwell, Pollock, M. Russell, Siskind

251

Lee Krasner (Lena Krassner). b Brooklyn, NY, 1908. d New York, NY, 1984. Milkweed. 1955. Oil and collage on canvas. h82⅜ x w57¾ in. h209.3 x w146.8 cm. Albright-Knox Art Gallery, Buffalo, NY.

Krimmel John

Fourth of July Celebration

A lively mix of Philadelphians gathers to celebrate Independence Day. The site of their assembly is significant, for the Neo-Classical building in the background was architect Benjamin Latrobe's newly constructed pumping station that brought fresh water to the city. In addition to commemorating the nation's anniversary, Krimmel's painting emphasizes one of the legacies of American independence:

scientific innovations directed toward the public good, represented here by the healthy, affluent populace. The scene additionally refers to the more recent War of 1812, with military men prominent in the crowd and through the posters and mottoes recalling significant battles displayed atop the tents. Although German-born, Krimmel was influenced by the Scottish painter David Wilkie and by the

English artist William Hogarth, both of whom concentrated on contemporary social issues.

☛ Greenwood, Hahn, Motley, Prendergast

252

John Lewis Krimmel. **b** Ebingen, Germany, 1789. **d** near Germantown, PA, 1821. **Fourth of July Celebration.** 1819. India ink and watercolors on paper. **h**12 x **w**18 in. **h**30.5 x **w**45.7 cm. The Historical Society of Pennsylvania, Philadelphia, PA.

Kruger Barbara

"Untitled" (I shop therefore I am)

The slogan presented here in billboard style is a commercial-era parody of seventeenth-century philosopher Rene Descartes' famous dictum, "I think, therefore I am." But who is speaking, and why? To whom does the helping hand belong? Kruger's large color photographs, which really are graphic collages made using pictures that have been reproduced elsewhere, lecture and sometimes hector their audience, but the discomfiting utterances are disembodied, like the voice of a public address system. Kruger uses the mode of public address to question cultural attitudes that we take for granted. "You are not yourself," "Your manias become science," and "Surveillance is your busywork" are slogans found in other of her works. Meant to be critical in a Deconstructivist sense, Kruger's pictures are also popular with a wide public. "I shop therefore I am" was reproduced on a tote bag that became a trendy fashion accessory.

☛ Holzer, Indiana, Weiner, Wool

253

Barbara Kruger. b Newark, NJ, 1945. **"Untitled" (I shop therefore I am).** 1987. Photographic silkscreen/vinyl. **h**120 x **w**120 in. **h**305 x **w**305 cm. Mary Boone Gallery, New York, NY.

Kühn Justus Engelhardt
Eleanor Darnall (Mrs. Daniel Carroll, 1704–1796)

A girl of about six years old pats and points to a spaniel, who may be her pet but is more likely another emblem in the complex world she inhabits. The large mask on the pedestal, whose form is echoed on the vase, appears in many Kühn portraits, but here its unusually calm stare seems to imply patriarchal supervision over the girl and her lush surroundings. The formal gardens behind Eleanor are not those of her family's estate, for no such plantings then existed in the colonies. Instead they derive from the codified iconography of European court portraiture and allude to the aristocratic pretensions of the Darnalls. Kühn, a German painter who arrived in the colonies around 1708, is best known for his elaborately symbolic portraits of children, although his estate papers mention "landskips" and coats of arms that have not been located. A Protestant presumably escaping Europe's religious wars, Kühn ironically found his best patronage among Maryland's wealthy Catholics.

☞ Hopkins, J. Johnson, Prior, William Williams

254

Justus Engelhardt Kühn. Active Germany, c1708–1717. d Annapolis, MD, 1717. Eleanor Darnall (Mrs. Daniel Carroll, 1704–1796). 1710. Oil on canvas. h54 x w44¹/₂ in. h137.2 x w113.1 cm. Maryland Historical Society, Baltimore, MD.

Kuhn Walt

Trio

Posed in bright, monochromatic costumes before a dark curtain, the three acrobats' muscular figures are thrown into bold relief against the shallow background. Their proud demeanor recalls the official portraits of warriors or noblemen, lending an uncommon dignity to characters associated with popular entertainment. After beginning his career as a cartoonist and illustrator, Kuhn had been an organizer of the 1913 Armory Show in New York City, which brought the latest European art to America. His work of the following decade was influenced by Matisse and Picasso, but he soon abandoned Modernist stylization in favor of a more naturalistic approach. Unlike Picasso's ethereal circus performers or the colorful carnival and burlesque characters favored by several of Kuhn's American contemporaries, his clowns and acrobats are solid, emphatic presences, made all the more imposing by isolation from their flamboyant surroundings.

☞ M. Barney, Disfarmer, DuBois, G. Hill

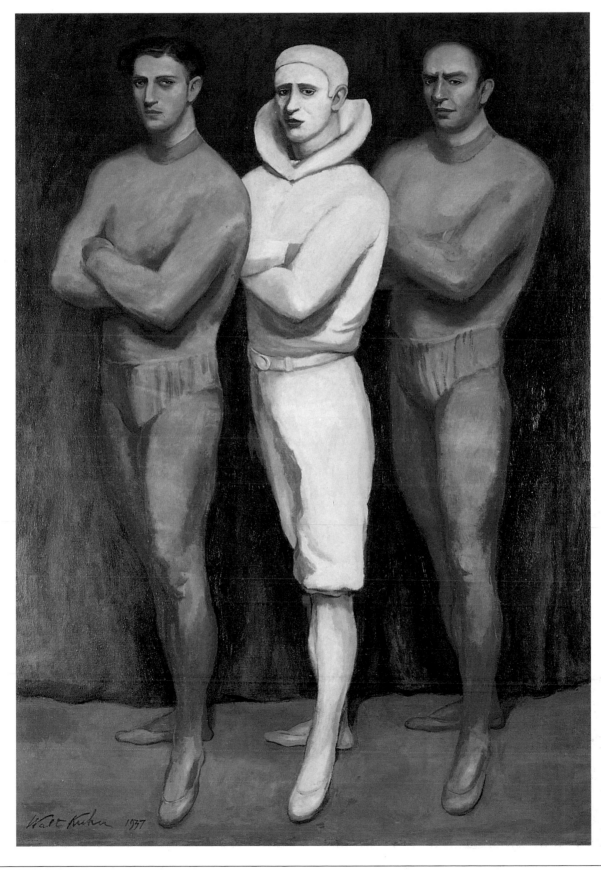

Walt Kuhn. b New York, NY, 1877. **d** New York, NY, 1949. **Trio.** 1937. Oil on canvas. **h**72 x **w**50 in. **h**183 x **w**127.1 cm. Colorado Springs Fine Arts Center, Colorado Springs, CO.

Kuniyoshi Yasuo

Season Ended

The blunt, simplified form of a woman dressed in t-shirt and tights appears both awkward and poetic. She presses on a chair-back while pulling a newspaper toward her. Her eyes are closed, as if the artist has caught her unaware during her morning routine. Within this quiet scene, however, the word "Nazis" is faintly visible on the newspaper, sketched in Kuniyoshi's characteristic mode of impressionistic realism. A scene of private life, *Season Ended* nevertheless refers to the turbulent history of World War II. Kuniyoshi was born in Japan but identified himself completely as an American artist. "My art training and education have come from American schools and American soil. I am just as much an American in my approach and thinking as the next fellow," he said. He was influenced by the Realist movement founded by the American artist Robert Henri at the New York School of Art in the early 1900s, which encouraged artists to observe and capture urban life as they saw it.

☛ Benson, Goldin, Pippin, Sherman

Yasuo Kuniyoshi. b Okayama, Japan, 1893. d New York, NY, 1953. **Season Ended**. 1940–45. Oil on canvas. h40¼ x w29⅗ in. h102.3 x w75.3 cm. Wichita Art Museum, Wichita, KS.

Lachaise Gaston

Standing Woman (Heroic Woman)

The massive figure — aloof, yet provocatively displaying her sexuality — is an idealized portrait of the artist's mate and muse, Isabel Dutaud Nagle, whom he married in 1913. An obsession with the female body as a metaphor of earthly fecundity inspired Lachaise to make many works with highly erotic overtones, yet he also saw *Standing Woman* as a symbol of cosmic enlightenment. To Lachaise, Nagle was "the primary inspiration which awakened my vision." In pursuit of the voluptuous Nagle, an American woman ten years his senior, Lachaise emigrated to Boston in 1906 from his native Paris, where he was traditionally trained at the École des Beaux-Arts. To raise money for his passage to the United States he carved decorative glass for the Art Deco designer René Lalique. After moving to New York, Lachaise exhibited in the 1913 Armory Show and was a leader of the Society of Independent Artists. He later worked as an assistant to Paul Manship while developing endless variations on the theme of "Woman."

☛ Bellocq, De Kooning, Hansen, Pearlstein

Gaston Lachaise. b Paris, France, 1882. **d** New York, NY, 1935. **Standing Woman (Heroic Woman).** 1932. Bronze. **h**88½ x **w**41 x **d**15 in. **h**224.9 x **w**104.2 x **d**38.1 cm. Franklin D. Murphy Sculpture Garden, University of California at Los Angeles, CA.

La Farge John

Athens

A partially draped woman (who is usually interpreted as an allegory of Nature) poses for another who draws her, while yet another watches the artistic process unfold. Because of their traditional attributes the figures can be identified. The one on the left as Athena (the ancient Greek goddess of wisdom and the arts, and protector of the city of Athens) and the seated figure as a personification of the city itself.

The multitalented La Farge studied painting from an early age and addressed many subjects throughout his career — still life, landscape, and figural narratives — using a wide variety of media. His ability to integrate architecture and painting in a unified work earned him several public mural commissions. He also executed decorative domestic pieces and stained glass for prominent American clients

such as the Vanderbilt family. *Athens* was La Farge's contribution to a series of mural decorations for the Walker Art Building at Bowdoin College, Brunswick, Maine, which were to represent the great centers of the arts through the ages.

☛ Hunt, Ives, Palmer, Pratt, Sully

258

John Lewis Frederick Joseph La Farge. b New York, NY, 1835. d Providence, RI, 1910. Athens. 1893–98. Oil on canvas. h108 x w240 in. h274.5 x w609.9 cm. Bowdoin College Museum of Fine Arts, Brunswick, ME.

Lane Fitz Hugh

Gloucester Harbor at Sunrise

The glow of the rising sun spreads from the horizon and turns the sky to warm golden tones, signaling the beginning of a day that promises good weather. Schooners are at anchor in the waters of Gloucester Harbor, their sails open and their masts creating emphatic verticals in the spare, horizontally ordered composition. Lane's dreamlike images are rooted in a fragile, rarefied stillness tinged with a sense of expectancy. Born in Gloucester, Massachusetts, Lane knew this harbor intimately and throughout his life consistently lived in fishing or sailing ports, a circumstance that probably accounts for his affinity for marine subjects. He first worked as a printmaker in Boston, but was painting by the 1840s. In his mature works he virtually eliminated narrative detail, pared down his compositions to the barest essentials, and removed visible traces of brushwork. Lane's work was not widely known until the mid-twentieth century, mainly because he operated apart from the New York art community.

☞ Blunt, Bradford, Colman, Salmon

Fitz Hugh (Nathaniel Rogers) Lane. b Gloucester, MA, 1804. d Gloucester, MA, 1865. **Gloucester Harbor at Sunrise.** 1850s. Oil on canvas. h24 x w36 in. h61 x w91.5 cm. Cape Ann Historical Association, Gloucester, MA.

Lange Dorothea

White Angel Breadline, San Francisco, CA, 1933

Caught unprepared by the onset of the Depression, the man at the center of this photograph seems to beseech heaven for relief. He is part of a large crowd of men waiting to receive a free meal from an anonymous, wealthy patron known as the White Angel. At the time Lange took this picture, she was a studio portrait photographer in San Francisco. Her venture onto the street that day was decisive:

For the rest of her career she devoted herself to photographing the dispossessed and downtrodden with intense compassion. Often working with the sociologist Paul Taylor, whom she married in 1935, Lange became an integral part of the Farm Security Administration's photography project, which sought to publicize the activities of this New Deal agency on behalf of farmers. She documented the

plight of migrant laborers in California and in the early war years photographed the forced relocation of Japanese-Americans to remote camps. Today Lange is considered one of the best documentary photographers of all time.

☞ Hine, Klein, Marsh, Soyer

Dorothea Lange. b Hoboken, NJ, 1895. d Marin County, CA, 1965. **White Angel Breadline, San Francisco, CA, 1933.** 1933. Gelatin silver print. The Oakland Museum of California, Oakland, CA.

Lassaw Ibram

Dharmadhatu

This sculpture's shimmering labyrinth of interwoven lines and volumes alludes to the Hindu principle of universal order, while the interplay of solids and voids illustrates Lassaw's concept of "polymorphous space." His forms seem capable of extending themselves to infinity and, despite their similarity, of being infinitely varied. Cosmic unity has been Lassaw's focus since the 1930s, when he was among the pioneers of abstract sculpture in America. His early work was influenced by Surrealism and Neo-Plasticism, but by the late 1940s he had achieved a singular organic style equally suited to expressing the essence of an atomic microcosm or the immensity of galactic space. Lassaw's interest in philosophy and spirituality, as well as the Jungian concept of archetypes, inspired him to explore universal themes. Working primarily in welded metal, he has developed a direct, spontaneous technique analogous to Abstract Expressionist "action painting."

☛ Bolotowsky, Lewitt, Pollock, D. Smith

Ibram Lassaw. b Alexandria, Egypt, 1913. **Dharmadhatu.** 1975. Bronze. **h**38 x **w**20 x **d**13$^{1/2}$ in. **h**96.6 x **w**50.8 x **d**34.3 cm. Collection of the artist.

Laughlin Clarence John The Mirror of Long Ago

The painted image of a beautiful young woman floats inexplicably in the reflection of a French Rococo-style room, suggesting the spirit of an age that expired long before photography. By printing two negatives together, the photographer was able to enhance what he called the "tragic and poetic beauty" of an abandoned antebellum plantation in southern Louisiana, which was built by a nobleman who had fled the French Revolution. Laughlin was a New Orleans artist and writer who combined a Surrealist reliance on subconscious accident with a deep affection for the fading splendor of his region. He intended all of his pictures to convey metaphoric meaning beyond what they literally described, and Laughlin himself provided captions for them so his intentions would not be overlooked. "My central position is one of extreme romanticism," he wrote in 1973, adding that "the 'reality' we think and know is only a small part of a 'total reality.' This position is now completely out of fashion."

☞ Dewing, Kienholz, Friedlander, Michals

262

Clarence John Laughlin. b Lake Charles, LA, 1905. d New Orleans, LA, 1985. The Mirror of Long Ago. 1946. Gelatin silver print. The Historic New Orleans Collection, New Orleans, LA.

Lawrence, Jacob

Harriet Tubman Series No. 7

Her massive body and muscled forearms evidencing her physical strength, African-American hero Harriet Tubman is shown chopping wood during her days as a slave. This is one of thirty-one panels Lawrence created that depict scenes from the life of Tubman, who escaped from slavery in 1849 and became an agent of the Underground Railroad, fearlessly helping many other pre-Civil War fugitives.

Lawrence's narratives of black history earned him unprecedented recognition while he was still in his twenties. Growing up in Harlem, he was encouraged by black mentors and was employed by the Works Progress Administration's (WPA's) Federal Art Project during the 1930s, when he developed his serial approach to historical themes. Lawrence's best-known series, *The Migration of the Negro*,

a sixty-panel epic of the movement of blacks from the rural South to the urban North, established him as the foremost contemporary African-American painter.

☛ Douglas, Gwathmey, Lachaise, Walker

Jacob Lawrence. b Atlantic City, NJ, 1917. **Harriet Tubman Series No. 7.** 1939–40. Casein tempera on gessoed hardboard. **h**17⅞ x **w**12 in. **h**45.4 x **w**30.5 cm. Hampton University Museum, Hampton, VA.

Lawson Ernest

Spring Night, Harlem River

A rich medley of cool blues and greens enlivened by sparkling high-lights of whites, yellows, and oranges, transforms the High Bridge crossing of New York's Harlem River into an unexpectedly decorative image. Like other members of the group of Realist painters known as The Eight, Lawson frequently depicted the changing urban landscape, particularly that of New York City. Yet his painting technique, which was marked by heavily scumbled surfaces and a fine sense of color (leading one critic to characterize his paintings as seemingly made of "crushed jewels"), indicates that his aesthetic aims transcended the concerns of his colleagues, who focused on wholly realistic depictions of city life and the working classes. The painting reveals Lawson's varied artistic background which included training with the Impressionists John Twachtman and J. Alden Weir, and the influence of the French painter Alfred Sisley, whom he had met in France in the 1890s.

☞ Hassam, Link, Twachtman, J. A. Weir

264

Ernest Lawson. b San Francisco, 1873. **d** Miami Beach, FL, 1939. **Spring Night, Harlem River.** 1913. Oil on canvas mounted on panel. **h** 25¹/₈ x **w** 30¹/₈ **h** 63.8 x **w** 76.5 cm. The Phillips Collection, Washington, D.C.

Lee Russell

San Marcos, Texas

At a time when gas stations offered full service as a matter of course, they also were primary sources for tires, as Lee's straightforward, documentary photograph attests. This particular station probably caught Lee's eye because of the way its neatly arranged tires create a Lifesaver-like false front for the clapboard structure, even covering the second-story windows in the name of order. Lee also would have

seen this gas station as a testament to American mobility and industriousness despite the overriding presence of an economic depression. When he took the picture he was working for the federal Farm Security Administration to record the poverty and social disruption then affecting rural communities. Along with the work of Walker Evans, Ben Shahn, and Marion Post Wolcott,

Lee's pictures produced for the government constitute an unmatched archive of American life in the difficult period from 1936 to 1942.

☛ Bartlett, Christenberry, Evans, Strand

265

Russell Lee. b Ottawa, IL, 1903. **d** Austin, TX 1986. **San Marcos, Texas.** 1940. Gelatin silver print. Library of Congress, Washington, D.C.

Leigh William R. Land of His Fathers

An adolescent Indian shepherd sits atop a slab of desert stone, his arm draped absent-mindedly on a raised knee as he surveys the landscape before him. Storm clouds gather in the sky and cast menacing shadows on the restless herd at his feet. At the time Leigh painted this pastoral, melancholic allegory of America's Native-American past, the country was on the verge of World War I, Morton Schamberg and Charles Sheeler were developing an American-style Cubism, and Marcel Duchamp had just proclaimed America as "the country of the art of the future!" While one sector of America viewed the city and technology as the key to a promising future, Leigh painted reminders of the past in the form of archetypal scenes of the American West. Along with the work of nineteenth-century artists such as Alfred Jacob Miller and John Mix Stanley, his canvases helped keep the image of the frontier alive well into the twentieth century.

☛ Couse, Curtis, O'Sullivan, Sharp

266

William Robinson Leigh. b Berkeley County, VA, 1866. **d** New York, NY, 1955. **Land of his Fathers.** 1916. Oil on canvas. **h**50 x **w**37 in. **h**127.1 x **w**94 cm. Gerald Peters Gallery, Santa Fe, NM.

Le Moyne Jacques

René de Laudonnière and the Indian Chief Athore visit Ribaut's Column . . .

Fair-skinned Indians kneel before a garlanded column, while their chief Athore confirms his tribe's allegiance to the French power it represents. Embracing Commander Laudonnière, Athore indicates the wondrous New World of loyal subjects and bountiful produce that the French will enjoy. This decorous tableau, both fantastic and documentary, honors the cooperation of the Timucuan people while commemorating the establishment of a French colony in 1564 at the site where a previous expedition erected the column. The Spanish destroyed Laudonnière's settlement in 1565; Le Moyne, the expedition's draftsman, was one of the few to escape. Returning to Europe, he prepared a written account and several drawings of his travels, which the German publisher Theodor de Bry later purchased. Le Moyne's original drawings have not survived, but many appear as illustrations to De Bry's second volume of *America* (1590), including this print. Here, the strange appearance of the Florida natives has been further enhanced by an imaginative colorist.

☛ Bartram, Catesby, Hesselius

Jacques de Morgues Le Moyne. b Dieppe, France, date unknown. d London, United Kingdom, 1588. René de Laudonnière and the Indian Chief Athore visit Ribaut's Column (Laudonnierus et Rex Athore ante Columnam a Praefecto Prima Navigatione Locatam Quamque Venerantur Floridenses, 27 June 1564). Hand-colored woodcut. From Theodor de Bry, ed., *America* (Frankfurt-am-Main, 1590). The New York Public Library, NY.

Leutze Emanuel Gottlieb

Washington Crossing the Delaware

George Washington stands heroically at the prow of a crowded boat powered by oarsmen who negotiate the ice flows choking the Delaware River. Behind him two men struggle to raise the colonial flag, which will help to galvanize the boatloads of troops that follow Washington's lead. This huge canvas commemorates the Battle of Trenton of 1776, a crucial engagement of the American Revolution.

Painted in Europe, this subject reveals Leutze's intention to link the stirring imagery of the colonial revolution with the tenets of political revolution then taking place in Germany. The German-born Leutze was raised in the United States, but returned to Europe in 1841. After attending the Royal Art Academy in Düsseldorf, he stayed there for almost two decades, becoming the central figure of that art center

and carrying on the strong tradition of history painting for which it was known. He returned to the United States in 1859 and spent the remainder of his career carrying out commissions for similar large-scale paintings featuring key events in America's history.

☛ Greenough, C. W. Peale, Stuart, Trumbull

268

Emanuel Gottlieb Leutze. b Schwäbisch-Gmünd, Germany, 1816. d Washington, D.C., 1868. **Washington Crossing the Delaware.** 1851. Oil on canvas. **h**149 x **w**255 in. **h**378.5 x **w**647.7 cm. The Metropolitan Museum of Art, New York, NY.

Levine Jack

Street Scene #2

Outside a saloon, loitering under the lurid glow of a gaslight, a group of neighborhood grifters scans the racing form. In the tradition of New York's Ash Can School of urban realists, but with more of an impulse toward caricature, Levine initially focused on the slum dwellers of his native Boston. Rejecting Modernism as not suited to his temperament or artistic needs, he developed a stylized approach to representation in which forms are animated by the interplay of scumbled highlights and translucent shadows. He joined the Works Progress Administration's (WPA's) Federal Art Project in 1935 at the remarkable age of twenty. While still in his early twenties, he won acclaim for his ambitious social satires, rendered with a distortion that recalls El Greco and in a distinctive chiaroscuro technique that pays homage to Rembrandt. His goal, he said, was "not to go back to Rembrandt, . . . but to bring the great tradition, and whatever is great about it, up to date."

☛ Bishop, Luks, Riis, Woodville

Jack Levine. b Boston, MA, 1915. **Street Scene #2.** 1938. Oil on Masonite. **h**27 x **w**37½ in. **h**68.6 x **w**93.5 cm. Portland Art Museum, Portland, OR.

Levitt Helen

New York (Children with Masks)

Starting out on an early evening round of trick or treat, these masked Halloween revelers seem both elfin and incongruous in a city environment built for much larger people. They are wearing their Sunday-best clothes with their masks, leading us to wonder whether the outfits are part of their disguises or simply their parents' idea of propriety. Levitt made a career of such odd urban sights, concentrating less on events than on anecdote. She worked with an inconspicuous 35-millimeter camera, having been inspired by the photographs of Henri Cartier-Bresson, and made herself virtually invisible as she photographed life on the streets of the Lower East Side and East Harlem in New York City. She also made films of the same subjects, in collaboration with writer James Agee. In the 1970s she reprised her black and white work of the 1930s and 1940s using color slide film. These pictures, like her earlier ones, depict gestures and interactions that are at once human and surreal.

☞ Hine, Mann, Pinney, Witkin

Helen Levitt. b New York, NY, 1913. **New York (Children with Masks).** c1942. Gelatin silver print. Laurence Miller Gallery, New York, NY.

Lewitt Sol

Open Modular Cube

Six open squares constructed from painted aluminum repeat in length, width, and depth, producing a 5-ft cubic form. This work is a series of visually dizzying geometric corridors stacked serially, as well as a statement about art being more akin to mathematics than to expression or representation. If grammar refers to the rules, as opposed to the content, of a language system, *Open Modular Cube*

might best be understood as a work about the grammar of a three-dimensional object. Lewitt made this claim in 1965 while under the spell of Minimalist sculpture, when he began to make meticulous three-dimensional lattices. A year after he completed *Open Modular Cube,* Lewitt rejected the primacy of the object in art altogether and made what is considered by critics to be one of the first statements

about Conceptual Art: "The idea or the concept is the most important aspect of the work." These words appeared in Lewitt's article "Paragraphs on Conceptual Art," published in *Artforum* in 1967.

☛ **Bartlett, Judd, Martin, Reinhardt**

Sol Lewitt. b Hartford, CT, 1928. **Open Modular Cube.** 1966. Painted aluminum. **h**60 x **w**60 x **d**60 in. **h**152.4 x **w**152.4 x **d**152.4 cm. Art Gallery of Ontario, Toronto, Canada

Lichtenstein Roy

Hopeless

A bright-yellow blonde cries cartoon tears, her thought-bubble expressing a generic despair common to comic-book characters and soap-opera stars. Indeed, Lichtenstein's jilted character is a far cry from Picasso's "Weeping Women." The artist appropriated the figure from a DC Comics romance serial, changing her hair color from black to blonde. Using Benday dots (a form of line engraving used in advertising) and clichéd themes, Lichtenstein once hoped to make "a painting so despicable no one would buy it." But his painterly attention to detail, as well as his interest in the intersection of mechanically reproduced "low" culture and handmade "high" art, made Lichtenstein a Pop Art pioneer. By the time *Hopeless* appeared, Robert Rauschenberg and Jasper Johns had already used cartoons in their work, but only as part of painted collages that harked back to the all-over canvases of Abstract Expressionism. Lichtenstein took the bold step of eschewing the recent history of painting altogether — creating a new one in the process.

☞ Indiana, Rosenquist, Warhol, Wesselman

Roy Lichtenstein. b New York, NY, 1923. **d** New York, NY, 1997. **Hopeless.** 1963. Oil on canvas. **h**44 x **w**44 in. **h**111.8 x **w**111.8 cm. Kunstmuseum, Basel, Switzerland.

Link O. Winston

Hawksbill Creek Swimming Hole, Luray, Virginia

"No. 96 lets off steam (safety is blowing) and so do these kids in Hawksbill Creek on this hot summer night," is how Link described this fantastic scene in his notebook. An experienced New York commercial photographer and steam engine buff, Link used a score of carefully hidden flashbulbs, all connected to his camera by wires, to record both kids and train in one complex, instantaneous blast.

Link may not have been thinking of Surrealism at the time, but the way in which the splashing bathers seem oblivious of the enormous, clattering engine over their heads brings to mind the paintings of Magritte. In fact, Link's motive was more mundane: During the 1950s, when railroads were rapidly replacing steam with diesel engines, he spent five years haunting the lines of the Norfolk and Western

Railway in Virginia to record the dying breed. The railroad did not pay him for his trouble, but it did let him radio the engineers to ask them to slow down (or even back up!) so that he could get his shot.

☞ Crawford, Lawson, Pettibon, Weegee

273

O. (Ogle) Winston Link. b Brooklyn, NY, 1914. **Hawksbill Creek Swimming Hole, Luray, Virginia.** 1956. Gelatin silver print. Collection of the artist.

Louis Morris

Claustral

Stained into the canvas rather than painted on its surface, narrow bands of intense color parallel one another in lines shaped by gravity's pull along the porous material. Each hue is independent and distinct, with minimal bleeding to muddy its purity. This is an example of Louis's "Stripes" series, in which optical color interaction and formally refined vertical rhythms replace the sensuous, flowing shapes and atmospheric translucence that dominated his earlier "Veils and Florals" series. After seeing poured paintings by Jackson Pollock and Helen Frankenthaler in the early 1950s, Louis and his contemporary Kenneth Noland began using liquid paint to create chromatic abstractions. Louis treated water-based acrylics like traditional watercolors, but enlarged the format to mural-scale proportions and eliminated all subject matter other than the paint itself. His early death from cancer cut short a career that inspired the later Color Field painters.

☛ Diller, Frankenthaler, Newman, Noland

274

Morris Louis (Bernstein). b Baltimore, MD, 1912. d Washington, D.C., 1962. **Claustral.** 1961. Oil on canvas. **h**85 x **w**64½ in. **h**216 x **w**162.5 cm. Virginia Museum of Fine Arts, Richmond, VA.

Lozowick Louis

Seattle

The planes of the Seattle cityscape are reduced to simple, clean blocks rising in precise rhythms above streets absent of people. Buildings are represented not as places of work or habitation but as pure lines of geometric perspective brought into relief by sun and shadow. In this regard, *Seattle* manifests the hallmarks of Lozowick's Precisionist style, which, as the artist wrote, expressed "the rigid geometry of the American city . . . the verticals of its smoke stacks . . . the parallels of its car tracks, the squares of its streets, the cubes of its factories, the arc of its bridges, the cylinders of its gas tanks." Those words appear in a well-known essay that Lozowick contributed to the catalog for the "Machine-Age Exposition" in New York City in 1927. Lozowick traveled and wrote extensively about European and Russian art movements, introducing Americans such as Charles Sheeler to the then-prevalent European enthusiasm for American technology. In 1925, he published a pioneering monograph on Russian Constructivism titled *Modern Russian Art*.

☛ Abbott, Demuth, N. Spencer, Storrs

Louis Lozowick. **b** Ludvinovka, Russia, 1892. **d** South Orange, NJ, 1973. **Seattle.** 1926–27. Oil on canvas. **h**30⅛ x **w**22⅛ in. **h**76.6 x **w**56.2 cm. Hirshhorn Museum and Sculpture Garden, Washington, D.C.

Luks George

Hester Street

This urban scene on the Lower East Side of New York City is as dense with activity as it is absent of air. Buildings recede to the horizon, blocking all sight of the sky, while layer upon layer of pedestrians gossip, entertain children, and exchange the news of the day. In the foreground a man demonstrates a wooden puppet to a group of spellbound children as a mustachioed man eyes what we assume to be his wife several feet away, conversing with a street vendor. With its emphasis on working-class subjects and the teeming, often bawdy scenes of urban life, this painting exemplifies the work of The Eight. This first dissident group of twentieth-century American painters also included Robert Henri and Everett Shinn. Luks trained under Henri at the Pennsylvania Academy of Fine Arts and studied at the Dusseldorf Academy in Germany. Also known as Lusty Luks, he was a renowned bohemian and worked as a newspaper illustrator and cartoonist from 1890 to 1900.

☛ Hahn, Krimmel, Winogrand, Wong

276

George Benjamin Luks. b Williamsport, PA, 1867. d New York, NY, 1933. Hester Street. 1905. Oil on canvas. h26¹/₈ x w36¹/₈ in. h66.3 x w91.8 cm. The Brooklyn Museum of Art, Brooklyn, NY.

Lundeberg Helen

Double Portrait of the Artist in Time

The temporal and psychic journey from childhood to maturity is symbolized by the clock on the little girl's table and by an adult's shadow joining the two portraits. Depicting herself as a towheaded toddler, alert and vivacious, Lundeberg places a stem of buds in her hand. The stem she holds as a contemplative adult is in bloom, although not all its flowers have yet opened — indicating the twenty-

seven-year-old artist's awareness that she was still evolving. Indeed, she had been a painter for fewer than five years when she created this canvas. In the early 1930s she studied with the Californian artist Lorser Feitelson, whom she later married, and with whom she developed an approach that became known as Post-Surrealism. Based on De Chirico's Metaphysical Realism, it was described by

Lundeberg as subjective and thoughtful, "an ordered, pleasurable, introspective activity; an arrangement of emotions or ideas."

☞ **Elmer, Huntington, Kienholz, Laughlin**

Helen Lundeberg. **b** Chicago, IL, 1908. **Double Portrait of the Artist in Time.** 1935. Oil on masonite. **h**48 x **w**40 in. **h**122 x **w**101.6 cm. National Museum of American Art, Washington, D.C.

McCarthy Justin

Mabel Normand

This lively portrait from 1921 captures silent-screen star Mabel Normand in a coquettish pose. Then the highest paid actor in films, Normand was one of the greatest comedians of her age. This watercolor combines two of McCarthy's favorite subjects: women and Hollywood. Like a proto-Pop artist, McCarthy derived most of his subject matter from printed media sources. In this case, the actress's coy gesture and fetching flapper attire most likely came from a publicity photograph. McCarthy began painting while hospitalized for mental illness. He was released in 1920 and embarked on a sixty-year career in which he developed his painting skills through sheer force of will. In this work, McCarthy's awkward technique is apparent in his rendering of Normand's improbably long arm. He never would master the rules of perspective or anatomical rendering, yet, as in this painting, his work can manifest vitality and charm. The background of abstract whorls of paint is typical of McCarthy's naïve innovation.

☛ Hirshfield, Käsebier, Nadelman

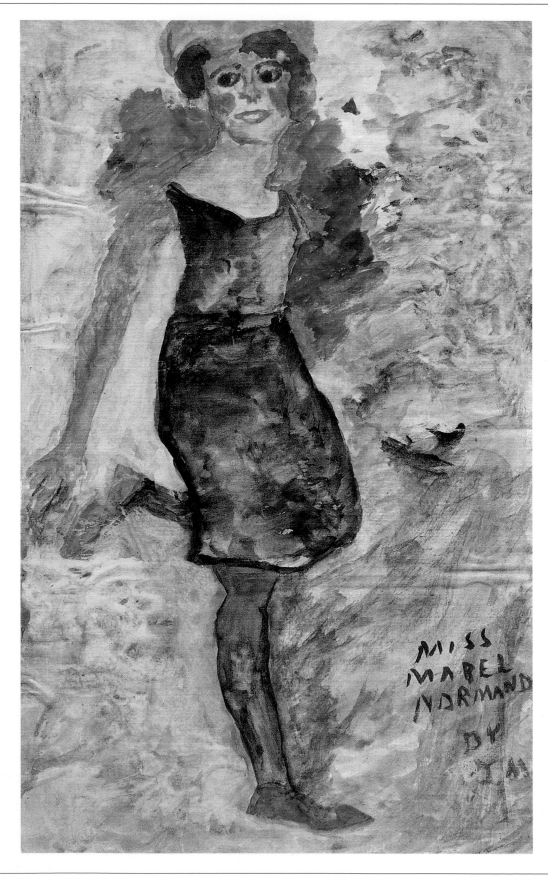

278

Justin McCarthy. b Weatherly, PA, 1891. d Weatherly, PA, 1977. **Mabel Normand.** 1921. Watercolor on paper. h6¹/2 x w8¹/2 in. h16.5 x w21.6 cm. Epstein/Powell Gallery, New York, NY.

McCarthy Paul

Bossy Burger

This shocking chef, who appears to be wearing a blood-stained apron, is really the artist, costumed in an Alfred E. Neuman mask (Neuman has been the *Mad* magazine mascot since 1955), red clown shoes, and a ketchup-splattered uniform. The photograph is a still from *Bossy Burger*, a video McCarthy shot on the set of a cancelled television sitcom. In it, McCarthy hosts his own improvisational cooking show in which he acts out absurdist Freudian scenarios with frantic physical energy and gallons of condiments. McCarthy's daring — and disgusting — live performances of the 1970s were unique amalgamations of Dada and Performance Art. In them he attempted to expose the limitations of American mores by coming to the very brink of transgression. Today, McCarthy concentrates on making life-sized animated sculptures that conjure up an X-rated Disneyland. He has also collaborated with the artist Mike Kelley in the medium of video.

☛ Acconci, Gober, M. Kelley

Paul McCarthy. b Salt Lake City, UT, 1945. **Bossy Burger.** 1991. Performance video. Luhring Augustine, New York, NY.

Macdonald-Wright Stanton Abstraction on Spectrum (Organization 5)

Fan-shaped gradations of brilliant orange and blue surround a molecular-looking cluster of orange and green circles in this celebration of color and its formal possibilities. Macdonald-Wright developed his Synchromist (meaning literally, "with color") system of chromatic formal organization in Paris around 1913, in collaboration with fellow American expatriate Morgan Russell. In the immediate aftermath of Cubism, the two were among a handful of American Modernists who attempted to purge painting of both representational and decorative associations. "I strive to make my art bear the same relation to painting that polyphony bears to music," he once explained. When Macdonald-Wright returned to the United States in 1916, his art became more figurative, although he continued to apply chromatic principles. After his move to California three years later, his compositions took on a distinctly Asian flavor that was reinforced by later travels to Japan.

☛ Carles, Gorky, Hartigan, M. Russell

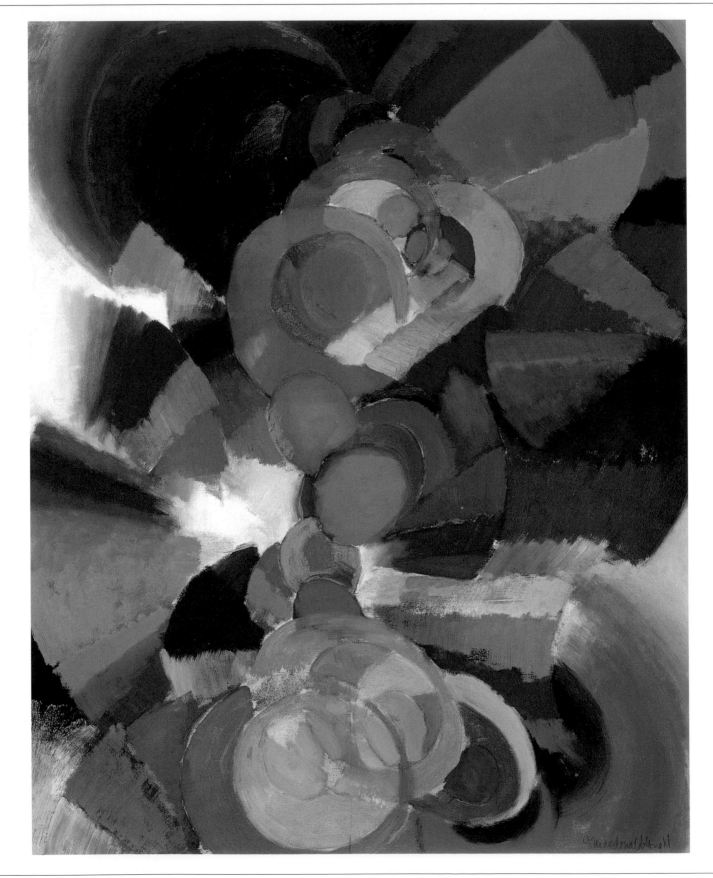

280

Stanton Macdonald-Wright. b Charlottesville, VA, 1890. **d** Santa Monica, CA, 1973. **Abstraction on Spectrum (Organization 5)**. 1915. Oil on canvas. **h**30$^{1}/_{8}$ x **w**24$^{3}/_{16}$ in. **h**76.6 x **w**61.5 cm. Des Moines Art Center, Des Moines, IA.

McIntire Samuel

Governor John Winthrop

John Winthrop, the theocratic first governor of the Massachusetts Bay Colony, casts his eyes heavenward in this memorial bust, carved after a seventeenth-century miniature portrait. The whitewashed wood and simplified forms suggest McIntire's attempt to imitate Neo-Classical marble sculpture, which he could have only known through books. To create this sculpture in the round, McIntire had to overcome the limitations of his two-dimensional model, as well as the absence of a robust sculptural tradition in America from which he could learn. McIntire spent his entire career in the seaport town of Salem, Massachusetts, where his carpenter father trained him as a builder. Responding to Salem's growing prosperity after the Revolution, McIntire extended his talents into architectural design, interior ornament, joined furniture, and ships' figureheads. His refined sense of design and exceptional woodworking skills can best be seen in the elegant relief carving of the furniture and Salem interiors that he created.

☞ Arneson, Powers, Rush, Stuart

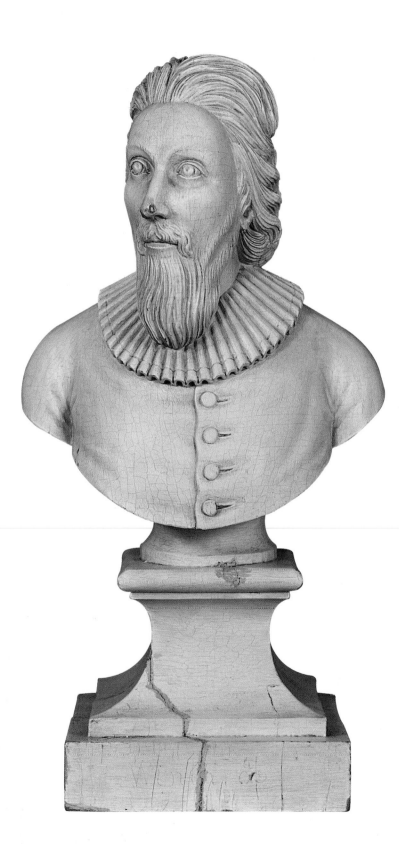

Samuel McIntire. b Salem, MA, 1757. **d** Boston, MA, 1811. **Governor John Winthrop.** 1798. Wood. **h**16 in. **h**40.7 cm. The American Antiquarian Society, Worcester, MA.

Maentel Jacob

Portrait of Dr. Christian Bucher

Maentel depicted this well-dressed doctor, who lived in the town where two of the artist's children were born, amid a colorful array of marked bottles, labeled drawers, and professional tools. The doctor's ambitious *portrait d'apparat* — a type of portrait depicting a sitter surrounded by the symbols or tools of his or her trade — suggests a sympathy between artist and sitter, perhaps based on

Maentel's initial training as a physician. It is not known if Maentel received any art instruction, but the tradition that he served Napoleon as both secretary and soldier perhaps implies that he worked as a military draftsman. By 1807 Maentel was in America, painting full-length profile portraits in watercolor. Maentel relied on stylistic formulas, which he altered and improved as time

went on. In his best work he lavished attention on landscape and interior settings, and rendered his sitters' features carefully to suggest individual character as well as likeness.

☞ Bundy, Eakins, Hubard, Neel

282

Jacob Maentel. b Kassell, Germany, c1763. d New Harmony, IN, 1863. Portrait of Dr. Christian Bucher. 1830–35. Watercolor, pencil, and ink on paper. h16⅝ x w10½ in. h42.3 x w26.7 cm. Museum of American Folk Art, New York, NY.

Malbone Edward Green

Eliza Izard (Mrs. Thomas Pinckney, Jr.)

The simple, natural look of this pretty girl who is shown against the foil of a cloudy sky and a hint of landscape signals the influence of Romanticism in the making of this exquisite miniature. The sitter was the seventeen-year-old Eliza Izard, a Charleston, South Carolina, resident whose portrait Malbone painted twice — the latter time in 1802, when she was courted by her smitten future husband, Thomas

Pinckney, Jr. Malbone was a self-taught artist of remarkable skill. A close friend of Washington Allston, the two traveled in 1801 to London, where Benjamin West was said to have marveled at Malbone's work. After his return he spent a five-month period in Charleston during which time he was said to have painted three miniatures per week. He went on to paint in other major cities,

leaving a legacy of these intimate, gemlike images to document the members of prominent families. Debilitated by tuberculosis, he ceased painting in 1806.

☛ **Phillips, Stuart, Sully, Wollaston**

283

Edward Greene Malbone. b Newport, RI, 1777. **d** Savannah, GA, 1807. **Eliza Izard (Mrs. Thomas Pinckney, Jr.).** 1801. Watercolor on ivory. **h**2⅞ x **w**2⁵⁄₁₆ in. **h**73 x **w**59 mm. Gibbes Museum of Art, Charleston, SC.

Mangold Robert

Curved Plane/Figure IV

Ghostly oval shapes are drawn onto the surface of two joined, shaped canvases, painted in subtle shades of blue and gray. At first glance the work seems like a typical piece of Minimalist art, a result of formulas, systems, and simplicity. But Mangold imbues his Minimalism with hints of uncertainty and emotion. In the case of *Curved Plane*, the top oval is more egg shaped, while both drawn figures must squeeze to fit within the constraints of the canvases' oddly truncated arc. The unusually shaped canvas and the mixture of drawing and painting are distinguishing features of Mangold's art. Like the paintings of Brice Marden, Mangold's often monochromatic works use pure colors tempered by the muted tones of nature, and they incorporate geometric forms that are never quite complete or that extend off the canvas and into space. Mangold paints his abstract artworks in a barnlike studio deep in the woods of his native upstate New York.

☛ Diebenkorn, Kelly, Man Ray, Marden

284

Robert Mangold. b North Tonawanda, NY, 1937. **Curved Plane/Figure IV.** 1995. Acrylic and black pencil on canvas. **h**98 x **w**142¾ in. **h**248.9 x **w**362.6 cm. PaceWildenstein, New York, NY.

Mann Sally

Gorgus

These girls have chosen an outdoor location for their impromptu beauty salon, and the pickup truck and curious dog on their flanks suggest that they live at a distance from sophisticated urban life. The beauty session is one of those universal adult rituals that children, in their early efforts to become like grown-ups, mimic with surprising accuracy but with often idiosyncratic results. To fully appreciate the picture, it helps to know that the girls are the photographer's daughters and that Mann has spent a large part of her career photographing them and her son in situations that suggest the trials of growing up. Mann, who feels that her pictures are largely autobiographical, began photographing her children in 1984, when her older daughter appeared at the door with her face swollen by gnat bites. In candid images like this one, Mann shows childhood to be not altogether innocent — a view some have found disquieting.

☛ E. Pinney, J. S. Sargent, Sloan, L. M. Spencer

285

Sally Mann. b Lexington, VA, 1951. Gorgus. 1989. Gelatin silver print. Edwynn Houk Gallery, New York, NY.

Man Ray

The Rope Dancer Accompanies Herself with Her Shadows

Pivoting at the waist to maintain her balance, the tightrope walker is an apt metaphor for Man Ray himself, who risked losing his creative equilibrium for the sake of experimentation. According to the artist, the "shadows" linked to his rope dancer by sinuous leashes were conceived accidentally. While he was cutting out stylized figures he had drawn on colored paper, the remnants fell to the floor in a chance arrangement of abstract shapes that inspired his composition. Well known for his seminal contributions to avant-garde photography, Man Ray began as a painter and was an early member of Alfred Stieglitz's modernist circle. After seeing the Armory Show in New York in 1913, he produced Cubist paintings, chromatic abstractions, air-brushed "aerographs," and found-object constructions. In 1921 he and Marcel Duchamp cofounded a New York incarnation of the Dada movement, which cloaked serious creative innovation in a guise of irreverent absurdist humor. Later that year Man Ray moved to Paris, where he spent most of his influential career.

☛ Davis, Hartley, Mangold, Weber

286

The Rope Dancer Accompanies Herself With Her Shadows

Man Ray (Emmanuel Radensky). b Philadelphia, PA, 1890. d Paris, France, 1976. **The Rope Dancer Accompanies Herself with Her Shadows.** 1916. Oil on canvas. **h**52 x **w**73³/₈ in. **h**132.1 x **w**186.4 cm. The Museum of Modern Art, New York, NY.

Manship Paul

Prometheus Fountain

Manship's gilded bronze monument, in the sunken central plaza of New York City's Rockefeller Center, represents Prometheus, the mythical Titan who stole fire from the gods and took it to Earth as a gift to humankind. As he descends through the heavens, symbolized by a zodiacal ring, Prometheus carries the spark ignited by the wheel of Apollo's chariot. The Titan was originally flanked by two human figures, male and female, that have been relocated to a nearby roof garden. Manship's sculpture, one of the city's most beloved landmarks, is among several artworks in the complex that deal with enlightenment, knowledge, and wisdom. His style is an amalgam of Classical prototypes updated by Art Deco stylization. As a preeminent twentieth-century academic sculptor, Manship received major public commissions in this country and abroad. Among his best known are the Rainey Gateway at the Bronx Zoo and celestial spheres for the League of Nations in Geneva and the 1964 World's Fair in New York.

☛ duBois, Koons, Lachaise, Nadelman

Paul Manship. b St. Paul, MN, 1885. **d** New York, NY, 1966. **Prometheus Fountain.** 1934. Gold-leafed bronze. **h**18 ft. **h**5.49 m. Rockefeller Center, New York, NY.

Mapplethorpe Robert

Ken Moody and Robert Sherman

This double portrait of a black man and a white man is less an attempt to illustrate racial difference than it is an appreciative meditation on the beauty of skin. The all-encompassing studio light used to isolate the profiles of these subjects gives their flesh the solid, impermeable appearance of marble Roman sculpture. Mapplethorpe's consummate technical skills may give this work a timeless feel, but the artist has also provided a subtle, intriguing narrative by closing the eyes of Ken Moody, one of his favorite models. Mapplethorpe is remembered by many for his homoerotic and sexually explicit imagery, and the ensuing controversy his work generated at several American museums in the late 1980s. These exhibitions ignited a heated political debate over public arts funding as well as censorship in the arts. Such subject matter, however, was only a small part of Mapplethorpe's output, which also included elegant still lifes, portraits, and images of sculpture.

☞ W. Kuhn, Michals, Nixon, Simpson

Robert Mapplethorpe. b New York, NY, 1946. d New York, NY, 1989. Ken Moody and Robert Sherman. 1984. Gelatin silver print. Robert Mapplethorpe Foundation, New York, NY.

Marden Brice

Study

The surface of this two-paneled painting, rendered in delicate shades of blue and gray, is uniquely opaque, like a dense layer of fog. Marden intends his paintings to be felt rather than just seen, their colors — and, in later works, their gestural lines — evoking natural phenomena and a sense of place. His flat planes of color and simple rectangular canvases place him squarely within the Minimalist tradition. However, since this designation precludes his art's emotional dimension, Marden is generally considered, along with Richard Tuttle and Eva Hesse, to be a "Post-Minimalist." Marden once wrote of his paintings' goal: "The rectangle, the plane, the structure, the picture are but sounding boards for a spirit." His pigments are often based in earth tones and mixed with luminous hot wax, the better to convey Marden's impressions of misty Mediterranean landscapes and rolling green fields.

☞ **Kensett, Mangold, Martin, Rothko**

Brice Marden. b Bronxville, NY, 1938. **Study.** 1966–69. Oil and wax on canvas. **h**35¹/₈ x **w**60¹/₂ in. **h**89.2 x **w**153.7 cm. Private collection.

Marin John

Off Deer Isle, Maine

Dividing Maine's rugged coastal landscape into a patchwork of inter-locking facets, Marin uses loose, sketchy brushstrokes to energize a solidly structured composition, with recognizable landmarks rendered in schematic shorthand. Marin was living in Europe during the development of Fauvism, Cubism, and their offshoots, and his early work shows the influence of Robert Delaunay. He began exhibiting at Alfred Stieglitz's "291" gallery in New York City in 1910, shortly before he returned permanently to the United States, and continued to show with Stieglitz throughout his career. Widely regarded as one of the foremost American abstractionists, Marin is best known for his watercolors and etchings, many of which depict Manhattan's soaring architecture and express the city's dynamic energy. After 1914, however, when he started visiting Maine, nature began to play an increasingly important role in his work. His abstracted land- and seascapes of that period align him more closely with his colleagues Arthur Dove and Georgia O'Keeffe.

☛ **Dasburg, Kensett, Kent, Stoddard, Watkins**

John Currey Marin. **b** Rutherford, NJ, 1870. **d** Cape Split, ME, 1953. **Off Deer Isle, Maine**. 1928. Watercolor on paper. **h**16 x **w**22 in. **h**40.7 x **w**55.9 cm. SBC Communications.

Mark George Washington

Dismal Swamp

Under the light cast by the moon a solitary Indian stands quietly observing the progress of a canoe crossing the lake of the Great Dismal Swamp. An air of mystery surrounds the couple in the boat, and the gothic nature of the scene is heightened by the cold, silvery palette and the sharp treatment of light as it outlines the jagged shapes of the trees, clouds, and the water's edge. Mark found his inspiration for this work in Thomas Moore's poem "A Ballad: The Lake of the Dismal Swamp," originally published in 1806 in *The Talisman*. The episode depicted focuses on the man in the canoe, who, driven into madness by the death of his lover, flees to the swamp, guided by the ghostly specter of his dead sweetheart. Little is known about Mark, but it is assumed that he was self-taught. In addition to painting pictures, he is recorded to have painted or stenciled furniture and reportedly devoted part of his Greenfield, Connecticut, home to an art gallery.

☛ Allston, Blakelock, Ryder, Whittredge

George Washington Mark. b Charlestown, NH, 1795. **d** Greenfield, CT, 1879. **Dismal Swamp.** 1840. Oil on canvas. **h**38 x **w**48 in. **h**96.5 x **w**122 cm. Virginia Museum of Fine Arts, Richmond, VA.

Marsh Reginald

Coney Island

New York's Coney Island, notorious site of American working-class summer leisure, is depicted here as a teeming mass of bawdy rippling flesh and preening, pompous seaside poses. Indeed, what makes Marsh's portrait so remarkable is that the landscape itself can hardly be located. It is indicated only by the carousel and the roller coaster, The Cyclone, hovering on the distant horizon. Born in France to

American parents, Marsh studied liberal arts at Yale University in the 1910s, then pursued professional art instruction at the Art Students League in New York City in the 1920s under Kenneth Hayes Miller, George Luks, and John Sloan. During this time he worked as an illustrator for leading illustrated magazines, including *Vanity Fair* and *The New Yorker*, and later served as a wartime correspondent

for *Life*. Marsh was a populist in his choice of themes as well as in his commitment to humorous, scenic Social Realism.

☛ French, Klein, Krimmel, Motley

Reginald Marsh. b Paris, France, 1898. **d** Dorset, VT, 1954. **Coney Island.** 1936. Tempera on panel. **h**59⅜ x **w**35⅜ in. **h**150.9 x **w**89.9 cm. Syracuse University Art Collection, Syracuse, NY.

Marshall Kerry James

Souvenir I

This angel is remembering the achievements of great African-American musicians from the worlds of jazz, blues, and R&B who float above, pulsating with energy and offering the names of their colleagues for a heavenly roll call. The angel's expression is serene but severe. She almost challenges us to contemplate the achievements of these performers, their role in society, and the circumstances of their deaths. The stark gray and white color scheme of this work suggests an old photograph, adding to this painting's sense of nostalgia. Marshall has set this scene in a typical middle-class African-American living room, updating the tradition of history painting to reflect African-American history and culture. Marshall was born in Birmingham, Alabama, and raised in Los Angeles — two cities central in the Civil Rights movement of the 1960s and 1970s. This painting is from the "Souvenir" series, a suite of four paintings commemorating the deaths of African-American political and cultural figures during the 1960s.

☛ Huntington, Osorio, Pippin, Tanning

Kerry James Marshall. b Birmingham, AL, 1955. **Souvenir I.** 1996. Acrylic, collage, and glitter on unstretched canvas. **h**9 x **w**13 ft. **h**2.7 x **w**3.96 m. Museum of Contemporary Art, Chicago, IL.

Martin Agnes

Untitled No. 4

A square white canvas measuring 6 ft by 6 ft is covered in thin, regularly spaced pencil lines. The shaky, hand-drawn horizontals gently activate the abstract painting's surface, lending it a meditative air. Martin's pencil grids — and later, her paintings of pastel-colored bands — have nothing to do with the purity of painted surfaces or form. Instead, they are attempts to convey a perfect state of emotional being. "In our minds there is awareness of perfection," Martin has said. While this sounds like the motto of a hard-core Modernist, Martin's "perfection" refers to an ideal state in which joy and serenity might be achieved. Though her works are based on organic elements, from the textures of woven cloth to the color of the desert around her New Mexico studio, Martin has called her paintings "anti-nature," in that they have nothing to do with the physical world, but rather with the spiritual and emotional realm.

☞ Judd, Mangold, Marden, Ryman

Agnes Martin. b Maklin, Canada, 1912. **Untitled No. 4.** 1984. Acrylic and pencil on canvas. **h**72 x **w**72 in. **h**183 x **w**183 cm. Private collection.

Matta-Clark Gordon Day's End/Pier 52

A crescent-shaped hole is cut through the 18-inch-thick walls of a steel-truss building on Manhattan's West Side, along the Hudson River. With its other strategic cuts and removals in the sides and roof of the abandoned pier building (formerly a railroad warehouse), *Day's End/Pier 52* allows light to pour into the decrepit, garbage-strewn space, transforming what Matta-Clark called an "industrial hangar" into a "sun-and-water temple." Trained as an architect (and a son of the Surrealist painter Matta), Matta-Clark was as devoted to the re-use of abandoned industrial sites as his colleague Robert Smithson — who, like Matta-Clark, also died young. Accomplishing the artist's stated goal of "converting a place onto a state of mind," Matta-Clark's sculptural projects gave abandoned buildings and forsaken houses a poetic finale long after their original functions were fulfilled.

☛ **Evans, Heizer, Smithson, M. White**

Gordon Matta-Clark. b New York, NY, 1943. **d** New York, NY, 1978. **Day's End/Pier 52.** 1975. Installation at Pier 52, Gansevoort Street and West Street, New York, NY.

Maurer Alfred H.

Women with Curlers

The faces of two women with their hair in rollers seem to conjoin at the eyes and chin, fusing into a single head. A shimmering aura of roughly scumbled white paint surrounding the two contributes to the hallucinatory effect of the image. Maurer was strongly influenced by Modernist developments in Paris, where he lived and worked from 1897 until the outbreak of World War I. He abandoned a conventional painting style to adopt Fauvism and Cubism and was instrumental in advising the organizers of the 1913 Armory Show about European avant-garde trends. His long series of abstract female portraits, known as the "sad girls," evolved after his return to the United States, where his paintings found few buyers. Increasingly at odds with his father, an illustrator for the printmaker Currier & Ives, Maurer was dependent on him financially. Soon after his father's death, he fell into despair and committed suicide, leaving a large body of work that illustrates his early and steadfast commitment to Modernism.

☛ Basquiat, De Kooning, Michals, Nutt

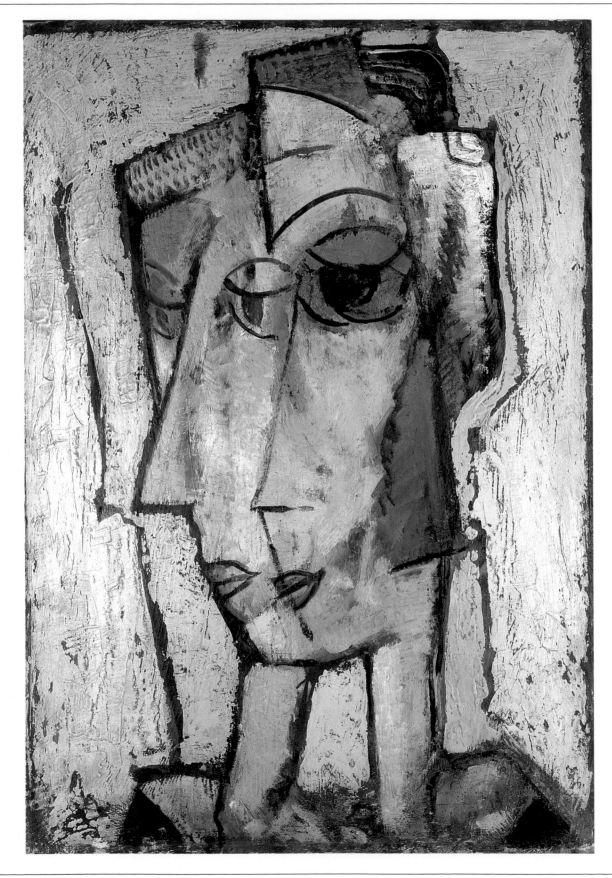

296

Alfred Henry Maurer. **b** New York, NY, 1868. **d** New York, NY, 1932. **Women with Curlers.** c1930–32. Oil on board. **h**26 x **w**18 in. **h**66 x **w**45.7 cm. Salander O'Reilly Galleries, New York, NY.

Metcalf Willard

Early Spring Afternoon — Central Park

The curving roadways of New York City's Central Park form a serpentine pattern leading the eye to the distant buildings that extend along Fifth Avenue. In this bird's-eye view painted from Metcalf's apartment in the Pamlico Building at Sixty-ninth Street and Central Park West, the urban character of the city is softened by the artist's emphasis on the budding greenery of the park and the late afternoon sunlight that infuses the still-crisp atmosphere with a glowing warmth. The feelings of well-being and detachment prevailing here echo the domestic calm that Metcalf achieved with his second marriage in 1911. The Impressionist mode displayed in this work doubtless stemmed from Metcalf's time in Giverny with Monet in the 1880s and was reinforced through his close association with Childe Hassam, a fellow member of a group of American artists dubbed The Ten. This group was formed in 1897 as ten painters who opted against exhibiting at the National Academy of Design in favor of more intimate, less orthodox settings.

☞ E. Porter, Twachtman, J. A. Weir, Wendel

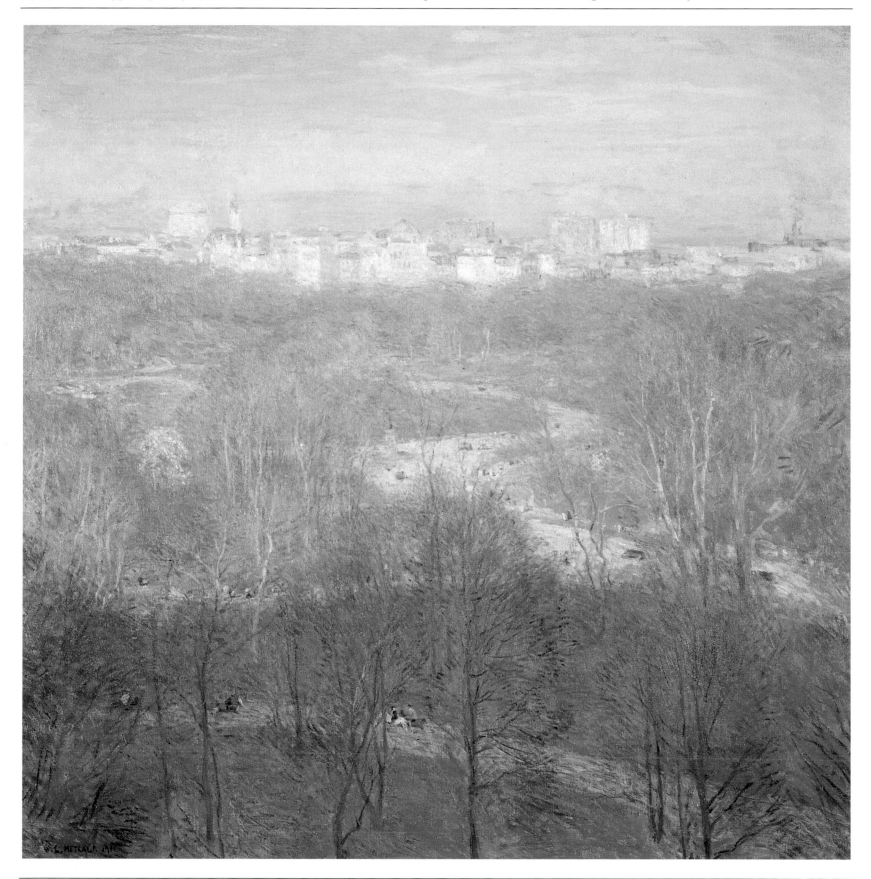

297

Willard Leroy Metcalf. b Lowell, MA, 1858. **d** New York, NY, 1925. **Early Spring Afternoon — Central Park.** 1911. Oil on panel. **h**36⅛ x **w**36 in. **h**91.7 x **w**91.4 cm. The Brooklyn Museum of Art, Brooklyn, NY.

Michals Duane

Who Am I?

The satyrlike young man holding the mirror is a figure simultaneously Classical and modern. Like the legendary Narcissus, he seems ready to drown in his own image, and like a student of Freud he seems suddenly aware of a duality within his very nature. By titling the image *Who Am I?*, the photographer suggests that the preoccupation with individual identity has a long history. Michals, who is best known for his "Sequences," or narrative serial images, of the 1960s and 1970s, began his career as a portrait photographer and has often returned to portraiture in the years since. In addition, he is known for writing short epigrams or fables in ink under his pictures, for painting over them in oils, and for arranging his subjects for the camera. While his methods evidence a desire to control the viewer's responses to his images, his subject matter reflects on the crucial role of the subconscious mind in art and in life.

☞ Goodes, Kienholz, Mapplethorpe, Maurer

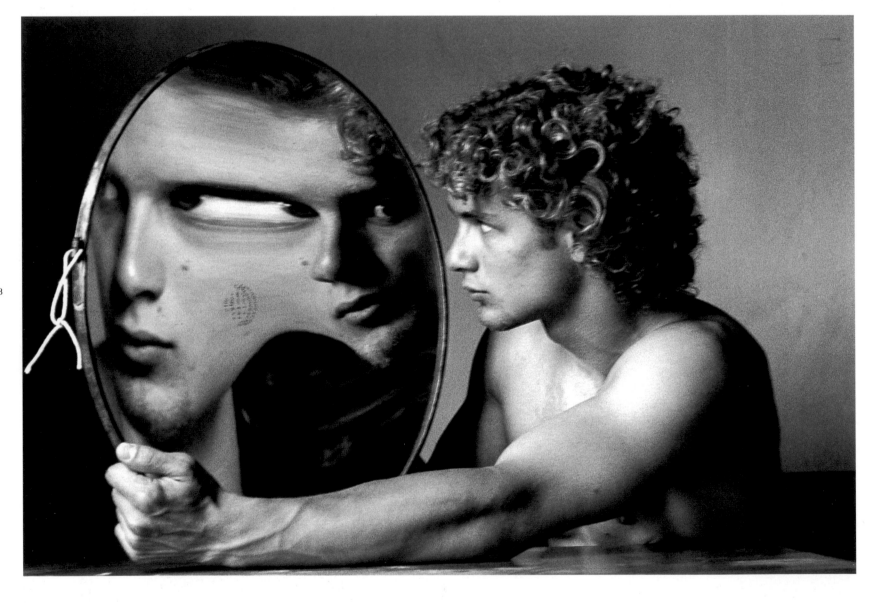

298

Duane Michals. b McKeesport, PA, 1932. **Who Am I?**. 1995. Gelatin silver print. Collection of the artist.

Miller Alfred Jacob

Interior of Fort Laramie

An Indian stands framed by the massive walls of a fort while another leans casually on a wooden railing, watching the activity of horses and men in the central courtyard. Across the quadrant, scouts peer over the wall. This is not a scene of war but rather one depicting white settlers and Indians cohabiting, apparently in peace. Miller was born in Baltimore, Maryland, and educated at the École des Beaux Arts in Paris. His life changed dramatically when he was hired by the Scottish nobleman Captain William Drummond Stewart to sketch scenes and events of a journey across the American West in the late 1830s. Miller's sketches are remarkable for their realistic documentation of Native American life within the context of white trappers, traders, and mountain men in the era before the Indian wars of the mid-nineteenth century. His sketches were also among the first records of other landmarks along the Oregon Trail, such as Chimney Rock and Scott's Bluff.

☛ Kern, C. Russell, Sharp, Wimar

299

Arthur Jacob Miller. **b** Baltimore, MD, 1810. **d** Baltimore, MD, 1874. **Interior of Fort Laramie.** 1858–60. Watercolor. **h**11⅝ x **w**14⅛ in. **h**29.5 x **w**36 cm. Walters Art Gallery, Baltimore, MD.

Misrach Richard

Desert Fire, #249

The distant glow that defines an otherwise featureless horizon provides both the chromatic splendor of this picture and its sense of ominous peril. The photograph is both an heir to the luminous tradition of nineteenth-century American landscape painting and a call for environmental awareness about the destruction of the American wilderness. It also embodies contradictions between past and present, beauty and negation, Man and Nature. Nothing the artist tells us indicates that human beings are responsible for the all-encompassing burn (before humans, lightning often set the desert ablaze), but we are likely nonetheless to feel a sense of loss and culpability. Misrach has photographed this region for more than two decades, producing series he calls Cantos that seek to illuminate the contemporary condition of a land that has often been abused precisely because it is so vast and seemingly limitless.

☞ Deas, Rothko, Ruscha, Turrell

300

Richard Misrach. b Los Angeles, CA, 1949. **Desert Fire, #249.** 1985. Color coupler photograph. Robert Mann Gallery, New York, NY.

Mitchell Joan

Charetiere

Explosive strokes and splashes of color burst through a field of white, like lava erupting from a snow-capped volcano. In spite of its lack of illusionistic imagery, Mitchell's canvas suggests the forces of nature, which she interpreted and translated into dynamic pictorial calligraphy. After studying art in her native Chicago, she arrived in New York City in 1948 and immersed herself in the avant-garde scene, quickly developing the bold, gestural style that won her early acclaim as a second-generation Abstract Expressionist. A white ground crisscrossed by interlacing diagonal strokes became a frequent compositional motif, one that evoked memories of her youthful talent as an ice skater. In 1959, disillusioned by Abstract Expressionism's diminishing status, Mitchell moved to France. There, she continued to explore the subjective territory of nature-based experience. As she explained, "I carry my landscape around with me."

☛ De Kooning, S. Francis, Pollock, Taaffe

301

Joan Mitchell. b Chicago, IL, 1926. **d** Paris, France, 1992. **Charetiere.** 1960. Oil on canvas. **h**76¼ x **w**58 in. **h**193.5 x **w**147.4 cm. Private collection.

Moran Thomas

The Grand Canyon of the Yellowstone

The vast majesty of the Yellowstone River Canyon is inspected by two men (one presumably white and the other Native American) who stand at the brink of the chasm. In the distance a cloud of mist partially obscures the great Yellowstone Falls, creating a focal point and also functioning as a reminder that it was the force of this water that carved the dramatic landscape. Moran first visited Yellowstone in 1871 with the US Geological Expedition. His sketches from that trip resulted in this panoramic canvas, which captured the natural grandeur of the land and also impressed Eastern audiences with the incalculable value of the nation's resources. The rich color and fluid paint surface reflect Moran's admiration for the English painter J. M. W. Turner, while the scale of the work recalls the spectacular landscapes of Thomas Church and Albert Bierstadt. Paintings such as this inspired national pride and also spurred action to preserve the wilderness. Moran was instrumental in helping to establish Yellowstone National Park in 1872.

☞ **Bierstadt, T. Hill, O'Sullivan, Watkins**

302

Thomas Moran. b Bolton, United Kingdom, 1837. **d** Santa Barbara, CA, 1926. **The Grand Canyon of the Yellowstone.** 1872. Oil on canvas. **h**84 x **w**144¼ in. **h**213.5 x **w**366.6 cm. National Museum of American Art, Washington, D.C.

Morgan Sister Gertrude

New Jerusalem

New Jerusalem, that heavenly city described by St. John in the Book of Revelations, is depicted here as a modern apartment building bustling with activity. Sister Gertrude herself occupies center stage as a string of admirers below and a great host of angels above attend her spiritual marriage to Christ. After an orphanage she had established in New Orleans was destroyed by hurricane in 1965,

Morgan founded her storefront Everlasting Gospel Mission to "whup up on sin." There, in a stark white interior, she preached, sang, and distributed her paintings as aids in her evangelical pursuits. Visitors to the Mission describe her as a formidable presence, dressed in white and testifying in a gravelly voice through a decorated megaphone. Her artworks detail rich, often apocalyptic

visions that warn of Satan's evils and celebrate an afterlife that awaits the faithful.

☛ Davis, Finster, Marshall, Harriet Powers

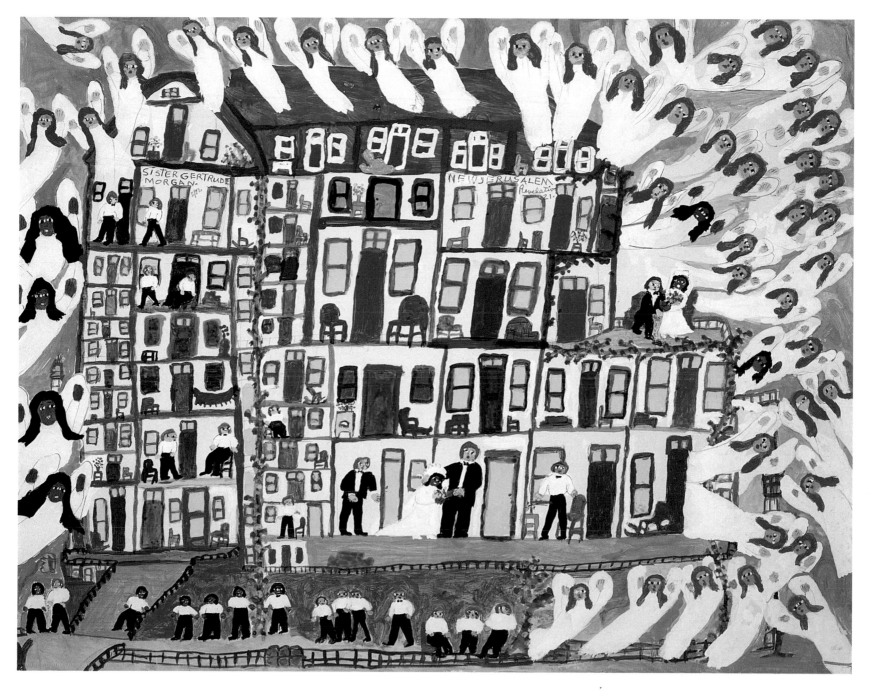

303

Sister Morgan Gertrude. b Lafayette, AL, 1900. **d** New Orleans, LA, 1980. **New Jerusalem.** 1972. Acrylic and ink on paper. **h**22 x **w**28 in. **h**55.9 x **w**71.2 in. Collection of Alice Yellen and Kurt Gitter.

Morris Robert

Untitled

Several rectangles of multicolored industrial felt, layered one on top of the other, are sliced repeatedly from top to bottom into a series of vertical bands with borders intact. The rectangle hangs from a wall so the uppermost ribbons are stretched taught while each of the subsequent bands descends into increasingly acute curves. Cutting, hanging, and gravity are the creative forces here, transforming huge layers of inert felt into a dynamic catenary, defined as the curve of a rope or chain of uniform density hanging freely from two fixed points. This work represents a key transition from the static, blunt, geometric abstraction of Minimalism to the dynamic, time-sensitive work known as Process Art. In 1968 Morris, a leading figure in the Minimalist movement, published "Anti-Form," an essay that argued for process and time as well the use of nonrigid, nontraditional materials in sculpture.

☛ Hesse, Puryear, Ramirez, Serra

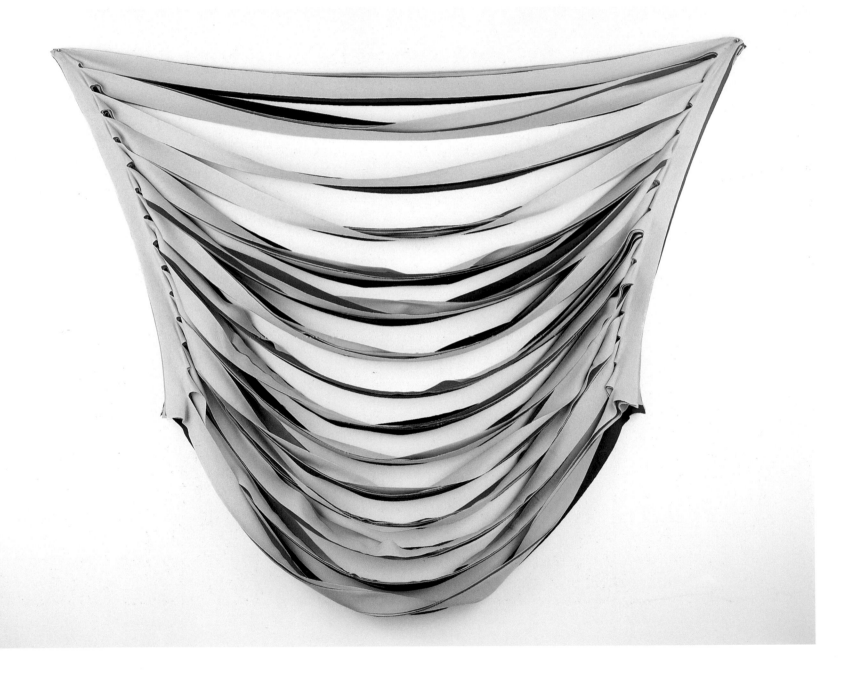

Robert Morris. b Kansas City, MO, 1931. **Untitled.** 1968. Felt, metal. **h**144 x **w**114 in. **h**366 x **w**290 cm. Walker Art Center, Minneapolis, MN.

Morse Samuel F. B.

The Old House of Representatives

A moment of quiet harmony reigns in the US House of Representatives as members and visitors gather for an evening session. At the center of this monumental canvas is a chandelier whose light casts an abstract pattern of shadows throughout the grand Classical space of the hall, which had been recently rebuilt by architect Benjamin Latrobe following the 1814 devastation of the Capitol by the English. Morse, a successful portraitist, had hoped that admission fees from the painting's tour to various US cities would repay his efforts. Despite the rare opportunity it provided audiences to glimpse the inner workings of the government, the painting failed to attract popular attention — largely because it lacked narrative drama and the average viewer had no connection to its subjects.

Morse ultimately quit painting in 1837, disappointed by the country's slow cultural advancement. He devoted the rest of his life to politics and inventing, and is best remembered for developing the telegraph and the Morse code.

☛ Persac, Robinson, H. Sargent, Trumbull

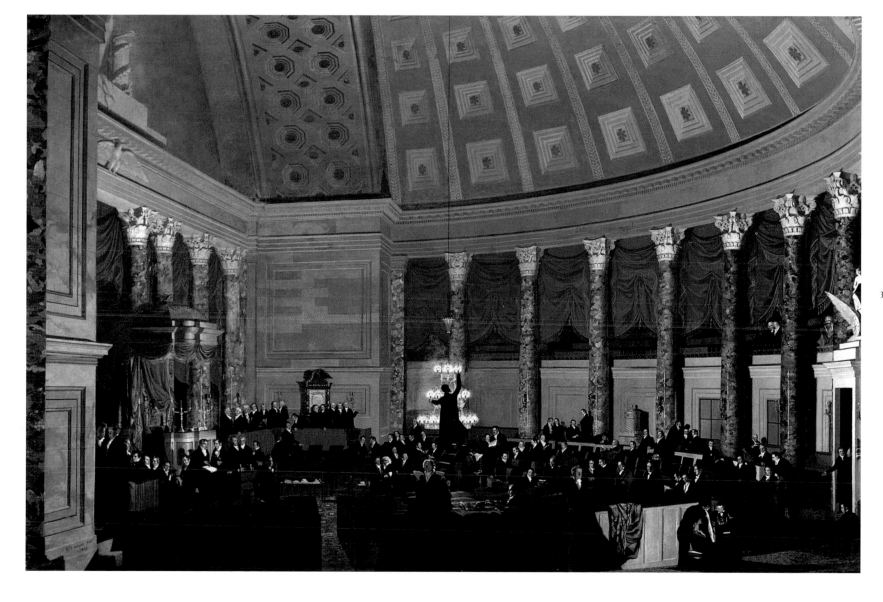

Samuel F. B. (Finley Breese) Morse. b Charlestown, MA, 1791. d New York, NY, 1872. **The Old House of Representatives**. 1822. Oil on canvas. h86½ x w130¾ in. h219.8 x w322.3 cm. The Corcoran Gallery of Art, Washington, D.C.

Moses Grandma

Hoosick Falls, NY, In Winter

Moses shares a fond childhood memory of life in this prosperous if modest turn-of-the-century community in rural upstate New York. Using a simple, direct pictorial image, she focuses on the town's busy denizens and a passing train in the foreground, leads us through the snow-covered landscape punctuated by neat houses, then draws the eye to the distant hills and sky. A devoted farm wife and mother of five, Grandma Moses was the self-taught pioneer of "memory painting," an unapologetically charming genre of folk art characterized by picturesque scenes of preindustrial America. Although as a child Moses painted farm scenes she called "lamb-scapes" with berry juice on paper, the artist was in her seventies when she began the oil paintings for which she is celebrated.

Influenced in part by images culled from newspapers, magazines, and Currier & Ives postcards, Moses immortalized a long-lost chapter in American history.

☞ Finster, Guy, Hofmann, Seifert

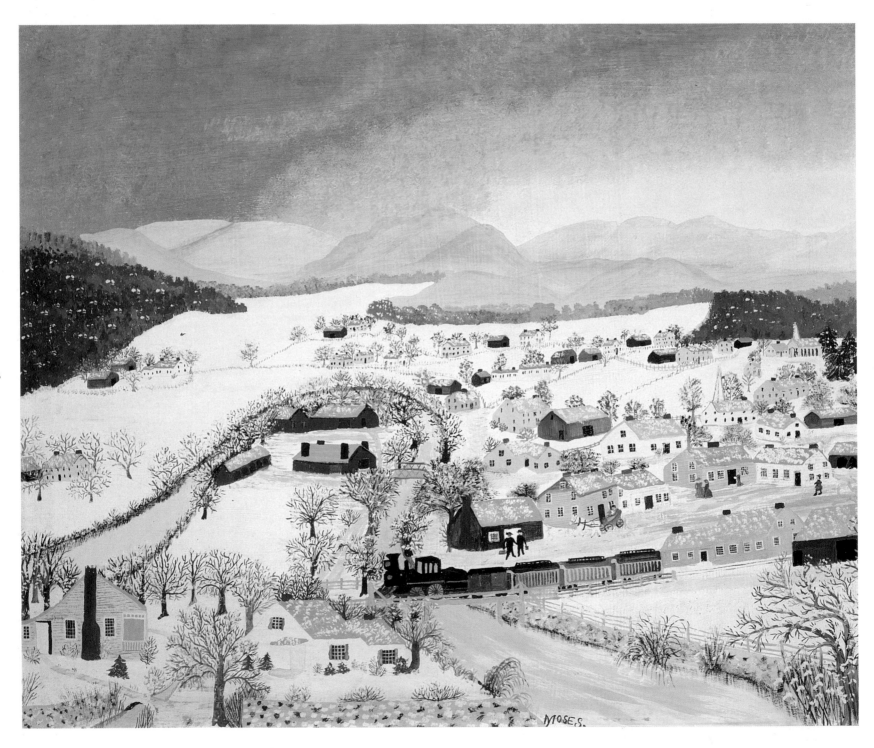

Grandma (Anna Mary Robertson) Moses. b Greenwich, NY, 1860. **d** Eagle Bridge, NY, 1961. **Hoosick Falls, NY, In Winter.** 1944. Oil on masonite. **h**20 x **w**24 in. **h**50.8 x **w**61 cm. The Phillips Collection, Washington, D.C.

Motherwell Robert

Elegy to the Spanish Republic No. LV

Two roughly oval shapes flank a densely brushed black rectangle on an equally sensuous white ground. The image has been likened to the genitals of a slain bull displayed against a whitewashed wall, and it is the primary motif of Motherwell's lengthy series of paintings memorializing the lost Republican cause in the Spanish Civil War. Motherwell began the series in 1949, more than a decade after

Spain's Republican Loyalists challenged the reactionary Falangists and captured the imagination of American liberals. His homage to the victims of the Spanish Civil War would occupy him for decades to come. One of the most articulate and philosophical of the Abstract Expressionist painters, Motherwell maintained that these paintings were not political but rather expressed his insistence that the war's

deaths should not be forgotten. Stark yet richly painted, the abstract symbolism is far from explicit. According to Motherwell, the series represents "general metaphors of the contrast between life and death, and their interrelation."

☞ Gottlieb, Kline, Krasner, Siskind

Robert Motherwell. b Aberdeen, WA, 1915. **d** Cape Cod, WA, 1991. **Elegy to the Spanish Republic No. LV.** 1955–60. Oil on canvas. **h**70 x **w**76¹/8 in. **h**178 x **w**193.5 cm. The Cleveland Museum of Art, Cleveland, OH.

Motley Archibald

Street Scene, Chicago

More than just a street scene, Motley's brightly colored genre study of urban African-American life celebrates a sense of community that erupts in high spirits, music, and conviviality. The beat cop in the foreground, however, is an unsettling presence even though he is ignored by the revelers behind him. Motley's distinctive style is an unusual combination of soft, sensuous figure modeling and highly formalized composition. At the Art Institute of Chicago, a series of lectures by George Bellows reinforced the young Motley's conviction that the everyday life of his people was a worthy theme. He was one of the first African-American painters to work in the Ash Can School tradition, depicting city dwellers sympathetically but honestly, as he saw them. Paradoxically, he lived and worked in a white neighborhood and had to visit black districts as an outsider in search of subject matter. In the 1930s, under the New Deal's art patronage projects, he became a supervisor for the Work Progress Administration (WPA) and painted murals for schools and an Illinois post office.

☛ **Cadmus, Greenwood, Krimmel, Marsh**

308

Archibald J. Motley, Jr. **b** New Orleans, LA, 1891. **d** Chicago, IL, 1981. **Street Scene, Chicago**. 1936. Oil on canvas. **h**36 x **w**42 in. **h**91.5 x **w**106.7 cm. Private collection.

Moulthrop Reuben Samuel Bishop

A portly man in a powdered wig sits upright in his chair, his eyes keenly alert and his finger holding his place in a book. Moulthrop's portrait acknowledges the vitality of an aged man still active in public service. Bishop had been an eloquent advocate of individual liberty during the raucous political debates of the 1760s; three decades later, at the age of 70, he succeeded Roger Sherman as mayor of New Haven, Connecticut. Moulthrop was one of several artists in middle Connecticut who answered locally the voracious demand for portraits after the Revolutionary War. Almost nothing is known of his early life or training, but he probably learned from the work of such artists as Winthrop Chandler and Ralph Earl. Moulthrop painted several accomplished portraits, but painting was apparently a sideline interest. Primarily he was a wax modeler and entrepreneur, displaying his wax figures in nearby towns and as far away as Boston and New York.

☞ Feke, Johnston, King, T. Smith

Reuben Moulthrop. b East Haven, CT, 1763. **d** East Haven, CT, 1814. **Samuel Bishop.** c1800. Oil on canvas. **h**35 x **w**30¹/₂ in. **h**88.9 x **w**77.5 cm. New Haven Colony Historical Society, New Haven, CT.

Mount William Sidney

Eel Spearing at Setauket

A young boy stills his oar, waiting for the second when the woman will thrust her spear at a fish. The suspenseful silence attached to this moment is reinforced by the carefully constructed composition, motionless water, and calm skies, all of which help to "freeze" the figures in time. Indeed, the subject originated in the memory of George Washington Strong, a New York lawyer who commissioned Mount to paint this nostalgic vision of his youth. Both men had been born in Setauket, on Long Island, and shared fond recollections of the area. Mount is remembered for genre paintings that glorified rural American values. In this instance, his patron, Strong, provided the specifics of this painting's imagery. His nephew modeled for the figure of the young Strong and the powerful woman was based on a servant in his father's household (the large double-chimneyed house at the center of the composition).

☛ Bingham, Durrie, Stoddard

310

William Sidney Mount. b Setauket, NY, 1807. **d** Setauket, NY, 1868. **Eel Spearing at Setauket.** 1845. Oil on canvas. **h**28¹/2 x **w**36 in. **h**72.4 x **w**91.5 cm. New York State Historical Association, Cooperstown, NY.

Murphy Gerald Watch

This pocket watch seems to have exploded, its face, hands, and gears scattered in space. Drawn with crisp precision and painted in flat, even tones, the carefully rendered mechanism could be an emblem for a nascent American avant-garde beginning its love affair with all things industrial. Murphy based his composition on two actual timepieces: a beloved pocket watch and a railroad watch designed for his family business, the Mark Cross company. The expatriate Murphy studied art in Paris with Goncharova and befriended Picasso and Léger. His cosmopolitan social circle also included Ernest Hemingway and F. Scott Fitzgerald, whose writings include characters based on Murphy and his wife, Sara. Influenced by Cubism and Purism (and anticipating Precisionism), Murphy developed an aesthetic that Picasso said was simple, direct, and, it seemed to him, American — certainly not European. After less than a decade, however, family circumstances forced Murphy to abandon his painting career.

☛ Bruce, Outerbridge, Roszak, Schamberg

311

Gerald Cleary Murphy. b Boston, MA, 1888. **d** East Hampton, NY, 1964. **Watch.** 1924–25. Oil on canvas. **h**78½ x **w**78⅞ in. **h**199.5 x **w**200.5 cm. Dallas Museum of Art, Dallas, TX.

Murray Elizabeth

Formerly Fleet

A pair of red shoes is seen in Cubist profile, the laces intertwined and illogically connected, the tops, sides, and heels of the shoes all visible at once. On a second look, the entire form resembles a guitar or violin — the staples of Picasso and Braque — but as filtered through the cartoon workshops of Walt Disney. Murray's shaped canvases, with their painted edges and warped angles jutting out from the wall, lend her paintings a sense of urgency and barely restrained motion. Murray developed her exuberant style — and her personal vocabulary of coffee cups, paintbrushes, and chairs — in the 1980s, just as Neo-Expressionism was becoming popular. She has been considered a Neo-Expressionist artist for her paintings' bright colors and muscular presence. Murray considers her paintings to be abstract, however, and her work has broadened a historically male-dominated field.

☞ **Haring, Man Ray, Puryear, Tuttle**

312

Elizabeth Murray. b Chicago, IL, 1940. **Formerly Fleet.** 1994–95. Oil on canvas. **h**99 x **w**76¹/₄ x **d**6 in. **h**251.5 x **w**193.7 x **d**15.2 cm. Museum of Fine Arts, Boston, MA.

Muybridge Eadweard

12 Exposures of Sally Gardner Galloping

This sequence of instantaneous photographs of a galloping horse named Sally Gardner shows something that was long thought to be impossible: the moment when all four of a horse's hooves leave the ground during forward motion. In the 1870s, California railroad magnate Leland Stanford had made just this claim, and hired Muybridge to prove it through a series of "locomotion studies." To make the series,

Muybridge used a bank of twelve glass-plate cameras with shutters that were tripped sequentially by wires strung at hoof-level. He continued the project through the 1880s under the auspices of the University of Pennsylvania. For a series of pictures intended to be used by painters, he photographed men and women running, climbing stairs, wrestling, and carrying buckets of water, among other activities. Born in

England, Muybridge made well-known images of the Yosemite wilderness area in California in the late 1860s. He also was known for inventing the zoopraxiscope, a device that was a forerunner of the modern movie projector.

☞ Baldessari, Remington, Troye, Warhol

313

Eadweard Muybridge. b Kingston-on-Thames, United Kingdom, 1830. **d** Kingston-on-Thames, United Kingdom, 1904. **12 Exposures of Sally Gardner Galloping.** 1878. Collotype print. George Eastman House, Rochester, NY.

Nadelman Elie

Dancer

Combining the charm of folk carvings with sophisticated stylization, Nadelman's figure embodies a romantic sensibility unusual in modern sculpture. Its sleek curves and complementary rounded and tapering forms are typical of his work, which had earned him acclaim in Paris and London before he emigrated to America in 1914. His first exhibition in this country, at Alfred Stieglitz's "291" gallery in New York City, was greeted with critical praise, and his work was eagerly sought by collectors and museums. Nadelman settled in Riverdale, New York, where he filled his home with a large collection of American folk art. In addition to bronze portrait heads and figures in painted and stained wood, he executed relief carvings for the Fuller Building and the Bank of Manhattan. In the early 1930s, however, Nadelman suffered financial reversals and retired from the art world, although he continued to make papier-maché and clay figures that were not exhibited until after his death.

☞ duBois, Hirshfield, W. Kuhn, Shapiro

314

Elie Nadelman. **b** Warsaw, Poland, 1882. **d** Riverdale, NY, 1946. **Dancer.** c1918–19. Cherry wood and mahogany. **h**28¼ in. **h**71.2 cm. Wadsworth Atheneum, Hartford, CT.

Nahl Charles Christian

Sunday Morning in the Mines

A series of vivid anecdotal dramas illustrating the widely varied activities of a mining camp on Sunday morning unfolds against the panorama of California's northern mountains. The wild, uncontrolled behavior of the men on the left creates a stunning contrast to the quiet, contemplative or domestic pursuits of the men on the right who are shown to observe the Christian sabbath customs as best they can in this raw environment. These episodes provide a moralizing visual essay of the crudeness and civility that existed side-by-side in California's rural mining camps. Nahl, who came from a family of respected German artists, abandoned a comfortable career in politically charged Europe for a new life in the United States around 1848. Caught up in the fevered excitement of the 1849 Gold Rush, Nahl went west and, for a brief time, worked in the California mines, where he observed firsthand the behavioral extremes that he later orchestrated in this masterful history painting.

☞ Anschutz, Hahn, Jewett, J. Thompson

315

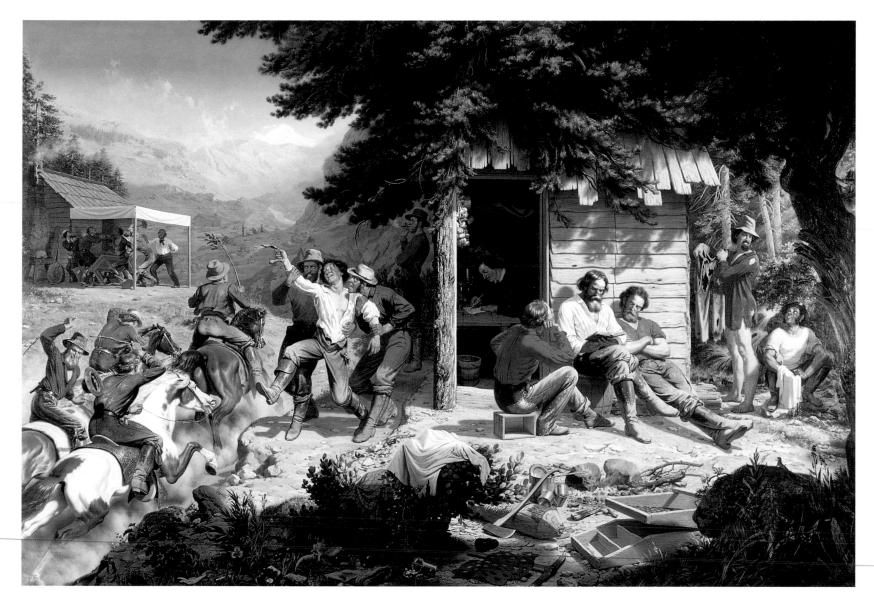

Charles Christian Nahl. b Cassel, Germany, 1818. **d** San Francisco, CA, 1878. **Sunday Morning in the Mines.** 1872. Oil on canvas. **h**72 x **w**108 in. **h**183 x **w**274.5 cm. Crocker Art Museum, Sacramento, CA.

Nauman Bruce

World Peace

What kind of statement about world peace is this? Five video monitors on simple metal stands face off in a loose circle, perched like stiff bureaucrats gathered for a meeting. The vacant cube under each monitor recalls the principles of Minimalism, utilized here to taunt the chattering box above with its significant emptiness. Isolated inside their framelike containers, the faces shout out to a lone office stool set in their midst, patiently "listening" to the cacophony. Made in the decade of globalization, *World Peace* extends Nauman's gift for deadpan wit. The artist defies categorization, working across a range of materials and media, from sculpture and performance to video and photography. A student of Robert Arneson at the University of California at Davis in the 1960s, his early work mined the history of art, particularly Dada, while his more recent work has been more concerned with political and social commentary. For Nauman, art is a form of research, an "investigative activity" that is about not objects but ideas.

☞ Baldessari, Berman, Friedlander, G. Hill

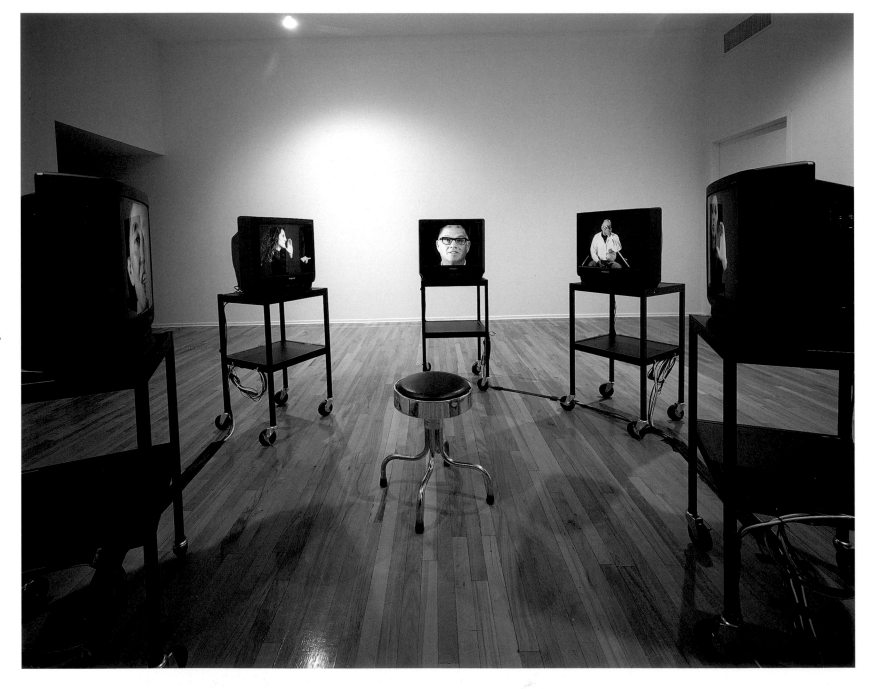

Bruce Nauman. b Fort Wayne, IN, 1941. **World Peace.** 1996. Video discs, monitors, video disc players, switchers, remote control, stool, utility carts. **diam** 126 in. 320 cm. The Saint Louis Art Museum (Modern Art), St. Louis, MO.

Neagle John

Pat Lyon at the Forge

The Philadelphia blacksmith Patrick Lyon is shown working in his smithy, with the cupola of the Walnut Street Jail visible through the window. The painting brought Neagle great acclaim because it boldly contradicted traditional portrait conventions by depicting a "common" laborer in the grand manner format usually reserved for the upper classes. Commissioned by Lyon eighteen years after he was exonerated from unjust accusations of burglary that had kept him locked in that very jail, the painting is a highly innovative portrait and a potent statement about the effectiveness of the justice system. Neagle's own humble beginnings doubtless increased his sympathy for Lyon's predicament. The painter successfully strove to transform himself from mere artisan to learned gentleman, adopting a sophisticated "high-style" painting technique inspired by his readings of Sir Joshua Reynolds and by his illustrious mentors, Thomas Sully (his father-in-law) and Gilbert Stuart.

☞ Anschutz, Healy, J. Kane, J. Weir

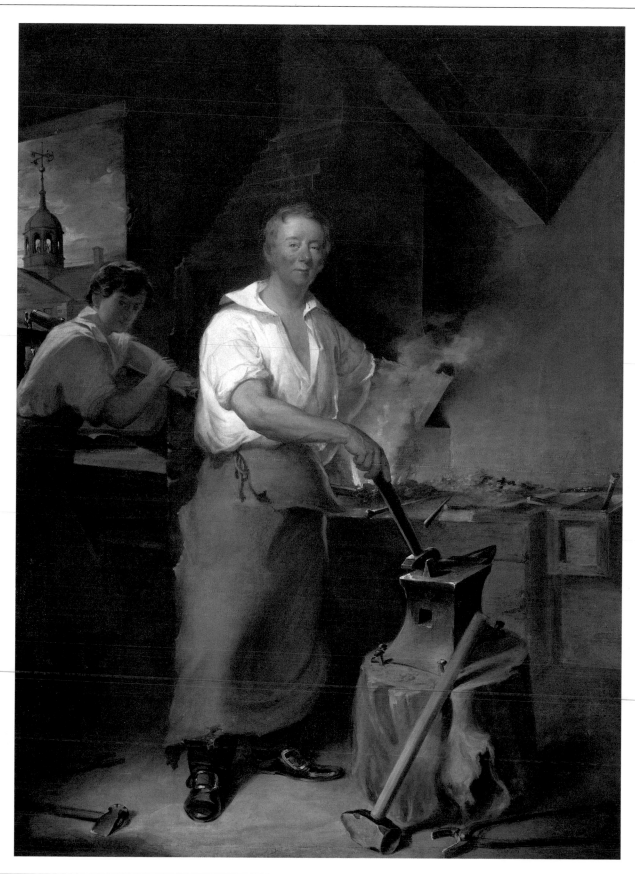

317

John Neagle. b Boston, MA, 1796. d Philadelphia, PA, 1865. Pat Lyon at the Forge. 1826–27. h93 x w68 in. h236.1 x w172.6 cm. Museum of Fine Arts, Boston, MA.

Neel Alice

Sherry Speeth

Looking us directly in the eye, Neel's subject seems to be making an earnest statement, stressing his point with gesticulating hands. The young man, a Canadian mathematician, was a graduate student at Columbia University when he posed for Neel. His dynamic, intense personality appealed to her, and his passion for mathematics prompted her to describe him as "all head," a quality she emphasized in the portrait. Even in New York City's bohemian art world, Neel was an eccentric figure. Heedless of changing trends, she pursued for some fifty years her own distinctive style of psychologically probing portraiture. Calling herself a "collector of souls," she used expressionistic distortion to reveal the sitter's inner self. She often portrayed victims of poverty or illness — both physical and mental — subjects unlikely to appeal to a mass audience. Her work went largely unrecognized until the 1960s, when renewed interest in figurative painting prompted critics and collectors to acknowledge her singular achievement.

☞ **Beaux, Earl, Rembrandt Peale, Southworth & Hawes**

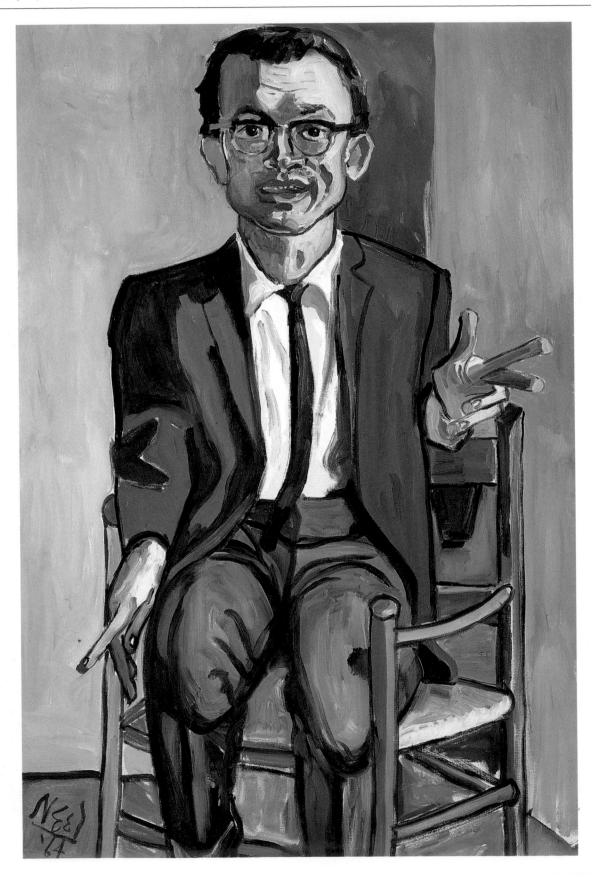

318

Alice Neel. b Merion Square, PA, 1900. **d** New York, NY, 1984. **Sherry Speeth.** 1964. Oil on canvas. **h**42 x **w**28 in. **h**106.7 x **w**71.1 cm. Cheim & Read, New York, NY.

Nevelson Louise

Black Chord

Recycled crates provide the framework for an assemblage of scrap lumber, furniture parts, balusters, and other salvaged elements, often picked up in the street outside Nevelson's lower Manhattan studio. Possibly as a result of growing up near her father's lumber yard, she developed a fascination with wood scraps that inspired a major body of modern sculpture. "Anywhere I found wood I took it home and started working with it," she said, adding that her aim was "to show the world that art is everywhere, except it has to pass through a creative mind." Here Nevelson, who once described herself as an "architect of shadows," has deployed the satiny black finish for which she is best known. Following the examples of artists such as Picasso and Joseph Cornell, she transformed mundane materials, often creating monochromatic, interrelated ensembles that prefigured installation art.

☞ **Albright, Cornell, Lewitt, Murphy**

Louise Berliowsky Nevelson. b Kiev, Russia, 1899. **d** New York, NY, 1988. **Black Chord.** 1964. Painted wood. **h**104½ x **w**117¾ x **d**12¼ in. **h**265.4 x **w**299.1 x **d**31.1 cm. Whitney Museum of American Art, New York, NY.

Newman Barnett

Be I

Splitting a radiant field of cadmium red, a stark white stripe creates tension and balance between the two mirror-image blocks of color. Newman's largest canvas to date, *Be I* was also his most reductive. When it was first exhibited, he instructed viewers to stand close to it, immersing themselves in the color and experiencing the unifying effect of the thin vertical element. This "zip," as Newman came to call it, began to appear in his paintings in the mid-1940s, when he was moving away from pictographic, myth-inspired abstraction toward a more transcendent, mystic, and universal vision. With his fellow Abstract Expressionists, he aimed to purge painting of narrative and anecdote without neglecting meaning, eliminating the need for representation in the process. "We are creating images whose reality is self-evident," he wrote, "and which are devoid of the props and crutches that evoke associations with outmoded images, both sublime and beautiful."

Dine, Flavin, Marden, Reinhardt

320

Barnett Newman. **b** New York, NY, 1905. **d** New York, NY, 1970. **Be I.** 1949. Oil on canvas. **h**94 x **w**76 in. **h**238.7 x **w**193 cm. The Menil Collection, Houston, TX.

Nixon Nicholas

F. K., Boston

A forehead covered by convoluted fingers and raked by sunlight is the central focus of this portrait, which defies the convention of highlighting the features of the face. In addition to giving a sign of the man's age, the deeply lined forehead suggests emotional turmoil and pain as clearly as if it were written in words. Nixon, who took the portrait in a Boston nursing home, has specialized in photographing people living with illnesses since 1983. After completing the nursing home project he began a series of portraits of people with AIDS, photographing them over the course of several years. He is also well known for his portraits of his wife and her sisters, which he has taken at the rate of one a year since the 1970s. At one time devoted to landscapes and architecture, Nixon uses the same bulky, large-format camera for his portraits, a technical feat made more amazing by the intimate distances at which he works.

☛ Arneson, Basquiat, Mapplethorpe, Nutt

Nicholas Nixon. b Detroit, MI, 1947. **F. K., Boston.** 1984. Silver contact print. Collection of the artist.

Noguchi Isamu

Cored (Cored Sculpture)

The irregular surface of a basalt boulder has been penetrated twice, first eccentrically, then with a more circular tunnel that literally exposes the stone's core. The sculptor's decision to enter the boulder at that particular point was apparently taken after a long period of frustrating uncertainty. Describing the process, Noguchi wrote that "sometimes, out of despair, when we have given up, the stone itself sends a message." Early in his career he was an assistant to Constantin Brancusi, from whom he learned principles of organic sculpture that were reinforced by his Asian heritage. The son of a Japanese father and an American mother, Noguchi maintained studios in both countries and executed public commissions around the world, as well as sets for the Martha Graham modern dance company. A formalist with a social conscience, he developed the concept of creative leisure in a series of park and playground designs that are now displayed in a garden museum devoted to his work in Long Island City, New York.

☛ Matta-Clark, Noland, Puryear, Siskind

Isamu Noguchi. **b** Los Angeles, CA, 1904. **d** New York, NY, 1988. **Cored (Cored Sculpture)**. 1978. Basalt. **h**74 x **w**33 x **d**26¹/2 in. **h**188 x **w**83.8 x **d**67.3 cm. The Isamu Noguchi Foundation, Long Island City, NY.

322

Noland Kenneth

Back and Front

From opaque red to translucent green, concentric rings of color become progressively more fluid as they resist the centrifugal force of the strong central circle. Darkness offsets the light that seems to emerge like the sun after an eclipse in this early example from Noland's "Target" series. The canvas illustrates his use of stained pigment as a response to Helen Frankenthaler's work of the early 1950s. At Black Mountain College in his native North Carolina, Noland had studied abstract painting with Ilya Bolotowsky, but his optical approach to color has more in common with Robert Delaunay's refracted discs. Later, however, Noland adopted a more geometric formalism, using a banded spectrum of colors and developing the shaped canvas as a major format in the 1960s.

Noland is a leading Color Field painter, but he has also turned his hand to sculpture.

☛ Dove, Irwin, Noguchi, F. Stella

Kenneth Noland. b Asheville, NC, 1924. **Back and Front**. 1960. Magna on canvas. **h**72 x **w**72 in. **h**183 x **w**183 cm. Private collection.

Nutt Jim

Boot

A woman in a geometrically patterned sweater stares off into space, her face composed of strangely modeled and earth-colored features. Nutt does not use live models for his portraits, instead building his faces improvisationally out of imaginary individual elements. Eyes, nose, ears, and lips are worked and reworked until they take on a life of their own. The sometimes disturbing results are reminiscent of Cubism, and especially Picasso's portraits of Dora Maar. Nutt began his career as a Pop artist in Chicago, as a member of a collective called The Hairy Who. His work has been identified with Chicago Imagism, a regional movement, though it shares even more affinity with the brash, hand-painted Pop Art of Peter Saul and the X-rated comics of Robert Crumb. For the past decade, Nutt has concentrated on such depictions of imaginary women, reinvigorating the genre of portraiture with his original, slightly offbeat approach.

☞ Close, De Kooning, Maurer, Phillips

324

Jim Nutt. b Pittsfield, MA, 1938. **Boot.** 1991. Acrylic on linen. **h**14 x **w**14³/₄ in. **h**35.6 x **w**37.5 cm. Galerie Bonnier, Geneva, Switzerland.

O'Keeffe Georgia

Two Calla Lilies on Pink

Painted at close range, these two flowers exude sensuousness tinged with cool restrain. Their swirling edges and golden pistils are simultaneously organic and erotic, while their surfaces seem molded in subtle gradations of white and gray. In the 1920s, O'Keeffe painted many such images of flowers and plants in which natural forms assume abstract shapes and swollen proportions. Richly toned blossoms and leaves nearly burst the edges of her canvases, suggesting a vibrant, unbounded creativity. O'Keeffe held her first solo exhibition at Albert Stieglitz's "291" gallery in New York City in 1917 at the age of thirty – a show that established her as a maverick trailblazer of American Modern art. That year she also visited New Mexico for the first time. Captivated by its colors and landscape, she returned throughout the years and eventually bought a house in Abiquiu. O'Keeffe lived most of her life in the Southwest, painting a luminescent world seemingly untouched by historical or artistic trends of the time, yet she was the artist who most defined a sublime native Modernism.

☛ Blume, Cunningham, Roesen, Taaffe

Georgia O'Keeffe. **b** Sun Prairie, WI, 1887. **d** Santa Fe, NM, 1986. **Two Calla Lilies on Pink.** 1928. Oil on canvas. **h**40 x **w**30 in. **h**101.6 x **w**76.2 cm. Philadelphia Museum of Art, Philadelphia, PA.

O'Sullivan Timothy

Ancient ruins in Cañon De Chelle, N.M., in a niche 50 feet above the canyon bed

Set into a vast canyon wall that dominates both the landscape and the picture surface, the ruins of Canyon de Chelly appear to be a folly, erected with as much difficulty and purpose as a ship in a bottle. Now a much-visited (and much-photographed) site, the pueblo was once a thriving, fortresslike community, but it had long been abandoned when it was discovered by the Wheeler Survey expedition in 1873. The expedition's photographer, Timothy O'Sullivan, was thirty-three years old at the time but was already a veteran of the Clarence King Survey of the Great Basin and of the battlefields of the Civil War, which he photographed for Mathew Brady and Alexander Gardner. Affected both by geological theories about the evolution of the Earth and by John Ruskin's aesthetic ideas concerning the close observation of nature, O'Sullivan pictured the West as a vast and overpowering landscape of sharp, often harsh features, its radical beauty seemingly independent of human sentiment and scale.

☞ Bierstadt, Dasburg, A. J. Russell, Watkins

326

Timothy O'Sullivan. b New York, NY, 1840. d Staten Island, NY, 1882. **Ancient ruins in Cañon De Chelle, N.M., in a niche 50 feet above the canyon bed.** 1873. Albumen print. The New York Public Library, NY.

Oldenburg Claes, and Coosje Van Bruggen Spoonbridge and Cherry

A 51-foot-long metal spoon forms a bridge to the center of a man-made pond. A bright red cherry balances on its tip, spraying water to make a rainbow. Oldenburg and his wife, writer Coosje Van Bruggen, have created many such large-scale public projects since their ongoing collaboration began in 1976. These works incorporate evocative and improbable everyday objects into the landscape. Such large-scale commissions as well as Oldenburg's earlier "soft" sculptures are classic examples of Pop Art, in which everyday objects and imagery are amplified into arresting art works. The theater-set quality of these sculptures can be traced in part to Oldenburg's pioneering role in Happenings, improvisational performances that were precursors to today's Conceptual and Performance Art. The stage-grabbing scale and exuberant color of Oldenburg's art was in part a reaction against the heroic aspirations of Abstract Expressionism. Today, works like Spoonbridge and Cherry still serve as a reminder of how Pop undermined the staid authority of Modernism.

☛ Acconci, Lichtenstein, Murray, Rosenquist

Claes Oldenburg. b Stockholm, Sweden, 1929. **Coosje van Bruggen. b** Groningen, The Netherlands, 1942. **Spoonbridge and Cherry.** 1988. Painted steel and aluminum. **h**354 x l618 x w162 in. **h**899.2 x l1569.7 x w411.5 cm. As installed at Walker Art Center, Minneapolis, MN.

Osorio Pepón

Scene of the Crime (Whose Crime?)

At a quick glance this scene looks like an ordinary dining room, perhaps belonging to a Catholic or Hispanic family. Hints of Puerto Rican culture and Catholicism dot the room: a black Virgin Mary guards the corner and myriad *chucherias* (a Puerto Rican term for knick-knacks) line the walls. But on closer inspection, the environment takes on a more theatrical aura. A movie light hangs

curiously over the table where a newspaper with the headline "He Beat My Wife" is visible. Portraits attached with zippers to four dining room chairs evoke an eerie reference to a once-present but now apparently absent family. Like a stage set without players, this installation provides clues to unwitnessed acts. Osorio emigrated to New York from Puerto Rico in 1975 at the age of twenty. For a

time he was a social worker in the child abuse prevention unit of the Human Resources Administration, turning to art in his late twenties when he saw it as a way of documenting the New York Puerto Rican, or Nuyorican, community.

☛ Kienholz, Marshall, H. Sargent, Sheeler

328

Pepón (Benjamin) Osorio. **b** Santurce, Puerto Rico, 1955. **Scene of the Crime (Whose Crime?).** 1993. Mixed media. As installed at the Whitney Museum of American Art, New York, NY.

Outerbridge Paul

Marmon Crankshaft

A crankshaft has never looked more heroic than in this paean to industry. Photographed in extreme close-up, the simple geometry of this engine part conveys strength and elegance. In the 1920s Outerbridge worked in a style known as Precisionism, which sought to portray the spirit of the Machine Age, and he frequently applied the style to commercial assignments he undertook for advertisers.

After studying at the Clarence White School of Photography in New York, where many of the first generation of advertising photographers got their start, Outerbridge became known for the precision of his compositions and for his pioneering color photographs. In addition to photographing consumer products in color, he made a series of fetishistic nudes that seem inspired by Surrealist art. Having forged

a successful career as a studio photographer in New York, Outerbridge moved to California in 1943 and lived in virtual retirement until his death.

☛ Groover, Murphy, Penn, Schamberg, Stieglitz

Paul Outerbridge, Jr. b New York, NY, 1896. **d** Laguna Beach, CA, 1958. **Marmon Crankshaft.** 1923. Platinum print. G. Ray Hawkins Gallery, Los Angeles, CA.

Page William

Mrs. William Page

The dark contour of a well-dressed woman dominates a composition that also depends on the dramatically irregular shape of the ruins of the Roman Colosseum looming behind her. There is a strange sense of timelessness in this painting, owing partly to the unnatural light and the uniform brushwork used throughout the canvas. Page, who had originally studied law and theology, later turned to painting.

Although he was eminently talented, his work was appreciated mainly by a small group of intellectuals, among them the Transcendentalist poet and critic James Russell Lowell. Page united his taste for high art with a spiritually based aesthetic influenced by the teachings of the Swedish philosopher Swedenborg. This portrait of his third wife, Sophia, embodies these views. Executed after their return from Rome,

the painting expresses Page's reliance on the enduring ideals of the Classical and Renaissance past and suggests his faith in the promised longevity of his marriage.

☛ Elliott, Neagle, Sully, Wood

William Page. b Albany, NY, 1811. **d** Staten Island, NY, 1885. **Mrs. William Page.** 1860/61. Oil on canvas. **h**60¼ x **w**36¼ in. **h**153 x **w**92.1 cm. The Detroit Institute of Arts, Detroit, MI.

Palmer Erastus Dow

Peace in Bondage

This low relief marble sculpture of a partially draped, winged female conveys an intentional measure of unease and spiritual anxiety that sets it apart from the emotional calm displayed by the ancient Greek sculptures that inspired it. Although Neo-Classical in style, the meaning of *Peace in Bondage* is rooted in the nation's paralyzed ideals during the Civil War. This theme permitted Palmer to depict the nude female figure — a generally unwelcome subject in America — because the powerlessness of this noble and mythological female neutralized her sexuality. Strong links existed between the ideas of Greek democracy and that of the United States, making the Neo-Classical vernacular an especially appropriate mode of expression for this tragic subject. Palmer began as a carpenter and then graduated to producing small cameo reliefs, but he created a remarkable body of work for one with so little formal training.

☛ **Ball, La Farge, Pope, Zorach**

Erastus Dow Palmer. b Pompey, NY, 1817. **d** Albany, NY, 1904. **Peace in Bondage.** 1863. Marble. **h**30 x **w**25¾ x **d**1½ in. **h**76.2 x **w**65.44 x **d**3.8 cm. Albany Institute of History and Art, Albany, NY.

Park David

Bather with Knee Up

Bold brushwork, thick impasto, saturated color, and a feeling of slablike solidity characterize this study of a bather, one of Park's most important themes. Park's painterly style is anchored in the human figure and reflects the strong influence yet ultimate rejection of Abstract Expressionism. He spent his professional life in California, where his early work emulated that of Picasso and the Mexican muralists. Following World War II, when Clyfford Still and Mark Rothko became his colleagues on the faculty of the California School of Fine Arts, Park briefly adopted an Abstract Expressionist style. By 1949, however, he had abandoned it as too egocentric. "A man's work should be quite independent of him," he once said, "and possibly very much more wonderful." Along with Elmer Bischoff, Richard Diebenkorn, and Nathan Oliveira, he was among the group known as the Bay Area Figurative Painters, who in the 1950s returned gestural painting to its representational roots in Fauvism and Expressionism.

☛ Bischoff, Fischl, J. Kane, K. Smith

332

David Park. b Boston, MA, 1911. d Berkeley, CA, 1960. **Bather with Knee Up.** 1957. Oil on canvas. **h**56 x **w**50 in. **h**142.3 x **w**127.1 cm. Orange County Museum of Art, Newport Beach, CA.

Parrish Maxfield

Riverbank Autumn

The luminous clarity and minute detail of this idealized landscape near the artist's home in Cornish, New Hampshire, make it look almost hyperreal. Parrish's singular and extremely popular style involved the use of delicate glazes to intensify his characteristic hues. His famous "Parrish blue" is subordinated here in favor of its complementary contrast, a glowing, autumnal orange. Parrish earned fame and fortune as an illustrator and then turned exclusively to landscape painting in the 1930s. He is best known for his widely reproduced images ranging from advertising art to fairy tales and imaginary scenes inhabited by nubile maidens. His work has appeared in countless magazines, books, calendars, and prints. Parrish also painted murals in several cities, including New York, where his version of Old King Cole and his court entertain the patrons of the bar in the St. Regis Hotel.

☞ Cropsey, A. Durand, Gifford, Whittredge

Frederick Maxfield Parrish. b Philadelphia, PA, 1870. **d** Plainfield, NH, 1966. **Riverbank Autumn.** 1938. Oil on board. **h**20 x **w**18 in. **h**50.8 x **w**45.7 cm. Cornish Colony Gallery & Museum, Cornish, NH.

Peale Charles Willson

Washington at the Battle of Princeton, January 3, 1777

Wearing the uniform of the Commander-in-Chief of the Continental Armies, George Washington commands center stage in this stately, didactic portrait. Pointing his sword toward the smoky battlefield of Princeton at the moment of British surrender, Washington also shields the dying General Hugh Mercer, attended by a surgeon and standard-bearer. The waving Stars and Stripes stabilizes the composition,

binding the painting's themes of victory and pathos, virtue and patriotism. The Trustees of Princeton College (now Princeton University, in present-day New Jersey) commissioned this work to replace a portrait of King George III that had been ruined by an artillery ball. Peale had studied briefly in London and set up a portrait practice in Maryland before serving Washington as a militia

captain and fighting in the Battle of Princeton. After the war, Peale continued to paint prosperous citizens and revolutionary heroes. Eventually he devoted his enormous energies to natural history and his museum in Philadelphia.

☞ Greenough, Jarvis, Leutze, Stuart

334

Charles Willson Peale. b Queen Anne's County, MD, 1741. d Philadelphia, PA, 1827. **Washington at the Battle of Princeton, January 3, 1777.** 1784. Oil on canvas. h93⅜ x w56⅞ in. h237 x w144.5 cm. The Art Museum, Princeton University, Princeton, NJ.

Peale Raphaelle

Venus Rising From the Sea — A Deception (After the Bath)

Except for a dainty bare foot and an upraised arm over which flows long blonde hair, nothing can be seen of the presumably nude female whose form is otherwise obscured. This intentionally provocative work is a rare trompe l'oeil still life purportedly made by the artist to tease his wife, who was sensitive to suggestive subject matter. On close inspection, the cloth is an illusionistically rendered napkin that appears to be pinned to a strip of fabric as if to conceal a painting showing the goddess of love. Raphaelle Peale, the eldest son of Charles Willson Peale (the patriarch of a family of talented artists), is considered the nation's first professional specialist in still-life subjects. Ignored until the twentieth century (largely because of the secondary rank still life held within the artistic hierarchy), this and Peale's more numerous spare, tabletop compositions featuring foodstuffs are now highly prized.

☞ Haberle, Ives, Peto, Pope

Raphaelle Peale. b Annapolis, MD, 1774. **d** Philadelphia, PA, 1825. **Venus Rising from the Sea — A Deception (After the Bath).** c1822. Oil on canvas. **h**29¼ x **w**24⅛ in. **h**74.3 x **w**61.3 cm. The Nelson-Atkins Museum of Art, Kansas City, MO.

Peale Rembrandt

Rubens Peale with a Geranium

A bespectacled young man is caught in a moment of unselfconscious contemplation, his thoughts apparently directed by his examination of the red geranium before him. Here, Rembrandt Peale, the seventh surviving child of Charles Willson Peale, created a sensitive portrait of his younger brother Rubens. In this painting Rembrandt displayed his own considerable powers of observation, particularly in the attention he lavished on the shimmering reflections on Rubens's cheeks formed by the light passing through his lenses. Plagued by poor eyesight, Rubens pursued the scientific rather than the artistic interests of his father, concentrating on the natural sciences and later on museum management. A product of Enlightenment attitudes, the portrait symbolizes the union of science and art through the empirical observation of the natural world. The painting was executed the year before the brothers sailed for Europe for further education and testifies to their shared belief in the cultural promise of the new nation.

☞ **Coburn, Neel, Sully, Wood**

Rembrandt Peale. b Bucks County, PA, 1778. **d** Philadelphia, PA, 1860. **Rubens Peale with a Geranium.** 1801. Oil on canvas. **h**28¼ x **w**24 in. **h**71.7 x **w**61 cm. National Gallery of Art, Washington, D.C.

Pearlstein Philip

Model with Crossed Legs and Luna Park Lion

A nude woman reclines cross-legged on a colorful blanket, the muscles and ridges of her body echoing the textile's geometric pattern and the lines of the amusement-park lion sculpture beside her. The use of a theatrical prop, as well as the woman's reclining pose, link this painting to a centuries-old tradition of nude portraiture. Yet Pearlstein's honest, unglamorous treatment of his model reveals an antiacademic attitude. His unstudied painting style, in which individual shapes and areas of color triumph over illusion, indicates an affinity with abstraction. In the late 1950s and early 1960s, artists rebelled against the ambiguity of Abstract Expressionism by creating Realist and Photorealist paintings. Pearlstein prefers the term "hard realism" to describe his paintings, which seek to balance the intellectual detachment of modernism with personal expression. As in the Minimalist portraits of his contemporary Alex Katz, Pearlstein proves that the tenets of abstraction need not necessarily be expressed in an abstract painting.

☛ Blume, Bourgeois, K. Smith, Wesselman

Philip Pearlstein. b Pittsburgh, PA, 1924. **Model with Crossed Legs and Luna Park Lion.** 1998. Oil on canvas. **h**48 x **w**36¼ in. **h**121.9 x **w**92.1 cm. Robert Miller Gallery, New York, NY.

Peck Sheldon

Anna Gould Crane and Granddaughter Jennette

A stern-faced woman and wide-eyed girl stare out of the canvas, intense and unsmiling. The grandmother's head is modeled sensitively but appears overly large. Academic as well as artisan portraitists sketched faces before adding settings and costumes, and Peck, like most itinerant painters competing with Daguerreotype photographers, used stylistic shortcuts and summary forms to reduce his working time. Several group portraits that Peck painted around 1845 during this short-lived challenge to photography feature nearly identical yellow floorboards and trompe l'oeil frames. By the 1850s the portraitist was advertising as a "decorative painter." Peck had probably practiced ornamental sign or furniture painting earlier as evidenced by the simulated wood grain of the frame and Bible cover or the trefoil pattern on Jennette's dress, which embellishes clothing and chairs in other Peck portraits. Peck was also a farmer, serving a rural clientele. Crane family records indicate that he painted this portrait "in trade for one cow."

☛ Brewster, Hopkins, Maentel, P. Vanderlyn

338

Sheldon Peck. b Cornwall, VT, 1797. **d** Lombard, IL, 1868. **Anna Gould Crane and Granddaughter Jennette.** c1837. Oil on canvas with simulated grain frame painted on canvas surface. **h**35¹/₂ x **w**45¹/₂ in. **h**90.2 x **w**115.6 cm. Private collection.

Penn Irving

Blast

An assemblage of steel blocks and cylinders sits precariously on a scuffled table top, looking like an industrial-strength children's building set or a study for a post-apocalyptic Stonehenge. Regardless of its associations, the arrangement takes on the quality of sculpture when seen in this photograph, an example of the personal work of one of America's most renowned magazine and advertising photographers, Irving Penn. Beginning in the 1970s, Penn retreated from his commercial career long enough to create fine-art photographs of cigarette butts, discarded street trash, and a variety of skulls and bones, all in service to an extended meditation on mortality. Originally a graphic designer before becoming a staff photographer for *Vogue*, Penn is noted for the spare elegance of his compositions and the restrained but clear-eyed beauty of his prints. Unlike artists who fear the taint of commercialism, Penn thrives by alternating between art and print assignments.

☞ Bailey, Nevelson, Outerbridge, Siskind

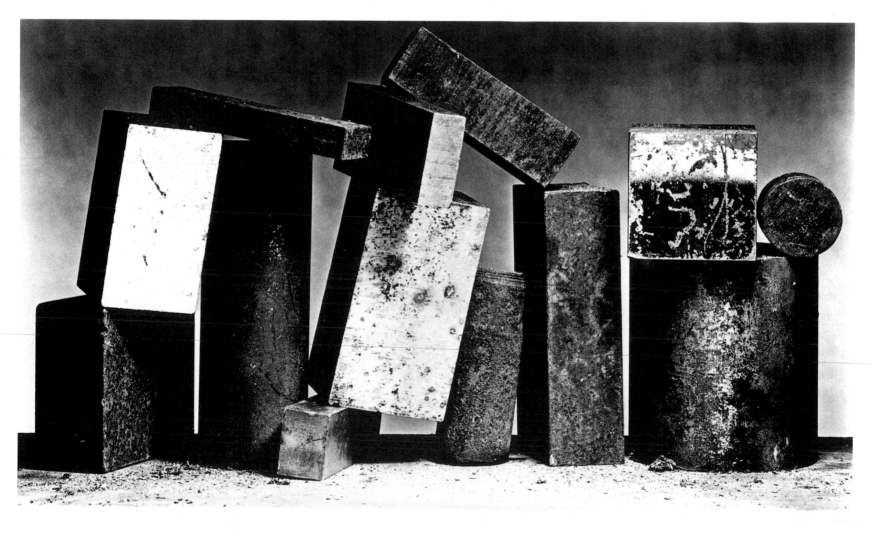

339

Irving Penn. b Plainfield, NJ, 1917. **Blast.** 1980. Platinum print. Irving Penn Studio, New York, NY.

Persac Marie Adrien

Saloon of Mississippi River Steamboat *Princess*

The impressive length of the main saloon of an elegant steamboat is accentuated by a radical perspectival rendering of the space. Despite the obsessive technical skill the artist used to depict the Neo-Gothic interior, he populated the foreground of his watercolor with figures cut from illustrated periodicals. Persac focused on the vessel's architectural symmetry, impeccable construction, and well-lit, pristine interior. He even color-coordinated the figures' garments with the tablecloths in the background: The woman's blue dress echoes the blue tablecloth at right, and the little girl's maroon skirts match the tablecloth at left. Persac was a surveyor and cartographer, specialties that required accurate draftsmanship but no particular competence in drawing the human form. He is believed to have arrived in America by 1851 and, like many Frenchmen of his generation, gravitated to the former French territory of Louisiana, where steamboats plying the Mississippi River were a major means of transportation in the nineteenth century.

👉 Bard, Colman, Morse, H. Sargent

340

Marie Adrien Persac. b near Lyons, France, 1823. **d** Manchik, LA, 1873. **Saloon of Mississippi River Steamboat** *Princess.* 1861. Goache with collage on paper. **h**17 x **w**23 in. **h**43.2 x **w**58.5 cm. Louisiana State University Museum of Art, Baton Rouge, LA.

Peto John F.

Reminiscences of 1865

A worn engraving of Abraham Lincoln hangs on wooden board among a seemingly arbitrarily chosen array of objects, among them a bowie knife, a pipe, and a faded newspaper clipping. Carved into the wood close to the portrait are "ABE" and "65," their placement obviously meant to identify Lincoln more completely and to indicate the year of his assassination. Peto painted numerous canvases along the Lincoln theme and his obsession is sometimes associated with the 1895 death of his father, a Civil War veteran, who reportedly found the knife pictured here at Gettysburg. The trompe l'oeil technique that Peto adopted shows the influence of his friend, the better-known painter William Michael Harnett, who was often mistakenly credited for Peto's unsigned paintings. It was not until the mid-twentieth century that scholars recognized a separate body of work belonging to Peto, allowing his career to emerge.

☞ T. Ball, Haberle, Harnett, Raphaelle Peale

John Frederick Peto. b Philadelphia, PA, 1854. **d** Island Heights, NJ, 1907. **Reminiscences of 1865.** 1897. Oil on canvas. **h**30 x **w**22 in. **h**76.2 x **w**55.9 cm. Wadsworth Atheneum, Hartford, CT.

Pettibon Raymond

No Title (That there is)

A series of melancholy texts handwritten above an ink-sketch of a speeding locomotive initially appears to be part of an underground comic strip. Yet on repeated scrutiny, the words and image seem evidence of a haunting and eloquent — if slightly quirky — existential quest. Pettibon's drawings include, in addition to his own philosophies, quotes from literary sources as diverse as William Faulkner and detective novelist Mickey Spillane, and he gleans imagery from Romantic painter Albert Pinkham Ryder, pornography, and film noir of the 1950s. Before Pettibon began to show his work in galleries, his drawings were printed on the record covers of Los Angeles punk-rock bands and in his own self-published comic books. Pettibon displays his drawings pinned directly to the gallery wall, often in clusters of up to one hundred at a time. Seen in such quantity, his recurring characters (like Ronald Reagan, Superman, and Gumby) and themes (the existential angst of surfers, the violence in American culture) coalesce into an exploration of the meaning of life.

☞ Lichtenstein, Link, Salle, Steinberg

Raymond Pettibon. b Tucson, AZ, 1957. **No Title (That there is).** 1988. Pen and ink on paper. **h**17$\frac{1}{2}$ x **w**11$\frac{1}{4}$ in. **h**44.5 x **w**28.6 cm. Regen Projects, Los Angeles, CA.

Phillips Ammi

Portrait of a Young Woman, possibly Mrs. Hardy

A young woman with dark eyes and full lips, her married status implied by black clothing and bound hair, bears an expression of imperturbable softness. Phillips created this effect by minimal means, gently shading the outlines of the woman's form and painting the background as a halolike aura. At the outset of his career Phillips boldly advertised an ability to paint portraits with "correct style, perfect shadows, and elegant dresses"; this woman's diaphanous sleeve and lacy headdress suggest the modest elegance of Phillips's earliest sitters. Phillips painted portraits in rural New York, Connecticut, and Massachusetts for more than five decades. As his artistry matured and the taste of his patrons changed, he adapted his style accordingly. So dramatic was his evolution that historians originally classified his paintings as the work of two artists. As his palette became bolder and his compositions more sophisticated, however, Phillips retained a compelling simplicity of design.

☞ **Feke, Malbone, Nutt, Prior**

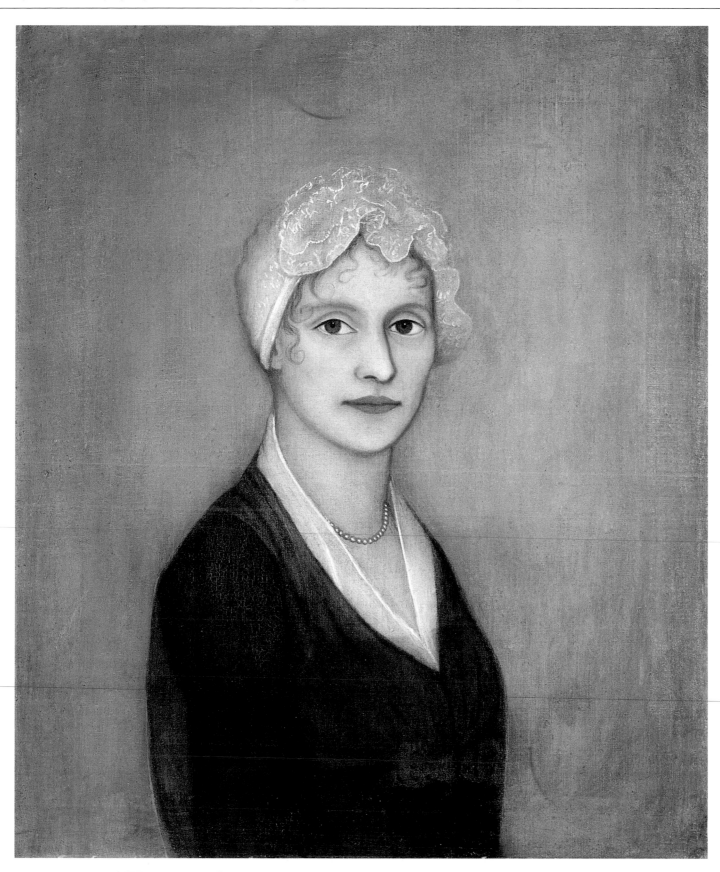

Ammi Phillips. b Colebrook, CT, 1788. **d** Western, MA, 1865. **Portrait of a Young Woman, possibly Mrs. Hardy.** c1812–19. Oil on canvas. **h**30 x **w**25 in. **h**76.2 x **w**63.5 cm. Private collection.

Pierce Elijah

Saul on the Road to Damascus

The voice of God strikes Saul like a thunderbolt, knocking him flat on his back. Folk carver Pierce offers a dramatic interpretation of the apostle Saul's conversion, compressing two moments of this Biblical event from the *Book of Acts* into one scene. On the left, Saul rides into Damascus, regal in posture and flanked by troops. Pierce depicts God's message as a golden arrow from a silver cloud, a force

so powerful it throws Saul from his mount in the right section of the work. On the far right, a radiant Christ appears above a flowering plant, a symbol for Saul's salvation and also the spiritual redemption Pierce sought for himself and others. As a lay minister, Pierce used such bas-relief wood carvings as teaching tools and depicted numerous Biblical events and moral parables. The barbershop he established in

1954 gradually evolved into a makeshift art gallery as Pierce devoted more time to carving and receiving visitors.

☞ Finster, Henderson, Job, Harriet Powers

Elijah Pierce. b Baldwyn, MS, 1892. **d** Columbus, OH, 1984. **Saul on the Road to Damascus.** 1966. Painted bas relief wood carving. **h**15 x **w**25 in. **h**38.1 x **w**63.5 cm. Private collection.

Pinney Eunice

Children Playing

On a verdant lawn, perhaps a town green, five children frolic soberly in a roughhouse game, perhaps "Bait the Bear," in which children buffet a kneeling "bear" while trying to evade his "keeper"—a captured assailant who becomes the next bear. The lively composition, with rhythmic motions of children echoed in wavy mounds of greenery, is probably copied from a print, although Pinney's handling of the lawn, with parallel strokes and alternating bands of color and white, seems to emulate embroidery. Presumably, Pinney practiced needlework before taking up watercolors around the age of forty, yet the well-born and well-educated Pinney was also known in her lifetime as "a woman of uncommonly extensive reading." Romantic literature often provided her subjects, and although she depended on printed illustrations for compositions, she was never a simple copyist. The uncommon boldness of design and coloring in her watercolors bespeaks a mature confidence of hand and mind.

☛ Elmer, Link, Mann, L. M. Spencer

Attributed to **Eunice Pinney. b** Simsbury, CT, 1770. **d** probably Simsbury, CT, 1849. **Children Playing.** c1813. Watercolor on paper. **h**7¹³/₁₆ x **w**9⅝ in. **h**18.1 x **w**24.4 cm. Abby Aldrich Rockefeller Folk Art Center, Williamsburg, VA.

Pippin Horace

Man on a Bench (Self-Portrait)

Autumn leaves add a sense of melancholy to this man's introspective pose, while in the background, a white squirrel assumes a ghostly presence. Pippin uses color to great effect in this work. His subject's somber attire suggests the falling leaves behind him, a stark contrast to the brilliant red bench and verdant grass. The artist completed this painting shortly before his death, and it is widely assumed to be an emotional self-portrait. He was living through a difficult period, with his wife in the hospital and the demands of his success as an artist taking a toll. After completing distinguished service in World War I, Pippin had returned to his hometown of West Chester, Pennsylvania, subsisting on a disability pension and painting in his spare time. His work was discovered in a local art exhibition in 1937, and he rapidly rose to national prominence, exhibiting at The Museum of Modern Art the next year.

☞ Eggleston, Goldin, Hopper, Marshall

346

Horace Pippin. b West Chester, PA, 1888. **d** West Chester, PA, 1946. **Man on a Bench (Self-Portrait).** 1946. Oil on canvas. **h**14 x **w**18 in. **h**35.6 x **w**45.7 cm. Collection of Mr. and Mrs. Daniel W. Dietrich II.

Pollock Jackson

Number 1, 1950 (Lavender Mist)

In this famous painting Pollock wove a rich tracery of color — which actually includes no lavender pigment — like a veil dappled with shimmering silver highlights. The artist's handprints embellish the edges of the canvas, declaring his authorship with the most universal of signatures. Pollock's rhythmic pattern of gestures belies the notion that his poured paintings are chaotic. Using fluid house paint as his primary medium, he worked spontaneously but deliberately to express, as he put it, "energy and motion made visible." Pollock, internationally recognized as the foremost figure in the Abstract Expressionist movement, developed his radical and still-controversial pouring technique as the most effective way to achieve his aims, once remarking that "technique is just a means of arriving at a statement." This masterpiece marks the high point of Pollock's career, which was cut tragically short by his death at forty-four in an automobile accident.

☞ De Kooning, Kline, Mitchell, E. Porter

Paul Jackson Pollock. **b** Cody, WY, 1912. **d** Springs, Long Island, NY, 1956. **Number 1, 1950 (Lavender Mist).** 1950. Oil, enamel, and aluminum on canvas. **h**87 x **w**118 in. **h**221 x **w**299.7 cm. National Gallery of Art, Washington, D.C.

Pope Alexander

The Trumpeter Swan

The majestic body of a trumpeter swan hangs suspended from a rope, its white luxuriant plumage posing a striking contrast to the plain wooden paneling that frames it. Depicted in this severe manner, almost as an icon, the image of the swan suggests strong associations with martyred saints and may reflect Pope's reportedly proconservation attitudes. Although known early on as the

"American Landseer" (in reference to the great British animal painter Edwin Landseer), Pope's treatment of the subject is extraordinarily confrontational by virtue of its scale as well as its simplicity. As such it certainly transcended the norm of animal specialty and is uniquely moving in comparison to other examples of Pope's art. The Boston-based painter enjoyed a modicum of success throughout his career.

However, his reputation rests on a group of approximately ten large trompe l'oeil canvases (including this painting) executed from the late 1880s onward.

☛ Bellamy, Harnett, Palmer, Peto

348

Alexander Pope. b Dorchester, MA, 1849. **d** Hingham, MA, 1924. **The Trumpeter Swan.** 1900. Oil on canvas. **h**56⅝ x **w**44⅜ in. **h**143.8 x **w**112.7 cm. Fine Arts Museums of San Francisco, CA.

Porter Eliot

Redbud Tree in Bottom Land, Red River Gorge, Kentucky, 1968

An intricate lattice of buds and branches depicted in a soft, encompassing light gives this picture the appearance of a puzzle: how, we might ask, does such a wealth of detail verge from the inchoate to an organized scene of beauty? In a sense, the visual problem here is similar to that in a Jackson Pollock drip painting, since our eyes and brains are forced to reconcile the competing demands of particularity and abstraction. Porter, who used color at a time when almost all "serious" photography was in black and white, often dwelt on abstract-looking forms and values in his landscapes, which were exhibited in the same New York gallery that showed Ansel Adams's black and white pictures. Porter's work, like Adams's, also was published in book form by the Sierra Club as a means of raising environmental awareness. Porter's photographic career began in the 1940s as an outgrowth of his scientific interest in birds, which he photographed with a large camera and color film to help in their identification

☞ Callahan, Caponigro, Metcalf, Pollock

Eliot Porter. b Winnetka, IL, 1901. **d** Santa Fe, NM, 1990. **Redbud Tree in Bottom Land, Red River Gorge, Kentucky, 1968.** 1968. Dye-transfer print. Amon Carter Museum, Fort Worth, TX.

Porter Fairfield

Chris, Sarah, Felicity

Squinting against strong sunlight, the children of the artist's friend Lucien Day pose casually with the family dog. Like many of Porter's figure studies, this group portrait has a snapshot quality. Perched on a saw horse and slumped against the wall, the youngsters are not arranged for a lengthy formal sitting. Influenced by the French painters Pierre Bonnard and Éduard Vuillard, Porter developed a figurative style that incorporated aspects of Modernism, including gestural paint handling and flattened, Post-Impressionist space. Although he worked outside the mainstream in New York during the heyday of Abstract Expressionism, he was friendly with many of the movement's leaders, including Willem de Kooning and Franz Kline. His perceptive reviews for *Art News* magazine reflected his appreciation of approaches other than his own, but he was committed to the honest depiction of what was significant to him. He believed that "you connect yourself to everything that includes yourself by the process of painting."

☞ T. Barney, J. Durand, J. S. Sargent, Tarbell

Fairfield Porter. b Winnetka, IL, 1907. d Southampton, NY, 1975. Chris, Sarah, Felicity. 1959. Oil on canvas. h48 x w48 in. h121.9 x w121.9 cm. Private collection.

Powers Harriet

Pictorial Quilt

A sermon in cloth, this quilt is composed of fifteen panels, each depicting the hand of God at work. Harriet Powers, a former slave, referred to her masterpiece as "the darling offspring of my brain," and her explanation of each scene was carefully documented. Some familiar Biblical events are recognizable: the Garden of Eden (panel 4), Jonah and the whale (panel 6), and the Crucifixion (panel 15).

These passages are interspersed with Powers's interpretations of extreme meteorological events from nineteenth-century lore. The center panel shows the falling stars of a meteor shower from 1833 while panel 11 shows the Cold Thursday of 1895, a day so chilly a man froze at his liquor bottle. Together, these sacred and secular scenes illustrate Powers's belief in a powerful God capable of apocalyptic

intervention and divine redemption. The appliquéd style of this quilt is reminiscent of traditional West African textiles, placing the quilt's themes of trial and deliverance in the context of slavery and the emancipation of African-Americans after the Civil War.

☛ Finster, Job, Pierce, S. F. W. Williams

Harriet Powers. b Athens, GA, 1837. **d** near Athens, GA, 1911. **Pictorial Quilt.** 1895–98. Pieced and appliquéd cotton embroidered with plain and metallic yarns. **h**69 x **w**105 in. **h**175 x **w**267 cm. Museum of Fine Arts, Boston, MA.

Powers Hiram

Andrew Jackson

Despite its attention to the ravages of age, the deeply furrowed cheeks and brow, the toothless mouth, and the sagging, leathery neck, this portrait of America's seventh president, Andrew Jackson, conveys the spirit of stubborn determination that characterized his military and political careers. Powers was "discovered" by Cincinnati businessman Nicholas Longworth, whose patronage relieved Powers from his job as a manual laborer in a waxworks. In 1837, with Longworth's help, Powers went to Florence, Italy. Like Horatio Greenough before him, he was drawn to Italy because of its strong connections with ancient Classical traditions that inspired the Neo-Classical bust format that Powers adopted for Jackson's portrait (replete with the toga of a Roman statesman). Although Jackson had sat for Powers in 1835, the artist did not begin to carve the portrait in earnest until he reached Florence. He kept it in his studio until 1846, doubtless because it served as a fine advertisement of his clientele's status and his own remarkable talents.

☞ **Arneson, Greenough, McIntire, Stuart**

Hiram Powers. b Woodstock, VT, 1805. d Florence, Italy, 1873. **Andrew Jackson.** 1837. Marble. **h**34¾ x **w**23½ x **d**15½ in. **h**88.3 x **w**59.7 x **d**39.4 cm. The Metropolitan Museum of Art, New York, NY.

352

Pratt Matthew

The American School

One young student remains absorbed in his project, but two others interrupt their artmaking to watch attentively as the American-born artist Benjamin West, the figure standing at left, gives pointers on drawing to Matthew Pratt. The setting is West's London home. Pratt was a Philadelphia portraitist, the first of many American artists abroad who sought out the much-admired West for professional advice. At a time when no art schools existed in America and London's Royal Academy taught only drawing, West encouraged aspiring painters by giving them a home base and practical instruction. Pratt's tribute to West's talent and generosity is both an informal gathering in the tradition of the British conversation piece and a privileged view into a working artist's studio. Back in the United States, Pratt found few opportunities to deliver on the promise of *The American School*. Resuming his portrait practice, he eventually found it necessary to turn to teaching and decorative sign painting.

☞ Eakins, Smibert, Trumbull, Woodville

Matthew Pratt. b Philadelphia, PA, 1734. **d** Philadelphia, PA, 1805. **The American School.** 1765. Oil on canvas. **h**36 x **w**50¼ in. **h**91.4 x **w**127.6 cm. The Metropolitan Museum of Art, New York, NY.

Prendergast Maurice The Promenade

A crowd of semiabstracted figures promenades along a lake's edge amid two clumps of trees in this scene of summertime frivolity. Faces are mere oblong spheres, while depth and specificity are sacrificed to the separation of brushstrokes that Prendergast learned from the European Impressionists while he was a student in Venice and Paris in 1886 and 1891. As a youth he worked as a sign-letterer in Boston, mastering fine hand control that produced the daubed abstracted rhythms of his later oils and watercolors. Regarded as a major figure of American Impressionism, Prendergast was also the oldest member of the Realist group known as The Eight. Such contradictions summarize his life and art. He was born in Newfoundland but raised in Boston, and his modern works emphasized the two-dimensionality of the canvas while they engaged themes of nineteenth-century nostalgia. Influenced by Bonnard, Gauguin, and Cézanne, Prendergast became one of the most admired of American painters.

☞ Chase, Luks, Tarbell, Wendell

354

Maurice Brazil Prendergast. **b** St. John's, Canada, 1859. **d** New York, NY, 1924. **The Promenade.** c1912–13. Oil on canvas. **h**28 x **w**40¹/₄ in. **h**71.1 x **w**102.3 cm. Columbus Museum of Art, Columbus, OH.

Prentice Levi Wells

Apples Beneath a Tree

The division between landscape and still life is blurred in this crisply rendered image of apples lying at the base of a tree. Seen from a worm's-eye view, the luscious red fruit fills the lower half of the canvas, pushed to the brink of the picture plane as if there for the taking. On second look, however, it is apparent that the better, unbruised specimens have already been spoken for, gathered in the rustic basket behind the tree. Prentice specialized in still-life subjects and is known to have devoted more than forty canvases to the apple — in "landscapes" such as this, as well as in more traditional tabletop formats. He apparently began his career as a portrait and landscape painter, and seems not to have addressed still life in his art until he moved to Brooklyn around 1883. His technique, characterized by an extraordinarily smooth paint surface, bright colors, and hard-edged forms, renders his paintings unmistakable among those of his contemporaries.

☞ Cady, Parrish, Roesen, J. Thompson

Levi Wells Prentice. b Lewis County, NY, 1851. d Philadelphia, PA, 1935. **Apples Beneath a Tree.** 1891. Oil on canvas. h16 x w12 in. h40.6 x w30.5 cm. Private collection.

Prince Richard

Untitled (cowboys)

This fragmentary glimpse offers enough clues to let us construct the larger scene: the cowboy hat, leather vest, and lariat are clear signs that a cowboy on horseback is rounding up what seem to be wild mustangs. We know this in part because of stereotypes of cowboys in the American West, which have been delivered to us repeatedly through movies, television, and advertisements — most notably in a series of print ads for Marlboro cigarettes. In fact, Prince's image is a fragment of one such Marlboro ad, chosen by the artist and "rephotographed" by him to heighten the sense of its artificiality and stereotypicality. Prince is a Postmodernist artist who in the 1980s specialized in the appropriation and reuse of mass-media photographs, largely inspired by his experience clipping magazine pages while employed by Time-Life. More recently, he has painted the text of jokes onto canvas and made sculpture in the shape of automobile hoods.

☛ Deas, Remington, Rothenberg, Warhol

Richard Prince. b Panama Canal Zone, 1949. **Untitled (cowboys).** 1986. Ektacolor print. Barbara Gladstone Gallery, New York, NY.

Prior William Matthew

Girl in a Red Dress

A young girl stands with iconic solemnity; only her flower basket, coral bracelet, and slightly shifted feet disrupt her symmetry. Thin outlines and subtle shadings define the girl's face, but broad strokes and formulaic daubs complete the image. This portrait is not an extreme example of Prior's "flat" style, but it does exhibit aspects of the "likeness without shade or shadow" that he offered at a cut rate.

Prior could paint in an accomplished three-dimensional style; he probably received some professional instruction from the portrait and landscape painter Charles Codman, and admired Gilbert Stuart enough to name a son after him. To satisfy clients and streamline his practice, however, Prior adapted techniques from ornamental painting and determined prices by the time spent painting. With

hindsight, the bold colors and insistent flatness of this portrait recall the work of Edouard Manet, suggesting why early twentieth-century Modernists were among the first to appreciate American folk art.

☛ J. Johnson, J. E. Kühn, Phillips, Wright

William Matthew Prior. b Bath, ME, 1806. **d** Boston, MA, 1873. **Girl in a Red Dress.** c1845. Oil on canvas. **h**38 x **w**26 in. **h**96.6 x **w**66.1 cm. Collection of Peter Tillou.

Puryear Martin

Untitled

An airy globe of wire mesh, over five feet tall and six feet wide, is weighed down by a coating of sticky black tar. While the sculpture's materials are both industrial and urban, its overall form is organic — the four holes might resemble the eyes in a coconut. As a young artist, Puryear traveled to Sierra Leone and studied in Scandinavia and Japan. Reflecting his travels, Puryear's sculptures combine the spartan aesthetics of Western Modernism and Far Eastern design with the hand-worked traditions of craft in the developing world. Puryear uses different species of woods, rope, deerskin, rawhide, as well as shapes reminiscent of Asian yurts (round wooden houses) and other "found" forms. Yet his art is different from most so-called multicultural work: While he eagerly learns the "trade secrets" of indigenous craftspeople, as a foreigner he does not presume to imitate their art — or even to fully understand its underlying cultural basis.

☛ Dove, Morris, Motherwell, Noguchi

358

Martin Puryear. b Washington, D.C., 1941. **Untitled.** 1997. Wire mesh and tar. **h**66 x **w**76¹/₂ x **d**37¹/₄ in. **h**167.7 x **w**194.4 x **d**94.7 cm. Donald Young Gallery, Seattle, WA.

Quidor John

The Money Diggers

Firelight eerily illuminates this nocturnal scene and defines the overwrought reactions of three men as their attention is drawn from the pit they have dug to the phantasmal figure gesturing to them from the rocky ledge at the upper right. *The Money Diggers*, a highly unusual painting for its time, is one of a series of works by Quidor that was inspired by the writings of Washington Irving. Here Quidor focused on the comic efforts of Wolfert Webber (left) to unearth buried pirate treasure with the help of the sinister Dr. Knipperhausen (center) and Black Sam, the Long Island fisherman, who frantically climbs from the excavation. Quidor enhanced Irving's gothic horror through chiaroscuro effects and by distorting the bodies and facial expressions of the men, converting them into grotesque personifications of greed and fear. After a fitful start as a commercial painter, Quidor went on to make some of the most inventive genre paintings of the nineteenth century. His penchant for caricature and humor was largely unappreciated by his peers, who valued a more realistic style.

☞ Blakelock, Mark, Ryder, Wimar

John Quidor. b Tappan, NY, 1801. **d** Jersey City, NJ, 1881. **The Money Diggers.** 1832. Oil on canvas. **h**16⅝ x **w**21½ in. **h**42.3 x **w**54.6 cm. The Brooklyn Museum of Art, Brooklyn, NY.

Ramirez Martin

Untitled (Super Chief)

A sleek train rounds a corner into a dark tunnel at the very bottom of this drawing; its destination remains a mystery. While the train may catch our eye, the tunnel itself is the subject of this dramatic composition. Ring after ring of graceful arcs defines this enigmatic space at the drawing's center. Ramirez had been institutionalized for eighteen years with a diagnosis of schizophrenia when he first presented his drawings to one of the hospital physicians. The iconography of Ramirez's drawings is not entirely clear, and Ramirez himself had stopped speaking before his work was discovered. Many works appear to allude to traditional iconography from his native Mexico, including banditos on horseback and the Virgin Mary. Several works feature trains rolling through labyrinthine passages, an image that may refer to Ramirez's experience as a railroad laborer. The delicate ornamentation of this drawing is also typical and suggests a dreamlike, otherworldly place.

☞ **Henderson, Morris, Pettibon, Yoakum**

360

Martin Ramirez. b Jalisco, Mexico, 1885. **d** Auburn, CA, 1960. **Super Chief.** c1953. Colored pencil and crayon on paper. **h**55 x **w**51 in. **h**139.8 x **w**129.6 cm. Collection of Dr. Leslie and Ellen Kreisler.

Ranney William Tylee On the Wing

A hunter steadies himself, scanning the sky as he prepares to aim at another target "on the wing." The intense watchfulness of the hunter is reinforced by that of his young companion, who crouches quietly beside him. Meanwhile, his dog eagerly awaits the chance to retrieve and add yet another prize of the hunt to the ducks he has already delivered to his master's feet. The stabilizing, pyramidal composition of the group bolsters the sense of tension-filled anticipation, and the almost sculptural stillness of the figures contrasts vividly with the windblown marsh grasses surrounding them. Ranney's career was at its height at the time he created this work, one of four known versions of this subject from his hand. With Arthur Fitzwilliam Tait, Ranney dominated the market for sporting pictures at mid-century, working from his Hoboken, New Jersey, studio and exhibiting frequently at the National Academy of Design in New York. His career was cut short when he died of pulmonary tuberculosis at the age of forty-four.

☞ Couse, Harnett, Mount, Tait

William Tylee Ranney. b Middletown, CT, 1813. **d** West Hoboken, NJ, 1857. **On the Wing.** c1850. Oil on canvas. **h**32 x **w**45 in. **h**81.3 x **w**114.4 cm. Butler Institute of American Art, Youngstown, OH.

Rauschenberg Robert Retroactive II

This composition is dominated by a press photograph of the dynamic young president, John F. Kennedy, during his inauguration speech in 1961. Surrounding this image is a seemingly random combination of material culled from printed sources and silk-screened onto the canvas. Rauschenberg's frequent recycling of this image immediately after Kennedy's assassination in November 1963 suggests that he was memorializing the slain president, but the artist maintained that his creations were "unbiased documentation." Nevertheless, as its title implies, Rauschenberg's work looks back to the spirit of optimistic energy that prevailed in America before Kennedy's death. Rauschenberg focused on mundane subject matter such as household items, found objects, and mass-media photographs.

He progressively eliminated brushwork and downplayed self-expression as a reaction against Abstract Expressionism. By blurring the distinction between art and life, Rauschenberg helped pave the way for Pop Art.

☛ **Berman, Rosenquist, Salle, Warhol**

362

Robert Rauschenberg. b Port Arthur, TX, 1925. **Retroactive II.** 1964. Oil and silkscreen on canvas. **h**84 x **w**60 in. **h**213.5 x **w**152.5 cm. Private collection.

Ray Charles

Unpainted Sculpture

A life-sized crumpled automobile is re-created in the gallery, sculpted entirely of gray hydrocal. The car was cast from one involved in a fatal accident. Ray molded and attached each section individually, from the crushed radiator to the sickeningly bent steering wheel. Ray's sculptures and self-portraits are known for their addled brand of Realism, incorporating self-deprecating references to mind-altering drugs, sex, fashion, and science fiction. Many consider *Unpainted Sculpture* to be Ray's masterpiece. Some see its monochromatic surface and tragic subtext as a reaction against the unaccountability of Minimalism; others see its methodical construction as a criticism of the emptiness of Realism. But there may yet be a third option, strongly suggested by the pattern Ray's work has taken in the past. This intricately fabricated, violently mutilated gray object may be a metaphorical self-portrait — of the artist's brain.

☞ Burden, Chamberlain, Kelley, Koons

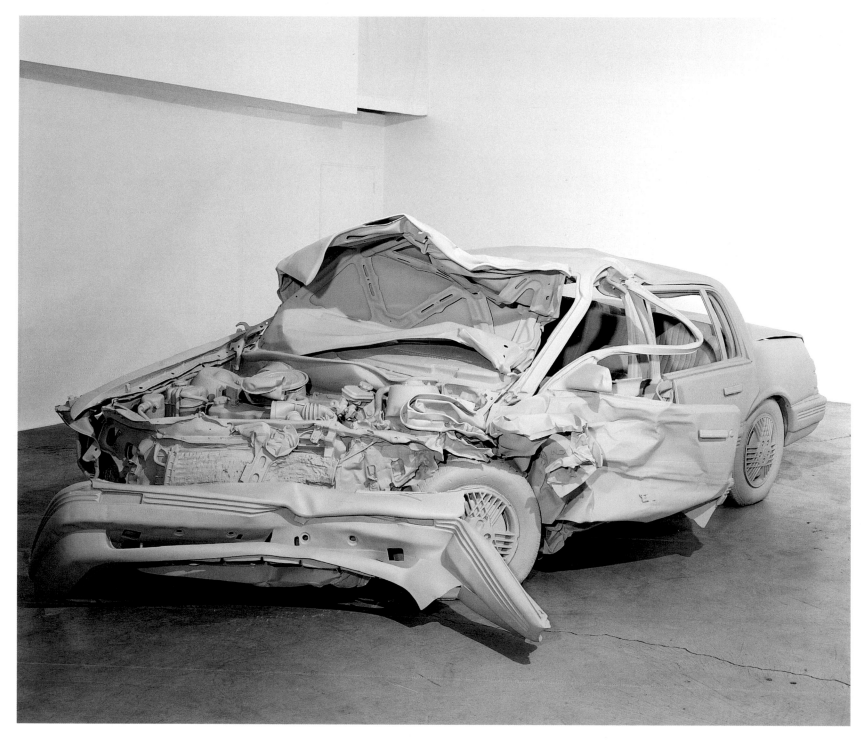

Charles Ray. b Chicago, IL, 1953. **Unpainted Sculpture.** 1997. Fiberglass, paint. **h**60 x **w**78 x **l**171 in. **h**152.5 x **w**198.2 x **l**434.6 cm. Walker Art Center, Minneapolis, MN.

Reed Eldress Polly A present to Mother Lucy to Eliza Ann Taylor

Richly detailed with both organic decoration and cryptic symbols, this intricate drawing offers a view into the elusive spiritual world of the utopian religious sect known as the Shakers. This "spirit drawing," done by a Shaker elder, combines pure ornament with Biblical symbolism. In the upper right corner, a dove is a "Messenger of glad tidings," while "Flowers of Love & Beauty" surround a rendering of

the group's temple in New Lebanon, New York, at center. The Shakers were persecuted for adopting unconventional practices such as communal living and "shaking," or possession by the Holy Spirit, during worship. Their spare, handcrafted furniture is renowned and widely collected today for its elegant beauty, but drawings such as these manifest a more emotional, effusive aspect of Shaker life.

They were not intended for public display but, reflecting personal insight into the Scripture, they were given as personal gifts to beloved friends or relatives in the Shaker community.

☛ Cohoon, Finster, J. Stella, Taaffe

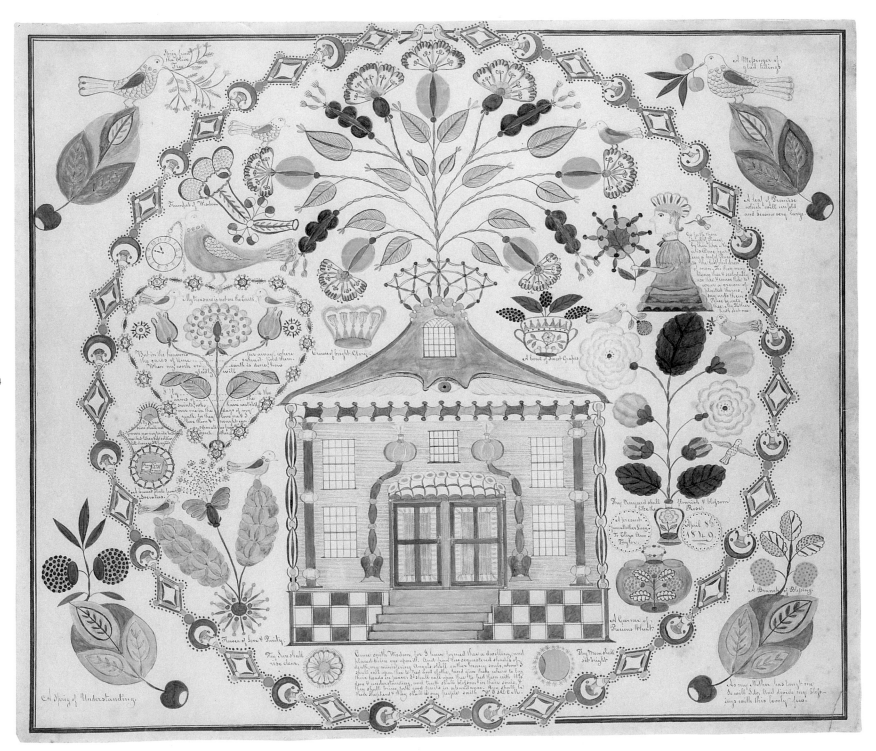

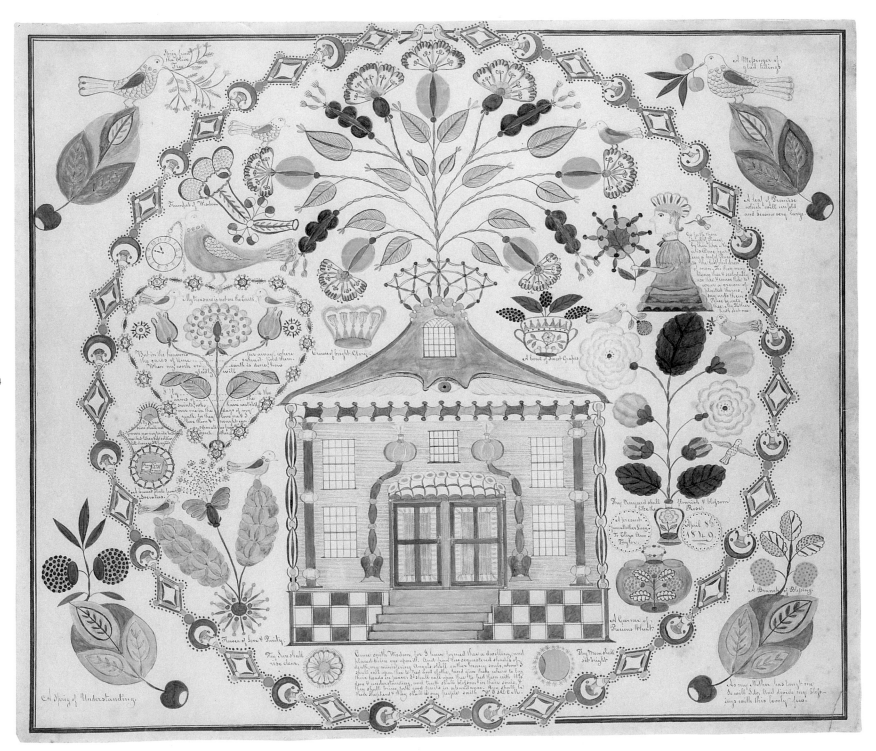

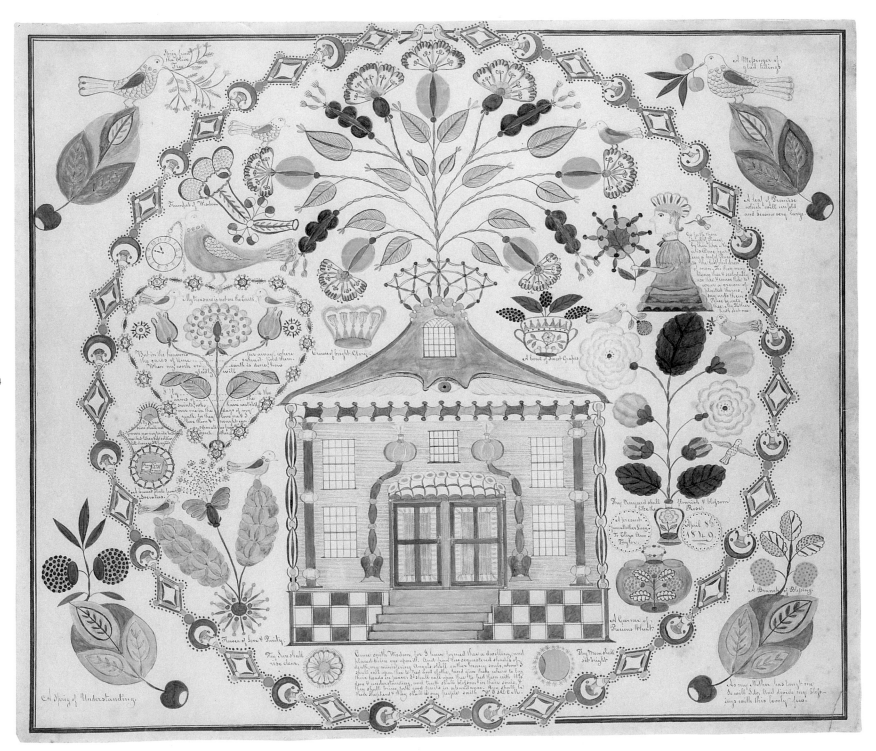

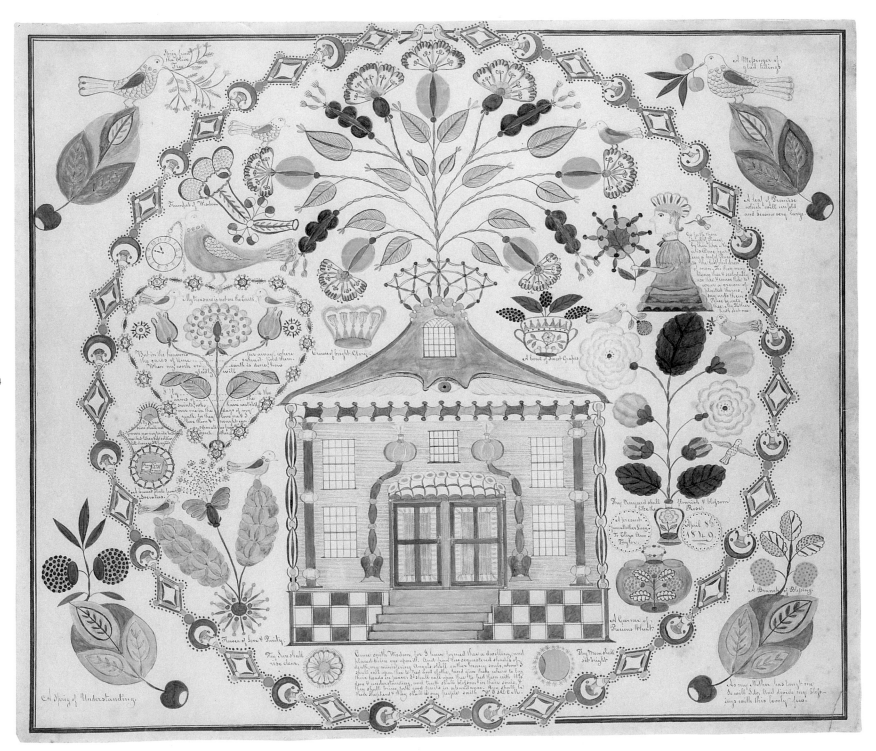

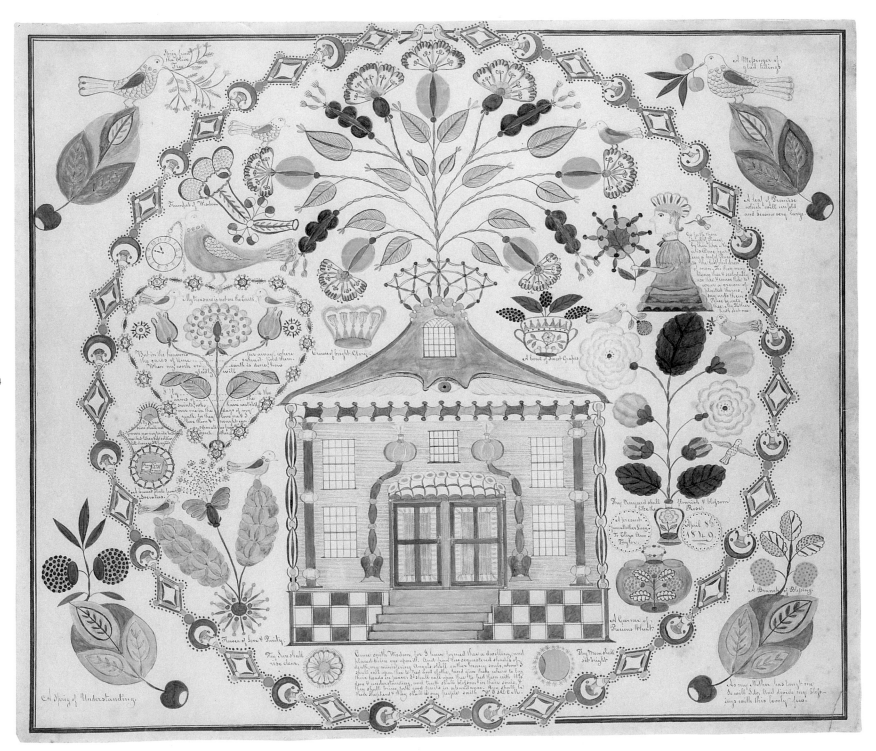

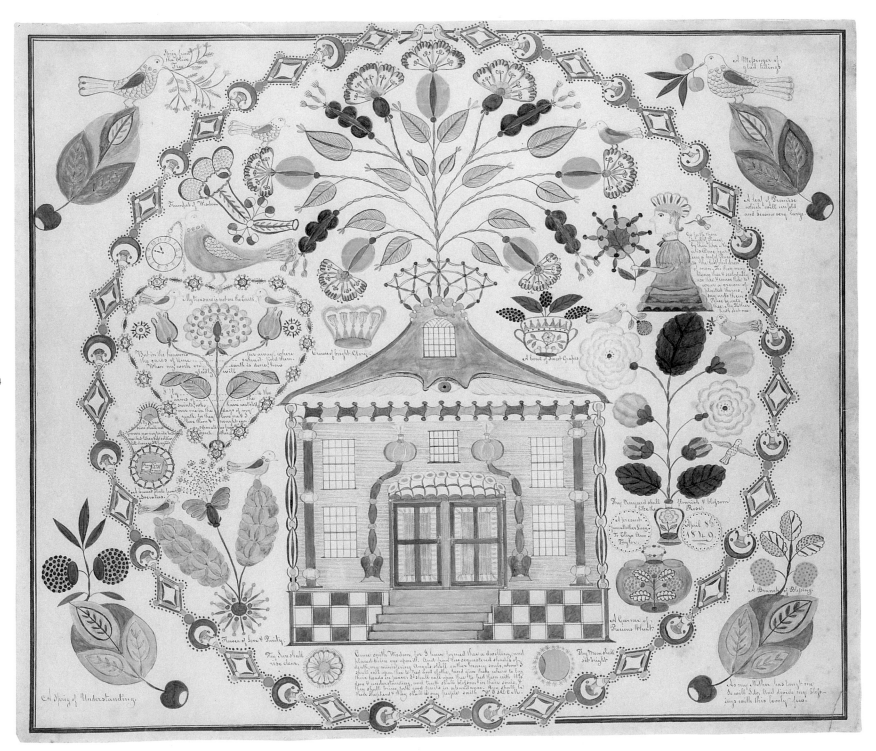

364

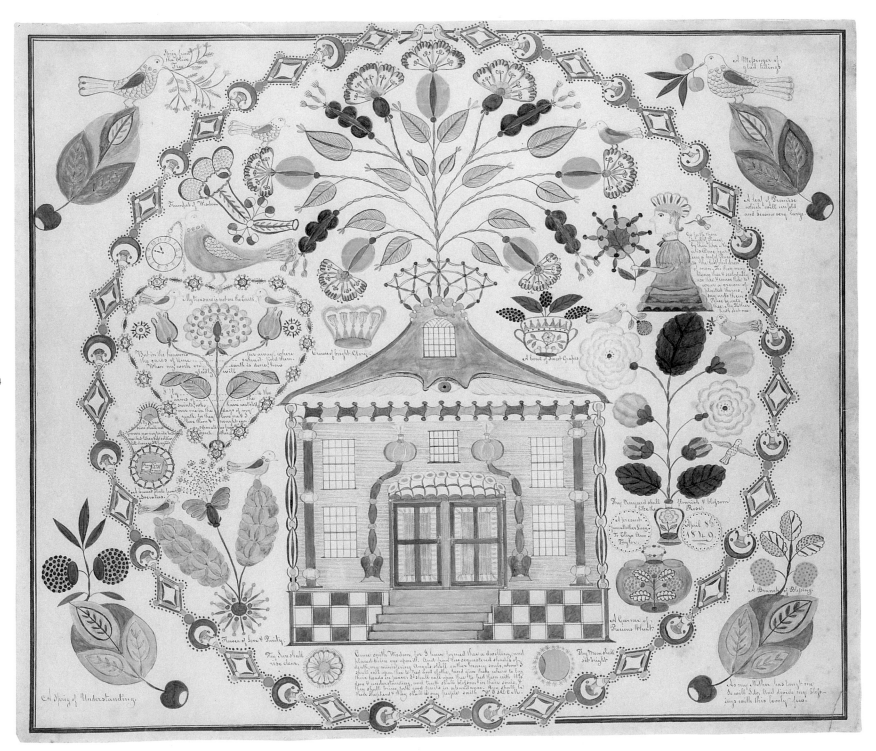

Eldress Polly Jane Reed. b Herkimer County, NY, 1818. **d** Mount Lebanon, NY, 1881. **A present to Mother Lucy** . . . 1849. Blue ink and watercolor on pale blue paper. **h**14 x **w**16⅜ in. **h**35.6 x **w**41.6 cm. Hancock Shaker Village, Pittsfield, MA.

Reid Robert

Woman with a Vase of Irises

A luminous pattern of whites shot with vibrant violets, yellows, and greens almost overwhelms the form of a young woman seated on a porch. Her melancholy expression and her tense grasp of the edges of a large ceramic planter lend a surprisingly disquieting note to the image. In familiar nineteenth-century iconography, women were likened to flowers — in terms of both their beauty and their fragility.

Here, however, Reid seems to contradict the usual symbolism by calling to mind the claustrophobic, restrictive conditions of womanhood and, at the same time, inviting the viewer to consider the overall beauty of his painting as an aesthetic object. Reid was an extraordinarily versatile artist who created easel paintings, murals, and stained-glass window designs. After receiving solid

academic training in Paris, he returned to the United States, where he eventually turned to the style of decorative Impressionism for which he is now best known.

☛ Blume, Dewing, Ives, Kasebier

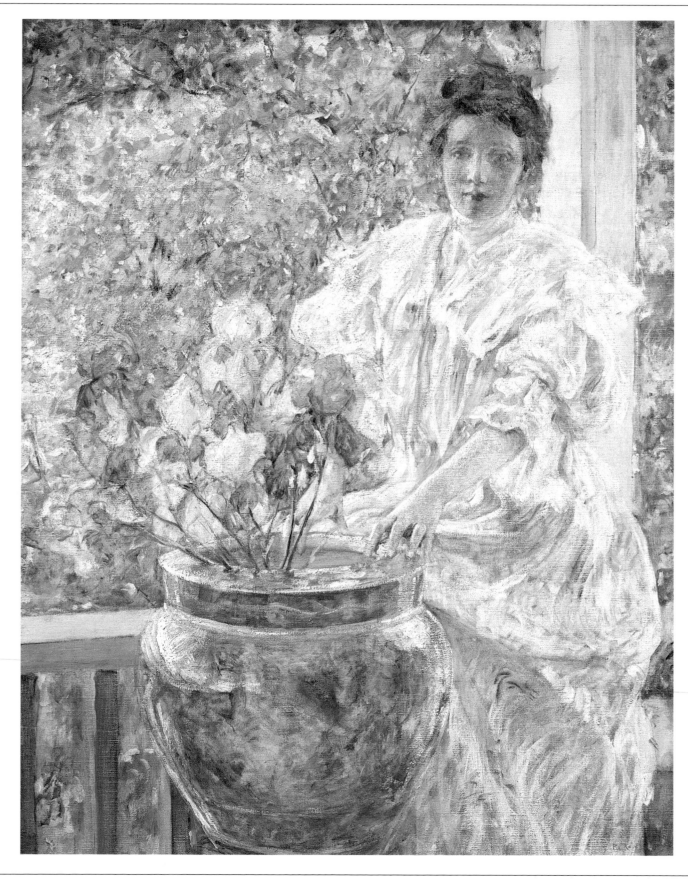

Robert Lewis Reid. b Stockbridge, MA, 1862. **d** Clifton Springs, NY, 1929. **Woman with a Vase of Irises.** c1906. Oil on canvas. **h**34 x **w**26 in. **h**86.4 x **w**66.1 cm. Private collection.

Reinhardt Ad

Abstract Painting, Blue

With its rectangular format composed of three equal squares, this canvas is part of a series devoted to variations on individual colors of close value. Reinhardt aimed to create an art of pure, monochromatic color and form, purged of nonaesthetic associations such as representation and narrative. His goal was to create paintings characterized by "irreducibility, unreproducibility, imperceptibility."

A caustic critic of artists who sought to inject their personalities into their work, Reinhardt nevertheless achieved a highly individual style of nuanced tonal painting. After early experimentation with geometric abstraction, in the 1940s he developed a looser, more gestural approach influenced by painters Mark Rothko, Barnett Newman, and Clyfford Still. Ultimately, however, he rejected

expressive brushwork and subjective content in favor of an art that set the stage for Minimalism.

☞ Halley, Kelly, Lewitt, Marden

Ad Reinhardt. b Buffalo, NY, 1913. **d** New York, NY, 1967. **Abstract Painting, Blue.** 1952. Oil on canvas. **h**30 x **w**10 in. **h**76.2 x **w**25.4 cm. PaceWildenstein, New York, NY.

Remington Frederic

Dismounted: The Fourth Trooper Moving the Led Horses

The US Census Bureau declared the Western frontier closed the year Frederic Remington painted this work. One would never know it based on Remington's depiction of fierce horses galloping at full speed alongside gaunt heroic troopers. The noise and dust are almost palpable in this cinematic scene. The troopers' role in history, however, is less important than the romanticized version of the Wild West they represent. Remington's West was mythical rather than factual, as was his life-long insistence that he had fought in the Indian Wars. A graduate of Yale University, Remington's career took a turn when he was hired by Theodore Roosevelt to illustrate his book *Ranch Life and the Hunting Trail*, published in 1888. He was then asked by editors of Western fiction magazines popular in the 1890s to illustrate their stories. His imagery of the American West became the dominant representation at a time when industrialization and urban growth were rapidly eclipsing rural America.

☛ **Catlin, Deas, Prince, C. M. Russell**

Frederic Sackrider Remington. **b** Canton, NY, 1861. **d** Ridgefield, CT, 1909. **Dismounted: The Fourth Trooper Moving the Led Horses.** 1890. Oil on canvas. **h**34 1/16 x **w**48 15/16 in. **h**86.5 x **w**124.3 cm. Sterling and Francine Clark Art Institute, Williamstown, MA.

Riis Jacob A.

Bandit's Roost

Officially known as 59 Mulberry Street, in lower Manhattan, the Bandit's Roost was a notorious hangout for ne'er-do-wells and ruffians like the gentlemen gathered here for a felicitously composed group portrait. Riis's intention was not to flatter these slumdwellers, however. As a muckraking journalist specializing in urban reform, he wanted to confront his readers with images of unfortunate living and working conditions in need of change. Riis used his photographs to illustrate lectures on reform; this image was probably hand-colored by an assistant to enhance its impact on the audience. Although the term "documentary" was not used in Riis's time in regard to photographs, his pictures are part of a tradition that lies at the heart of much of today's photojournalism. His pictures were first published as woodcuts in magazines such as *Scribner's*. In 1890 they were reproduced in his book *How the Other Half Lives* — one of the earliest examples of halftone reproduction of photographs, a process still in use today.

☞ **Gardner, Hine, Lange, Weegee**

Jacob August Riis. b Ribe, Denmark, 1849. **d** Barre, MA, 1914. **Bandit's Roost.** 1887. Handcolored lantern slide. Museum of the City of New York, NY.

Rimmer William

Flight and Pursuit

A man, a dagger belted at his waist, runs through the hall of an exotic, Moorish-style building, his action paralleled by a ghostly apparition running in an adjacent corridor. A third figure is implied by the forked shadow that interrupts the otherwise vacant area at the lower right. Although many interpretations of this haunting image have been offered, none has resolved the essential mystery of its meaning. General consensus holds that Rimmer's own troubled personality (perhaps induced by his father's lifelong delusion that he was the rightful, endangered heir to the French throne) is the key to this unsettling work. Often characterized as isolated, Rimmer, a practicing physician, nonetheless gained note as an instructor of anatomical drawing. Admired for his sculpture, *The Falling Gladiator* (shown at the 1867 Paris Exposition), Rimmer rarely displayed his paintings publicly. Ironically, this self-imposed lack of visibility only enhanced his feelings of being unjustly ignored.

La Farge, Persac, Quidor, Ryder

William Rimmer. **b** Liverpool, United Kingdom, 1816. **d** Boston, MA, 1879. **Flight and Pursuit.** 1872. Oil on canvas. **h**18 x **w**26¹/₄ in. **h**45.7 x **w**66.7 cm. Museum of Fine Arts, Boston, MA.

Rivers Larry

Dutch Masters I

Rivers based his loose interpretation of Rembrandt's 1662 group portrait, *Syndics of the Drapers' Guild*, on a crude version, printed in reverse, from the lid of a Dutch Masters cigar box. Seeing the image blown up to gigantic proportions on a billboard inspired him to use it. "I suddenly realized it was sort of perfect," he later recalled. "You're looking at Rembrandt — in neon! Advertising cigars. It was too much, it was irresistible." Rivers further revised the image in abstract terms, translating its forms into brushy color blocks and figure details into linear shorthand, and went on to create a long series of paintings and reliefs derived from it. His respect for art history and the foremost Modernists coexists with an iconoclastic irreverence fueled by his omnivorous visual appetite, which is stimulated equally by high and popular culture. This sense of irony, along with the appropriation of advertising and media imagery, appears in the work of later Pop artists such as Roy Lichtenstein.

☛ Johns, Pratt, Rauschenberg, Smibert

370

Larry Rivers (Yitzroch Loiza Grossberg). b New York, NY, 1923. **Dutch Masters I.** 1963. Oil on canvas. **h**40 x **w**50 in. **h**101.7 x **w**127.1 cm. Cheekwood Museum of Art, Nashville, TN.

Robb Samuel Anderson

Baseball Player

Though his uniform looks familiar, this baseball player's stiff pose is decidedly antiquated. He brandishes his bat like a sword, his feet firmly planted and ready for action. The *G* on his cap probably stands for a New York team, the Gothams or Giants, but his presence as a carved trade figure attests to the growing popularity of a game that was played for the first time in 1846 in nearby Hoboken, New Jersey.

Large-scale carvings like this on rolling pedestals were prominent fixtures on city sidewalks after 1850, attracting attention and soliciting the patronage of passersby. This carved figure is an early example of modern advertising, marking a transition between nineteenth-century wooden trade signs and today's ubiquitous product endorsements by sports celebrities. For decades, sculptor

Robb operated a busy shop in downtown New York City, producing cigar store Indians, ship figureheads, and other commercial carvings.

☛ Edmondson, Job, W. Kuhn, Rush

Samuel Anderson Robb. b 1851. **Active** New York, NY. **d** 1928. **Baseball Player.** 1888–1902. Wood and paint. **h**84¼ x **w**23 x **d**25¾ in. **h**214.1 x **w**58.5 x **d**65.4 cm. Heritage Plantation of Sandwich, MA.

Robinson Theodore

World's Columbian Exposition

An elevated vantage point permits a panoramic view of a portion of the fairgrounds for the World's Columbian Exposition that opened in Chicago in 1893. Organized to celebrate the best that the world's cultures had to offer, it brought together the latest developments in industry, arts, and sciences, all of which were displayed in an architectural complex designed to declare the United States'

admission to a position of cultural eminence. It is one of two works that Robinson was commissioned to execute for reproduction in a deluxe publication intended to commemorate the Exposition. Although the painting is heralded as one of Robinson's triumphs, his diary reveals his disappointment in it, mainly because the commission required that he base the work on documentary

photographs of the scene. Despite his own negative opinion of it, the work stands as a brilliant testimony to the nation's optimism and confidence.

☛ Grooms, Lawson, Morse, Prendergast

372

Theodore Robinson. **b** Irasburg, VT, 1852. **d** New York, NY, 1896. **World's Columbian Exposition.** 1894. Oil on canvas. **h**25 x **w**30 in. **h**63.5 x **w**76.2 cm. Manoogian Collection.

Rockwell Norman

Shuffleton's Barbershop

Glimpsed through the cracked pane of a venerable front window, a barbershop quartet is practicing in the cozy confines of a neighborhood institution. Instead of singing the four-part vocal harmonies of "Sweet Adeline," however, Shuffleton's group is playing chamber music. Painting for the mass audience of *The Saturday Evening Post*, one of the America's foremost weekly magazines of the early

twentieth century, Rockwell asserted that ordinary folks can have refined sensibilities. His loving attention to detail does not necessarily ensure a realistic depiction. In this barbershop, for example, music soothes the "savage beast" — the resident cat — and the American flag poster reassures us that this is a patriotic gathering. Rockwell's enormously popular illustrations are carefully calculated narratives

in which each element plays a symbolic role. The artist readily acknowledged that he was not simply holding a mirror to America. As he once said, "I paint life as I would like it to be."

☛ Goings, Hovenden, Miller, H. Sargent

Norman Rockwell. b New York, NY, 1894. **d** Stockbridge, MA, 1978. **Shuffleton's Barbershop.** 1950. Oil on canvas. **h**46¼ x **w**23 in. **h**117.5 x **w**50.5 cm. The Berkshire Museum, Pittsfield, MA.

Roesen Severin

Nature's Bounty

A rich array of luscious fruit is artfully displayed in an unusual double-tiered format. The almost surreal arrangement of edibles — with some partially peeled and some still bearing their leaves — introduces a startling artificiality to objects usually associated with simplicity and naturalness. Such works by Roesen have been interpreted in the context of the natural abundance of the New World. However, this interpretation is connected with the seventeenth-century Dutch *vanitas* tradition that experienced a revival in Roesen's native Germany, where he is thought to have been a porcelain painter. He emigrated to the United States in 1848, possibly for political reasons, and established himself as a still-life specialist in New York City. For reasons unknown, he left New York and eventually settled in Williamsport, Pennsylvania, where he continued in his specialty and exerted considerable influence as a teacher.

☞ **Bailey, Francis, Goodes, Prentice**

374

Severin Roesen. b probably Cologne, Germany, c1847. d Philadelphia, PA, c1871. **Nature's Bounty.** c1857–72. Oil on canvas. **h**36 x **w**50 in. **h**91.5 x **w**127 cm. Berry-Hill Galleries, New York, NY.

Rogers John

The Town Pump

This small sculpture narrates a coincidental meeting at a town water pump, in which a young woman clutches the end of her shawl as she guardedly listens to a young soldier's tales. His backpack and equipment suggest that he is merely passing through the area, a stranger uprooted from his own hometown as a result of the Civil War. The two will most likely go their separate ways — she to her home in town and he back to the road. Rogers effectively captured such common American experiences in this and the many other genre sculptures he created. Armed with little formal training, he went against the prevailing Neo-Classical taste and in 1859 began to create small works that were eventually patented, reproduced in plaster, and mass-marketed. These easily understood narrative vignettes were affordable and extraordinarily popular, and it was reported that by 1893 he had sold more than seventy thousand of them, many of which were ordered by mail from catalogs of his productions.

☛ T. Ball, Durrie, Homer, J. Thompson

375

John Rogers, Jr. **b** Salem, MA, 1829. **d** New Canaan, CT, 1904. **The Town Pump.** 1862. Painted plaster **h**13 in. **h**33 cm. Private collection.

Rosenquist James

Promenade of Merce Cunningham

This painting includes three image layers: a woman's face, a photograph of spaghetti, and a pair of dancing feet, a tribute to avant-garde dancer Merce Cunningham. Rosenquist's paintings are Pop collages of advertisements and news photos found in magazines, forming narratives that do not always make sense. Like Robert Rauschenberg's "combines," Rosenquist's often mural-sized paintings convey a sense of the turbulence and exploding media imagery of the 1960s. Other subjects include John F. Kennedy and Vietnam-era fighter jets. Before he became an artist, Rosenquist was one of the youngest and most popular New York billboard painters, an occupation that taught him a smooth, Photorealistic painting style. At first he tried to unlearn this style, but soon realized that depicting "specific things that couldn't be confused with anything else" was the perfect antidote to the precious drips of Abstract Expressionism, the dominant art style at the time.

☛ Lichtenstein, Rauschenberg, Salle, Wesselman

376

James Rosenquist. b Grand Forks, ND, 1933. **Promenade of Merce Cunningham.** 1963. Oil on canvas. **h**60 x **w**70 in. **h**152.4 x **w**177.8 cm. The Menil Collection, Houston, TX.

Roszak Theodore

Airport Structure

Resembling a precision machine with an undisclosed function, Roszak's sleek metal tower also suggests futuristic architecture. His art is infused with his love of science fiction, leading to the invention of fantastical yet oddly rational forms. Roszak was the first American sculptor to adopt the machine aesthetic. He was an early exponent of Constructivism, which he first encountered while studying in Europe from 1929 to 1931. Although he did not attend the Bauhaus in Germany, he was deeply influenced by its precepts. After turning from painting and printmaking to sculpture, he set up his own tool and die shop. In 1938, he joined the faculty of the Design Laboratory founded by László Moholy-Nagy in New York to perpetuate Bauhaus principles. Roszak's fascination with aviation led to an extensive exploration of flight mechanics and eventually to actual aircraft construction work during World War II.

☞ Murphy, Outerbridge, Schamberg, Storrs

Theodore Roszak. **b** Poznan, Poland, 1907. **d** New York, NY, 1981. **Airport Structure.** 1932. Copper, aluminum, steel, and brass. **h**19¹/₂ in. **h**48.6 cm. The Newark Museum, NJ.

Rothenberg Susan Accident #2

A horse tumbles head over heels from the top of the painting. Though the title implies a traumatic event, the animal seems almost peaceful, falling through a thickly painted ground that could easily be a sky. *Accident #2* is from a series inspired by the sight of the artist's husband, the Conceptual artist Bruce Nauman, being thrown from a frightened mount. Rothenberg began painting horses in 1973, when she first unconsciously doodled one on a piece of raw canvas. In the 1970s, horses were the sole subject of Rothenberg's slashing, frenetic paintings, allying her uneasily with feminist and Performance art of the time. In the 1980s, Rothenberg incorporated a wider vocabulary: human and animal heads, landscapes, and whirling dancers that earned her another tentative label, this time as a Neo-Expressionist painter. In 1990, Rothenberg moved to New Mexico from New York, and inspired by her western surroundings, began painting horses again.

☞ Butterfield, Deas, Prince, Remington

378

Susan Rothenberg. **b** Buffalo, NY, 1945. **Accident #2**. 1993–94. Oil on canvas. **h**66 x **w**125 in. **h**167.7 x **w**317.6 cm. The Eli Broad Family Foundation, Santa Monica, CA.

Rothko Mark

Number 14

Hovering in a shallow, misty space, two opposing rectangular clouds of coral orange and cobalt blue create a mood of spiritual transcendence that has been called the "abstract sublime." Yet Rothko thought of his floating color-forms as objects in their own right rather than abstractions. Indeed, when viewed at length these forms and colors acquire a meditative beauty expressive of what

the artist called "basic human emotions — tragedy, ecstasy, doom." Considered among the foremost Abstract Expressionists, Rothko began his career painting figurative work, including portraits and street scenes, but in the 1940s he began to adopt Surrealist symbolism and mythological imagery as means of communicating more universal messages. A friendship with Milton Avery planted seeds that would

bear fruit in his evocative use of nonliteral color, and his association with Color Field artists Adolph Gottlieb, Barnett Newman, and Clyfford Still reinforced his conviction that "only that subject matter is valid which is tragic and timeless."

☞ Avery, Baziotes, Kensett, Marden, Steichen

Mark Rothko (Marcus Rothkowitz). **b** Dvinsk, Russia, 1903. **d** New York, NY, 1970. **Number 14.** 1960. Oil on canvas. **h**114¹/₂ x **w**105³/₄ in. **h**291 x **w**268.8 cm. Private collection.

Ruscha Ed

Hollywood

Los Angeles's famous Hollywood sign is here transported from its familiar urban hillside to the top of a barren desert peak, with the fiery sun setting behind it. This silkscreen distills the city into three minimal elements crucial to its identity: the Hollywood hills, the world-renowned sign, and LA's ubiquitous golden light. Los Angeles and its beckoning, glittering glow attracted the Nebraska-born

Ruscha — along with countless other aspirants — in the late 1950s. His small photography books published in the 1960s, like *Twentysix Gasoline Stations* and *Every Building on the Sunset Strip*, are classic examples of Ruscha's deadpan wit and cool understatement. In other artworks, Ruscha has used food to stain paper and canvas, lined an entire room in chocolate, and painted the Los Angeles County

Museum of Art as if on fire. His language-based prints and paintings mark an axis between audacious Pop Art and introspective Conceptualism, both of which arose in the 1960s.

☞ **Cottingham, Indiana, Kent, Misrach**

Edward Ruscha. b Omaha, NE, 1937. **Hollywood.** 1968. Silkscreen print. **h**17¹/₂ x **w**44 in. **h**44.5 x **w**111.8 cm. Anthony d'Offay Gallery, London.

Rush William

Allegory of the Waterworks (The Schuylkill Freed)

This sculpture was originally painted white to simulate stone or marble and harmonize with its Neo-Classical setting, a pediment of the Fairmount Waterworks on Philadelphia's Schuylkill River. In an allegory of the pumping station, an elegant woman "frees" the river by guiding its stream past a waterwheel; behind her a pipe spews ribbons of water into an urn symbolizing reservoirs. Blending Neo-Classical ideals with a homegrown artisan tradition, this sophisticated carving suggests why many consider Rush the first American sculptor. Son of a ship's carpenter, Rush apprenticed to a wood-carver and began his career making ship's figureheads. His interests in fine art, indicated by his participation in Philadelphia's fledgling art academies, led him to stretch the native carving tradition to its highest limits. Rush carved monumental figures for his city's public buildings and plazas and made several portrait busts, both carved in wood and modeled in terra-cotta.

☞ Fuller, Ives, Koons, McIntire

William Rush. b Philadelphia, PA, 1756. **d** Philadelphia, PA, 1833. **Allegory of the Waterworks (The Schuylkill Freed).** 1825. Painted Spanish cedar. **h**41¹/₃ x **l**87¹/₄ x **d**30¹/₂ in. **h**105 x **l**221.7 x **d**77.5 cm. Philadelphia Museum of Art, Philadelphia, PA.

Russell A. J.

On the Mountains of Green River, Smith's Butte in Foreground

A central but distant human figure provides scale in this expansive view of Utah's Green River. The figure also serves a second, less aesthetic purpose: Surveying the territory beyond, he indicates to this photograph's nineteenth-century audience that the uncharted vastness of the American West is now part of the white man's domain. Russell, who cut his photographic teeth during the Civil War, made this picture while employed by the Union Pacific Railroad, which at the time was racing to complete a transcontinental rail link. When the link was completed at Promontory Point, Utah, in May 1869, Russell was there with his camera to record the historic event. The Union Pacific later published an album of Russell's photographs titled *The Great West Illustrated*, and newspapers and magazines in the East reproduced many of them in the form of engravings. In the same momentous year, while photographing for the Clarence King survey, Russell wrote, "The sun reveals untold beauties . . . Words cannot express or describe it. But the truthful camera tells the tale, and tells it well."

☞ Heizer, T. Hill, Jackson, O'Sullivan

382

A. J. (Andrew Joseph) Russell. **b** Nunda, NY, 1830. **d** Brooklyn, NY, 1902. **On the Mountains of Green River, Smith's Butte in Foreground.** 1868. Albumen print. Union Pacific Museum, Omaha, NE.

Russell Charles

Lewis and Clark Meeting Indians at Ross' Hole

Raising spears in the air and straining to control their spirited horses, a group of Flathead Indians gathers on a vast plain in Montana. Russell painted this scene from the journey of Lewis and Clark for a mural installed in the Montana State Capitol in 1912. Under orders from President Thomas Jefferson during the years 1804–1806, the expedition led by Meriwether Lewis and William Clark set out to map the first and most practical land route from East to West. Russell chose to emphasize the Native Americans who met the expedition on September 4, 1805, on its journey through Montana to St. Louis, Missouri. One of the most prominent artists of the West, Russell was raised in an affluent family in St. Louis but ran away to Montana at the age of fifteen to become a cowboy. Along with Frederic Remington, he became one of the most renowned artists of the American West. This mural occupies a prominent place in the Capitol building, above the Speaker's platform at the front of the House of Representatives chamber.

☞ Le Moyne, Prince, Remington, Stanley

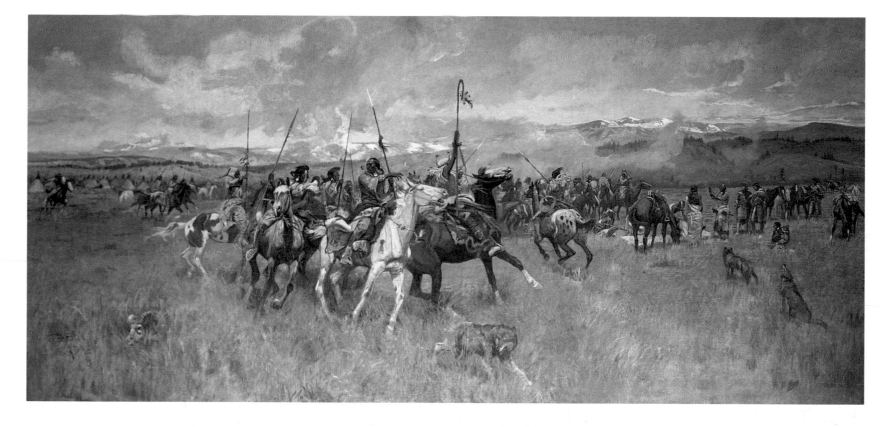

Charles Marion Russell. b St. Louis, MO, 1864. **d** Great Falls, MT, 1926. **Lewis and Clark Meeting Indians at Ross' Hole.** 1912. Oil on canvas. **h**25 x **w**12 ft. **h**7.62 x **w**7.8 m. The Montana Historical Society, Helena, MT.

Russell Morgan

Synchromy

Thick daubs of brightly colored paint are assembled on a diminutive canvas to resemble the multiple facets of objects floating on a blue plane. Russell often based his chromatic compositions on three-dimensional forms in space, applying a system of abstraction known as Synchromism, which literally means "with color." He originally studied architecture and sculpture, and he developed this system together with Stanton Macdonald-Wright, whom he met in Paris in 1911. The two artists first exhibited together as Synchromists in Europe in 1913 and showed their work in New York the next year. Their theories attracted a few adherents, including Andrew Dasburg and Thomas Hart Benton, but Russell's dream of Synchromism as a "new art of forms and colors" did not progress beyond a limited following.

Nevertheless, his concept of chromatic orchestration was an important influence on the development of American Modernism. Divorcing himself from the avant-garde, Russell returned to figurative imagery after World War I remained in France until 1946.

☛ Carles, Gorky, Hartigan, MacDonald-Wright

384

Morgan Russell. b New York, NY, 1886. **d** Ardmore, PA, 1953. **Synchromy.** c1914–23. Oil on canvas mounted on board. **h**7¾ x **w**5¾ in. **h**19.7 x **w**14.6 cm. Pensler Galleries, Washington, D.C.

Ryder Albert Pinkham

The Race Track (Death on a Pale Horse)

A phantasmal figure of Death speeds around a racecourse, his horse at full stride and his scythe slashing the suffocating yellow-green atmosphere. In the murky foreground a serpent raises its head as if responding to the grisly vision. Although there are numerous artistic precedents for this treatment of the inevitability of death (for example, Benjamin West's *Death on a Pale Horse*), Ryder's direct inspiration for this work was the tragic fate of an acquaintance whose gambling debts at the track led to his suicide. This probably occurred in 1888, but the painting is not mentioned in Ryder literature until 1896. As was his habit, the artist doubtless worked on it intermittently until 1913, when it was purchased. Ryder, who is classed among America's great visionary Romantics, created a body of work steeped in literary allusion and expressed in a poetic, antiacademic painterliness that foreshadowed Modernist aesthetic values.

☛ Allston, Blakelock, Mark, Quidor

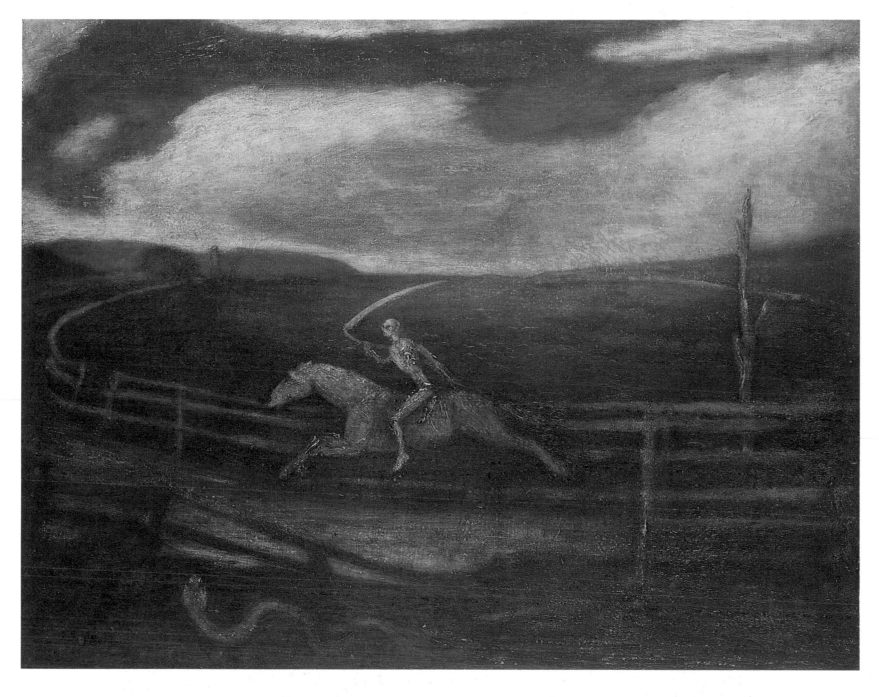

Albert Pinkham Ryder. b New Bedford, MA, 1847. **d** Elmhurst, NY, 1917. **The Race Track (Death on a Pale Horse).** c1886–1908. **h**27¾ x **w**35½ in. **h**70.5 x **w**90 cm. The Cleveland Museum of Art, Cleveland, OH.

Ryman Robert

Savoy

A small square of canvas is covered in thick, wiggly brushstrokes, the white paint exposing a brownish undertone. Ryman has called himself a "realist," and his abstract paintings such as this one have their own reality — the reality of white pigment, explored in all its many guises. In his works since the mid-1950s, Ryman has used the thick brushstrokes of Abstract Expressionism and the self-limiting strategies of Minimalism to explore the possibilities of paint. Along the way, he has employed an encyclopedic list of materials: synthetic and oil paints, including casein, enamel, and gouache, on surfaces including linen, metal, newsprint, and corrugated paper. As a young artist in the 1950s, Ryman worked as a guard at New York's Museum of Modern Art, where he encountered the work of Abstract Expressionists like Mark Rothko, Jackson Pollock, and Willem de Kooning, as well as that of contemporaries like Frank Stella.

☛ Martin, Mitchell, Nevelson, Pollock

386

Robert Ryman. b Nashville, TN, 1930. **Savoy.** 1964. Oil on canvas. **h**27⅜ x **w**27⅝ in. **h**69.5 x **w**70.2 cm. Private collection.

Saar Betye

Friends & Lovers

This collage evokes a tender nostalgia. Faded and torn photographs of an African-American couple and family are surrounded by souvenirs and other signifiers of memory — a silver cross, a funereal ribbon, bits of cloth, old hand-written letters. Whether this amalgam of images and objects is designed to evoke one particular person's story or the notion of personal history in general is unclear. As in much of Saar's art, the tension between the general and the specific is designed to both communicate and embody the fragmented history of African-American people — especially women — as well as their efforts to forge strong families and communities. By using artistic rather than polemical methods, Saar communicates her message about African-Americans' ongoing struggle for life, liberty, and the pursuit of happiness without succumbing to overtly political strategies that might undermine the haunting solemnity of her art.

☞ Berman, Cornell, Jess, Samaras

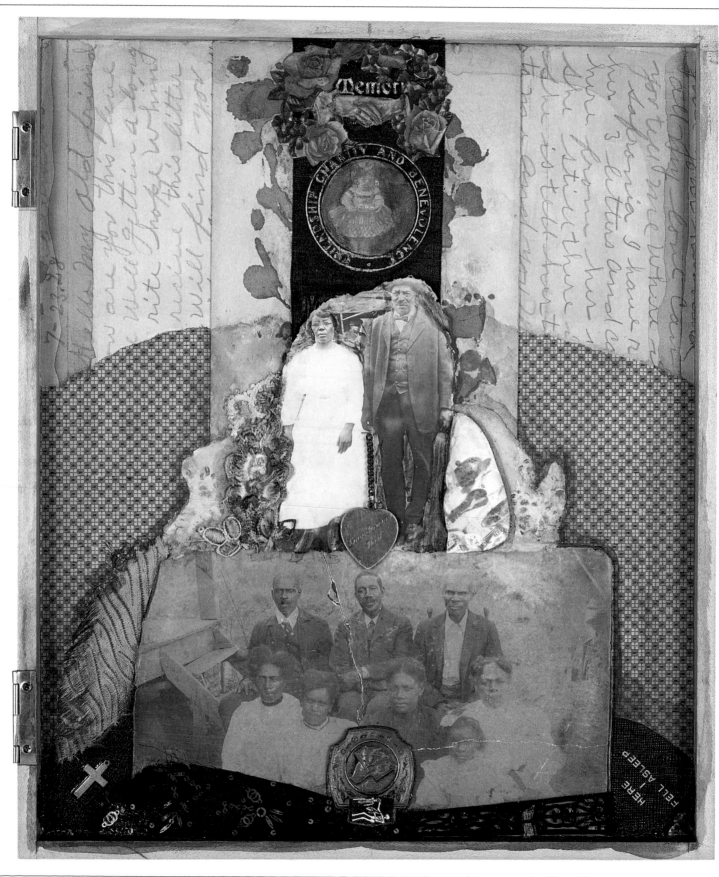

387

Betye Saar. b Pasadena, CA, 1926. **Friends & Lovers.** 1974. Mixed media collage. **h**18 x **w**14 in. **h**45.7 x **w**35.6 cm. Private collection.

Saint-Gaudens Augustus Shaw Memorial

A young Union Army officer reins in his powerful horse in an effort to stay within the pace of the African-American troops in his command. Above them a winged female figure bearing an olive branch and poppies (symbols of peace and death, respectively) directs them toward their fate. It is significant that the officer rides with and not ahead of his soldiers, for this magisterial bronze relief memorializes not only Colonel Robert Gould Shaw, but also the men of the Massachusetts Fifty-fourth Regiment, one of the first African-American army corps assembled in the North to fight in the Civil War. Gould and many of his men met their deaths in an 1863 assault on Fort Wagner, a strategic defense point for the Confederate port of Charleston, South Carolina. Saint-Gaudens was raised in New York City and trained as a cameo cutter. After studying in Paris and Rome, he returned to New York, where he established himself as America's finest practitioner of a naturalistic portrait style.

☛ Palmer, C. W. Peale, Hiram Powers, Stanley

388

Augustus Saint-Gaudens. b Dublin, Ireland, 1848. d Cornish, NH, 1907. Shaw Memorial. 1897. High relief, bronze. h11 x w14 ft. h3.35 x w4.27 m. Saint-Gaudens National Historic Site, Cornish, NH.

Salle David

Footmen

A series of mysterious yet uncannily familiar images are repeated and layered upon each other like jump-cuts from an experimental movie, interrupted by painterly passages depicting a cowboy with exaggerated red lips and a cartoon femme fatale. Salle was one of the first Neo-Expressionist painters to gain international fame in the 1980s, making dramatically scaled paintings that embodied the tenets of Postmodernism. His brash, multilayered works gathered all of modern American visual culture — from photography and cinema to furniture and abstract painting — and selectively combined it in a new art form that shocked some and excited others. In this painting, Salle's own photographs of a half-clothed model are screenprinted on red canvas, in a homage to the Pop paintings of Andy Warhol. The blue target may be a reference to Jasper Johns, and the splash of paint behind it a reminder of long-ago Abstract Expressionism.

☞ Berman, Rauschenberg, Rosenquist, Warhol

389

David Salle. b Norman, OK, 1952. **Footmen.** 1986. Oil, wood bowl/canvas. **h**93 x **w**120 in. **h**236.4 x **w**305 cm. Private collection.

Salmon Robert

The Boston Harbor from Constitution Wharf

A feeling of serenity pervades this view of Boston Harbor with the nearby community of Charlestown in the distance. Although men are working on the docks and rowing to and from the ships at anchor, everything appears to take place at a measured, even pace. The harmonious impression is conveyed largely by the composition, in which the decks of the ships align carefully with the low horizon.

Foreground elements — the timber floating in the water, the long shadows of the men, and the dock itself — draw our eye through the central, open portion of the harbor and up to the brilliant light of the sky. It is possible that Salmon included an American flag prominently on each side of the composition to underscore the remarkable changes that had occurred in the life of the new nation in the relatively brief

time since the Revolution. A marine specialist, Salmon was in his fifties when he left England for Boston in 1828. He was among the first marine specialists to address subject matter that was once at the heart of the rebellion.

☛ Birch, Blunt, Bradford, Burdett, Lane

390

Robert Salmon. b Whitehaven, United Kingdom, 1775. d probably Boston, MA, c1848–51. The Boston Harbor from Constitution Wharf. 1833. Oil on canvas. h26¾ x w40¾ in. h68 x w103.6 cm. US Naval Academy Museum, Annapolis, MD.

Samaras Lucas

Box #119

A plain rectangular box, made of wood and wire mesh, is transformed into something extraordinary. Encrusted with colorful beads, ersatz gems, pins, hardware, and coiled yarn — and featuring insect motifs and photos of the artist — the box and its decoration approach religious intensity. This devotional attention to visual seduction is similar to the jeweled reliquaries containing the bones of saints that Samaras encountered as a child in his native Macedonia Samaras is best known for his elaborately staged self-portraits in painting, photography, and film, as well as his collaged sculptures and mirrored-room environments. Since the early 1960s, his work has straddled many American art movements, including Pop and Performance Art — and as many mediums — while fitting comfortably into none. Hybridity, narcissism, and spiritual concerns combine in his art with a passion for technical exactitude to form a style that is uniquely Samaras's own.

☞ Conner, Cornell, Durham, Saar

Lucas Samaras. b Kastoria, Macedonia, 1936. **Box #119.** 1987. Mixed media. Opened: **h**15¾ x **w**35¾ x **d**13 in. **h**40 x **w**90.9 x **d**33 cm. Private collection.

Sargent Henry

The Dinner Party

Elegantly attired gentlemen, attended by two servants, partake of a fine dinner in the tastefully appointed dining room of Henry Sargent. The view into deep architectural space, arrangement of figures, and careful attention to the effects of light led critics to note its dependence on François Marius Granet's popular painting *The Choir of the Capuchins*, which had captivated Boston audiences a few years earlier. Far from being a copy of the French work, Sargent's painting (and its later companion piece, *The Tea Party*) converted an unusual compositional device into an inventive statement about Boston society. Sargent, a portraitist, later confessed that this was his "first attempt at a work of this kind." This rare artistic document of contemporary manners provides portraits of Sargent's friends (the painting is believed to depict a meeting of the Wednesday Evening Club, a gentlemen's social club whose members met regularly in private homes). It also records a building designed by New England architect Charles Bulfinch.

☛ **Chicago, Greenwood, Morse, Rockwell**

392

Henry Sargent. **b** Gloucester, MA, 1770. **d** Boston, MA, 1845. **The Dinner Party.** c1821. Oil on canvas. **h**61⅝ x **w**49¾ in. **h**156.5 x **w**126.4 cm. Museum of Fine Arts, Boston, MA.

Sargent John Singer

The Daughters of Edward Darley Boit

Four little girls, the children of the Boston-born American painter Edward Boit, appear lost in the seemingly cavernous interior of their parents' Paris apartment. In this eccentric composition, which was inspired by Velázquez's 1656 painting *Las Meninas,* Sargent portrayed the girls as ambiguous personalities separated from each other not only by physical distances but also by a compelling sense of psychological isolation that charges the atmosphere around them. Painted in the early years of Sargent's career, this innovative work with its strong lights and darks brings an unusual emotional weight to children's portraiture and confirms the boldness of Sargent's vision. While he was celebrated later as one of the era's foremost portraitists, his oeuvre also includes a large number of striking genre and landscape subjects, as well as a body of watercolors, which later gained him respect as a master of that medium.

☛ J. Durand, The Freake-Gibbs Painter, F. Porter, C. White

393

John Singer Sargent. b Florence, Italy, 1856. **d** London, United Kingdom, 1925. **The Daughters of Edward Darley Boit.** 1882. Oil on canvas. **h**87⅜ x **w**87⅝ in. **h**221.9 x **w**222.6 cm. Museum of Fine Arts, Boston, MA.

Savage Augusta

Gamin

With an expression worldly wise and at the same time immature, the young subject embodies the preadolescent experience of poor urban boys, regardless of race. This bust of a street urchin, a popular genre subject, is more than a sensitive version of a generalized character type: it is a portrait of the artist's nephew, Ellis Ford. Savage executed several editions of this sculpture in painted plaster

before a final version was cast in bronze. Her gifts as a portrait sculptor and her commitment to nurturing young talent made her a respected figure in the Harlem Renaissance. In 1932 she opened the Savage School of Arts and Crafts, and five years later, under the Works Projects Administration's (WPA's) Federal Art Project, she founded the Harlem Community Art Center, an important training ground for

the next generation. After executing a prestigious commission for the 1939 World's Fair in New York, Savage suffered personal and professional setbacks that virtually ended her career by 1945.

☞ Arneson, Blythe, Duveneck, Henri, Hiram Powers

394

Augusta Christine Fells Savage. b Green Cove Springs, FL, 1892. **d** New York, NY, 1962. **Gamin.** c1930. Painted plaster. **h**9.25 x **w**5.5 x **d**4.4 in. **h**23.5 x **w**14 x **d**10.2 cm. Private collection.

Schamberg Morton

Untitled (Machine Series)

The surface of this board shimmers with the gleam of metal rendered in oil paint. A rod connected to lines and colored balls runs diagonally between two spherical disks suspended in a neutral field. The abstract geometric shapes resemble a machine whose purpose could be related to weather (a barometer?), balance (a scale?), or merely the movement of highly aestheticized gears.

Schamberg was deeply influenced by Francis Picabia's machine aesthetic, which he discovered while living in Europe. He was part of a group of American modern artists who, under the influence of European avant-garde movements such as Cubism and Dada, rejected realism in the first decades of the century. Schamberg was also a close friend of Charles Sheeler, who coined the term Precisionism

in the 1920s to describe the machine inspired art that Schamberg developed with enthusiasm.

☛ Noland, Outerbridge, Roszak, M. Russell

Morton Schamberg. b Philadelphia, PA, 1881. **d** Philadelphia, PA, 1918. **Untitled (Machine Series)**. 1916. Oil on board. **h**15¾ x **w**12 in. **h**40 x **w**30.5 cm. SBC Communications, Inc.

Schimmel Wilhelm

Eagle, Cumberland County, Pennsylvania

This eagle has great presence despite its diminutive size. The bright plumage of his outstretched wings together with his sharply curved beak suggest a fierce disposition. According to local legend, his maker, Schimmel, possessed a similarly fiery temperament. Schimmel arrived in Pennsylvania's Cumberland Valley from his native Germany shortly after the conclusion of the Civil War. His past was subject to much local speculation, and his new neighbors were wary of what his obituary called "his very surly disposition." Nevertheless, he found a place within this community of Pennsylvania Germans, wandering from town to town and bartering his carvings along the way. His repertoire included lions, parrots, roosters and occasionally human figures, but Schimmel's eagles have won him his stature as one of America's most important folk carvers. The eagle was a favorite of Schimmel and his clientele, particularly the saloonkeepers with whom he exchanged works like this one for lodging, food, and most frequently, drink.

☛ Bellamy, Bourke-White, Tolson, Westerman

396

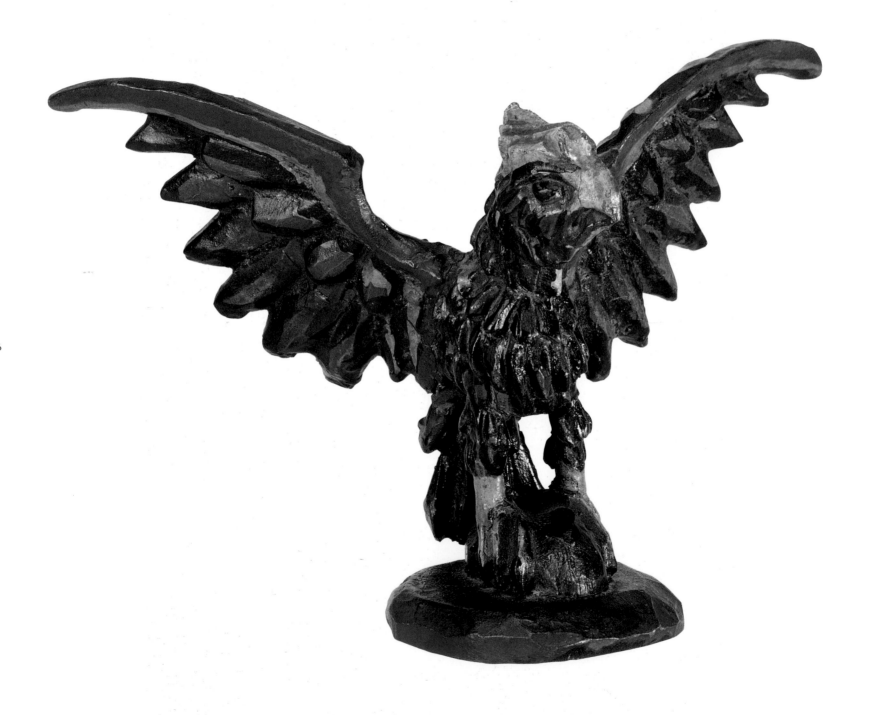

Wilhelm Schimmel. b location unknown, 1817. **d** Carlisle, PA, 1890. **Eagle, Cumberland County, Pennsylvania.** c1860–90. Carved and painted pine. **h**5 x **w**7¹/² in. **h**12.7 x **w**19.1 cm. Olde Hope Antiques, New Hope, PA.

Schnabel Julian

Self-Portrait in Andy's Shadow

In this tribute to the late Pop artist Andy Warhol, Schnabel is depicted in full-frontal view, the left side of his face shadowed by the name "Andy" and the date of Warhol's death. Painted on broken crockery, the work's operatic scale, heavy impasto, and vigorous painting style are characteristic of Neo-Expressionism; however, its unabashed egoism is all Schnabel's own. After moving back to New York from his boyhood home in Texas, Schnabel became one of the youngest and brashest artists of the early 1980s, famous for his ever-larger paintings on unconventional materials like velvet and canvas tarpaulins. His mostly figurative works reference opera and European painters like El Greco, as well as his own romanticized life. Schnabel's paintings remain true symbols of the headiest days of New York in the 1980s, when art rivaled the stock market as a topic of conversation and financial speculation.

☞ Arneson, Basquiat, Close, Nutt

Julian Schnabel. b New York, NY, 1951. **Self-Portrait in Andy's Shadow.** 1987. Oil, Bondo, and plates on wood. **h**103 x **w**72 in. **h**261.8 x **w**183 cm. The Eli and Edythe L. Broad Collection, Santa Monica, CA.

Segal George

The Diner

A patron sits at a dim diner counter as a waitress pours a cup of coffee. Though they share the same space, each character seems oblivious to the other. Both figures are made from strips of cloth dipped in plaster, which Segal casts from live models and later reassembles; the sparse diner accoutrements are all real hardware. Segal's life-sized figures are frequently identified with Pop Art and

have been called "frozen Happenings." But his mute, all-white tableaux, suffused with urban ennui, are really closer to Social Realist art, as evidenced by his other subjects: Biblical scenes and paeans to the Depression and the Holocaust. Such themes embody Segal's concern for the "real world" and those living on the fringes of society. Segal's lesser-known work includes pastels from the

1950s and 1960s and a recent series of portrait drawings and paintings — all in color.

☞ Goings, Hopper, Kienholz, K. Smith

George Segal. b New York, NY, 1924. **The Diner.** 1964–66. Plaster, wood, chrome, laminated plastic, Masonite, fluorescent lamp, glass, paper. **h**93¾ x **w**144¼ x **d**96 in. **h**238.3 x **w**366.6 x **d**244 cm. Walker Art Center, Minneapolis, MN.

Seifert Paul A.

Wisconsin Farm Scene

A simple farm scene radiates order and serenity. Horses prance and livestock graze; fertile fields are implied by divided green areas between the buildings and distant hills. Seifert's drawing could be childlike, as in the sun's rays that look like spokes, and his methods unconventional, such as the use of metallic paint to effect the glow of sunset. Still, his patterned daubs and flat washes of green create a tonal harmony suggesting the calm abundance of farm life in summer. Seifert both painted and lived this life, having left Germany as a young man to avoid military service. Settling in southern Wisconsin, he raised his family in a simple log cabin and earned a living growing flowers, fruits, and vegetables. By the late 1870s he was drawing watercolor farm portraits, some of which he sold to neighbors. He also practiced taxidermy and oil painting on glass. "People like my work and I like to paint for them," he claimed

☛ Hofmann, Inness, Moses, Strand

Paul A. Seifert. b Dresden, Germany, c1840–46. **d** near Gotham, WI, 1921. **Wisconsin Farm Scene.** 1880. Watercolor and oil on cardboard. **h**16⅝ x **w**28¾ in. **h**42.3 x **w**73 cm. New York State Historical Association, Cooperstown, NY.

Serra Richard

Torqued Ellipses

One does not merely look at *Torqued Ellipses*, one moves in and through its three massive twisted conical forms. The piece confronts viewers with the unexpected shifting of volume, depth, mass, and location of its phenomenally heavy and inert steel ellipses, two of them weighing approximately thirty-six tons, and one, the double ellipse, weighing approximately ninety tons. Serra, a leading figure of 1960s Minimalist sculpture, searched for and found only one of two steel rolling machines left in the world that was capable of rotating the steel sheets; the machines were originally used in the manufacture of World War II battleships. Nonetheless, it took one year to successfully achieve the first form. "I wasn't interested in the aesthetics of these pieces," he says, "but in the fact that a generic form, an ellipse, could be torqued on itself to produce a form not seen before. This form doesn't exist in architecture, nor in pottery."

☞ DiSuvero, Mangold, Motherwell, D. Smith

400

Richard Serra. b San Francisco, CA, 1939. **Torqued Ellipses.** 1997–98. Cor-Ten steel. **Torqued Ellipse I:** h144 x w245 x l348in. h365.8 x w622.3 x l884 cm. **Torqued Ellipse II:** h157 x w247 x l348in. h398.8 x w627.4 x l884cm. **Double Torqued Ellipse:** outside ellipse: h157 x w325 x l311in. h398.8 x w825.5 x l790cm. As installed at Dia Center for the Arts, New York, NY.

Serrano Andres

The Morgue (AIDS Related Death II)

What appears to be a ribbon tied like a bracelet to this man's wrist is in reality an identification tag relating to his death. Photographed up close and in color, the cold, anonymous body's nearly palpable presence makes many viewers recoil, yet our curiosity about death also makes the picture fascinating and irresistible. Serrano, who spent much of 1992 photographing bodies in a morgue, has made a career out of bestowing beauty upon frequently disturbing subjects, producing a sense of perverse attraction in viewers. In an earlier series of pictures, bodily fluids were used to create large fields of color. The most famous of these, *Piss Christ*, created a political controversy when members of Congress learned that federal funds had been used to support Serrano's work. Although some found Serrano's interpretation of religion troubling, he was in fact raised as a Roman Catholic and is broadly interested in the iconography of religion as a subject for both art and popular culture.

☛ Blume, Bourgeois, Gober, Sherman

401

Andres Serrano. b New York, NY, 1950. **The Morgue (AIDS Related Death II).** 1992. Cibachrome, silicone, Plexiglas, wood frame. **h**49 x **w**60 in. **h**124.5 x **w**152.5 cm. Paula Cooper Gallery, New York, NY.

Shahn Ben

Study for Jersey Homestead Mural

This image was a study for a 45-ft mural that traces the progress of immigrant workers through "disillusionment in the sweat shops, then the struggle for and growth of their union, and the final emergence of the long-cherished ideal of the co-operative community," as the artist described it. The fresco was commissioned by the Federal Resettlement Administration for a community center at the Jersey Homesteads, an experimental housing development now known as Roosevelt in New Jersey. The mural features many recognizable personalities, including Albert Einstein and the executed anarchists Sacco and Vanzetti at the left. They are flanked on the right by New Deal planners, under a portrait of President Franklin D. Roosevelt examining a blueprint of the government-financed project. Using a system of symmetry he learned while assisting Diego Rivera, Shahn composed interlocking vignettes unified by diagonal rhythms. One of the foremost Social Realists, he believed so strongly in the homestead experiment that he became a resident of the community.

☞ Brooks, Evergood, Levine, Soyer

402

Benjamin Hirsch Shahn. b Kovno, Lithuania, 1898. d New York, NY, 1969. **Study for Jersey Homestead Mural.** c1936. Tempera on board. h19¹/₂ x w27¹/₂ in. h49.6 x w69.9 cm. Private collection.

Shapiro Joel

Untitled

Two abstract sculptures made from blocks of painted wood uncannily resemble dancing figures. The mostly black, "red-headed" figure seems the most accurately descriptive of a human form, while the other, mostly red, sculpture seems a confusion of limbs, implying motion, though of a type that is irreconcilable with a specific human action. The latter is one of Shapiro's "crashing" forms, a figure whose limbs have been removed or altered to become literally unrecognizable yet somehow familiar. Shapiro has stated that his sculptures and drawings are intended to evoke "one's internal feeling of movement" rather than describe a particular action or position. Shapiro's work since the late 1960s has included larger-than-life sculptures, as well as small bronze models of generic houses and chairs. His art is considered Post-Minimalist for its imbuing rigid Minimalist conventions with human emotion and indeterminate meaning.

☛ Calder, Haring, Nadelman, Walker

Joel Shapiro. b New York, NY, 1941. **Untitled.** 1995–97. Oil paint on wood. Unit one: **h**109 x **w**77 x **d**46 in. **h**276.9 x **w**195.6 x **d**116.8 cm. Unit two: **h**51 x **w**62 x **d**28 in. **h**129.5 x **w**157.5 x **d**71.1 cm. PaceWildenstein, New York, NY.

Sharp Joseph Henry

Crow Camp at Wyola

In this vibrant pastel of a lakeside Native American encampment, nature and culture exist as one. The rainbow-hued Crow Indians' tipis are sketched in colors and strokes that blend with the forest, while the people themselves are depicted less as individuals than as a group of accents that dot, and enhance, the landscape. Painted near the Big Horn Mountains of Montana and Wyoming, not far from

General Custer's battlefield, the work memorializes a way of life that had all but disappeared by the early twentieth century. Sharp became interested in Western subjects, especially Native Americans, in the early 1880s, when such subjects enjoyed wide popularity in this country and abroad. A regular visitor to New Mexico during the following decade, he was a founder of the Taos Society of Artists

and a leading member of the art colony's first generation. In 1902, he began wintering at Crow Agency, Montana, where his studies of Native Americans emphasized their austere living conditions and romanticized their struggle for survival.

☞ Couse, P. Kane, Leigh, Wimar

404

Joseph Henry Sharp. b Bridgeport, OH, 1859. **d** Pasadena, CA, 1953. **Crow Camp at Wyola.** n.d. Oil on canvas. **h**16¼ x **w**24 in. **h**41.3 x **w**61 cm. Gerald Peters Gallery, Santa Fe, NM.

Shaw Charles

Plastic Polygon

This shaped painting evokes abstracted modern buildings. Its stepped structure echoes the setback construction of early-twentieth-century skyscrapers, and the thin, multicolored columns painted on its surface suggest an array of solid, tall forms. Shaw, an early member of the American Abstract Artists group, had in fact studied architecture before turning to art, and he acknowledged that

his fascination with the Manhattan skyline inspired his work. In 1938, he wrote that "the polygon sprouting, so to speak, from the steel and concrete of New York City, I feel to be essentially American in its roots." Many of Shaw's paintings are actually sectional constructions, comprising several separate panels and sometimes relief elements. Some are geometric, while others

have biomorphic shapes derived from Jean Arp's painted wood reliefs. Together with Charles Biederman, Alexander Calder, and other abstract artists whose work combined aspects of painting and sculpture, Shaw was known as a Concretionist.

☞ Abbott, Diller, Reinhardt, Storrs

Charles Green Shaw. b New York, NY, 1892. d New York, NY, 1974. **Plastic Polygon.** 1937. Oil on wood. **h**45 x **w**30 in. **h**114.4 x **w**76.2 cm. Collection of J. Donald Nichols.

Sheeler Charles

American Interior

Despite its generic title, this painting's warm, inviting room is actually Sheeler's own. The eclectic group of American textiles and objects — including a table (bottom left) and round box (upper right) made by the Shaker community — is viewed from a steep overhead vantage point. Sheeler based this composition on a photograph taken from his stairway, a technique that accounts for the unusual perspective as well as the overall flattening effect. In fact, Sheeler began his career as an architectural photographer. He never abandoned the medium, often using his photographs as the starting point for his paintings of interiors, rural landscapes, and industrial scenes rendered in the crisp, hard-edged style known as Precisionism. In this work, the Precisionist hallmarks of broad areas of flat color and a dynamic, almost abstract composition are played against the intimate nature of the subject. The painting is a tour-de-force of perspective while remaining a simply homily to the American home.

☛ Demuth, Lozowick, Marshall, Osorio, Steiner

Charles Sheeler. b Philadelphia, PA, 1883. **d** New York, NY, 1965. **American Interior.** 1934. Oil on canvas. **h**32¹/₂ x **w**30 in. **h**82.6 x **w**76.2 cm. Yale University Art Gallery, New Haven, CT.

406

Sherman Cindy

Untitled #93

With her lace nightgown signaling vulnerability and the clenched blanket signaling apprehension, this blonde young woman looks not at the camera, as she would if she were having her portrait taken, but at someone approaching above and in front of her, as if she were caught up in an event or its rehearsal. The woman is the photographer herself, and the picture is part of a series that followed on the heels of Sherman's most famous photographs, called "Untitled Film Stills." Instead of attempting self-portraits, Sherman made near-duplicates of the roles or stereotypes assigned to young women in movies and television. Her aim, like that of many of her fellow Postmodernist artists, was to suggest that the self is not self-created but a product of a culture suffused with photographic images. This photograph trades on tropes established in such genres as detective, romance, and horror films of the postwar years. Today Sherman's repertory of sources has expanded to include folk tales, fashion, and Old Master paintings.

☞ Blume, Goldin, Lichtenstein, Serrano

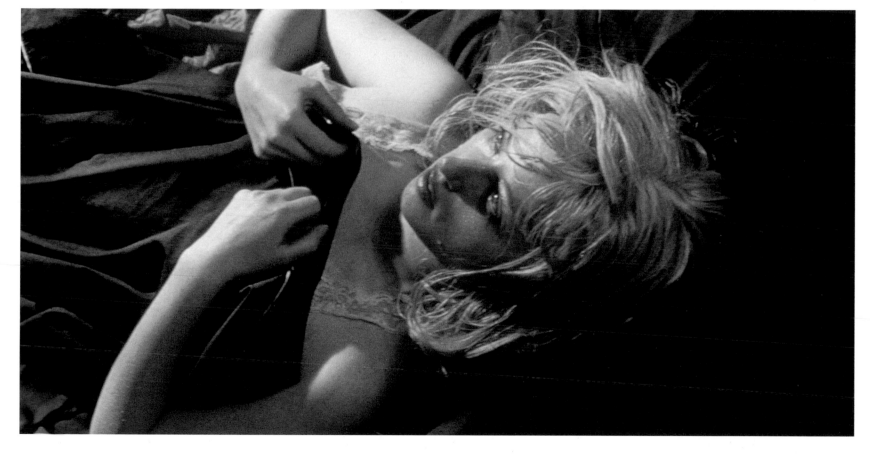

Cindy Sherman. b Glen Ridge, NJ, 1954. Untitled #93. 1981. 35mm color slide. Metro Pictures, New York, NY.

Shinn Everett

The Orchestra Pit, Old Proctor's Fifth Avenue Theatre

The furtive vantage point in this painting draws the viewer into the playful eroticism of a night out at a music hall. Seen from behind the head of an orchestra member, himself blocked off by the brass railing and velvet curtain of the orchestra pit, the stage is merely a slash of light, and dazzling taffeta-gowned females peer down as though in a peep show. Although Shinn's early work was considered rebellious in subject matter, his style was less inflammatory, influenced as it was by the European master of theatrical scenes, Edgar Degas. Shinn began his career as a newspaper illustrator at the *Pennsylvania Gazette*. Under the spell of the visionary teacher and artist Robert Henri at the Pennsylvania Academy, Shinn and several of his fellow artist-reporters followed him to New York. They eventually changed the meaning and history of American art as The Eight, a group that reacted against the academic, pastoral art of the preceding decades to depict the realities of urban life.

☛ Alexander, duBois, Glackens, Nadelman

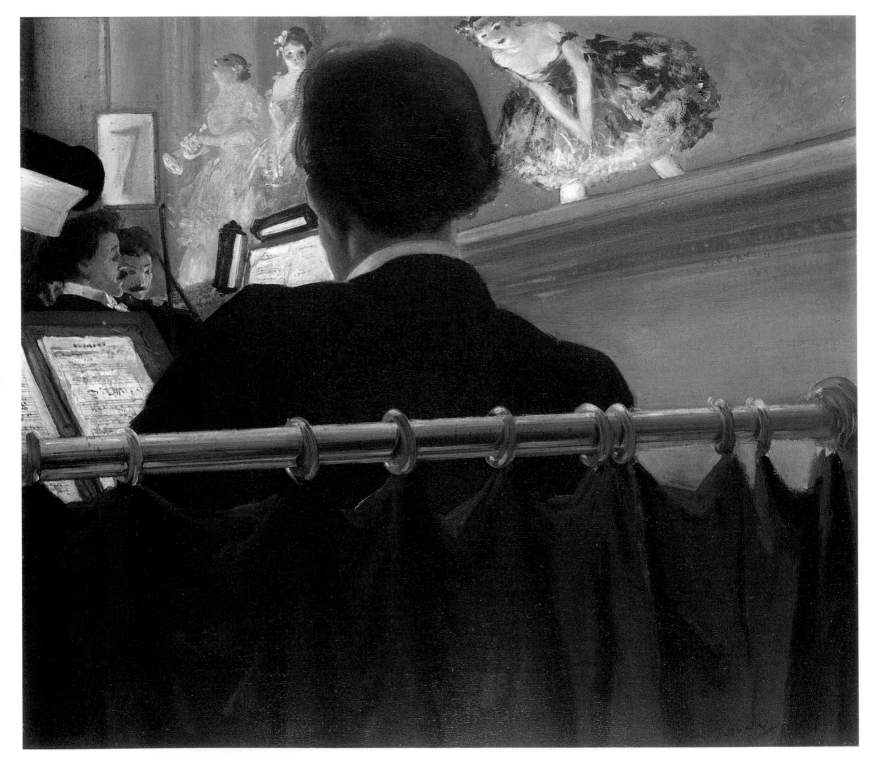

Everett Shinn. b Woodstown, NJ, 1876. d New York, NY, 1953. **The Orchestra Pit, Old Proctor's Fifth Avenue Theatre.** c1906–07. Oil on canvas. h17⁷/₁₆ x w19¹/₂ in. h44.6 x w49.5 cm. Private collection.

Simpson Lorna

Back

Joined by a single frame, these two pictures have little in common except a focus on hair — specifically the hair of an African-American woman, and one whose presence in the left picture is rendered symbolic because we see only her back. Hair has a rich metaphorical history in the African-American community, and this woman's hair appears to occupy a middle ground between straightened, Caucasian styles and the more politicized, natural Afros and dreadlocks of later decades. "Eyes in the back of your head" is a commonplace expression, but it takes on a more provocative tone when framed by the severed braid on the right. Simpson frequently pairs pictures and texts in her work, which addresses issues of gender, race, and power in subtle but effective ways. She began exhibiting in the late 1980s, at a time when a number of African-American artists, including Carrie Mae Weems and Clarissa Sligh, had begun to use photography as a vehicle for exploring their racial and cultural heritage.

☛ Dewing, Kruger, Shinn, Wool

eyes in

the back of

your head

Lorna Simpson. b Brooklyn, NY, 1960. **Back.** 1991. 2 color Polaroid photographs, 3 plastic plaques. **h**25¹/₂ x **w**41¹/₂ in. **h**64.8 x **w**105.5 cm. Sean Kelly Gallery, New York, NY.

Siskind Aaron

Martha's Vineyard

What some might see as a photographic record of the art of stone masonry, others could consider an appreciation of that most basic of life forms, lichen. Neither of these ideas speaks to the intentions of the photographer, however. By 1954, Aaron Siskind had spent a decade making an art of photographing essentially flat natural forms. Siskind's postwar approach to photography was to dispense with traditional perspectival space as a means of probing the abstract potentials of the camera. His interest in abstraction was influenced by his association with New York School abstract painters, who in turn were influenced by him; Franz Kline is one Abstract Expressionist whose paintings bear comparison to Siskind's photographs. The photographer's interest in focusing attention on the flat surface of the picture plane constituted a radical departure from most prior forms of photography, as well as from his own eariler work, which included social-documentary projects such as "Harlem Document" and "Portrait of a Tenement."

☛ Indiana, Kline, Motherwell, Penn

410

Aaron Siskind. **b** New York, NY, 1903. **d** Rhode Island, NJ, 1992. **Martha's Vineyard.** 1954. Gelatin silver print. George Eastman House, Rochester, NY.

Sloan John

Sunday, Women Drying Their Hair

In John Sloan's turn-of-the-century New York, an ordinary rooftop is transformed into a ladies' beauty parlor. Arms raised akimbo in a series of rhythmic triangles, three woman stand atop a steamy rooftop, guiding the wind and summer heat through their wet locks of hair. Clean laundry rustles on a clothesline as the billowing smoke of industrial America colors the air in the distance. Trained as an illustrator, Sloan worked first in Philadelphia and settled in New York City, where he was fascinated by the everyday life of the working classes. His art was noted for its acute but sympathetic depiction of an urban underworld that included gritty back streets and crowded tenements, but also ribald dance halls and fresh-faced, merry young women. This sympathetic representation of city life became known as The Ash Can School. In this style of realist painting, poverty is made visible, and even picturesque.

☞ Bishop, Luks, Mann, Witkin

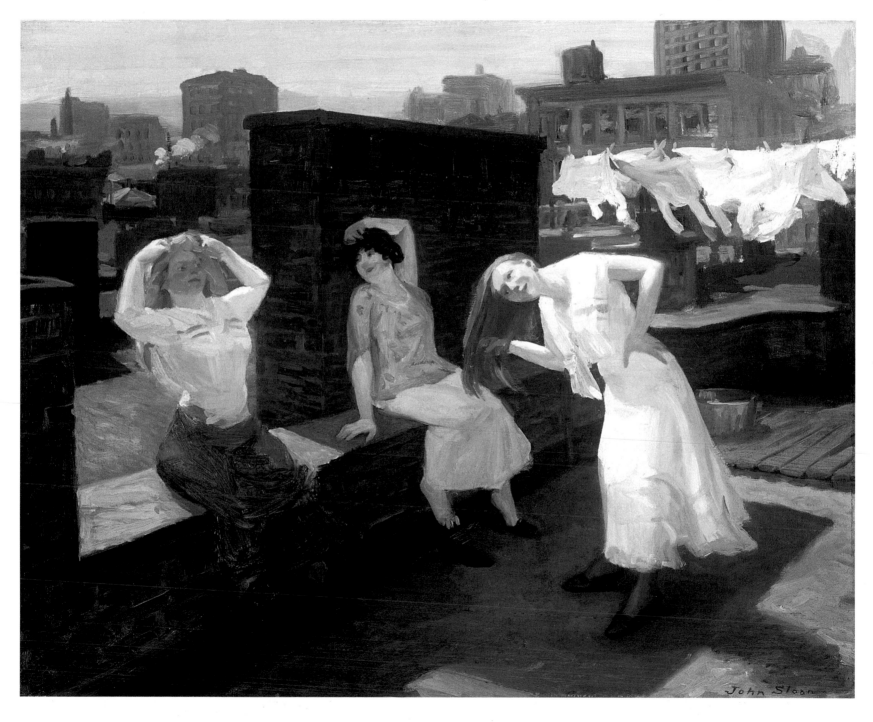

411

John Sloan. b Lock Haven, PA, 1871. d Hanover, NH, 1951. **Sunday, Women Drying Their Hair.** 1912. Oil on canvas. h26 x w32 in. h66.1 x w81.3 cm. Addison Museum of American Art, Phillips Academy, Andover, MA.

Smibert John

The Bermuda Group

Eight figures, united through a rhythmic interplay of gaze, gesture, and attitude, gather around a table laden with books and covered with an Oriental carpet. Paused in mid-thought at the right stands Dean George Berkeley, the Irish-born empiricist philosopher who assembled this group to help him establish a college in Bermuda. At the left, the artist Smibert stares out from the canvas. When funds for the philosopher's project failed to materialize and the entourage returned to London, Smibert remained in Boston, readily attracting patronage. Having studied art in London and taken a Grand Tour of Europe, Smibert worked in the manner of Godfrey Kneller's last Baroque court portraits. He moderated this style to suit the simpler pretensions of New England's wealthy merchant class. Smibert's studio served as a gallery, art supply shop, and showplace. There, *The Bermuda Group*, by far the most accomplished and sophisticated painting available in the colonies, continued to inspire young artists even after Smibert's death.

☞ **Field, Pratt, Rivers, Trumbull**

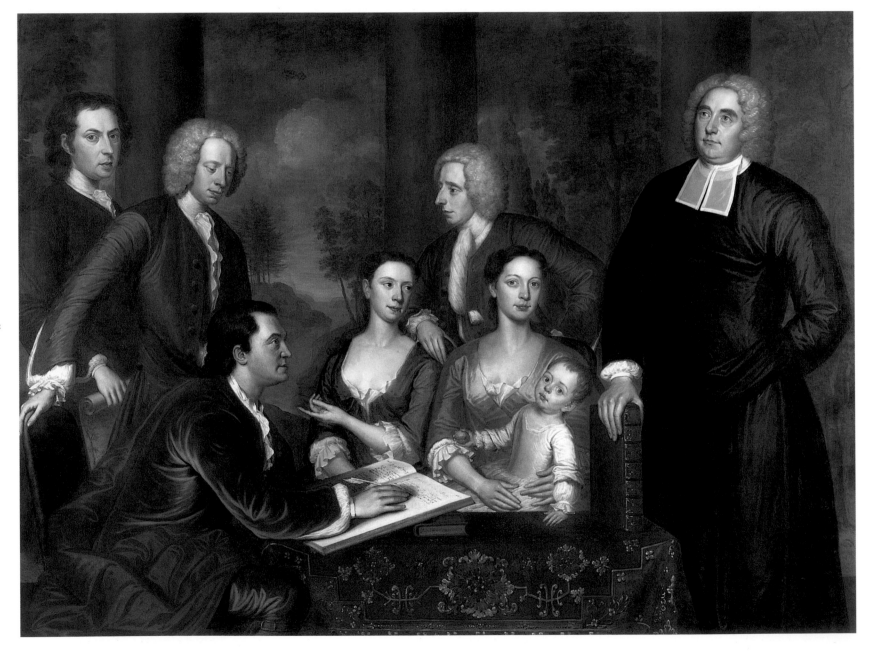

John Smibert. b Edinburgh, Scotland, 1688. **d** Boston, MA, 1751. **The Bermuda Group.** 1729. Oil on canvas. **h**69¹/₂ x **w**93 in. **h**176.6 x **w**236.4 cm. Yale University Art Gallery. New Haven, CT.

Smith David

Primo Piano II

A shield-shaped central plate balanced by a waving wing at one side and a disk at the other allows a keyhole view of the landscape through its circular hole. The elements are arranged like components of an abstract collage. Indeed, many of Smith's geometric constructions were planned using spray-painted scraps of cut paper. A pioneer of welded steel sculpture in America, Smith applied a practical knowledge of metalwork to the problems of organizing forms in space. He trained as a painter, however, which may account for the pictorial strategies — including collage, surface texturing, and applied color — in his approach to sculpture. Smith was deeply intrigued by steel itself, and hand-fashioned it into imposing structures that may be cool and refined or raw and aggressive.

Sculpture, he once said, "is my way of life, my balance, and my justification for being."

☛ Dove, DiSuvero, Schamberg, Shapiro

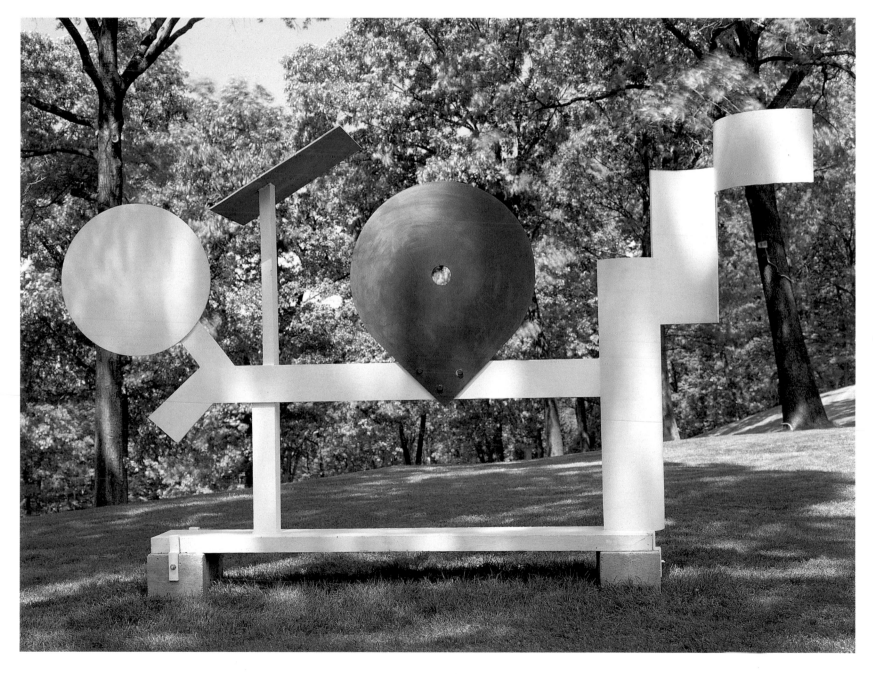

David Smith. b Decatur, IN, 1906. **d** Bennington, VT, 1965. **Primo Piano II.** 1962. Painted steel, bronze, stainless steel. **h**91¼ x **w**162 x **d**30 in. **h**231.8 x **w**411.5 x **d**76.2 cm. Jardin des Tuileries, Paris, France.

Smith Kiki

Honeywax

A human figure, hands thrust at her sides, assumes a position that normally would be painful, if not impossible, to maintain. The body seems frozen, even petrified, then unceremoniously toppled onto the gallery floor. Made from warm-colored beeswax, *Honeywax* is typical of Smith's sculptures, which incorporate a host of hand-worked materials, from cast bronze and blown glass to latex and papier-maché. In the early 1980s, Smith began her exploration of the human body from the inside out, casting individual organs, nervous and venous systems, and finally whole figures in states of repose and decay. Smith does not cast her figures from living subjects, but instead finds them in anatomy books or gleans them from memory. This strategy is intended to reduce their specific political and cultural allusions, allowing Smith's haunting art to speak to all viewers who have bodies, and not just to those who share her opinions.

☞ **Bourgeois, Pearlstein, Segal, Serrano**

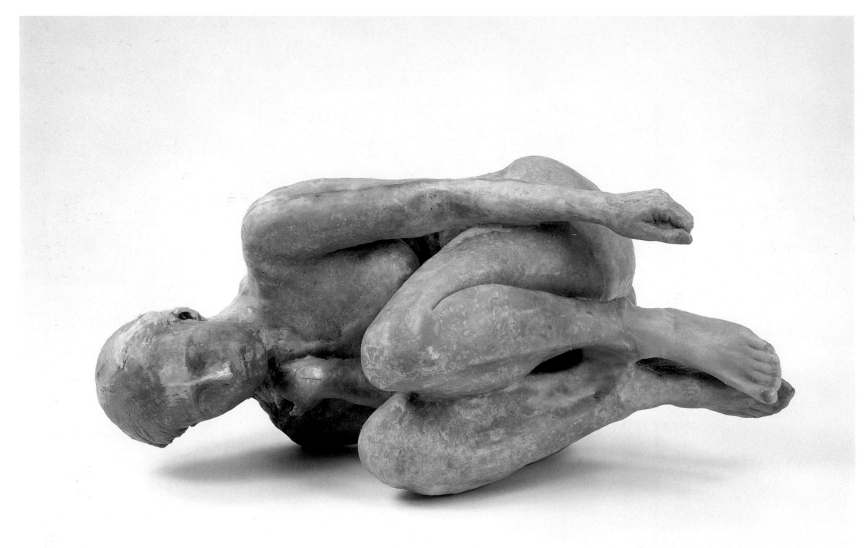

414

Kiki Smith. b Nuremberg, Germany, 1954. **Honeywax.** 1995. Beeswax. **h**15½ x **w**36 x **d**20 in. **h**39.4 x **w**91.5 x **d**50.8 cm. Milwaukee Art Museum, Milwaukee, WI.

Smith Thomas Self Portrait

With his somber expression, weary eyes, and hand holding a skull, Smith presents himself reflecting on old age and impending death. Further instilling a message of Puritan gloom is the poem: "Why Why should I the World be minding / therein a World of Evils Finding / Then Farwell World . . ." However, Smith's double chin, coiffed hair and lace cravat denote a man who has enjoyed material pleasures and worldly accomplishments. The seascape view shows a naval skirmish in which Smith, a mariner, may have taken part. No other self-portrait from seventeenth-century New England is known, and no other painting from this time depicts so well the competing pressures of secular prosperity and spiritual longing in Puritan society. Smith is one of the very few identified artists from seventeenth-century Boston. Although nothing is known of his training, this portrait, along with three others attributed to him, suggests that Smith was well-versed in the conventions of Dutch and English Baroque portraiture.

☛ Chandler, Feke, The Freake-Gibbs Painter, Moulthrop

415

Thomas Smith. b unknown. **d** Boston, MA, c1691. **Self Portrait.** c1680. Oil on canvas. **h**26¾ x **w**23¾ in. **h**62.9 x **w**60.4 cm. Worcester Art Museum, Worcester, MA.

Smith Tony

Duck

A geometric form of black-painted steel floats on a bright green sea of freshly mown grass. The work's title, *Duck*, encourages viewers to examine the sculpture for resemblance to an aquatic animal or maybe to a crouching human figure. Smith once remarked that pure abstraction is impossible; accordingly, his monumental abstract sculptures all have anthropomorphic elements despite their sharp geometric planes. Though usually identified with Abstract Expressionism or Minimalism, Smith's sculptures also employ elements of Constructivism and Surrealism in their deceptively simple forms. Each one is an investigation into the razor-thin line between figural abstraction and representation and into the affinities shared by architecture and biology. Smith attributes his signature material of somber black steel to an incident in his childhood, when, recovering from tuberculosis, he slept in a room with a looming black-iron stove as his only company.

☛ Covert, DiSuvero, Hesse, Serra

416

Tony Smith. b South Orange, NJ, 1912. d New York, NY, 1980. Duck. 1963. Steel, painted black. h11 ft. 4 in. x w13 ft. 10 in. x d9 ft. 3 in. h3.45 x w4.22 x d2.82 m. Private collection.

Smithson Robert

Spiral Jetty

A path of limestone rock advances from the land, spilling out into the Great Salt Lake of Utah where it spirals into a vortex frozen in time. Is this some uncanny natural formation or the result of creative human labor? Smithson pioneered a movement known as Land Art, which addresses the distinctions between site (the natural location or source material from which a piece of art, or "earthwork," is made) and nonsite (the traditional gallery or exhibition space). Earth was his palette and his material, and the constraints of the gallery and museum were a limitation to be mined for creative inspiration. Smithson completed *Spiral Jetty* three years before he died at the age of thirty-five in a plane crash while surveying for his earthwork *Amarillo Ramp*. Despite its monumentality, *Spiral Jetty* is not permanent. Indeed, since its creation, its appearance has been dramatically altered by rising tides and other natural phenomena.

☞ Bricher, De Maria, Heizer, Kensett

Robert Smithson. b Rutherford, NJ, 1938. **d** Amarillo, TX, 1973. **Spiral Jetty.** 1970. Rock, salt crystals, earth, and water. **diam** 1500 ft. **diam** 457 m. (approx.) Great Salt Lake, UT.

Southworth & Hawes

John Quincy Adams

Having already finished his term as the sixth president of the United States, an older but wiser John Quincy Adams sits sternly for this Daguerreotype portrait, taken within ten years of photography's invention. Adams's upright, Brahmin pose could be explained by the long exposures needed at the time; most likely his neck was clamped in a brace to prevent his head from moving. In any case, the photographers have managed to convey his dignified, distinguished presence in a picture both technically and aesthetically polished. Southworth, a former pharmacist, and Hawes, a former painter, were the proprietors of Boston's most celebrated photography studio and brought their combined skills to bear on a number of luminaries of the day, including Daniel Webster. In the 1850s Southworth went west to mine for gold and made some of the first photographs of the newly rich city of San Francisco.

☞ Beaux, Currier, Earl, Inman

418

Albert Sands Southworth. b West Fairlee, VT, 1811. **d** Charlestown, MA, 1894. **Josiah Johnson Hawes. b** East Sudbury, MA, 1808. **d** Crawford's Notch, NH, 1908. **John Quincy Adams.** c1845. Daguerreotype (copy). The Metropolitan Museum of Art, New York, NY.

Soyer Raphael

Waiting Room

As passengers patiently await the arrival and departure of their trains, a woman in the back tries to hide a yawn that expresses the general boredom pervading the room. The mood is lifted by the bright red hat at the painting's center. The young woman who wears it seems transplanted from a Rembrandt painting despite her modern clothes. Soyer was devoted to the honest representation of contemporary life,

although he modeled his approach on that of the Dutch Masters as well as earlier realists such as Thomas Eakins and Gustave Courbet. He found his inspiration in New York City and its inhabitants. "People — that's content to me," he once said. "Humanity, humans, people." Together with his twin brother, Moses, and younger brother Isaac, Soyer was a leading urban Realist of the 1930s. Embittered by the

dominance of Abstract Expressionism in the Cold War era, when many figurative artists fell out of favor, he nevertheless continued to pursue a lifelong commitment to depicting human experiences in his characteristic natural style.

☞ Bishop, Evergood, Lange, Levine

419

Raphael Soyer (Schoar). b Tombov, Russia, 1899. **d** Brooklyn, NY, 1987. **Waiting Room.** 1940. Oil on canvas. **h**34¼ x **w**45½ in. **h**87 x **w**115.6 cm. The Corcoran Gallery of Art, Washington, D.C.

Spencer Lilly Martin

War Spirit at Home

A servant watches three jubilant children parade around the parlor, enacting their youthful responses to the news of the Union victory at Vicksburg, Mississippi, during the Civil War. The principal figure of this domestic narrative, however, is the mother on the right, whose pyramidal, monumentalized form seems to exude rather than reflect the bright light that accentuates her. She balances a baby on her lap while reading the newspaper (a symbol of the world outside the home), and represents an entire generation of women pressed by the Civil War into activity beyond the domestic sphere. Although the painting's title refers overtly to the children's playful celebration, it also introduces a larger meaning about the expanded duties of women responsible for maintaining life on the domestic front while their men went to war. This work held personal meaning for Spencer, a woman working in a male-dominated profession, who balanced her roles as artist, wife, mother of thirteen, and breadwinner for her family.

☛ Hovenden, Pinney, J. S. Sargent, C. White

Lilly Martin Spencer. b Exeter, United Kingdom, 1822. **d** New York, NY, 1902. **War Spirit at Home (Celebrating the Victory at Vicksburg).** 1866. Oil on canvas. **h**30 x **w**32¾ in. **h**76.2 x **w**83.2 cm. The Newark Museum, NJ.

Spencer Niles

The Watch Factory, #2

A simple palette of brown, beige, ochre, and black articulates the elemental patterns of a factory in the afternoon light. This sectioned, abridged portrait combines the naïve, flattened perspective of early American primitive scenes with the hard-edged machine aesthetic of the Precisionists with whom the artist was associated. Spencer was a member of an informal summer artists retreat in Ogunquit, Maine,

where he acquired a passion for American folk art while simultaneously developing what has been called his Modernist style of Cubism "seen in nature." His work was included in a 1926 group show at America's first museum of modern art, the Phillips Memorial Art Gallery in Washington, D.C., of artists labelled the following year as Precisionist. While the movement branched off into various strains

In the 1930s, Spencer remained one of the primary figures of Precisionism, along with Charles Sheeler and Ralston Crawford.

☛ Baltz, Demuth, Lozowick, Shaw

421

Niles Spencer. b Pawtucket, RI, 1893. **d** Dingman's Ferry, PA, 1952. **The Watch Factory, #2.** c1950. Oil on canvas. **h**10 x **w**15½ in. **h**25.4 x **w**39.4 cm. Curtis Galleries, Minneapolis, MN.

Spero Nancy The Goddess Nut

Female human figures march, leap, and run across a series of paper scrolls. Their progression follows neither the standard form of scroll-paintings nor any chronological order. The disorderly women are icons, both anonymous and famous, from across the seas of history. Nut is an ancient Egyptian goddess who appears alongside the Venus of Willendorf, a fertility symbol, and in the lower section of the third panel from the right, a photograph of a bound woman found on a dead Gestapo officer during World War II. Spero discovered this image with the help of her husband, painter Leon Golub, another politically-oriented artist. Spero's artworks marry the handmade strategies of street-level propaganda to the rarefied venues of high art. Her simple yet effective consciousness-raising techniques alert us to the subservient way women have been depicted in art over the centuries, while presenting us with competing images of power and grace.

☞ Chicago, Fuller, Golub, Walker

Nancy Spero. b Cleveland, OH, 1926. **The Goddess Nut.** 1989. Handprinting/collage on paper. 7 panels. Each panel: **h**110¼ x **w**20½ in. **h**280 x **w**52 cm. Barbara Gross Gallery, Munich, Germany.

Stanley John Mix

On the Trail

A sinuous column of Piegan Indians, a band of the larger Blackfoot tribe, filters through the rocky region of the Pacific Northwest on their way to a peace council with Isaac I. Stevens, then governor of the newly created state of Washington. In the foreground, Chief Low Horn, astride his handsome white horse and dressed in decorated buckskin and feather bonnet, leads the peaceful line. Stanley witnessed this scene firsthand while working as an illustrator for the Pacific Railroad Survey in the 1850s, and he painted it from memory one year before he died. Although *On the Trail* represents a peaceful event involving Indians and white men, the painting was once retitled *On the War Path* to increase sales. Regarded as one of the premier white settler painters of Native Americans, Stanley was also one of the earliest Native American photographers, carrying Daguerreotype equipment with him to record portraits and landscapes. He always gave duplicate copies to the Native Americans he photographed and used as models for his paintings.

☛ Catlin, Curtis, Prince, Remington, C. M. Russell

423

John Mix Stanley. b Canandaigua, NY, 1814. **d** Detroit, MI, 1872. **On the Trail.** 1871. Oil on canvas. **h**36 x **w**48 in. **h**91.5 x **w**121.9 cm. Gerald Peters Gallery, Santa Fe, NM.

Steichen Edward

The Flatiron

Photographed here in an atmospheric haze reminiscent of Whistler's nocturne paintings, the Flatiron Building is a monument both to architectural invention and to New York City's urbanity. The structure was built on a narrow triangular Fifth Avenue plot in 1902. Three years later, when Steichen took this atmospheric view, it was becoming a favorite subject of photographers, in part because an adjacent park provided a supply of tree limbs with which to frame the scene. In Steichen's print an emulsion layer of gum-bichromate adds a color tint to the otherwise black and white image. Steichen at this time was associated with Alfred Stieglitz and the Photo-Secession movement, an American elaboration of the international style known as Pictorialism. But after taking charge of an aerial photography unit in World War I, he switched gears and became a magazine photographer.

☞ Abbott, Rothko, Storrs, Whistler

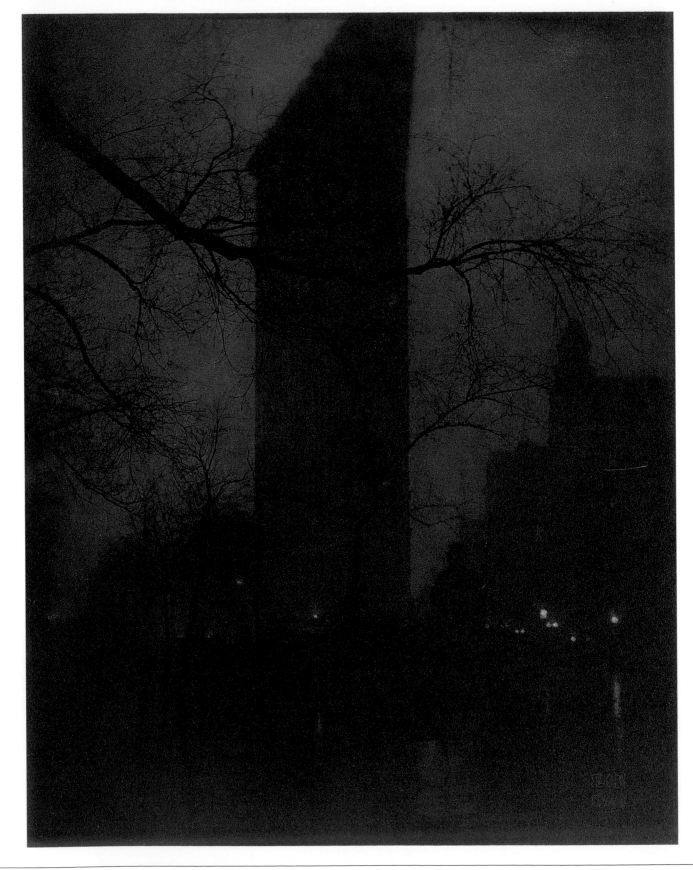

Edward Steichen. b Luxembourg, 1879. d West Redding, CT, 1973. **The Flatiron.** 1905. Brown pigment gum-bichromate over gelatin silver print. The Metropolitan Museum of Art, New York, NY.

Steinberg Saul

Wilshire & Lex

Shortening the distance from Manhattan to Los Angeles by some 2,500 miles, the artist has constructed an imaginary intersection where only a few steps separate New York subway riders from a cactus-studded California fantasyland. On the horizon, a transplanted Statue of Liberty — now a saber-wielding fool in cap and bells — lampoons American militarism. This is one of Steinberg's many variations on America's image of itself, a theme he has explored since 1941 in cartoons and covers for *The New Yorker* magazine. His penetrating, deceptively simple drawings often feature cryptic calligraphy, false official seals, and images that look like passport photographs. His obsession with travel and identity may be due to his background. A Romanian émigré who served with the US Navy in Europe, Africa, and the Pacific during World War II, he once observed that an American is "a foreigner who came here and said, *tiens!* what a country. Let's go West."

☛ **Burchfield, Frank, Hockney, Pettibon**

Saul Steinberg. b Râmnicul-Sarat, Romania, 1914. **Wilshire & Lex.** 1994. Crayon, watercolor, and wax on paper. **h**22¼ x **w**15¼ in. **h**56.5 x **w**38.7 cm. PaceWildenstein, New York, NY.

Steiner Ralph

American Rural Baroque

This antique wicker rocker may have been designed in the nineteenth century, but its shadow speaks as thoroughly to the twentieth century as does a Cubist painting by Picasso. The stylistic disparity between the chair and its shadowy double suggests that Steiner was being ironic when he gave the image its portentous title, *American Rural Baroque*. The photograph was taken only a decade after Paul Strand's similarly sited photograph *Abstraction, Porch Shadows*, an image that for many marks the beginning of the Purist style of modern photography. Steiner met Strand for the first time in 1928, and subsequently modeled his technique on Strand's, working as an independent advertising and magazine photographer. Steiner's influence on modern photography was far greater than his current reputation suggests. For example, he taught Walker Evans to use a view camera at the beginning of Evans's career.

☞ Eggleston, Lee, Sheeler, M. White

Ralph Steiner. b Cleveland, OH, 1899. **d** Thetford Hill, VT, 1986. **American Rural Baroque.** 1930. Gelatin silver print. The Museum of Modern Art, New York, NY.

Stella Frank

Spectrum

Two identical square canvases are painted with a series of six nested squares of increasing size. In each canvas, the order of colors is reversed, beginning or ending with black or yellow. Stella was the first American artist to use both rigid systems and prosaic materials to create his abstract paintings, building a bridge between Abstract Expressionism and later developments such as Minimalism. Stella's "Black Paintings," large canvases painted only with black geometric lines, were made when the artist was only twenty-three, yet they are among the seminal works of American art history. Stella's early paintings emphasize the flatness and color of the picture plane, aspects that remove the work from painting's traditional signifiers of illusion and preciousness. *Spectrum* followed a series of paintings made with house paint. Later works used aluminum and copper paint, as well as geometrically shaped canvases. Stella's current work includes massive, cut-metal sculptures that explore the bonds between sculpture and painting.

☞ Bartlett, Judd, Lewitt, Louis

Frank Stella. b Malden, MA, 1936. **Spectrum.** 1961. Alkyd on canvas. **h**8 x **w**16 in. **h**20.3 x **w**40.7 cm. Private collection.

Stella Joseph

Tree of My Life

Overwhelmed by lush jungle growth, this ancient tree's rotten trunk supports a glowing halo that illuminates a tapestry of exotic flowers and fruits. Stella painted this large and complex personal allegory in the aftermath of World War I. He depicts a primitive but robust New World paradise that revitalizes the decaying symbol of Europe, where his ethnic and artistic identities were forged. After emigrating to the United States from Italy as a teenager, Stella studied art in New York and worked as an illustrator. He returned to Europe in 1909 and remained there until 1912, a period during which he encountered the work of the Italian Futurists, whose aesthetic he adapted to American subjects. As a member of the Société Anonyme and other avant-garde groups in New York City, Stella became known for his dynamic Futurist treatment of urban and industrial scenes, but he was equally adept at sensitive nature studies. Vociferously antiacademic, he once declared that "the motto of the modern artist is freedom — real freedom."

🖙 Jess, E. Porter, Tiffany, Yoakum

428

Joseph (Guiseppe) Stella. b Muro Lucano, Italy, 1877. **d** Astoria, NY, 1946. **Tree of My Life.** 1919. Oil on canvas. **h**83½ x **w**75½ in. **h**212.2 x **w**191.9 cm. Collection of Mr. and Mrs. Barney A. Ebsworth.

Stettheimer Florine

Spring Sale at Bendel's

Chic shoppers, their vanity affectionately but accurately caricatured, struggle to snag the bargains at one of Fifth Avenue's fashionable emporiums. A critic described the scene as "an antic tableau that has something of the quality of a Marx Brothers romp." Stettheimer's eccentric canvases, often high-camp burlesques of the the social and cultural life of New York's upper echelons, are mistakenly thought to be naive. But the artist had extensive technical training and a sophisticated knowledge of modern art. With an independent income and no pressure to exhibit or sell her work, she painted to please herself and her elite circle. She designed the sets and costumes for the Gertrude Stein–Virgil Thomson avant-garde opera, *Four Saints in Three Acts*, which premiered in 1934. Her work was hardly known until two years after her death, when The Museum of Modern Art's memorial retrospective revealed Stettheimer's singular chronicle of, as she put it, "America having its fling."

☛ Bishop, J. McCarthy, Prendergast, H. Sargent

429

Florine Stettheimer. b Rochester, NY, 1871. **d** New York, NY, 1948. **Spring Sale at Bendel's.** 1921. Oil on canvas. **h**50 x **w**40 in. **h**127.1 x **w**101.7 cm. Philadelphia Museum of Art, Philadelphia, PA.

Stieglitz Alfred

Hands with Thimble

Like the fingers of a pianist, these delicately arched digits seem poised to produce a magical chord, although the presence of the thimble suggests the more mundane activity of mending. One might guess from their position in the frame that they belong to two different women, but in fact both are the hands of Georgia O'Keeffe, who would become one of the best-known American painters of the twentieth century.

At the time this picture was taken, O'Keeffe was the much-younger lover of Alfred Stieglitz (they married in 1924), and Stieglitz was in the midst of making a remarkable serial portrait of her that consisted of scores of pictures of her hands, face, and body. The sensuality of these pictures was unprecedented for Stieglitz, as the majority of his images depict clouds, skyscrapers, and New York street scenes. In

addition to being a world-famous photographer, he played an important role in introducing modern art to America through his "291" gallery and his magazine, *Camera Work*.

☛ Blume, Käsebier, Nixon, O'Keeffe

430

Alfred Stieglitz. b Hoboken, NJ, 1864. **d** New York, NY, 1946. **Hands with Thimble.** 1920. Gelatin silver print. The Buhl Collection, New York, NY.

Still Clyfford

Untitled

A bright white, totemic form punctuates the dense, craggy surface of Still's visionary abstraction, one of his many paintings exploring the duality of light and dark, the material and the spiritual. His jagged forms and earthy colors often evoke aspects of landscape, but Still dismissed any such literal analogies. Rather than discussing the nature and meaning of his imagery, he preferred to proclaim what his paintings did not represent. Often monumental in scale, Still's canvases reflect his search for transcendent imagery that expressed, as he once put it, "the Earth, the Damned, and the Recreated." With somewhat grandiose rhetoric, he rejected European Modernist precedents and argued that art is a journey of discovery not unlike that of the pioneers who settled the American West from which he hailed. Among the early Abstract Expressionists, Still is alone in combining the luminosity of the Color Field paintings with the dynamic gestures and apparent spontaneity of "action painting."

☞ Baziotes, Blakelock, Tack, Whistler

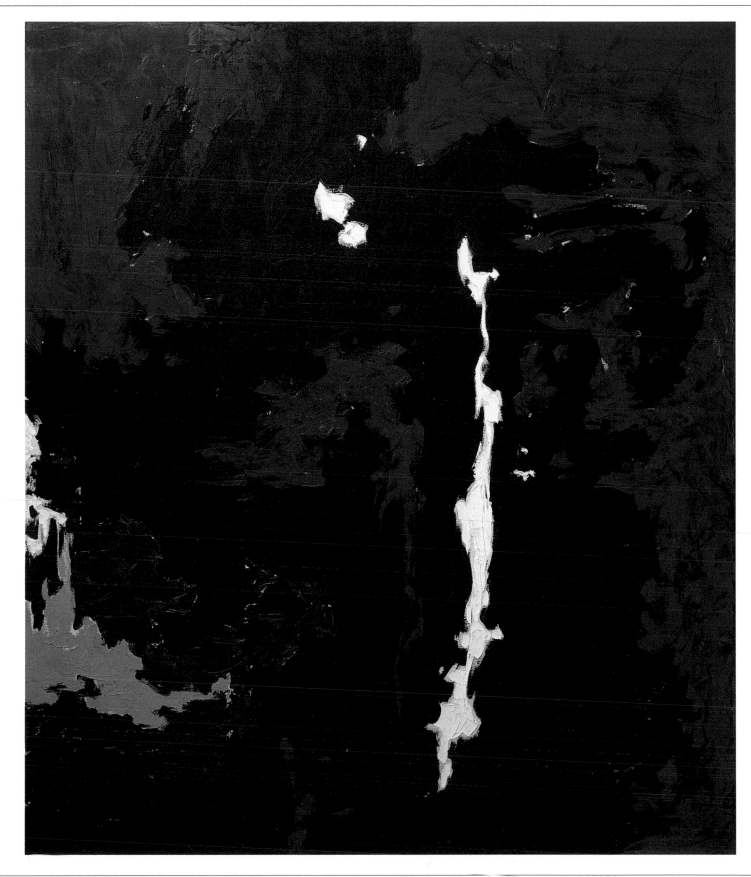

Clyfford Still. b Grandin, ND, 1904. d New Windsor, MD, 1980. Untitled. 1949. Oil on canvas. h80 x w68¾ in. h203.3 x w174.7 cm. Private collection.

Stoddard Seneca

The Hudson River. "The Old Man of the Mountains," from Catskill

A rowboat approaches shore on glassy water with the dreamy quality of a mirror, although the boat crane on the left suggests that business may not be far off. Much of the Hudson River served as a major thoroughfare for trade in the nineteenth century, yet for many artists it still possessed the bucolic allure of a country pond. Stoddard, one of the first promoters of the upper Hudson and Adirondack regions, specialized in airy, horizontal scenes like this, which were called Luminist after a popular painting style of the day that emphasized simple compositions and an attention to the quality of light. From his base in Glens Falls he ventured out to the areas around Lake George, Saratoga Springs, and Lake Champlain, often traveling by canoe to find his subject matter. In addition to photographing, he also wrote guidebooks and made maps to encourage tourists to come visit what was then, and still is now, a significant preserve of natural beauty.

Bingham, Colman, Gifford, Mount, Watkins

Seneca Ray Stoddard. b Wilton, NY, 1843. **d** Glens Falls, NY, 1917. **The Hudson River. "The Old Man of the Mountains," from Catskill.** c1880. Albumen print. Adirondack Museum, Blue Mountain Lake, NY.

Storrs John

Forms in Space No. 1

Ostensibly abstract, this sculpture cannot help but bring to mind a skyscraper, a dramatically new building form in the 1920s. The strong vertical poles are arranged in a pyramidal composition to convey a feeling of dramatic upward movement. Meanwhile, the sawtooth ornamentation hints at the influence French Art Deco was exerting on skyscraper design, a trend that would culminate some six years later

with the completion of the Manhattan Art Deco landmark, the Chrysler Building. The stepped-back profile augurs the design of the even taller Empire State Building completed the following year. Storrs was among the pioneers of abstract sculpture in the years before World War I. He studied sculpture with Rodin and was in Paris during the advent of Cubism, which laid the foundation of his abstract formalism. Dividing

his time between America and France, he also created traditional figurative sculpture and, in the 1930s — encouraged by his close friends Marsden Hartley and Fernand Léger — began to develop as a painter. But Storrs is most admired for his streamlined architectonic structures that seem to embody the dynamic spirit of the Jazz Age.

☞ Abbott, Roszak, Shaw, Westermann

John Henry Bradley Storrs. b Chicago, IL, 1885. **d** Orleans, France, 1956. **Forms in Space No. 1.** c1924. Marble. **h**76¾ x **w**12⅝ x **d**8⅝ in. **h**194.9 x **w**32.1 x **d**21.9 cm. Whitney Museum of American Art, New York, NY.

Strand Paul

The White Fence

The bleached pickets of the foreground fence, the flat, slablike side of the barn, and the white house beyond were separated by a yard and probably a driveway as well, but in this photograph distance collapses and they seem to butt against each other. The effect was quite radical in 1916: *White Fence* is elegantly poised on a stylistic divide between Pictorialism, essentially a nineteenth-century movement that valued the subtle rendering of atmosphere, and Purism, which took its cues from Cubism. Strand was one of the major forces in propelling this change to a twentieth-century vision. When his work was published in Alfred Stieglitz's magazine *Camera Work*, in 1917, it caused Stieglitz himself to renounce Pictorialism and to proclaim a new era of photographic art. Strand's work was also an important influence on Edward Weston, Ansel Adams, and other giants of modern photography. In later years, Strand made documentary films and photographed cultures not yet under the influence of Western-style industrialism.

☛ **R. Adams, Lee, N. Spencer, M. White**

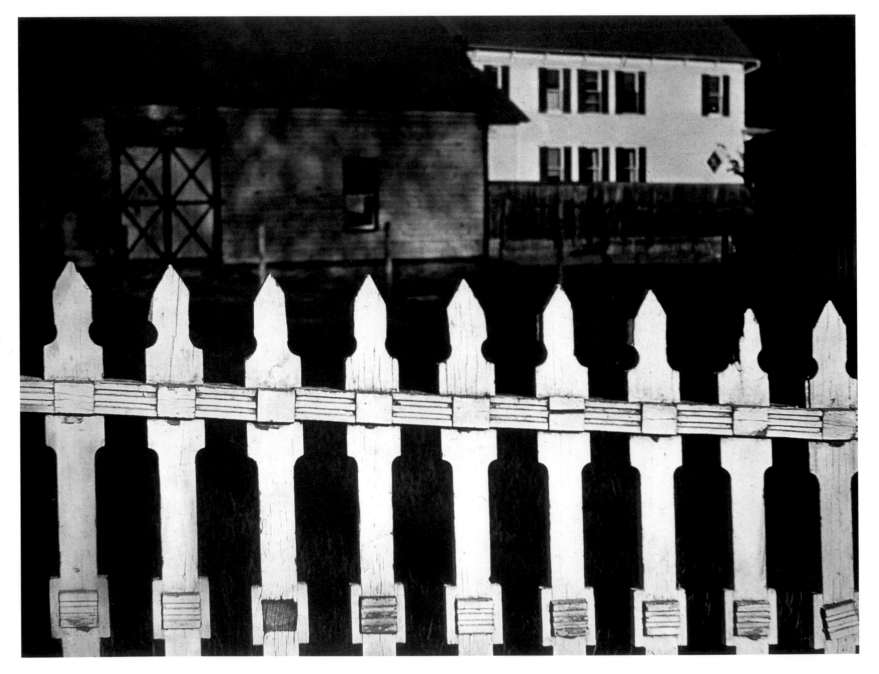

Paul Strand. b New York, NY, 1890. **d** Orgeval, France, 1976. **The White Fence.** 1916. Silver gelatin developed-out print. National Gallery of Art, Washington, D.C.

Stuart Gilbert

George Washington

This icon of America's first president is almost too familiar: Stuart made over sixty replicas from it, and millions of one-dollar bills bear its image. Yet this original and unfinished portrait still resounds with freshness and candor. No other version so captures the strength and weariness of America's great statesman and general toward the end of his public career. Fusing a dignified restraint of composition with lively spontaneity of technique, his likenesses radiate immediacy and timelessness. Stuart's reputation is closely bound with his Washington portraits, but he also painted hundreds of prominent citizens, both national and local heroes, creating an unmatched record of Federalist America. The finest American portraitist of his age, able to capture likeness with a few quick strokes, Stuart developed his virtuoso style in London. He studied with his compatriot, the history painter Benjamin West, but adopted the painterly manner of British portraitists Thomas Gainsborough and George Romney.

☞ Greenough, Leutze, Malbone, Peale

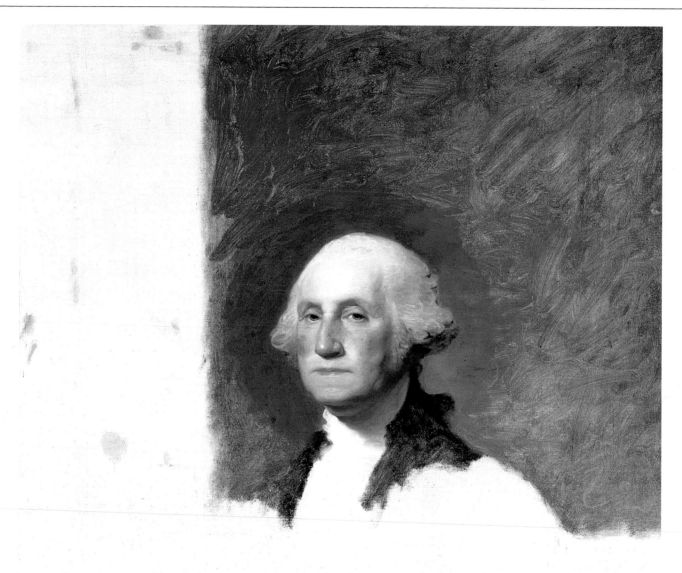

435

Gilbert Stuart. b North Kingstown, RI, 1755. **d** Boston, MA, 1828. **George Washington.** 1796. Oil on canvas. **h**47¾ x **w**37 in. **h**121.3 x **w**94 cm. Museum of Fine Arts, Boston, MA, and the National Portrait Gallery, Washington, D.C. (joint owners).

Sully Thomas

Lady with a Harp: Eliza Ridgely

A young woman plucks a string on a harp that she balances against the length of her body. In her other hand she holds a tuning key, perhaps indicating that she has briefly interrupted her playing to adjust the strings of her instrument. These seemingly incidental features help to describe the character of this portrait's subject, sixteen-year-old Eliza Ridgely, the daughter of a successful Baltimore merchant. The strong formal correspondence between the graceful, elongated curves of her body and the lines of the harp suggest that she also has been finely tuned in preparation for entry into polite society. Her fashionable costume, the landscape framed by the window, and the majestically scaled architecture are elements of the grand manner portrait formula that Sully learned from the art of Sir Thomas Lawrence in England. Although American in identity if not by birth, his 1838 commission to paint Queen Victoria brought him his greatest acclaim.

☛ Alexander, Ives, Reid, Thayer

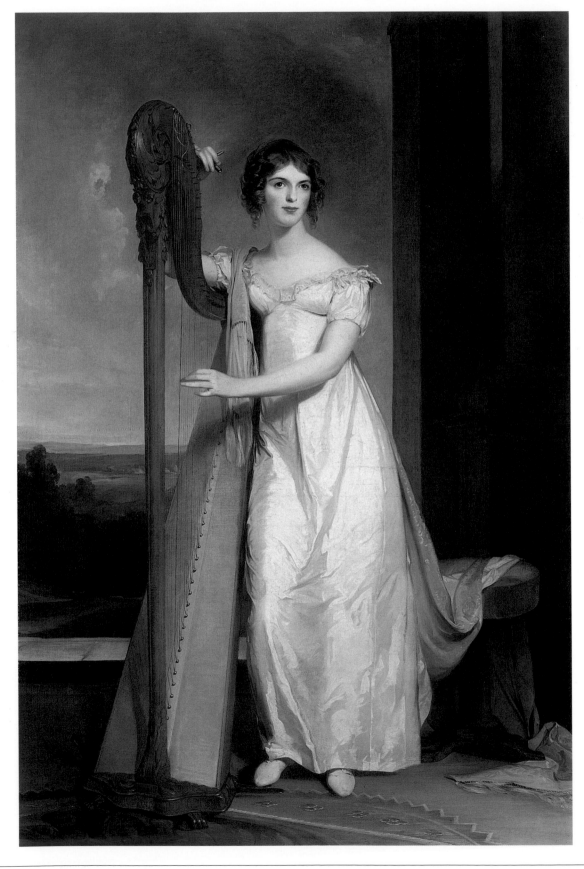

436

Thomas Sully. b Lincolnshire, United Kingdom, 1783. **d** Philadelphia, PA, 1872. **Lady with a Harp: Eliza Ridgely.** 1818. Oil on canvas. **h**84³⁄₈ x **w**56¹⁄₈ in. **h**214.5 x **w**142.5 cm. National Gallery of Art, Washington, D.C.

Taaffe Philip

Loculus

Lilies and other plant forms are painted, stained, and stenciled onto raw canvas, arranged in overlapping layers that adhere loosely to a grid. As in all of Taaffe's art, the decorative and the meaningful are present at once. The work's title is also a duality: a "loculus" is both the pollen pod of a plant and a place where religious relics are stored. Taaffe borrows decorative motifs from countries and cultures all over the globe — from Egyptian hieroglyphs to Celtic runes — and combines them to create works that look like Op Art abstractions. Using cardboard stencils and sandpaper rubbings, he creates multilayered surfaces that produce the effect of looking through one set of decorative architectural elements, like a metal grille, onto another, like a tile floor. Taaffe compares his melding of multicultural ornamental motifs to classical music composers who quote folk melodies in their symphonies.

☛ Mitchell, O'Keeffe, Reed, Tiffany

Philip Taaffe. b Elizabeth, NJ, 1955. **Loculus.** 1997. Mixed media on canvas. **h**88 x **w**114½ in. **h**223.6 x **w**291 cm. Private collection.

Tack Augustus Vincent

Aspiration

The delicate, ascending shapes in this gold-tinged panorama resemble fragments from the natural world: rising waves, perhaps, or a cloud-swept mountaintop. *Aspiration* is one of a series of murals created for Duncan Phillips, founder of the Phillips Memorial Gallery in Washington, D.C., America's first museum of modern art. Tack was a devout Catholic who sought a nonliteral, transcendent approach to religious expression. A highly successful painter of conventional landscapes, portraits, and murals, he found his inspiration on a trip to Death Valley, California, in 1925. There, he photographed rock formations that he called "abstracts fashioned by nature's artistry." Enlarged and transferred to canvas, these patterns formed the basis of lyrical compositions representing "the creation of the world" that occupy a singular niche in modern American art. Unlike other abstract painters of his day, Tack found a ready market for his nonrepresentational work. After the mid-1930s, however, he largely abandoned abstraction and concentrated on portraiture.

☛ S. Francis, Pollock, Still, Whistler

438

Augustus Vincent Tack. b Pittsburgh, PA, 1870. **d** New York, NY, 1949. **Aspiration.** Commissioned 1928. Oil on canvas. **h**76½ x **w**135½ in. **h**194.3 x **w**344 cm. The Phillips Collection, Washington, D.C.

Tait Arthur Fitzwilliam

The Life of a Hunter: A Tight Fix

An enraged bear raises its huge paw, preparing to strike the hunter who raises a knife in defense. Their blood mingles in the trampled snow as they remain immobilized by their wounds. Such scenes were far removed from Tait's youth in industrialized England, where his job in a Manchester print store sparked his interest in the arts. His technical skill was obtained largely through practical architectural training and self-directed study. In 1850 he sailed to New York City and soon became fascinated with the vigorous life of hunting and mountaineering. His regular trips to the Adirondack wilderness in upstate New York provided the inspiration for his paintings, many of which were published in print form by Currier & Ives. Despite their specifically North American subjects, Tait's paintings retained a distinctly English Victorian essence because of the melodramatic ironies of his narratives.

☛ Deas, Fischl, Jackson, Ranney

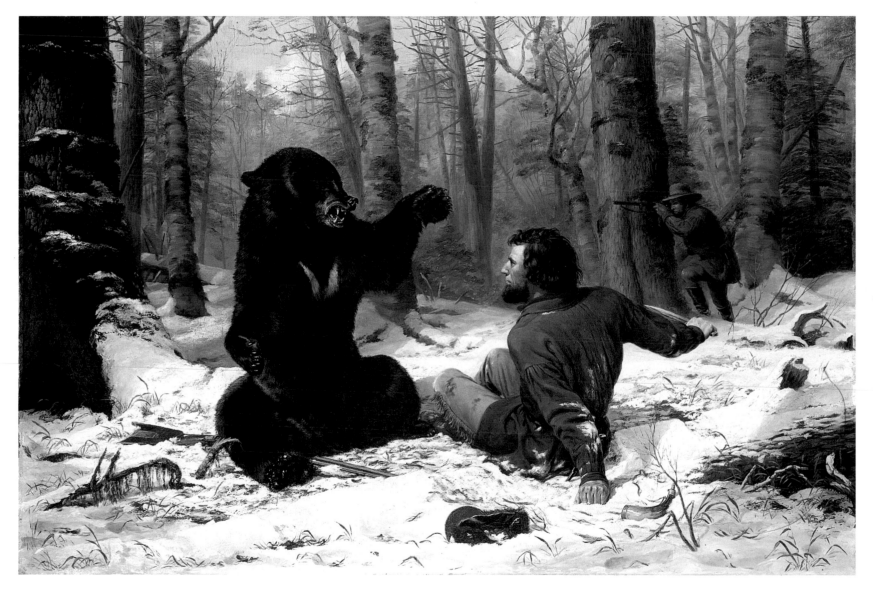

Arthur Fitzwilliam Tait. b Livesey Hall (near Liverpool), United Kingdom, 1819. **d** Yonkers, NY, 1905. **The Life of a Hunter: A Tight Fix.** 1856. Oil on canvas. **h**25 x **w**30 in. **h**63.5 x **w**76.2 cm. Manoogian Collection, Taylor, MI.

Tanner Henry Ossawa

The Banjo Lesson

An elderly African-American man tenderly gives a child instruction on the banjo in the center of a sparsely furnished interior. The dark faces of the figures are finely modeled and take on varying tones as a result of the light emanating from two sources — the cool light from an unseen window on the left and the warm light from a hearth on the right. As the first African-American painter to achieve international acclaim, Tanner was especially attentive to the manner in which African-Americans were treated in art. Here, he challenged the stereotypical, often caricatured imagery of the happy, banjo-playing black man by investing the subject with a monumentality and sobriety that emphasized the dignity of his sitters. Tanner's disappointment with early critical response to his art prompted a trip to Paris in 1891 for further study. He took up permanent residence there, returning infrequently to the United States.

☞ Brush, Cassatt, Couse, Hayden

440

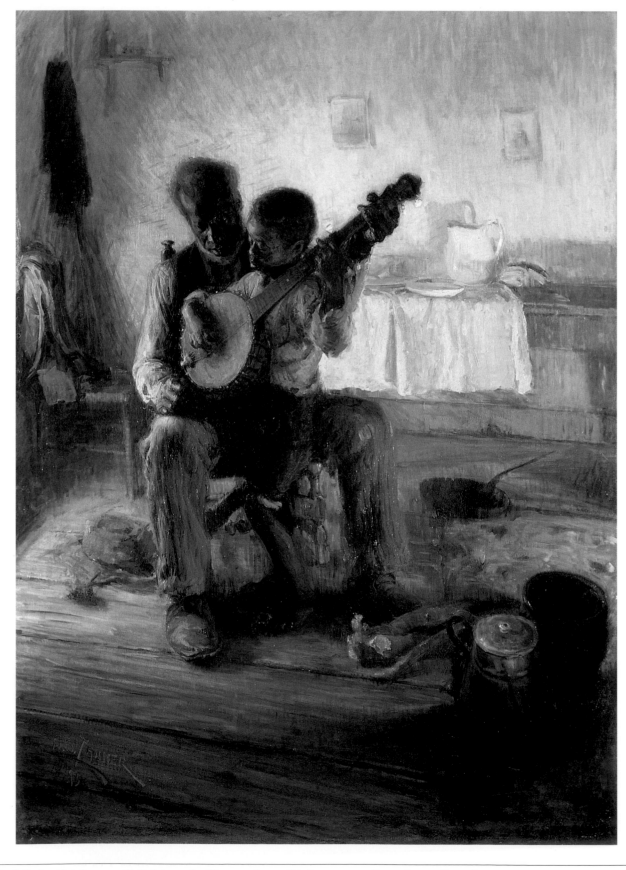

Henry Ossawa Tanner. b Pittsburgh, PA, 1859. d Paris, France, 1937. The Banjo Lesson. 1893. Oil on canvas. h49 x w35½ in. h124.5 x w90.2 cm. Hampton University Museum, Hampton, VA.

Tanning Dorothea

Guardian Angels

In a nightmarish role reversal, the protector becomes the aggressor as grotesque, malevolent "angels" pluck girls from their beds and smother them. The fatal embrace, a key device in Surrealist art, is here imposed on children — or rather the symbolic child-women who served as surrogates for the artist herself. Draped and wrapped forms are another of Tanning's repeated motifs, suggesting hidden layers of meaning beneath their surfaces. Her first exposure to Surrealism, a movement inspired by dreams and the unconscious, immediately captivated her romantic imagination. In the early 1940s, her work came to the attention of the Surrealist master Max Ernst, whom she married the year this picture was painted. It is tempting to speculate that the image of the smothering guardian expresses her fear of Ernst's overwhelming influence. If this is true, her anxiety was apparently groundless. Tanning maintains that during their thirty-year relationship Ernst encouraged rather than stifled her creativity.

☛ Albright, Huntington, Lundeberg, Palmer

Dorothea Tanning. b Galesburg, IL, 1910. **Guardian Angels.** 1946. Oil on canvas. **h**48 x **w**36 in. **h**121.9 x **w**91.5 cm. New Orleans Museum of Art, New Orleans, LA.

Tansey Mark

The Innocent Eye Test

A crowd of scientists unveils a painting of a bull for an audience of one: a real cow, whose "innocent" eye will be tricked if the painting is illusionistic enough. The bull is a copy after a 1647 work by Paulus Potter; nearby is one of Claude Monet's famous haystacks (another subject of interest to cows). Tansey's comical painting has a serious purpose. It is a comment on the modern condition of art, in which what we see depicted in an artwork has less to do with its eventual meaning than the cultural and intellectual worlds that surround it. (It could, however, also be construed as an indictment of uneducated art audiences.) Tansey's allegorical paintings attempt to bridge the gap between philosophy and studio art, and can include text in their surfaces. They are created with photocopy machines and the grisaille technique, a method of painting in gray monochromes that resemble the photogravures in old history textbooks.

☛ Michals, Pratt, Troye, Wegman

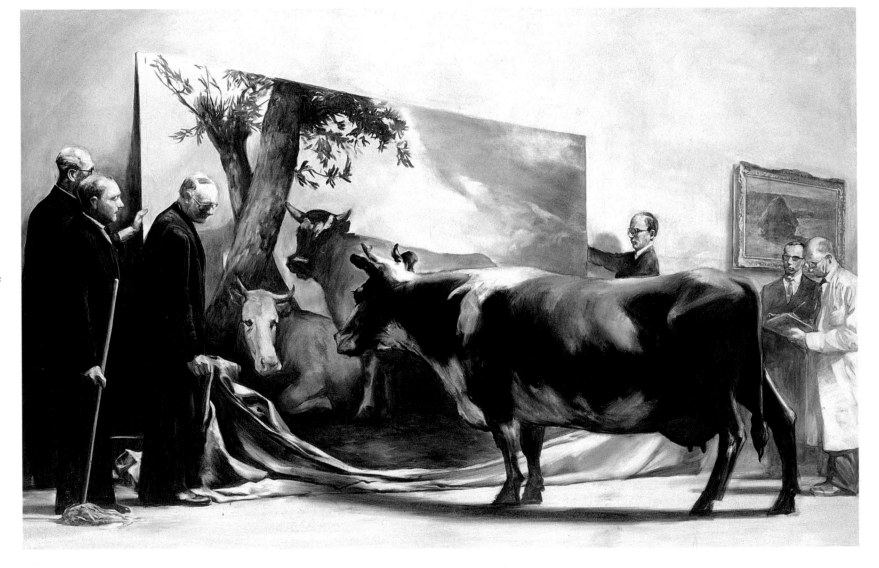

Mark Tansey. b San Jose, CA, 1949. **The Innocent Eye Test.** 1981. Oil on canvas. **h**78 x **w**120 in. **h**198.2 x **w**305 cm. The Metropolitan Museum of Art, New York, NY.

Tarbell Edmund C.

In the Orchard

In this informal gathering of four young women and a male companion, the pleasant, sunlit environment suggests the naturalness of their casual grouping and brings an unusual intimacy to a painting of this large scale. The locked gazes of the young man and the woman who stands apart from the group, however, introduce a note of dramatic tension. When this painting was shown in the 1893 World's Columbian Exposition in Chicago, Illinois, it attracted a great deal of attention. Not only did it announce Tarbell's vigorous commitment to the "new" style of Impressionism, but it also realistically portrayed an ordinary social exchange on a scale usually reserved for more high-minded or historicized subjects. Tarbell had encountered French Impressionism while studying in Paris at the Académie Julian. It was not until later, however, that he concentrated on blending his strong academic drawing skills with Impressionism's broken brushwork and high-key palette.

☞ Chase, F. Porter, Vonnoh, Wendel

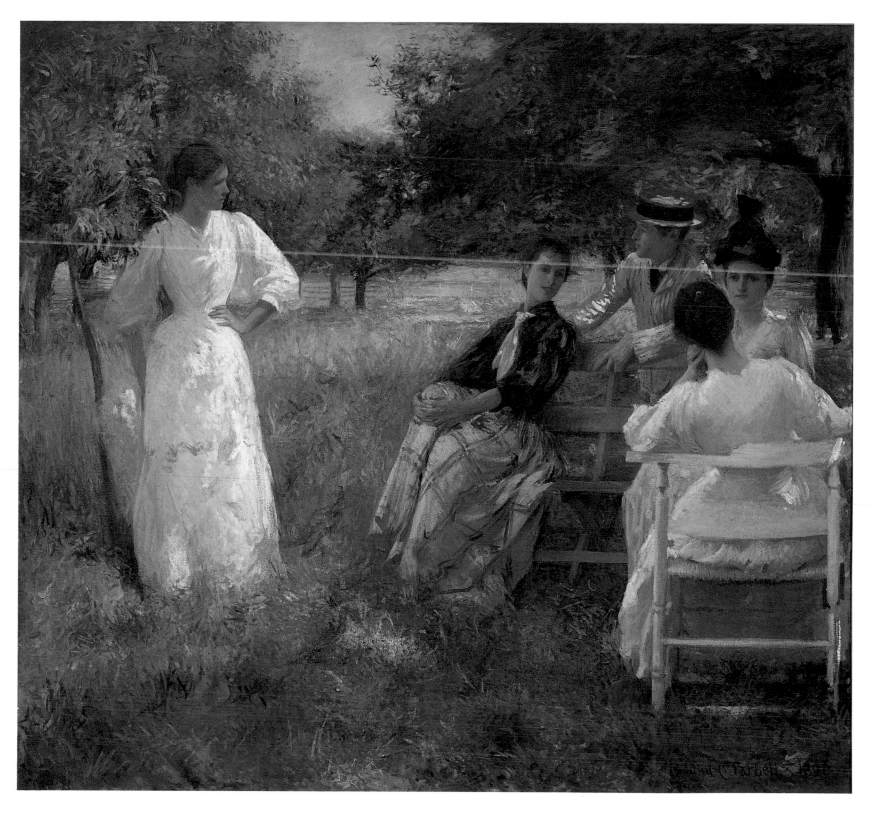

443

Edmund Charles Tarbell. b West Groton, MA, 1862. **d** New Castle, NH, 1938. **In the Orchard.** 1891. Oil on canvas. **h**60¾ x **w**65½ in. **h**154.4 x **w**166.5 cm. Terra Museum of American Art, Chicago, IL.

Thayer Abbott Handerson A Virgin

A girl on the verge of womanhood takes two children by the hand and strides vigorously toward the viewer. Her drapery, reminiscent of classical Greek dress, flutters in the air around her, emphasizing the force of her movement. The clouds behind her form contours that extend like wings from her shoulders, alluding subtly to the famous Hellenistic sculpture, *Winged Victory of Samothrace*. Thayer was noted for his idealized visions of women. These works were often discussed in the context of the American Renaissance because they recalled Classical Greek and Italian Renaissance art. His children frequently modeled for him; and here, his eldest daughter Mary is shown between her sister Gladys (left) and brother Gerald (right). Although the painting's title and composition (typical of the Virgin Mary flanked by two saints) suggest religious content, Thayer brushed off specific interpretations, claiming that he simply aimed to "symbolize an exalted atmosphere."

☞ Ives, Malbone, Rush, Sully

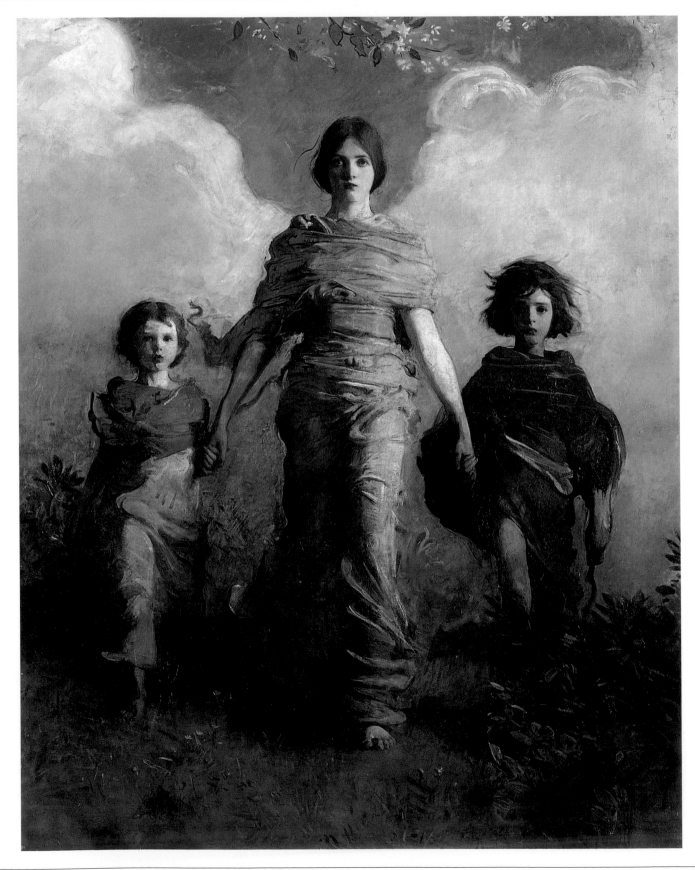

Abbott Handerson Thayer. b Boston, MA, 1849. d Dublin, NH, 1921. A Virgin. c1892–93. Oil on canvas. h90⅜ x w70⅞ in. h229.7 x w182.5 cm. Freer Gallery of Art, Washington, D.C.

Thiebaud Wayne

Candy Counter

An enticing array of red candy apples and rainbow-striped mints sits in a brightly lit display case. The confectioner's counter and its contents are rendered in oil paint as thick as cake frosting, giving the picture an overall feeling of delectability. Though his renderings of sweets, hot dogs, and gumball machines are highly realistic, Thiebaud is considered a Pop artist due to his penchant for colorful

exaggeration. His paintings also contain elements of Minimalism, both in their repetition and reduction of natural forms to simple geometric shapes, such as the cylindrical apples and tubular peppermint sticks seen here. Growing up in Southern California, Thiebaud worked in restaurants, where he first discovered that the form of a pie with a piece removed could be poetic. Thiebaud has

painted landscapes and figures, and began his art career in the 1950s as an Abstract Expressionist. He considers himself a still life painter, adapting the European tradition to his favorite American themes.

☛ Bailey, J. Francis, Oldenburg, Roesen

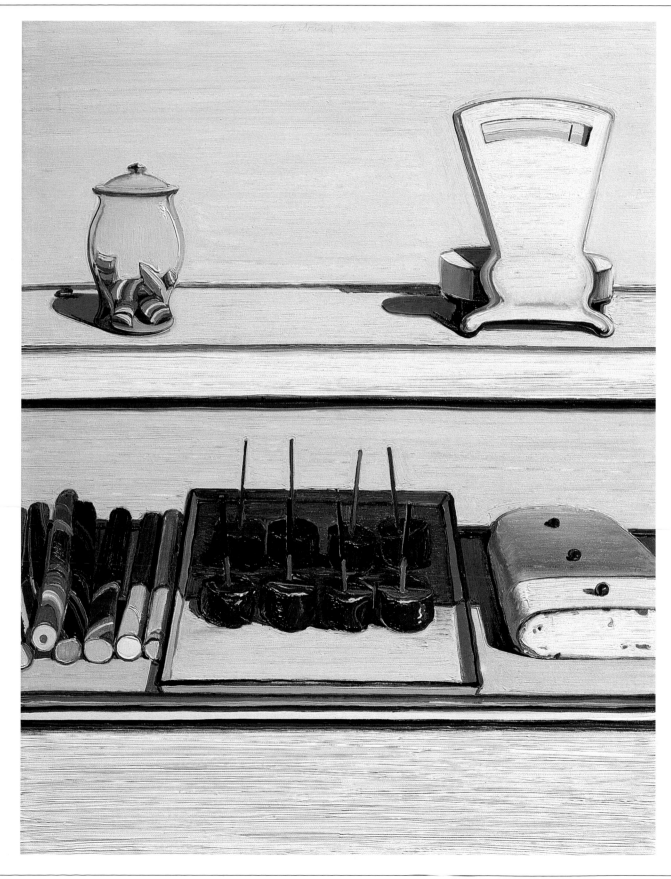

Wayne Thiebaud. b Mesa, AZ, 1920. **Candy Counter.** 1969. Oil on canvas. **h**47½ x **w**36⅛ in. **h**120.7 x **w**91.8 cm. Private collection.

Thompson Bob

Satyr and Maiden

In this reinterpretation of a Classical mythological scene, the figure and landscape elements are rendered as flattened areas of bold color. Thompson's hybrid paintings incorporate jazz themes, Old Master iconography, and a repertoire of abstracted animal and human forms, some benign, some malevolent. In a brief but meteoric career of only six years, Thompson executed more than one thousand works, often created with manic energy. Thompson moved to New York City in 1959 and not only embraced the bohemian culture of Beat poets, artists, and musicians, but became a charismatic favorite of dealers and collectors. On trips to France and Spain in the 1960s, he studied the work of Goya, Poussin, Tintoretto, and El Greco, adapting their subjects in his eccentric, visionary style. Sadly, Thompson's substance abuse cut short his career, and the gifted young African-American painter died at the age of thirty-nine.

☛ Bruce, Hunt, LaFarge, Walker

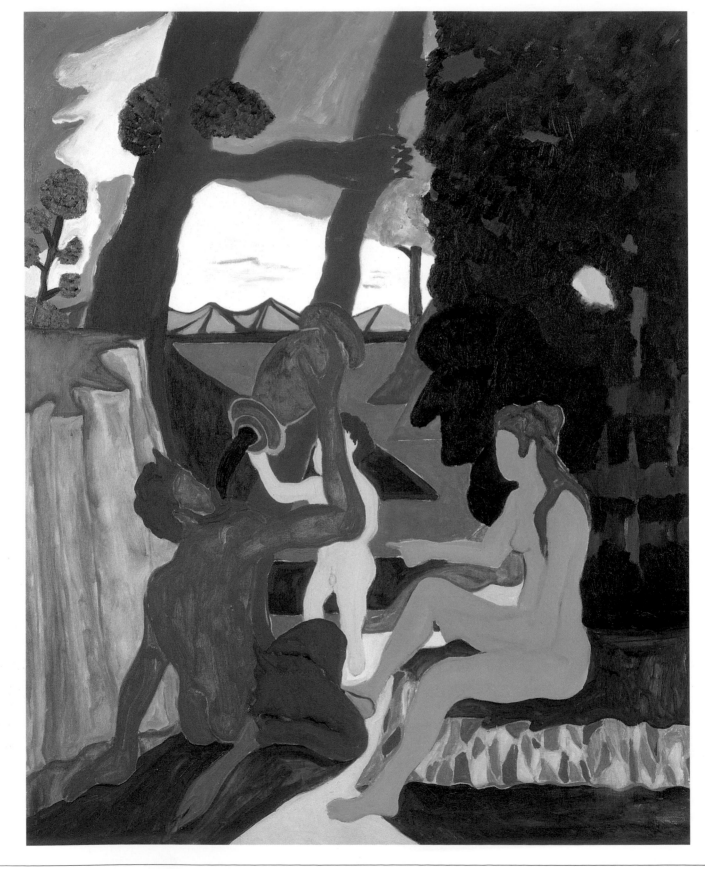

Bob (Robert Louis) Thompson. **b** Louisville, KY, 1937. **d** Rome, Italy, 1966. **Satyr and Maiden.** 1965. Oil on canvas. **h**60 x **w**48 in. **h**152.5 x **w**121.9 cm. Private collection.

Thompson Jerome

Apple Gathering

An urbane young man, seated on an upturned bucket, diverts three attractive farm girls from their harvest chores. As he regales them with his stories — most probably tales of city life — the youth on the ladder attempts to regain the attention of the distracted girl. Despite the idyllic mood of flirtatiousness in this sunlit orchard, the scene suggests a hint of social discord. Painted when many young

men left their isolated family farms for more lucrative jobs in urban areas, Thompson's work may be interpreted as a comment on the temptations of city life. This message is enhanced by the symbolism of the apple and its associations with Adam and Eve in the Garden of Eden, or the Judgment of Paris from Greek myth. Thompson himself had left his rural Massachusetts home against his father's wishes in

1831. By 1835 he was specializing in portraiture in New York City, but turned to genre subjects in 1844, probably in response to the art of William Sidney Mount.

☛ Homer, E. Johnson, Rogers, Tarbell

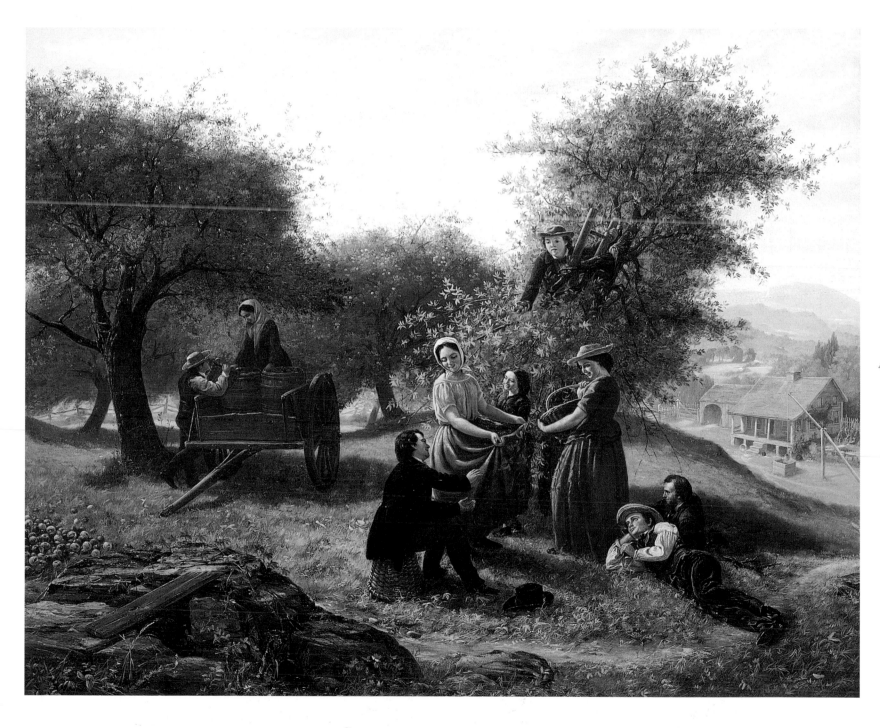

Jerome B. Thompson. b Middleboro, MA, 1814. **d** Glen Gardner, NJ, 1886. **Apple Gathering.** 1856. Oil on canvas. **h**39¹³/₁₆ x **w**49¾ in. **h**101.2 x **w**126.4 cm. The Brooklyn Museum of Art, Brooklyn, NY.

Tiffany Louis Comfort

Leaded Glass Window

Jewellike facets of colored glass are masterfully wrought to capture the serene view near a palatial mansion along New York's Hudson River where this window originally hung. The gothic-style tracery shapes that support the elements of this large arched window help create an illusion of depth by suggesting that the profusion of hanging trumpet vines and the vertical stalks of the hollyhocks occupy a space "outside" the walls of the mansion. Tiffany, son of the founder of the noted jewelry firm, began his career as a painter in oils and watercolors. After 1879, with the founding of Louis C. Tiffany and Associated Artists, he directed most of his energies to interior decoration. His succession of firms produced an impressive variety of sumptuous domestic items, including lamps as well as elaborate mosaics and colored glass windows. With a veritable army of artist-craftsmen under his direction, Tiffany emerged as the most influential figure in interior design in America in the decades surrounding the turn of the century.

☞ Chicago, S. Francis, J. Stella, Taafe

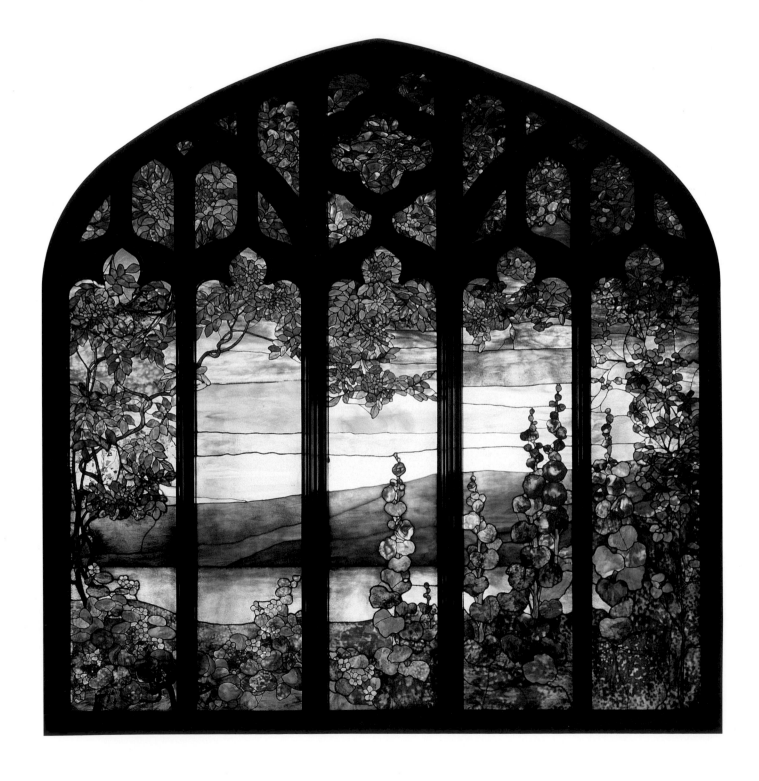

448

Louis Comfort Tiffany. b New York, NY, 1848. d New York, NY, 1933. Leaded Glass Window. 1905. h136³⁄₈ in. h346.2 cm. The Corning Museum of Glass, Corning, NY.

Tirrell George

View of Sacramento, California, from Across the Sacramento River

The crisp outlines of the boats anchored along both sides of the river form a pleasing decorative pattern of geometric shapes shown in relief against the placid surface of the water. The horizontality of the composition is reinforced by the regular and distinct transitions from the small band of earth in the foreground, through the line of boats, to the wide stretch of water, and, finally, to the low, warm-toned buildings of the city of Sacramento that ultimately mark the division between Earth and sky. The soft treatment of the luminous sky contrasts vividly with the hard-edged style used to define the boats, a disunity that suggests that Tirrell was a self-trained painter. Although he appears to have specialized in California views, little else is known about him. The naïve, literal quality of Tirrell's style lends an eerie sensibility to this scene in which time seems to have stopped.

☛ Bard, Colman, Lozowick, Persac

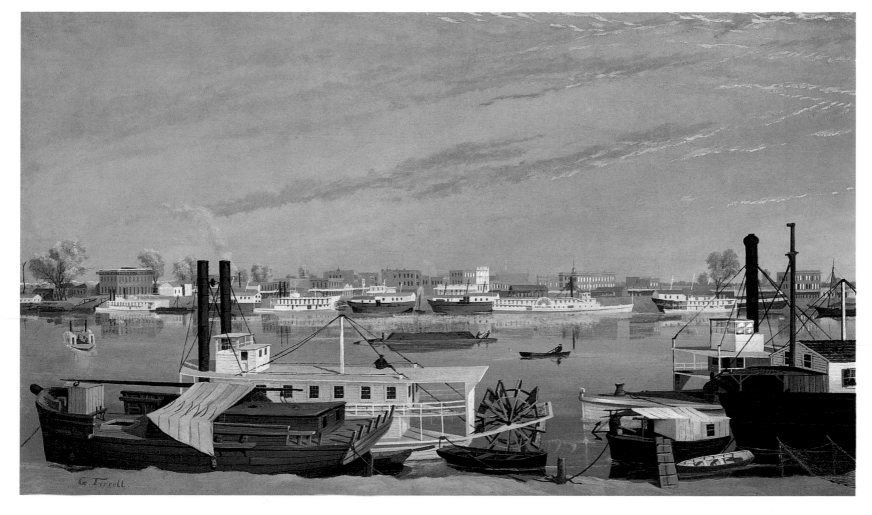

449

George Tirrell. Active in San Francisco and Sacramento, CA, and New Orleans, LA, c1826–75. **View of Sacramento, California, from Across the Sacramento River.** c1855–60. Oil on canvas. **h**27 x **w**47³/4 in. **h**68.6 x **w**121.2 cm. Museum of Fine Arts, Boston, MA.

Tobey Mark

Ghost Town

Far from being deserted, this fanciful town is populated by a visual cacophony of cryptic, swirling signs and symbols. The artist developed his system of all-over pictorial calligraphy, which he called "white writing," in the mid-1930s and continued to refine it throughout his career. An adherent of the Bahai World Faith, which emphasizes humankind's essential unity, Tobey was the first modern painter to fuse aspects of American and Asian art into an abstract aesthetic. He also shared an affinity with the visionary Swiss artist Paul Klee, whose aim, "to take a line for a walk," Tobey clearly endorsed. He was briefly associated with the New York School and is widely considered one of the premier Abstract Expressionists, but his work lacks the unpremeditated quality of gestural abstraction and the undifferentiated surfaces of Color Field painting. Tobey worked primarily in Seattle, Washington, during the 1940s and 1950s, but he traveled widely and spent the last sixteen years of his life in Switzerland.

☛ Graves, Mitchell, Pollock, Ryman, Twombly

Mark Tobey. b Centerville, WI, 1890. **d** Basel, Switzerland, 1976. **Ghost Town.** 1965. Oil on canvas. **h**81¾ x **w**52¾ in. **h**207.8 x **w**134.1 cm. Michael Rosenfeld Gallery, New York, NY.

Tolson Edgar

Expulsion (from The Fall of Man Series)

Sword in hand, the angel of the Lord banishes Adam and Eve from Eden in this stark tableau. The black serpent taunts with a wicked hiss. Adam and Eve look over their shoulders in regret as they slowly realize the consequences of their actions. With stunning economy, Tolson distills this epic Biblical event into a psychologically charged moment as Adam and Eve seem touchingly human in their moment

of loss. Subtle artistic gestures, such as the slight pedestal elevating the Lord and the placement of Adam and Eve at the very edge of the sculpture's base, are used to great effect. Tolson's sculpture began with the solitary figures he called "dolls" and evolved into scenes such as this one that illustrate events from the Old Testament. Working with a pen knife and poplar wood, he elevated the traditional

pastime of woodcarving into a vehicle for profound expression. Critics have suggested Tolson's plain, unadorned carving style reflects the cultural values of his native Appalachia.

☞ Aragon, Finster, Job, Schimmel

451

Edgar Tolson. b Lee City, KY, 1904. **d** Manchester, KY, 1984. **Expulsion.** 1969. Poplar, water birch, cedar, paint, varnish, glue, pencil, and marker. **h**12½ x **w**7½ x **d**15 in. **h**31.8 x **w**19.1 x **d**38.1 cm. Milwaukee Art Museum, WI.

Tooker George

The Subway

In this generically hostile space, Tooker's characters are alienated from one another and, at the same time, united by a shared sense of dread. Their expressions, often partly obscured by the prisonlike walls and bars, range from fearful to grim to blank. Most of the figures, like the pregnant-looking woman whose protective gesture signals her anxiety, are impossibly large in relation to their surroundings, increasing the feeling of claustrophobia. Although Tooker lives and works in rural Vermont, he has long been fascinated by the city, which he typically interprets as a dehumanizing environment. To him, the subway "seemed a good place to represent a denial of the senses and a negation of life itself." His meticulous technique and fondness for the antiquated medium of egg tempera ally Tooker technically with early Renaissance masters and seem anachronistic for a contemporary of the Abstract Expressionists, but his sensibility is distinctively modern in its focus on existential isolation in urban settings.

☛ Bishop, French, Lundeberg, Winogrand

George Tooker. b Brooklyn, NY, 1920. **The Subway.** 1950. Egg tempera on composition board. **h**18⅛ x **w**36⅛ in. **h**46 x **w**91.8 cm. Whitney Museum of American Art, New York, NY.

Traylor Bill

Man Talking to Bird

What are these two creatures discussing? The large black bird leans toward the man, almost daring him to make good on his threatening gesture. The interaction between man and animal takes on a magical tone reinforced by the bright blue and orange colors. Folk artist Bill Traylor excelled in such imaginative scenes, depicting whimsical events in a bold, abstracted style. In this drawing, he has confined the activity to the very top of the composition, using the building's geometry as a dramatic counterpoint. Born a slave, Traylor moved to Montgomery, Alabama, after a lifetime of farm work. There, he began to draw on scavenged cardboard. "It just come to me," he explained. He worked outdoors, capturing the denizens of Monroe Street in lively portraits. In other drawings, such as this one, Traylor depicted recollections of farm life. He often humorously embellished such scenes to give them the quality of a folk tale.

☞ Christenberry, Morgan, Westermann

Bill Traylor. b near Benton, AL, 1854. **d** Montgomery, AL, 1947. **Man Talking to Bird.** c1939–42. Posterpaint on cardboard. **h**16¹/2 x **w**13¹/4 in. **h**41.9 x **w**36.7 cm. Collection of Alice Yellen and Kurt Gitter.

Troye Edward

American Eclipse

The horse's slumped back and visible ribs hint at his age. The great New York racehorse American Eclipse was twenty years old and long retired when Troye painted this picture. Yet in this heroic commemorative portrait Troye gives his subject a commanding physical presence that recalls his past glory as the paragon of New York breeding. The artist placed the stallion on a natural pedestal, a plateau overlooking a vast landscape. *American Eclipse* was undefeated in several highly celebrated "North vs. South" contests in which he routed his Southern challengers. As the leading artist of American racehorses, Troye led a somewhat itinerant life, traveling throughout the South, eventually settling in Kentucky and, later, Alabama. He had begun his career in London before emigrating to the United States at age twenty-three. However, *American Eclipse* has a distinctly American flavor. Gone are the stable hands and racing accoutrements prominent in many sporting paintings. Here, Troye depicts this magnificent animal unadorned amid an unspoiled American wilderness.

☛ **Butterfield, Curtis, Wegman**

454

Edward Troye. **b** Lausanne, Switzerland, 1808. **d** Huntsville, AL, 1874. **American Eclipse.** c1834. Oil on canvas. **h**24 x **w**29 in. **h**61 x **w**73.7 cm. National Museum of Racing, Saratoga Springs, NY.

Trumbull John

The Declaration of Independence, 4 July 1776

Forty-eight men have gathered in a room, witnesses to the momentous consequences of their assembly. At the center, John Adams, Roger Sherman, Robert Livingston, and Benjamin Franklin surround Thomas Jefferson, who hands a newly drafted resolution to John Hancock, president of Congress. Calm dignity characterizes the figures and their orderly arrangement, although colorful trophy flags suggest the war and victory that followed the Declaration of Independence. Trumbull conceived his painting in Paris after discussions with Jefferson, who gave him recollections and a (faulty) sketch of the Philadelphia meeting room. The artist went on to secure life portraits of thirty-six surviving members of the 1776 Continental Congress. Trumbull served as Washington's aide-de-camp in the Continental army, yet left to study art in London (where he was briefly imprisoned as a spy). Inspired by the modernized history paintings of Benjamin West and John Singleton Copley, he dedicated his own career to depicting the events and heroes of America's Revolutionary War.

☛ Morse, Pratt, Smibert, West

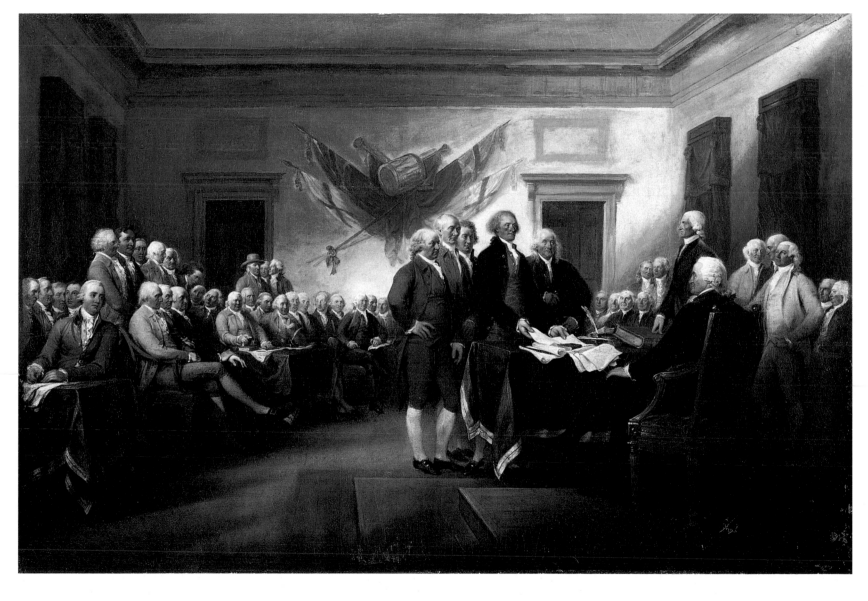

455

John Trumbull. b Lebanon, CT, 1756. d New York, NY, 1843. **The Declaration of Independence, 4 July 1776.** 1787–1820. Oil on canvas. h21⅛ x w31⅛ in. h53.7 x w79.1 cm. Yale University Art Gallery, New Haven, CT.

Turrell James Milkrun

This vibrant rectangle, a field of luminous scarlet pierced with violet and yellow-white lines, evokes the smooth, two-dimensional surface of the great Color Field painters such as Barnett Newman or Mark Rothko. Its eerie beauty, however, is not achieved with paint on canvas. Rather, it is an effect of colored light projected into three-dimensional space, creating chromatic depth and volume. Turrell has been dazzling viewers with his optically challenging light projections since the late 1960s, when he and the artist Robert Irwin founded the Los Angeles "Light and Space" movement. Turrell's installations challenge conventional notions of physical space, transforming perception itself into a medium. Since the 1970s he has worked on the Roden Crater project, a massive earthwork outside of Flagstaff, Arizona. The title of this work refers to Turrell's experiences as a pilot, specifically his observations of sunrise during early morning deliveries to rural locales.

☞ Flavin, Irwin, Misrach, Newman

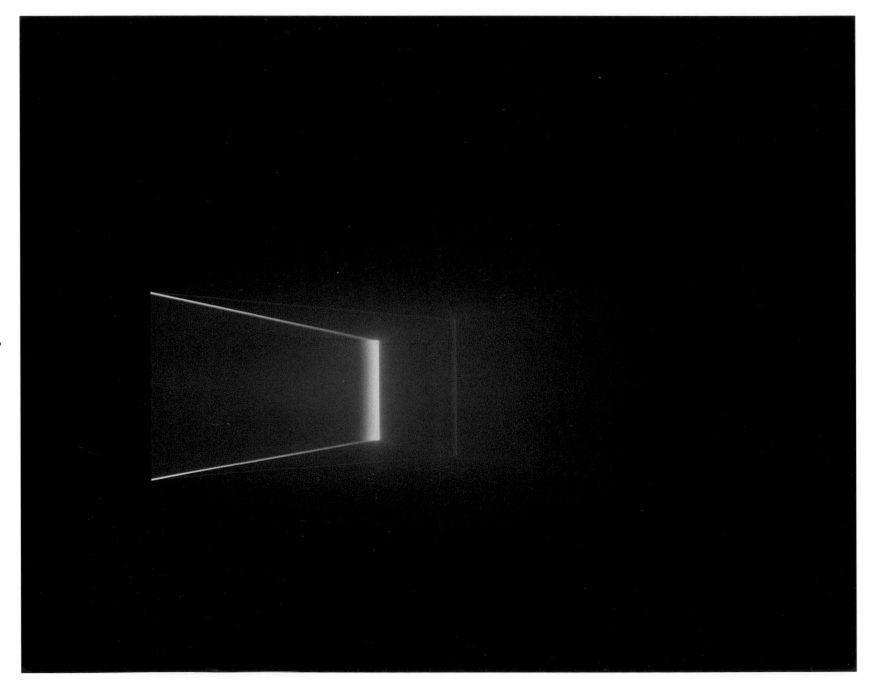

456

James Turrell. **b** Los Angeles, CA, 1943. **Milkrun.** 1996. Fluorescent light. Installation view at Stroom Gallery, The Hague, The Netherlands.

Tuttle Richard

Sum Confluence

The muted gray-green wooden sculpture looks almost typographic, like the missing piece of an advertising sign. The "confluence" in this work could be among the lines branching off the form's central artery or between its muddled colors. Like Tuttle's other drawings, watercolors, and cut-paper collages, *Sum Confluence* has a hesitant, improvisational feel, lending it an affinity with jazz. Tuttle's small, often delicate abstract artworks are concerned with philosophies of form and color, as viewed through Tuttle's own investigative lens. Like other Post-Minimalist artists, Tuttle is not interested in making monuments or absolute statements, but in opening up the solid colors and geometries of Minimalism to human emotion and ephemerality. Each of his works is an attempt to create a piece of art right for the moment and place of its creation, a prelude to the next movement.

☛ Kelly, Mangold, Murray

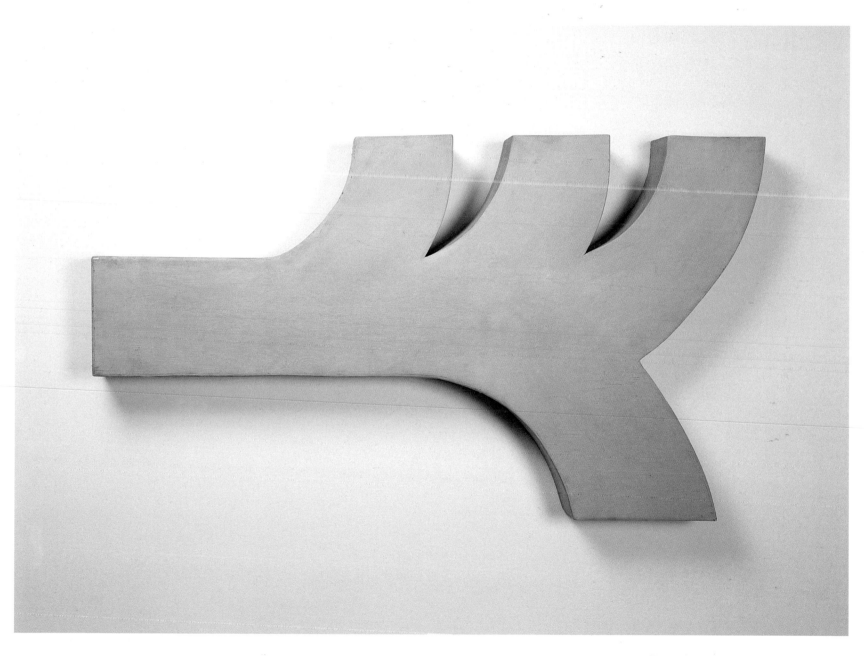

Richard Tuttle. b Rahway, NJ, 1941. **Sum Confluence.** 1964. Painted wood. **h**20⅝ x **w**36½ x **d**3 in. **h**52.4 x **w**92.7 x **d**7.6 cm. Sperone Westwater, New York, NY.

Twachtman John The White Bridge

The outline of a quaint white wooden bridge emerges from a spray of branches and delicate spring greenery, rendered as a fine, painterly veil of broken and lightly scrubbed brushwork. The horizonless view, the simplified shapes, and the softened outlines of forms that blend one with another allow the composition to exist simultaneously as a flat pattern and a recognizable landscape. Twachtman painted this picturesque spot on his Greenwich, Connecticut, property many times, depicting it at varying seasons and under different atmospheric conditions in much the same way that Monet approached his series paintings, such as those of waterlilies. Twachtman had successfully explored a variety of styles before turning to an Impressionist mode. His intimate connection with the rural Connecticut landscape moved him emotionally as well as aesthetically, and it ultimately inspired many of his finest Impressionist works.

☞ Lawson, Metcalf, J. A. Weir, Wendel

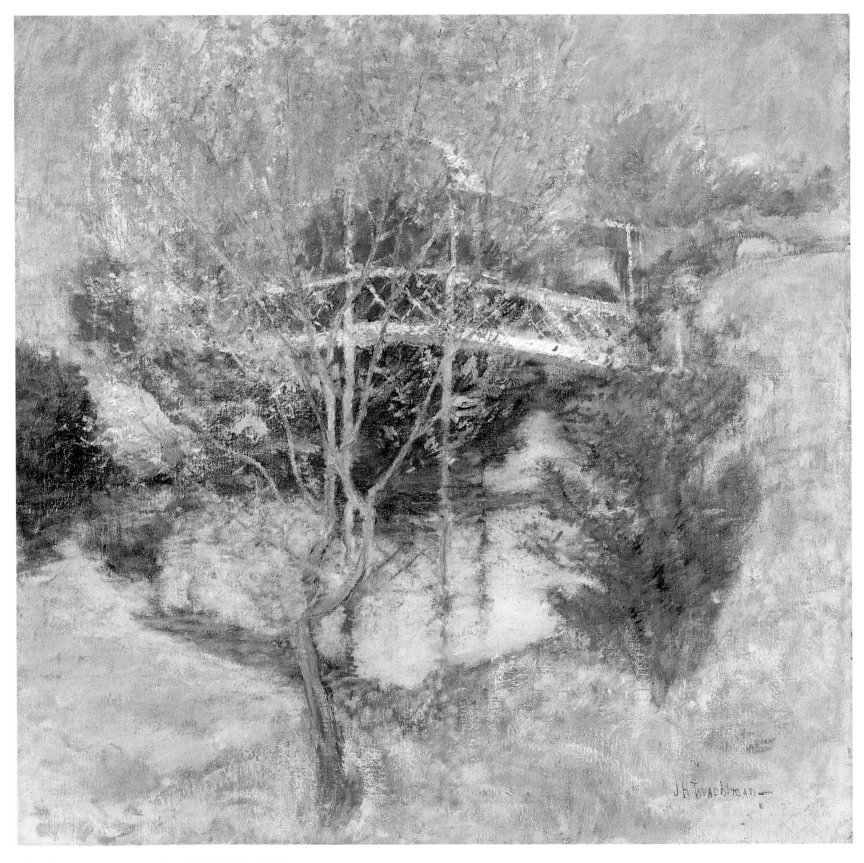

458

John Henry Twachtman. b Cincinnati, OH, 1853. **d** Gloucester, MA, 1902. **The White Bridge.** Mid-1890s. Oil on canvas. **h**30¼ x **w**30¼ in. **h**76.8 x **w**76.8 cm. The Minneapolis Institute of Arts, Minneapolis, MN.

Twombly Cy

Hero and Leander

In this painting any allusions there may be to the Greek myth of drowned lovers Hero and Leander are encoded in a cryptic calligraphy that resists narrative interpretation. Sometimes dense and jumbled, sometimes spare and rhythmic, Twombly's marks occasionally include numbers, words, and associative shapes, but more often they appear to be completely abstract. As if responding to Jackson Pollock's contention that art should make a statement, Twombly combines painting and writing in his work, and like the Conceptualists, he suggests that art is "information." This approach is evident especially in his canvases that replicate the appearance of chalk markings on a blackboard, the cryptic messages of street graffiti, or unconscious scribblings. Twombly has lived in Italy for the majority of his career and, consequently, has developed outside the New York School mainstream. This locale accounts in part for the artist's affinity for classical themes. His style is a distinctive synthesis of gestural abstraction, diaristic notation, and Neo-Dada conundrum.

☞ **Graves, Mitchell, Ryman, Tobey**

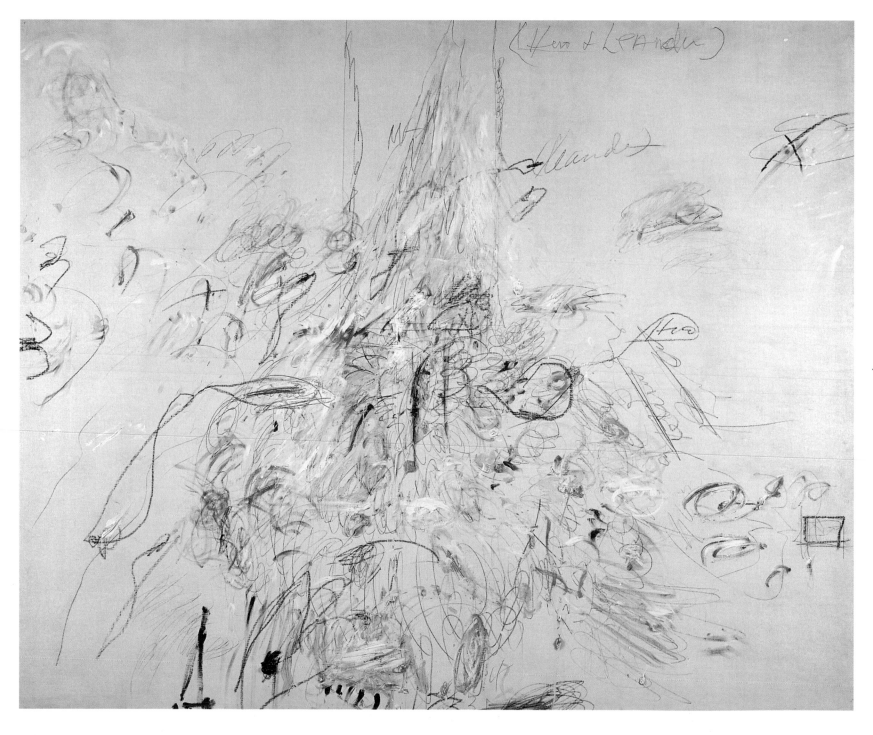

Cy Twombly. b Lexington, VA, 1929. **Hero and Leander.** 1962. Oil paint, lead pencil, wax crayon on canvas. **h**78¾ x **w**95¾ in. **h**200 x **w**243 cm. Gagosian Gallery, New York, NY.

Ulmann Doris

Baptism in the River

Standing knee-deep in the still water of a shaded river, three African-Americans in white robes lock hands and form a human triangle in the spirit of the Holy Trinity. This cinematic, almost too-perfect scene of a full-immersion baptism in progress could only have been taken in the American South, and only by a photographer whose sympathies had gained her the trust of the faithful who posed for her camera.

Ulmann was a New York portrait photographer who in the late 1920s and early 1930s traveled with folklorist John Jacob Niles throughout the Appalachian region of the South, seeking to document a way of life they believed was rapidly vanishing. Because Ulmann relied on the same soft-focus lens she used for her portraits, her pictures seem to belong to an earlier era than the documentary images of the Farm

Security Administration photographers who followed in her footsteps less than ten years later.

☞ Blakelock, A. Durand, VanDerZee, Whittredge

460

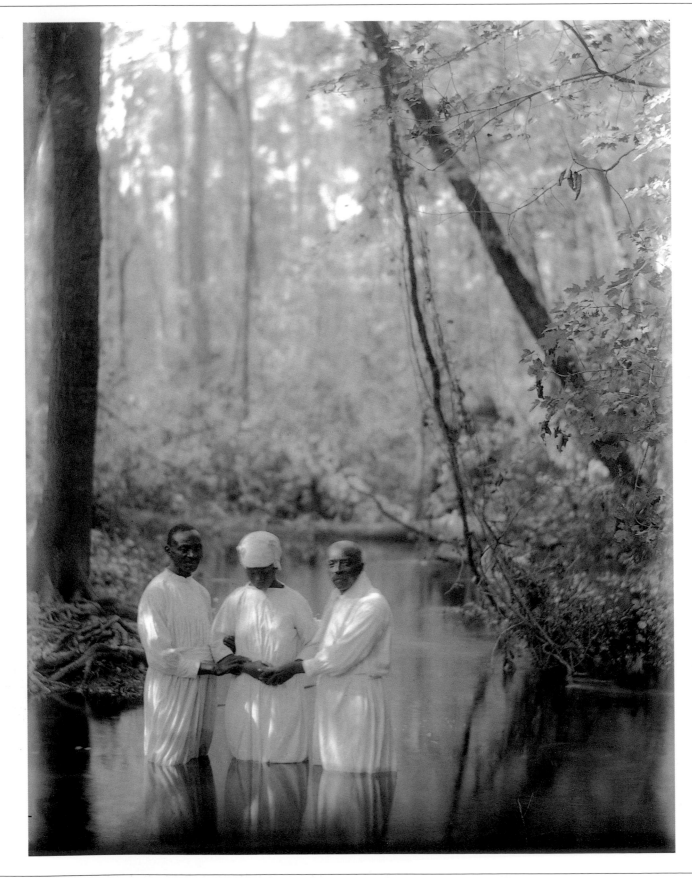

Doris Ulmann. **b** New York, NY, 1884. **d** New York, NY, 1934. **Baptism in the River.** c1929–30. Platinum print. The University of Oregon Library, Eugene, OR.

Vanderlyn John

Ariadne Asleep on the Island of Naxos

A voluptuous nude woman lies asleep outdoors, her smooth, pallid skin and the red and white draperies on which she rests offering a stunning contrast to the forested landscape she occupies. The departing ship in the distance signals her identity as the mythological Ariadne, who was abandoned by her lover Theseus as she slept. Vanderlyn painted this work in Paris, where he had lived for the better part of the previous decade absorbing the French Neo-Classical style and sophisticated subject matter. Vanderlyn achieved critical success at the Paris Salon in 1810 and 1812, where *Ariadne* had been shown. Nevertheless, when he returned to America in 1815, he found a provincial art audience with little interest in anything but portraiture, a genre to which he was forced to turn for his living.

Ariadne toured several American cities but was poorly received because of the general antipathy for nude subjects.

☞ Duncanson, La Farge, Pearlstein, Zorach

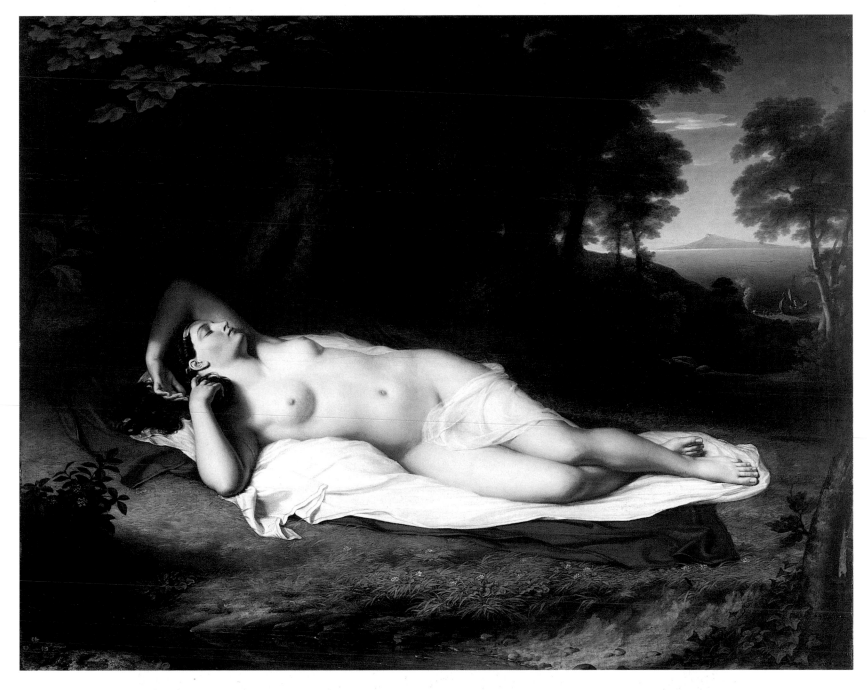

John Vanderlyn. b Kingston, NY, 1775. **d** Kingston, NY, 1852. **Ariadne Asleep on the Island of Naxos.** 1809–14. Oil on canvas. **h**68¹/₂ x **w**87 in. **h**174.1 x **w**221.1 cm. Pennsylvania Academy of the Fine Arts, Philadelphia, PA.

Vanderlyn Pieter

Pau de Wandelaer

Posed beside a wooded riverbank, Pau de Wandelaer holds one hand in his vest as befits a decorous gentleman. Perched on his other hand is a bird, a common attribute of childhood in eighteenth-century portraits. Thus suspended between maturity and youth stands the eldest son of a wealthy Dutch merchant family in New York's Hudson River Valley. Although Vanderlyn relied on British mezzotint portraits for compositions, he often gave his sitters particular and personalized settings, such as the Hudson River behind Pau de Wandelaer, and the distinctive sloop that probably alludes to the mercantile source of his family's wealth. In the early eighteenth century, prosperous families in this region commissioned portraits from a distinctive group of largely self-taught artists, sometimes known as "Patroon Painters."

Of this group, only some of whose names have been identified, Pieter Vanderlyn stands out for the clarity and restraint of his draftsmanship and paint handling.

☛ Couturier, Hathaway, J. E. Kühn, J. Wright

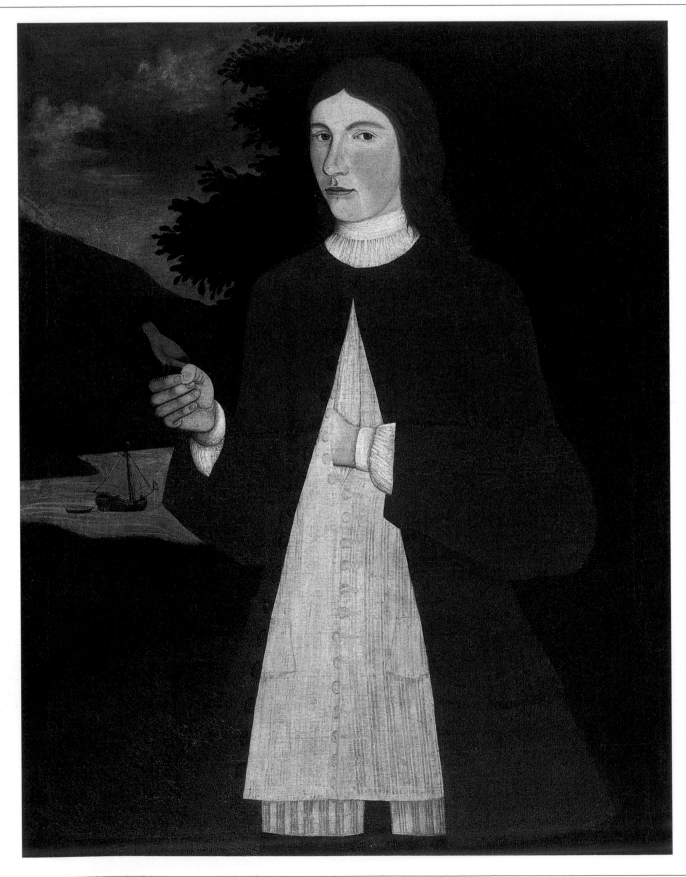

462

Attributed to **Pieter Vanderlyn. b** The Netherlands, c1687. **d** Shawangunck, NY, c1778. **Pau de Wandelaer.** c1730–40. Oil on canvas. **h**44¾ x **w**35¼ in. **h**113.7 x **w**89.6 cm. Albany Institute of History and Art, Albany, NY.

VanDerZee James

Harlem Billiard Room

There is no sign of "trouble with a capital T" in this pool room — the gentlemen (and lone woman) posed here seem very models of respectability. The locale is Harlem, America's best-known African-American neighborhood, yet the image belies any stereotype of Harlem as a poverty-stricken urban ghetto. The photographer, who maintained a commercial studio there from 1916 to 1968, may not have intended a sociological statement, but by placing the pool players at a respectful middle distance, he reinforced their dignity as well as the orderly and prosperous demeanor of the billiard parlor. VanDerZee photographed many aspects of Harlem life during his long career but specialized in portraiture. He also portrayed the cultural leaders of the Harlem Renaissance in the 1920s. VanDerZee became famous himself at the end of his life, after his photographs were included in the popular but controversial exhibition *Harlem on My Mind* (1969) at The Metropolitan Museum of Art in New York.

☛ Hine, Persac, H. Sargent, Ulmann

James VanDerZee. **b** Lenox, MA, 1886. **d** New York, NY, 1983. **Harlem Billiard Room.** c1930. Silver gelatin print. Collection of Donna Mussenden VanDerZee.

Vedder Elihu

Memory

Waves lap the shore, establishing a gentle, hypnotic rhythm created by their regular placement paralleling the distant horizon. Above the crisply delineated waters are amorphous cloud masses from which emerges the haunting vision of a face. Only faintly visible in the nocturnal heavens, it is impossible to determine the age or sex of the phantom being. The hallucinatory nature of this image signals Vedder's concerns with spiritual matters, and the composition, with its division of Earth and sky (alluding to the material and the ethereal, respectively), seems also to provide a metaphor for objective and subjective thought. Vedder spent much of his career in Europe, and in the 1870s his art began to reflect the content of poetic mystery preferred by the Pre-Raphaelites and the Symbolists. It is likely that *Memory* was inspired by Alfred Tennyson's poem, "Break, Break, Break," in which meditation of the sea elicits thoughts of the departed.

☞ Bricher, Celmins, Hunt, Huntington

Elihu Vedder. b New York, NY, 1836. **d** Rome, Italy, 1923. **Memory.** 1870. Oil on canvas. **h**20⁵/₁₆ x **w**14³/₄ in. **h**51.6 x **w**37.5 cm. Los Angeles County Museum of Art, Los Angeles, CA.

Viola Bill The Crossing (detail of "Fire")

Hands outstretched like a tightrope walker, a man stands undefended while a pillar of fire rises from the ground, threatening to consume him. Dressed in casual garb, this man has journeyed through a horizonless black void in slow motion to stand like a witness before the viewer. Projected onto a double-sided video screen shimmering with the aura of stained glass, the figure is pounded by cascades of water on one side of the screen while fire roars on the other. Video in Viola's hands acquires the qualities of a natural, as opposed to a technological, substance. A student of Eastern mysticism, Viola began to use video in the early 1970s to explore spiritual themes of consciousness, life, death, and regeneration. *The Crossing* engages the viewer in changing concepts of space and time as it cycles endlessly through complementary simultaneous actions: deluge and conflagration, annihilation and purification.

☞ G. Hill, Misrach, Nauman

465

Bill Viola. b New York, NY, 1951. **The Crossing (detail of "Fire").** 1996. Video/sound installation. From "Trilogy — Fire, Water, Breath." Anthony d'Offay Gallery, London, United Kingdom.

Vonnoh Robert In Flanders Field — Where Soldiers Sleep and Poppies Grow

The fiery red tones of a poppy field in full bloom dominate this massive canvas and make almost tangible the heat of the midday sun. Within this blaze of light and color, children gather flowers and wave to a person in the cart bordering the field. The painting's title adds a somber note, for it refers to the tragic losses in battles fought on similar fields during World War I. This painting was Vonnoh's most

ambitious work and earned him critical acclaim at the Paris Salon of 1891 and at the Munich International Exposition of 1892. Stunned by Vonnoh's bold application of paint, one writer declared that *Poppies*, as the artist originally titled it, was "less like an oil-painting than a relief in oils." Trained in Boston and Paris, Vonnoh resigned his teaching post at the Boston Museum School in 1887 to return to

France. He frequently visited the village of Grez-sur-Loing, a center for plein-air painting, where he was encouraged to experiment with color and technique.

☞ Chase, E. Johnson, Wendel

466

Robert William Vonnoh. b Hartford, CT, 1858. **d** Nice, France, 1933. **In Flanders Field—Where Soldiers Sleep and Poppies Grow** (originally, **Coquelicots, [Poppies]**). 1890. Copyright, 1914. Oil on canvas. **h**58 x **w**104 in. **h**147.4 x **w**264.3 cm. The Butler Institute of American Art, Youngstown, OH.

Voulkos Peter

Big Missoula

With the bulbous body and tall chimney of a brick kiln, this "stack" form echoes that of the oven in which the clay was fired. But the structure, composed of wheel-thrown ceramic elements with intentional and accidental cracks, patches, mottling, and other irregularities, is a really a monument to the delicate balance between creation and destruction. Voulkos was the first American sculptor to adapt the spontaneity of the Abstract Expressionists' "action painting" to traditional ceramics, and the stack form has preoccupied him for more than thirty years. After first meeting Abstract Expressionist painters at Black Mountain College in North Carolina in 1954, he began to approach clay improvisationally. He places the highest value on the process rather than the end product, which has entirely lost its functional quality and crossed the boundary between craft and art. Derived from the forms of bowls, plates, and vessels, his non-utilitarian pieces are records of his encounters with his materials.

☛ Butterfield, Chamberlain, Outerbridge, Puryear

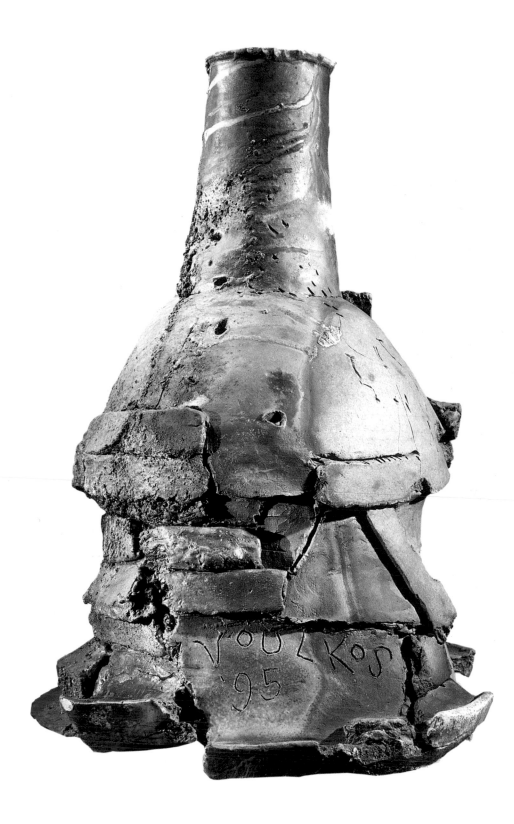

467

Peter (Panagiotis Harry) Voulkos. b Bozeman, MT, 1924. **Big Missoula**. 1996. Wood-fired stoneware. h22½ x w23 x d5¼ in. h57.2 x w58.5 x d13.3 cm. Private collection.

Walker Kara

A Work on Progress

Two female figures whose head-garb and stereotyped profiles evoke nineteenth-century slave caricatures occupy a white void. One figure leaps backward, shooed away by the other woman's broom, her broken shackles dangling awkwardly from her wrists. Neither woman is granted context or individual expression. Instead, each jumps and gestures at the other, and each is portrayed as a dimensionless black cutout on a stark white background. Walker's redeployment of the silhouette — a portrait genre that predates photography — refers to the history of the representation of African-Americans. Her choice of medium also updates Southern gothic narrative traditions in which slavery was deemed natural and black and white women were pitted mercilessly against one another. Although Walker's work is related to the identity politics of early 1990s art, *A Work on Progress* is as much a comment on the aesthetic atrocity of stereotype and caricature as it is about the continued racial and sexual legacy of slavery in the United States.

☞ Bearden, Lawrence, Shapiro, Simpson

468

Kara Walker. b Stockton, CA, 1969. **A Work on Progress.** 1998. Cut paper and adhesive on wall. **h**69 x **w**80 in. **h**175.4 x **w**203.3 cm. Wooster Gardens, New York, NY.

Warhol Andy

Elvis I & II

Posed in perpetuity as a gunslinging cowboy, rock and roll legend Elvis Presley is repeated four times, on the left in vivid reds and blues, and on the right in shimmering aluminum paint. The source of the image is a still from one of Elvis's kitschy films, *Flaming Star* (1960). Yet in Warhol's un-ironic paintings, Elvis (as well as his female doppelgänger and cultural icon, Marilyn Monroe) is treated no differently than the race riots, car crashes, and electric chairs that Warhol was painting at the time. While some Pop artists of the early 1960s, such as Lichtenstein and Rauschenberg, rebelled against Abstract Expressionism by making self-consciously messy or low-brow art, Warhol celebrated American painting by combining it with other modern American art forms: advertising, Hollywood movies, and rock music. His uncanny ability to identify spectacles and make them even more spectacular irrevocably changed the face of American art and culture.

☛ Berman, Lichtenstein, Rauschenberg, Salle

Andy Warhol. b Pittsburgh, PA, 1928. **d** New York, 1987. **Elvis I & II.** 1964. Two panels: synthetic polymer paint and silkscreen ink on canvas, aluminum paint and silkscreen ink on canvas. **Each panel: h**82 x **w**82in. **h**208.2 x **w**208.2 cm. Private collection.

Watkins Carleton E.

Yosemite Mirror View of the North Dome, 3730 ft.

Cut into the western flank of the Sierra Nevada range, Yosemite Valley offers unequalled views of what has become the quintessential landscape of the American West, shown as unpeopled wilderness and majestic peaks reflected in pristine waters. Even in the nineteenth century visitors to California were drawn to Yosemite Valley, and Watkins was one of the first to carry a camera there to record its

splendors. In 1861 he was a member of a party of explorers that also included the painter Albert Bierstadt. Although Watkins was limited to a monochrome medium, it was his photographs, not Bierstadt's paintings, that helped convince Congress to grant Yosemite land to the state of California for preservation in 1864. Watkins later traveled throughout the West both on assignment and on his own, recording

scenes that would sell at his San Francisco studio. His business ultimately failed, however, and his studio and glass-plate negatives were destroyed in the 1906 earthquake.

☞ Bierstadt, T. Hill, Jackson, A. J. Russell

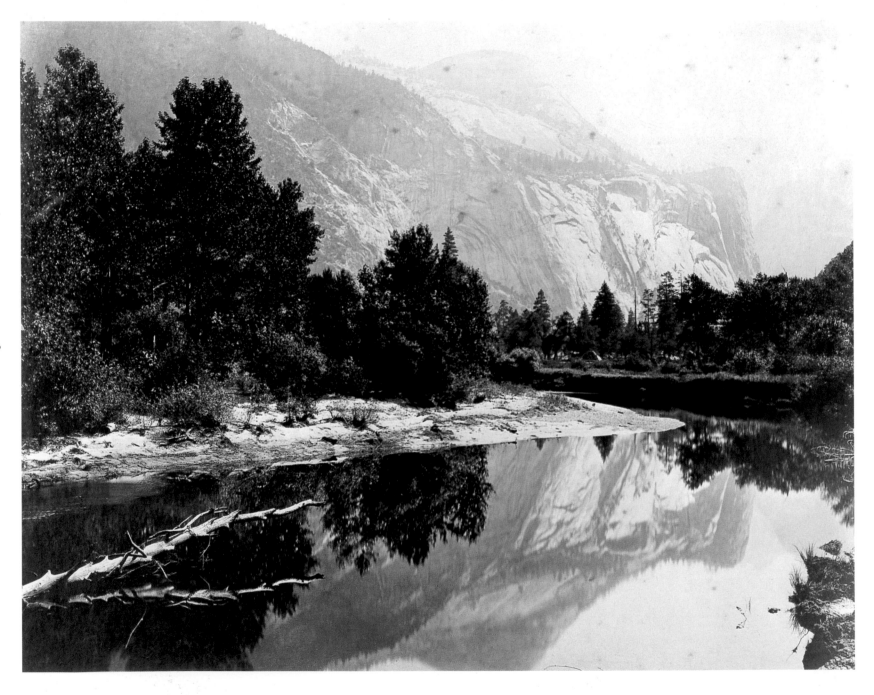

470

Carleton E. Watkins. b Oneonta, NY, 1829. d San Francisco, CA, 1916. **Yosemite Mirror View of the North Dome, 3730 ft.** c1886. Albumen print. Bancroft Library, University of California at Berkeley, CA.

Weber Max

Chinese Restaurant

Details such as hexagonal floor tiles, the scroll foot of a table, and the faces of diners anchor Weber's faceted composition to its source in direct experience. The artist explained what he called his "kaleidoscopic" interpretation as a response to entering a New York restaurant at night. As he stepped in from the darkness, he said, "a maze and blaze of light seemed to split into fragments the interior and its contents." An early proponent of Cubism, Weber was studying art in Paris when Braque and Picasso were pioneering the movement. On his return to the United States in 1909, he developed his own distinctive approach, synthesizing elements of Cubism, chromatic abstraction, and Kandinsky's abstract expressionism. Together with Arthur Dove, Georgia O'Keeffe, John Marin, and other advanced painters, Weber exhibited at Alfred Stieglitz's "291" gallery in New York City, where the first generation of American Modernists found a refuge from hostile critics and an indifferent public.

☛ Carles, Feininger, Hartley

471

Max Weber. b Bialystok, Russia, 1881. **d** Great Neck, NY, 1961. **Chinese Restaurant.** 1915. Oil on canvas. **h**40 x **w**48 in. **h**101.6 x **w**121.9 cm. Whitney Museum of American Art, New York, NY.

Weegee

Joy of Living

A pile of newspapers on the sidewalk is not enough to conceal the true object of the camera's attention: a dead body, watched over by a crowd of curious bystanders. The title on a movie marquee in the background lends an ironic touch. Except for one man who looks directly at the camera, however, the crowd and the police seem unaware of this photo opportunity. Weegee, born Arthur Fellig, was famous for photographing crime scenes in New York, and his pictures were frequently featured in the newspaper *PM*. Weegee was the quintessential spot-news photographer of the time, and there are two accounts of how he got his name. According to one, his ability to reach the scene of the crime just as the police arrived suggested that he had psychic powers — and that he employed a Ouija board. According to another, Weegee was a variant of squeegee; an early job as a newspaper darkroom assistant required him to squeegee wet prints. After his book *Naked City* was published in 1945, Weegee moved to Hollywood, where he became an unsuccessful curiosity.

☛ Klein, Lange, Riis, Winogrand

Weegee (Arthur Fellig). b Zloczew, Austria (now Poland), 1899. **d** New York, NY, 1968. **Joy of Living.** 1942. Gelatin silver print. International Center of Photography, New York, NY.

Wegman William

Man Ray Contemplating the Bust of Man Ray

The weimaraner dog staring intently at his image in clay is unwittingly parodying a famous painting, *Aristotle Contemplating a Bust of Homer,* by Rembrandt. This good-natured send up manages to amuse while referencing issues of self-identity explored in the 1970s by artists such as Vito Acconci and Bruce Nauman. The dog Man Ray (named after the American Surrealist painter and photographer) was the star performer in Wegman's conceptually based photographs and videotapes of the 1970s and established the artist's reputation as a humorist with a broad public appeal. A camera hound since he was a puppy, the dog was happy to pose in whatever position or costume Wegman desired, even if the results sometimes impinged on his dignity. Since Man Ray's death in 1982, Wegman has photographed a succession of Man Ray's heirs, including the well-known Fay Ray, for a variety of projects, including museum exhibitions, children's books, and the television program "Sesame Street."

☞ Michals, Tansey, Troye

William Wegman. b Holyoke, MA, 1942. **Man Ray Contemplating the Bust of Man Ray.** 1978. Gelatin silver print. Collection of the artist.

Weiner Lawrence

The words "GIVE OR TAKE" as well as the mathematical symbols for positive and negative — literally, "more" or "less" — are painted directly onto the wall of an otherwise empty gallery. The visual information here is spare, to say the least, right down to the no-frills typeface designed by the artist. This work of Conceptual art is activated rather by the mind as much by the eyes. By equating two very different ways of conveying the same idea of approximation ("give or take"), Weiner encourages us to ponder the arbitrariness of language itself. Weiner was one of the key members of the 1960s Conceptual art movement. His contribution was to help shift visual art into the realm of ideas, specifically by taking it to its most linguistic extreme, replacing images with pure text. Such a practice seems radical, even contrary to the nature of artistic expression. Weiner's project, however, is actually the result of combining traditional disciplines such as graphic design and poetry in a fresh fashion.

☞ Holzer, Indiana, Kruger, Wool

474

Lawrence Weiner. b New York, NY, 1942. **More or Less That as it is Give or Take This as it Was.** 1997. Paint on wall. As installed at Leo Castelli Gallery, New York, NY.

Weir J. Alden

The Red Bridge

The red framework of a new iron bridge provides a strong focal point as it spans a quiet river near Weir's summer retreat in rural Connecticut. While the bridge signified the changing landscape of the area (which Weir regretted) it was aesthetically appealing to the artist. It created a dynamic composition of oblique angles, shimmering reflections, and resonant effects caused by the vibrating complementaries of red and green. The broken brushstrokes and scumbled surface of this painting testify to its stylistic alignment with Impressionism, which by 1895 Weir had fully embraced. Initially trained by his father, the painter Robert Weir, J. Alden received further instruction in New York and Paris. Schooled in a conservative academic technique that emphasized drawing skills, Weir's conversion to Impressionism was slow. Ultimately, however, he was a founder of The Ten, an organization of American painters closely connected with the advancement of Impressionism in America.

☛ Lawson, Metcalf, Twachtman, Wendel

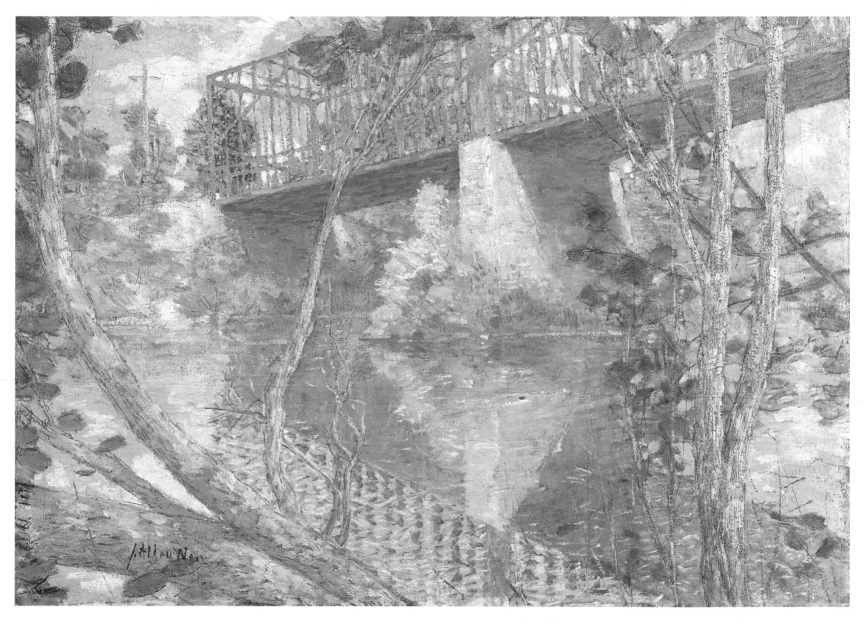

Julian Alden Weir. b West Point, NY, 1852. **d** New York, NY, 1919. **The Red Bridge.** 1895. Oil on canvas. **h**24¹/₄ x **w**33³/₄ in. **h**61.6 x **w**85.7 cm. The Metropolitan Museum of Art, New York, NY.

Weir John F. The Gun Foundry

From their safe vantage point on the right, a group of well dressed men and a woman observes the workings of a gun foundry, which possesses a spectacular visionary quality comparable to passages from Dante's *Inferno*. Indeed, this tour of the factory "underworld," with its brawny men working in hellish conditions, would have provided for the genteel visitors an exotic glimpse of the underpinnings of America's growing industrialism. The painting's subject is extremely unusual, and it represents a rare foray into industrial imagery in American art of this period that only Weir seems to have explored with any significant result. The son of artist Robert F. Weir and the elder brother of artist Julian Alden Weir, John Weir was trained by his father, an art instructor at the West Point Military Academy. Like his father, Weir enjoyed a long and successful career in teaching, mainly at Yale University where he was director of the School of Fine Arts from 1869 to 1913.

☞ **Anschutz, Hine, Neagle**

476

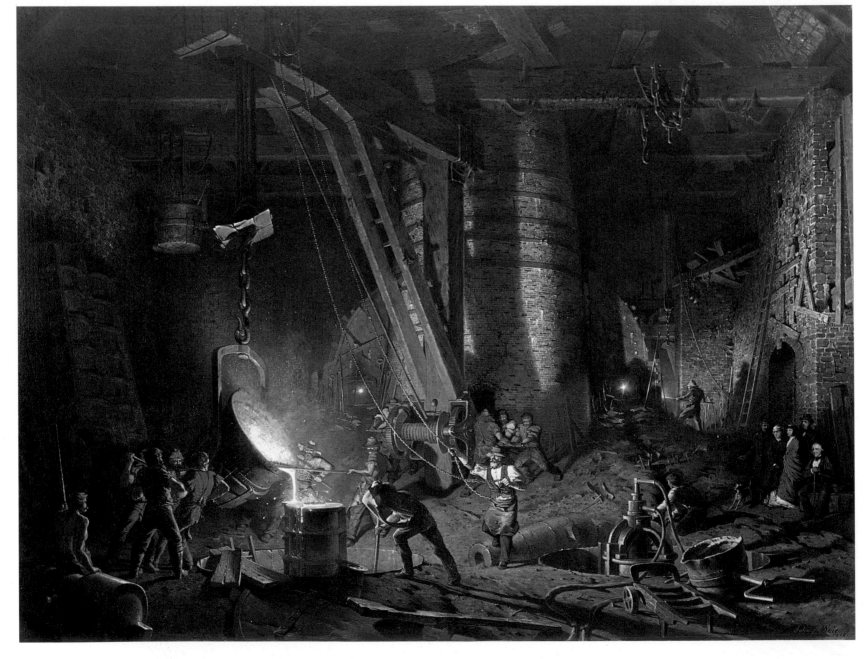

Welliver Neil

Back of Hatchett

A cluster of white birch trees and young evergreens throws parallel shadows on the brilliant snow, a mountain looming behind them. The abstract interplay of angles and colors in this large painting links Welliver to Alex Katz and Philip Pearlstein, other "New Realist" painters who seek to fuse the coolness of abstraction with the emotional content of figuration. Though he is not an abstract painter, Welliver introduces the concerns of abstraction into his nature paintings. His primary subject is the woods surrounding his studio in rural Lincolnville, Maine, where he moved in 1962. Welliver studied at Yale University with the Color Field painter Josef Albers in the late 1950s. Reflecting his mentor's influence, Welliver avoids using colors that are directly representative of nature, instead mixing his paints to reflect the color relationships among grass, sky, light, and snow.

☛ Callahan, Caponigro, E. Porter, Whittredge

477

Neil Welliver. b Millville, PA, 1929. **Back of Hatchett.** 1978. Oil on canvas. **h**96 x **w**144 in. **h**244 x **w**396 cm. Tibor de Nagy Gallery, New York, NY.

Wendel Theodore

Lady with Parasol, Ipswich

A woman's white dress and parasol are reflected in the quiet stream that cuts diagonally through this serene landscape. Although minute in scale, the vertical white patches created by the woman and her reflection provide a visual anchor that stabilizes the composition and, along with the vertical red chimney above them, brings the picture into a final, delicate balance. The presence of the figure reinforces

the spirit of this springtime view by emphasizing the "feminine," generative aspects of the verdant, blossoming landscape. Wendel rejected the dark tonalities of his early style acquired through Munich training in favor of this Impressionist, plein air manner after spending time in the French art colony of Giverny, the home of French Impressionist Claude Monet. On returning to the United

States around 1889, Wendel settled in Boston, where he taught at the Cowles Art School. After his Boston studio burned in approximately 1898, he moved to Ipswich, Massachusetts, which became the principal subject of his art.

☛ Metcalf, Tarbell, Twachtman, J. A. Weir

478

Theodore Wendel. b Cincinnati, OH, 1859. **d** Ipswich, MA, 1932. **Lady with Parasol, Ipswich.** c1889. Oil on canvas. **h**20 x **w**30¼ in. **h**50.8 x **w**76.9 cm. Private collection.

Wesselman Tom

Great American Nude #35

A cartoonish nude with blonde hair, no eyes, and a deep tan line is painted in front of a reproduction of the Mona Lisa. Next to her is a collage composed of a real window and a shelf holding plastic bottles of beer and soda. Wesselman is a Pop artist with classical tastes. His "Great American Nude" and "Smokers" series of the early 1960s referenced garish contemporary advertisements and grocery-store displays, as well as European masters like Henri Matisse, whose influence can be seen here in Wesselman's odalisque nude and curtained bedroom. Like much Pop Art, Wesselman's painted collages mock America's taste for sex and consumer goods while celebrating the freedom and prosperity that made them possible. Later in his career, Wesselman turned to laser-cut steel and aluminum "drawings" of landscapes and nudes. In recent years, these colorful, three-dimensional works have become increasingly abstract.

☛ Kienholz, Lichtenstein, Pearlstein, Rosenquist

Tom Wesselman. b Cincinnati, OH, 1931. **Great American Nude #35.** 1962. Oil, polymer, and mixed media on board. **h**48 x **w**60 in. **h**121.9 x **w**152.3 cm. Virginia Museum of Fine Arts, Richmond, VA.

West Benjamin

The Death of General Wolfe

British Major General James Wolfe lies dying on the battlefield of Quebec, at the very moment a scout rushes in to bring news of the French retreat. Clear skies push aside the tempestuous clouds of battle; Wolfe will not die in vain. A pensive Indian (whose presence on the battlefield was wholly imagined) locates the event in the New World. Although West derived his composition from traditional

Christian Lamentations and Depositions, he defied convention by portraying Wolfe's heroic sacrifice in contemporary dress rather than classical attire and so changed the face of history painting. America's first expatriate, West left Pennsylvania in 1760 and made a Grand Tour of Italy before settling in London. Ambitious and confident, he cultivated the patronage of George III and eventually became

president of the Royal Academy. American artists found West's example inspirational; many passed through his London studio, where they received professional instruction and influential support.

☛ Leutze, C. W. Peale, Trumbull

480

Benjamin West. b Swarthmore, PA, 1738. d London, United Kingdom, 1820. **The Death of General Wolfe**. 1770. Oil on canvas. h60¹/₈ x w84⁷/₈ in. h152.6 x w214.5 cm. National Gallery of Canada, Ottawa.

Westermann H. C.

Burning House

Expertly crafted and lovingly decorated, the sturdy little building balances on incongruously spindly legs as stylized metal flames erupt from its windows. Atop the roof, an onion-domed spire suggests a house of worship instead of a dwelling, or perhaps a memorial to the unidentified "Johnny" whose name adorns the top window. Many of Westermann's constructions have a whimsicality that masks a barbed social or political message, such as strong antiwar sentiments couched in humor and fantasy. Loosely associated with the Chicago "funk" group, Westermann considered himself an object-maker rather than a sculptor. A quixotic figure who also worked as a professional acrobat, he often used his assemblages to comment on aspects of popular culture. His iconoclastic shrines parody the disposable culture of consumerism and icons of mass production. They are monuments to individual displacement and anxiety in the modern world.

☛ Haring, Shapiro, Tolson, Traylor

Horace Clifford Westermann. b Los Angeles, CA, 1922. d Danbury, CT, 1981. Burning House. 1958. Pine, brass, tin, glass, enamel. h43 x w16 x d12 in. h109.3 x w40.7 x d30.5 cm. Lennon, Weinberg Inc., New York, NY.

Weston Edward

Dunes, Oceano, 1936

Snaking sinuously across the picture surface, these sand dunes near California's Pacific shore seem both beautiful in their own right and suggestive of human sensuality. Weston, whose photographs of female nudes are legendary for their intense eroticism, adamantly insisted that his pictures of nature had nothing to do with sex, as some critics had suggested. Nonetheless, one can see similarities of form among his nudes, landcapes, and much-admired close-ups of vegetables and shells. Using a style that combines precise description and nearly abstract composition, Weston became one of the best-known artists of the 1930s. He was at the center of a West Coast group of photographers known as Group f.64 because of their preference for using small apertures, thus ensuring total sharpness.

Living in a secluded hillside cabin on the Monterey Peninsula and eating a spartan diet of fruit and nuts for breakfast and lunch, Weston epitomized the aspirations of photography to be taken seriously as a form of art.

☛ Celmins, Covert, Misrach

482

Edward Weston. b Highland Park, IL, 1886. d Carmel, CA, 1958. **Dunes, Oceano, 1936.** 1936. Gelatin silver print. Center for Creative Photography, Tucson, AZ.

Whistler James

Nocturne in Black and Gold, The Falling Rocket

Brilliant spots of hot color glow against a dark ground of blue tonalities. The startlingly abstract character of this painting initially thwarts the realization that this painting represents the nighttime spectacle of a fireworks display at London's Cremorne Gardens along the Thames River. The paint calls attention to itself and barely suggests the smoke, shimmering water, and spectacle of the scene.

The painting was the center of controversy in 1878, when Whistler sued the noted English critic John Ruskin for libelous statements which claimed that the work was merely "a pot of paint flung in the face of the public." Whistler won the suit, but it was a Pyrrhic victory that bankrupted him financially. The always mercurial American expatriate pioneered the aesthetic of "art-for-art's-sake"

and vehemently campaigned against the notion of artistic "schools" or prescribed styles

☞ Abbott, Gonzalez-Torres, Pollock, Steichen

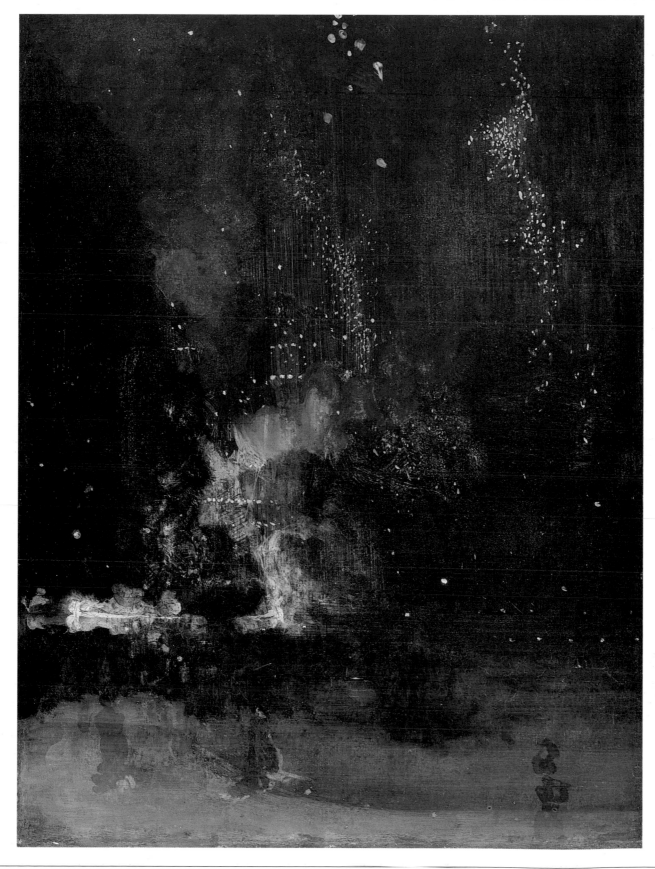

483

James Abbott McNeill Whistler. b Lowell, MA, 1834. **d** London, United Kingdom, 1903. **Nocturne in Black and Gold, The Falling Rocket.** c1875. Oil on panel. **h**23¾ x **w**18⅜ in. **h**60.2 x **w**46.7 cm. The Detroit Institute of Arts, Detroit, MI.

White Clarence

The Ring Toss

Dressed in their finest frocks, three girls enjoy an indoor sport on what seems a pleasant day at the turn of the century. A study in beautiful composition and lighting, White's picture is in fact an artful contrivance intended to suggest domestic tranquility and to resemble the luminous paintings of contemporaries such as John Singer Sargent. Practicing a style influenced by Impressionist painting but known as Pictorialism, White would join with Alfred Stieglitz and Edward Steichen in establishing the influential Photo-Secession movement in 1902. Later he served as president of the Pictorial Photographers of America. As a teacher at Columbia University and at the Clarence White School of Photography in New York City, which he founded, the one-time bookkeeper trained a new generation of modern photographers, including Margaret Bourke-White, Dorothea Lange, and Ralph Steiner. Today their reputations exceed that of their teacher.

☞ Pinney, J. Sargent, L. M. Spencer

484

Clarence Hudson White. b West Carlisle, OH, 1871. **d** Mexico City, Mexico, 1925. **The Ring Toss.** 1899. Platinum print. The Library of Congress, Washington, D.C.

White Minor

Windowsill Daydreaming

A twentieth-century version of a spirit photograph, this picture seems permeated by the supernatural presence of a circle of light. Never mind that the wondrous and mysterious shape is simply the result of sun reflecting off the curtain and onto the window casing and interior wall — the photographer asks us to abandon our usual sense of reason to experience the scene as if it were a dream.

White, one of the most influential advocates for the art of photography in the 1950s and 1960s, was a student of Zen and a variety of forms of Eastern mysticism. Partly as a result, he believed that photographs could best be understood through meditation. *Windowsill Daydreaming* is one of twelve images in his "Jupiter Portfolio," a limited edition of selected photographs that White

sequenced with the idea that the meaning of each photograph would be influenced by the images before and after it.

☞ **Evans, Friedlander, Matta-Clark, Stieglitz**

Minor White. b Minneapolis, MN, 1908. **d** Cambridge, MA, 1976. **Windowsill Daydreaming.** 1958. Gelatin silver print. The Minor White Archive, Princeton University, Princeton, NJ.

Whittredge T. Worthington The Old Hunting Grounds

An abandoned canoe rests at the edge of a shadowed pool in the depths of a forest where only deer disturb the melancholy stillness. The arched trees create a darkened foreground and frame a sunlit stand of birches that forms the backdrop to a conceptual stage where the drama of the vanishing Native American civilization unfolds. Whittredge painted this canvas approximately four years after his return from a ten-year stay in Europe. Determined to adopt a distinctly American subject matter, he turned to the quintessentially nativist Hudson River School manner. As implied by the title, the days of the hunt are gone and the land formerly used by a strong and active Native American people has been overtaken by the wildlife they had once pursued. Only the ruined canoe remains as the nostalgic evidence of their prior strength.

☛ Couse, Parrish, E. Porter, Ulmann

486

Thomas Worthington Whittredge. **b** nr. Springfield, OH, 1820. **d** Summit, NJ, 1910. **The Old Hunting Grounds.** 1864. Oil on canvas. **h**36 x **w**27 in. **h**91.5 x **w**68.6 cm. Reynolda House, Museum of American Art, Winston-Salem, NC.

Williams Sarah Furman Warner | Coverlet made for Susannah Nexsen Warner (Greenfield Hill Coverlet)

At the center of this ambitious design in fabric and stitchery is a New England town green, where finely-dressed townsfolk promenade before a steepled church and gather beneath a fruit-laden tree. Beyond the town, farmers tend livestock near a windmill and an apiary. Interlacing vines, leaves, flowers, and birds border this scene of rural abundance and civic pride, created from fabric pieces carefully cut, hemmed, and appliquéd to a cotton support. Six bouquets were cut from printed chintz; the remaining elements are composed from patches of humbler cloth. Despite the American subject, the design recalls the fashionably exotic bed hangings that were being imported from India at that time. Williams made this remarkable coverlet for her niece Susannah, who married a minister in Greenfield Hill, Connecticut, in 1816. She sewed an equally beautiful coverlet, now in the Metropolitan Museum of Art, for her cousin Phebe. Both objects reveal a lively creative vision behind the hands of a sophisticated seamstress.

☞ Fisher, Harriet Powers, Reed

Sarah Furman Warner Williams. b possibly New York, NY, c1765. **d** (unknown). **Coverlet made for Susannah Nexsen Warner (Greenfield Hill Coverlet).** c1800–20. Appliquéd and embroidered cotton. Henry Ford Museum, Dearborn, MI.

Williams William

Deborah Hall

Fifteen-year-old Deborah Hall stands stiffly resplendent in a pink robe and fine lace, at once a child with a pet squirrel and a woman holding a rose. Nearly every detail of her elaborate setting bears some emblematic reference to love. With their sweet smell and sharp thorns, roses suggest pleasure and pain, but in cultivation, they wind around Cupid's arrow. In contrast, the languid vine, according to one eighteenth-century guide, denotes the unmarried woman, unable "to support herself without some Help-mate." Such didactic cues came naturally to Williams, whose artistic pursuits in Philadelphia also included painting stage scenery. He also composed poetry, novels, and an illustrated edition of Vasari's *Lives of the Painters*. Self-taught as an artist, he ventured into several genres, painting portraits, for example, as "conversation pieces" set in the landscape. His example inspired the young Benjamin West, who later in life recalled that without Williams, "I shd. not have embraced painting as a profession."

☛ Alexander, J. E. Kühn, Sully, Wollaston

488

William Williams. b Bristol, United Kingdom, 1727. **d** Bristol, United Kingdom, 1791. **Deborah Hall.** 1766. Oil on canvas. **h**71⅜ x **w**46⅜ in. **h**181.4 x **w**117.9 cm. The Brooklyn Museum of Art, Brooklyn, NY.

Wimar Charles Ferdinand

The Buffalo Dance

Deep hues of atmospheric red convey the almost palpable heat of the bonfire around which dancers, dressed in buffalo skin and ceremonial headdress, circulate. Only the moon illuminates this nighttime gathering of the Mandan Indians for the ritual of the buffalo dance. Even seen at a distance, details of their ceremonial dress glisten in the reflected fire and moonlight. The German-born Wimar dedicated

himself to detailed and accurate portrayals of Native American life such as this one. He did not move to the United States until he was fifteen, at which point his flawed English and shy demeanor caused him to identify with the Native Americans who traded furs near his stepfather's tavern in St. Louis, Missouri. Two years after painting this canvas, Wimar died at age thirty-four from consumption, but his

historical canvases served as models for such turn-of-the-century artists as Charles Russell and Frederic Remington.

☞ Catlin, Couse, Kern, Miller

489

Charles Ferdinand Wimar. b Sieberg, Germany, 1828. d St. Louis, MO, 1862. **The Buffalo Dance.** 1860. Oil on canvas. h24⅞ x w49⅝ in. h63.2 x w126.1 cm. The Saint Louis Art Museum (Modern Art), St. Louis, MO.

Winogrand Garry

Los Angeles, California

This photograph offers almost too much to look at: three women in short skirts in the center, a man in a wheelchair on the left, a family waiting for a bus on the right, rays of reflected sunlight intersecting down the middle, and much more. While some viewers find such a plethora of visual incident confusing, if not chaotic, for Winogrand it was magical and delightful. Associated with a "snapshot" school of street photography that prospered during the social upheavals of the 1960s and early 1970s, Winogrand tried to jam as much life as possible into his pictures, creating dense, multilayered compositions that dispense with such traditional niceties as straight horizon lines and centers of interest. His interests in women, politics, and animals provide a thematic coherence and consistency to his work. This picture, for example, is part of a series called "Women Are Beautiful," published in book form in 1975. Asked once how long it took him to make a photograph like this one, Winogrand replied, "I think it was about one 1/125th of a second."

☞ Bishop, Hahn, Klein, Weegee

490

Garry Winogrand. b New York, NY, 1928. **d** Tijuana, Mexico, 1984. **Los Angeles, California.** 1969. Gelatin-silver print. Fraenkel Gallery, San Francisco, CA.

Winters Terry

Lumen

A series of red-orange forms floats against a dark background like an army of fiery balloons. While "lumen" is defined as a unit of light, it is also a scientific term for both a cell structure and a part of a tubular organ. All three definitions are applicable to Winters's glowing organic orbs. An amateur expert on minerals and plant structures, Winters is also interested in architecture and geometry.

His paintings are complex yet serene layerings of these diverse fields, self-referential works that at once embody and describe the "nature" of painting. Winters joins the ethos of Process Art with a look reminiscent of both Minimalism and Abstract Expressionism. His heavily impastoed webs, crystals, spores, fungi, mollusks, plants, and honeycombs are made with hand-mixed and natural

pigments. The forms in his paintings, as well as their titles, all refer to the cellular compositions of the paint, the canvas, and even the painter himself.

☛ Bess, Dove, Gowin, Wojnarowicz

Terry Winters. b Brooklyn, NY, 1949. **Lumen.** 1984. Oil on linen. **h**101 x **w**68 in. **h**256.5 x **w**172.7 cm. Private collection.

Witkin Joel-Peter

Siamese Twins, New Mexico

Dressed in identical slips and wearing masks, the conjoined twins are connected here not only physically but also by their participation in a masquerade. The bouquet and mourning dove function symbolically, as they would in a painting. In fact Joel-Peter Witkin bases most of his figure compositions as well on precedents in the history of painting. We do not need to know the specific antecedent of this image,

however, to be taken aback at what may appear to be a casual use of human deformity. Throughout his career Witkin has photographed hermaphrodites, dwarfs, amputees, and body parts borrowed from morgues. All are part of his theatrical repertory, which pits the obvious reality of a photograph against the painterly sensibilities of his compositions. Witkin trained as a sculptor and studied photography

at the University of New Mexico in the 1970s. He emerged in the early 1980s as the inheritor of a Surrealist tradition that extends back through Frederick Sommer to European photographers such as Raoul Ubac and Hans Bellmer.

☞ W. Kuhn, Laughlin, Levitt, Mapplethorpe

492

Joel-Peter Witkin. b Brooklyn, NY, 1939. **Siamese Twins, New Mexico.** 1988. Gelatin silver print. Collection of the artist.

Wojnarowicz David Where I'll Go If After I'm Gone

This dense, painted photo collage, with its references to mythology, transportation, and the cosmos, recalls the Constructivist era of the 1920s, a period when art was enlisted in the cause of social change. The cause here is not socialism or Marxist Leninism, however, but the fight against AIDS, and the artist, whose face appears near the bottom of the collage, made the picture when he was struggling to survive the disease. The circular motif in this work calls to mind celestial bodies as well as human cells, such as those depicted in the lower left corner. Wojnarowicz gained fame toward the end of his life both as an artist and as an AIDS activist; he often made angry works that engendered controversy and discussion. Earlier in life he had been a street hustler and a graffiti artist who collaborated with Keith Haring. Here, his typical anger is muted as he attempts to envision an afterlife in which suffering is not a part of the picture, and paradise seems possible.

☞ Jess, Reed, Saar, J. Stella

David Wojnarowicz. b Red Bank, NJ, 1954. **d** New York, NY, 1992. **Where I'll Go If After I'm Gone.** 1988–89. Acrylic and black/white photographs on canvas. **h**45 x **w**64 in. **h**114.4 x **w**162.6 cm. Private collection.

Wolcott Marion Post

A member of Wilkins family making biscuits . . . , Tallyho, North Carolina

Nostalgia blends with incredulity in this prototypical scene of domestic Americana. The good farm wife is hard at work in a kitchen at once spare and decorative, indicating the perseverance of basic family rituals during a time in which economic uncertainty (the Depression) and climatic upheavals (the Dust Bowl) threatened them with ruin. Wolcott made the photograph while working for the Farm Security Administration's photography section, which documented rural American life during the New Deal era of the 1930s. Unlike her predecessors at the agency, who included Walker Evans and Dorothea Lange, Wolcott was assigned the task of showing how the New Deal had restabilized the economy on which the family farm depended. After the photography project ended in 1942, Wolcott herself returned to a traditional female role, giving up photography to raise a family.

☛ Bearden, Evans, Lee

494

Marion Post Wolcott. b Montclair, NJ, 1910. **d** Santa Barbara, CA, 1990. **A member of Wilkins family making biscuits on corn-husking day, Tallyho, North Carolina.** 1939. Gelatin silver print. Library of Congress, Washington, D.C.

Wollaston John

Mrs. John Beale

Demure but confident, Mrs. Beale fingers pearls at her breast and has her other hand cocked at the hip. Jewels decorate her neck and hair, while a brocaded robe adorns her shoulders. Glowing light and a low lace neckline accentuate her female charm. Wollaston portrayed this young wife of a Charleston, South Carolina, merchant as the luxurious incarnation of a Baroque court beauty painted by Sir Godfrey Kneller,

the German-born artist active in London at the turn of the eighteenth century. Wollaston trained with his portraitist father in London, where he is presumed to have been a drapery specialist. He arrived in the colonies in 1749, bringing with him a fashionable English style marked by studied informality, genteel sensuality, and occasional stylistic mannerisms such as almond-shaped eyes. Working the

seacoast from New York to Charleston, Wollaston flattered his sitters with elegant costumes and aristocratic poses. In Annapolis, Maryland, he was feted with poetry as well as commissions, and in Philadelphia his example briefly held the young Benjamin West in thrall.

☛ Alexander, Käsebier, Phillips, William Williams

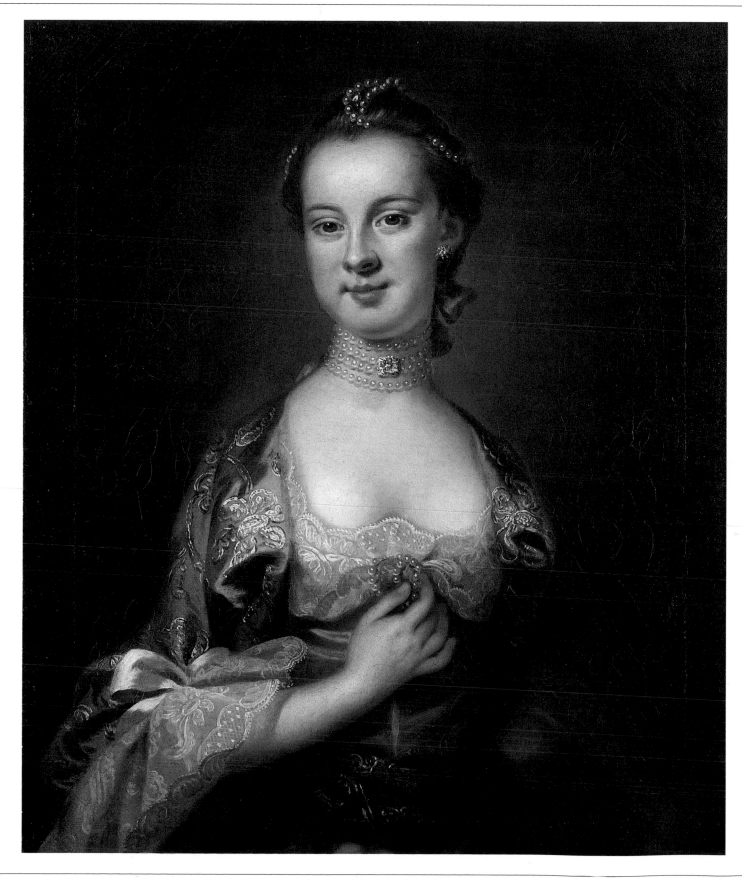

495

John Wollaston. Active in America, 1749–67. **Mrs. John Beale.** 1765–67. Oil on canvas. **h**30 x **w**25 in. **h**76.2 x **w**63.5 cm. Museum of Early Southern Decorative Arts, Winston-Salem, NC.

Wong Martin

Grant Avenue, San Francisco

A bustling street scene in San Francisco's Chinatown is captured with a mix of painterly elegance and cartoonish exuberance. Like the somewhat garish yet authentic Avenue itself, Wong's painting features an improbable blimp coasting over the traditional hanging lanterns and pagoda roofs. Local residents pepper the scene. Raised in San Francisco, Wong moved to the predominantly Puerto Rican Lower East Side of New York City in the late 1970s, just as the downtown art scene began to bloom. Instead of jumping into the art-world mainstream, however, Wong captured local neighborhood buildings and personalities in paintings that recall the Ash Can School of the 1920s, incorporating graffiti, sign language, and homoerotic themes. In addition to his figurative paintings, Wong has painted life-sized New York storefronts that border on the abstract, reminiscent of the heavily textured, monochromatic compositions of Robert Ryman.

☛ Bishop, Hahn, Hassam, Luks

496

Martin Wong. b San Francisco, CA, 1946. **Grant Avenue, San Francisco.** 1992. Acrylic on linen. **h**108 x **w**42 in. **h**274.5 x **w**106.7 cm. Private collection.

Wood Grant

Woman with Plant(s)

In this meticulously detailed painting, the artist's seventy-one-year-old mother, Hattie Weaver Wood, holds a sansevieria plant that symbolizes her hardy, upright character. This portrait reflects Wood's admiration for early Flemish art and German New Realism, which he had studied during a trip to Munich the previous year. Back home in Iowa, he applied Old Master technique to local subject matter.

Not all Wood's depictions of typical Iowans are as sympathetic. He could be critical of their insularity and narrowmindedness, although his barbs are often blunted by humor, as in his famous painting of a farmer and his wife, *American Gothic*. But much of his work celebrates the frontier heritage he shared with them. In the 1930s, as a leader of the Regionalist school, Wood organized an art colony at Stone City, taught at the University of Iowa, and supervised the state's Public Works of Art Project.

☛ **Eggleston, Elliot, Page, Rembrandt Peale**

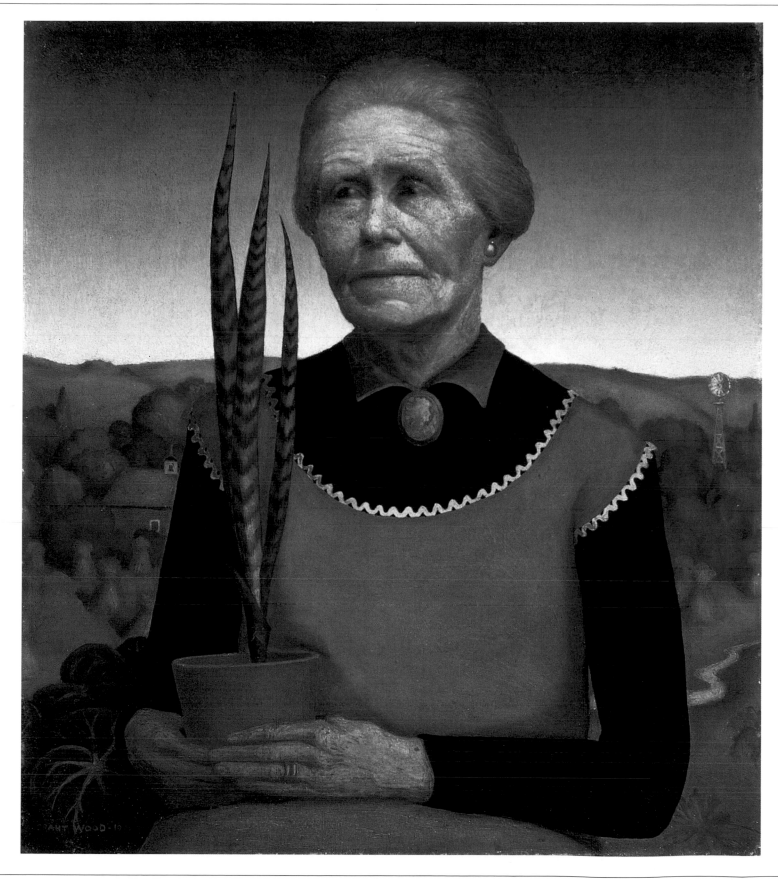

Grant Wood. b Anamosa, IA, 1891. **d** Iowa City, IA, 1941. **Woman with Plant(s).** 1929. Oil on upsom board. **h**20½ x **w**17⅞ in. **h**52.1 x **w**45.3 cm. Cedar Rapids Museum of Art, Cedar Rapids, IA.

Woodville Richard Caton

War News from Mexico

Men of varying ages and social status cluster eagerly on the porch of a ramshackle frontier hotel, straining to hear the latest news as it is read by the excited, top-hatted gentleman in their midst. The central position of the newspaper in this scene underscores the difficulty rural Americans encountered in keeping current with national events. Filled with anecdotal vignettes that explore ranges of human behavior and emotion, Woodville's paintings often introduced serious social issues. Here, for instance, the African-American man and child at the lower right and the old woman in the shadows are excluded from the main group — their place in the composition echoes their marginality in American society. Woodville trained in Germany and spent the most productive part of his short career in England. Collected by a select group of American patrons, his paintings became widely appreciated through print reproduction.

☛ Durrie, Hovenden, Nahl, L. M. Spencer

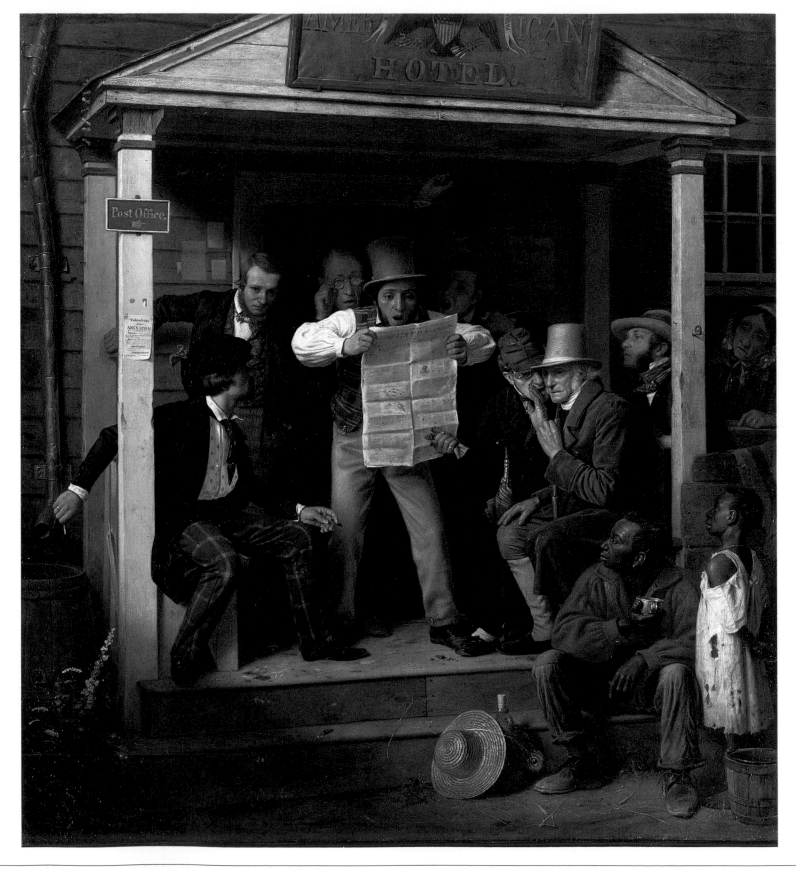

Richard Caton Woodville. b Baltimore, MD, 1825. **d** London, United Kingdom, 1855. **War News from Mexico.** 1848. Oil on canvas. **h**27 x **w**24¾ in. **h**68.6 x **w**62.9 cm. Manoogian Collection, Taylor, MI.

Wool Christopher

Untitled

The words "You Make Me" are stenciled in slick black paint onto a large sheet of white-painted aluminum. The phrase could be a sentence — a statement of love or completion — or an accusatory fragment, as in "You make me sick." Wool is a painter of found poetry. In addition to appropriating words, Wool has also incorporated nonverbal symbols, stenciling them on canvas to create a wallpaper-like effect. Other subjects of Wool's textual gleaning include snippets from Vietnam War movies, and single words like "please" that when repeated over and over begin to seem ominous. Wool's paintings represent everything that high art claims to eschew: the quick and easy shocks, pleasures, and trendy code-words of pop culture, and especially television, painting's supposed antipode. With his deadpan delivery and consistent style, Wool takes no overt position, pro or con, regarding his own sound-bites. He allows viewers to read into them their own proclivities toward juicy melodrama or dry media critique.

☞ Holzer, Horn, Kruger, Weiner

Christopher Wool. b Chicago, IL, 1955. Untitled. 1997. Enamel on aluminum. h108 x w72 in. h274.5 x w183 cm. Luhring Augustine, New York, NY.

Wright Joseph

John Coats Browne

Young John Browne, the son of a Philadelphia blacksmith, stands in the pose of another ironmonger's son, Jonathan Buttall, as seen in Thomas Gainsborough's famous 1770 portrait, *The Blue Boy*. Wright, however, would not have expected his American audience to catch the literal reference. His intent, underscored by the stately column and voluminous drapery, was rather to translate the European Grand Manner to American circumstances, a task suggested by his irrepressible mother, the wax modeler Patience Lovell Wright. An ardent Yankee, she advised her son in 1781 to cut short his European education, return to America, and paint new heroes rather than copy Old Masters. Wright did portray several members of the emerging American government before turning his attentions to engraving and medalmaking. He had embarked on a promising career with the US Mint when he fell victim to one of Philadelphia's worst epidemics of yellow fever.

☛ **Beardsley Limner, Chandler, Hopkins, Prior**

500

Joseph Wright. b Bordentown, NJ, 1756. **d** Philadelphia, PA, 1793. **John Coats Browne.** c1784. Oil on canvas. **h**61³/₈ x **w**42⁷/₈ in. **h**396.5 x **w**277 cm. Fine Arts Museums of San Francisco, CA.

Wyeth Andrew

Winter, 1946

A boy runs down a grassy slope, bathed in winter's raking light and leaning into its bracing wind. Wyeth's dry-brush paintings like this one are at once brittle and warm, embodying an emotional aloofness characteristic of his New England roots and of Puritan America in general. This is the first painting Wyeth made after the death of his father, the illustrator N. C. Wyeth, in a car accident just over this same hill. Wyeth's decades-long career has been one of the most celebrated in American art history. He considers himself an abstractionist rather than a painter of American life in the tradition of Thomas Eakins and Winslow Homer. Wyeth has made surprisingly loose watercolors, though his contemplative portraits and farm scenes are far more popular. He has called his paintings "untruthful," in that they are inspired by an emotion which is then systematically covered up.

☛ Leigh, Mann, Pinney, Rimmer

501

Andrew Wyeth. b Chadds Ford, PA, 1917. **Winter, 1946.** Tempera on board. h31⅜ x w48 in. h79.7 x w121.9 cm. North Carolina Museum of Art, Raleigh, NC.

Yoakum Joseph

Red mtn and Red Clay Pass in San Juan Range near Telluride Colorado

This view of the Rocky Mountains appears as if in a dream. The swirling lines suggest a landscape in motion, where the flowers grow as tall as the neatly ordered trees. Joseph Yoakum was a master of such visionary landscapes and the drawings he created during the 1960s influenced a generation of Chicago's contemporary artists. Born into an African-American family and raised on a Navajo reservation,

Yoakum was exposed to a range of cultural traditions, including Native American animistic beliefs. He went on to travel the world through a variety of jobs including stints with the circus and the railroads and later in the armed forces. While it is unclear whether Yoakum actually saw the hundreds of sites he depicted, his wanderlust found expression through his art. He was entirely self-

taught, but his work suggests influences as far reaching as Navajo mythology and the prints of nineteenth-century Western landscape paintings used to advertise railroad travel.

☛ Benton, Ramirez, Watkins, Weston

502

Joseph Yoakum. **b** Window Rock, AZ, 1886. **d** Chicago, IL, 1972. **Red mtn. and Red Clay Pass in San Juan Range** . . . n.d. Colored pencil, watercolor, and ballpoint pen on paper. **h**19 x **w**12 in. **h**48.3 x **w**30.5 cm. Collection of Jill and Sheldon M. Bonovitz.

Zorach William

Rock a Bye (Crescent Moon)

The sleeping figure, cradled in her own hair, is partly covered by a roughly chiselled blanket that contrasts with the smoothness of her creamy skin. Her simplified form appeals to modern tastes while referencing ancient and tribal art. Zorach admired ethnographic carvings, which he saw while studying painting in Paris, where he absorbed Fauvist and Cubist influences. His interest in African

sculpture intensified after his return to New York City in 1912. However, he did not begin working as a sculptor until five years later, when he first experimented with wood. Zorach was an early proponent of direct carving, a technique he popularized through his writings and as a teacher at the Art Students League. He took up stone carving in 1921, often using boulders collected on the Maine coast and retaining

their natural textures. He also executed monumental works, including commissions for Rockefeller Center, New York City's Municipal Court Building, and the Mayo Clinic in Rochester, Minnesota.

☛ Edmondson, Ives, Palmer, Rush, Wesselman

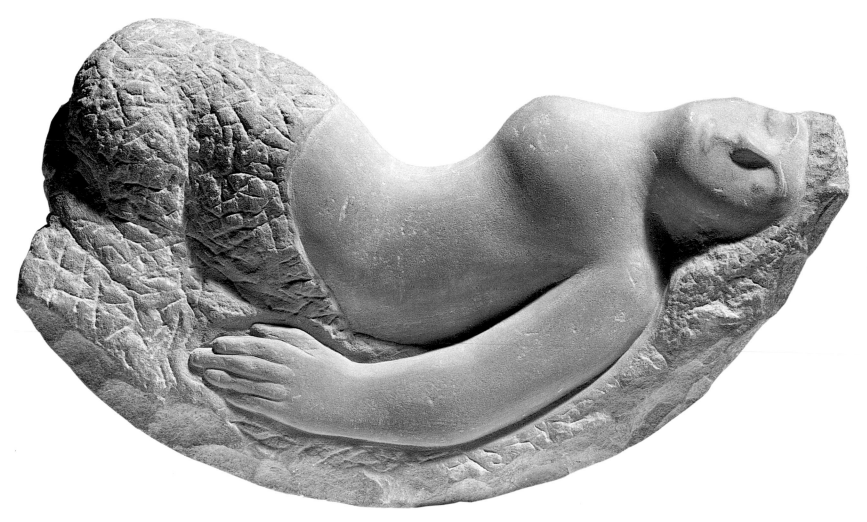

William Zorach. b Eurburg, Lithuania, 1887. **d** Bath, ME, 1966. **Rock a Bye (Crescent Moon)**. 1951. Stone. **h**8 x **w**12 x **d**3 in. **h**20.3 x **w**30.5 x **d**7.6 cm. Private collection.

Glossary of terms

Abstract

A form of art which does not seek to represent the world around us. The term is applicable to any art that does not represent recognizable objects, but refers particularly to forms of twentieth-century art in which the idea of art as imitation of nature has been abandoned. Charles Biederman, Stanton MacDonald-Wright, and Morgan Russell were among abstraction's early pioneers in the United States.

Acrylic

A synthetic paint, first used in the 1940s, combining some of the properties of oil and watercolor. It can be used to create a variety of effects, from thin washes (see David Hockney) to textured brushwork (see Peter Halley).

Albumen print

Albumen printing paper was introduced by Louis-Désiré Blanquart-Evrard in a communication to the Académie des Sciences, Paris, on 27 May 1850, and it remained in general use until about 1895. It could be bought partly prepared, i.e. coated with a thin film of white of egg and was then sensitized with silver nitrate solution by the photographer. Toning with chloride of gold checked fading and produced a sepia effect (see A.J. Russell), avoiding the unattractive reddening to which the paper was prone.

Armory Show

Landmark exhibition of modern European and American art held in 1913 at the Sixty-ninth Infantry Regiment Armory in New York City. Officially titled the "International Exhibition of Modern Art," it was organized by a group of artists (led by the painters Walt Kuhn and Arthur Davies) who came together with the intention of introducing to a US audience the latest avant-garde trends in European and American art. More than three hundred artists and one thousand works were represented, from French Impressionism, Fauvism, and Cubism to contemporary paintings by Americans such as Stanton MacDonald-Wright, Charles Sheeler, and members of The Eight. The exhibition drew record crowds and received massive attention in the press, not all of it favorable: Critics derided the art for what they perceived as its unfamiliar appearance, foreignness, and unconventional colors, compositions, and subject matter. The show, however, had a monumental and lasting effect on the American art world, changing the way that artists, collectors, and even the general public viewed modern art.

Assemblage

The incorporation of three-dimensional, non-art materials and found objects into a work, originally inspired by the techniques of collage. The roots of assemblage lie in the early part of the twentieth century when Picasso began using real objects in his Cubist constructions – adding, for example, a spoon to his witty sculpture, *Glass of Absinthe* (1914). One of the earliest and most famous antecedents of assemblage was Marcel Duchamp's bicycle wheel attached to a stool, which he labelled the "ready-made." Later, the Dadaists and Surrealists based their work on surprising conjunctions of disparate objects and images. The technique was particularly popular in the late 1950s, when artists such as Jim Dine made assemblage works, assimilating various materials, which included food and junk, into painting and sculpture. The growth of the use of assemblage in twentieth-century art reflects an anarchic approach to formal artistic practice.

Camera Work

Alfred Stieglitz founded the magazine *Camera Work* in 1903. It went through fifty issues before it was discontinued in June 1917 and became, deservedly, the most esteemed and famous of all the many photographic magazines. Stieglitz published the work of a broad range of significant photographers and devoted the last issue of the magazine to the pictures of Paul Strand.

Collage, Photomontage

Collage, coming from the French world *coller* (meaning "to stick"), is a technique in which pieces of paper, cloth, and other miscellaneous objects are pasted onto a flat surface. The Cubists were the first to use collage as a serious artistic technique. Photomontage applies the same principles to the use of photographs; it was an important technique in Dadaism and Surrealism, and continues to be used in contemporary art (see John Baldessari, Romare Bearden, and David Wojnarowicz).

Conceptual Art

In Conceptual Art it is the "concept" behind the work, rather than the technical skill of the artist in making it, that is important. Conceptual Art became a major international phenomenon in the 1960s and its manifestations have been very diverse. The ideas or "concepts" may be communicated using a variety of different media, including texts, maps, diagrams, film/video, photographs, and performances, and displayed in a gallery or designed for a specific site (see David Hammons and Gordon Matta-Clark). In some cases the gallery itself becomes an integral part of the artist's work (see Vito Acconci). The ideas expressed through Conceptual work have been drawn from philosophy, feminism, psychoanalysis, film studies and political activism. The notion of the Conceptual artist as a maker of ideas rather than objects undermines traditional ideas about the status of the artist and the art object.

Daguerreotype

This was the first commercial photographic process. It was made public by Louis-Jacques-Mandé Daguerre in 1839. Daguerreotypes were unique images fixed on silver-coated copper plates. The silvered surface was treated with iodine and bromine vapors, to create a light-sensitive halide. After an exposure of several minutes' duration in a camera, the plate was developed over a dish of heated mercury, to bring out the latent image, which was then fixed in a bath of sodium thiosulfate. Daguerreotypes were reversed images. Positives, they could not be multiplied; they also had to be protected by a glass cover from oxidation and abrasion. Early exposure times were of fifteen to twenty minutes, although that time was reduced in 1840-1 to make the process suitable for portraiture. The process was abandoned during the 1850s, with the introduction of the wet-collodion process, although it remained popular in the United States until the mid-1860s (see Southworth & Hawes).

Farm Security Administration (FSA)

The FSA, as it is usually known, was established in 1935 with a set of responsibilities which included support for small farmers and the refurbishment of land and communities ruined by the Depression. Roy Emerson Stryker was appointed to head the Historical Section and decided to put together a photographic collection. The result was one of the most celebrated archives in the history of the medium. Among the photographers were Arthur Rothstein, Walker Evans, Carl Mydans, Ben Shahn, Dorothea Lange, Russell Lee, Jack Delano, Marion Post Wolcott, and John Vachon. Although the influence of the FSA photographers was considerable at the time, it was even more noticeable during the 1970s, when many books on its history were published.

Figurative

Art that depicts recognizable images of the world around us. These images may be acutely accurate (see Ralph Goings) or heavily distorted (see Lionel Feininger). The term "representational art" is used synonymously with figurative art.

Folk Art

Art and craft objects made by artists with no academic training, often using local materials to express a personal vision or set of beliefs unique to a culture or region. Folk art can be considered the visual equivalent of oral tradition, and working methods may be handed down from generation to generation. American folk art originated in the eighteenth century with objects such as scrimshaw, woodcarvings, quilts, and samplers. Folk paintings and drawings characteristically lack perspective (see John Durand and Erastus Salisbury Field). Twentieth-century folk artists such as Howard Finster and Sister Gertrude Morgan have brought the folk paradigm into the present.

Genre painting

Painting that depicts scenes of everyday life rather than idealized or religious subjects. Genre painting was particularly popular in Holland in the seventeenth century, and artists often specialized in subjects such as tavern scenes, musical parties, or simple interiors. The style became more prevalent elsewhere in the eighteenth century (see John Greenwood), and particularly popular in the United States in the nineteenth century. Subject matter ranged from domestic scenes (see Thomas Hovenden) to local scenery and pastimes (see George Caleb Bingham and William Sidney Mount).

Gelatin silver print

The standard contemporary monochrome photographic print. The paper (first introduced in 1882) is treated with the same gelatin silver emulsion used in the gelatin dry-plate process. By 1895 the gelatin silver print had replaced the albumen print.

Happening

A fusion of art, theater, and dance performed in front of an audience, and often involving participation. The term was coined by the artist Allan Kaprow in 1959 and comes from the title of his multimedia event at the Reuben Gallery in New York, which was called 18 Happenings in 6 Parts. Originating in the Dadaist performances at the Cabaret Voltaire in Zurich, and in the activities of the Japanese Gutai Group, Happenings attempted to bring art to the attention of a wider public. They were particularly used by the Fluxus group and some of the Pop artists, including Jim Dine, Claes Oldenburg, and Andy Warhol.

History Painting

A term identifying paintings that depict both actual and legendary events and figures of the past, particularly those of Classical antiquity and the Italian Renaissance. In American art, History Painting reached its zenith in the early to mid-nineteenth century, paralleling the vogue for the European Grand Tour as a way to augment one's cultural and artistic education. The paintings often served as models for engravings that were reproduced in periodicals, which were a popular medium for conveying these historical themes to a broader public. Many of the paintings were executed on large canvases, the scale an appropriate expression of the subject's grandeur. Some artists painted specific scenes from American history (see Samuel F.B. Morse and Benjamin West), while others concentrated on scenes from mythology (see John Vanderlyn).

Impasto

This term has two meanings. It is thickly applied pigment such as oil or acrylic, which often carries visible brushstroke (see David Park), or the marks of a palette knife. It also refers to the technique of application, which artists have used to evoke emotion, to create drama through texture or emphasize their struggle with paint.

Installation

Originally used to describe the process of positioning works in the gallery setting, installation has also come to denote a distinct kind of art-making. In Installation Art, the individual elements arranged within a given space can be viewed as a single work and are often designed for a particular gallery (see Red Grooms). Such works are known as site-specific and cannot be reconstructed anywhere else: The setting is as much part of the work as the things it contains (see David Hammons). First appearing in the late 1950s and the early 1960s, when Pop artists such as Andy Warhol began to design environments for Happenings, Installation Art typically involves theatrical dramatizations of space. Installations are frequently temporary, and, due to the fact that they are often unsaleable, most permanent installations are created specifically for major private collections.

Land Art, Earth Art

A form of art which uses natural elements. Arising in the mid-1960s as a reaction against the growing commercialization of art, and the traditional context of the gallery or museum, Land Art (also known as Earth Art) entered into a direct dialogue with the environment.

Some artists brought nature into the gallery, while others worked in the landscape, transforming it into abstract formations through ploughing, digging, levelling out and cutting away, which often required the use of bulldozers and mechanical excavators (see Michael Heizer). Often large-scale and situated in remote places, Land Art is frequently impermanent and subject to the erosive forces of nature. It therefore relies on photography as a means of documentation (see Walter De Maria and Robert Smithson).

Neo (-Classicism, -Expressionism, -Romanticism)

The prefix "neo," meaning "new," refers to a revival of previous trends or ideas. Neo-Classicism, for example, was a movement that developed in the latter half of the eighteenth century; its aims were a return to Classical values and a revival of the elegant styles of Ancient Greek and Roman art. In art and architecture it is characterized by a preference for line and symmetry, and by its frequent borrowing from Antique sources. Neo-Expressionism refers to the re-emergence of Expressionist characteristics in the work of particular artists in the United States and Europe, especially Germany, in the late 1970s. Neo-Expressionist works tend to be highly personal, often executed with violent fervor. Neo-Romanticism refers to a strongly theatrical form of twentieth-century painting that combines both Romantic and Surrealist elements.

New Topography

Much landscape photography from the 1970s onwards, in Europe as well as the United States, has been described as New Topography. The term was coined in 1975 by William Jenkins, who organized the exhibition "New Topography: Photographs of a Man-Altered Landscape" at George Eastman House in Rochester, New York. The style was very objective with respect to even the most barbaric human interventions in nature. The New Topographers asked audiences to exercise their own discernment and to treat pictures as if they were of evidence still to be sorted (see Lewis Baltz).

Oil, Oilstick

Oil paint consists of pigment (color) bound together with an oil medium, usually linseed oil. Its invention is usually credited to Jan van Eyck in the fifteenth century. Oil has the advantage over tempera of being slow to dry and therefore reworkable. It can be applied with a brush (see Elmer Bischoff) or a palette knife, generally onto canvas, though certain woods (particularly poplar) were used in earlier periods. Oilsticks are a more recent invention, combining some of the properties of oil paint with those of pastel crayons. They come in various sizes and can either be gripped in the hand like a pencil and applied "neat," or diluted with a suitable medium.

Pastel

A drawing material consisting of a stick of pigment (color) bound together with resin or gum. It is generally used on paper and a variety of effects can be achieved, from sharply defined lines to soft shading. The powdery nature of pastel means that without careful handling the drawn image can quickly deteriorate. Pastel dates back to sixteenth-century Italy when colors were limited to black, white, and terracotta red. Its heyday was during the eighteenth century, when it became popular in portraiture (see Henrietta Johnston); the medium underwent a revival in the nineteenth century with the work of the Impressionists.

Photomontage see Collage

Prints

A variety of techniques can be used to make prints, including woodblock, woodcut, engraving, etching, silkscreen, screenprint, and lithography. Woodblock and woodcut are known as "relief methods" because the parts of the block that are to print black are left in relief while the rest is cut away (see Jacques Le Moyne). Engraving and etching are "intaglio methods," in which the design is engraved on a metal plate, or in the case of etching bitten into the plate by means of acid (see Mark Catesby). In silkscreen and other forms of screen printing, a stencil is attached to a screen (traditionally made from silk) stretched on a frame, and color is forced through the unmasked areas of the screen (see Andy Warhol). With lithography, the design is drawn with wax onto a slab of stone and through the opposition of grease and water, areas which receive and reject the printing ink are separated.

Public Art

An extremely loose term describing any artwork made for a public space outside the gallery or museum. Public Art flourished in the 1960s, when governments started to allocate funding for community projects, and artists began to make large-scale outdoor works. Controversially, such works are not always commissioned in consultation with the local community. Many artists use communal spaces in order to reach a non-art audience, and to make political statements. In addition to public squares and parks (see David Hammons), artists have appropriated billboards, bus shelters, derelict houses and underground stations as sites for their work.

Realism

A type of art that attempts to reproduce the world around us accurately. The term originated in the nineteenth century, and was used to describe the work of Gustave Courbet and a group of painters who rejected idealization, focusing instead on everyday life. In the twentieth century, artists have used realism for particular purposes, including the group of artists known as The Eight, and the Social Realists. In the 1980s, some artists used an exaggerated, realistic style, making works that are disturbing because of their photographic accuracy (see Richard Estes and Neil Welliver).

Site-specific

Art which is conceived and produced for a particular location or environment. The meaning of a site-specific work is often closely related to the place in which it is situated. Political, social or geographical aspects are taken into consideration and are intended by the artist to frame the viewer's experience and interpretation of the work (see Michael Heizer). In some cases, the intention of this approach has been an explicit rejection of the traditional context of the museum and other institutional spaces (see Walter De Maria). It often takes the form of installation (see Gordon Matta-Clark), Land Art (see Robert Smithson) and Public Art (see David Hammons).

(the) Sublime

An aesthetic value that describes the separate sensations of pleasure and awe combined with the feeling of personal vulnerability in the natural world. In landscape paintings of the (especially later) Hudson River School, the visual representation of this feeling is rendered by jagged, rough terrain where the figure of man is dwarfed in comparison to grandiose (often-mountainous) scenery. Edmund Burke wrote "An Essay on the Sublime and the Beautiful" in 1756 and the scientist Humboldt wrote of the sublime experience in his widely read travel journals of the Americas in the early 1800s. Both contributed to the appropriation of this concept to American painting by such landscape artists as Albert Bierstadt, Thomas Cole, and Asher Brown Durand in the late 1800s; and in photography by Timothy O'Sullivan, Seneca Ray Stoddard, and Carleton Watkins.

Video Art

Artists have used video since the 1960s, both to make a record of performances and other impermanent works, and as a medium in its own right. The growth of Video Art coincides with the development and availability of video technology, and its use is historically linked to artists' forays into filmmaking. While some Video Art is made for television programs, much is designed for galleries and other spaces, often in the form of installations (see Bruce Nauman). Video Art is not constrained by the small screen — artists have projected videos onto buildings or other objects, worked with multiple screens (see Gary Hill), or made complex juxtapositions of video with lighting, sound, and sculptural elements (see Bill Viola).

Watercolor

Pigment (color) bound by a water-soluble medium such as gum arabic. This is usually diluted with water to the point where it is translucent, and applied to paper in broad areas known as washes. White paper is often left exposed to create highlights and washes applied over one another to achieve gradations of tone (see John Marin). Watercolor lends itself well to the creation of atmospheric effects and was particularly popular with eighteenth- and nineteenth-century landscape painters (see Richard Kern) and naturalist-artists (see John Audubon).

Works Progress Administration (WPA)

This government organization was formed under the administration of President Franklin Delano Roosevelt in the 1930s to employ Americans in social and artistic projects during the Depression. The WPA administered programs for writers, photographers, and visual artists. One of these was the Federal Art Project, in which visual artists created artworks for federal buildings across America from 1935 to 1943. At its peak, the Federal Art Project employed more than five thousand people. It was responsible for founding galleries and community art centers in parts of the country where traditionally exhibited art was virtually unknown. The WPA employed such artists as Arshile Gorky, William Gropper, Philip Guston, and Ben Shahn, and the public murals produced under the program influenced Jackson Pollock and other New York School artists through the power of their large-scale design.

Glossary of artistic movements

Abstract Expressionism

A movement in American painting that developed in New York in the 1940s. Most Abstract Expressionists were energetic (or "gestural") painters. They invariably used large canvases and applied paint rapidly and with force, sometimes using large brushes, sometimes dripping or even throwing paint directly onto the canvas. This expressive method of painting was often considered as important as the painting itself. Other Abstract Expressionist artists were concerned with adopting a peaceful and mystical approach to a purely abstract image. Not all the work from this movement was abstract or expressive, but it was generally believed that the spontaneity of the artists' approach to their work would draw from and release the creativity of their unconscious minds.

☞ Baziotes, de Kooning, S. Francis, Gorky, Gottlieb, Hartigan, Kline, Krasner, Motherwell, Newman, Pollock, Still, Tobey

Ash Can School

A term applied retroactively to a loose movement that arose at the turn of the nineteenth century which focused on realistic paintings of urban, working-class people and situations. The Ash Can School is closely associated with the group of young, mostly New York-based artists known as The Eight, many of whom had studied under Robert Henri at the Pennsylvania Academy of the Fine Arts, and later at the New York School of Art. "Ash can" refers to the gritty, unpolished environments often seen in their works — including tenements, dance halls, and boxing rings — and to the fact that the artists themselves embraced the chaos and often messy surroundings of the city as vital to the urban experience. The initial movement was active to about 1920, but its influence continued through the early 1940s (see Yasuo Kuniyoshi and Reginald Marsh).

☞ Bellows, Bishop, Glackens, Henri, Luks, Shinn, Sloan, Soyer

Color Field

Color Field painting grew out of the Abstract Expressionism movement. Artists associated with this style emphasized creating fields of rich, even color and large, simplified shapes rather than expressing a sense of emotion and the unconscious through signature brushstrokes and gestural painting. Color Field artists often made series of paintings with similar compositions, varying the colors and tonalities to achieve different effects (see Mark Rothko). In Color Field paintings, representation and figural expression are eliminated, and emphasis is on the relationship between colors, shapes, and the physical boundaries of the canvas.

☞ Avery, Louis, Newman, Noland, Rothko, Still

Cubism

This revolutionary method of making a pictorial image was invented by Pablo Picasso and Georges Braque in the first decade of the twentieth century. Although it may appear abstract and geometrical, Cubist art does in fact depict real objects. These are "flattened" onto the canvas so that different sides of each shape can be shown simultaneously from various angles. Instead of creating the illusion of an object in space, as artists had endeavored to do since the Renaissance, Cubist art defines objects in the two-dimensional terms of the canvas. This innovation gave rise to an extraordinary reassessment of the interaction between form and space, changing the course of Western art forever. Cubism had a significant influence on a generation of American Modernists, many of whom had studied in Paris at the beginning of the century.

☞ Dasburg, Douglas, Feininger, Man Ray, Maurer, Murphy, N. Spencer, Storrs, Weber

Dada

The name Dada is deliberately meaningless and was given to an international "anti-art" movement that flourished from 1915 to 1922. Its main center of activity was the Cabaret Voltaire in Zurich, where like-minded poets, artists, writers, and musicians would gather to participate in experimental activities such as nonsense poetry, "noise music," and automatic drawing. Dada was a violent reaction to the snobbery and traditionalism of the art establishment: Its members were ready to use any means within their imagination to cause outrage among the bourgeoisie. A typical Dada work of art was the "ready-made," essentially an ordinary object taken from its original context and put on exhibit as "art." The Dada movement, with its cult of the irrational, was important in preparing the ground for the advent of Surrealism in the 1920s.

Fauvism

In 1905 an exhibition was held in Paris which included a room full of paintings that blazed with pure, highly contrasting colours. They seemed to have been painted with great enthusiasm and passion. One critic dubbed the creators of these paintings 'les fauves' — French for "wild beasts" — and the name stuck. This "wildness" manifested itself mainly in the strong colors, dynamic brushwork, and expressive depth of their pictures, which evoke a fantastical, joyous world of heightened emotion and color.

Feminism

Primarily a political movement, feminism has had a huge impact on twentieth-century art. Its rejection of the notion that a heterosexual, white, male view of the world is a universal one has influenced not only artists but also art historians and critics. The term "feminist art" (which can be applied to the work of artists such as Judy Chicago and Nancy Spero) emerged only in the 1960s, but women artists have been fighting for, and winning, increased visibility since the start of the twentieth century. As a move away from male-dominated traditions of painting, they have been experimenting with crafts, film, video, performance, installation and text-based art. By changing the ground rules of how art is both made and perceived, feminism has influenced the work of a number of artists such as Nan Goldin, Barbara Kruger, and Cindy Sherman, who examine the way in which women have been represented by men. Feminists have also questioned the accepted orthodoxies of art history, initiating research into women artists who had been overlooked by generations of scholars.

Fluxus

Active between the early 1960s and the mid-1970s, Fluxus was as much a state of mind as a particular style. The term was first used in 1961 by George Manciunas, and was intended to describe a condition of perpetual activity and change. Fluxus had a similar iconoclastic ideology to Dada and was focused on a loosely interconnected, revolutionary group of artists in Europe and the United States, who reacted against traditional art forms. The style manifested itself in Happenings, interactive performances, videos, poetry and found objects, and was important in paving the way for Performance and Conceptual Art.

Group f.64

Active in the San Francisco Bay area from around 1930 to 1935, Group f.64 took its name from one of the smallest apertures available on the large-format cameras of the period. Use of the f.64 aperture resulted in images of great clarity and depth of field. The group, whose aesthetic was drawn from the idea that a physical response to nature was important, produced "straight" pictures that contrasted with the hand-manipulated, soft-focus imagery of the Californian Pictorialists of the 1920s. Among the group's principal members were Edward Weston, Ansel Adams, and Imogen Cunningham. Group f.64 exhibited together only once, in 1932 at the M.H. de Young Memorial Museum in San Francisco.

Harlem Renaissance

The 1920s witnessed a remarkable explosion of African-American arts and letters centered in the New York neighborhood of Harlem, at that time a magnet for an increasingly affluent, black middle class. This dynamic cultural movement is known as the Harlem Renaissance, yet its influence spread far beyond that area to galvanize African Americans in other cities such as Chicago and Detroit. African-American writers such as Langston Hughes and Zora Neale Hurston were instrumental to the movement, and together with other artists they expressed a rising black consciousness and used literature, music, and the visual arts to celebrate their cultural, political, and artistic identity. Visual expression in the Harlem Renaissance ranged from genre studies to photographs of an emerging African-American middle class, to idealistic visions drawing on Egyptian iconography and other elements of African history and culture.

☞ Douglas, Fuller, W. Johnson, Jones, Motley, Savage, VanDerZee

Hudson River School

Beginning in the 1820s, a group of American painters inspired by the conservationist writings of Henry David Thoreau and Ralph Waldo Emerson began concentrating on landscapes of New York's Hudson River Valley and the surrounding Catskill mountain area. In these works, nature often is a romantic metaphor for America, a gift worthy of admiration, respect, and protection. Hudson River School paintings are characterized by a skillful rendering of light and other atmospheric effects, by meticulous attention to detail — as in the color and profusion of leaves and branches — and by dramatic perspectives that emphasize the sweeping grandeur and sublime qualities of the natural landscape. The human figure, if it appears at all, is usually shown as a diminutive presence. The Hudson River School influenced a second generation of landscape painters working in the 1860s and 1870s in the Western states.

☞ Church, Cole, Colman, Cropsey, Doughty, Duncanson, Durand, D. Johnson

Impressionism

A movement in painting that originated in France in the 1860s. Impressionist painters celebrated the overwhelming vision of nature seen in the splendor of natural light — whether dawn, daylight or twilight. They were fascinated by the relationship between light and color, painting in pure pigment and using free brushstrokes. They were also radical in their choice of subject matter, avoiding traditional historical, religious, or romantic themes to concentrate on landscapes and scenes of everyday life. The movement's name, initially coined in derision by a journalist, was inspired by one of Claude Monet's paintings titled *Impression — Sunrise*.

☞ Benson, Cassatt, Chase, Lawson, Metcalf, Reid, Robinson, Tarbell, Twachtman, Vonnoh, J. A. Weir, Wendel

Luminism

A term that describes a style of nineteenth-century painting prevailing from around 1850 to 1875 which focused on the effects of light to evoke a sense of mystery and place in landscapes and seascapes. Luminist paintings appear to glow with subtly reflected light, an effect artists achieved by making their brushstrokes invisible and by using graduated tonalities of color. The works generally feature a horizontal composition and are characterized by the absence of people. Often the artist has merged aspects of the real environment with his or her ideal concept of it, creating a work that celebrates nature's perfection.

☞ Allston, Bradford, Casilear, Gifford, Kensett, Lane

Minimalism

A trend in painting and sculpture that developed primarily in the United States during the 1960s and 1970s. As the name implies, Minimalist Art is pared down to its essentials; it is purely abstract, objective and anonymous, free of surface decoration or expressive gesture. Minimalist painting and drawing is monochromatic and often draws on mathematically derived grids and linear matrices; yet it can also evoke a sensation of the sublime and of states of being. Sculptors used industrial processes and materials, such as steel, perspex, even flourescent tubes, to produce geometric forms, often made in series. This sculpture has no illusionistic properties, relying instead on a bodily experience of the work by the spectator. Minimalism can be seen as a reaction against the emotionalism of Abstract Expressionism, which had dominated modern art through the 1950s.

☞ Andre, Artschwager, Flavin, Hesse, Irwin, Judd, Kelly, Lewitt, Mangold, Martin, Morris, Ryman, Serra, Shapiro, T. Smith, F. Stella, Turrell, Tuttle

Modernism

More of an attitude than a specific style, Modernism was a phenomenon which first arose in the early part of the twentieth century, and was an affirmation of faith in the tradition of the new. From the Impressionists' depictions of the fashionable bourgeoisie, to the radical new style of the Cubists, to the early abstractionists, artists became more and more concerned with finding a visual equivalent to contemporary life and thought. Modernism encompasses many of the avant-garde movements of the first half of the twentieth century.

☛ Bolotowsky, Biederman, Bruce, Carles, Covert, Davies, Davis, Diller, Dove, Hartley, Lachaise, Lassaw, MacDonald-Wright, Man Ray, Maurer, Manship, Murphy, Nadelman, O'Keeffe, Roszak, M. Russell, Schamberg, Shaw, N. Spencer, J. Stella, Storrs, Tack, Weber, Zorach

New York School

Originally a term synonymous with Abstract Expressionism, the New York School is used more generally now to signify the Western art world's shift — both physically and conceptually — to New York City in the years after World War II and continuing through the 1960s. The term originated with a 1965 Los Angeles County Museum of Art exhibition, 'The New York School: The First Generation Painting of the 1940s and 1950s,' which featured the work of Willem de Kooning, Philip Guston, Robert Motherwell, Jackson Pollock, and Mark Rothko, among others. Paintings by the first generation of New York School artists were large and abstract, and emphasized bold, aggressive brushstrokes; critic Harold Rosenberg coined the phrase "action painting" to describe these works. Subjective and highly gestural, they addressed the theme of human impulse and desires, in addition to commenting on society's need to impose order on such expression and to define and control taboos through myth.

☛ Baziotes, de Kooning, S. Francis, Frankenthaler, Gorky, Gottlieb, Kline, Krasner, Mitchell, Motherwell, Newman, Pollock, Rauschenberg, Reinhardt, Rothko, D. Smith, Still

Photo-Secession

In 1902 Alfred Stieglitz broke with the New York Camera Club, of which he was Vice-President, and founded the Photo-Secession. He took the title from the various secessionist movements occurring in European fine art at that time. Members included Alvin Langdon Coburn, Gertrude Käsebier, and Edward Steichen. With Steichen, Stieglitz opened the Photo-Secession Gallery at 291 Fifth Avenue, New York, in November 1905.

Pictorialism

Some photographers in the late nineteenth century began to think of themselves as artists or as makers of pictures rather than documents. They held to the idea that artists should organize their pictures for aesthetic effect. To separate themselves from naïve and from trade photography, they set up exhibiting societies. In 1902, Alfred Stieglitz, editor of *Camera Notes*, founded the American Photo-Secession, and in 1903 he established *Camera Work*, the most influential magazine in the history of the medium. Pictorialists were specialist printers who made use of a wide variety of techniques: platinum and gum printing especially. The Pictorial movement survived into the 1920s but a new generation of "straight" photographers saw it as overly subjective, exquisite and degenerate.

Pop Art

A movement in the United States and Britain that emerged in the 1950s and took its inspiration from the imagery of consumer society and pop culture. Comic strips, advertising, and mass-produced objects all played a part in this movement, which was characterized by one of its members, Richard Hamilton, as "popular, transient, expendable, low cost, mass-produced, young, witty, sexy, gimmicky, glamorous and Big Business." The brashness of subject matter is often emphasized by hard-edged photograph-like techniques in painting and minute attention to detail in sculpture. Photomontage, collage and assemblage are also common in Pop Art.

☛ Close, Hanson, Haring, Indiana, Katz, Lichtenstein, Rosenquist, Thiebaud, Warhol, Wesselman

Precisionism

Precisionism was a style that developed beginning in the early 1920s as a response to the increasingly urban and industrial landscape in America. The term was first used by painter Charles Sheeler and refers to the sharp, precise lines and blocks of color that compose his works. Precisionists took manmade forms as their subject matter — skyscrapers, factories, grain elevators, bridges, and machinery — and represented these structures in high-contrast paintings that employed large, flat areas of color and straight lines. The movement was closely influenced by photography, and in fact Sheeler often painted from photographs of his subjects. Precisionism was part of a general machine aesthetic taking root in America in the 1920s.

☛ Crawford, Demuth, Lozowick, Sheeler, N. Spencer

Pre-Raphaelites

An association of young English artists formed in 1848 with the intention of returning to the painting style of early Italian art from the period before Raphael. Their influence emerges in America in the late 1800s, early 1900s as a hybrid of pseudomedieval romanticism mixed with influences of the French Barbizon vocabulary (where emotional tensions are expressed indirectly by the atmospheric surroundings). Subjects included depictions of literary, historical, and religious scenes. Romantic in nature, the American artists such as Ralph Blakelock, Albert Pinkham Ryder, and Elihu Vedder were influenced by the Pre-Raphaelites. This moody painting style provided a starting point for the beginnings of American Impressionism.

Regionalism

In the early 1930s, American artists who were not part of the dominant New York-based art world began to make works that focused on themes unique to specific regions of the United States, particularly the Midwest. They argued for a uniquely American art that would celebrate the country's local heroes and regional subjects. Regionalist art depicted rural and small-town America, especially the crises and concerns generated by the Great Depression. The movement received a boost in 1933 via the government's creation of the Public Works of Art Project, which employed nearly four thousand artists to produce murals and other art for public buildings. A similar federal program, the Federal Arts Project, operated under the Works Progress Administration (WPA) from 1935 to 1939. Regionalism's popularity diminished in the 1940s as World War II brought influences from abroad to the United States. Regionalism is sometimes referred to under the broader term American Scene Painting.

☛ Benton, Burchfield, Curry, Hogue, Wood

Romanticism

A movement in the arts that flourished in northern Europe and the United States during the late eighteenth and early nineteenth centuries. Romanticism is so varied in its manifestations that a single definition is almost impossible. Romantic artists turned away from intellectual disciplines and placed importance on the imagination and individual expression. Their paintings often depict grand emotions such as fear, desolation, victory, and true love. The movement had officially died out by the mid-nineteenth century, but romantic tendencies have survived into the twentieth century in artistic strains such as Expressionism and Neo-Expressionism.

Social Realism

This movement arose in the 1930s and was very similar to Regionalism in its portrayal of everyday American subjects and struggles. Social Realist artists, however, were much more political in their outlook and often depicted the hardships facing Americans in the form of a class struggle. Politically left-wing, these artists brought a distinctly more subjective point of view to their work and used it as a vehicle to argue for improved working and living conditions.

☛ Bishop, Evergood, Gwathmey, Shahn, Soyer

Surrealism

Surrealism originated in France in the 1920s. In the words of its main theorist, the writer André Breton, its aim was to "resolve the previously contradictory conditions of dream and reality," and the ways in which this was achieved varied widely. Artists painted unnerving and illogical scenes with photographic precision, created strange creatures from collections of everyday objects, or developed techniques of painting which would allow the unconscious to express itself. Surrealist pictures, while figurative, represent an alien world, whose images range from dreamlike serenity to nightmarish fantasy.

☛ Jess, J. Stella, Tanning

The Eight

An informal name given to a group of American Realist artists who banded together against the well-established National Academy of Design after certain of them were not accepted into the academy's 1907 spring show. The original eight artists included Robert Henri, the group's unofficial leader, and Everett Shinn, John Sloan, Arthur B. Davies, Ernest Lawson, Maurice Prendergast, George Luks, and William Glackens. The Eight rejected academic convention and focused on depictions of urban, working-class New York — a subject considered radical at the time. The group held an independent show at the Macbeth Gallery in New York City in 1908 that provided the foundation for this type of unidealized street-life painting, later to be dubbed the Ash Can School.

☛ Davies, Glackens, Henri, Lawson, Luks, Prendergast, Shinn, Sloan

The Ten

A group of American painters formed in 1897 for the purpose of exhibiting independently of the Society of American Artists and The National Academy of Design, the prevailing fine arts organizations at the time. Members of The Ten were John Twatchman, J. Alden Weir, Childe Hassam, F.W. Benson, Joseph De Camp, Thomas Dewing, Willard Leroy Metcalf, Robert Reid, E. E. Simmons, and Edmund Tarbell, to be joined later by William Merritt Chase. The Ten felt their work better suited to a more intimate installation and were instrumental in influencing the way art is exhibited today. The group did not award prizes, for example, and their shows inspired quiet contemplation in a setting where even the walls were painted in complementary colors to harmonize with their mostly impressionistic work. Dubbed "Ten American Painters" by the press, the group exhibited together from 1898 to 1918 in New York, and occasionally in other American cities.

☛ Benson, Chase, Dewing, Hassam, Metcalf, Reid, Tarbell, Twachtman, J. A. Weir

Directory of museums and galleries

United States

Arizona

Arizona State University Museum of Art
Speedway & Park Avenue
Tucson, AZ 85721

Gropper, *Migration*

Center for Creative Photography
The University of Arizona
843 East University Boulevard
Tucson, AZ 85721

Weston, *Dunes, Oceano, 1936*

California

The Bancroft Library
University of California, Berkeley
Berkeley, CA 94720-6000

Watkins, *Yosemite Valley from the 'Best General View'*

Crocker Art Museum
216 O Street
Sacramento, CA 96814

Hahn, *Market Scene, Sansome Street, San Francisco*
Nahl, *Sunday Morning in the Mines*

Fine Arts Museums of San Francisco
M.H. De Young Memorial Museum
Golden Gate Park
San Francisco, CA 94118

Anshutz, *The Ironworkers' Noontime*
The Freake-Gibbs Painter, *The Mason Children: David, Joanna, and Abigail*
Harnett, *After the Hunt*
Pope, *The Trumpeter Swan*
Wright, *John Coats Browne*

J. Paul Getty Museum
17985 Pacific Coast Highway
Malibu, CA 90265-5799

Evans, *The Cotton Room at Frank Tengle's Farm, Hale County, Alabama*

Los Angeles County Museum of Art
5905 Wilshire Boulevard
Los Angeles, CA 90036

Alexander, *Portrait of Mrs John White Alexander*
Vedder, *Memory*

The Franklin D. Murphy Sculpture Garden
UCLA at the Armand Hammer Museum of Art &
Cultural Center
10899 Wilshire Boulevard
Los Angeles, CA 90024-4201

Lachaise, *Standing Woman*

The Museum of Contemporary Art
250 South Grand Avenue
Los Angeles, CA 90012

Burden, *The Big Wheel*

The Oakland Museum of California
1000 Oak Street
Oakland, CA 94607

Lange, *White Angel Breadline, San Francisco, CA, 1933*

Orange County Museum of Art
850 San Clemente Drive

Newport Beach, CA 92660

Bischoff, *Two Figures at the Seashore Park, Bather with Knee Up*

Timken Museum of Art
1500 El Prado
Balboa Park
San Diego, CA 92101

Johnson, E, *The Cranberry Harvest, Island of Nantucket*

Colorado

Colorado Springs Fine Arts Center
30 West Dale Street
Colorado Springs, CO 80903

Kuhn, *Trio*

Connecticut

New Haven Colony Historical Society
114 Whitney Avenue
New Haven, CT 06510

Moulthrop, *Samuel Bishop*

Wadsworth Atheneum
600 Main Street
Hartford, CT 06103

Casilear, *Lake George*
Nadelman, *Dancer*
Peto, *Reminiscences of 1865*

Yale University Art Gallery
1111 Chapel Street
New Haven, CT 06520

Covert, *Brass Band*
Earl, *Roger Sherman*
Ives, *Undine Receiving Her Soul*
Sheeler, *American Interior*
Smibert, *The Bermuda Group*
Trumbull, *The Declaration of Independence, 4 July 1776*

Florida

Miami Art Museum
101 West Flagler Street
Miami, FL 33130

Hamilton, *Mantle*

Illinois

Art Institute of Chicago
111 South Michigan Avenue
Chicago, IL 60603-6110

Albright, *Poor Room*
Cassatt, *The Child's Bath*
Diller, *First Theme*
Glackens, *At Mouquin's*

Arts Club of Chicago
201 E. Ontario Street
Chicago, IL 60611

Calder, *Red Petals*

Museum of Contemporary Art
220 East Chicago Avenue
Chicago, IL 60611

Marshall, *Souvenir I*

Terra Museum of American Art
66 North Michigan Avenue
Chicago, IL 60611

Jewett, *The Promised Land – The Grayson Family*
Tarbell, *In the Orchard*

Indiana

Indianapolis Museum of Art
1200 West 38th Street
Indianapolis, IN 46208-4196

Indiana, *Love*

Iowa

Cedar Rapids Museum of Art
410 Third Avenue S.E.
Cedar Rapids, IA 5248

Wood, *Woman with Plant(s)*

Des Moines Art Center
4700 Grand Avenue
Des Moines, IA 50312

Hopper, *Automat*
Macdonald-Wright, *Abstraction on Spectrum (Organization 5)*

Kansas

Wichita Art Museum
619 Stackman Drive
Wichita, KS 67203

Henri, *Eva Green*
Kuniyoshi, *Season Ended*

Louisiana

Historic New Orleans Collection
533 Royal Street
New Orleans, LA 70130

Laughlin, *The Mirror of Long Ago*

Louisiana State University Museum of Art
Memorial Tower
Baton Rouge, LA 70803-3403

Persac, *Saloon of Mississippi River Steamboat 'Princess'*

New Orleans Museum of Art
City Park
1 Collins Diboll Circle
New Orleans, LA 70179-0123

Tanning, *Guardian Angels*

Maine

Bowdoin College Museum of Art
Walker Art Building
Bowdoin College
Brunswick, ME 04011

Kent, *Resurrection Bay, Alaska (Blue and Gold)*
La Farge, *Athens*

William A. Farnsworth Library and Art Museum
356 Main Street
Rockland, ME 04841

Fisher, *A Morning View of Blue Hill Village*

Maryland

Maryland Historical Society
201 West Monument Street
Baltimore, MD 21201

Kühn, *Eleanor Darnall (Mrs Daniel Carroll,*

1704–1796)

National Archives and Records Administration
8601 Adelphi Road
College Park, MD 20740-6001

Brady, *Lt. Gen Ulysses S. Grant*

US Naval Academy Museum
118 Maryland Avenue
Annapolis, MD 21402

Salmon, *The Boston Harbor from Constitution Wharf*

Walters Art Gallery
600 North Charles Street
Baltimore, MD 21201-5185

Miller, *Interior of Fort Laramie*

Massachusetts

Addison Museum of American Art
Phillips Academy
180 Main Street
Andover, MA 01810-4161

de Forest Brush, *Mother and Child*

American Antiquarian Society
185 Salisbury Street, Room 100
Worcester, MA 01609

McIntire, *Governor John Winthrop*

The Berkshire Museum
39 South Street
Pittsfield, MA 01201

Rockwell, *Shuffleton's Barbershop*

Cape Ann Historical Museum
27 Pleasant Street
Gloucester, MA 01930

Lane, *Gloucester Harbor at Sunrise*

Cushing House Museum
Historical Society of Old Newbury
98 High Street
Newburyport, MA 01950

Brewster, *James Prince and Son William Henry*

Hancock Shaker Village
Routes 20 & 41
Pittsfield, MA 01201

Cohoon, *Tree of Life*
Reed, *A present to Mother Lucy to Eliza Ann Taylor*

Heritage Plantation of Sandwich
67 Grove Street
Sandwich, MA 02563-2147

Robb, *Baseball Player*

Mead Art Museum
Amherst College
Amherst, MA 01002

Hawthorne, *Three Women of Provincetown*

Museum of Fine Arts Boston
465 Huntington Avenue
Boston, MA 02115-5523

Allston, *Moonlit Landscape*
Blunt, *Boston Harbor*
Copley, *Paul Revere*
Dove, *Sunrise I*
Field, *Joseph Moore and His Family*
Neagle, *Pat Lyon at the Forge*

Sargent, J, *The Daughters of Edward Darley Boit*
Stuart, *George Washington*
Tirrell, *View of Sacramento, California, from Across the Sacramento River*

New Bedford Whaling Museum
18 Johnny Cake Hill
New Bedford, MA 02740

Bradford, *The Ice Dwellers Watching the Invaders*

Smith College Museum of Art
Elm Street at Bedford Terrace
Northampton, MA 01063

Avery, *Surf Fisherman*
Elmer, *Mourning Picture*
Feininger, *Gables I, Luneburg*

Sterling & Francine Clark Art Institute
225 South Street
Williamstown, MA 01267

Remington, *Dismounted: The Fourth Trooper Moving the Led Horses*

Worcester Art Museum
55 Salisbury Street
Worcester, MA 01609-3196

Smith, Thomas, *Self Portrait*

Michigan

William L. Clements Library
The University of Michigan
909 S. University Avenue
Ann Arbor, MI 48109-1190

Catesby, *Largest White Billed Woodpecker (Picus Maximus Rostro Albo) with Willow Oak*

The Detroit Institute of Arts
5200 Woodward Avenue
Detroit, MI 48202

Demuth, *Buildings Abstraction, Lancaster*
Doughty, *In Nature's Wonderland*
Page, *Mrs William Page*
Whistler, *Nocturne in Black and Gold, The Falling Rocket*

Henry Ford Museum
20900 Oakwood Boulevard
Dearborn, MI 48121-1970

Williams, S.F.W., *Coverlet made for Susannah Nexsen Warner (Greenfield Hill Coverlet)*

Muskegon Museum of Art
296 W. Webster Avenue
Muskegon, MI 49440

Curry, *Tornado Over Kansas*

Minnesota

Minneapolis Institute of Arts
2400 Third Avenue South
Minneapolis, MN 55404

Hartigan, *Billboard*
Jarvis, *Portrait of Captain Samuel C. Reid*
Twachtman, *The White Bridge*

Walker Art Center
Vineland Place
Minneapolis, MN 5503

Irwin, *Untitled*
Kienholz, *Portrait of a Mother with Past Affixed Also*
Morris, *Untitled*

Oldenburg, *Spoonbridge and Cherry*
Segal, *The Diner*

Missouri

Nelson-Atkins Museum of Art
4525 Oak Street
Kansas City, MO 64111-1873

Hanson, *Museum Guard*
Inness, *Old Farm — Montclair*
Peale, Raphaelle, *Venus Rising From the Sea — A Deception (After the Bath)*

The St. Louis Art Museum
Forest Park
St Louis, MO 63110

Benton, *Cradling Wheat*
Bingham, *Raftsmen Playing Cards*
Greenwood, *Sea Captains Carousing in Surinam*
Nauman, *World Peace*
Wimar, *The Buffalo Dance*

Washington University Gallery of Art
One Brookings Drive
St Louis, MO 63130-4899

Hartley, *The Iron Cross*

Montana

Montana Historical Society
225 North Roberts
Helena, MT 59620

Russell, C, *Lewis and Clark Meeting Indians at Ross' Hole*

Nebraska

Union Pacific Museum
1416 Dodge Street
Omaha, NE 68179

Russell, A.J., *On The Mountains of Green River, Smith's Butte in Foreground*

New Hampshire

Cornish Colony Gallery & Museum
RR3
Cornish, NH 03745

Parrish, *Riverbank Autumn*

New Jersey

Montclair Art Museum
3 South Mountain Avenue
Montclair, NJ 07042-1747

Beardsley Limner, *Little Boy in a Windsor Chair*

Newark Museum
49 Washington Street
Newark, NJ 07101

Roszak, *Airport Structure*
Spencer, L, *War Spirit at Home*

The Art Museum Princeton University
Princeton University
Princeton, NJ 08544-1018

Peale, C. W., *Washington at the Battle of Princeton, January 3, 1777*
White, M, *Windowsill Daydreaming*

New Mexico

Museum of International Folk Art
706 Camino Lejo
Santa Fe, NM 87505

Aragon, *El Alma de la Virgen (Virgin with Dove)*

New York

Adirondack Museum
Route 30
Blue Mountain Lake, NY 12812

Stoddard, *The Hudson River. "The Old Man of the Mountains," from Catskill*

Albany Institute of History & Art
125 Washington Avenue
Albany, NY 12210

Palmer, *Peace In Bondage*
Vanderlyn, P, *Pau de Wandelaer*

Albright-Knox Art Gallery
1285 Elmwood Avenue
Buffalo, NY 14222

Gorky, *The Liver is the Cock's Comb*
Krasner, *Milkweed*

American Craft Museum
40 W. 53rd Street
New York, NY 10019

Arneson, *Self-portrait of the Artist Losing His Marbles*

Brooklyn Museum of Art
200 Eastern Parkway
Brooklyn, NY 11238-6052

Davis, *The Mellow Pad*
Deas, *Prairie Fire*
Guy, *Winter Scene in Brooklyn*
Luks, *Hester Street*
Metcalf, *Early Spring Afternoon — Central Park*
Quidor, *The Money Diggers*
Thompson, J, *Apple Gathering*
Williams, W, *Deborah Hall*

Corning Museum of Glass
One Museum Way
Corning, NY 14830-2253

Tiffany, *Leaded Glass Window*

Dia Center for the Arts
542 West 22nd Street
New York, NY 10011

De Maria, *The Lightning Field*
Serra, *Torqued Ellipses*

George Eastman House
900 East Avenue
Rochester, NY 14607

Barnard, *Burning Mills, Oswego, NY, July 5, 1853*
Bourke-White, *Chrysler Building*
Coburn, *Ezra Pound*
Hine, *Breaker Boys in coal chute, South Pittston, Pennsylvania, January, 1911*
Jackson, *Berthoud Pass Looking North, Colorado*
Siskind, *Martha's Vineyard*

Solomon R. Guggenheim Museum
1071 Fifth Avenue
New York, NY 10128-0173

Baziotes, *Dusk*
Francis, S, *Shining Back*

Hesse, *Expanded Expansion*
Holzer, *Various texts*

Hecksher Museum
2 Prime Avenue
Huntington, NY 11743

Blakelock, *The Poetry of Moonlight*

International Center of Photography
1133 Avenue of the Americas
New York, NY 10036

Weegee, *Joy of Living*

Metropolitan Museum of Art
Fifth Ave and 82nd Street
New York, NY 10028

Cole, *View from Mount Holyoke, Northampton, MA, after a Thunderstorm — The Oxbow*
Haberle, *A Bachelor's Drawer*
Hathaway, *Lady with Her Pets (Molly Wales Fobes)*
Kensett, *Eaton's Neck, Long Island*
Leutze, *Washington Crossing the Delaware*
Powers, Hiram, *Andrew Jackson*
Pratt, *The American School*
Southworth & Hawes, *John Quincy Adams*
Steichen, *The Flatiron Building, Evening, New York*
Tansey, *The Innocent Eye Test*
Weir, J. A., *The Red Bridge*

Museum of American Folk Art
2 Lincoln Square
New York, NY 10023

Maentel, *Portrait of Dr. Christian Bucher*

Museum of the City of New York
1220 Fifth Avenue
New York, NY 10029

Abbott, *The Night View*
Riis, *Bandit's Roost*

The Museum of Modern Art
11 West 53rd Street
New York, NY 10019

De Kooning, *Woman I*
Johns, *Map*
Kane, J, *Self-Portrait*
Man Ray, *The Rope Dancer Accompanies Herself with Her Shadows*
Steiner, *American Rural Baroque*

National Academy Museum
1083 Fifth Avenue
New York, NY 10128

Elliott, *Portrait of Mrs. Thomas Goulding*

National Museum of Racing
191 Union Avenue
Saratoga Springs, NY 12866

Troye, *American Eclipse*

New-York Historical Society
2 West 77th Street
New York, NY 10024-5194

Audubon, *Great Blue Heron*
Couturier, *Governor Peter Stuyvesant*
Durand, J, *The Rapalje Children*
Seifert, *Wisconsin Farm Scene*

New York Public Library
Fifth Ave and 42nd Street
New York, NY 10018

Durand, *Kindred Spirits*
Le Moyne, *René de Laudonnière and the Indian*

Chief Athore visit Ribaut's Column ...
O'Sullivan, *Ancient ruins in Cañon De Chelle, N.M., in a niche 50 feet above the canyon bed*

New York State Historical Association
Lake Road
Cooperstown, NY 13326

Hicks, *Peaceable Kingdom*
Job, *Cigar Store Figure Female (African-American)*
Mount, *Eel Spearing at Setauket*

Isamu Noguchi Foundation, Inc
32-37 Vernon Blvd
Long Island City, NY 11106

Noguchi, *Cored (Cored Sculpture)*

The Parrish Art Museum
25 Job's Lane
Southampton, NY 11968

Chase, *The Bayberry Bush*

Putnam County Historical Society
63 Chestnut Street
Cold Spring, NY 10516

Weir, J. F., *The Gun Foundry*

Schomburg Center for Research in Black Culture
The New York Public Library
515 Malcolm X Boulevard
New York, NY 10037-1801

Fuller, *The Awakening of Ethiopia*

Syracuse University Art Collection
Sims Hall
Syracuse, NY 13210

Burchfield, *Sun, Moon, Star*
Marsh, *Coney Island*

510

University of Rochester Memorial Art Gallery
500 University Avenue
Rochester, NY 14607

Hopkins, *Pierrepont Edward Lacey (1832–after 1860) and His Dog, Gun*

Whitney Museum of American Art
945 Madison Avenue at 75th Street
New York, NY 10021

Nevelson, *Black Chord*
Osorio, *Scene of the Crime (Whose Crime?)*
Storrs, *Forms in Space No. 1*
Tooker, *The Subway*
Weber, *Chinese Restaurant*

North Carolina

Museum of Early Southern Decorative Arts
924 S. Main Street
Winston-Salem, NC 27108

Johnston, *Colonel Samuel Prioleau*
Wollaston, *Mrs. John Beale*

North Carolina Museum of Art
2110 Blue Ridge Road
Raleigh, NC 27607

Wyeth, *Winter, 1946*

Reynolda House
Museum of American Art
Reynolda Road
Winston-Salem, NC 27116

Johnson, D, *Natural Bridge, Virginia*
Whittredge, *The Old Hunting Grounds*

Ohio

Butler Institute of American Art
524 Wick Avenue
Youngstown, OH 44502

Benson, *Red and Gold*
Blythe, *Street Urchins*
duBois, *Trapeze Performers*
Hill, T, *Bridalveil Falls, Yosemite*
Ranney, *On the Wing*
Vonnoh, *In Flanders Field – Where Soldiers Sleep and Poppies Grow*

Cincinnati Art Museum
953 Eden Park Drive
Cincinnati, OH 45202-1596

Duveneck, *The Whistling Boy*

Cleveland Museum of Art
1150 East Boulevard
Cleveland, OH 44106

Bellows, *Stag at Sharkey's*
Motherwell, *Elegy to the Spanish Republic No. LV*
Ryder, *The Race Track (Death on a Pale Horse)*

Columbus Museum of Art
480 E. Broad Street
Columbus, OH 43125

Prendergast, *The Promenade*

Oregon

Portland Art Museum
1219 SW Park
Portland, OR 97205

Levine, *Street Scene #2*

University of Oregon Library
200 Lawrence Hall
Eugene, OR 97403-5249

Ulmann, *Baptism in the River*

Pennsylvania

Carnegie Museum of Art
4400 Forbes Avenue
Pittsburgh, PA 15213-4080

Brook, *Georgia Jungle*
Gwathmey, *Hoeing*

Historical Society of Pennsylvania
1300 Locust Street
Philadelphia, PA 19107

Birch, *The United States and the Macedonian*
Hesselius, *Lapowinsa*
Krimmel, *Fourth of July Celebration*

Thomas Jefferson University Art Museum
1020 Walnut Street
619 Scott Building
Philadelphia, PA 19107-5587

Eakins, *The Gross Clinic*

Pennsylvania Academy of the Fine Arts
118 N. Broad Street
Philadelphia, PA 19102

Hunt, *Study for "The Flight of Night"*
Huntington, *Mercy's Dream*

Vanderlyn, J, *Ariadne Asleep on the Island of Naxos*

Philadelphia Museum of Art
26th Street and the Benjamin Franklin Parkway
Philadelphia, PA 19101-7646

Homer, *Gloucester Farm*
Hovenden, *Breaking Home Ties*
O'Keeffe, *Two Calla Lilies on Pink*
Rush, *Allegory of the Waterworks (The Schuylkill Freed)*
Stettheimer, *Spring Sale at Bendel's*

Rhode Island

Redwood Library & Athenaeum
50 Bellevue Avenue
Newport, RI 02840 3202

Feke, *The Reverend Thomas Hiscox*
King, *John Caldwell Calhoun*

South Carolina

Gibbes Museum of Art
135 Meeting Street
Charleston, SC 29401

Malbone, *Eliza Izard (Mrs Thomas Pinckney, Jr.)*

Tennessee

Cheekwood Museum of Art
1200 Forrest Park Drive
Nashville, TN 37205

Rivers, *Dutch Masters I*

Fisk University
Carl Van Vechten & Aaron Douglas Galleries
1000 17th Avenue North
Nashville, TN 37208

Douglas, *Building More Stately Mansions*

Texas

Amon Carter Museum
3501 Camp Bowie Boulevard
Fort Worth, TX 76107-2695

Bierstadt, *Sunrise, Yosemite Valley*
Kern, *Valley of Taos, Looking South, N.M., 1849*
Porter, E, *Redbud Tree in Bottom Land, Red River Gorge, Kentucky, 1968*

Chinati Foundation
1 Cavalry Row
Marfa
Texas, TX 79843

Judd, *Untitled Works in Mill Aluminum*

Dallas Museum of Art
1717 North Harwood
Dallas, TX 75201

Bricher, *Time and Tide*
Hogue, *Drouth Stricken Area*
Jess, *Arkadia's Last Resort: or, Féte Champètre up Mnemosyne Creek*
Murphy, *Watch*

The Menil Collection
1515 Sul Ross
Houston, TX 77006

Chamberlain, *Nanoweap*
Newman, *Be I*
Rosenquist, *Promenade of Merce Cunningham*

The Museum of Fine Arts Houston
1001 Bissonnet Street
Houston, TX 77005

Bruce, *Peinture/Nature Morte*

Utah

Brigham Young University Museum of Art
North Campus Drive
Brigham Young University
Provo, UT 84602

Gifford, *Lake Scene*

Vermont

Shelburne Museum
Rt 7
Shelburne, VT 05482

Durrie, *Settling the Bill*

Virginia

Abby Aldrich Rockefeller Folk Art Center
Colonial Williamsburg Foundation
313 First Street
Williamsburg, VA 21385-1776

Cady, *Fruit in a Glass Compote*
Church, H, *The Monkey Picture*
Hofmann, *View of Henry Z. Van Reed's Farm, Papermill and Surroundings*
Pinney, *Children Playing*

Hampton University Museum
Hampton University
Hampton, VA 23668

Lawrence, *Harriet Tubman Series No. 7*
Tanner, *The Banjo Lesson*

Valentine Museum
1015 East Clay Street
Richmond, VA 23219

Hubard, *Horatio Greenough, The American Sculptor, in His Studio in Florence*

Virginia Museum of Fine Arts
2800 Grove Avenue
Richmond, VA 23221-2466

Davies, *Line of Mountains*
Frankenthaler, *Mother Goose Melody*
Gottlieb, *Rolling*
Louis, *Claustral*
Mark, *Dismal Swamp*
Wesselman, *Great American Nude #35*

Washington, DC

The Corcoran Gallery of Art
500 Seventeenth Street, NW
Washington, DC 20006-4899

Church, *Niagara*
Morse, *The Old House of Representatives*
Soyer, *Waiting Room*

Freer Gallery of Art
Smithsonian Institution
12th Street and Jefferson Drive
Washington, DC 20560

Thayer, *A Virgin*

Hirshhorn Museum and Sculpture Garden
Independence Avenue at Seventh Street, SW
Washington, DC 20560

Lozowick, *Seattle*

Library of Congress
105 Independence Avenue, SW
Washington, DC 20540

Currier, *The Bicycle Messengers Seated*
Gardner, *Lewis Paine*
Lee, *San Marcos, Texas*
White, C, *The Ring Toss*
Wolcott, *A member of Wilkins family making biscuits . . ., Tallyho, North Carolina*

National Gallery of Art
Between 3rd and 7th Streets NW
on Constitution Ave
Washington, DC 20565

Bundy, *Vermont Lawyer*
Chandler, *Captain Samuel Chandler*
Cropsey, *Autumn – On the Hudson River*
Hassam, *Allies Day, May 1917*
Peale, Rembrandt, *Rubens Peale with a Geranium*
Pollock, *Number 1, 1950 (Lavender Mist)*
Strand, *The White Fence*
Sully, *Lady with a Harp: Eliza Ridgely*

National Museum of American Art
8th and G Streets, NW
Washington, DC 20560

Beaux, *Man with the Cat; Portrait of Henry Sturgis Drinker*
Colman, *Storm King on the Hudson*
Dewing, *The Spinet*
Johnson, W, *Cafe*
Jones, *Les Fétiches*
Lundeberg, *Double Portrait of the Artist in Time*
Moran, *The Grand Canyon of the Yellowstone*

National Portrait Gallery Washington
8th at F Street, NW
Washington, DC 20560

Chandler, *Captain Samuel Chandler*
Inman, *Sequoyah (after a painting by Charles Bird King)*

The Phillips Collection
1600 21st Street, NW
Washington, DC 2009-1090

Lawson, *Spring Night, Harlem River*
Moses, *Hoosick Falls, NY, In Winter*
Tack, *Aspiration*

Smithsonian Institution
1000 Jefferson Drive, SW
Washington, DC 20560

Greenough, *George Washington*

US Navy Art Collection
Washington Navy Yard
Navy Art Gallery, Building 67
Washington, DC 20374

Cadmus, *The Fleet's In!*

The White House
1600 Pennsylvania Avenue
Washington, DC 20500

Healy, *John Tyler*

Wisconsin

Milwaukee Art Museum
750 North Lincoln Memorial Drive
Milwaukee, WI 53202

Smith, K, *Honeywax*
Tolson, *Expulsion (from The Fall of Man Series)*

Canada

Art Gallery of Ontario
317 Dundas Street, W
Toronto, Ont M5T 1G4

Lewitt, *Open Modular Cube*

National Gallery of Canada
38 Sussex Drive
Ottawa, Ont K1N 9N4

Käsebier, *Portrait – Miss N. (Evelyn Nesbit)*
West, *The Death of General Wolfe*

Royal Ontario Museum
100 Queen's Park
Toronto, Ont M5S 2C6

Kane, P, *Falls at Colville*

Russia

State Russian Museum
Michajlowskij Palace
Inzhenernaja ul.4
St Petersburg 191011

Goings, *Unadilla Diner*

Sweden

Royal Collections
The Royal Palace
S-111 30 Stockholm

Duncanson, *The Land of the Lotus Eaters*

Switzerland

Offentliche Kunstsammlung Basel Kunstmuseum
St Alban-Graben 16
4010 Basel

Andre, *Equivalent I*
Lichtenstein, *Hopeless*

United Kingdom

Natural History Museum
Cromwell Road
London SW7 5BD

Bartram, *Savannah Pink or Sabatia & Imperial Moth*

The Saatchi Gallery
98a Boundary Road
London NW8 0RH

Katz, *Blue Umbrella #2*

Contributing editor: Jay Tobler
Contributing writers: Barbara Dayer Gallati, David Greene, Andy Grundberg, Helen Harrison, Sally Mills, Thyrza Nichols Goodeve, Jay Tobler
Consultants: Jonathan Green, Linda Roscoe Hartigan, Patricia Junker, Brooke Kamin Rapaport, Rochelle Steiner, Theodore E. Stebbins, Gerard C. Wertkin

The publishers are indebted to Jay Tobler for his vital contribution to the shaping of this book. We would also like to thank Gabriel Catone and Thea Westreich for their generous assistance.

And Alan Fletcher for the jacket design.

Photographic Acknowledgments

Abby Aldrich Rockefeller Folk Art Center, Williamsburg, VA: 70, 87, 208, 345; Photography Ansel Adams. Copyright © 1998 by the Trustees of the Ansel Adams Publishing Rights Trust. All Rights Reserved: 7; © Addison Gallery of American Art, Phillips Academy, Andover, Mass./photo Greg Heins: 111; © Addison Gallery of American Art, Phillips Academy, Andover, Mass., All Rights Reserved. Museum Purchase (1938.67): 411; Collection of the Albany Institute of History & Art, gift of Catherine Gansevoort Lansing (1918.1.3): 462; Collection of the Albany Institute of History & Art, gift of Frederick Townsend/photo Joseph Levy, 1994: 331; Albright-Knox Art Gallery, Buffalo, NY, gift of Seymour H. Knox, 1952: 167; Albright-Knox Art Gallery, Buffalo, NY, gift of Seymour H. Knox, 1976: 251; courtesy Alexander Gallery, New York: 232; courtesy Mr and Mrs Arthur G. Altschul: 408; courtesy American Antiquarian Society: 281; Collection American Craft Museum, New York, gift of Johnson Wax Company/photo Eva Heyd: 15; Amon Carter Museum, Fort Worth, Texas (1966.1): 44; © 1990, Amon Carter Museum, Fort Worth, Texas, bequest of Eliot Porter. Courtesy of Scheinbaum & Russek Ltd., Santa Fe, New Mexico: 345; Collection of the Arizona State University Art Museum, gift of Oliver B. James: 176; Art Gallery of Ontario, purchase, 1969/photo Carlo Catenazzi: 271; The Art Institute of Chicago, gift of Ivan Albright, 1977.35: photograph © 1998 The Art Institute of Chicago, All Rights Reserved: 8; The Art Institute of Chicago, Friends of American Art Collection (1925.295), photograph © 1998 The Art Institute of Chicago: 160; The Art Institute of Chicago, Painting and Sculpture Committee Purchase (1964.39), photograph © 1998 The Art Institute of Chicago, All Rights Reserved: 118; The Art Institute of Chicago, Robert A. Waller Fund (1910.2), photograph © 1998, The Art Institute of Chicago, All rights reserved: 76; Hans Hinz-Artothek, Munich/Collection Ludwig, Kunstmuseum Basel: 272; Art Resource, New York: 35, 93, 116, 195, 220, 233, 277, 302, 377, 420; Art Resource, New York/National Museum of American Art, Smithsonian Institution: 172; Arts Club commission, Elizabeth Mabel Johnston Wakem Bequest Fund, 1942: 71; Copyright © 1985 Richard Avedon. All rights reserved: 27, 175; © 1998 Louis Bourgeois, courtesy Cheim & Reid, New York: 55; Bowdoin College Museum of Art, Brunswick, Maine, Museum purchase, anonymous gift: 244; Brigham Young University Art Museum, gift of Mr and Mrs O. Leslie Stone/photo David W. Hawkinson: 159; courtesy The Eli Broad Family Foundation, Santa Monica, California: 30, 250, 397; Brooklyn Museum of Art, Frank L. Babbolt Fund (66.85): 297; Brooklyn Museum of Art, gift of the Brooklyn Institute of Arts and Sciences (97.13): 178; Brooklyn Museum of Art, bequest of Edith and Milton Lowenthal (1992.11.6): 109; Brooklyn Museum of Art, gift of Mr and Mrs Alastair Bradley Martin: 110 (48.195), 359 (48.171); Brooklyn Museum of Art, Dick S. Ramsay Fund: 276 (40.339), 488 (42.45); Brooklyn Museum of Art, Dick S. Ramsay Fund and funds from Laura L. Barnes Bequest (67.61): 447; courtesy The Buhl Collection, New York: 430; Chris Burden: 66; © Harry Callahan, courtesy PaceWildensteinMacGill, New York: 72; Cape Ann Historical Association Collection (before restoration): 259; © Paul Caponigro: 73; Carnegie Museum of Art, Pittsburgh; Patrons Art Fund (39.7): 61; Carnegie Museum of Art, Pittsburgh, Patrons Art Fund (44.2)/photo Richard Stoner: 179; courtesy Leo Castelli, New York: 179; courtesy Leo Castelli, New York/photo © 1998 Dorothy Zeidman: 427; courtesy Leo Castelli Gallery, New York/photo Dorothy Zeidman: 474; © Cedar Rapids Museum of Art, Art Association Purchase: 497; © 1981 Center for Creative Photography, Arizona Board of Regents: 482; The Chinati Foundation, Marfa, Texas/photo © Todd Eberle, 1991: 236; © William Christenberry, courtesy PaceWildensteinMacGill, New York: 85; courtesy Christie's, New York: 289; Cincinnati Art Museum, gift of the artist (#1904.196): 132; courtesy William L. Clements Library, University of Michigan, Ann Arbor: 77; © The Cleveland Museum of Art, Hinman B. Hurlbut Collection (1133.1922): 38; © The Cleveland Museum of Art, purchase from the J. H. Wade Fund (1928.8): 385; Contemporary Collection of the Cleveland Museum of Art, Cleveland, OH, © 1998 Dedalus Foundation, Inc.: 307; courtesy C & M Arts, New York: 117, 431; Colorado Springs Fine Arts Center, gift of the El Pomar Foundation: 255; Columbus Museum of Art, Ohio, gift of Ferdinand Howard: 354; courtesy Paula Cooper Gallery, New York: 11, 54, 401; courtesy Paula Cooper Gallery, New York/photo D. James Dee: 416; courtesy of the artist and Paula Cooper Gallery, New York/photo Russell Kaye: 161; Collection of The Corcoran Gallery of Art, Washington, DC; Museum Purchase, William A. Clark Fund: 419; Collection of The Corcoran Gallery of Art, Washington, DC, Museum Purchase, Gallery Fund: 86, 305; courtesy of The Corning Museum of Glass: 448; Photo from the archives of Alma Gilbert, Cornish Colony Gallery & Museum: 333; E.B. Crocker Collection, Crocker Art Museum, Sacramento, CA: 181, 315; © 1970 The Imogen Cunningham Trust: 103; courtesy Curtis Galleries, Inc., Minneapolis: 101, 421; Dallas Museum of Art, Dallas Art Association Purchase: 209; Dallas Museum of Art, Foundation for the Arts Collection, gift of the artist: 311; Dallas Museum of Art, Foundation for the Arts Collection, gift of Mr and Mrs Frederick Mayer: 60; Dallas

512